From Eden to Eternity

THE MIDDLE AGES SERIES

Ruth Mazo Karras, Series Editor
Edward Peters, Founding Editor

A complete list of books in the series
is available from the publisher.

From Eden to Eternity

❧

Creations of Paradise in the Later Middle Ages

Alastair Minnis

PENN

UNIVERSITY OF PENNSYLVANIA PRESS

PHILADELPHIA

Published by
University of Pennsylvania Press
Philadelphia, Pennsylvania 19104-4112
www.upenn.edu/pennpress

Printed in the United States of America on acid-free paper
1 3 5 7 9 10 8 6 4 2

A catalogue record for this book is available
from the Library of Congress.
ISBN 978-0-8122-4723-7

For Felix

CONTENTS

Illustrations follow page 158

ILLUSTRATIONS

Creating Paradise

Very old are we men;
Our dreams are tales
Told in dim Eden
By Eve's nightingales . . .
—Walter de la Mare, "All that's past"[1]

Eden has given generations of writers the opportunity to imagine an alternative universe, a Utopia free from the brevity, and the pain and suffering, of what passes as "normal" life on earth. Here have been found the origins of human society itself; of sexuality, marriage, of man's relationship with nature, of property rights, of law and the proper regulation of the state. The prelapsarian world has been used to justify both egalitarianism and slavery, equality and inequality, and the dignity and inferiority of womankind—to name but a few of the compelling issues that have arisen in discussion of life in, and after, Eden.

The schoolmen of the later Middle Ages found in the state of innocence an enabling context, perhaps even a transformative space, for thought wherein the present-day situation of humankind could be set aside. It allowed them to engage in investigation free from the restrictions imposed by the conditions and demands of life after the Fall, in what generally was termed "the state of misery." To some extent, then, their Eden was a never-never-land or fantasy world, where speculation could be pursued without concern for practical consequence or contemporary relevance. When medieval theologians debated the nature of sex, horticulture, dining, worship, or just about any form of human activity before the Fall, they were talking about what

might have been rather than what actually *had* been at an actual historical moment. And imagining what human existence would have been like if Adam and Eve had observed the divine prohibition from eating the fruit of the Tree of Knowledge of Good and Evil, and the state of innocence had continued indefinitely—until God chose to elevate humankind to an even higher level of existence, thereby effecting the transition from Eden to eternity[2] with no intervening pain or suffering.

According to a long-standing tradition, Adam and Eve fell the very same day on which Eve was created.[3] "Why did they not in fact couple until they had departed from paradise?" asked the formidable—and, in medieval thought, ubiquitous—St. Augustine of Hippo (d. 430). He offers as the quick answer: "because no sooner was the woman made than the transgression occurred, before they came together."[4] So, then, our first parents had a very short space of time in which to get to know either their beautiful habitation or indeed each other. Was Adam in Eden long enough to have eaten from the Tree of Life? asked Peter Lombard (d. 1160) in his *Libri sententiarum*, which was to become the theological textbook *par excellence* of the later Middle Ages.[5] Perhaps he was: Eve was created from him, and he named all the animals, which would have taken some time to accomplish. But no one doubted that the tenancy of both humans together in paradise was of short duration—certainly too short for children to have been born. To quote Augustine again, "the happy life of the man and his wife in the fruitfulness of paradise . . . was so brief that none of their offspring came to any awareness of it."[6] So, then, as a fully functioning paradise, with its original complement of creatures (Adam and Eve included), the Garden of Eden did not last long. Therefore, comment about the conditions which prevailed therein was inevitably speculative, prefaced, whether explicitly or implicitly, with a perpetual "what if . . . ?"

On the other hand, the theologians regularly remembered Eden as they investigated certain crucial characteristics of humankind and of human society which self-evidently existed in the world after the Fall. If something was to be judged fundamentally and irrefutably human, it had to be found in Eden. This harking-back to paradise was essentially a search for origins: by finding the starting points of forms of behavior, ideals, and institutions, the theologians hoped to understand them better. The foundation of holy matrimony is a clear case in point—and particularly worthy of mention because its prelapsarian source has been noted in countless wedding services

from the earliest Christian era through the twenty-first century. According to the age-old doctrine, marriage was established before the Fall as a means of multiplying the human species. "To increase and multiply and replenish the earth according to God's blessing is a gift of marriage, and . . . God instituted marriage from the beginning, before man's sin, in creating male and female."[7] This imperative held good in the world after the Fall. But a second reason was then added: marriage became a "remedy" for lechery, a means of controlling and containing unruly sexual desire. "The true effect of marriage cleanses fornication and replenishes Holy Church with good lineage, for that is the end of marriage; and it changes mortal sin into venal sin between those who are married, and makes the hearts all one of those who are married, as well as the bodies."[8] Here I quote from *The Parson's Tale* of Geoffrey Chaucer (d. 1400), a treatise which stands in a long line of religious reference books and priests' handbooks. The way in which the aspirations of romantic love (termed *fin amor* in the High Middle Ages) have infiltrated the standard late medieval theology of marriage is particularly interesting.

"Allas, allas! That evere love was synne!" to quote another of Chaucer's characters, the Wife of Bath.[9] Love (though in a form unfamiliar to us) would not have been sin in the state of innocence. Inappropriate desire did not exist in Eden, because there the human body, including its genitalia, was well ordered by the rule of reason. Such was the opinion of St. Augustine,[10] indubitably the most influential of the Church Fathers who glossed the Book of Genesis—indeed, the saint wrote no fewer than three substantial accounts of Eden, including a magnificent literal/historical exposition (the *De Genesi ad litteram*), together with briefer treatments in works which also enjoyed a wide readership, particularly *De civitate Dei*. Augustine's statement that prelapsarian erections were no more pleasurable than the moving of one's hands or feet[11] was frequently quoted by his late medieval successors. But not everyone went along with it; they had contrary authorities at their disposal. Elaborating on Aristotle's *De animalibus*, Albert the Great, O.P. (d. 1280), says that "touch is surer in the human than in the brute beast," which is why human beings have more sexual pleasure than animals. "The pleasure of intercourse consists in touch," and "where there is a better and surer sense of touch, there is more pleasure."[12] Since in Eden, men's senses functioned in ways far more acute than they do now, does this not mean that the joy of sex was a feature of the land described by the Vulgate Bible as a *paradisus voluptatis*

(Genesis 2:8), a veritable "garden of delights"?[13] Some thinkers, including several of the most formidable of their time, were perfectly willing to countenance that idea. Speculation about prelapsarian love in particular and life in general was by no means monolithic during the medieval centuries, and certainly not monotonous. On the contrary, a rich array of attitudes—ranging from the sublime to the ridiculous, the compelling to the bizarre—may be discerned. In this book I hope to do justice to some of them.

The time frame with which I am primarily concerned extends from the 1220s until circa 1564, though significant materials from before and after those dates are cited on occasion. Earlier writings, including (indeed, especially) those of Augustine, are discussed in light of their subsequent significance. Chief among the later writings quoted is John Milton's *Paradise Lost* (completed 1658–63), which has proved particularly useful in posing and clarifying vital questions. The year 1564 saw the death of John Calvin, foundational theologian of the Reformation and progenitor of Puritanism, while during the period 1223–27 Peter Lombard's *Sentences* replaced the Bible in lecture courses in the faculty of theology at the University of Paris, a bold innovation attributed to Alexander of Hales, O.F.M. (c. 1185–1245). The *Sentences* was the authoritative textbook for the study of speculative theology until the sixteenth century; even the young Martin Luther (1483–1546) dutifully produced a commentary.[14] Its second book treats of the creation, posing a series of questions which were debated, sometimes with considerable vehemence, by generation after generation of scholars, in their *Sentences* commentaries, quodlibets, and *summae*. The answers offered by a representative range of those texts shall be considered below. Thomas Aquinas, O.P. (c. 1225–1274), will frequently be consulted on power, death, and the body in and after Eden—not least because in his *Summa theologiae* there are some surprises in store, or at least surprises to those who think of him simplistically as a gatekeeper of intellectual conservatism, a role he was assigned in the Counter-Reformation.

Indeed, the schoolmen seem to have claimed a kind of intellectual license when they discussed the world that would have been had the Fall not occurred, a world which existed only in the minds of fallen men. For example, the authors of the *Summa Alexandri* (the magnificent *summa* associated with Alexander of Hales)[15] felt free to write in some detail and with apparent enthusiasm about the manifold perfections of Eve. Eve was created "immediately" or directly by God, just as Adam was; God did not treat her as a second-rate creation by subcontracting the work (so to speak) to angels.[16]

Her nobility is her own; she is rightly celebrated as "the mother of all the living" (cf. Genesis 3:20).[17] This accolade is all the more honorific if the circumstances of the state of innocence are recalled. Originally marriage was a more glorious thing than virginity—for in Eden virginity would not have had the virtuous status it enjoyed after the Fall, and Eve would have performed the natural work of marriage by being ever fecund.[18] Presumably the crucial idea here is that only the fallen body is in need of mortification,[19] and for a postlapsarian woman to reject the temptations of the flesh—most obviously by entering a religious order—is therefore a virtuous act indeed.

But was Eve's degree of perfection such that Adam's "seed could have been introduced" into Eve's womb "with no loss (*sine ulla corruptione*) of the wife's integrity"[20]—in other words, that in the act of conception Eve's hymen would have remained intact? Augustine's suggestion to that effect, as quoted here, troubled some of his successors, not least because it seemed to imply that Eve's body shared a special privilege and status with the perpetually virginal body of the Virgin Mary. St. Bonaventure of Bagnoregio, O.F.M. (d. 1274), grumbles about the issue not being a very useful one to discuss, but since St. Augustine had brought it up he feels obliged to do so.[21] His basic response is that, had Eve remained corporeally intact, Adam could not have had sexual relations with her. The phrase "corruption of integrity" may be understood in three ways. It can refer not only to the physical "opening of the womb" (*claustrorum apertionem*) but also to the experience of pain (*poenalem passionem*) and filthy pleasure (*foedam delectationem*). "The first belongs to nature"—meaning that it is a natural process—and quite appropriate to the initial paradise. But the second and third are features of the fallen world, associated with punishment and the corruption brought about by vice.[22] If Adam had engaged in sexual intercourse with his wife in Eden, Bonaventure explains, her womb would indeed have opened, "yet there would not have been the suffering of pain nor foul delectation"—and therefore to that extent her integrity would have remained intact, her virginal dignity preserved even though, in simply physical terms, she had ceased to be a virgin.[23] Thus Eve is shown to be quite unlike the blessed Virgin. Mary's conception of Christ was unique, proper to her alone, "a miracle . . . above nature and contrary to nature," whereas any "commingling"[24] between Adam and Eve would have followed the regular course of nature. Things may have deteriorated since the Fall, but, in this respect at least, the mechanics of intercourse have remained the same as they were designed to be in Eden. At least, according to Bonaventure.[25]

Such speculation was conducted in the name of scientific research (as understood within scholasticism), all perfectly proper within the social confines of the schools. What layfolk were to be told was a different matter; their weak and untrained minds could not be expected to cope with theological complexities, and the possibility of heresy was an ever-present danger. However, a substantial corpus of "vernacular"[26] and/or revisionist discourse concerning the beginnings of human history did develop in Western Europe. At one end of the scale there are amplifications of the Genesis narrative which add individually modest but collectively significant amounts of detail, as when, in the *Speculum humanae salvationis* (written originally in Latin verse during the period circa 1310–24 but soon translated into the major European languages), Eve's deceptive eloquence is emphasized, even as its author admits he has no hard scriptural support for this accusation. To her sin of eating the apple, the woman added another one—she encouraged Adam to eat also, using "glosing" (flattery, cajolement).

For thogh the Bibles text apertly noght it write,	*openly*
No doubt sho broght him inne with faging wordes white.	*beguiling*
O man, be warre in this of wikked wommans glosing,	
If thow passe wele that paas sholde it no little thing.	*situation*
Adam, that noble man, loke, and the stronge Sampsoune—	*behold*
David, Gods hertes choise, loke, wisest Salomoune—	
Sen thus stronge men and wise eschaped noght wommans arte,	*escaped*
If thov be nothink swilk, in tyme ware at thi parte.	*not at all like that*
	[i.e., strong and wise],
	be on your guard while there's still time

(355–64)[27]

At the other end are found the radical inversions characteristic of the *commendationes mulierum*, including the *Declamatio de nobilitate et praecellentia fœminei sexus* of Henricus Cornelius Agrippa (1486?–1535), theologian, astrologer, and alchemist. Whereas in the *Speculum humanae salvationis* the noble Adam is the victim of Eve's wheedling words (and history repeats itself in the cases of Sampson, David, and Solomon), in the *Declamatio* Eve—at once ignorant and superlatively excellent—is the victim of Satan's deceit: "God did not punish the woman for having eaten, but for having given to the man the occasion of evil, which she did through ignorance, tempted as he was by the devil. The man sinned in all knowledge, the woman fell into error

through ignorance and because she was deceived. For she was also the first whom the devil tempted, knowing that she was the most excellent of creatures."[28] Agrippa reinforces that final point by insisting that it was Eve's excellence which provoked the tempter to direct his envy against her alone.

We shall be hearing more of Agrippa's contrarian testimony later. My main interest, however, is in what Latin scholasticism (and the larger culture it influenced) had to say about Eden as an alternative world and as the original locus of the principles governing human nature, behavior, and aspiration, all of which came to enjoy their full fruition and perfection in that paradise superior to Eden, the land of the blessed, which they called the *patria* (henceforth translated as "homeland," to avoid the unwanted baggage associated with the term "fatherland"). When elite theologians scanned the Genesis account of creation, how exactly did they read it, what hermeneutic techniques did they bring to bear? While entering the caveat that different methods of reading Eden are characteristic of different times, places, and schools of thought, it may be noted that a remarkable consensus emerged in respect of the fundamental principles, well summed up as follows: "paradise . . . is not to be understood either solely in a literal way, nor solely in a figurative way: it is to be understood in a literal and figurative way at one and the same time."[29] This statement is from the *Hexaëmeron* commentary of Robert Grosseteste (c. 1170–1253), who served as *lector* to the Oxford Franciscans during the period 1231–35 and subsequently was elected Bishop of Lincoln. It is heavily dependent on St. Augustine's extensive discussion, in the eighth book of *De Genesi ad litteram*, of the problems involved in interpreting Genesis.

Augustine had identified three basic ways of reading paradise: taking it only in "the literal material sense (*corporaliter*)," taking it "only according to the spiritual sense (*spiritualiter*)," and taking it in both senses, reading one and the same text in different ways.[30] Though Adam can stand for something apart from himself, as when St. Paul identifies him as the form of the one to come, Jesus Christ (cf. Romans 5:14), nevertheless we are to understand the creature made from mud "as a human being set before us in his own proper nature, who lived a definite number of years and after producing a numerous progeny died just as other human beings die" (here Augustine is talking of the fallen Adam, obviously). Similarly, the paradise "in which God placed him" is to be understood as "quite simply a particular place on earth, where the man of earth[31] would live." Augustine distinguishes between "the figurative kind of language (*genere locutionis figuratarum rerum*)" found in the Song

of Songs and the narrative method (*narratio*) used in Genesis, which "quite simply tells of things that happened (*omnino gestarum*)" and therefore is comparable to the books of Samuel and Kings.[32]

Those who "are not prepared to have paradise understood literally and properly, but only figuratively (*non proprie, sed figurate paradisum intelligi volunt*)," are then criticized.[33] Augustine expresses some surprise at their inability to understand it as "a most delightful place, that is, shady with groves of fruit trees and extensive too and rendered fertile by a huge spring."[34] Surely such readers could have learned from their own experience of, for example, seeing "many tracts of grassland turn into woods without any human labor, just by the hidden work of God." Here Augustine is referring to what nowadays might be called the natural process whereby trees grow in grassland, quite transforming the landscape. In his view, such a transformation should give observers some insight into the way in which God could create the beautiful landscape of paradise. But some people, it seems, are unable to conceive of things "which do not meet the gaze of eyes fixed on the ordinary course of nature"—that is, phenomena that go far beyond those which are visible in the natural world that we experience nowadays.[35] Grosseteste backs up this Augustinian observation with the following remark: "You should consider that the first things have to be unusual; nothing can be so lacking in precedent or parallel in the whole world, as is the world itself. One should not believe that God did not make the world merely because he does not make worlds now, or that he did not make the sun because he does not make suns now."[36] God's first creation was unprecedented, unthinkable, since before it came into being there was, quite simply, nothing like it. And the fact that God makes neither worlds nor suns nowadays does not mean that he did not make them then, in the manner described in Genesis. (This is, of course, only a "fact" within the Aristotelian/Ptolemaic theory of a static universe, which denied the ongoing creation of other worlds and suns that later science has proved to us.) Little wonder, then, that some people should have a problem in believing that the Genesis account of creation is to be understood literally and historically throughout, no matter what spiritual sense may be discerned therein. But this is precisely what we should believe, according to Grosseteste *cum suis*.

Augustine was willing to admit that, once upon a time, he himself had experienced such a problem. When he was writing on Genesis against the Manichees, that book's openness to comprehensive reading *corporaliter* had not yet dawned upon him.[37] On that occasion he had said that, where no

literal understanding seems possible, it may be supposed that certain things "have been set forth figuratively and in enigmas," in order to ensure that the text "may be understood in a manner that is pious and worthy of God."[38] Augustine justified such exegesis with reference to the authority of the Apostles, "by whom so many of the enigmas in the books of the Old Testament are solved." Now, however, writing in *De Genesi ad litteram*, he is confident that all of Genesis can sustain literal exegesis. "It has pleased the Lord that after taking a more thorough and considered look at these matters, I should reckon (and not, I think, idly) that I am able to demonstrate how all these things were written straightforwardly in the proper, not the allegorical mode (*secundum propriam, non secundum allegoricam locutionem*)."[39]

These hermeneutic reflections on the interpretation of Genesis were quoted again and again as Augustine's successors justified the provision of extensive readings both *corporaliter* and *spiritualiter*. For instance, in his *Hexaëmeron* commentary Grosseteste presents himself as dealing with the text "according to the literal sense" as far as he can (meaning, according to the best of his ability) before moving to "make some remark on the allegorical and moral senses of it, that fit with faith and morals."[40] A rich array of allegorical possibilities for paradise are provided, including: "the present church on earth and the future church in heaven, or both together"; the faithful soul, likened in Isaiah 58:11 to "a watered garden"; "the blessedness and delightful rest of the human being" in the Heavenly Paradise;[41] "intellectual vision, by which vision the truth is seen";[42] and "sacred Scripture," in which all true pleasures are to be found.[43]

On occasion certain theologians were alleged to have denied the material existence of Eden, and taken to task for it—as when Thomas Aquinas criticized the Alexandrine exegete Origen (c. 185–254) for positing that paradise was not a corporeal place, and that all that was said about it was allegorical discourse, to be interpreted spiritually.[44] Origen's exegetical error served as an awful warning. The general consensus among the schoolmen was that non-literal readings of Genesis were perfectly possible, and indeed desirable, providing they were not taken to extremes. Even the greatest of all the late medieval literal commentators on Genesis, Nicholas of Lyre, O.F.M. (c. 1270–1349), offered a moral reading of the text in his *Postilla moralis*, a collection of tropological interpretations written as a supplement to his monumental *Postilla litteralis*. And despite the Reformation's valorization of the literal sense of Scripture—Luther memorably condemned allegorical exegesis as "tomfoolery, however brilliant the impression it makes"[45]—figurative reading

of Genesis survived, particularly in the contexts of preaching and private devotion.[46] Much of the material in John Bunyan's *Exposition on the First Ten Chapters of Genesis and Part of the Eleventh*, published posthumously in 1691, would not look out of place in Grosseteste's *Hexaëmeron* commentary. For example, Bunyan interprets Genesis 2:8 ("And the Lord God planted a garden eastward in Eden") as follows: "Thus the Holy Ghost speaks clearer and clearer; for now he presents the church to us under the similitude of a garden, which is taken out of the wide and open field, and inclosed; 'A garden inclosed is my sister, my spouse'; a garden inclosed, 'a spring shut up, a fountain sealed' (Cant. 4:12); and there he put the man whom he had formed. An excellent type of the presence of Christ with his church. (Rev. 1:12, 13)."[47] The Catholic schoolman and the Nonconformist polemicist shared the belief that Eden could appropriately be read in terms of Christ and His church—though they would have argued about who its true members were.

So, then, what sort of literal picture of the Garden of Eden was current in the later Middle Ages? In terms of artistic visualization, excellent examples are afforded by Plate 1 (the work of the incomparable Simon Marmion, c. 1425–89) and Plate 2 (from a copy of Nicholas of Lyre's literal postil on Genesis, made during the period 1395–1402 and bearing the arms of Gian Galeazzo Visconti, first duke of Milan). In terms of standard theology, the account given at the beginning of John Wyclif's *De statu innocencie* (dated mid-1376) is quite typical, and he shall be our main guide, in the following pages, to mainstream thought about the first paradise. That may seem a strange role in which to cast a turbulent priest who had 267 articles from his writings anathematized at the Council of Constance in 1415, and his physical remains exhumed, burned, and scattered on the River Swift in 1427. But the traditional nature of the material in question, together with the dexterity with which it is expressed, justifies this decision—and elsewhere in the present book (in Chapter 2) some of the more radical opinions of this supposed "morning star of the Reformation" will be given their due.

Wyclif is confident that the Fall was not due to external influences within the earthly paradise—whether of climate or other physical conditions.[48] No wild or dangerous beasts threatened humankind, no wicked man nor even the devil himself (at least, not yet). The innocent had nothing to fear save God alone—and that took the form of the fear which a son has for his father—meaning fear of a fitting kind, the consequence of an unequal hierarchical relationship. The air he breathed was the most temperate possible. No wise man ordains an end without providing the requisite means to that end;

God had ordained the immortality of man if he persevered in innocence, so of course the sum of all wisdom provided the species with temperate air at the outset. Paradise was ideally suited to human life, enjoying a temperate location (being neither too hot nor too cold), and being sufficiently spacious for the race of men which would have been generated in this fertile place. Wyclif generalizes from this situation the proposition that the just have dominion over every part of the world, and nothing divinely bestowed upon them is superfluous. Thus it was in Eden—a world appropriately designed to accommodate the human race as God had planned it.

In paradise there was no hard manual labor to be done, and hence no physical fatigue, Wyclif assures us.[49] As far as food was concerned, there was neither deficiency nor superfluity; man was provided with everything necessary for his existence, and his appetite was ruled by reason. Wyclif refuses to speculate on how much, when, and how often during the day food was consumed in Eden; it is enough for us to know that the matter was well regulated. It is probable that humankind lived wholly on the fruits which grew in paradise. Whether water or fruit juice was drunk is unclear, but we can be sure that man imbibed nothing that was artificial. This discussion is permeated by notions of the classical "Golden Age" which the Middle Ages inherited primarily from Virgil (*Georgics*, iv) and Ovid (*Metamorphoses*, i.113–43), well summed up in Boethius's *De consolatione philosophiae*, II met. 5 (itself heavily influenced by Ovid):

O happy was that long lost age
Content with nature's faithful fruits
Which knew not slothful luxury. . . .
A grassy couch gave healthy sleep,
A gliding river healthy drink;
The tallest pine-tree gave them shade. . . .
War horns were silent in those days
And blood unspilt in bitter hate . . . (II, met. 5)[50]

A striking vernacular version of this unspoiled world is included in Jean de Meun's continuation (c. 1269–78) of the highly popular *Roman de la Rose*, a poem which is extant in around 320 manuscripts and manuscript fragments. Here the Golden Age is adapted to suit the needs of a speech by Ami (the lover-narrator's friend and adviser), who conjures up a fantasy world wherein love, and all other human activity, was free from discord and strife. "In the

days of our first fathers and our first mothers, . . . love was loyal and true, free from covetousness and rapine, and the world was a very different place." Men were "not so fastidious in the matter of food and dress," and instead of eating "bread, meat, and fish, they gathered acorns in the woods," and "sustained themselves abundantly with the honey that ran down the oak-trees and drank pure water, without asking for spiced or aromatic wine (*sanz querre pigment ne claré*)." The earth had not yet been ploughed, but was "just as God had prepared it"; of its own accord it produced "the things with which each man fortified himself." People "wore shaggy skins and made garments from wool (*fesoient robes des laines*), just as it came from the animals, without dyeing it with plants or seeds," and lived in the woods, where "the green trees spread the tents and curtains of their branches in order to protect them from the sun. There, these simple, secure folk would have their dances, games, and gentle amusements (*leur queroles, leur jeus et leur oiseuses moles*)," enjoying their pleasures "free from every care" (8325–35, 8346–59, 8405–14).[51]

Some of these details are beautifully illustrated in Plate 3 (from London, British Library, MS Harley 4425, fol. 75v, a copy of the *Rose* produced in Bruges c. 1490–c. 1500). Underneath the protective tents and curtains of large tree branches, a primitive people are shown wearing garments of simple, undyed wool (*robes des laines* rather than hairy animal skins) and expressions of simple contentment. On the left-hand side of the picture, men are harvesting acorns, while on the right, a group of men and women are engaged in some sort of "gentle amusement," perhaps a version of the aristocratic pastime known as *Le jeu du Roi qui ne ment* or *Le jeu du Roi et de la Reine*, where a "king" or "queen" would be crowned as the judge who searches out the truth in a debate about matters of love.[52] This is a highly appropriate entertainment for a Golden Age in which, as Jean de Meun puts it, "people enjoyed the games of love (*li jeu d'amors*) without greed or violence" (8403–4). Presumably the poet is referring metaphorically to the actual practice of sexual love, but the Bruges artist has offered a literalized rendering.[53] Clearly, all of this parallels, or echoes, or post-figures, the Garden of Eden.

In an extraordinary passage in his *Purgatorio,* Dante Alighieri (1265–1321) seeks to explain the resemblance between Christian and classical paradises by having an Eve-like figure named Matelda,[54] who acts as the Dante-persona's hostess during his progress through a vision of Eden, refer to those pagan poets who sang of the Age of Gold and its felicity. Perhaps they were dreaming of this very place, she suggests; here is the primal innocence and sweetness of which each one speaks.

"Quelli ch'anticamente poetaro
l'età de l'oro e suo stato felice,
forse in Parnaso esto loco sognaro.
Qui fu innocente l'umana radice;
qui primavera sempre e ogne frutto;
nettare è questo di che ciascun dice."
(*Purgatorio*, XXVIII, 139–44)[55]

["They who in olden times sang of the Age of Gold and its happy state perhaps in Parnassus dreamed of this place. Here the root of mankind was innocent; here is always spring, and every fruit; this is the nectar of which each tells."]

On this reckoning, Eden is the *fons et origio* of all subsequent imaginations of an earthly paradise.

Wyclif's vision of Eden lacks any comment about song, understood either as rustic *jeu* or classical *carmen*; he and some of his followers were remarkably dour on the topic of religious music. Rather he notes that in the initial paradisal state, healthy digestion was the norm, and man had innocent sources of pleasure, as when he meditated upon his certain beatitude without the prospect of fear or oppression.[56] The liberal or mechanic arts were not studied, there being no reason for them to exist in paradise—which was quite free of the syllabus of the trivium and the quadrivium. Only one language, Hebrew, sufficed, and this maintained its status until the building of the Tower of Babel. But now, alas, men babble in different languages under an alien sky.[57] According to the philosophers, every thirty miles a different language is spoken, and according to the experts (*doctores*) there are seventy-two languages in total, the same number as there were sons of Noah.

Handicrafts were not necessary for man originally, Wyclif continues.[58] What would have been the use of a house or clothing or other such trappings, when people went around naked? (Primitive clothing, of the kind illustrated in Plate 3, was worn only after the Fall; cf. Genesis 3:7, "And the eyes of them both were opened: and when they perceived themselves to be naked, they sewed together fig leaves, and made themselves aprons").[59] What need for agriculture when the fruits of paradise were available to all? What need for arms and harness when there was no physical strife? There would have been no legal system; all disagreements and disputes are a result of the Fall. Wyclif then raises the objection that nature has formed man more helpless

than the beasts, who can protect themselves by means of fleeces, feathers, claws, beaks, teeth, or horns.

This protest about the helplessness of humankind has a long and tortuous history, with Shakespeare's formulation (itself heavily influenced by Michel de Montaigne's) arguably being the most memorable: "Is man no more than this? Consider him well. Thou ow'st the worm no silk, the beast no hide, the sheep no wool, the cat no perfume. . . . Thou art the thing itself; unaccommodated man is no more but such a poor, bare, forked animal as thou art" (*King Lear*, III.iv). But, within the context of discussion of the state of innocence, it causes Wyclif little difficulty. This is a problem only in the postlapsarian world, he explains; things were different in Eden. The helplessness of mankind was not a feature of his first creation, but a punishment for his transgression.[60] Generally speaking, in Eden the body (including the sexual organs) obeyed the soul, just as the soul obeyed God, and all the powers of body and soul worked in harmony.

Had the Fall not occurred, what would have happened to Adam and Eve; what sort of future could they and their large family have expected? Human bodies would have developed to become as the bodies of the blessed, Wyclif explains. And, when they had attained their full stature, God would have effected their transference to the Heavenly Jerusalem.[61] Once again, Wyclif's account is quite typical of his time. Peter Lombard had stated that, from the state of innocence, humankind "was to be transferred with his entire posterity to a better and worthier state, where he would enjoy the celestial and eternal good which had been prepared for him in the heavens."[62]

. . . so heo scholden to heuene wende,	*journey*
To the blisse withouten ende,	
Withouten drede of dethes dome.	*the sentence of death*
And al the ofspring that of hem come,	
From that ilke day to this,	*same*
Scholde so steyghen to heuene blis,	*ascend*
To the heritage of wynne and wele,	*joy and wellbeing*
Among the murthe of aungeles fele.	*pleasure, many*
(159–66)	

Thus the process of ascension is described in the Middle English *Castle of Love* (c. 1300).[63] All earthly things would be left behind, even the pleasures of the earthly paradise.

What pleasures *were* those, exactly? "While resident in paradise" man "led a life of bliss that was rich in every respect," according to St. John of Damascus (d. 749).[64] Augustine was similarly confident, exclaiming, "If men then had feelings of the same sort as we have now," how blessed would they have been "in that place of unspeakable bliss that was Paradise."[65] Both these authorities are cited in Thomas Aquinas's discussion of the extent of man's spiritual happiness in Eden.[66] But what about corporeal happiness? Given the strong sexual desires which men have now, were they part of that "unspeakable bliss" which prevailed when the world was young? Having extolled the beauties of Adam and Eve—

Als cunnyng Clerkis dois conclude,	*As learned clerks*
Adam preceld in pulchritude	*excelled*
Most Naturall,—and the farest man	
That euir wes, sen the warld began,	
Except Christ Iesu, Goddis Sonne,	
To quhome wes no comparisone;	*whom*
And Eua, the fairest Creature	
That euer wes formit be nature. (791–98)[67]	*formed*

—the Scottish courtier poet Sir David Lindsay (c. 1486–1555) puts the question: in light of this mutual "pulchritude," was it the case that "Thay luffit vther Paramour" (836–37), loved each other sexually?[68] "No maruell bene thouche swa suld be" (838); that would hardly be a surprise. And for a man there is no greater pleasure than to see his lady stand unashamedly naked before him, ready to satisfy his desires.

Quhat plesour mycht ane man haif more	*What greater pleasure for a man*
Nor haif his Lady hym before,	*Than to have*
So lustye, plesand, and perfyte,	*pleasure-loving/vigorous, pleasing,*
Reddy to serue his appetyte! (801–3)	

The schoolmen were confident that no such passionate encounter had taken place before the Fall. Genesis 4:1 proved it: "Adam knew (*cognovit*) Eve his wife: who conceived and brought forth Cain." So, evidently Adam had not sexually "known" Eve until that moment.[69] Why not? According to Augustine, this was either because they had been cast out of Eden immediately after the woman's creation and therefore had insufficient time to do the deed, or

because God had not yet ordered them to act in this way (such an order perhaps being necessary at a time—pace Lindsay's ardent fantasy—before sexual desire served as a major driving force).[70] But, if they had not fallen, would they have had sex and, if so, would they have enjoyed it? Augustine thought paradisal sex would have been without pleasure (as already noted). But others disagreed. This was a complicated and controversial issue, and will be examined at some length below.

Substantial discussions were also offered of the power relations which existed between Adam and Eve, in respect of their relative degrees of nobility, dignity, strength, and so forth. This included examination of the nature of Adam's supposed sovereignty over Eve, as the female of the species and as a sociopolitical subject—or was she a co-ruler of paradise? Furthermore, had the state of innocence continued indefinitely, would men have lived as equals and with goods held in communal ownership, or would a managerial class have existed even then, with the green shoots of capitalism being visible? Opinion was sharply divided. And raised issues of grave social consequence. Was it possible to create an Eden in this miserable world of ours; could a community of divinely chosen souls live in a state approximating to Adam's primeval innocence?

Our consideration of power in paradise will also involve an examination of scholastic doctrine concerning humankind's dominion over the animals and, indeed, over vegetable life. Exactly what sort of "service" were the lower animals supposed to render to "the most perfect of all animals,"[71] man? What exactly were they *for* in Eden, since Adam and Eve did not need them for clothing (being unashamed of their nakedness) or for food (since they fed on the fruits of paradise) or for transportation (their bodies being strong enough to get them around—and certainly stronger than present-day human bodies)? Bonaventure defends animal existence on four counts.[72] In the first instance, their obedience to man showed his power (*imperium*) over the natural world in general. Second, they did much to make man's dwelling beautiful, for Eden was decorated with an abundance not only of trees but also of animals. Third, they were intended to excite the human senses, so that man might see in their "diverse natures . . . the many forms of the Wisdom of their Creator." (Aquinas puts this a little differently: man needed animals so he could acquire knowledge "of their natures" by experience [*experimentalem cognitionem*], the point presumably being that they were there to educate the first humans about God's grand design).[73] Fourth, animals were supposed to move the *affectus* (disposition, will) of man, so that when he saw them, according to

the *rectitudo* (rectitude, uprightness) of their nature, running around and loving in accordance with their natures, he would be moved to the love of God. There, it is tempting to say, speaks a follower of Francis of Assisi, who is credited with having preached to the birds and even to wildflowers.[74]

So, then, our first parents were vegetarians. The testimony of Genesis 3:2 ("Of the fruit of the trees that are in paradise we do eat") was hard to read otherwise. According to Grosseteste (quoting St. Basil "the Great" of Caesarea, d. 379), "if we want to lead a life that resembles that of paradise" we too can be vegetarians, "and eat fruits and seeds and the shoots of trees."[75] We should not thereby hate animals, Grosseteste adds hastily, "because of the one who created them." Yet we should not seek to please our flesh by eating their flesh. However, late medieval theologians in general had few, if any, problems with the contrast between the present-day habit of eating flesh and the absence of that practice before the Fall.

But did that mean that all the animals of Eden were also limited to a vegetable diet? Some thought so, but many others—Aquinas and Bonaventure among them—were quite willing to countenance the view that certain animals had preyed on each other for food, then as now.[76] That idea was not confined to the schools; it bursts into vivid, shocking life in the "Eden" panel of that most ambitious and difficult of all the paintings of Hieronymus Bosch (c. 1450–1516), the triptych usually known as *The Garden of Earthly Delights* (Plate 4a). Here a lion, far from lying down with a lamb,[77] is shown as eviscerating a deer, while a large cat (perhaps a cheetah) is carrying a lizard in its jaws, and exotic (indeed fantastic) birds devour tiny amphibians (see Plate 4b).[78]

Which raises the problem of death in paradise. If animals ate each other, clearly they inflicted death upon each other. But death was a punishment for sin, brought into the world by man's disobedience. So why, then, did animals have to die, since they were innocent of transgression? A major conundrum, which prompted much tortuous discussion. And what would have happened to the animals had the state of innocence continued indefinitely? Wyclif's *De statu innocencie* includes the confident assertion that, when the perfected bodies of humankind were translated into heaven, the earth would then have been denuded of its animal and plant life, since following the departure of humankind those other parts of creation would have lost their very reason for existing.[79] That was the usual consensus. Which may be better understood if it is placed in the context of the belief that there was no place for animal life in the "new heaven and new earth" (Apocalypse 21:1)[80] believed to come

into being after the Last Judgment and Bodily Resurrection. For they lacked rational souls.[81] There is no place for plants there either. "Dumb animals, plants, and minerals, and all mixed bodies" are "corruptible both in their whole and in their parts," declared Aquinas.[82] Thus they cannot possibly remain following the *renovatio* of the universe at the General Resurrection.

Such grim consequences of man's dominion over nature have been challenged by some, including those two founding fathers of the Protestant Reformation, Martin Luther and John Calvin. Luther felt that, without its "sheep, oxen, beasts, and fish," the "earth and sky or air cannot be," and Calvin also conceded the future existence of plants and animals—though in "perfect" form, whatever that meant (he admitted he did not know).[83] Both seemed to have envisaged a "new earth" which, while of no actual use to incarnated souls, was an object of contemplation which they all could enjoy, if from an aloof distance. In any case, Luther and Calvin wrote very little on the subject. Far more thoroughgoing was John Wesley (1703–91), the pioneer of Methodism, who asserted that, at the General Resurrection, the entire animal world will be restored to life, in forms far superior to the ones they occupy at present.[84] Medieval theologians were not unaware of arguments of at least some of those kinds, but they rejected them as blurring necessary dividing lines between mankind and inferior life forms, and as threatening to reduce man to his merely "animal" (i.e., material, physical, sensible) nature.

The crucial, vast, fundamental, and intractable problem with which they were obliged to grapple with was that, at Judgment Day, the body comes back. And for the elect, it comes back in a much improved (or "glorified") state—which means that it no longer needs the services rendered by animals and plants, and is relieved of the animal necessities of eating, drinking, and sexual intercourse. It will nevertheless be recognizable as one's own body and no one else's.

> At the round earths imagin'd corners, blow
> Your trumpets, Angells, and arise, arise
> From death, you numberlesse infinities
> Of soules, and to your scattred bodies goe,
> All whom the flood did, and fire shall o'erthrow,
> All whom warre, dearth, age, agues, tyrannies,
> Despaire, law, chance, hath slaine, and you whose eyes,
> Shall behold God, and never tast deaths woe.[85]

The expression of these commonplaces by John Donne (1572–1631) is unsurpassed. His medieval predecessors would have endorsed everything in this poem, including its opening reminder that the earth's four corners are a mere fantasy, since belief in a spherical earth[86] formed part of Aristotelian/Ptolemaic cosmological doctrine. However: when those "scattered bodies" reconstituted, when each and every soul was reunited with its own specific (though bettered) body, what sort of sensory perceptions would they have? Would they, how could they, feel, taste, see, hear, smell? What could they feel, taste, see, hear, smell? According to the teachings of Aristotle (whose impact on late medieval thought on this subject was immense), human knowledge is gained through sense-perception, on which all our learning and understanding is dependent. But according to Neoplatonism (endorsed in some measure, and adapted to Christian needs, by Augustine)[87] the human soul is "fastened to a dying animal," the body, that "knows not what it is"—which prompts the question, how can any vestige of man's animal body possibly survive, what function could it possibly perform, in the afterlife?[88]

All of these issues will be addressed in this book. Suffice it to say here that, according to the schoolmen, some parts of nature (the sun, moon, stars, planets, and spheres) will indeed participate in the process of renewal, and the intellectual and spiritual processes which they once advanced in human beings will definitely continue, albeit through interaction with angels and the glorified bodies of the blessed, including that of Jesus Christ Himself. And sense will survive. Not quite as we know it, admittedly, but it would seem that the abnegation of the flesh which was recommended for the spiritual progress of *homo viator* (man as wayfarer) as he journeyed to his heavenly home will be redundant following the General Resurrection, even as it was in Eden. Which raises fascinating issues about the relativism of virtue, *sub specie aeternitatis*.

Aristotle was the thinker whose influence, more than that of any other mortal, got the medieval schoolmen to this pass. The intellectual tensions between Aristotelian and Neoplatonic methodologies of describing life after (and before) death will be a recurrent theme in this book, as the differences between various medieval creations of paradise, both prelapsarian and post-resurrection, are considered. In one sense, my subject is a narrow one: that part of the Genesis narrative which describes the earthly paradise together with those few biblical passages which anticipate (or were believed to anticipate) the paradise which will emerge following the General Resurrection. In

another, it is a vast one, inasmuch as it attempts to comprehend aspects of
the elaborate intellectual structures which Western Christian thinkers built
upon them, with the assistance of other ancient works now deemed apocry-
phal, and a formidable commentary tradition which went back to the church
fathers.

The scriptural texts of the late medieval biblical canon were respected as
foundational; here was God's plenty, food to nourish the souls of His crea-
tures, no matter what difficulties that consumption presented. Indeed, in the
preface to his widely read *Historia scholastica*, Peter Comestor (d. 1178/9)
likened the Bible to a dining room in which the blessed words of divine
doctrine were served as delightful dishes. The fifteenth-century English trans-
lation renders this passage as follows: "Now hath He chose Holy Screptur to
be his cenacle [dining room], wherin his royall deyntes shal be distrubid and
depertid, that is to sey, 'Fedynge euery creatur with the blissid wordis of his
doctrine,' the which we fynde wrytyn in his cenacle, that is to sey, Holy
Screpture, wherof God, Makere of hevene and erth, is funder and bygyn-
ner."[89] Other books were celebrated as alternative sources of information, of
course, but—as Robert Grosseteste put it—Scripture offers "in yet more
abundance" things that are taught elsewhere, while also containing "things
that are never taught anywhere else, but which are learned from Scripture
alone, in marvellous sublimity and marvellous lowliness."[90] This was regarded
as particularly true of what the Bible said about the origins and the ultimate
destiny of the human race.

Yet that grand narrative was incomplete, with many stories left untold, an
abundance of questions unanswered. Because of the irreducible otherness of
paradise, speculation based on present-day conditions inevitably fell short.
"We do not, indeed, now have any example by which to demonstrate how
this might have come about," said Augustine, recognizing the difficulty of
understanding how, before the Fall, marriage "would have produced children
to be loved, but without the shame of lust."[91] Faced with conflicting opinions
from Augustine and Jerome concerning how exactly, at the General Resurrec-
tion, God shall treat those who never tasted death's woe, Peter Lombard
remarked: "as to which of these may be more true, it does not pertain to
human judgment to define it."[92]

Such admissions of inadequacy are a regular feature of medieval inquiries
into the state of innocence, in both its original and ultimate forms. The
Middle English poem known as the *Cursor Mundi* (written c. 1300) calls on
God Himself to express the inexpressibility of life in Eden:

Is no man with herte to thenke
Ne clerke that may wryte with enke *ink*
The mychel ioye that hem is lent *great, given*
That done here my commaundement . . . (640–50)[93]

But, alas, Adam and Eve broke God's "commaundement." And present-day
men and women lack a sufficient number of examples, parallel experiences,
and helpful analogies, to work from, as they attempt to "write with ink"
what it must have been like, for however brief a time. This problem of
inscription and representation—a major concern throughout the present
book—was even more acute in respect of life after death. In Canto X of the
Paradiso, the Dante-persona finds himself in the sphere of the sun, sur-
rounded by spirits of such brilliance that their description defeats all human
ingenuity,[94] art, and skill:

Perch' io lo 'ngegno e l'arte e l'uso chiami,
sì nol direi che mai s'imaginasse;
ma creder puossi e di veder si brami.
E se le fantasie nostre son basse
a tanta altezza, non è maraviglia;
ché sopra 'l sol non fu occhio ch'andasse. (43–48)

[Though I should call on "genius," art, and practice, I could not tell it so that
it could ever be imagined; but one may believe it—and let him long to see it.
If our fantasies are low for such a loftiness, it is no marvel, for our eyes never
knew a light brighter than the sun.][95]

Here Dante is, of course, dealing with disembodied spirits, saintly souls resid-
ing in heaven awaiting the restoration of their bodies. Their *altezza* is beyond
our normal *imaginatio* or *phantasia*, the image-making faculty of the human
[mind] without which it cannot think (according to the Aristotelian models
of perception and knowledge-making current in scholasticism). Later Dante
asserts that, when those spirits rejoin their bodies, the resulting composites
will shine even more brilliantly than separated souls alone can shine in heaven
(cf. *Paradiso*, XIV, 43–51). For, following the General Resurrection, they will
glow seven times brighter than the sun, and the sun itself—the brightest light
we know—will glow seven times brighter than it does now (cf. Isaiah 30:26).
Does this mean they will move even farther beyond *fantasie nostre*? That

might seem to be a self-evident conclusion. Yet it is not. For the reconstituted body will come complete with its senses, both external and internal (*imaginatio* being a vital inner sense). But how exactly will they function? Here the schoolmen freely admitted that they had reached the limits of what human reason could reliably deliver. Many aspects of life in the *patria*, as in Eden, remained unknown; perhaps were unknowable, at least in this life.[96]

However, all was not lost. Wyclif took comfort in the efficacy of what he called "probable reasoning";[97] his fellow theologians used similar terminology. Here was a way of understanding sense in paradise, of making some sense of paradise. There is no problem whatever, Wyclif declares, in establishing "by probable reasoning the many things which existed in the state of innocence even though they were not expressed in Scripture." "Nor would this be a useless study (*studium inutile*),"[98] he continues, because the material in question, while difficult, is neither "impossible" in itself nor incomprehensible by our powers of sensory perception (*sensibilitas*). In other words, in seeking to amplify—and better understand through such amplification—scriptural information about the state of innocence, we may exercise our reason in a way which will deliver not certainties but probabilities. The implication is that these are quite good enough for most, if not all, of our purposes.

Here Wyclif may have had in mind St. Augustine's defense, in *De Genesi ad litteram*, of the appropriate use of speculation where Scripture is silent. "We in our ignorance have to fill in by conjecture the gaps" which the inspired author "by no means out of ignorance left in the picture," says Augustine. That is a complicated sentence, which is trying to do (at least) two things at once. On the one hand, the use of decorous conjecture by "us" present-day readers is being justified. On the other, we are being advised to refrain from blaming the Bible for our current exegetical plight. The gaps which "we strive in our own small way" to fill were not the result of ignorance on the part of inspired writers. Those authors must be treated with all due respect, and their texts kept free from the charge of inconsistency and from ridiculous interpretation. "No absurdity or contradiction" which "would offend the good sense of readers" is to be "attributed to the holy Scriptures."[99]

Moving forward to the twentieth century, we find art historian Hans Belting wondering, in the context of a study of Hieronymus Bosch, if holy Scripture may have left a "gap between what might have happened and what actually happened? What if the Bible itself allowed scope for the imagination, room to muse on how life in Paradise might have been without the Original

Sin?"[100] Belting proceeds to discuss how, in *The Garden of Earthly Delights*, Bosch addressed those questions, as he filled the gap between the actual and the possible with fantastical, and often quite troubling, figments of the imagination.

In the later Middle Ages, such musing was not just a matter for the painters and poets. Theologians also made major creative efforts to round out what their sources said about worlds without sin, appealing to written authority and the good sense of their audiences.[101] Their conjectures are the subject of this book.

The Body in Eden

At first I couldn't make out what I was made for, but now I think it
was to search out the secrets of this wonderful world and be happy
and thank the Giver of it all for devising it.

—Mark Twain, *Eve's Diary*[1]

In the widely read *Liber de ordine creaturarum*, an anonymous seventh-
century author draws on all the stylistic devices at his disposal to convey some-
thing of the wonderful life that Adam and Eve could have enjoyed. "But while
man lived there, immortal and blessed, was not the domination of the whole
orb subjected to him? . . . Fire would neither burn him, nor water drown him,
nor the strength of beasts rend him, nor the stings of thorns (or anything else)
wound him, nor the absence of air suffocate him, nor would all those things
which harm mortals hinder him."[2] Such sentiments were echoed again and
again by his successors. They envisaged a world wherein our first parents were
untroubled by the present-day perils or fire, water or air, free from the violent
attacks of wild beasts or indeed of their fellow-men. And death had no domin-
ion over them. The human body has never had it so good.

"Tot tens poez vivre sit u tiens mon sermon,
E serras sains, nen semtiras friczion.
Ja n'avras faim, por bosoing ne beveras,
Ja n'averas frait, ja chalt ne sentiras;
Tu iers en joie, ja ne te lasseras,
Et en deduit ja dolor ne savras.
Tute ta vie demeneras en joie . . ." (50–56)

["You can live forever, if you obey my word; you will forever enjoy health, never will you be afraid. You will never be hungry, nor will you drink because you need to, never will you be cold, nor will you feel heat; you will live in joy without ever feeling weary, and in our pleasure you will never know pain. Your whole life you will spend in joy . . ."][3]

Thus speaks the voice of God in an Anglo-Norman play dated circa 1125–75, the *Ordo representacionis Ade*.

Adam and Eve were fine physical specimens, in possession of superlative degrees of nobility, dignity, strength, intelligence, and spiritual insight that were lost following the Fall. The robustness of their bodies was well attested by the fact that, in the early days of the human race, men stayed alive for several centuries. According to Genesis 5, Adam lived for 930 years. Or, as our first father himself eloquently puts it, as reported by Dante,

". . . vidi lui tornare a tutt' i lumi
de la sua strada novecento trenta
fiate, mentre ch'ïo in terra fu'mi." (*Paradiso*, XXVI, 121–23)

[". . . while I was on the earth I saw him (= the sun) return to all the lights of his path nine hundred and thirty times."][4]

When Adam was 130 years old he begot a son named Seth, who himself lived for 912 years. Other descendants enjoyed similarly impressive life spans: 905 in the case of Enos, 910 in the case of Cainan, 895 in the case of Malaleel, and 962 in the case of Jared. If such extraordinary longevity was possible outside Eden, how much more durable would the human body have been within it? Would it have lasted for ever? That question was a hypothetical one, of course, since the durability of the original human body was never put to the test, because the Fall quickly rendered it fragile, disorderly, and mortal. Indeed, it was doubly hypothetical, inasmuch as, had the first humans not yielded to temptation, they would have been transferred, without dying, to an even better state, a place where their bodies would no longer require material nourishment but would be sustained only by the spirit.[5]

But nevertheless the schoolmen speculated. It was common to pose the question of whether the body of the unfallen Adam was capable of "dissolution" (*posset dissolvi*) or destruction, and answer it in the negative. Typically, Bonaventure concludes that "in the state of innocence" the human body

"could not actually be dissolved, though it had the potential (*potentia*) to be dissolved," which potentiality became reality after the Fall.[6] It would have been "unfitting (*inconveniens*) and contrary to the order of the Divine Justice" for "the body of a man" to have been dissolved "in the state of innocence," that being possible only after Adam's fault, by way of punishment. John Duns Scotus, O.F.M. (d. 1308), took a more robust line, his crucial point being that the first human being was created immortal in paradise not through some intrinsic gift or some inherent feature of his body which only his disobedience could have revoked or altered, but rather because of an act of extrinsic divine protection. That is to say, God undertook to ensure that humans would stay in good shape for as long as they lived in Eden.[7] Adam's body would have been translated into heaven well before it could have developed any debility which would have resulted in death. Had Adam, and by extension the first family, not been thus translated, they would have died. To stay close to Scotus's technical language: divine grace did not exclude formally the potential to die, but only the act of dying. It would seem, then, that the original human body had a "sell-by date"—but of a very long duration, which would not have expired before the time that its owner was elevated to a higher existence.[8]

Creating Bodies

Elsewhere in his *Sentences* commentary, Scotus joined his contemporaries in celebrating the many excellences of the bodies of Adam and Eve.[9] Peter Lombard was confident that Adam was made "of a fully mature stature"—not because that was how God *had* to create him, but rather because that was the way God *chose* to create him.[10] The first man's proud manliness was sometimes imaged in plastic art by giving him a face wearing a fully grown beard, as, for instance, in the depiction of Adam and Eve with God and the animals in paradise which is included in British Library, MS Egerton 912, fol. 10r (c. 1415, from the Paris area), a French translation of Orosius's *Historiae adversum paganos* (see Plate 5). Quite how Adam came by that beard is an interesting puzzle: was he created with it ready-grown, or did his hair grow with great speed once God placed him in paradise? Setting that quibble aside, the symbolism is obvious. The "association of hairiness with holiness," as Giles Constable nicely puts it, is of long standing.[11] Throughout the Middle Ages Jesus was generally depicted with a beard, and the same was true of such

major biblical figures as Moses, Abraham, St. Peter, and John the Baptist, not to mention legions of subsequent hermits, saints, and sages. A beard, then, frequently bespoke wisdom and authority.

More broadly, the "universal and obvious meaning of beards was their association with masculinity, virility, and strength."[12] In his *Enarrationes in psalmos* Augustine asserts that "The beard signifies strong men; the beard signifies young, vigorous, active, quick men. When therefore we describe such men, we say that a man is bearded."[13] A similar statement, couched in the discourse of late medieval medicine, may be found in the *Le Livre des Eschez amoureux moralisés* of Evrart de Conty, regent master 1353–1405 in the Paris faculty of medicine and physician to King Charles V of France. A beard shows man's great dignity (*grant dignité*) and powerful heat (*chaleur vertueuse*), and makes known his generative power.[14] "And so wise philosophers say that animals which have more hair, and birds that have more feathers" than others of their kind "are more potent (*poissans*) than others."[15] Similarly, according to the pseudo-Aristotelian *Problemata*, the growth of facial hair marks a boy's passage from boyhood to manhood; indeed man "grows hair when he begins to be capable of sexual intercourse."[16] There are aesthetic considerations also: "The beard looks very good on men and is an honest and beautiful thing," to quote Evrart again.[17] In contrast, Nature "ordained no beard at all for women, for it would be repugnant to their complexion, which is cold compared to that of men." Indeed, Evrart claims, this function of clear sexual differentiation is the "principal end and the greatest profit" which nature intends by the beard.[18] Men who shaved their facial hair (in fashionable ways offensive to moralists) or—worse—were incapable of growing beards at all, were deemed effeminate and suspected of sexual deviancy.[19]

The sexes are clearly differentiated in the Egerton illumination. Adam's normative masculinity is powerfully conveyed. Bearded, and making hand gestures which express wonder and respectful receptivity,[20] he gets most of God's attention; indeed, God has his face turned toward him. Writing around 1150, the Leviticus commentator Ralph of Flaix remarked, "The beard on a man is a sign of the perfect age. Whence the virtue of the saints is often designated by a beard."[21] The "perfect age" (widely supposed to be around thirty-two) was the age at which Christ had died and Adam was created.[22] So, then, the Egerton artist has used a beard to intimate the physical perfection of the newly created Adam, and his virtue both physical and spiritual—all the strength of his robust mature body, all the mental prowess at the command

of this most intelligent of men. Eve in all her feminine beauty comes across as dignified and self-possessed yet subordinate. Her left hand seems to be clutching God's left hand or wrist, in a gesture of daughterly respect and submission to this the ultimate father figure.[23] It is an unusual, and arguably rather moving, touch, which brings a hint of familial warmth to a scene which could easily become stiff and quite unrelentingly formal (though, of course, a high degree of formality is obligatory here). Even as it presents a woman who knows her place.

But did not the fact that Adam was made from "the slime of the earth" (*de limo terrae*; Genesis 2:7) somewhat mar his image of *grant dignité*, of proud and potent masculinity? By no means. The schoolmen explained that, as a matter of fact, all of the elements were involved in his composition, not just earth and water (slime being a mixture of earth and water). Admittedly, these were the dominant components, but that is only to be expected of worldly or "lower" creation. (In contrast, fire and air—the nobler elements—are the prime constituents of the heavenly bodies, the sun, moon, planets, stars, and spheres).[24] Man remains the most honorable of God's creatures on earth, the noblest of animals (in Aristotle's phrase).[25] He stands erect—for many good reasons.[26] The other animals, Aquinas explains, use their senses to obtain the necessities of their lives, taking pleasure in the objects they sense only inasmuch as they involve sex or food. But man uniquely "takes pleasure in the actual beauty of sense objects for its own sake."[27] Here Aquinas is specifically thinking of how the senses can function in the pursuit of knowledge.[28] Given that "the senses are mainly concentrated in the face," it makes good sense for the faces of animals to be close to the ground, so they can seek out food.[29] But the face of man must be held aloft, so its senses "may be free to become aware of sense objects in every direction, in the earth and in the heavens, so that from them all he may gather intelligible truth (*intelligibilem veritatem*)."[30] Besides, man's big brain has got to be positioned up there so that it works to best advantage.

Aquinas then offers a grotesque image of what a man would look like if he had been created with a horizontal rather than a vertical posture. In that case his hands could not be the wonderful tools they now are because he would have to use them for feet. Indeed, he would have to use his mouth to gather food. "And so he would have an oblong mouth, and hard coarse lips, and also a hard tongue to prevent it being injured by external objects, as is clear from the characteristics of other animals." Human speech, "which is the special activity of reason,"[31] would have been impossible. Here, then is a

monstrous creation, an alternative design which God in His wisdom chose not to follow.[32] For a brief moment we are allowed a glimpse of how things might have been otherwise, in some strange and troubling alternative universe, even as Aquinas affirms that humankind "has the best possible disposition (*dispositio*) in relation to the disposition of the world as a whole." It was utterly appropriate (*conveniens*) for our first parents to walk tall.

But a cluster of issues emerged, concerning size and scale. When God spoke of increasing and multiplying (cf. Genesis 1:28), what did he mean— that Adam and Eve needed to grow bigger, taller, following their initial creation? Robert Grosseteste dismissed any such (potentially demeaning) suggestion, asserting that "they were created with perfect stature,"[33] and therefore the Genesis passage must refer to the bodily increase and multiplication of humankind in general—though, to be sure, God in His wisdom has on occasion taken this ability away from certain individuals, leaving them barren. (That last remark refers to the postlapsarian world, of course.) But how could a fully grown woman have been made from a much smaller thing, Adam's rib (cf. Genesis 2:21–22)? Peter Lombard defines the problem thus: if God had added anything extrinsic to the rib in making the body of the woman, then "the addition would be greater than the rib itself," and so the woman was made not primarily from the rib but from something added to the rib, some material greater in size than the rib.[34] Which would seem to challenge the supposition that God had made Eve from Adam's rib. Could it be that Eve was shaped from material far inferior than that which constituted the first man, stuff that lacked even a name in the Genesis narrative? A troubling thought.

In dismissing it,[35] Thomas Aquinas remarks that from a smaller thing a larger thing can be made either by addition (i.e., more matter must be added to it) or by "rarefaction" or "thinning out" (i.e., when the same matter receives greater dimensions, as when a gold ingot is beaten flat so that it covers a larger surface area).[36] In the case of Eve's creation there is no evidence of *rarefactio*, so we must admit an addition of matter (*multiplicatio materiae*). But what sort of addition was involved? Either "by creation from nothing or . . . by conversion of other material," says Aquinas, opting for the latter. Augustine is quoted as having said that "Christ fed five thousand men on five loaves in the same way as he produces thick corn-fields from a few grains"[37]—that is, by conversion of the nourishment. "Nevertheless he is said to have fed the five thousand on five loaves, or to have formed the woman out of a rib, because the addition was made to the already existing material

of rib or loaves."[38] In other words, the extraordinary process of *multiplicatio* whereby Christ fed the five thousand with five loaves and two fishes (Matthew 14:15–21) helps us to rationalize another extraordinary addition, whereby Eve was created from Adam's rib. The discourse of Aristotelian physics helps to formulate the question but does not really help to answer it. However, Aquinas's central point is perfectly clear: what is involved in such cases is not a breach of natural process but rather a cooperation (however extraordinary in itself) with nature—and therefore comparable to the process whereby God produces an abundant harvest of corn from a few seeds.[39]

Bonaventure agreed, arguing that, if by a "miracle" (*miraculum*) one understands "something contrary to nature," then the creation of Eve, and also the feeding of the five thousand, should be called *mirabilia* ("wonders") rather than *miracula*, for in these cases God worked above nature (*supra naturam*) but not contrary to it (*contra naturam*).[40] However, his treatment of the relationship between Eve and Adam's rib is somewhat different from Aquinas's, inasmuch as he places particular emphasis on the notion that the rib was not the only material used by God.[41] Some of Adam's flesh was used as well, as is indicated by his own remark, "This now is bone of my bones, and flesh of my flesh" (Genesis 2:24). Indeed, given that the womanly sex (*sexus muliebris*) is naturally more infirm than the manly sex (*sexus virilis*), it could be argued that Eve should have been made from Adam's infirm parts, from his flesh rather than from his bone. But no, Bonaventure explains; she was made primarily from his bone, one possible reason being that man "confers strength (*robur*) upon woman, and woman is strengthened (*vigoratur*) through association with man (*per viri consortium*)." In contrast, man is softened (*emollitur*) through association with woman. This is why flesh is said to have "filled up" the space left by Adam's rib (cf. Genesis 2:22, "He [God] took one of his [Adam's] ribs, and filled up flesh for it"). Man confers strength (the rib), whereas woman imparts infirmity (symbolized by the flesh which replaced Adam's extracted rib). Traditional gender stereotyping concerning male strength and female weakness (which will be discussed in more detail in Chapter 2) is in play in the beginning, even as Eve's very creation is discussed. It contrasts with other moves (as made by Bonaventure and his contemporaries) toward interpreting the formation of Eve from Adam's rib—rather than some higher or lower part of his body—as indicative of "a certain equality of mutual society," an egalitarianism which exists to the extent that (arguably *only* to the extent that) a "strong and singular bond" unites man and woman, according to the divine plan.[42]

The fact that God formed Eve from Adam while he was asleep (cf. Genesis 2:21) posed problems for the theologians.[43] This was potentially worrying since it seemed to imply that Adam suffered from some weakness or debility (*debilitas*), which was hard to square with his situation in Eden.[44] The infirmity of Eve was a comprehensible aspect of her human nature as a woman. But one expected more from Adam. Given the robust nature of his paradisal body, his senses were not wearied (what, indeed, was there in Eden to tax them?), and so he did not need sleep. Therefore, on this argument, sleep was unnatural to Adam, and it seems strange that God should have done something which was inappropriate to the nature of the first man. Furthermore (as Bonaventure poses the problem), would it not have manifested God's power more if He had produced Eve from the side of Adam when he was awake, ostentatiously not causing the man any pain, and nullifying the horror of this action, rather than when he was asleep—when, one might presume (though Bonaventure himself does not make this point), the pain was lessened and the horror concealed? Perhaps here one may detect the anxieties of people who, lacking any knowledge of the extraordinary procedures of modern surgery, tended to see the divine invasion (if so it may be called) of Adam's body to obtain the materials from which Eve was created as a potentially violent act, involving blood, guts, and suffering. Manuscript illuminators neatly bypassed such possible horrors by devising a (quite standardized and almost ubiquitous) picture of Eve emerging from the side of a sleeping Adam, as in Plate 6. This beautiful image is from *The Ashmole Bestiary* (Oxford, Bodleian Library MS Ashmole 1511, fol. 7r), which was produced at the beginning of the thirteenth century. Here we have no pain or anxiety, no gore or gaping wound. Rather we witness a scene of some serenity, indeed of restfulness. The sleeping male figure conveys an impression of ease, security, and confidence in the God who benignly oversees the fulfillment of His will, whereas Eve's hands are raised in the gesture of *conturbatio*, expressive of surprise and wonder.[45] Bonaventure remarks that Adam's sleep indicates that man and woman "were so made, as to be conjoined to one another, and so that from this one might be put to rest (*quietaretur*) in the other and one be sustained by the other."[46] It is tempting to see such a "putting to rest" in the Ashmole illumination, and the dozens which share its formal features, though few attain the excellence of its execution.

The schoolmen roundly rejected the suggestion that Adam's sleep was the result of weariness or some other *debilitas*. Bonaventure notes that Adam's

sleep was the result not of weariness on his part, but of a direct divine inter-
vention; what he calls an *imissio*, following the Vulgate's description, at Gen-
esis 2:21, of how God "sent" (*immisit*) a "deep sleep" (*sopor*) on Adam.[47]
(Peter of Tarantasia, O.P. [d. 1276], developed this idea by contrasting mere
sleep (*somnus*) with deep sleep (*sopor*); the former belongs to nature alone,
but the latter is also a work of grace, because therein the animal powers rest
while the intellectual powers intensify.)[48] And God was certainly capable of
separating the rib from a wide-awake Adam "without pain and horror";[49]
Bonaventure is anxious to dismiss any such doubt concerning divine omnipo-
tence. God acted as He did on account of the spiritual significance (*signifi-
catio*) here being established and because He wished to raise up (*sublevatio*)
the mind of Adam: "as the Saints say, Adam in that deep sleep foresaw
many things."[50] Awaking full of prophecy, when he saw the rib—that is,
Eve—before him, Adam pronounced, "This now is bone of my bones, and
flesh of my flesh; she shall be called woman, because she was taken out of
man. Wherefore a man shall leave father and mother, and shall cleave to his
wife: and they shall be two in one flesh" (Genesis 2:23–24). How is this a
prophecy? Because, Bonaventure explains, Adam is speaking concerning the
great sacrament of marriage, which subsequently would be commended by
St. Paul (at Ephesians 5:31, where Adam's words are echoed).[51]

However, Bonaventure's understanding of the sacramental signification of
the creation of Eve stretched far beyond that, since in the very text he was
expounding (distinction xviii of the *Sentences*) Peter Lombard had said that
"in this work, the sacrament of Christ and his Church" is prefigured (*figura-
tum est*). For, "just as the woman was formed from the side of the sleeping
man, so the Church was formed from the sacraments which flowed from the
side of Christ sleeping on the cross, namely blood and water, by which we
are redeemed from punishments and washed clean of our faults."[52] The sacra-
ments of blood and water being, of course, those of the Eucharist and Bap-
tism, this being Peter Lombard's spiritual reading of John 19:35: "One of the
soldiers with a spear opened his [Christ's] side, and immediately there came
out blood and water." To elaborate this point with the aid of a statement
which Bonaventure had made earlier in his discussion,[53] Adam's sleep corre-
sponds to Christ's death, and "the removal of the rib to the opening of [His]
side." "For the Church is formed out of Christ, when there flowed forth
from the side of Christ sleeping on the Cross the Blood and Water, the
efficacy of which overflowed in the Sacraments of the Church, through which
Sacraments the Church was founded."

Here we have a shocking foretelling of the pain and pathos of the Cruci-
fixion, sentiments absent from the iconographic tradition whereby Eve is
shown emerging serenely from Adam's side, as illustrated in Plate 6. How-
ever, they are intimated clearly in a different kind of "creation of Eve" image,
one highly characteristic of manuscripts and early prints of the *Speculum
humanae salvationis*. Written originally in Latin verse during the period circa
1310–24 but soon translated into many vernaculars, this highly popular work
(extant in approximately 394 manuscripts of the fourteenth and fifteenth
centuries) systematically reads human history from creation to resurrection[54]
in terms of Old Testament prefiguration and New Testament fulfillment.[55]
Plate 7, from an English manuscript of the late fourteenth or early fifteenth
century now in Yale University's Beinecke Library (MS 27, fol. 7v), reveals a
gaping wound in Adam's side, with one rib being turned into Eve (half
woman, half bone) while the other ribs are clearly visible in his opened,
vulnerable body. An obvious anticipation of horrors to come, when Christ's
side will be opened on Calvary.

Bodily Functions

The bodies of Adam and Eve having been created, how were they main-
tained, what sustenance did they need? In the state of innocence they could
neither die nor decline into old age, and crucial to the maintenance of this
situation was recourse to the Tree of Life. They ate from it "so that death
might not steal upon them from any direction, and so that they might not
be worn out with age and decay after they had run through a certain course
of time," as Augustine said in *De civitate Dei*.[56] Peter Lombard put it even
more clearly in stating that the Tree of Life was so called "because it was
divinely given the power that, if one ate of its fruit, one's body would be
strengthened in constant health and perpetual firmness, and it would not fall,
by any illness or infirmity of age, into debility or death."[57] However, those
fruits nourished in a quite atypical way, bestowing "enduring health, not as
with other food, but by some hidden infusion of vigorous well-being," to
quote Augustine again, this time from *De Genesi ad litteram*.[58] Here he
explains the mysterious workings of the Tree of Life with reference to Elijah's
flight from Jezebel, as recounted at III Kings 19. An angel orders Elijah to eat
a hearth cake (*subcinericius panis*), which has appeared at his head, and drink
from a vessel of water (*vas aquae*). After having eaten a second time, Elijah

arose "and walked in the strength of that food forty days and forty nights, unto the mount of God, Horeb." Though made of ordinary flour, clearly that cake "had a little extra something about it" (*aliquid tamen amplius habuit*), as Augustine puts it. So too, it may be inferred, had the fruit of the Tree of Life.

But however special this tree was, it was still a tree—and how could something which was, by its nature, subject to change and "corruption," to decay and fresh growth, confer unchangeableness on human beings, "the ability not to die"? Aquinas's answer is that when the fruit of the Tree of Life was taken as nourishment, it did not totally and completely "bestow the power to last forever."[59] Rather it "strengthened the natural power to endure longer by a fixed period of time"; humans would have to keep on ingesting it "in order to live longer, and so on until human beings could be brought to the condition of glory, in which they would no longer need nourishment." So, then, the Tree of Life was certainly "an aid to immortality, but the chief cause of immortality was the power conferred by God on the soul."

That was not the only fruit allowed to Adam and Eve. They "still took other nourishment," making "use of food as men do now; for their bodies were not yet spiritual, but animal and earthly only," to return to Augustine's account in *De civitate Dei*.[60] Whereas they tasted the Tree of Life to avoid aging and death, they tasted other fruit "so that their animal bodies might not experience the vexation of any hunger or thirst." Aquinas generally agreed, updating Augustine's account of the needs of the prelapsarian human body with some help from Aristotle's *De anima*.[61] The soul of man has a "nutritive" aspect, the functions of which are "digestion, procreation,[62] and growth," and these functions would have applied to the first man, whose body needed food, unlike the resurrected body, which will not. Therefore, just as currently the human body loses some of its "proper moisture" due to the body's natural internal heat, and to counteract this man needs the sustenance of food, this would have been the case also in Eden.[63]

But, if Adam and Eve consumed food in Eden, did this mean that they defecated and urinated? Surely not, in a place of such perfection! Aquinas spells out the problem thus.[64] "Some say that man in the state of innocence would have taken no more food than was exactly necessary for him," the argument being that since nothing superfluous was eaten there was nothing to purge. Shifting his ground somewhat, Aquinas declares that it's unreasonable to assume that the foods available in Eden were quite different from

those available now, so that they could be assimilated fully by the human body, without anything being left over. There would indeed have been a residue in need of purgation, and our first parents would have been obliged to purge it. However, Aquinas adds, God would have arranged matters so that this would have been done decently (*nulla . . . indecentia*). On what that might have meant in practice, Aquinas is silent. Bonaventure is a little more direct.[65] Adam would not have sweated or purged rheum because in him "the natural virtues were efficacious in their operations." However, he would indeed have defecated and urinated, because following the digestive process, what was less suitable to his body would have been "cast away outside." This is, after all, the designated function of the "vessels and intestines and orifices (*vasa et intestina et foramina*)" of the human body, which has been like that ever since its first condition. In other words, when God made those parts of the body for Adam and Eve, He expected them to be used initially in a way very similar to the way we use them now. However, Bonaventure assures us that paradisal purgation would not have been accompanied "with such a stench (*foetore*) and filthiness, as happens nowadays."

Similar justifications were offered for the existence of semen in paradise— for that too was regarded as a residue in need of purgation, given that it was supposedly a "superfluity" (i.e., an excess or by-product) of food in the final stage of digestion.[66] Wherever there is a "superfluity" (*superfluum*) there is a faultiness or "viciousness" (*vitiositas*), but since in Eden there could be no *vitiositas* neither could there be any superfluity such as semen. Bonaventure, who poses the problem in this way, resolves it by explaining that, while semen is superfluous to the nutritive process and need of the individual human who emits it, it is necessary for the human species as a whole, which requires semen for its generation. Here then is no vicious superfluity, but rather one which serves the goodness and completion of human nature, as God intended.[67] To put it a bit more bluntly than Bonaventure does here, without semen Adam and Eve could not have obeyed the divine command to "be fruitful and multiply, and fill the earth" (Genesis 1:28), a command which applied to their lives in Eden.

Behind such talk of shit, bad smells, and semen lay major anxieties concerning how much the human body has in common with the bodies of animals, and the concomitant desire to affirm man's superior position as "the noblest of animals." Nowhere was this matter more intensively debated than when questions were asked about the purpose and workings of the senses. Men shared them with the animals, so what made them different when they

functioned in the human body? Several thirteenth-century theologians met the problem head-on by asking, if man lacked nothing, was perfect in his creation, why was he not given sharper senses and swifter movements, natural protective coverings and weapons, which are characteristic of the bodies of other animals? For example, Aquinas noted that "dogs are better at smelling things, and birds move faster,"[68] while Giles of Rome, O.E.S.A. (d. 1316), points out that "elephants and many other animals" enjoy a longer life than men do.[69] The straightforward answer, as offered by Aquinas, is that God, the great artificer, made each and every one of his creatures fit for its proper purpose.[70] A craftsman who makes a saw for cutting wood makes it out of steel rather than glass: glass may be more beautiful, but it would interfere with the tool's purpose—a glass saw could not cut wood. In like manner, the purpose of the human body is to serve the soul and its operations, and it is well designed to this end. But there is a price to pay. Among all the animals, man has the worst sense of smell. The explanation is that, to perform all his proper functions, he needed the biggest possible brain. Now, a big brain is very moist—and the preponderance of this humor is detrimental to the sense of smell, "which requires dryness."[71] Aquinas further applies the scientific theory of the humors to portray man as blessed with "a perfectly balanced composition," which is incompatible with swift action of the kind engaged in by certain animals. Further, horns and claws and hooves, and thick coverings of fur and feathers, indicate an abundance of earth. Which, once again, "is incompatible with the balance and softness of the human composition."[72] But this composition causes no problem for man, who has the power of reason and his own hands, thanks to which he can provide himself with an abundance of armaments and coverings. Here Aquinas cites Aristotle's designation of the human hand as "the tool of tools."[73]

This discussion is remarkable for the scientific basis on which it rests, the way in which Aquinas applies the medical theory of the bodily humors and in general brings to bear an Aristotelian conviction that knowledge is reached through the senses, sense perception being the beginning and basis of all knowledge. "It is man's nature to acquire understanding of things through the senses," Aquinas wrote; "that is why the soul is in union with the body, because it needs it for its own activity."[74] Others did not think in quite the same terms about "man's nature," being more heavily influenced by Augustinian (and hence in large measure Neoplatonic) epistemology. One of them was Bonaventure, and it is hardly a surprise that his treatment of sense perception and sensory pleasure in paradise (and beyond) is fascinatingly different from Aquinas's.

The Pleasures of Paradise

The great Franciscan doctor imagines the eyes of Adam delighting more in the sight of light, and his ears taking more pleasure in the hearing of a sonorous song (*cantus sonori*), than the sight and hearing of a fallen man could possibly do.[75] Therefore, Bonaventure suggests, one might say that Adam took greater delight in his taste and touch, when something stimulated those senses.[76] It is no surprise to see Bonaventure prioritizing sight and hearing here, because according to a rank order very common in the later Middle Ages they were assigned the top positions in the relevant hierarchy.[77] They are, in a manner of speaking, the most cognitive of the senses, Aquinas claimed, since they contribute "most to our knowledge" when they serve the reason.[78] Taste and touch were often deemed the lowest, a fact which may help us understand Bonaventure's subsequent move, which involves the erection of a barrier between what he sees as crucially different types of sense. The delight we take in touching something is not the same as that we take in either seeing or hearing something. The more noble the object of sight may be, and the more spiritually inclined it is (*magis accedit ad naturam spiritualem*), the more delight we take in it. Shifting from the paradise before death to the paradise after death, he affirms that the pleasure of sight will be intensified most of all in the resurrected bodies of the blessed. A similar point may be made concerning hearing, Bonaventure adds; that too, it would seem, will be of great use in the transformed world. But the sense of touch is different, inasmuch as it takes pleasure in what is gross and material[79]—the implication being that the more "gross" (*grossus*) and material something may be, the more intense is the pleasure which touch takes in it.

So, then, on this reasoning, touch is a highly suspect sense, doomed to association with the physical and the carnal, incapable of admirable intensification as it moves toward the spiritual. In Eden, one might object, it would have moved as far toward the spiritual as it could possibly have done, but Bonaventure is not interested in discussing that possibility. A marked difference in emphasis (at the very least) may be found in the article from Aquinas's *Summa theologiae* on which I drew above, wherein "touch" is judged to be "the basis of the other senses," and "more perfect in man than in any other animal," this being a consequence of the fact that "man has the most finely balanced composition of all the animals."[80] Touch, Aquinas might well have said, would have been of crucial importance to Adam as he explored his paradisal environment and sought to learn about the nature of things, and a

good sense of touch would definitely have helped the proper functioning of that "tool of tools," the human hand.

Bonaventure seems to be thinking on a different plane. He has predominantly in mind the way in which touch functions nowadays, in our present "state of misery"; hence his statement that "the intensification of its delectation is more repugnant to the spiritual state and renders man more carnal and animal, of which kind is man in the state of misery."[81] Which explains why, when he comments on Peter Lombard's account of the future paradise of the blessed in the fourth book of the *Sentences*, Bonaventure has no problem in identifying touch as one of the two senses (the other being sight) which definitely will function in the resurrected body: that body, renewed and far removed from the carnal and the animal, will resurrect with the properties of brightness and lightness (*levitas*), and therefore must be able to see and touch.[82] Little is offered by way of explanation here; we may turn to Aquinas for a fuller account. St. Thomas admits that "touch is said to be the most material of the senses," because "it has a greater measure of material alteration (*immutatio*) connected with it."[83] By *immutatio* (alteration, exchange, substitution) is meant the tactile experience of, say, a human hand encountering the surface of some material object, the resultant perception being regarded as a change or transition from one state of awareness to another. Here a brief incursion into Aristotle's perception theory as outlined in *De anima* is in order, to explain St. Thomas's argument. Perception "seems to be a kind of immutation," says Aristotle, because it "comes about with [a sense organ] being changed and affected."[84] So, to take a couple of examples offered by Aquinas himself, when the hand touches a hot object it is heated, and when it comes into contact with a fragrant object it becomes fragrant.[85] However, glorified bodies, by reason of their "impassibility" (exemption from change, suffering, decay) are "immune from natural immutation."[86] In other words, their organs cannot be changed or affected in ways such as those exemplified above. Does that mean that, in the paradise beyond death, they will be unable to touch anything, and/or not have anything to touch? No, opines St. Thomas. The glorified body will retain the sense of touch, but it will function in a different way, a way which will not involve physical alteration.[87] After all, when the eye's pupil "receives the species of whiteness"— experiences something as white—it "does not itself become white."[88] By the same token, something akin to touching as we know it will be felt by the renewed bodies of the blessed, as they encounter each other, the various orders of angels who are their eternal companions, and the resurrected body

of Christ Himself. Here are ways whereby the godhead will make itself known and (in appropriate measure) knowable to the bodies and minds of the blessed.

Such medieval speculation concerning the heavenly roles and functions of the human senses will be discussed in more detail in Chapter 3. Suffice it to note here that the dogma of the resurrection of the body put Christian theologians—especially those profoundly influenced by Aristotelian epistemology—on their mettle, because they had to come up with a convincing explanation of the way in which the senses had been renewed, glorified, blessed, as inalienable aspects of the human body. The indisputable fact of corporeal renewal (often termed *innovatio*) demanded no less. Had the biblical prophets foretold a paradise populated with disembodied souls, their interpreters would have had a much easier task.

Not that the matter of how the senses functioned in Eden, and what sensory pleasures the body could appropriately enjoy there, was capable of easy solution either. The "nature of this garden" is such that no delight (*delit*) is lacking, declares the voice of God in the *Ordo representacionis Ade*, and a Latin stage direction envisages the actors playing Adam and Eve strolling about paradise, "virtuously enjoying themselves" (*honeste delectantes*).[89] What exactly did the author have in mind? We have already cited Bonaventure's claim that Adam would have taken a special pleasure in the sense of sight, and his ears would have especially enjoyed hearing a "sonorous song." Perhaps he was thinking of the light-bathed beauty of the Garden of Eden and the bright divine manifestations (of God and His angels) which appeared therein—a feast for Adam's eyes indeed. And perhaps also of the heavenly music which some of those same angels could have made, and/or the transcendent music of the spheres, subsequently (following the Fall) blocked from human hearing.

Angels are depicted entertaining Adam and Eve in an extraordinary illumination found in the so-called *Livre de merveilles du monde*, Bibliothèque nationale de France, MS fr. 2810, which Jean sans Peur, Duke of Burgundy, commissioned in 1412 as a gift for his uncle Jean, Duc de Berry (fol. 221r; see Plate 9). This compilation includes copies of Marco Polo's *Le divisament dou monde* (c. 1298?)[90] and the highly popular and widely translated *Book of John Mandeville*, which first appeared in French between 1356 and 1371.[91] The illumination accompanies Mandeville's account of the "Paradys Terrestre, where that Adam, our formest fader and Eue weren putt that dwelleden there but lytylle while."[92]

However, there is no precedent in the Mandeville text for the pleasures depicted by the BnF fr. 2810 artist. For his inspiration we must look to an earlier text in the same manuscript and the illumination which accompanies it. Marco Polo's *Le divisament* includes the story of an "old man of the mountain," Alaodin by name,[93] who, in order to extend his power and influence, built "a luxurious garden, stored with every delicious fruit and every fragrant shrub that could be procured," and populated it with "elegant and beautiful damsels, accomplished in the arts of singing, playing upon all sorts of musical instruments."[94] The prophet Mahomet "having promised to those who should obey his will the enjoyments of paradise, where every species of sensual gratification should be found, in the society of beautiful nymphs," Alaodin wished his followers to believe "that he also was a prophet and the compeer of Mahomet, and had the power of admitting to Paradise such as he should choose to favour."[95] With this travesty of Muslim belief may be compared John Mandeville's description of the "Saracen" paradise as "a place of delytes, where men schulle fynde alle maner of frutes in alle cesouns [seasons] and ryueres rennynge of mylk and hony and of wyn and of swete water; and . . . thei schulle haue faire houses and noble, euery man after his dissert, made of precyous stones and of gold and of sylver; and . . . every man schalle haue iiii.xx. [= four score] wyfes all maydenes, and he shalle haue ado euery day with hem, and yit he schalle fynden hem alleweys maydenes."[96] The facsimile of this paradise which the duplicitous Alaodin created to entice his followers is illustrated on fol. 16v of BnF fr. 2810, at the beginning of Marco Polo's account of the "old man of the mountain" (Plate 10). It shows Alaodin looking on with obvious approval while a man has sexual "ado" with a woman, serenaded by two musicians who play stringed instruments presumably intended to suggest a lascivious type of music, very different from what the two angels depicted on fol. 221r are playing on their trumpet and portative organ—the former instrument has obvious associations with the trumpets of the Apocalypse (8:6–12; 9:1, 13–14; 11:15), while the latter often features in depictions of heavenly choirs and the music made by the prophet-musician David.[97] The old man's mountain is included within the walled garden, somewhat awkwardly given the amount of space it occupies.

These two illuminations evidently form a matching pair,[98] which depict the true and the false paradises, as understood by the Western Christians who were the consumers of this lavish manuscript. The illumination on fol. 16v depicts Alaodin's earthly replica of the "Saracen" land after death (which no doubt its Christian viewers would have taken as an accurate representation

of Muslim doctrine), whereas its partner picture offers a Christian view of the land before ordinary human life began, a place which indeed still existed on earth, but was strictly off-limits to errant humankind.

The BnF fr. 2810 artist offers (on fol. 221v) a vision of Adam and Eve *honeste delectantes*, dandling their hands in a stone-edged well from which a rivulet flows; evidently this represents the water source which, in Mandeville's account, "casteth out the iiii. flodes that rennen be dyuerse londes"—that is, the Pison or Ganges, the Gehon or Nile, the Tigris, and the Euphrates (cf. Genesis 2:10).[99] Adam, resplendent in his full beard, and Eve, her protruding belly decorously suggesting her ability to be fruitful and multiply, seem quite uninterested in coitus, and modestly hide their private parts from the viewer's gaze (Plate 9). Obviously the illuminator wants their behavior to stand in sharp contrast to that of the sexually active couple in the garden of fleshly delights depicted on fol. 16v (Plate 10). However, in what might be called the mainstream of Christian thinking on the subject, the possibility and the feasibility of prelapsarian sex were widely admitted. And by the time of the High Middle Ages many theologians were willing to concede that some sensory pleasure could have accompanied the process, though its quality and quantity were matters of debate.

"In what kind of manner would (our) first parents, had they not sinned, procreated children, and what kind of children would have been born?"[100] Peter Lombard's formulation of that question follows the general assumption that de facto Adam and Eve did not procreate children until after the Fall.[101] Yet there is another assumption embedded in the Lombard's words: procreation would have been *possible* had the Fall not intervened. Peter notes that not everyone has accepted this proposition, that there are those who denied the possibility outright.[102] But he moves quickly on. Others did name names, as, for example, when Aquinas attributed to St. Gregory of Nyssa (d. after 394) the belief that "the human race could have been multiplied" by means other than copulation, just as the "angels were multiplied without mating, by an operation of the divine power."[103] This saint claimed further that, when God bestowed upon Adam and Eve the wherewithal to copulate, He was thinking ahead to "the manner of copulation which would be used after they sinned," of which (of course) He had foreknowledge. Had our first parents continued to live in Eden, they would not have copulated. "But this is not a reasonable position," Aquinas declares, "for everything that is natural to man is neither withdrawn from him nor given to him by sin."[104] The sexual organs were part of the prototypical human body as created in Eden,

and it cannot be said that "they would not have been used before sin," any more than any other body part which was included in the original design.

Why then did Adam and Eve not have sex in Eden? Once again the Lombard turns to *De Genesi ad litteram*,[105] now to quote Augustine's two possible explanations: either our first parents did not have world enough and time (their transgression having occurred soon or presently—Augustine's term is *mox*—after the creation of Eve), or God had not yet commanded them to do the deed. If the idea that Adam and Eve had, or indeed were able, to await the divine command before having sex may seem strange, an explanation is to hand: "concupiscence was not driving them to do it."[106] Given the way in which reason then controlled desire, abstention from sex was an easy matter.

But, had they done it, what would it have been like? Augustine, and Peter Lombard after him, proceed by speculating what it would have *not* been like.[107] The carnal union (*carnali copula*) of Adam and Eve would have been without sin, their intercourse without concupiscence (*sine concupiscentia*), their marriage bed without stain (*immaculatus*).[108] Children would have been begotten "without the ardor of violent desire (*sine ardore libidinis*)," "without corruption (*sine corruptione*)," and "without the painful labour of childbirth (*sine labore pariendi*)." The human genitalia would not have been afflicted by that uncontrollable "itch of the flesh (*excitatio pruritu carnis*)" which was a consequence of the Fall—a "lethal sickness" (*lethalis aegritudo*) indeed. No "unlawful movement" (*motum illicitum*) would have occurred; rather the members of generation would have functioned just like any other part of the body. Having an erection would have been no different from bringing the hand to the mouth. Hence Adam and Eve could have begotten children in Paradise "through an immaculate union (*coitum immaculatum*)."[109]

Thus Peter Lombard laid down the terms in which many theologians sought to contend with the issue of prelapsarian sex for centuries. The dominance of Augustinian discourse is obvious, and commentators professed their agreement with the saint even as they amplified his thinking almost (or indeed far) beyond recognition. Such amplification was rendered necessary by the sometimes intersecting, and sometimes conflicting, views of Aristotle and Galen of Pergamon (d. c. 200), whose joint influence on medieval medicine was immense. The way in which Augustine had expressed himself (as quoted above) seemed to indicate that prelapsarian sex would feature not just a lack of *violent* desire but no desire at all. This was difficult to square with the views of Galen, who held that conception required a mingling of seed

from both the male and the female, for the release of which sexual excitement and orgasm were necessary. Therefore, in order to procreate successfully both partners needed to experience pleasure. It was frequently pointed out that Aristotle disagreed with Galen in respect of female seed, as, for example, in that most influential of all medieval commentaries on *De animalibus*, written by Albert the Great in the period from 1259/60 through 1263.[110] "The entire formative power is in the male's sperm and it is therefore called sperm by a true name and in a true sense,"[111] Albert argues, whereas the fluid which a woman emits during intercourse can be called "sperm" only in an equivocal sense. What the woman contributes to her impregnation is rather menstrual blood, as material (lacking any creative or formative power) on which the male sperm acts.[112]

However, as far as the issue of sexual pleasure was concerned, Albert was able to allow some consensus between Aristotle and Galen. In his earlier engagement with *De animalibus*, a series of disputed questions conducted in Cologne in 1258 and preserved in Conrad of Austria's *reportatio* (c. 1260?), we find the declaration that, according to Aristotle, "the highest pleasure occurs in the emission of sperm." (Here Albert is thinking of "sperm" in the abovementioned equivocal sense). He proceeds to qualify this with the remark that pleasure may also arise "from the contact of the male's sperm with the womb or from contact of the penis with the vulva."[113] Furthermore, "among all the animals" the human female "has more pleasure in conception"; in Albert's view, this is because "she has a more subtle power of sensation, and pleasure during intercourse is caused by the movement" of what may loosely be called "sperm" and "its passage over the sensible members."[114] So, then, it seems quite clear that several activities associated with conception regularly involve pleasure.

In his subsequent *De animalibus* commentary, Albert feels obliged to cite certain "women who are experienced in conception" as saying "that quite often a woman becomes pregnant without having pleasure during the act of intercourse."[115] But, on the other hand, a woman who *has* pleasure during the act of intercourse may become pregnant—and this, Albert seems to believe, is the more common outcome, for when the woman is not experiencing pleasure, that crucial "white fluid" (which some improperly call sperm) does "not descend" into the womb, and hence impregnation is less likely. Similarly, Giles of Rome, who also elevated Aristotle over Galen in such matters, argued that "a woman can be impregnated without experiencing pleasure just as she can with pleasure, as some say, because impregnation can occur either way,"

but adds that "for it to happen with pleasure is more obvious and common-place."[116] In short, there is no denying the high frequency with which plea-surable sex results in successful propagation.

Such opinions must have been a major determinant in scholastic accep-tance and justification of pleasure (of however limited and qualified a kind) in sexual activity both before and after the Fall. They certainly presented a challenge to the theory of desire-free intercourse which Augustine regarded as appropriate for Eden, and we may detect their influence in the ways in which Bonaventure and Aquinas allowed a measure of pleasure to paradisal sex.

At the outset it should be noted that Bonaventure's conclusions are identi-cal with those offered in the *Summa* associated with Alexander of Hales,[117] though there is some variation in respect of the arguments for and against, and hence the resolutions thereof; moreover, Bonaventure's version is alto-gether more succinct. It begins by addressing the view of "certain ones" who suppose that in Eden sexual pleasure was as great or greater than it is now, *without* being immoderate (because at that time intercourse was under the full control of reason).[118] Thus there was no antipathy between sexual plea-sure and reason; rather reason (so to speak) went all the way with desire. Bonaventure cannot understand how that possibly could have happened, so he moves quickly on to his preferred solution, which, he assures us, "is more concordant with the words of Augustine"—and also accords better with "the probability of reason (*et probabilitati rationis*)." This argument runs as fol-lows. In paradise there would have been *some* pleasure, *delectatio* of "a moder-ate and measured" kind, "in the shedding of seeds and the commingling of the sexes (*in decisione seminum et commixtione sexuum*)." Such pleasure was fully in accord with what the rectitude (*rectitudo*) of man required, and tem-pered by human reason. Therefore "it was not as great, as it is now" in the fallen world. For nowadays reason does not exercise such control over the body's lower powers, and this slackening of restraint has enabled an intensi-fication of sexual pleasure. It is as if the "reins" of reason are loosened (*laxatis sibi habenis*), a metaphor which leads nicely into Bonaventure's explanatory exemplum concerning a sexually aroused horse (*equus lascivus*). Having bro-ken its bridle, such an animal goes running about more quickly and impetu-ously than it would do when properly bridled and controlled by its rider. The clear implication is that now men and women may throw themselves inordinately into sexual pleasure, thereby experiencing greater carnal delight than was ever possible in paradise. And so Bonaventure reaches his conclusion

that "there was not so great an intensity of pleasure at that time, not as much as there is now," because in the postlapsarian world such pleasure takes a form which observes neither restraint nor due order.

Thomas Aquinas's treatment is markedly different—and indeed, he may well have had the *Summa Alexandri* and Bonaventure in mind when he expresses his disagreement with "some" who claim that sexual pleasure would not have been as great in Eden as it is today.[119] On the contrary, Aquinas declares, it would have been greater in paradise, in proportion to the "greater purity of man's nature and sensibility of his body." (The concomitant—which Aquinas does not spell out here—is that, after the Fall, the human body deteriorated considerably, being subjected to illness, aging, and death. Accordingly, sexual pleasure lessened.) Aquinas admits that in the state of innocence the force of concupiscence would not have thrown itself into sexual pleasure as inordinately as it does now, because it was ruled by reason then. But, he adds, it is not reason's job to lessen sensual pleasure—a quite striking statement in itself. What reason *does* do, he explains, is prevent the pleasure urge from cleaving to sensual pleasure immoderately.[120] In place of Bonaventure's exemplum of the lascivious horse, Aquinas offers the analogy of a sober person who does not experience less pleasure in food taken in moderation than does the glutton who eats and drinks to excess. The moderate person's "pleasure urge does not wallow so much in this sort of pleasure." One might develop the comparison by suggesting that a connoisseur who eats the small but exquisite portions characteristic of cordon bleu cuisine does not enjoy his dinner any less than a person who stuffs himself with huge amounts of fast food. Indeed, it may be argued that the gourmet experiences even more pleasure than the glutton. That seems to be similar to what Aquinas thinks about prelapsarian sexual pleasure being greater than the inferior fallen variety. In both cases, wallowing in pleasure does not make the pleasure itself any more intense.

Here Aquinas has taken us some distance from Augustine, while claiming to be speaking in consonance with the saint's words ("hoc sonant verba Augustini").[121] A quite audacious act of appropriation is taking place. According to Aquinas, Augustine did not actually "exclude magnitude of pleasure from the state of innocence, but rather impetuous lust and disturbance of mind." That phrasing echoes part of a passage in *De civitate Dei*: "the sexual organs would have been moved by the same command of the will as the other members are," without "the excitement of passion" and "in tranquility of mind."[122] But the fit is far from exact, and by no means

convincing. Aquinas totally avoids the fact that Augustine had inescapably downgraded and restricted any possibility of intense sexual pleasure in Eden, by likening it to the minimal sensation experienced when the hand is brought to the mouth. The reality is that Aquinas has introduced distinctions which Augustine simply had not made, thereby gaining a result substantively different from his predecessor's, while preserving an impression of consonance. An impression which cannot withstand much probing.

The differing viewpoints here described are neatly reiterated in the *Sentences* commentary which Richard of Middleton wrote in Paris during the period 1281–84. In Eden, Richard asks, would there have been *in carnali copula delectatio*?[123] He does not identify his sources, but gives both major positions considerable space, starting with the one which may identified as Aquinas's (i.e., that the sensory delight experienced in coitus would have been greater in paradise) and then proceeding to the one found in Bonaventure's *Sentences* commentary and the *Summa Alexandri* (i.e., lacking rational restraint, the force of desire and delight is greater nowadays, as illustrated by the *exemplum* of the lascivious horse with the broken bridle). Though himself a Franciscan, Richard prefers the Thomistic opinion, affirming that in Eden the nobler reason did not strive to control sensual pleasure (at a time when there was no disorderly love or bodily alteration). The second (i.e., the Franciscan) opinion would be true, he continues, only if all other things were equal, if conditions in Eden were the same as those appertaining today. But in the state of innocence there was greater perfection in respect of corporeal strength and sense, which enabled a greater intensity of pleasure than is possible in this corrupt, fallen state.

Richard develops this argument by means of a contrast between bodies young and old. Although an intemperate old man may desire the sexual act more intensely than a temperate young man, nevertheless the temperate young man will experience greater pleasure in having carnal knowledge of a woman than the intemperate old man possibly can. In other words, the youthful virility which may be attributed to the unfallen Adam indicates that greater intensity of sexual pleasure would have occurred in Eden, in comparison with which postlapsarian sex is like the impotent fumblings of old men—the spirit may be very willing but the flesh is weak.[124]

Being Fruitful and Multiplying

A crucial caveat must be entered here. Aquinas's argument that "the pleasure of sense would have been all the greater"[125] in Eden should not obscure the

fact that, in his view—a view widely held by the great schoolmen of the later Middle Ages—paradisal coitus was directed to one end and one end alone, the multiplication of the species.[126] Adam and Eve could not have "known" each other sexually apart from this purpose. Arguments to the contrary were sometimes offered, and generally found wanting. Here are some examples, as provided by Bonaventure. In the state of nature man satisfied his natural appetite for food when he ate in an appropriate manner, so why could he not have satisfied his natural appetite for sex likewise?[127] "Therefore it seems, that whether the woman could conceive or not, the man would sometimes have known [her] apart from (*praeter*) the necessity of generating offspring." In other words, having (appropriate) sex with Eve may have been the outlet for a quite standard impulse on Adam's part; he need not have been trying to impregnate her every time. Further, "matrimony was more holy at that time than in the time of lapsed nature," and since today carnal union within marriage is excused from fault (to some extent and in certain circumstances) "even when there is no necessity of generating offspring,"[128] surely it would have been even more excusable in the better world of Eden?

In his response, Bonaventure is unequivocal: progeny would have resulted from every act of prelapsarian sex, and this for two reasons. First, in Eden the generative force was perfectly subjected to reason, and since at that time sex was for the sole purpose of replenishing the earth, every sexual act would have produced a child. In Bonaventure's terms, "the generative force would never function, except for the sake of the generation of offspring." Second, Adam's body was always "potent to generate," and likewise Eve was always ready to conceive ("according to her time and place"); therefore, offspring would result every time.[129] The comparison with eating is rejected.[130] A regular intake of food (in the right proportion) is necessary for the nutrition of the body, whereas it is not necessary to have sex with the same frequency, but only "at determined times." Nowadays chaste men think very differently about carnal union than they do about food, and the highly rational Adam would have been even more aware of that distinction. The comparison with present-day marriage cannot stand either, because in the fallen world marital sex is not only for the duty (*officium*) of generating offspring but also serves as a remedy (*remedium*) for the avoidance of fornication, a problem which did not exist in paradise.[131]

However: if Adam's body was always "potent to generate" and Eve's fertility knew no impediment, does this not mean that every sexual act would have produced a male child, or that, at the very least, more men than women would have been born? According to Aristotle, woman is a *vir occasionatus*

(an imperfect or unfinished man).[132] And one would not expect such imperfections to be present in paradise, certainly not in large numbers. Having cited that (now infamous) passage from *De generatione animalium*, Bonaventure looks elsewhere in the same authoritative text to find the proposition that "Nature always desires what is better."[133] Since the male sex is superior to the female sex, it follows that Nature wants to "generate man more than woman," and therefore in Eden more men than women would have been born. Taking even further a proposition which he is setting up for rejection, Bonaventure turns to the natural philosophers and medical doctors (*naturales et medici*), who say that males are generated on account of "the vigor of the generating virtue and of the seed emitted."[134] Since in paradise "the generative virtue and seed emitted had complete and ample virtue," males would always—or at least more often—be generated, as the male's seed would usually dominate over the female's.

Bonaventure proceeds to refute this viewpoint, arguing that "if man had remained in the state of innocence, nature would have multiplied men and women equally."[135] In respect of the end to which sexual intercourse was directed, the multiplication of the species, there is no problem in coming up with an answer. *Multiplicatio* was a duty enjoined on all, to be governed by "the law of marriage" (marriage itself, we must recall, having been instituted in Eden), which means that one woman belongs to one man, and vice versa. Had nature not fallen, Bonaventure envisages a situation in which there would have been as many women as men, since "no woman would lack a man, and no man would lack a wife, nor would one woman belong to several men, nor several to one." However, he admits to a certain difficulty in explaining how this process would happen effectively. And so he seeks further information in natural philosophy and medicine—which, within the hierarchy of knowledge, are servants to the supreme science of theology. However, the practitioners of those sciences are not in agreement. When asked why a male is generated on one occasion and a female on another, they come up with three possible answers.[136]

The first is that if the male seed is received in the right side of the womb, "a man is generated on account of the strong heat which thrives there"; if the seed is received on the left side, then a woman is generated.[137] Second, if the man's seed predominates in the mingling process, then a male child is generated, and if the woman's seed[138] predominates, then a female is generated. The third explanation focuses on the strength of the man's seed. If it is strong, a virile (i.e., male) child is generated; if it is weak, then "a softer and

more fragile coagulation" occurs, "and there is generated from it the infirm sex, namely, the feminine." Bonaventure pronounces this third reason the crucial one, for the other two cannot function without it.[139] The strength or debility of the *semen virilis* is the single most important factor in determining the sex of the resultant child: if it is very strong, then where it lodges in the womb is less important, for it will prevail over the woman's seed without difficulty.

But sometimes the male seed is not sufficiently strong; it can be weakened by several factors. First and foremost is penis temperature. "The warmth and good disposition" of "the male member" is vital, in Bonaventure's view; to ensure potency it must be neither too hot nor too cold. External circumstances, such as the weather and climatic conditions, also play a part: far better to have sex when the invigorating north wind is blowing than the debilitating south wind. (Here Bonaventure is echoing a passage in Aristotle's *Historia animalium*; as Albert the Great reiterates the principle, "the north wind causes the generation of males, and the south wind the generation of females.")[140] Finally, there are the effects of the soul, or the mind and its imaginations, on the body. Experience (*experimentum*) shows us that the memory of past pleasures frequently excites "the itch of the flesh (*excitatio pruritus carnis*),"[141] as in the case of nocturnal emissions. "From a strong imagination in dreams there is wrought an effusion of seed," just as if the individual concerned was in the actual "presence of a woman."[142]

Thus the imaginative power (*imaginativa*)[143] greatly helps the formation of strong seed. The downside is that it also contributes to resemblance, influences the physical constitution of a child, in ways which intrigued and perturbed Bonaventure and his contemporaries. Bonaventure refers to the biblical account (at Genesis 30:37ff.) of how Jacob took rods from various trees, partly removing their bark so that in color they were partly green and partly white. "He put them in the troughs, where the water was poured out; that when the flocks should come to drink, they might have the rods before their eyes, and in the sight of them might conceive" (Genesis 30:38). Evidently what the ewes were looking at while they conceived determined the appearance of their offspring: "in the very heat of coition, the sheep beheld the rods, and brought forth spotted, and of divers colours, and speckled" (30:39). (The point of this enterprise was that Jacob could then claim—as per his agreement with Laban—the multicolored sheep as his own, thereby getting the better of Laban, who was left with fewer animals.) To this narrative Bonaventure adds the medical case of a woman who, because she looked at a

dwarf when she was having sex with her husband, "conceived all dwarf sons."
That startling report goes back to Avicenna, as was noted by Albert the
Great,[144] who sees it in the same light as Jacob's success in breeding spotty
sheep, and the claim that "when a woman imagines the form of a certain
demon depicted on a curtain above the bed she always conceives children
like the picture."[145] All of these phenomena, Albert says, may be taken as
evidence that "the imaginative power" rules "the generative power in some
way," leaving its impression on that natural power "because it is superior to
it and dominates it."[146]

Bonaventure and Albert are drawing on a tradition concerning the role of
imagination in determining the appearance of offspring which goes back to
Aristotle and Galen at least, and survived through the eighteenth century. In
the treatise on midwifery which he published in 1737, Henry Bracken cites
the story of Jacob and Laban's sheep, remarking that "if Brutes are stigma-
tized or mark'd by the Force of Imagination," what then "must be the Effects
of it in rational Beings, whose Memories are more lasting?"[147] Anything that
a human mother witnessed or dreamed had a highly significant effect on the
formation of the fetus. Hence Galen recommended that a picture of a hand-
some man or a beautiful doll should be placed in clear sight of an expectant
mother, so she would produce a handsome son or a beautiful daughter.[148]
Again leaping across many centuries, in Torquato Tasso's hugely popular
"romantic epic," the *Gerusalemme liberata* (first published in 1581), we find
the story of a ferocious woman warrior named Clorinda, white with lovely
blonde hair, who was born of black Ethiopian parents.[149] This marvel
occurred because her mother had looked intently at a picture, hanging on
the wall, of St. George rescuing a snow-white heroine from a fierce dragon.[150]
Which explains Clorinda's skin coloring and formidable fighting skills.

Such is the power of the female imagination—or, rather, the power which
female imagination can exert when male agency is weak. With strong male
seed and "the high quality of men's fantasy" (intense sexual imaginings of
the kind that cause wet dreams), the resultant children tended "to reproduce
the virtue and the beauty conveyed in their father's mind at the time of
copulation."[151] But if the man's seed was weak, then female fantasy—by
inducing resistance or disobedience in the woman's seed[152]—might produce
a marvel or a monster, a beauty or a beast. As Albert the Great said in a
comparable context, such an outcome "sounds extraordinary," but it may
well be "part of the physical world (*licet sit physicum*)," one of the—quite
natural—marvels of nature.[153]

In the treatise which he wrote to prove that nature has many marvels which are not to be confused with miracles, Nicole Oresme (d. 1382) also posed the question, "can a pregnant woman alter her own fetus by the power of her *virtus ymaginativa*?" His answer is wonderfully circumspect: "yes, but not always, and not in just any way, too."[154] For Oresme this is an aspect of the more general question of whether a person's imaginative faculty can cause primary qualities (such as heat etc.) in one's own body, and also such secondary qualities as whiteness and shape. For instance, could a white man "through his own imagining . . . heat himself up and turn himself black," or indeed change his shape?[155] Oresme is willing to admit that in certain circumstances those phenomena may indeed occur. However, he refutes categorically the suggestion that a man's imagination can effect changes in the outside world by acting on a material object or the body of another person or an animal. "But that your imagining would move me, when I am unwilling, or would move a stone, is directly contrary to Aristotle." To say otherwise "is contrary to reason," as when Avicenna posits that by the power of his imagination a man can make "a mule fall down." Algazel tells a similar tale about a camel;[156] this seems to have been a popular example, and may be the source of Oresme's mobile mule.[157]

Here, then, are startling instances of what can happen when the imagination overpowers weaker forces and influences, interfering with their own natural tendencies and purposes—interventions which, in themselves, are quite natural. And in such doctrine, according to Albert the Great, may be found an explanation for the way in which "the eye of an enchanter alters the bodies of children (and this is how it is said that the eye of an enchanter (*oculis fascinantis*) once threw a serf into a ditch)." This is seen as an extreme version of the process whereby "fear and trembling are produced in children" when they are startled by frightening shapes and objects.[158] At this point Albert is not distinguishing between imaginative impact on the bodies of others and on one's own body (in the manner of Oresme), for he proceeds to offer, as further examples of ways in which "the entire body is altered by various imaginings," the case of "that royal woman, whom Avicenna described, imagining the shape of a demon or a dwarf (or, according to others, an Ethiopian) [and] bore children resembling them." Here is one of Clorinda's foremothers, a woman whose own corporeal "power succumbed at the moment of conception" (or perhaps Albert means it succumbed "in the fetus"), "owing to the violent imagination (*vehementem imaginationem*), and the natural power was altered according to the kind of thing she was imagining." Albert then refers

to "animals looking upon things of various colors" (perhaps he has Jacob's unusual sheep-breeding techniques in mind), the point being that a soul's impression can result "in a change in the entire body. And it is similar for the semen." That is to say, semen is also affected by the action of the mind upon it.

Which brings us back to Bonaventure's *Sentences* commentary. Having taken us through the twists and turns of arguments concerning the factors affecting procreation, Bonaventure then admits that, in the form he has couched them, they apply only to *fallen* nature, where sexual fantasy cannot be controlled and the result of coitus is unpredictable.[159] Things were very different in Eden. There the principle of "mind over matter" was not merely important but made *all* the difference. Adam was in total control of the strength of his own seed.[160] If he wanted to generate a son, then the seed he produced would have been sufficiently strong for that purpose. But as and when Adam willed and imagined (*vellet et imaginaretur*) that he would have a daughter, then his "seed would be less strong, and the feminine sex would be generated." On each and every occasion, one may infer, Eve would deliver accordingly, her body obeying Adam's will, her imagination not obstructing the intended outcome of his seed, whatever the degree of its strength. And since in that primal time and place reason would, of course, ensure that everything was done in an ordinate fashion, as many women as men would have been born, so that each and every man might have a wife. (It would seem that in Eden everyone had to get married, and no one could remain celibate—this being understandable since the command "Be fruitful and multiply" applied to everyone.)

Nowadays, however, the generative force cannot be controlled in this efficient way, and there is no accurate means of determining how many males and how many females are born. When a man thinks that he is generating a boy he may well generate a girl, and vice versa; further, some men "generate more females, others more males."[161] Furthermore (to amplify Bonaventure a little) the success of a device like Jacob's trick with the rods cannot be guaranteed, and during sex dwarves and painted demons may perhaps be looked upon without fear. *Licet sit physicum* . . . such strange-sounding events may be "part of the physical world," but we cannot depend on them, any more than we can depend on some less surprising natural outcome; in this present state of misery only uncertainty is certain. How unlike the state of innocence, with its rational breeding program and obedient prenatal imagination.

When he addresses the same issues in his *Summa theologiae*,[162] Aquinas focuses more sharply on what conditions may have been like in Eden, thinking his way back into that lost world (or, lost chance of a world) with admirable precision and consistency. Part of this process is the startling hypothesis that there may have been no need for a woman other than Eve. Since our first parents were "to live in perpetuity" (without, one may add, any decline in their reproductive powers since aging would have been unknown to them), they themselves could have carried out all the necessary multiplication. Furthermore, since in Eden there would have been "no failure of strength on the part of the male, or unreadiness of material on the part of the female," the clear question presents itself, would all the offspring of Adam and Eve have been males, or not?

Earlier in his *Summa* Aquinas had explained that "the active power of the seed of the male tends to produce something like itself" (that is, a male child),[163] and specified three reasons for the generation of a female: "some debility of the active power," some "unsuitability (*indispositio*) of the material," or some external factor. Now[164] he is faced with the (supposed) fact that, in Eden, Adam's seed and Eve's *materia* would always have been in perfect condition. Thus he avoids any discussion of postlapsarian sexual debility. And the burden of his argument immediately falls on that "external factor." Aquinas places a little more emphasis than Bonaventure had done on the diverse effects of different climatic conditions, quoting Aristotle's claim that "a north wind conduces to the procreation of males, a south wind to the procreation of females."[165] However, St. Thomas seems unhappy with the implication that Adam and Eve would have generated a boy or a girl depending on which wind was blowing at the crucial time. So he proceeds to affirm the principle of mind over matter, though without reference to Jacob's unorthodox methods of sheep-breeding. On occasion a baby's sex is determined by the result of some strong mental impression (*ex conceptione animae*), by which the body is easily affected. That is to say, if the mind wants something badly enough, and the force of this *conceptio* is sufficiently strong, then the body can be directed to act in accordance with that wish. This phenomenon would have been "particularly likely in the state of innocence, when the body was more subordinate to the mind; so that, in a word, the sex of the progeny would have been settled by the decision of the progenitor,"[166] who in the first instance would have been Adam. Furthermore, had children been born in Eden, they would have lived a natural or "animal" life, "to which procreation is as proper as is the use of nourishment." Therefore

"it would be natural for all to procreate, and not only the first parents." So, then, Eve should not be seen as some sort of unique baby factory; the tasks of conception and gestation were not hers alone. Aquinas adds, "The consequence of this would seem to be that as many females would have been engendered as males"—which assumes that all the parents in paradise wanted it that way, that all their individual choices of the sex of their infants worked out on a 50–50 basis.

Aquinas does not pursue that apparent consequence of his argument. He probably assumed what Bonaventure makes explicit, that sexual transactions would have been conducted in an orderly fashion, the result being equal proportions of males and females. What Aquinas does say, and say very well, is that the variety and difference of gender contributes to the perfection and completeness (*complementum*) of human nature. This is a consequence of the rich diversity of creation, and the many hierarchies present throughout it. Here is a principle of considerable force and persistence, which we find deployed again and again as medieval theologians seek to describe the conditions appropriate to the first state of innocence. And, indeed, to its final state as well, the *patria* or homeland of the blessed. The very principle enlisted to justify an equal allocation of men and women in Eden also underpins scholastic advocacy of sex difference in the world following the General Resurrection (as we shall see in Chapter 3).There men and women will have their original, gendered bodies back, albeit in radically improved versions.

The Children of Eden

Yet another contribution to the *complementum* of human nature in Eden would have been the production of children—as babies, generated through conception rather than created fully grown like their parents,[167] and therefore subject to at least some of the vexations and frustrations experienced by young children nowadays. Presumably the progeny of Adam and Eve would have had more robust and functional bodies than those of contemporary infants, in line with the exceptional (by today's standards) strength possessed by their parents' bodies. But did they possess full physical strength the moment they were born? Ordinary children are vexed when they are unable to get at something nice (*delectabile*) which is set before them. Since such vexation seems out of place in paradise, perhaps its babies did have sufficient strength for the full use of their limbs immediately after birth? Aquinas, who

raises this particular issue, remarks that, if we allow ourselves to be guided by the nature of things (as we understand them now), we will find this suggestion unlikely.[168] Children have very humid brains,[169] which means that their nerves cannot yet move their limbs; as they mature, they gain sufficient strength to do so. Presumably these facts of child development would also have applied in Eden. On the other hand, "no catholic will doubt that it could happen, by divine power, that children should have complete power to move their limbs the moment they are born." It is all very well to be guided by nature, but certain matters are "handed down to us by divine authority" and go beyond nature as we know it.

God's ultimate authority having respectfully been invoked, the question then becomes, *did* divine power operate in such a special way, so as to ensure that each and every child born in Eden had the full use of its limbs? Aquinas thinks not, and solves the problem with reference to the different ways in which the human will operates at different stages in a person's life. In Eden the body was perfectly subjected to the soul, and its members could not fail man's well-ordered will. Man's will is well-ordered "when it exerts itself in actions that are appropriate to him." However, "the same actions are not appropriate to a man at any and every age." Different ages require the performance of different actions; what is appropriate changes with time. Therefore the children of Eden would have willed only those things which were suitable to infancy, "such as sucking breasts and the like." If more needs to be added by way of explanation, "you can say they would not have wanted anything except what was proper (*conveniens*) to their condition"—thanks, yet again, to well-ordered wills. Richard of Middleton concurs.[170] At present the corporeal weakness of children concerns not only what, in physical terms, they are incapable of doing but also their lack of patience. Richard is confident that the first children would have been a patient lot. Unable to do certain things, they would nevertheless have been content to do what they *could* do, tasks appropriate for children (even paradisal ones).

Having cleared up the issue of the state of the bodies of Eden's newborns, questions remained about the amount of knowledge they would possess at birth, and the extent of their powers of reason. It was generally assumed that in paradise, infants would have had a better use of reason than is the case now, "with reference to things that suited them in the condition of that state [of innocence]," as Aquinas put it. That is to say, they would have been much more rational than young children are at present, while being children rather than miniature adults. Furthermore, they would have been better

behaved, with "sufficient understanding to govern themselves in those deeds of justice in which men are governed by general principles of right and wrong." That claim concerning the instant righteousness of Adam and Eve's progeny has surprised one of St. Thomas's modern editors, Thomas Hill, who sees here an advocacy of "a justice capable of immediate exercise in act." The children of Eden would have "a sufficient understanding . . . of first moral principles," meaning that "they would have been capable of actual thought from birth; which is not easy to square" with the appeal to "the pattern of nature" (i.e., nature's normal processes) made elsewhere in this *quaestio*, and indeed in Aquinas's discussion of the bodily strength of primordial infants (as discussed above). "Perhaps we must say," Hill concludes, "that the patterns of nature are held nowadays to be much more restrictive of hypotheses than was thought in the thirteenth century."[171] One might imagine Aquinas responding that our present-day understanding of "the patterns of nature," and the "hypotheses" we base on them, are inevitably deduced from the world as we find it rather than as God initially created it. Much of what we regard as normal childhood behavior is predicated on what are, in fact, features of fallen nature. While the patterns of prelapsarian nature can to some extent be inferred from those of fallen nature, at certain points the analogies fail to convince, and important differences must be conceded.

Besides, St. Thomas did not go so far as to say that Eden's children would have been born wholly mature in understanding and with the untrammeled use of reason. On the contrary, he was quite convinced that this would not have been the case. Here his Aristotelian theory of knowledge (or, more specifically, theory of the acquisition and processing of knowledge) is deployed to great effect. "The use of reason depends in some way on the use of the powers of sense," and if these powers are hindered (as when, for example, people are either asleep or in delirium), then they lack the full use of reason.[172] Given the "excessive humidity of the brain" in infants, "they have not got the untrammeled use of reason, any more than they have of their limbs." As they grew to their full stature, the greater their powers of reasoning would have become.

Furthermore, man was designed to acquire knowledge through the senses; "that is why the soul is in union with the body, because it needs it for its own activity."[173] As Aquinas explained earlier in the *prima pars* of his *Summa*, while the soul is united to a "passible" body—a body capable of change, suffering, and corruption—in order that the intellect may gain understanding it needs the "sensitive" powers (particularly the imagination) to function, and

those powers make use of bodily organs.[174] Applying this to his discussion of the learning curve of Eden's hypothetical infants, it may be said that they would have needed some time to acquire and process knowledge with the aid of the sensitive powers. If "straightaway from the beginning" the children of Eden "had an understanding of things not acquired through the sense faculties,"[175] that would be quite contrary to our normal process of acquiring knowledge. Here Aquinas is allowing "the patterns of nature," as understood in this, our fallen world, to carry the argument. He has not, after all, strayed far from this principle.

What Adam Knew

But Adam was quite different from any child of Eden, in respect of the kind of knowledge and moral awareness which he possessed; the fact that he was not born of woman but arrived, fully grown, thanks to the direct operation of divine power, made him a unique case. Here Aquinas and his contemporaries had to go beyond "the patterns of nature" to confront the singular operation of grace. Unlike his possible progeny, Adam came with considerable knowledge "ready made," so to speak. He promptly named the animals (Genesis 2:20), which indicates that he knew their natures—hence he may have known many other things as well. Sir David Lindsay believed that Adam surpassed Solomon in wisdom, Aristotle in natural philosophy, Virgil in poetry, and Cicero in oratory (in addition to excelling Sampson in strength and Absolon in beauty; *The Monarche*, ll. 957–65). But how could he have known so much?

Rather than acquiring knowledge by experience (his exceptional creation having rendered that impossible), Adam gained it through divine "infusion" (*infusio*), Aquinas claims.[176] Thereby God dispensed with the usual process whereby material objects act on the organs of the sense faculties (eyes, ears, tongues, noses, hands) to produce impressions on the soul which are the beginning of knowledge. However, Adam had the capacity, all the necessary physical and mental organs and abilities, to acquire knowledge in that way. Elsewhere Aquinas makes the same point more clearly by saying that in Eden man had "two kinds of knowledge of God," one "by means of an internal inspiration due to the irradiation of divine wisdom," and the other, "by which he knew God as we do, through sensible creatures."[177]

Adam was given a head start, as it were, because he had important work to do—not only the multiplication of the species but also its education and management. Just as his body was produced in a perfect state so he was "capable of immediate procreation," his soul was established in a perfectly mature state so he could immediately set about instructing and governing others.[178] Since knowledge is necessary for instruction, Adam was granted instant "knowledge of all those things for which man has a natural aptitude"—by which Aquinas means whatever truths man is able to know naturally (though of course, given his exceptional prelapsarian mental powers, Adam's natural ability would have far surpassed ours. But he had been unable to exercise it as yet, and God did not want him to start from scratch). Moreover, in order "for the direction of human life in that state of innocence," Adam was endowed with such knowledge of supernatural truths as was necessary.

This does not mean that Adam knew everything. Far from it. There are many things which a man cannot know by his own efforts, things which in any case are not necessary to know for the successful "direction of human life." And these were not known by the first man either. According to Aquinas they include "men's thoughts" (i.e., one cannot know exactly what someone else is thinking), some future events with an unpredictable outcome, and certain individual facts, such as the number of pebbles in a stream.[179] A somewhat whimsical thought, but beautifully evocative of all the things that not even the first, the most perfect, natural man could possibly have known.

Of course, Adam would gain further knowledge of things, with further experience of Eden. His capacity for acquiring knowledge, and conveying it to others, was far in excess of what is characteristic of fallen humankind. Aquinas envisages Adam quickly advancing in the pursuit of natural knowledge, inasmuch as his manner of knowing would have become more secure and definite: "what he knew speculatively he would subsequently have known by experience," and (it may be added) the potential scope of his experience in the Garden of Eden was extraordinary, by postlapsarian standards, as was his intellectual ability to gain secure knowledge from it. Maybe Adam could indeed have gained some idea of the number of pebbles in one of paradise's streams, had he set his powerful mind to it. But knowing what men think in their hearts would, no doubt, have remained difficult if not impossible. The minds of the children of Eden would not have been wholly open to their father. Even more obviously, Adam was unable to know the mind of Eve, on an occasion when it really mattered.

More on that in our next chapter. What I want to emphasize here is the widespread scholastic belief that Adam's mechanisms for gaining and using knowledge were basically the same as ours. (But of course, we lack— exceptional gifts of divine grace apart—the special divine infusion of infor- mation which God lavishly bestowed upon the first man as a sort of "startup.") Aquinas seeks to clarify the matter with the (actually rather cryp- tic) remark that "the eyes which Christ gave to the man born blind were not different from those given by nature" (cf. John 9:1–7).[180] Which I take to mean: the fact that the beneficiary of this miracle was given fully formed eyes as a unique divine gift does not mean that they worked any differently from the ones nature normally gives a person at birth. The general point which may be inferred is that Adam's five external senses (sight, touch, hear- ing, taste, and smell) and four internal senses (*sensus communis*, imagination, reason/intellect, and memory) functioned in basically the same way as ours do now. Perceptions of objects by his exterior senses would meet in his "com- mon sense," and his imagination, stimulated by these sensations, would form the mental pictures (*imagines* or *phantasmata*) necessary for thought. Images thus produced would be handed over to his reason, which would employ them in the formation of ideas. These ideas, with or without their related images, would then be stored in his memory. However, one of the internal senses in particular, while quite indispensable to human thought, could also be unreliable and misleading, at least in the fallen world. This was the *virtus imaginativa*; at once the most problematic and the most fascinating of all the "inner wits."[181] We have already noted how this power was credited with influencing the sex, appearance, and disposition of a fetus in the womb, in ways which might be troubling and subversive; some scholars even suspected that it could effect startling changes in the external world (by relocating a stone, camel, or mule, for instance). Now we must consider the more routine functions assigned to *imaginatio*, its role in cognition and its ability to pro- duce images of things not normally (or not at all) perceptible to the senses, in order to address the question, how would Adam's imagination have func- tioned in Eden? Could it possibly have deceived him, even in that state of innocence?

The importance of the imagination in gaining understanding was empha- sized in a much-quoted passage in Aristotle's *De anima*: "the soul under- stands nothing without a phantasm," a mental image.[182] Aquinas elaborated on this statement as follows: "whenever the intellect actually regards anything there must at the same time be formed in us a phantasm, that is, a likeness

of something sensible."[183] And in his *Summa theologiae* he further affirmed that in our present state of life "it is impossible for our intellect . . . actually to understand anything without turning to sense images (*phantasmata*)."[184] The imagination is vital both in the acquisition of fresh knowledge and in the application of knowledge already acquired. Aquinas appeals to experience here, noting that when we try to understand something, we create certain images to serve us by way of examples, and if we are helping someone else to understand something, "we lay examples before him" from which he forms his own phantasms for "the purpose of understanding." Adam, one may presume, would have found such didactic devices useful in his educational program, even with the exceptionally bright students in his paradisal classroom.

The problem is, the imagination comes with certain inbuilt limitations and risks. It possesses not only the reactive capacity to make images from sense-data but also the active capacity to form images of things which the senses either had not or could not perceive (in the latter case, because those things did not exist, at least not in the everyday world). Bartholomew the Englishman explains that by the "vertu ymaginatif" (cf. the Latin forms *vis/virtus imaginativa*), we form likenesses and shapes of things which are based on apprehensions of the exterior sense, as when it seems that we see golden hills or the hill Mount Parnassus, on account of the resemblance to other hills and mountains.[185] In other words, the imagination can take (for instance) the sense-generated image of the color gold and compound it with the sense-generated image of a mountain, to produce an image of a golden mountain, a mental picture such as we have never seen in real life.[186] Could Adam's imagination have acted in this way, bringing him into a state of confusion? Even when the empirical objects in question are right before our eyes, Aristotle warns, the imagination can potentially be deceptive— as when it tells us that the sun is only a foot in diameter. If such a problem, as experienced while one is awake, were not bad enough, in sleep things get even worse. Freed from the firm control of reason, the imagination can run riot in our dreams, conjuring up all sorts of strange and suspect images.[187]

What, then, was the stuff that the first man's dreams were made on?[188] The stakes here may be clarified by a later treatment of the problematics of Edenic imagination, as found in John Milton's *Paradise Lost*. The fourth book of this poem includes a vivid description of Satan sitting "Squat like a Toad, close at the eare" of the sleeping Eve,

Assaying by his Devilish art to reach
The Organs of her Fancie, and with them forge
Illusions as he list, Fantasms and Dreams . . . [189] (801–3)

Adam's subsequent attempt to analyze her terrifying experience begins with
an expression of puzzlement. He fears that this "uncouth dream" is "of evil
sprung"—"Yet evil whence?" Where could such evil come from? He has no
idea, of course, that Satan is the source of the trouble. Working on the
assumption that no external agent has manipulated Eve's sleeping imagina-
tion to produce the prideful conceit of becoming a goddess, Adam offers his
wife a learned explanation of how the human imagination works—all the
more fascinating for purporting to be about the imagination of paradise, as
yet uncorrupted by Original Sin.

> . . . know that in the Soule
> Are many lesser Faculties that serve
> Reason as chief; among these Fansie next
> Her office holds; of all external things,
> Which the five watchful Senses represent,
> She forms Imaginations, Aerie shapes,
> Which Reason joining or disjoining, frames
> All what we affirm or what deny, and call
> Our knowledge or opinion; then retires
> Into her privat Cell when Nature rests.
> Oft in her absence mimic Fansie wakes
> To imitate her; but misjoining shapes,
> Wilde work produces oft, and most in dreams,
> Ill matching words and deeds long past or late . . . (V, 100–113)

Even in Eden, it would seem, the imagination can engage in "wilde work,"
misjoining ideas and images from real life to produce something which is
inaccurate and potentially misleading. Adam finds in Eve's dream some genu-
ine "resemblances" of their "last Eevnings talk" (the occasion of Raphael's
visit), "But with addition strange." Then he proceeds to reassure Eve that
she is in no way to blame for her dream.

> . . . yet be not sad.
> Evil into the mind of God or Man
> May come and go, so unapprov'd, and leave

No spot or blame behind: Which gives me hope
That what in sleep thou didst abhor to dream,
Waking thou never wilt consent to do. (V, 116–21)

Only if she assented mentally to her dream's vain vision, only if she actually
tried to become a goddess by eating the forbidden fruit, would Eve be culpa-
ble. In Eden, as now, we cannot be held morally responsible for our fantasies;
imaginations in themselves are not directives to action.

The terms of reference in play here recall those of late medieval scholasti-
cism (which is hardly surprising, given how much Aristotelian thought that
transformative intellectual movement bequeathed to the Renaissance). How-
ever, Bonaventure was more optimistic than Milton about the reliability of
our original parents' dreams. Within a given dream, reason would police any
potentially misleading imagination, saying to the person dreaming, "You are
dreaming."[190] Besides, since in Adam's case the inferior powers were subject
to reason, a different purpose may be sought for his dreams: they were
divinely sent, as a means of bestowing enlightenment. In a similar vein, John
Wyclif claims that Adam would have enjoyed healthful and wholesome slum-
ber, unperturbed by the disorders which nowadays are caused by excessive
humors or external sensible influences.[191] Therefore he could experience accu-
rate dream-visions of future events (the principle being that the purer the
dreamer, the clearer his visions).

Aquinas agreed with that, at least in part. In one of his *Quaestiones disputa-
tae de veritate* he notes that, whatever may happen in one's sensitive part, it
is the understanding "which judges that things exist in reality in the way in
which sense portrays them."[192] The understanding can be deceived. But this
never happened in the case of Adam, since in dreaming "his understanding
would have refrained from judgment"—he would have exercised a sort of
suspension of judgment, it would seem. When awake, Adam would have
had no problem at all in accurately making judgments concerning "sensible
objects."

In other words, errors of perception may come and go in the mind of God
or Man, "unapprov'd" and without moral consequence; the "wilde work" of
imagination is not inevitably harmful. And Aquinas's account in his *Summa
theologiae* has even more in common with Milton's dramatization of paradisal
dreaming; there his thoroughgoing Aristotelianism shines through. A man is
not accountable (*non imputantur*) for "what happens in sleep," Aquinas
robustly declares, because "he has not got the use of reason then."[193] Which

William of Auxerre (d. 1231) considers the possibility that, even in Eden, Adam might have sinned in a manner which is common among men.[200] Unsurprisingly, the discussion ends with a reassuring conclusion—we are investigating something quite miniscule and unproblematic. The argument runs as follows. Mortal sin was impossible in paradise (at least, right up until the time of the Fall), because Adam's powers were not disordered but rather governed by reason. That fact would also seem to rule out the possibility of venial sin—that is, sin of a lesser and easily pardonable kind. However, William manages to come up with a category of venial sin which does not involve the *fomes peccati* ("tinder for sin"), those corrupted desires of the sentient appetite which assail humankind nowadays. In Augustine he found mention of a type of misdemeanor which involves a man loving his wife and children beyond what is owed (*debtum*). (In Shakespearean phrase, one should love according to one's bond, no more, no less). If a man loves his family members more than he loves God, this is mortal sin; however, if he loves them less than he loves God, though still beyond what is owed, then the sin is venial. William relates the latter category to Adam. If a man can sin venially in this way, then Adam could have sinned venially in this way—though Adam was more of his own master (*liberam*) than any ordinary man can be.

So, then, on the one hand, Adam was one of us—the prototypical human, the very blueprint for all men and women who have ever lived and ever will live. But on the other hand, he possessed such perfection of body and soul that he was far superior to us, in all his works and thoughts. Within the grand scheme of things, however, human beings were inferior to angels, and it also was important to make distinctions between their capabilities and those characteristic of the bodies of the blessed, the happy few who are to see God in the post-resurrection paradise.

This helps to explain the maneuvers which St. Thomas makes in discussing the kind of contemplation which man could experience in Eden.[201] The issue was given an added impetus by Peter Lombard's assertion that in the state of innocence, man "saw God without intermediary (*sine medio*),"[202] which implies that Adam enjoyed direct vision of the Divine Essence. Given that "man's happiness consists in the vision of the Divine Essence," it would seem that this was appropriate to humankind's initial paradise, a place of indescribable happiness.[203] But such a suggestion must be rejected, Aquinas explains, because if Adam had indeed enjoyed such vision and the knowledge which came with it, he could not have turned away from God, and sinned by eating the forbidden fruit. "Nevertheless he knew God with a more perfect

would seem to indicate that, even in the state of innocence, some degree of confusion might have arisen from Adam's dreaming—if we may assume that not even Adam had the full use of his reason while asleep. However, if any confusion did arise, Aquinas is confident that soon it would have been cleared up. A man cannot be blamed for entertaining a false opinion about something to which his knowledge does not yet extend, providing that he does not assent rashly to some falsehood, come to believe it firmly. Once Adam's knowledge grew, and/or with some divine guidance from above, he would recognize the falsehood for what it was, and immediately reject it.[194] Not even Eden could rise to a genuinely golden mountain; if Adam's imagination had constructed such a thing, his perception of waking reality would promptly have dispelled it. One might add the thought that, in any case, Adam's wildest dreams would have been a lot more modest and restrained than what is possible for modern humans. So there would have been little to correct.

But is it just possible that, while awake, Adam's imagination could have led him astray, by providing the reason with an inaccurate phantasm of a given object? Nowadays we find it difficult to judge the size of far-off objects (as Aristotle had noted),[195] and since the nature of the eye is not changed by sin, it would seem to follow that, in the state of innocence also, "man would have been mistaken about the size of things seen, as he is now."[196] Aquinas rejects this comparison with present-day conditions out of hand. If anything had been presented to the imagination of the first man which was "otherwise than it is in fact (*in natura rerum*)," he would have recognized this instantly, as his reason enabled him to discern the truth.[197] Thus in such a case Adam would not have been deceived.

The arguments here quoted form part of Aquinas's treatment of the question of "Whether man in his first state could be deceived." Here he is focusing on the situation prevailing in Eden until the point at which the inner sins of Eve (pride) and Adam (sinning in his heart) left them open to falsehood, and the Fall ensued.[198] This enables the general conclusion that "the rightness (*rectitudo*) of the first state was not compatible" with any deception of the intellect whatsoever, Adam's original disposition and situation being quite resistant to such an outcome.[199] Yet Aquinas has conceded some complexities and admitted some qualifications. He and his fellow-schoolmen sought to find a balance between Adam as Everyman and Adam as Other. Example after example of such negotiations fill their treatises, and a wish to shock, or at least to pique professional interest, is often evident—as when

knowledge than we do now." Therefore, while Adam did not experience perfect spiritual happiness in Eden (that being possible only in the *patria*), he was happy to a large extent, endowed with what Augustine called "a blessed life to a certain degree (*secundum quendam modum*)."[204] Certainly a larger measure than man can experience in the fallen world. For example, in Eden man could meditate upon his certain beatitude without the prospect of fear or oppression, to cite Wyclif's *De statu innocentiae* yet again.[205]

Augustine had raised the possibility that God used to speak to the first man as He speaks to the angels, by "enlightening their minds with the unchangeable Truth itself," "even if he did not give them such a full partici-pation in the divine Wisdom as the angels can take."[206] Once again we see the desire to keep man, even a man of such perfection as Adam, in his rightful place in the hierarchy, positioned under the angels. Talking of angels, could Adam have seen them in *their* essence, that being an experience obviously conducive to the happiness we associate with paradise?[207] No, says Aquinas, but "nevertheless he had a more excellent kind of knowledge" regarding the angels than we fallen creatures possess, because his knowledge of such things "was surer and steadier than ours." It was on account of this excellence of knowledge that St. Gregory the Great says that man "consorted with the angelic spirits."[208] Manuscript illuminations which depict the Edenic scene often show angels in familiar (if somewhat formal) association with men, perhaps entertaining or educating them. As already noted, angelic musicians feature in Plate 9, which illustrates the innocent pleasures of Adam and Eve, in contrast to the lewd corporeal delights prominent in the false paradise devised by that treacherous "old man of the mountain," Alaodin (Plate 10). Here was yet another source of spiritual happiness available to Adam.

So, then, the innocent pleasures of Eden definitely included (or, would have included) an appropriate and hierarchically determined exercise of the intellect—less extensive that that of the angels, but far more incisive than that of fallen humanity. And only a mere inkling of what the blessed will experience and enjoy in the *patria*, when God will indeed be seen *sine medio*, and where knowledge will be directly infused to a far greater extent than was possible in the state of innocence.[209] Bonaventure sums up the matter con-cisely by saying that "in the state of glory alone will God be seen immediately and in His essence, such that there will be no obscurity there," whereas in the state of misery—the world we have now—God "is seen through a mirror obscured through the sin of the first man." Before the first man sinned, God was seen through a mirror clean and clear, as yet not darkened by the "cloud

of sin."²¹⁰ Such was Adam's (relatively) happy lot, in the cloudless Eden of the mind.

Creating Souls

The creation of the body of Eve from Adam's side attained the status of a standard illustration. Plates 6 and 7 represent the standard tableau of God presiding over the process, but Plate 8 proves that some variation was possible. This is from Bibliothèque nationale de France, MS fr. 599 (a French translation of Boccaccio's *De mulieribus claris*), and is probably the work of the brilliant Robinet Testard, who served Charles, Count of Angoulême (d. 1496), and subsequently his widow, Louise of Savoy. Here God is out of the picture, as Eve's freshly opened eyes gaze down at the leonine male body from which she is emerging into a flower-strewn forest.

When it came to the subject of the creation of the souls of Adam and Eve, however, medieval artists tended to leave the matter to the theologians. But a few exceptional treatments have survived, including the illumination printed here as Plate 11. This is from Bibliothèque nationale de France, MS fr. 134, a manuscript (dating from the second half of the fifteenth century) of Jean Corbichon's translation of Bartholomew the Englishman's *De proprietatibus rerum*. It is located at the beginning of Bartholomew's chapter on the properties of the rational soul. God, in regal attire, raises his hand in the traditional gesture of benediction over the prone bodies of Adam and Eve. Maybe this simply illustrates the fact that that the souls of Adam and Eve were the first two to be created. An alternative explanation is that here the artist is showing their souls being infused, a depiction which, to achieve its representational end, sets aside the sequential narrative of Adam's body and soul being created first, followed by Eve's. Curiously, Eve seems the more self-aware of the two, her body more articulated than Adam's. But this does not imply any precedence of the production of Eve's soul before Adam's. Evidently Adam is still in the "deep sleep" (*sopor*) into which God cast him when He wished to create Eve (cf. Genesis 2:21); the iconographic convention of an awakening or awake woman emerging out of, or from behind, the body of a bearded sleeping man has left its mark. In sum, this image is not as unusual as might at first appear.

The schoolmen did give such issues their fullest and best attention—hardly surprisingly, for they impinged on that most foundational of all theological questions, the origin and incarnation of the human soul. Here, far

more acutely than anywhere else, arose the problem of whether the first man was as other men, or significantly different from lesser mortals. In view of the extraordinary creation of Adam's body, was his soul made (or "infused," to use the technical term) in the same way as ours, or was it too the result of a one-off divine intervention? Did its production differ significantly from the origination of subsequent souls—of Eve's, and those of their children and their children's children?

Two relevant passages in Genesis seemed not to fit together well. At Genesis 1:26, where the sixth day of creation is being described, God says, "Let Us make man to Our image." But at Genesis 2:7, following the account of the seventh day, we read, "God formed man from the slime of the earth." The first passage may be read as referring to the formation of the soul; the second, to the formation of the body (according to Bonaventure's treatment in his *Sentences* commentary).[211] If so, it would seem that Adam's soul was made before his body, outside his body rather than inside it, and united with it subsequently. Thus arose, as Peter Lombard nicely put it, "a tangled question (*scrupulosa quaestio*) among the learned."[212] He credits Augustine with teaching that "the soul was created with the angels and without a body; it came into the body afterwards."[213] (This statement is made without qualification—here, the Lombard implies, is what Augustine actually taught on this matter.) In contrast, "others" say that "the soul of the first man was created in the body." As proof they adduce Genesis 2:7, where God is said to have "breathed" in Adam's "face the breath of life," reading it as a statement that, at this point in the chronological sequence of events, God "created the soul in the body so it might animate the whole body." Peter proceeds to offer a useful qualification. Whatever opinion one may hold concerning the soul of the first man, in the case of the souls which followed Adam's, it may be believed that they are "created in the body, for in creating them God infuses (*infundit*) them, and creates by infusing (*infundendo*) them."[214] St. Augustine had no problem at all with that proposition, as Bonaventure emphasizes in his own relevant comments.[215]

However, evidently he believes that Augustine's statement that Adam's soul was produced before his body requires more careful analysis and contextualization. With consummate deference, Bonaventure remarks that "the outstanding doctor . . . seems to have been in doubt about this question."[216] Augustine's exact phrasing (which was only partly quoted by Peter Lombard) is as follows: "So let it be supposed then, if there is no scriptural authority (*auctoritas*) or evident argument of reason (*ratio*) against it, that the man was

made on the sixth day in such wise that while the causal framework of the human body was created in the elements of the world, the soul was itself created just as the original day was established."[217] Bonaventure has hardened his predecessor's admission of uncertainty into a *dubitatio* in the sense (as understood by the schoolmen) of a hypothesis put forward to advance an argument, which would be either accepted or rejected in the concluding *responsio* or *determinatio*. He has, so to speak, given Augustine the benefit of a doubt (a doubt which the Lombard had erased),[218] attributing to the *egregius doctor* a recognition that both sides of the question can be argued well, that each point of view has value. "Each side seems to be able to be sustained in a probable manner." Aquinas was somewhat tougher. Having accepted that Augustine does not say this by way of assertion (*non dicit asserendo*),[219] he proceeds to dismiss the argument itself as "altogether impossible" to be held by anyone who believes—as, of course, Aquinas himself did—that "the soul is united to the body as form to matter," and is naturally a part of the complete human nature.[220]

His own preference is crystal clear: "it must be held as true and more appropriate, that the soul of Adam was produced in his body, and that God did not produce it before the formation of his body." Yet Bonaventure skillfully maintains the "reasonableness" of Augustine's view. The argument that God produced Adam's soul ahead of his body does make the (quite unexceptionable) point that the soul "does not depend upon the body, but is able to subsist through itself"; thus its nature may be compared to the angelic nature inasmuch as both possess the capacity of reason and both are directed toward beatitude (as a general principle, one might add, because not all individual men will fulfill that grand destiny).[221] However, "it seems by far more reasonable to posit, that the soul was produced immediately with the body." Therefore Bonaventure will adhere to "this side as the more probable and secure one." And those two apparently conflicting passages in Genesis (1:26 and 2:7) cause no real problem, for either the first statement is an anticipation of the second or the second is a recapitulation of the first.[222]

Bonaventure's handling of Augustine's troubling claim—a claim that would put Adam's soul in quite a different category from that of any other human being—is a masterpiece of tact. But why did Bonaventure choose to go through such an elaborate convolution? Because, I believe, he was worried lest a view expressed by one of the greatest (arguably *the* greatest) of the Church Fathers might smack of Neoplatonism—or, rather, of a facet of Neoplatonism which was impossible to assimilate to orthodox Christian doctrine,

as Origen's spectacular failure in this regard made all too clear.[223] The notion that Adam's soul existed before his body could conjure up the specter of "the fabulous pre-existence of souls," as the Fifth General Church Council termed it when pronouncing an anathema.[224] Far safer to take the line that all souls, including Adam's, were created with their bodies (which, in the case of Adam's successors, meant that their souls came into being at birth).

The extent of the problem with Plato becomes quite clear when Bonaventure, focusing on the production of the souls of Eve and other humans, asks whether they were produced all at once or successively brought into existence.[225] There are three ways of tackling the issue, he says: according to "the estimation of certain philosophers," according to the "invention of certain heretics," or according to "the teaching of the holy Doctors." The outcome of the argument is no surprise. But the way in which Bonaventure structures and conducts it is truly impressive.

First, "the estimation of certain philosophers." Here Bonaventure has in mind the theory of reincarnation, as articulated by "Plato and his followers": "Souls were created together in companion stars (*stellis comparibus*), and subsequently, bodies suitable to them having been formed, they descended to vivify these bodies through a milky heaven (*lacteum caelum*) and the other orbs of the planets." Following the decay and death of those same bodies, the souls leave them to return to their stars, and "after a while they descend again" to animate new bodies. Here, whether directly or indirectly, Bonaventure is drawing on doctrine which Plato attributed to the Pythagorean philosopher Timaeus in the dialogue named after him.[226] The Franciscan identifies Macrobius as one who had striven hard "to approve" that doctrine, in his commentary on Cicero's *Somnium Scipionis*. There the heavenly rather than the earthly origin of souls is affirmed. "They are merely exiled to earth, sojourning here for a time," declares Macrobius. "The region below [i.e., the sublunar region] possesses nothing divine but only receives it; for it receives it and sends it back."[227] Bonaventure might also have mentioned that other major *locus classicus* for Timaean teaching in the Middle Ages, Boethius's *Consolatio philosophiae*, Book III, meter ix, which envisages "lesser souls and lesser lives," which God has affixed to their respective "chariots" and dispersed over earth and heaven, returning to render back "their fires" to him, "by a law benign" (18–21). This passage caused its medieval explicators considerable difficulty. In the most widely disseminated of all medieval commentaries on the *Consolatio*, written by the English Dominican Nicholas Trevet (d. c. 1334),[228] the claim of "certain Platonists" that God first created souls in

heaven and subsequently conveyed them into earthly bodies is rejected. Rather it should be understood that God produces each soul anew in the body, but the body is dependent on heavenly power and influence for its disposition. The statement about rendering back "their fires" (l. 21) refers to the operation of charity, which restores men to the virtues from the vices; thereby God makes the soul "come back to Him" as the end and sum of all good.

Here is special pleading of a high order—though actually a misreading of Boethius's words, imposed in order to affirm their orthodoxy. The underlying attitude seems similar to that intimated by Dante's Beatrice, as she sharply contrasts her insider's view of paradise to the inaccurate opinion of Plato's Timaeus:

> "Dice che l'alma a la sua stella riede,
> credendo quella quindi esser decisa
> quando natura per sua forma la diede . . ." (*Paradiso*, XIV, 52–54)

> ["He says the soul returns to its own star, believing it to have been severed thence when nature gave it for a form . . ."][229]

But maybe, Beatrice adds graciously, Timaeus's opinion (*sentenza*) "is other than his words sound, and may be of a meaning not to be derided" (55–56). Nicholas Trevet, as quoted above, certainly read Boethius's reiteration of that *sentenza* as other than his words sound.

Bonaventure, on the other hand, goes all out to deride the meaning. The doctrine of reincarnation is dismissed as "more of a dream rather than an authentically true saying" (*plus est somnium quam aliquod dictum authenticum*). Furthermore, he continues, the notion that souls are in a state of constant circulation, as they descend to and ascend from various earthly bodies, is not susceptible of rational proof, and no one can remember any such thing happening to him. It also contains a manifest absurdity, inasmuch as it denies that "the soul is not the true perfection of a body"—here, yet again, Aristotle's theory that the soul is the form of the body is deployed, this time to refute Plato.[230] Even more damningly, if souls are constantly on the move they can never achieve the stability of beatitude, never come to enjoy the eternal pleasures of the paradise beyond death.[231]

Time now for Bonaventure's inventive heretics.[232] He has in his sights the Manichaeans (a sect to which Augustine once belonged, it is worth

remembering, especially in light of our earlier discussion).[233] According to Bonaventure's contemptuous account, they believed that "human souls were created together with the angels in Heaven," but "after a while they sinned at the suggestion of the god of darkness," and "were thrust down" into the prisons of earthly bodies, "to be purged there, and when they have been purged, they will be recalled to their heavenly fatherland (*caelestem patriam*)." This, Bonaventure thunders, is not only against the Catholic Faith, but against philosophy and what our own experience (*sensibilem experientiam*) tells us as well. It is against the Faith, because it claims that souls sinned before they were united to their bodies and that no soul is finally damned. It is against philosophy, because the notion that a soul passes through many bodies is contrary to Aristotle's assertion that "one's own form has to come to exist in one's own matter." It is against reason and "sensible experience" (i.e., counter to what the ordinary person feels), because we see that the soul, however good it may be, does not want to be separated from its body at death, and that would not be the case if it regarded its body as a prison. "Sensible experience" is appropriated also to dismiss the Platonic theory of recollection—that is, that the soul can remember things learned during its previous existence, which argument was used by Plato to prove the preexistence of souls. This is simply untrue, Bonaventure declares, because "we know nothing apart from those things which we have learned, since we were born." Had our souls been created long before, and had sinned in heaven, surely we would know a lot more than we actually do! And if one objects that souls temporarily forget what they know because they are oppressed by the mass of the bodies in which they have been imprisoned, then Bonaventure's response is, "Why, after the passage of time, do they not come to remember some things?"[234] Thus Manichaeism is refuted, with remarkable vigor.

At last, we come to "the teaching of the holy Doctors." The opinion that "souls were not created together, but are produced successively in their own bodies" is shared by all the orthodox writers who treat this subject. It is so certain, Bonaventure believes, that it cannot be doubted—at least, not by any of the people who really matter. He is especially keen to affirm that Augustine subscribed to it, even though he wondered (on Bonaventure's generous reading, as described above) whether the soul of Adam was created before his body or in his body. The *catholici tractatores* are unanimous that learning by the ongoing acquisition of knowledge is not the same as recollecting prior knowledge (*non enim addiscere est reminisci*). Bonaventure seems anxious to

emphasize this consensus. When in some orthodox treatise an *auctoritas* (i.e., an important passage) seems to claim something otherwise, it is to be reverently understood (*pie intelligenda*).[235] The author in question may have been expressing someone else's opinion. If he was expressing his own, then he was speaking about the precedence of the soul over the body not according "to the order of time but according to the order of nature": that is, no temporal priority was being implied, but a statement was being made about the priority or superiority which the soul has over the body in terms of the hierarchy of being. If the relevant words of the *auctores* (particularly those of Augustine, it would seem) are interpreted in this "pious" manner,[236] then all is well, any apparent doubts being resolvable.

So then, what exactly is the Catholic doctrine on which these reverend sires so heartily agree? That our souls cannot be said to have been produced before their bodies, for two reasons: on account of their ignorance (i.e., they lack knowledge which, had they previously existed, they would have possessed) and because the preexisting sin of which the Manichaeans speak did not exist in Adam's soul when it was infused into his body. Rather, our first parents brought Original Sin into the world at the Fall. Admittedly, this was passed on to their descendants. But they themselves had a fresh start, were created with freedoms which they squandered; in Manichaean thought (as presented by Bonaventure) they would not have had them in the first place. And for the seraphic doctor, original sin is a far less fraught legacy than the oppressive and increasing burden which, according to the heretics, accompanies the perpetually recycled soul on its every incarnation.

A final crucial piece of this intellectual jigsaw remains.[237] Was Eve's soul created from Adam's, just as her body was created from Adam's? Or were the souls of our first parents created from one and the same substance; indeed are "the souls of all men . . . one in substance"? In order to reject such dangerous thinking, Bonaventure has to take on the great Andalusian Muslim scholar who was known to the medieval West as Averroes, and honored as *the* Commentator on Aristotle just as Aristotle was deemed *the* Philosopher.[238] Specifically, Bonaventure aims to rescue Aristotle's *De anima* from the false interpretation which, he claims (on somewhat dubious grounds), Averroes has imposed upon it. The core idea which troubles Bonaventure is that the human or intellectual soul is one and the same in everyone (i.e., it has numeric unity). Part of the argument here is that, because this soul is incorruptible, it does not need to be multiplied, and in any case the body is incapable of individuating it. However much Averroes "polishes" (*coloret*)

this opinion, Bonaventure declares, "it is the worst one and heretical," "quite contrary to the Christian Religion" because, if all souls were one, there could be no individual merit or demerit. "It is also contrary to right reason," because "the intellective soul . . . is the perfection of a man," what makes someone human. Therefore each and every person has to have his own intellect and rational soul. Furthermore, from our own experience (once again, the appeal to *experientia*) we know that different people have "contrary thoughts and contrary affections." Thus Bonaventure affirms the principle of individuation (while taking care to emphasize that this is not dependent on the body alone). To sum the whole thing up, "according to the Faith and truth . . . diverse men have diverse rational souls." Getting back to Eden (for Bonaventure has taken us some distance from there): Adam and Eve have their own rational souls, as do all their descendants, even until the end of the world, when the production of new souls will cease.

Bonaventure's account of the origins and nature of the human soul, and the way we should understand its precedence over and relationship with the body, is a brilliant tour de force, conducted with impressive flair and consistency. Peter Lombard had asserted that the Catholic Church teaches "neither that souls were made simultaneously, nor from one another, but that they are infused into bodies which have been inseminated and formed through coition, and they are created at the moment of their infusion."[239] The seraphic doctor has endorsed and elaborated all those "catholic truths" to great effect. Such discussion well illustrates the way in which late medieval scholars sought the origins of their humanity in Eden. And no questions were more important than those which concerned the human soul.

Inevitably the answers the theologians gave were abstruse, the outcome of extensive professional education and training in the scholastic methodologies of research. Attempts to popularize the key points tended (quite predictably) to keep well within the realm of the safe and uncontentious. However, when it came to treating the dwelling place God had created for Adam and Eve, characterizing the beauties of Eden itself, there was considerable creative engagement between learned and demotic, Latin and vernacular, idea and image.

Eden as Human Habitat

. . . the divine paradise [was] planted in Eden by the hands of God, a storehouse of joy and universal exultation. For "Eden" means "delight" (*voluptas*).[240]

Its site is higher in the East than all the earth: it is temperate and the air that
surrounds it is the rarest and purest: evergreen plants are its pride, sweet
fragrances abound, it is flooded with light, and in utter beauty and sensory
freshness it transcends understanding: in truth the place is divine, a suitable
home for him who was created in God's image; no creature lacking reason
made its dwelling there but man alone,[241] the creation of God's own hands.

This description by the Syrian monk St. John of Damascus (d. 749)[242] was
frequently quoted by theologians of the later Middle Ages, and generally
squares with the iconography of the *paradisus voluptatis* followed by the poets
and painters of that period. A particularly rich version features in the popular
account of faraway places with strange-sounding names which circulated
under the name of "Sir John Mandeville." Here "wyse men" are quoted as
saying that the terrestrial paradise "is the highest place of erthe that is in alle
the world, and it is so high that it toucheth nygh to the cercle of the mone,
there as the mone maketh hire torn. For sche is so high that the Flode of
Noe [Noah] ne myght not come to hire that wolde have couered alle the
erthe of the world alle abowte and abouen and benethen, saf Paradys only
allone."[243] But nowadays "without special grace of God" no mortal man can
possibly reach it, because

by londe no man may go for wylde bestes that ben in the desertes and for the
high mountaynes and grete huge roches that no man may passe by for the
derke places that ben there and that manye. And be the ryueres may no man
go, for the water runneth so rudely and so scharply because that it cometh
doun so outrageously from the high places abouen that it renneth in so grete
wawes that no schipp may not rowe ne seyle agenes it.[244]

Mandeville modestly includes himself among those who were not there ("I
was not worthi"),[245] and therefore he cannot speak properly about the place
but must hold his peace, confining his attention to places which he *has* (alleg-
edly) seen. Eden, then, enjoys a certain status in this text, as one place (maybe
the one place) Mandeville is not willing to fantasize his way into. Hence his
ostentatious deference to what the "wyse men" say.

 In fact, while the "wyse men" of academe did share some basic assump-
tions with the mysterious Sir John, they were rather less credulous than he.
The vernacular writer was seeking to create an aura of mystery around the

wonders of the Orient which his book disingenuously presented, whereas the
professional theologians who inquired into the logistics of Eden were in the
business of reconciling their faith with their reason through the application
of the best science available to them. But that certainly does not mean that
the theological disquisitions are free of wonder or lacking in appreciation of
the exotic landscape and living conditions which our first parents enjoyed (or
would have enjoyed, had they stayed in paradise long enough). The supposedly
eastern location of Eden was addressed by Peter Lombard, who notes that,
whereas in the Latin Vulgate (Genesis 2:8) we read that the "Lord God had
planted a paradise of pleasure from the beginning (*a principio*)," the *antiqua
translatio* (i.e., the Septuagint) instead says "to the east" (*ad orientem*). There-
fore some argue that paradise is in an eastern region (*in orientali parte*), cut
off from the regions in which men dwell by an intervening space whether of
sea or land, "secretly hidden away and positioned on a high place, stretching
up to the lunar circle (*lunarem circulum*)"—that is, the orbit of the moon: so
high indeed that the waters of Noah's Flood did not reach there.[246]

The schoolmen were adept at pointing out the difficulties in this account.
No place on earth reaches up to the lunar circle, Aquinas says; that is quite
impossible because beneath the moon lies a region of fire, which would con-
sume the earth.[247] Bonaventure concurs. No human could possibly survive in
such a place, given its intense heat.[248] Furthermore, since the air in its supe-
rior part is of so great a thinness that birds cannot live there (as Augustine
says),[249] then neither could man, with his animal body. Given its high eleva-
tion, it would be very close to the sun and hence extremely hot and intemper-
ate, qualities which are incompatible with paradise. "Nothing can live or
flourish there," in that place of excessive heat and light, says Peter of Taran-
tasia, whose account of Eden's altitude is largely a repackaging of points made
by Aquinas (though he does devote a discrete *articulus* to the topic).[250] Aqui-
nas himself further notes that Scripture mentions four rivers as rising in
paradise (Genesis 2:10), but the rivers mentioned therein have visible sources
elsewhere.[251] And surely, given that men have explored "all the places of
the habitable earth" (there speaks a man writing before the discovery of the
Americas) "yet none of them mention the place of paradise."[252] All of which
would seem to indicate that there is no such place on earth.

It is crucial to understand the context of these incisive comments by the
abovementioned schoolmen. They do not constitute an outright rejection of
the idea of an earthly paradise, but rather are offered in support of the argu-
ment that the Bible may mean not a corporal place but rather a spiritual

one—an argument which they refute by asserting that both are meant. The dimensions of the problem are clearly stated by Peter Lombard, who, in attempting to summarize a long tradition of discussion of the nature of the earthly paradise,[253] said there were three fundamental methods of interpreting what Scripture says about the habitation made for humankind. It may be understood only corporally, only spiritually, or in both those ways.[254] Peter says he is attracted by the last of these positions. While Eden may be taken as a type or prefiguration (*typum*) of the present or future Church,[255] according to the letter (*ad litteram*) it must be understood "to be a most pleasant place, with very fruitful trees (*magnum fructuosis arboribus*) and fecundated by a great spring."[256] In fact, here the Lombard is merely reiterating St. Augustine's declared preference for the view that "paradise was both corporeal and spiritual."[257] This view was widely shared by the major schoolmen of the later Middle Ages, who felt that there was nothing wrong with believing in Eden as a spiritual paradise, providing belief in the historical truth of the Genesis narrative was maintained. So, Aquinas endorses Isidore's explanation that paradise "is a place set up in eastern parts, whose name translated from Greek means Garden."[258] "It is suitably said to have been placed in eastern parts. For we must believe that it was placed in the noblest spot of the whole world. And since the East is on the right hand side of the heavens, as we are told by the Philosopher,[259] and the right side is nobler than the left, it follows that paradise was suitably located by God in eastern parts."

What about that apparently intolerable climate? Bonaventure offers a scientific explanation. Since Eden is of so great an altitude, "vapors elevated in the air do not ascend all together there," but rather the air is "clean and pure, suitable for the state of perpetuity"—our first parents and their progeny could have lived there in great climatic comfort for the duration of their time on earth. The purity of the air would have moderated the heat of the sun.[260] The idea that paradise stretches up to the orbit of the moon (here that specific statement is attributed to Bede)[261] is made by way of similitude, Bonaventure suggests, rather than as identifying an actual location, because Eden is like the moon in terms of rarity, luminosity, and tranquility. For his part, Aquinas claims that Bede was speaking figuratively in this case, because (as Isidore says) the atmosphere there is of "a continually temperate climate," which is utterly appropriate for paradise.[262] But why did he single out the "lunar circle" in particular, "rather than the other spheres"? Because, Aquinas explains, the moon is nearest to us, and of all the heavenly bodies is the most akin to the earth. This serves well the figurative statement that paradise

reaches up to the moon's orbit—for, relatively speaking, it has not far to reach.[263]

There is no real problem concerning the source of the four rivers in question, according to Aquinas, since rivers often flow underground for some distance, and then spring up elsewhere, and so we have no great difficulty in believing that they originated in Eden.[264] (See Plate 12, another illumination from BnF fr. 2810.) Why, then, has no world traveler actually discovered the location of Eden? Because it is "cut off from where we live by barriers such as mountains or seas, or some torrid region which cannot be crossed," and so people who have written about topography make no mention of it.[265] This is not very far away from Mandeville's image of a land protected from the curiosity of men by deserts infested with ferocious animals, high mountains, huge rocks, and tempestuous rivers.

A place must be appropriate to the person located therein, and since humankind was the most noble of dwellers, therefore it was appropriate that he should live in the most noble location on earth—and that place, in respect of climate, pleasure, and fertility, was the Garden of Eden. Thus Peter of Tarantasia enthuses.[266] But was the Garden of Eden *really* the best possible abode for man? Evidently the angels were assigned an even better place—was that fair? From the very beginning they were to dwell in the empyrean heaven, so why could man not share that habitation with them? Because he did not belong with the angels, replies Aquinas, angelic nature being different from human nature. The first humans were incorruptible and immortal not in the way the angels were, but rather because they were to eat from the Tree of Life which God appropriately had provided. Furthermore, given that an atmosphere of unequal temperatures adversely affects the human body (as we know from our present-day situation), Eden's temperate climate was highly conducive to man's well-being. "Whence," Bonaventure says, "it is clear that Eden was most fit to be a dwelling-place for man, and in keeping with his original state of immortality." Here, then, is the reason why our first parents were not placed from the beginning in the empyrean heaven, but were destined to be transferred thither later in their existence. Bonaventure adds the point that living in Eden offered a foretaste of the *patria* or homeland, the even better paradise yet to come.[267] God prepared a pleasant exterior dwelling to correspond to the interior delights enjoyed by the soul, which also may be seen as a dwelling, a Temple of God, and the first man had this also. Furthermore, God wished to have man dwell in a place of such excellence so that he would realize fully what he had lost through his own fault.

Was it not somewhat awkward that, following the Fall, Eden was left unoccupied, rendered redundant? (Though it should be noted that some entertained the possibility that Enoch and Elijah still lived there.)[268] Since "a place in which nothing is contained is pointless," could it be that God made paradise to no purpose?[269] Quite a charge to lay before the Almighty. But, of course, the schoolmen deny it. Aquinas says that Eden did not become pointless through being unoccupied by man after sin, just as immortality was not conferred on man in vain, "though he was not going to keep it." For thereby "God's kindness towards man is shown," and "what man has lost by sinning."[270] Thinking even further about the putative uselessness of Eden, Bonaventure asked if its creation was really necessary in the first place, "since the whole earth was fruitful (*fructifera*) at that time and the air tranquil" and thus all of it was suitable for man.[271] Yes, he replies, because the outside world was nevertheless surpassed by Eden, and—had man stood steadfast rather than fallen—it would have provided a suitable dwelling place for the beasts that served him. Moreover, the land beyond would have manifested by its relative inferiority the superiority of man's dwelling, and adorned by its magnitude the excellence of that earthly paradise, "just as a large courtyard (*magna platea*) decorates a palace, and just as an entrance hall (*aula*) decorates a vaulted chamber (*camera*)."

Such accounts illustrate well how the schoolmen felt able, perhaps even licensed, to use their imaginations as they argued that "the place of paradise was conveniently made for the sake of man as originally instituted," even as the land outside paradise "was conveniently made for the sake of man, whom God had foreseen was going to fall."[272] But no doubt they would have wished to emphasize that their imaginations were working in the service of reason. In any case, the resultant conclusions concerning paradise, in all its primal beauty and promise, inspired, and in some measure authorized, medieval artists to create worlds which stayed largely within the ideological parameters thereby established (see Plates 1, 2, 5, 9, 11). Late medieval painters regularly depicted an Eden with a richly verdant landscape, shining rivers, and abundant wildlife—indeed, they took the opportunity to include such exotic animals as unicorns and griffins, then supposed to exist beyond the pages of bestiaries. (The total effect tends to be distinctly European rather than eastern.)[273] But going beyond even that, some of them offer landscapes at once like and unlike Eden, topographies which present an inevitably diminished version of humankind's original habitation even as they recall its unique excellence.

Plates 13a–c, featuring images from the *Vanderbilt Hours* (Beinecke MS 436, fols. 16v–17r), are particularly fascinating in this regard. In this manuscript, illuminations depicting the Genesis narrative of creation, temptation, and Fall are followed by an extraordinary series of 113 sylvan scenes featuring not only bizarre beasts but also "wild men" (and occasionally wild women and children), pursuing a surprisingly wide range of activities, including fishing, butchery, cooking, enjoying music, dancing, archery, and, most commonly, fighting—whether with each other, with animals real or fabulous, or with knights.[274] Again and again we see armored knights and hairy wild men engaged in battle, jousting (as in fols. 16v–17r, Plate 13a), besieging, or locked in hand-to-hand combat. While these part-human, part-animal figures may be interpreted as emblems of fallen mankind, an interpretation encouraged by their positioning after an illumination of Adam and Eve being expelled from paradise (fol. 6v, Plate 16; the wild men start to appear on fol. 8r), the motive here may be parody of, perhaps even satire on, aristocratic fantasies of prowess and desire, as found in medieval romances. On fol. 75r (Plate 13b) a wild woman, riding a unicorn, leads a knight on his horse to the woods; on fol. 86r (Plate 13c) the image is inverted as a wild man, carrying a large axe, leads a human female, also riding a unicorn, to his cave: given that the unicorn is a common symbol of chastity these scenes may seek to titillate by implying the prospect of barbarous sexual encounters, occasions of miscegenation.[275] Here, then, are grotesque equivalents of the calm and collected embodiments of the Golden Age described by Jean de Meun in the *Roman de la Rose*, ll. 8325ff. (and in part illustrated in Plate 3; Harley 4425, fol. 75v). While the rustic creatures described by Jean wear hairy animal skins,[276] the "wode-woses"[277] themselves are hairy; those rational, peaceful vegetarians have mutated into aggressive, cruel carnivores whose behavior uncomfortably, if sometimes amusingly, apes the condition of men in "the state of misery."

Intricate as the images of the *Vanderbilt Hours* undoubtedly are, they have narrower parameters of possible interpretation than those surrounding Bosch's *Garden of Earthly Delights* (Plates 4a–d),[278] but their juxtaposition may throw some light on this profoundly ambiguous work. The debate has focused on the central panel of this triptych (Plate 4c), which has been read as an imagination of what the world would have been like, particularly in terms of its sexual pleasures, had the Fall not occurred, or, on the contrary, as a playground of vice, showing the corruption of sexuality following Original Sin. Paul Vandenbroeck has supported the latter position.

Black people, hairy savages, mermen and mermaids feature prominently in the
centre panel. The hairy people are "wild men," about whom countless stories
and myths were recounted in the Middle Ages. . . . Wild men lived where
civilized people did not and could not, including distant, mythical times—the
primeval era or the Golden Age when humanity was newly created. . . . Black
people . . . represented strange and distant lands with heathen customs.[279]

Vandenbroeck proceeds to speak of a "wild ride" of men "on all manner of
creatures," who are not led by, but rather lead, their riders, which indicates
their subservience to "their own base impulses"; here "animals themselves
allude to the animal nature of human beings."[280] On the other hand, "the
traditional iconography of lust is nowhere to be seen," as Laurinda S. Dixon
has noted. "In all Bosch's other works . . . evil doers appear as sinister, ugly
or old," whereas in this case there is a marked "absence of any conspicuous
wrongdoing by Bosch's contented folk."[281] Thus *The Garden of Earthly
Delights* stands in marked contrast to *The Hay Wain*, where the sin of avarice
appears to be the unifying theme, with the central panel depicting the present
world beset by greed.

So, could it be that, after all, there is something to be said for Wilhelm
Fränger's thesis that here we are being asked to observe an "unbroken continua-
tion of Paradise"?[282] That may be conceded without accepting Fränger's (quite
unbelievable) conclusion that the panel depicts an "Adamite" paradise, the
fantasy of "Free Spirit" heretics who—allegedly—advocated sexual immorality
under the guise of returning to the innocent sexuality of Eden.[283] The orthodox
medieval theologians quoted above were, as I hope is clear by now, eminently
capable of hypothesizing about the continued existence of the original paradise.
Bosch's painting may be echoing at least some aspects of their speculation. The
landscape is overwhelmingly and unapologetically natural; such buildings as do
exist seem designed for recreational purposes rather than for protecting vulnera-
ble human bodies from inclement weather. Eden's temperate climate prevails.
No one wears functional clothing, or eats anything other than fruit. Animals,
birds, and fish (even a large clam) are the playfellows of humans rather than
their food; the structures of large plants afford further opportunities for play.
(Indeed, the entire tableau is suffused with extraordinary humor.) A rich array
of quadruped species (including the horse, ox, bear, deer, lion, and leopard) are
quite happy to be ridden by men—perhaps indicative not of the "animal nature
of human beings" but rather of the animals' Edenic subservience to, and easy
relations with, their natural superiors in the hierarchy of being. (Animals may

eat each other—as they are shown doing in the left-hand panel of the triptych, which depicts the original Eden—but in this central panel they exhibit no antagonism whatever to their masters). Here there is no violence, either between men (murder was introduced into the world by Cain, following the Fall) or between men and the rest of creation (neither hunting nor fishing is in evidence).

On this argument, we are viewing a scene which lacks obvious savagery or wildness (to return to Vandenbroeck's terms); Bosch may be striving to depict a society which existed before what we know as "civilization," that itself being a feature of the fallen world. Some Golden Ages were genuinely golden, at least in the imaginations of their creators; extending the scope and duration of a traditional paradise does not inevitably lead us to a "false paradise."[284] Bosch's "hairy savages" are hardly hairy at all, in comparison with those of the *Vanderbilt Hours;* rather they conform to then-standard conventions of physical beauty. "Black people" indeed came to be associated with devil-worship or sexual deviancy.[285] (The improbably white skin of Tasso's heroine Clorinda, which sets her apart from her Ethiopian parents, is definitely to be read as racially and socially advantageous). But that is true only of the state of misery. Perhaps a prelapsarian society would have been more tolerant; thus Bosch shows black women freely associating with whites. Of course, everyone is young, of the perfect age at which Adam and Eve were created; constant nourishment from the Tree of Life keeps the human body in excellent shape, and in this ongoing state of innocence there is neither debilitating aging nor death. Furthermore, rather than vessels of erotic significance, those mermen and mermaids may be exotic creatures of the kind beloved by illuminators of Eden—including Bosch himself, as the left-hand panel of *The Garden of Earthly Delights* (Plate 4a) makes abundantly clear. The large birds which feature in the central panel retain their natural beauty; it has simply been magnified rather than distorted. Again in contrast with the *Vanderbilt Hours,* there is no suggestion of the repellently monstrous here.[286] Bosch has reserved his extreme grotesquerie for the right-hand panel (Plate 4d), which takes as its subject the punishments that Hell has in store for all kinds of sexual sin.

What, then, of Bosch's treatment, in the central panel, of sexuality? Bonaventure and Thomas Aquinas agreed that sexual pleasure would have been a feature of life before the Fall, though they disagreed on the degree of its intensity, with Aquinas—anticipated by Albert the Great and followed by William de la Mare and Richard of Middleton—claiming that it was greater in paradise than it is nowadays. From that position it may be inferred that,

had Eden continued, so would the greater intensity of sexual pleasure. Is such an idea in play here? It must be said that interpretation of Bosch's work has been hindered by the imposition of a narrowly Augustinian view of passionless sex in Eden (or rather, a view of Augustinian thought much more narrow than the one which St. Thomas managed). In fact, there is no need to interpret the kissing and bodily contact depicted here as evidence of lechery.[287] Neither should nakedness inevitably be associated with lustful sexual arousal of the kind which became commonplace after the Fall—a point repeatedly made by those theologians who justified the nakedness of Adam of Eve in the first paradise, and the nakedness of resurrected bodies in the final paradise.[288] On the central panel there is no blatant sexual degeneration or depravity of the kind represented in the lower part of the Hell panel (Plate 4d), where the state of misery is quite evidently on display.[289]

Then there is the intriguing fact that no children are present in the central panel, which may seem particularly strange given the obvious debt of Bosch's portrayal of our first parents (in the left-hand panel) to depictions of God blessing the marriage of Adam and Eve (cf. Plate 5).[290] It may be recalled that, in the *Roman de la Rose*, Jean de Meun attacks a Garden of Mirth (the creation of his predecessor Guillaume de Lorris) as an illusory paradise of narcissistic love, in the context of an affirmation of the superior values of procreative sex; the poem ends with the impregnation of the virgin Rose.[291] Could Bosch's pleasure garden be read in similar terms? Possibly, but the argument is far from compelling. Maybe Bosch wanted to avoid, in this special and surreal context, that frequently reiterated justification for marital sex, the generation of children. If such was indeed his motivation, he had a formidable corpus of theology and canon law on his side. *Proles*, having children, was only one of the three "goods of marriage" as commonly defined, the others being *sacramentum* (affirming the couple's indissoluble lifelong bond) and *fides*, mutual fidelity which included sexual availability to each other.[292] Procreation was not an absolute requirement for matrimony; those unable to have children could nevertheless marry, the institution being seen as a "remedy" for lechery, a means of avoiding (or at least diminishing) sin.[293] To be sure, here we have moved into discussion of conditions after the Fall. But (to round off the present argument) all the viewers of *The Garden of Earthly Delights* are fallen men, inevitably the marred measure of all things.

Alternatively, it could be argued that Bosch is using paradisal details of a kind acceptable to theologians (or at least inferrable from theological discussions) for the purposes of parody—the more (supposedly) accurate the

details, the more effective the parody. If so, what is being parodied? Perhaps humankind's impossible dream of a *paradisus voluptatis* wherein men and women enjoy a life free from hard work, dangerous beasts, disease, and death? Those hopes could well be dismissed as vain, an easy target for skepticism or even satire. Yet considerable support for them was found in Genesis, which medieval interpreters managed to reconcile with the latest science. Those twin sources of authority were a formidable combination. But: behold what the unbroken continuation of Eden might look like, and wonder![294]

Other worlds, worlds of the Other . . . the accounts of the origins of the human body and soul which we have sampled above illustrate well the ways in which the schoolmen thought their way back to Eden to discover fundamental truths about humanity, seeking certainty in matters of crucial importance for the very definition of orthodox Christian thought and the eradication of heresy. Or to engage in speculation about matters which, they freely admitted, were not susceptible of firm proof. No one could be confident about where Eden was located on this earth, really know what its weather was like, or whether or not Enoch and Elijah still lived there, awaiting the End Time. Some of this mattered a little, much of it mattered a lot. "Probable reasoning" (to revert to Wyclif's term) did its best, but could only reach so far. Eden transcended human understanding, both as a place of sensuous freshness and beauty and as an ideal environment for men.[295] It was difficult if not impossible to fill in all those "gaps" which, as Augustine respectfully noted, had been "left in the picture" by the inspired authors of holy Scripture.[296] Yet those gaps afforded an extraordinary amount of creative space to late medieval theologians—and painters and poets—as they tried to understand the place which God had deemed worthy of the creature made in His image.

Power in Paradise

The first person who, having fenced off a plot of ground, took it into his head to say this is mine and found people simple enough to believe him, was the true founder of civil society.

—Jean-Jacques Rousseau[1]

What kind of power structure is most appropriate for paradise? St. Robert Bellarmine (1542–1621), Jesuit cardinal and formidable polemicist of the Counter-Reformation, was in no doubt. Monarchy is the "perfect form of government" and finds its ultimate perfection in the *patria*, the paradise of blessed souls. "Monarchy, which is the best form of government, is not only found with God, but is there only true and perfect, for He is not only terrible to 'the Kings of the Earth' (as the Psalmist magnificently sings), but is also 'a great King over all Gods,' as we read in another Psalm.[2] . . . This is the God who rules in Heaven: He alone is the great, the true, the Eternal King."[3] These remarks echo scholastic thought which goes back several centuries, as does Bellarmine's subsequent attempt to explain that, in a manner of speaking, "*all* the blessed spirits are kings," "endued with all royal qualities," yet at the same time servants of "the King of Heaven," under whom (to extend the paradox) they enjoy "a most complete and universal liberty."[4] As Bellarmine's younger Protestant contemporary, John Milton (1608–74), put it, "Orders and Degrees / Jarr not with liberty, but well consist."[5] The words are Satan's, but he is an angel (though soon to be a fallen one) who has learned his politics in the heaven which existed before the creation of Eden.

The power structure of Eden proved harder to describe. Immediately after his creation, Adam became king of the world—an event well captured in Plate 14, another image from *The Vanderbilt Hours* (Beinecke MS 436, fol. 3v). But did he maintain that position following the arrival of Eve? What kind of power (*dominium*) over the animals did our first parents enjoy, and what kind of service were they owed? And did God's gift of dominion extend to include rights over all the world's material things? It was generally supposed that, according to the original divine plan, Adam and his expanding family would have held all the goods of the earthly paradise in common, until the time came for their elevation to an even better paradise. But did that mean that all men would have been equal in Eden, no one exercising any authority over the others—a difficult position to accept, since surely then (as now) different people have different talents, and so certain distinctions, constituting a hierarchy, would have been quite compatible with a state of innocence? Further: what about the situation between Adam and Eve, paradigmatic for power relations between men and women ever after? Were the first human beings created equally in the image of God (cf. Genesis 1:27)? Eve is called Adam's "helper like himself" (*adiutor similis eius*; Genesis 2:18 and 2:20). How exactly should that phrase be understood? Was she his servant, inferior, subject? Such are the concerns of the present chapter.

Dominion over the Animals

The Middle English *Cursor mundi* portrays Adam as master of all that he surveys, and lord of the "beestes":

In mychel blisse was he bistade	*placed*
Of his wyf so faire and fre	*with, beautiful and generous*
That myche myrthe was on to se	*it was a great joy to behold*
These beestes coom hym alle aboute	*came to him from all around*
As to her lord hym to loute	*greet/make obeisance to*
Foule in flighte fisshe on sonde	*flight, on [God's] command*
Alle bowed hym to foot & honde	*to his foot and hand (making oath of fealty)*
At his wille thei yeode & cam	*went*
As he hadde ben makere of ham . . .	*as if he had been their creator*
(674–82)[6]	

Belief in man's power (*dominium*) over animal and plant life was ubiquitous. It seemed to follow directly from the divine word as recorded in the first book of Genesis.

Let us make man to our image and likeness: and let him have dominion (*praesit*) over the fishes of the sea, and the fowls of the air, and the beasts, and the whole earth, and every creeping creature that moveth upon the earth. . . . (1:26).

And God blessed them [Adam and Eve], saying: Increase and multiply, and fill the earth, and subdue it, and rule over (*dominamini*) the fishes of the sea, and the fowls of the air, and all living creatures that move upon the earth. (1:28)

However, in between these passages, in verse 27, comes the statement that God created "male and female," and at Genesis 2:19–22 it seems quite clear that Adam was given dominion over the animals before Eve was created. The problem of her possible exclusion from that crucial event, and from vital knowledge thereof, is addressed robustly in the Anglo-Norman *Ordo representacionis Ade*, where God's address to Adam is certainly intended for Eve's ears as well: "I say this to you, and I want Eve to hear it, too. If she does not pay attention to it, she will indeed be a fool."

"De tote terre avez la seignorie;
D'oisels, des bestes, e d'altre manantie.
. . . tot li mond vus iert encline." (60–62)

["You have mastery over all the earth; over birds, beasts, and over the rest of the earth's inhabitants. . . . the whole world will be subject to you."][7]

But why did God create so many other creatures before He created Eve? In order that Adam should not think "the makyinge of woman ydle and vnprofitable," according to Peter Comestor's *Historia scholastica*. As the fifteenth-century English translation puts it, our Lord "brought vnto hym al maner of creatures that euer toke lyf, that he, as Lord God, gouernour, shulde name them at his will and know parfitely that ther were none made byfor like to hym, and so, of ther parfitely vndrestondynge that ther was no creature lyke to hym, but as souerange aboue al other, put to euery thynge ther propre

name."[8] So, then, by this means God made clear to Adam the "lord gouernoure" his superiority over the rest of creation, and also his need of a mate, since he alone of all male creatures still lacked one.

This delegation of power meant that Adam had dominion over all animals, including poisonous and dangerous ones. But why were "grevous beestis, that is to sey, serpentis, adders and other the which beth contraryus to mankynde," created before the Fall of man? Originally they were created "not to his hurt," Peter Comestor answers. "But after he had synned, they were ordeyned to his hurt and detremente."[9] These remarks reflect the treatment of the matter provided in Augustine's *De Genesi ad litteram*,[10] a highly influential account which Peter Lombard drew on extensively in his *Sentences*, partly verbatim but with some summarizing and interpretation.[11] Originally created as harmless to humankind, certain dangerous creatures began "to do sinners harm" after the Fall, thereby "giving examples of patience to help others make progress and of people growing in self-knowledge through their trials."[12] The original tameness of fierce creatures should not surprise us, Augustine asserts, since "Daniel survived safe and sound and fearless among the lions, while the Apostle had a deadly viper clinging to his arm and doing him no harm."[13] In his *Sentences* commentary Bonaventure affirms that, had man stood fast and not fallen, "no animals would offend him, but all would be meek to him, just as sometimes by the Divine Command the most cruel wild animals have become meek to God's Saints."[14] The fact that subsequently they harm and offend man is due to "the sin of man, not on account of a new power given to them, but on account of the presidency of dignity (*dignitatis praesidentiam*) lost by man." A healthy eye is not harmed by the sun, but if it becomes infected and bleary-eyed (*lippus*) it is immediately affected—not on account of some "change made in the sun," but due to the change in the eye. The same principle applies to man's relationship with dangerous beasts, which became dangerous to him only after he was infected by sin. Thus he lost a large measure of his power over them.

Very similar, if not identical, arguments were offered concerning man's dominion over plant life, and his loss thereof. What should be said about those herbs and trees which now are unfruitful, of no use to man? Were they created like that, or did their present situation come with the Fall? The latter, says Peter Comestor.[15] They "bare froyte byfor that Adam synned. But now they beth altered and made vnfrofyfull," because in their present state they cause humankind "the more laboure," in accordance with God's subsequent statement to Adam and Eve: "Thorns and thistles shall it [the earth] bring

forth to thee" (Genesis 3:18). "That is to sey," explains Comestor, "the erth shal brynge fourth to the, thornes and bremell, whereas hit brought forth froytfull trees byfor."[16] Thus Adam, Eve, and their descendants were doomed "with labour and toil" to obtain and cultivate food for all the days of their lives (Genesis 3:17).

The creation of "the minutest animals" was harder to justify; the nature of man's original dominion over them harder to explain. Augustine appealed to a "certain worth or grace of nature" that is possessed, to some extent, "by all things, even the tiniest." Therefore, when we observe them and wonder at them, we are moved to praise "the almighty craftsman . . . more rapturously than ever." Wisdom, who "reacheth . . . from end to end mightily, and ordereth all things sweetly" (Wisdom 8:1), "creates animals whose bodies are as tiny as can be, but whose senses are so sharp that if we pay close attention we are more amazed at the agile flight of a fly than at the stamina of a sturdy mule on the march; and the cooperative labors of tiny ants strike us as far more wonderful than the colossal loads that can be carried by camels."[17] So far, so good. However, the problem is that most of those minute creatures "are either bred from the sores of living bodies, or from garbage and effluents, or from the rotting of corpses; some also from rotten wood and grass, some from rotten fruit." We cannot deny that God is their creator. Yet it is difficult to account for their presence in paradise, that place of perfection from which corruption should be absent. Were they indeed "introduced in the original establishment of things," or "later on from the consequent disintegration of perishable bodies"?[18]

Augustine had no problem with the notion that those tiny things which nowadays "spring from the waters or the earth" were created in paradise; they came into being on the third day, when the dry land appeared, rather than being part of the subsequent creation of the beasts of the earth, sea, and air. Therefore, it would seem, they do not count as real animals, or at least do not form part of the tally conducted in later verses of Genesis. Rather they "should be understood as supplementing the furnishing of the habitation rather than as belonging to the number of its inhabitants." So, then, there is nothing dubious about the manner of their origin, and they perform a decorative function; their existence may easily be justified.

But what of those other tiny creatures, "which are generated from the bodies of animals, especially dead ones"?[19] Augustine balks at the idea that "they were created at the same time" as their host animals. And seeks an alternative explanation: "possibly there was some natural tendency in all

animated bodies, so that they already had seeded and threaded into them beforehand, as it were, the first beginnings of the future animalcules, which were going to arise, by an inexpressible arrangement, in their various kinds from the decay of such bodies, all things being put in motion without any change in him by the creator." Peter Lombard (who, as already noted, draws extensively on Augustine's account of man's dominion over creatures great and small) sums up that esoteric statement as: "they were not created with the animals, except potentially and materially." And the Lombard firmly distinguishes those creatures linked to corruption from "those which are born from the earth or the waters, or from those things which come from the germinating earth"; such animals may be said, without difficulty, to have been created in Eden.[20]

But perhaps "things that are now born from the corruption of human flesh" might "then have been born from the corruption or decay of something else. Or would they have been born from the human being, but from its uncorrupted body?" Those are the suggestions of Robert Grosseteste.[21] Alternatively, he continues, nowadays we might be dealing with creatures which are "a sort of degeneration from perfect species" which existed before the Fall, species which propagated in ways different from the ways we see them do nowadays. But Grosseteste found it hard to imagine "perfect species" of which the louse and worm are degenerations—how could such things possibly be improved upon, even in Eden? "I leave this to be determined by wiser people," he concludes somewhat lamely.

No wiser people came forward, to judge by the solutions they offered. Peter Comestor solved the problem by simply insisting that all animals that feed on corruption were created after the Fall. Here he has no time for attempts to rationalize the transition between the two historical periods:

> But whydre was this small wormes or flees, that is to sey, waspis, malshawys [caterpillars], butterflees with other suche, made byfor that Adam synned or after? Wherto may be answerede thus, that al tho wormes or flees that levith and takyth ther mete of clene mater as butterflees, the whiche comyth of the water and other suche, was ordeyned byfor the synne of man, and al tho that levith or takyth ther foode of corrupte mater was made after the synne of man.[22]

Before Adam's sin there was "nothynge corrupte in this world, but al thynge clene and pure." After man sinned and himself became corruptible, things

which hitherto had been "pure & clene" then became "corrupte," whereof grew small creatures such as wasps, flies, caterpillars, and the like.[23] Whereas man lost his dominion over lions, "the which is a prencipall [principal] beest of any that God made," so that he might realize the joy he once had and how he loot it, he lost his dominion over "smal beestis, that is to sey, in flees," so that he should remember and understand "his viletude and filth, wherof he is made."[24]

Whatever the status of their existence in Eden (or the lack thereof), in the postlapsarian world those "smal beestis" proceeded to do their worst. "Lice and gnats of the air" bit Adam and Eve, "and likewise fleas and all other kinds of reptiles" (to draw on a vivid passage in the *Exameron Anglice* by Ælfric of Eynsham, d. c. 1010).[25] Small and (to human perception) nasty insects have found few friends, even among those rare thinkers who countenance the idea that at least some animals may share in the General Resurrection. The distinguished medievalist and Christian apologist C. S. Lewis (1898–1963), who speculated that domestic pets and other loved animals might have some presence in the future paradise through association with their owners' immortality,[26] drew the line at newts. In the course of a moving discussion of "Animal Pain," he opines that the life of a newt is "merely a succession of sensations"; immortality cannot have any meaning for such a creature, which is not endowed with "Consciousness or Soul."[27] However, "ants, bugs and all unpleasant, stinking creatures" fared better with Martin Luther, who believed that, in the new heaven and new earth, they "will be most delightful and have a wonderful fragrance."[28] In order to gain admittance, it would seem, their current characteristics must undergo radical transformation.

At any rate, in the homeland the blessed shall be spared the irritations caused by such "stinking creatures"; there was widespread agreement on that. Moving from annoyance to enjoyment, the pleasures associated with other, higher creatures are also to be absent from the paradise beyond death, which is hardly surprising because (according to mainstream Catholic theology) those animals themselves will be absent from that place. In Lorenzo Valla's *De voluptate* (originally published in 1431) the following statement is put in the mouth of one Antonio Raudense (Antonio da Rio), a Franciscan friar and theologian, who appears to enjoy the last and best word in this treatise.[29] Whatever problems of interpretation the work may pose (and they are many), this seems to be offered as the voice of Catholic orthodoxy.

"Pleasures denied to us as mortals will be offered to us in great numbers in heaven—not necessarily those I have mentioned but greater ones, full of

religion and holiness. Certainly all of the pleasures that we used to enjoy but which are inconsistent with the majesty of the eternal region will cease, as, for instance, hunting, bird catching, and fishing: in heaven there are no dogs, hares, fish, birds; there are greater, more delightful, more numerous things, in the enjoyment of which it will become impossible for you to desire those pointless and merely childish pleasures."[30]

Those "merely childish pleasures" involving animals evidently involve the deaths of animals, and the use of some animals (particularly hunting dogs) to achieve the deaths of others. For Valla this is quite unproblematic; his aim is to emphasize the far greater pleasures in store in the *patria*, by way of compensation.

The means whereby medieval theologians excluded animal (and plant) life from the *patria*, and addressed the related issue of whether animal death was conceivable in Eden, will be considered in the next chapter. My concern in the next few paragraphs is the ways in which, according to several major thinkers, man appropriately exercises his God-given right to "hold sway" over the animals. Aquinas's *quaestio* on the subject in his *Summa theologiae*—the first in a series on the nature of power (*dominium*) within the state of innocence—affords a good point of departure. "Things that ought to be subject to man started disobeying him as a punishment on him for his own disobedience to God."[31] "And so," Aquinas continues, before that disobedience "nothing that should naturally be subject" to man "withstood him." He means all the animals, for they "are naturally subject (*naturaliter subjecta*) to man." This he proceeds to prove in three ways. First, because of the order observed by nature. The imperfect are for the use of the perfect: the plants make use of the earth for their nourishment, and animals make use of plants, and man makes use of both plants and animals. Therefore it is in keeping with the order of nature that man should be master over the animals. Hence Aristotle says that "hunting wild animals is just and natural, because it is how man claims what is by nature his own."[32] Second, by the order of divine providence, which "always governs lower things by higher." Since man was made in the image of God, the animals are rightly subject to his government. Third, animals possess "a certain share of acumen (*prudentia*) with regard to particular activities. But man has—or can have—a universal acumen that is the measure of all possible activities."[33] So the subjection of beasts to man is natural.

Indeed, mankind has an obligation to bring the beasts under subjection, according to Robert Grosseteste. Before sin they were all perfectly obedient to the human being and "peaceful towards one another";[34] subsequently they

"do not keep the peace among themselves, but live in a state of uproar and strife."[35] Therefore humankind must restore order, endeavor to control the animal world through the application of reason, as when sea creatures, however monstrous, are entangled in nets or tricked with bait, and even the powerful lion "is caught by the human being in a little net by the skilful device of the reason."[36] Thus "Every nature of beasts . . . is tamed, and hath been tamed, by the nature of man" (James 3:7).

The methods of taming illustrated by Grosseteste may well seem (to many present-day readers) as far in excess of what the maintenance of natural order might require, and hardly an adequate justification of the pain inflicted by human beings on beasts in the process. Unsurprisingly, statements of that kind have attracted a lot of negative comment within contemporary debate concerning the ethical treatment of animals, including the claim that "by arbitrarily relegating animals to the category of 'things,'" theologians like Aquinas "have effectively excluded them from the moral and ethical consideration due them as sentient beings."[37] A full engagement with such matters is beyond the scope of the present book. Suffice it to mention the suggestion by one of St. Thomas's most robust modern interpreters, Herbert McCabe, that Aquinas and his contemporaries would have thought it "a mere metaphor" to speak of "animal rights," simply because animals cannot possibly be citizens of a society, and—for Aquinas and his fellow admirers of Aristotle's sociopolitical philosophy—only citizens can have rights. Nevertheless, animals are "part of our social world and treating them with kindness and compassion . . . is part of *general* justice, though kindness and compassion are in themselves exercises in the virtue of temperateness rather than justice."[38] McCabe finds ample precedent in Aquinas for the notion that "there can and should be a companionship and solidarity" between man and "other animals," but the crucial point is that this is to be seen "more like an analogue of friendship" rather than as an aspect or part of "citizenship."[39]

Of course, such latter-day "reverent interpretation"[40] of Aquinas begs the question of whether the citizens of this world can appreciate such reasoning to the extent that they will extend their "temperate" behavior to include animals. Setting such skepticism aside, McCabe's intervention reminds us of the importance of placing the schoolmen's statements about the destiny of animals within their ideological contexts. Take, for instance, Bonaventure's remark that a beast "is not capable of wretchedness."[41] This forms part of an application of the doctrine that humankind is the only animal capable of reason, born to be blessed (and rewarded) just as he was born to be wretched

(and punished). Only man has been granted the power of discretion to choose between good and evil, between truth and falsity. Therefore he alone is the wretch, for he knows—or ought to know—when he has done evil. In contrast, "if a beast grieves, when it is slain or wounded," "it is not capable of wretchedness" in the sense here defined. (Here we might recall C. S. Lewis's meditation on the newt, wherein such a creature is said to be merely sentient, lacking self-consciousness and hence any moral awareness.)[42] To speak in this way is not, it should be recognized, to deny or devalue the fact that a beast "grieves when it is slain or wounded." Bonaventure's point is rather that such grieving may be contrasted with the human being's unique capacity to recognize his own sinfulness.

St. Augustine had expressed the belief that, when the human soul observes an animal in pain, it can recognize a fellow sufferer, experience some measure of unity with a creature which does not "suffer corruption and dissolution" with "indifference" but rather with "outrage" (*indignatio*). However, this appears within a rationalization of animal pain as providing "us human beings with plenty of salutary admonitions." When we see the amount of self-protecting resistance put up by beasts no matter how big or small, and the number of precautions they take "to safeguard their bodily, time-bound health and welfare," we humans should become conscious of the care that needs to be taken concerning "our spiritual, everlasting health and welfare," by which "we so surpass all non-rational animals."[43] If some beasts did not prey on others for their sustenance, such defensive actions would not be there for our observation and edification; a situation involving animal pain and death can therefore be said to have benefits for us. Once again, the ultimate value of animal behavior is supposed to lie in the nature and/or extent of the service it performs for man. But, at the very least, the possibility of cross-species empathy[44] has been recognized, along with the ability of an animal to react with something approaching outrage, a feeling well known to humans.

Further light is thrown on the matter by the testimony of Bridget of Sweden (d. 1373), visionary, saint, and mother of another saint, founder of the Bridgettine order, and well-connected lobbyist of popes and princes. In the fifth book of her *Revelationes* the question is posed, why do animals suffer infirmities (*incommoda*) when they will not have eternal life and lack the use of reason?[45] Prima facie, this situation seems blatantly unjust: these creatures of God seem to have a dismal life in this world and no life at all in the next. Christ as Judge provides the following answer. In animals, "as in everything else," everything is "disordered." Following the Fall, "all other things began

to take on [man's] disorder; and all that should have revered him began to oppose and resist him. Therefore, it is out of this vice of disorder that so very many annoyances and adversities befall both man and the animals." So, then, the fault is man's alone, but both men and beasts suffer the consequences of his sin. In particular, "when the things that man loves are plagued or withdrawn"—presumably Bridget is thinking here of animal disease or death—man is thereby led to "consider what great punishment *he* deserves"; after all, he has the use of reason, which the beasts do not, and therefore his (punitive) suffering should be the greater. "Indeed, if mankind's sins did not demand it, the animals that are in man's hands would not be so singularly afflicted." In other words, sometimes the need to teach men a lesson necessitates animal suffering. Here is a stark illustration of animals' "service" to the superior creatures who have *dominium* over them.

Bridget attempts to mitigate this bleak picture by claiming that animal pain may, in some cases at least, be explained in terms of natural processes: beasts "sometimes suffer because of the intemperance of their own nature— sometimes for the mitigation of their wildness and the purging of nature itself." (A counter-argument would be that the processes in question are characteristic of fallen nature, and thus a consequence of human "disorder.")[46] Furthermore, sometimes suffering is a blessing in disguise for beasts, for it may bring a swifter end to their sad lives, shorten their time of miserable toil. But—and here is the crucial point—"not even they suffer without great justice (*iusticia*)." "Let man therefore fear me, his God, more than everything else and be all the more gentle toward my creatures and animals, on whom he must have mercy for the sake of me, their Creator. For this reason, I, God, gave man the precept concerning the Sabbath, for I care about *every one* of my creatures."[47] This move is partially reminiscent of McCabe's elaboration of Thomistic "general justice," as summarized above. Men should be merciful to animals for God's sake, even as God is merciful to men. The Sabbath was instituted as a day of rest—for animals as well as for men. Here is a "precept" which gives us a clear directive concerning the "gentle" way in which we should treat our fellow creatures.

The dominion which man exercises over animals nowadays is, of course, a pale shadow of what occurred in Eden (or what could have occurred, had Eden endured). Just as humankind, by acting contrary to reason, "abandoned and threw off its obedience towards God," creatures which are lacking in reason "came to revolt against the human being."[48] Grosseteste, whom I have been quoting here, elaborates this point as follows: "It is not that the human

being lost its natural power of dominion (*potestatem dominii*), i.e. the power of reason to command. But this power was weakened and vitiated by sin, and so irrational things, at the Fall of the human being, were made worse, and less able to obey the command of reason. Hence the human being cannot naturally exercise its task of peaceful and undisturbed dominion over its subjects." This situation is then likened to what happens when "the father of a family, of sound mind and body, supported by every kind of prosperity" and unquestioningly obeyed by "his whole household," becomes "sick in body" due to "his own vice" and is "seriously weakened in the rightness of his reason."[49] His household is likewise "made ill," and less ready and willing to perform "the actions which used to be carried out pleasantly and easily." Where once there was "tranquility of peace and order," now there is "a confused and upset tumult." Yet, despite this, the *paterfamilias* retains "his power to rule," and his household retains "a natural duty to obey," although they may have great difficulty in so doing—and, indeed, "justice would demand that they should not obey their master when he abuses his power." But if they did disobey their master, "the obedient duty of serving" would nevertheless "not be dissolved."

After the Fall, as before, the inferior is in a situation of natural subservience to the superior. God lords it over humans, even as humans lord it over animals—and the head of a household lords it over his wife, children, and servants. Such is the unbreakable chain of command, the hierarchical design of dominion.

Domestic Dominion: The Origins of Economics

Household management was termed "economics" within the tripartite division of practical philosophy (also comprising ethics and politics) which the schoolmen inherited from Aristotle.[50] "Economics treats of the household and politics deals with the city or state," explains Nicole Oresme in his commentated translation of the Pseudo-Aristotelian *Œconomica*, a text which, whatever its origins, is generally consonant with what the indubitably authentic Aristotle said elsewhere.[51] Economics and politics, Oresme explains, "differ also because politics is concerned with the shared authority of several rulers, while economics is concerned with one authority only." And within the household, that one authority is the husband, father, and head of the family. "Next to the master, the wife as his companion holds first place,"[52]

and their association (*communication*) is a natural one," as both the Bible and Aristotle say. A quotation from Genesis ("Be fruitful and multiply"; 1:28) is followed by one from *De anima*: "It is a most natural activity among created things to seek to make another creature like unto themselves."[53] As is also true of other animals, "neither the female without the male nor the male without the female can accomplish this."

Aquinas probably had this passage in mind when, in one of the questions *de productione mulieris* included in his *Summa theologiae*, he set about interpreting Genesis 2:18, "it is not good for man to be alone: let us make him a help like unto himself (*adiutorium similem sui*)." "It was absolutely necessary to make woman, . . . as a help for man; not indeed to help him in any other work . . . , because where most work (*opus*) is concerned man can get help more conveniently (*convenientius*) from another man than from a woman; but to help him in the work of procreation."[54] Some of the Church Fathers had supposed that, in the state of innocence, no procreation by copulation would have taken place (which was related to the belief that lust always accompanied copulation; because lust had no place in paradise, therefore neither had copulation).[55] But Aquinas insists that the imperative of being fruitful and multiplying was the singular reason why God created woman as Adam's *adiutor*. However, this is not to say that the human male and female have to have sex all the time. Their lives are devoted to nobler work (i.e., the understanding of things), unlike plants, which have no function nobler than generation and do it all the time. In the next question ("Should woman have been made from man?") Aquinas does allow that sex is not the only work which men and women share. Here, with some help from Aristotle's *Ethics*, the behavior of humans is distinguished from that of the other animals.[56] "As Aristotle says, with man male and female are not only joined together for purposes of procreation, as with the other animals, but to establish a home life (*propter domesticarum vitam*), in which man and woman work together at some things, and in which the man is head of the woman (*vir est caput mulieris*)."[57] The domestic virtues and pleasures as vouched for by Aristotle are eulogized with more enthusiasm, and rendered more consonant with Genesis, in Oresme's translation and exposition of the *Economics*. There it is emphasized that procreation is not the only "economic" reason why a husband and wife naturally associate together.[58] They assist each other, work together. And there is even more to it than that—an additional, and crucial, characteristic which Oresme identifies as "married friendship" (*amisté de mariage*), a bond which "is permanent and stable and is not to be broken,"

according to Aristotle's *Politics*.[59] The Bible concurs, in its injunction that those who have been joined together by God should not be put asunder by any man (Matthew 19:6).[60] The Book of Genesis features prominently in Oresme's subsequent discussion, as when he declares that "a man will leave his father and mother for this love of woman and will cleave to his wife" (2:26), and notes that Jacob "served seven years for the love of Rachel and the time seemed short because of the greatness of his love" (29:18). "Nature granted carnal pleasures to the animals only for the purpose of reproduction; but it accorded the human species this pleasure not only for reproduction of its kind but also to enhance and maintain friendship between man and woman." So great is this unity that, as Aristotle says in the *Politics*,[61] "two friends desire to become a single being." Oresme returns to Genesis for his clinching argument. "We may say that husband and wife are more nearly a unit than the male and female of other species because the first woman was formed from the rib of her husband and this was not the case with the other animals." Therefore, he continues, "Scripture [i.e., Genesis 2:24] says that a married couple is two persons in a single skin ("les maries sunt .ii. en une char"; cf. the Latin, *duo in carne una*). Thus we may "perceive how this life of husband and wife together is based upon friendship." In this case, the prophet (Moses being the putative author of Genesis) and "the Philosopher" (Aristotle alone having been honored with that appellation) seem to be in total agreement.

Such is the basis of the proper relationship between man and woman, husband and wife, as established in Eden—though it must be admitted that Oresme is more idealistic than most, which is hardly surprising, given that he was writing largely for an audience of layfolk, for whom marriage was a regular life choice, in contrast with those celibate clerics who were the authors and audiences of and for most of the texts discussed in this book. Procreation was crucial for the relationship between Adam and Eve, but not its only motivation, function, or outcome. Evidently Oresme envisaged our first parents as having enjoyed (or at least, as having had the potential to enjoy) a domestic life of "married friendship." Peter Lombard, here following Hugh of St. Victor (d. 1141),[62] spoke in terms of "a partnership of love":

> . . . she [Eve] was formed not from just any part of his body, but from his side, so that it should be known that she was created for the partnership of love (*consortium dilectionis*), lest, if perhaps she had been made from his head, she should be perceived as set over man in domination (*ad dominationem*); or if

from his feet, as if subject to him in servitude (*ad servitutem*). Therefore, since
she was made neither to dominate, nor to serve the man, but as his partner
(*nec domina nec ancilla parabatur, sed socia*), she had to be produced neither
from his head, not from his feet, but from his side, so that he would know
that she was to be placed beside himself whom he had learned had been taken
from his side.[63]

That excursus (in many shapes and forms) achieved a quite extraordinary
depth of cultural penetration. Having been discussed and dissected in fine
detail by the Lombard's many legions of readers, in their *Sentences* commen-
taries and elsewhere, it also appeared regularly in the compilations and manu-
als which, during the thirteenth and fourteenth centuries, were prepared in
considerable numbers for parish priests and friars working in the field. It was
elaborated and abbreviated, affirmed and indeed undermined—as when, in
Chaucer's *Parson's Tale*, the rider "because she cannot patiently suffer" is
added to the statement that "God did not make woman from the foot of
Adam."[64] "Where the woman has the headship (*maistrie*)," Chaucer adds as
a concomitant, "she makes too much disorder (*desray*)."

Here was a succinct way of describing the orderly power relationship
between man and woman, the type of *dominium* which a husband should
exercise over his wife. When Eve was made from Adam's rib, this signified
the type of companionship (*socialis conjunctio*) which should exist between
the sexes, claims Aquinas. On the one hand, the woman should not "have
authority over the man" (cf. I Timothy 2:12), and this "explains why she was
not formed from his head." On the other, she should not "be despised by
the man, as though she were merely his slave (*serviliter subjecta*)—and so she
was not formed from his feet."[65] So, then, the woman is subject to the man,
but certainly not a slave. There are two kinds of subjection, Aquinas explains;
"one is that of slavery (*servilis*), in which the ruler (*præsidens*) manages the
subject for his own advantage, and this sort of subjection came in after sin.
But the other kind of subjection is domestic or civil (*œconomica vel civilis*),
in which the ruler manages his subjects for *their* advantage and benefit. And
this sort of subjection would have obtained even before sin."[66] "Economic"
and "civil" (i.e., political) rule are put together here, since in both cases—the
governance of a household, the governance of a state—the less wise are ruled
by the wiser, for their own good. Were things organized differently, the popu-
lace would lack the benefit of governance by its wiser members. And, it may
be added, the wife would lack the benefit of being directed by her husband,

who is wiser than she. Such, Aquinas asserts, "is the subjection in which woman is by nature (*naturaliter*) subject to man."

A more elaborate version of what is fundamentally the same doctrine may be found in Giles of Rome's *Sentences* commentary—as one might expect of the scholar who went on to make Aristotelian practical philosophy accessible and attractive to an aristocratic audience, in his *De regimine principum* (written c. 1280 and addressed to the future king of France, Philip "the Fair"; a few years later Henri de Gauchy made a French translation).[67] In Aristotle's *Politics*, Giles finds a useful distinction between regal, political, and despotic rule.[68] The first appertains to the rule a father exercises over his sons, for their own good. The second involves governance in line with certain laws and conditions, rather than the imposition of decisions freely made by the ruler, and this appertains to the relationship between a man and his wife. The third, despotic rule or domination, exists between the *paterfamilias* and certain members of his household; here Aristotle had in mind the master–slave relationship).[69] Giles concludes that woman was appropriately made from man's side rather than from his head or his feet, in respect of the type of governance which is relevant here; inasmuch as both parties are bound by certain laws and agreements, their relationship is one of parity.

Power and Gender

However, this is not the same as saying that Adam and Eve were created equal, and that God rendered Eve inferior to Adam only after the Fall, using the words, "thou shalt be under thy husband's power, and he shall have dominion over thee" (*sub viri potestate eris et ipse dominabitur tui*; Genesis 3:16). Subjection and inferiority (*subjectio et minoratio*) are not a direct "result of sin," Aquinas explains; they go back earlier, to Eden itself.[70] Eve was created for sound "economic" reasons, as Adam's helpmate in general and sexual partner in particular. But her natural inferiority remains a fact. "Woman is by nature of lower capacity (*virtutis*) and quality (*dignitatis*) than man." Because "the power of rational discernment is by nature stronger in man," woman is naturally "subordinate to man," the principle being that those with stronger rational discernment should exercise dominion over those who possess it to a lesser extent.[71] In brief, gender inequality was the norm in our original paradise—there in the beginning, it evermore shall be, until the end of the world. When only gender difference (in contrast with inequality)

will remain, inasmuch as in the *patria* women will retain their original female bodies, though sexuality will have no meaning there. To revert to Augustine once again: "Both sexes are to rise. For then there will be no lust, which is now the cause of confusion. . . . Vice will be taken away from those bodies, . . . and nature prevail. And the sex of a woman is not a vice, but nature."[72]

None of this means that, until that happy day dawns, woman should be despised by man. Eve was not formed from Adam's feet; she was no slave. *Nec domina nec ancilla, sed socia* . . . Such is the thrust of the arguments we have canvassed above. But many late medieval theologians did allow highly derogatory statements about the female sex to enter their accounts of paradise. "The sex of a woman" may only be a matter of "nature," but often it sounds like "a vice." Take this statement from Grosseteste's *Hexaëmeron*, for instance: "A woman is more pitiful than a man, and weeps more easily. She is more envious and is more prone to quarrelling and punishing. Malice of soul is greater in women than in men. Women are less hopeful, and lie more: they are more shameless and are easily deceived. The female, universally, moves more ponderously. The male is more daring than the female and of greater benefit."[73] Here Grosseteste is following Aristotle's *Historia animalium.*[74] Prima facie, this seems a far cry from the philosophical thought that enabled Nicole Oresme to devise his doctrine of *amisté de mariage*. The same may be said, even more emphatically, about certain statements made by Albert the Great in the lectures on Aristotle's *De animalibus* which he delivered at Cologne in 1258. For instance: "Generally, proverbially, and commonly it is affirmed that women are more mendacious and fragile, more diffident, more shameless, more deceptively eloquent, and, in brief, a woman is nothing but a devil fashioned into a human appearance."[75]

Albert proceeds to cite a certain (unnamed) woman of Cologne, "who seemed to be a saint and yet, in brief, ensnared everyone with her love." Thus he easily concludes that "a female is less suited for proper behavior than is a male," bringing in some science to back this up. "A female's complexion is moister than a male's," and herein lies many moral dangers. "Moisture is easily mobile and this is why women are inconstant and always seeking after new things." Indeed, a woman who is having sex with one man may well be thinking about another: "when she is engaged in the [sexual] act under one man, at that very moment she would wish, were it possible, to lie under another. Therefore, there is no faithfulness in a woman." Little wonder, then, that "wise men almost never disclose their plans and their doings to their wives. For a woman is a flawed male (*mas occasionatus*)"—here Albert deploys

one of Aristotle's most infamous statements[76]—"and, in comparison to the
male, has the nature of defect and privation." It is not simply that men
distrust women: indeed, women distrust themselves. This is why a woman
will strive to acquire "through mendacity and diabolical deceptions" certain
things which, she believes, she is incapable of acquiring by any other means.
"Therefore, to speak briefly, one must be as mistrustful of every woman as
of a venomous serpent and a horned devil, and if it were allowed to say what
I know about women, it would stupefy the entire world."[77] One can only
wonder if Albert is indulging in an imaginative rhetorical gesture here, or
speaking from (bad) personal experience of certain women of Cologne (as
gained in the confessional?).[78]

Yet elsewhere, in his *Summa theologiae*, we find this same thinker express-
ing his belief that Eve had been made directly by God.[79] Here is the only
appropriate view of the creation of woman, Albert declares, and it is a view
which he holds in common with the saints. It seems that this does not entail
the rejection of Aristotle's designation of a woman as a flawed male (*mas
occasionatus*),[80] but rather its careful definition in what, for Albert, is its cor-
rect technical sense. The natural tendency of male semen is indeed the pro-
duction of males, the generation of the likeness of the father. Therefore, if a
female is to be generated, some flaw, lack or interference must be involved.
Without an *occasio* there would be no women—an impossible state of affairs,
given the divine plan (to amplify Albert a little). In other words, we are
dealing with an inevitability of nature, not something that calls for moral
condemnation of the female sex.

A similar though fuller resolution of the problem is offered by Albert in a
Cologne lecture on *De animalibus* other than the one cited above. Here the
question is posed, "Whether nature intends the generation of a female."[81]
Given the large numbers of females that have been and are being generated,
it can hardly be said that the female is "generated contrary to the intent of
nature."[82] The problem is solved with the aid of a distinction between two
types of nature, universal and specific. "Specific nature . . . intends to produce
something like itself, and because the power of the male is the agent for the
generation of the animal," in a given sexual act the principal intention is
the production of a male. However, "universal nature intends to conserve the
entire universe and its parts," which involves the conservation of the various
species, for which both males and females are required. To that end, "univer-
sal nature intends the female" as "that without which the species cannot
be preserved."[83] Returning to the notion of "specific nature," Albert then

qualifies his statement that this "principally intends a male" with the rider that "nonetheless it secondarily and in a flawed way (*occasionaliter*) intends a female." Which certainly is no bad thing.

What, then, does Robert Grosseteste have to say on this front, he who (as quoted above) described woman as more emotionally uncontrolled, envious, quarrelsome (etc.) than man? Quite a lot in fact, much of which is strikingly positive. At one point Grosseteste focuses on Genesis 1:27, "God created man to his own image: to the image of God he created him: male and female he created them." That "plural means that we have to understand that the woman too was made to the image of God," declares Grosseteste; the term *imago Dei* is "applied . . . to the human being without qualification."[84] He proceeds to quote from St. Basil some of the most approbatory things ever said about Eve during the Middle Ages. "The woman comes into being according to the image of God as much as does the man. For their natures are of the same dignity (*eiusdem dignitatis*), their virtues are equal, their struggles are equal, and their rewards are equal. The woman should not say 'I am weak.' Weakness is in the flesh, but power is in the soul. Since, then, an image of the same dignity is in them, the image of God, their virtue is equal and so is their right to good deeds."[85] However, Grosseteste adds, "For in all things that have to do with true virtues the woman can be equal to the man, if she wants." That is, at best, a qualification of what St. Basil had said, rather than a straightforward endorsement of his words. At worst, it is a serious blurring of categories that deflects attention from the larger issue to hand. What a particular *mulier fortis* can do "if she wants," in terms of achieving virtue and performing good deeds, is a matter quite different in scale, scope, and general consequence from the one of origination raised by Genesis 1:27.

Even more radical qualification and containment of Basil's words is found in Albert's *Summa theologiae*. He begins by saying that "in respect of the works of grace and merit," man and woman "are equal if they receive equal grace."[86] Examples include Judith, praised by the Hebrews as "the glory of Jerusalem," "the joy of Israel," and "the honour of our people" (Judith 15:10), and the virtuous mother of the Machabees who "was to be admired above measure," and in whom "a man's heart" was joined "to a woman's thought" (II Machabees 7:20, 21). So, then, it may be inferred, Basil was right in saying that their virtues are equal, their struggles are equal, and their rewards are equal. But this does *not* mean that "their natures are of the same dignity." Pace Basil, as specifically quoted by Albert,[87] a woman's body is not equal in dignity (*dignitas*) to a man's. Speaking in absolute terms (*simpliciter*), man is

more worthy (*dignior*) than woman, because he is the head (*caput*) or ruler. As Aristotle says in the *Politics*,[88] in activities which males and females share the male is the principal (*principans*) and the woman the subject (*subjecta*), while at Ecclesiasticus 25:30 we read that "a woman, if she have superiority, is contrary to her husband." However, in special cases (*secundum quid*) a particular woman may be more worthy than a particular man. This, Albert continues, is how Basil's statement should be understood: not *simpliciter* but *secundum quid*. Man and woman are equal only inasmuch as "they participate equally in the grace of innocence, and are equally placed in relation to virtue and merit." Returning to the realm of general distinction, Albert says that women may be more worthy in spheres of activity which they do not share with men.[89] Presumably he has in mind such functions as conception, child-birth, and nurture, these being activities to which (as he has said a little earlier) the female is disposed by nature and wherein she is stronger (*fortior*) than the male.[90]

That said, the great schoolmen of the later Middle Ages were convinced that woman was made in God's image. True "power is in the soul" (to reprise yet another phrase from Basil), and at the level of mind (*mens*) and/or soul (*anima*) there was, and is, equality. Aquinas claims that Genesis (1:27) makes this point in stating "male and female he created them"; this is "not to present the image of God in terms of sexual distinctions, but because the image of God is common to both sexes, being in the mind which has no distinction of sex (*distinctio sexuum*)."[91] Whence St. Paul said that in Christ Jesus "there is neither male nor female" (Galatians 3:28).[92] Bonaventure concurs, arguing that the image of God according to its very "being" (*quantum ad suum esse*) "consists principally in the soul and its powers," and here there is no distinction between male and female, bond and free (Galatians 3:28 again).[93] In these terms, the *imago Dei* is "not found more in the man than in the woman."[94]

However, in his first letter to the Corinthians, St. Paul had said that "the head of the woman is the man" (11:3); furthermore, man is "the image and glory of God. But the woman is the glory of the man. For the man is not of the woman: but the woman of the man" (11:7–8). The schoolmen set about reconciling and developing the Apostle's remarks as follows. According to Aquinas, in its principal signification, namely its intelligent nature, "God's image is found equally in both man and woman." But, he continues, in a secondary sense, "God's image is found in man in a way in which it is not found in woman, for man is the beginning and end of woman, just as God

is the beginning and end of all creation." This is what St. Paul meant at I Corinthians 11:7–8, the key idea being that "man was not created for the woman, but the woman for the man."[95] Bonaventure similarly argues that the *imago Dei* is "found in a more excellent manner in the masculine sex than in the feminine, not by reason of that which concerns the very "being" of the image itself, but by reason of that which is adjacent to it"—that is, the human body, as annexed to the soul. Here we are talking of "accidental property" rather than essence. Given that, at the corporeal level, there is indeed a distinction between the sexes, the issue arises of which body expresses more clearly, or better represents, the image of God. Two principles (*raciones*) must be represented, those of "presiding" (*racio praesidendi*) and "origination" (*racio principiandi*).[96] On all these fronts, the male body wins, since, as the head of woman, man presides over her; she originated from Adam's rib and was made "for the sake of man," as his helpmate.[97] Here we are dealing with the soul's relation to the body, Bonaventure emphasizes; in terms of the soul itself, there is neither male nor female. But the potentially subversive force of Galatians 3:28 has been neutralized.

All of the above readings of the primal power relationship between Adam and Eve largely rest on the discourse of *imago Dei* found at Genesis 1:27, which supports the idea that both male and female were created in the divine image.[98] But a different—and exclusively androcentric—interpretation may be elicited from Genesis 1:26, where no mention is made of the female; there God says he will "make man to our image and likeness," and give him dominion "over the fishes of the sea," etc. That interpretation can, and did, find support at I Corinthians 11:7–8, where, according to Bonaventure, "the man is separated from the woman," and therefore "either the woman is not an image, or if she is an image, she is not so express [*expressa*, meaning "prominent," "distinct," "clear"] an image as is the man."[99]

The former option is taken in a canon included in Gratian's *Decretum*, which credits Augustine with arguing that "woman is not created in the image of God."[100] A little later Ambrose also is cited, as having taken St. Paul's words to mean that "a woman must cover her head because she is not the likeness of God; in order that she may appear submissive . . . she must wear this sign."[101] In fact, here we are dealing with Pseudo-Augustine and Pseudo-Ambrose. In *De Genesi ad litteram* the real St. Augustine did not rule out the possibility that the mind of the woman can receive the image of God, since St. Paul—even though at I Corinthians 11:7 he specifies Adam as "the image and glory of God"—says that in Christ's grace "we are neither male

nor female" (Galatians 3:28 yet again).[102] The Pseudo-Ambrose in question is the infamous fourth-century author now known as "Ambrosiaster," whose deeply misogynistic commentary on the Pauline Epistles was widely influential, due to the belief—not effectively challenged until the sixteenth century—that it was a genuine treatise by the saint himself.

The latter option is taken in the commentary on the *Decretum* by the canonist and Cardinal-Bishop of Ostia, Hostiensis (Henry of Susa, c. 1200–1271).[103] Woman partakes less of the dignity of the *imago Dei* than man does, for three reasons. First, in the beginning one man was created from whom all others followed; to this extent man is God-like, because everything proceeded from the one God. Obviously, Eve did not enjoy, or share, such status. Second, Hostiensis continues, just as from the side of Christ on the cross the origin of the Church flowed, so from Adam's side emerged a rib from which his spouse was formed. Third, just as Christ is head of the Church, so man is head of woman. So, then, while Hostiensis was willing to concede that Eve was also made in God's image, he was keen to emphasize her lowlier status. The male form rightly signifies freedom and preeminence, while the female form signifies subjection. A "fourth way" is then offered, according to which both the man and the woman may be said to present an image of God. It is possible to understand Genesis 1:26 as referring to the rational and intellectual nature of mankind in general, male and female being taken together. Allegorical interpretation, as ever, has come to the rescue, saving the appearances and reconciling apparent contradictions in Scripture. But literally as much as allegorically, woman's inferiority to man was believed to have originated in Eden, and hence was paradigmatic for every subsequent exclusion of the female sex from power over men.

Nowhere was this more blatant than in the late medieval exclusion of women from the priesthood, that being a primary objective of the canonical materials I have been paraphrasing. In their discussions of female ordination, the schoolmen—here I have particularly in mind Bonaventure, Aquinas, and Duns Scotus—were in broad agreement that the power of holy orders resides in the soul, where (as already noted in the discussions of creation *in imago Dei* quoted above) sexual difference does not appertain. *Ordinum potestas in anima fundatur. Sed sexus non est in anima.*[104] Thus Aquinas. But this did not support the case for women priests. The sacrament of holy orders does not relate to the soul alone, as Bonaventure's version of the argument has it, but to the soul as it is joined to the body.[105] Two major issues are at stake here. The first concerns signification (*ratio significationis*), the necessity of

providing an appropriate visible sign. The second concerns the practical necessity of carrying out (*exsecutio*) those rites which ordination entails, for which some bodily actions are essential. That is to say (and here I am expanding what Bonaventure actually did say), a soul cannot, for instance, hold aloft a chalice, be clothed in holy vestments, make the vocal utterances necessary for preaching and ministry of the sacraments. Priests need bodies. And holy orders need some visible sign which involves the body. Therefore sexual difference matters after all. The human body must be either masculine or feminine, and only the masculine body is perceived as capable of bearing the requisite sacramental symbolism. "In this sacrament the person who is ordained signifies Christ the Mediator," declares Bonaventure, "and since the Mediator was only of the male sex, he can [only] be signified by the male sex. Therefore the capability of receiving [Holy] Orders is suitable only to men."[106] It was not that Eve did not bear the *imago Dei*, but rather that Adam bore it in a more perfect and evident manner. Christ incarnated in male form, and the bodies of the priests who act in his stead are appropriately male, for in the sacrament of ordination man represents the image of God in a special manner: "man in a certain way becomes God, or divine," inasmuch as he "is made a participant in divine power."

Furthermore, Eve was supposed to lack the high degree of eminence (*eminentiae gradus*) which was required for the appropriate symbolizing of the divine in the performance of priestly duties. This was due to her inferior subject-position (*status subjectionis*), which went back to the very beginning of the world.[107] According to Duns Scotus, holy orders mark "a certain degree of eminence over other people in the Church," and this should be signified by an "eminent condition and [high] status in nature."[108] But woman does not possess such status, since she is naturally subject to man. "Therefore she ought to have no degree of eminence over any man, because as much by nature as by condition and nobility women are less noble than any man; whence after Sin the Lord subjected her to the dominion (*dominium*) and power (*potestas*) of the man." Duns states that, were woman to have holy orders bestowed upon her, she would be able to preside over (*praesidere*) and to rule (*dominari*), which is contrary to her condition. As St. Paul says at I Timothy 2:12–13, "I suffer not a woman to teach, nor to use authority over the man (*dominari in virum*): but to be in silence. For Adam was first formed; then Eve."[109] The gender hierarchy is clear and incontrovertible. What, then, are we to make of Paul's statement at Galatians 3:28 that in Christ Jesus "there is neither male nor female"? Duns's reply is that,

"although with regard to salvation and eternal life there is no difference between male and female, slave nor freeman, there is nevertheless a difference between them with regard to possessing office and eminent position in the Church, because in this a man is preferred to a woman."

Another obvious challenge to such subordination and silencing of women was presented by the considerable number of strong women whose achievements are recorded in both the Old and the New Testaments. Discussing the case of Deborah, who masterminded a major Israelite victory against the army of Canaan (Judges 4), Bonaventure identifies this as an example of a woman "dominating" in temporal terms.[110] But this, he claims, is quite different from "spiritual dominion," which requires in the official a sign that he typifies Christ as head. Since woman "cannot be the head of man," she is unable to effect this signification, to bear this typology, and "therefore she cannot be ordained." In this manner, Bonaventure separates out temporal or secular power from spiritual power; possession of the former affords no precedent for possession of the latter.

It is not that the schoolmen sought to deny that, in spiritual terms, individual women had attained higher states of perfection than many men. Being a prophet, it was widely assumed, is a higher calling than being a priest, and the Bible offers many accounts of the wondrous deeds of female prophets. However, as far as holy orders are concerned, this was deemed to be of no consequence. Because *sexus non est in anima*, Aquinas explains, the gift of prophecy and many other spiritual gifts can be received by women—but not ordination, which (unlike prophecy) is a sacrament, and uniquely relevant to the male sex.[111]

That statement by Aquinas is quite typical of a discourse of exceptionalism which functions to acknowledge the special status of outstanding women (as prophets and indeed, *in extremis*, as preachers), while entering two major caveats. First, the special divine gifts those individuals received were conferred to enable the performance of specific and carefully limited tasks—tasks which did not include those duties (such as the celebration of the sacraments) which were reserved for the male clergy. Second, their gifts were theirs alone, given by God and not by man; nontransferable to other women and creating no precedent for the female sex as a whole. It is, of course, a matter of historical record that many holy women did indeed rise to positions of considerable power and influence in the later Middle Ages.[112] But that did little to elevate the *dignitas* and *nobilitas* of women in general, as assigned in late medieval thought. Individuals may have enjoyed some measure of success, but the prevailing ideology remained largely unchanged.

There were, however, a few dissenting voices—one of the most articulate and astute being that of Christine de Pizan (1363–c. 1434), the daughter of an astrologer and physician employed by King Charles V of France. Following her husband's death, Christine sought to make a living within the traditionally male profession of court writer. Christine's *Livre de la cité des dames* may be regarded as a pro-feminist version of Augustine's *De civitate dei*; here women are defended against male attack and defamation in a way broadly reminiscent of the saint's affirmation of Christian truth over pagan error. Eve forms a major building block in this architectural allegory. "The Supreme Craftsman was not ashamed to create and form the feminine body," and therefore Nature cannot possibly look on it as an imperfect creation. Eve was created in the image of God, and "how can any mouth dare to slander the vessel which bears such a noble imprint?"[113] Christine claims that Eve was created of nobler matter than Adam, since she was made from the body of man—whereas Adam had been made from the slime of the earth.[114]

The origins of this long-standing tradition concerning Eve's superior substance are obscure, but by Christine's time it had frequently been cited in scholastic discussion, in the form of a "contrary" opinion which needed to be reconciled with the incontrovertible fact of Adam's greater nobility. For example, in the *Summa theologica* associated with Alexander of Hales the truth of the proposition is admitted, but instantly qualified with the point that, although Eve was created in paradise she was not created from something in paradise, because she was made from Adam's rib—it may be recalled that Genesis 2:15 ("The Lord God took man, and put him into the paradise of pleasure") was commonly read as an indication that Adam had been created outside paradise and subsequently brought into the garden.[115] At a single stroke, two possible pieces of evidence for Eve's greater nobility—made from a superior substance, made in a superior place—are undermined. Such a move was encouraged by a passage in Peter Lombard's *Sentences* which explained Adam's extra-paradisal creation as follows.[116] Either Moses, the author of Genesis, wished to highlight the fact that man was not going to remain in paradise for long, or to emphasize that his presence there should be ascribed not to nature, but to grace—i.e., Adam had no natural right to live in paradise, but was placed there as a special act of divine benevolence. His commentators built on those statements, as when Giles of Rome says that the first man's "translation" into paradise was effected so that, having been moved to a nobler place, he might appreciate more fully God's benevolence, and more fully be aroused to act well.[117] Second, on account of this

transition he would know himself a traveler or wayfarer (*peregrinus*), and therefore be more cautious in fending off evil, abstaining from anything that would result in his descent from that place. In sum, Adam was placed in paradise so that he could work for the good and to conserve the good, avoiding evil to ensure he did not lose himself to it. From this a third reason emerges: experiencing a taste of something good, and then losing it, renders one more eager to repent from evil and to labor to regain the good. At this point Giles does not engage in a comparison and contrast with the origins of Eve, but the key point is obvious: Adam's creation in a less noble place and subsequent move into a nobler one was done for excellent reasons, and cannot be taken as evidence that he was less noble than Eve.[118]

But what about the argument that, because Eve was made from superior material, Adam should have been made from her, and not vice versa? Peter of Tarantasia resolves this with reference to Boethius's *De consolatione philosophiae*.[119] It is necessary that the imperfect has its prime origin in the perfect, and therefore woman rightly had her origin in man. Material formation can be understood in two senses, Peter continues. It involves either a separation of parts or a transformation of the whole thing, and only in the latter sense can something perfect be said to be made from something imperfect. Eve was made from Adam through a separation of Adam's parts, and therefore the principle, as explained by Boethius, about the imperfect having its origin in the perfect applies here. Thus Adam's hegemony is affirmed.

Despite such efforts to dismiss any arguments for feminine superiority, the later Middle Ages did witness the emergence of an intermittent and somewhat inchoate discourse of "the privileges of women,"[120] which was to enjoy fuller formulation in early humanism. Within certain privileged circles, a genre of *laudatio mulierum* flourished in the fifteenth and sixteenth centuries; Conor Fahy has listed no fewer than forty-one examples published in Italy during that period.[121] Here treatment of the Genesis account of Eve's creation, and her status in relation to Adam, are de rigueur. A particularly elaborate version is included in the *Declamatio de nobilitate et praecellentia fœminei sexus,* which Henricus Cornelius Agrippa of Nettesheim published in 1529.

[God] created two human beings in his image, man first, then woman, in
whom the heavens and the earth, and every embellishment of both, are
brought to perfection. For when the Creator came to the creation of woman,
he rested himself in this creation, thinking that he had nothing more honorable
to create; in her were completed and consummated all the wisdom and power

of the creator; after her no creation could be found or imagined. Since, therefore, woman is the ultimate end of creation, the most perfect accomplishment of all the works of God and the perfection of the universe itself, who will deny that she possesses honor surpassing every other creature? . . . For woman was the last work of God, who introduced her into our world as the queen of a kingdom already prepared for her, adorned and perfect in everything.[122]

It is hard to know what to make of such writing. Some of it seems indebted to the fashionable Renaissance practice of paradoxical argument, which, as Rosalie Colie has demonstrated, exploited "the fact of relative, or competing, value systems. The paradox is always somehow involved in dialectic: challenging some orthodoxy, the paradox is an oblique criticism of absolute judgment or absolute convention."[123] Defense and commendation of the female sex was an obvious, and highly attractive, subject for such treatment. But to what end? It has been suggested that at least some of the *commendationes mulierum* were intended as oblique and ironic means of laying bare the unworthiness of the female sex, amusing to male readers who sought and found therein confirmation of their superior abilities and understanding.[124] Others may readily be regarded as attempts to win the patronage of wealthy women. Agrippa's *Declamatio* was part of his attempt to curry favor with Margaret of Austria, to whom the second dedicatory epistle in this work was written.[125] An earlier treatise, Bartolomeo Gogio's *De laudibus mulierum* (1487), was addressed to Eleanor of Aragon, the first Duchess of Ferrara.[126] Then again, such exaggerated praise of womankind can be interpreted as a sophisticated "gender game," produced primarily for purposes of entertainment and social display.[127] In reading about, and debating in coterie gatherings, issues relating to the nature and excellence of the female sex, both women and men (of privileged birth together with the upwardly mobile) could affirm their membership of an elite group of sophisticates.[128]

Whatever social needs those texts served, at least they did make available to women writers a rhetoric of self-defense which they could appropriate and deploy for their own polemical purposes. Examples may be found in the writings of a few rare Italian female humanists, such as Moderata Fonte's *Il merito delle donne* and Lucrezia Marinella's *La Nobiltà et l'eccellenza delle donne, co' difetti et mancamenti degli uomoni*, both published in 1600. Addressing the "material cause from which woman is composed," Lucrezia Marinella declares that she need not make much "effort over this since, as

woman was made from man's rib, and man was made from mud or mire, she will certainly prove more excellent than man, as a rib is undoubtedly nobler than mud."[129] Moderata Fonte focuses on the priority and the place of creation. The fact that Adam was created before Eve does not prove man's superiority, argues her spokeswoman Corinna;[130]

". . . rather, it proves ours, for they were born out of the lifeless earth in order that we could then be born out of living flesh. And what's so important about this priority in creation, anyway? When we are building, we lay foundations on the ground first, things of no intrinsic merit or beauty, before subsequently raising up sumptuous buildings and ornate palaces. Lowly seeds are nourished in the earth, and then later the ravishing blooms appear; lovely roses blossom forth and scented narcissi. And besides, as everyone knows, the first man, Adam, was created in the Damascene fields, while God chose to create woman within the Earthly Paradise, as a tribute to her greater nobility."[131]

Both these accounts seem indebted to Agrippa's *Declamatio*.

A dissenting voice of a different tenor was that of Rachel Speght (b. 1597?, d. in or before 1661?), a Calvinist minister's daughter now regarded as "the first Englishwoman to identify herself, by name, as a polemicist and critic of contemporary gender ideology."[132] In 1617 *A Mouzell for Melastomus* was published—this being Speght's attempt to "muzzle" or render silent a "black mouth" or defamer of women, one Joseph Swetnam, who two years previously had published an *Araignment of Lewde, Idle, Froward, and Unconstant Women*.[133] Whereas Lucrezia Marinella had spoken of just one of the major "four causes,"[134] the material cause or rib from which Eve had been formed, Speght used all four to structure her lively interpretation of the relevant parts of Genesis, which affirms the equality of Adam and Eve rather than attempting to prove the superiority of the one over the other. The evaluative model of Aristotle's four causes had been rediscovered, and endlessly analyzed and developed, in scholastic thought, so it may be said that Speght is using a highly conservative discourse here, one that would have instantly been recognized by Bonaventure, Aquinas, and their contemporaries. However, in the conclusions which Speght reaches through it, they would have been confronted with a mental world which, in their terms, was turned upside-down.

Speght begins with the "efficient cause of womans creation," identified as "*Iehouah* the *Eternall*," whose work cannot be anything other than good: "That worke then can not chuse but be good, yea very good, which is

wrought by so excellent a workeman as the Lord: for he being a glorious Creator, must needes effect a worthie creature. Bitter water can not proceede from a pleasant sweet fountaine, nor bad worke from that workman which is perfectly good, and in proprietie, none but he."[135] Then comes the material cause—and a version of the body metaphor which was quoted above in Peter Lombard's formulation. "Secondly, the materiall cause, or matter whereof woman was made, was of a refined mould, if I may so speake: for man was created of the dust of the earth, but woman was made of a part of man, after that he was a living soule: yet was shee not produced from *Adams* foote, to be his too low inferiour; nor from his head to be his superiour, but from his side, neare his heart, to be his equall; that where he is Lord, she may be Lady." This affirmation of equality is rendered even more convincing because, thanks to the Geneva Bible's version of Genesis 1:26, Speght can add that God gave "man" (read as humankind in general) dominion over the creatures, appointing "*them*" (evidently designating Adam and Eve together) to rule over the fish of the sea, and so forth—this being in contrast with the Vulgate's singular verb form *praesit* as used in the clause "et praesit piscibus maris," etc. (rendered in Douay-Rheims as "and let *him* have dominion over the fishes of the sea," etc.). "By which words," Speght continues triumphantly, God "makes their authority equall, and all creatures to be in subiection unto them both."

Third, the "formall cause, fashion, and proportion of woman was excellent": for Eve was "neyther like the beasts of the earth, foules of the ayre, fishes of the Sea, or any other inferiour creature, but Man was the onely object, which she did resemble." "For as God gaue man a lofty countenance, that hee might looke up toward Heaven, so did he likewise giue unto woman. And as the temperature of mans body is excellent, so is womans. For whereas other Creatures, by reason of their grosse humours, have excrements for their habite, as foules, their feathers, beasts, their haire, fishes, their scales, man and woman onely have their skinne cleare and smoothe."[136] Speght clinches this argument with the declaration that "in the Image of God were they both created; yea and to be briefe, all the parts of their bodies, both externall and internall, were correspondent and meete each for other." Which brings her, "fourthly and lastly," to "the finall cause, or end, for which woman was made," which "was to glorifie God, and so be a collaterall companion for man to glorifie God, in using her bodie, and all the parts, powers, and faculties thereof, as instruments for his [God's] honour." Here, once again, the equality of Adam and Eve in their creation by God may be asserted and

celebrated. However, this excursus skirts around the crucial question of the *extent* to which Eve was made in, and expresses, the image of God.

Some fifty years after the publication of *A Mouzell for Melastomus*, John Milton's *Paradise Lost* (which had assumed its final form during 1658–63) at last saw the light in print. In its eighth book Adam, having listened to the angel Raphael's long account of the creation of the world, describes his own experience of his creation and first encounter with Eve. Due to his love and admiration for her, she seems "wisest, vertuousest, discreetest, best"—an ill omen of things to come—even though, rationally, Adam is fully aware of the facts of their power relationship.

> ". . . well I understand in the prime end
> Of Nature her the inferior in the mind
> And inward faculties which most excel;
> In outward also her resembling less
> His image who made both and less expressing
> The character of that dominion given
> O'er other creature . . ." (VIII, 540–46)

Later, when Eve has fallen and the horrified Adam is talking himself into falling with her, he terms her the "fairest of creation, last and best / Of all God's works" (IX, 896–97). This profession recalls the discourse of *commendatio mulierum*—but the context renders it blatantly untrustworthy, given Adam's state of mind at this point. And the earlier reference to Eve's image "less expressing" the dominion which God gave to both of his creations takes us right back to the realm of the late medieval *Sentences* commentaries: as when Bonaventure presents the proposition that, if the woman is an *imago Dei*, she is not so express (*expressa*) an image as is the man,[137] and Richard of Middleton answers the question *utrum expressius sit imago Dei in viro, quam in muliere?* in the affirmative.[138] In addition to making the usual point about how the "accidental" qualities of the man's body express the divine image with greater dignity than the woman's, Richard complicates the principle (which we have seen Bonaventure and Aquinas endorse in their discussions of ordination) that *sexus non est in anima* with the argument that, as a general rule (*de communi lege*) and in respect of specific natural properties (such as rationality), the soul of man is nobler than that of woman. It is conceded that some women have souls which are nobler than those of certain men— indeed, the Virgin Mary's soul is piously believed to be nobler than that of

any pure man. But here, on Richard's reasoning, we are dealing with exceptions that prove the rule. The argument that, in terms of the soul, certain women are purer than men (not least because certain women have received greater gifts of grace than men), which—as noted above—was used to rationalize the existence of many strong and holy women, who exercised secular dominion and/or received exceptional prophetic gifts, has here been turned around, deployed to negative effect; its exceptionalism is starkly exposed.[139]

Despite the many "contrary opinions" which concentrate on the other side of the coin, opinions which, cut loose from their dialectical contexts, came to serve as viable arguments in favor of the equality, and even of the greater nobility, of the female sex, the belief persisted that woman is inferior both "internally" and "externally." That is to say, she was deemed unequal in terms of both her "inward Faculties" and her "outward" appearance—an exterior which resembles less the *imago Dei* and expresses less "the character of that dominion" which God gave them "ore other Creatures." Adam's dominion over Eve was thereby conceptualized in a way which has had a long and invidious legacy.

Plate 15, a postlapsarian scene from *The Visconti Hours* (c. 1388–90), says it all. Here the normative relationship between Adam and Eve is imaged, the man being dominant, his hand firmly on the woman's head, keeping her in her proper, inferior, place. The text scroll which curls down from God to man has not been filled in, but the entire tableau obviously reflects the Almighty's words to Eve as recorded at Genesis 3:16: "thou shalt be under thy husband's power, and he shall have dominion over thee."

Unequal Men: The Origins of Politics

Such attitudes may be understood more readily if it be accepted that we are confronting thought systems in which order—understood as hierarchical positioning—is valued more highly than equality. "Things that are from God are set in order" (Romans 13:1).[140] And such order seems to consist principally in disparity, adds St. Thomas; "ordo . . . maxime videtur in disparitate consistere."[141] He quotes Augustine as saying that "order is the disposition of equal and unequal things in such a way as to give to each its proper place."[142] Here Aquinas finds support for the view that, in Eden, "which would have been supremely well ordered, disparity would have been found." This principle is at the very center of what scholasticism envisaged as the well-ordered but unequal relationship between Adam and Eve.

In the *quaestio* I have been quoting here, Aquinas is addressing the question, "would all men have been equal in the state of innocence?" While his initial formulation of the relationship between order and disparity is (quite deliberately) a rather acute one, it is left fundamentally intact in the ensuing discussion. Aquinas uses it to justify the existence *in primo statu* of sexual difference and of age. Generation requires the difference of sex, and some people would have been born of others and hence younger than they (but of course the bodies of older people would not deteriorate as they do now). Staying with bodily disparity: in Eden the body was dependent on food to sustain life, as it is nowadays, and so also it would have been affected by the same "exterior agencies" which contribute to bodily disparity nowadays—such as climate, for instance, or the movement of the stars. (Here Aquinas has in mind the commonplace medieval belief that the alignments of stars and planets at birth influenced one's appearance, personality, and general preparedness for life.) Therefore in our original paradise some people would have been born more robust in body than others, or bigger, or more beautiful, or of a better constitution.

But this is not to say, Aquinas promptly adds, that those who were thus surpassed had any defect or fault in either body or soul. Inequality may arise in nature without any defect of nature. One might infer from this that in Eden there were (or, rather, there would have been) no ugly or corporeally deficient people; its inhabitants were not materially flawed in any way, although some had better bodies than others.

The principle of disparity applies in respect of the soul also; Aquinas is confident that differences in terms of knowledge and morals existed then, or would have existed then. There was no obligation to act or work (the verb used is *operare*) in that garden of delights; it was a matter of individual choice. An individual could freely chose the extent to which he applied himself to doing something or knowing something (*vel volendum vel cognoscendum*). Consequently, some men would have been more advanced in virtue (*justitia*, in the sense of moral probity) and knowledge (*scientia*) than others. To fill out this argument a little more: no one would have been stupid or lacking in "justice" in Eden, but in those abovementioned respects (at least) some people would have been superior to others.

In our present, fallen state a major cause of inequality between men seems to be due to God Himself, notes Aquinas, since He rewards some and punishes others. But surely "there would have been none of this in the original state"? Furthermore, "likeness and equality is the essence of mutual love,"

and since "in that state love, the bond of peace, abounded among men," it would seem that all men were equal then. Not so, says Aquinas. Inequality is not necessarily antithetical to love, for there can be greater love between unequals than between equals—as in the case of a father's love for his son, for example, which is naturally greater (according to Aquinas) than the love between brother for a brother. Further, in Eden—had humankind not fallen—God would have had no cause to punish some and reward others, but He could well have exalted some above others, "so that the beauty of order" might "more splendidly" be "reflected among men." Does the (rather alarming) conclusion then follow, that the more inequality God imposes, the more He manifests the beauty of order? No, for Aquinas has in mind here Augustine's statement about order involving the assigning of equals and unequals to their rightful hierarchical positions. *Ordo . . . maxime videtur in disparitate consistere.* So then—however counterintuitive it may seem to us, in Aquinas's view order and love are not necessarily subverted by disparity; on the contrary, they function with it and through it.

The principle of disparity goes even deeper than this. It underlies St. Thomas's treatment of the power relationships between men which might have appertained *in primo statu*—the "politics" of Eden, in the technical late medieval philosophical sense of *politica*. "Would some men have held dominion over others in that state?" Aquinas asks.[143] And he believes that they would—but not in the sense in which a master rules over a slave.[144] For a man can hold sway over a free subject, by directing him either toward his individual good or to serve the common good. Such dominion would have existed between men in the state of innocence, for two reasons. First, man is naturally a social animal (according to Aristotle),[145] and in any society one person has to preside over others, to look out for the common good (in contrast with the multitude of other people who seek many different things). "Therefore the Philosopher says that wherever many are geared to one thing, you will always find one of them to be principal or director (*ut principale et dirigens*)."[146] Second, if one man surpassed another in knowledge and justice, "it would be all wrong if he did not perform this function (of being principal or director) for the benefit of others." Such dominion would not be exercised in a domineering, coercive way. As Augustine says, the just do not rule "out of any desire for mastery (*dominandi cupiditate*)" but "from a dutiful concern for others."[147] In other words, the ruling class had its origins in Eden. But its members worked for the common good, not for personal profit.

This managerial elite did not enjoy a remuneration package commensurate with its status, Aquinas seems to think. Rather, possessions would have been "used in common, without any danger of discord"—unlike in the world after the Fall where, as Aristotle says, "possession in common is fraught with discord."[148] Elsewhere Aquinas says it is "not merely legitimate for a man to possess things as his own"; it is actually "necessary for human life."[149] And this for three reasons—all of which come from Aristotle's *Politics*.[150] First, "each person takes more trouble to care for something that is his sole responsibility than what is held in common or by many." Second, "because human affairs are more efficiently organized if each person has his own responsibility to discharge; there would be chaos if everybody cared for everything." (Evidently this complicates the argument summarized in my previous paragraph, whereby Aquinas lauded those exceptional managerial types who look out for the common good. It may be inferred that, at the top managerial level, only a few people should and can be involved, otherwise confusion will result; everyone else should confine himself to discharging his own responsibility.) "Third, because men live together in greater peace where everyone is content with his task. It is noticeable that quarrels often break out amongst men who hold things in common without distinction." In Eden, however, possessions were held in common, without discord, and "in the measure and manner that suited the situation of each, the things that came under their ownership" (i.e., their *dominium*, here used in this specific sense).[151] That is to say, people used as and when needed the possessions which they shared.

"Even now," Aquinas concludes, this practice "may be observed to be the case among many good men." The implication is that nowadays exceptional people can recuperate something of the original state of innocence, when everyone acted in such a way. It seems that they can create and enjoy their own little piece of paradise. An attractive idea. But also a potentially disruptive and dangerous one, as the next section will demonstrate.

Power and Possession: The Origins of Ownership

Not long after St. Thomas's death, the nature of the differences between paradisal power and its fallen derivatives came to be debated as never before, with ever-increasing rigor and destructive partisanship. The discourse of dominion changed utterly during the controversy concerning Franciscan poverty, as its constituent terms were incessantly defined and redefined, with

more heat than light. One of the most formidable participants, the English Franciscan William of Ockham (d. c. 1347), asserted that such words as *dominium* (lordship), *dominator* (lord), and *dominari* (to be lord over, to dominate) are quite ambiguous, as used differently in different disciplines. "They are taken in one way in moral philosophy, in another way in natural philosophy, in another way sometimes in common speech, and in another way in legal science; and therefore, since according to Augustine theology in a way includes all the sciences, these words are taken equivocally in various places in divine Scripture."[152] Ockham discusses these various usages one by one, with the objective of demonstrating that "*dominium* (lordship) has some meanings which the term *proprietas* (ownership, property) does not have," and vice versa[153]—for reasons which, I hope, will become sufficiently clear in the following pages.

Polemicists on both sides sought to bolster their positions by weaving elaborate fantasies about the power relations and property rights which appertained in Eden. Did both Adam and Eve exercise lordship over all things, or was God's gift to Adam alone? (This was a different question from that relating to the gender hierarchy; in the debates we are about to investigate Eve's economic subject-position was assumed rather than emphasized, because to emphasize it would have clouded the clear lines of argument concerning political power.) Since Adam was created before Eve, did he hold individual property as sole owner of the original world, and, if so, what difference did Eve's arrival make to that status? Indeed, did God's gift of dominion really include the granting of property rights, or did it simply entail the conferral of political power, the right to rule over and direct the earth's creatures? Did Adam own the fruit that he ate in paradise? Did Adam and Eve wear as private possessions the garments they made for themselves after the Fall—and, if so, was this by divine command or by human initiative? When God ordered Adam to eat *his* bread by the sweat of his brow (Genesis 3:19), does that imply his sole ownership of that bread? I have not invented any of these questions; they were all framed and debated with utter seriousness and considerable emotion during the long-running controversy.

Perhaps the perennial jibe about schoolmen being willing to debate the number of angels who could occupy a pinhead comes to mind at this point. But matters of the gravest historical consequence were involved, as the Order of Friars Minor sought to reconcile the ideals of its charismatic founder with the changing needs of a highly successful multinational organization. Only a few decades after the death of St. Francis (in 1226), his order was well

endowed with grand convents, large donations of money and property, sub-
stantial libraries, and the highest academic honors. Did this amount to a
deviation from its original Rule of Poverty? St. Bonaventure, who had been
elected Master-General of the Franciscans in 1265, tried to lay such fears to
rest in his *Apologia pauperum* (1269), where a tendentious distinction is made
between "simple use" (*simplex usus*) and "ownership" (*proprietas*): the order
could practice "simple use" of worldly necessities (dwellings, clothing, food,
and so forth) while not owning them "in fact."[154] This position was endorsed
by Pope Nicholas III in his bull *Exiit qui seminat* (1279): the papacy actually
owned the property and goods which the order merely used.[155] Thus the
appearances were saved. But the matter did not rest there; much faction-
fighting was to ensue for centuries to come. The 1320s and 1330s were a
particularly troubling time for the Franciscans. This period saw *Exiit qui
seminat* undermined by fresh legislation introduced by Pope John XXII, and
the deposition of the then master-general of the order, Michael of Cesena,
who fled (in 1329) from the papal court at Avignon to seek the protection of
Ludwig the Bavarian, the Holy Roman Emperor. Cesena was accompanied
by several loyal supporters, including Ockham and Bonagratia of Bergamo.

 We may pick up the tortuous tale around 1322, when Bonagratia of Ber-
gamo wrote his *Tractatus de Christi et apostolorum paupertate*.[156] The early
lives of St. Francis had chronicled his "exceptional attitude to the natural
world, his love and compassion for all creatures, and his extraordinary power
to control birds and animals";[157] Bonagratia's achievement was to build on
this an argument in favor of a life of poverty which initially had been lived
in paradise, subsequently by the Apostles, and most recently by Francis and
the Franciscans.[158] In Eden, Bonagratia claimed, there was no "mine" and
"yours"; Adam did not actually own the fruit that he ate.[159] It and the other
consumables available in Eden were held and used in common; our first
parents had no legal *right* of use, and no personal possessions. Of course,
"the idea that all things were common in an original state of nature was
widespread in earlier writing," as Brian Tierney has emphasized.[160] Aquinas
readily accepted it (as noted above),[161] and there was a long tradition of canon
law in its favor. Hence Hugutio of Pisa asserted that "By natural law, that is
by the approval of reason, all things are common, that is they would be
common if there had been no sin"; private property was instituted after the
Fall.[162] But Bonagratia takes the matter much further, down a quite radical
route. His view "that the primeval state of innocence was a normative condi-
tion to which humans could and should return was a new and potentially

subversive doctrine."[163] Christ's first disciples had returned to that state, and the Franciscans were following in their footsteps. Here, then, was a quite extraordinary means of defending the order's distinction between ownership and use. Its members could claim they lived in a state of innocence in which, de facto, they used worldly goods, including food, without having any legal right of use of such things; thus they owned nothing by and for themselves. Bonagratia's De paupertate offers an apotheosis of Franciscan poverty, the ideals of St. Francis being manifest in the social fabric of Eden.

Pope John XXII responded to these and similar arguments with a series of decretals, two of which are of particular importance for our inquiry into paradisal power: Quia quorundam mentes (1324) and Quia vir reprobus (1329).[164] In the first of these, John attacked the Franciscan appeal to "factual use" (usus facti) as being different from ownership. To use something unavoidably involved an act of use, and such an act implied the right to use that particular thing; if someone were to use something without having the right to do so, that would be an unjust act.[165] In the second bull, Quia vir reprobus, the pope claimed that God's original grant of dominion was to Adam alone, when he was yet outside paradise and before Eve was created:

> . . . it seems that before Eve was formed the lordship of temporal things was exclusive (proprium) to Adam, not common. Indeed it could not have been common, since at that time he was alone, and in respect of one who has never had any fellows nothing can be called common. This seems to be said explicitly in Ecclesiasticus 17[:1], where it is said: "God created man from the earth and made him according to his own likeness. . . . He gave him power over things upon the earth and put fear of him upon all flesh, and he dominated the beasts and birds." From this it is clear that he dominated by himself (solus dominatus). And from this it follows that for that time he had lordship (dominium) by himself . . .[166]

At first, Adam held individual property as sole owner or lord (solus dominus) of the world. Later, after the creation of Eve, our first parents owned things in common, but after the Fall individual property rights were reintroduced, and subsequently the Bible depicts the Apostles as owning property personally. According to Pope John this conferral of the right to own the goods of this world was by direct divine institution, and therefore cannot be renounced. Hence the Franciscans could not voluntarily give up their ownership of those goods which (they said) they were using merely as a matter of

fact.[167] Taken together, these two decretals sought to destroy the Franciscan order's special claim to sanctity, by refusing to allow its members to make the grandiose assertion that they were living in innocent poverty.

In his *Opus nonaginta dierum*, a blow-by-blow refutation of *Quia vir reprobus* (written during the period 1332–34), Ockham vehemently denies that the lordship of temporal things was, in the first instance, bestowed upon Adam alone. In his view, the Book of Genesis makes it quite clear that God created "male and female" and blessed both of them—not just Adam alone—when he said, "Increase and multiply, and fill the earth, and subdue it" (Genesis 1:28).[168] Evidently this blessing was given after Eve was formed. For how could offspring be multiplied by a man without a woman? Of course both had to be involved in that activity, just as both were given "lordship" over all the earth's creatures.

More specifically, the notion that "before Eve was formed Adam had exclusive lordship (*dominium proprium*) of temporal things" is quite erroneous, according to Ockham.[169] We are invited to consider the situation in which the monks of an abbey died or were killed, all except one. That sole survivor could not be supposed to have exclusive lordship of all the goods of the abbey and hence be regarded as their owner. Yet, in Ockham's view, that is precisely what John XXII wants us to believe about Adam before Eve appeared on the scene. And such an argument is "altogether false," Ockham declares. Lordship cannot be called exclusive just because one person happens to have it. The term rather refers to the case in which lordship cannot pass from one person to another unless that person dies or performs some specific action such as making a "gift, sale, bequest, or some other human contract by which lordship of a thing is transferred to someone else." Our hypothetical monk does not have that right—he cannot transfer any of the monastery's assets to anyone else. Ockham does not spell that out; rather he chooses to offer a second monk's tale, this one about a monk who is the first recruit to enter a newly founded monastery. When a second monk enters, he also enjoys some kind of lordship over the monastery's goods, "just like the first." The same may be said of Adam and Eve. When Eve was created, "lordship of temporal things could come to [her] without any grant (*ordinatio*) of Adam's, or his act or death" (i.e., without Adam actually doing something to effect a change, or dying so that Eve became his heir).

Indeed, Ockham continues, in the state of innocence there was no such thing as a "grant" (*ordinatio*). "Anyone, whenever he found something suitable to his use, or, also, to his comfort," would simply take it and use it.[170]

Therefore, he concludes, Adam did *not* enjoy exclusive lordship before the
creation of Eve:[171] "When Eve was formed she had lordship (*dominium*) of
all things just as Adam did; therefore, when Eve was formed, Adam did not
then have exclusive lordship (*dominium proprium*), and consequently he did
not have exclusive lordship before Eve was formed, because if he had had it,
when Eve was formed he would have been deprived of this exclusive lordship
without any fault of his." Ockham is not saying that Adam originally lacked
all lordship "before Eve was formed": rather that, whatever lordship he may
have been given, it was not exclusive lordship. "He did not then have exclu-
sive lordship, because that lordship was not given to him for himself alone,"
but rather to our first parents "and all their posterity."

Besides, the order in which events actually happened may have been differ-
ent from the order in which they are inscribed in Scripture.[172] According to
Ockham, the pope "argues badly" when he asserts that because something
"is written later, therefore it was done later."[173] There are "infinite counter-
instances" in the Bible. Take the case of I Machabees 3:1–3, for instance.[174]
In verses 1–2 we read that Judas Machabeus succeeded his father, "and all his
brethren helped him, and all they that had joined themselves to his father,
and they fought with cheerfulness the battle of Israel." Then, in verse 3, we
are told that "he put on a breastplate as a giant, and girt his warlike armour
about him in battles." But this does not mean that Judas Machabeus armed
himself after he had fought "the battle of Israel"; clearly, he must have done
so beforehand, in order that he could fight. Ockham proceeds to apply the
same interpretive principle to Genesis 2:20: "Adam called all the beasts by
their names, and all the fowls of the air, and all the cattle of the field: but for
Adam there was not found a helper like himself." It might be concluded
from this passage that Adam had dominion over "the beasts and birds of the
sky" before Eve was created, since it describes that calling and naming before
going on to say that God created for Adam a helper like himself. But just
because a text positions something later does not necessarily mean that the
event in question actually occurred later. Therefore Genesis 2:20 cannot be
taken as proof that "before Eve was formed Adam had lordship of things."
Or (more precisely) as proof that before Eve was formed Adam had *exclusive*
lordship of things—because (reverting to the previous argument) if Adam
had originally been given some measure of lordship, it was not exclusive
lordship; "he did not receive it only for himself but also in some way for
others." The liberties which Ockham takes here with the order of these pas-
sages from Genesis may seem quite surprising, not least because his practice

may seem at odds with that firm insistence on literalistic scriptural exegesis which is found elsewhere in his anti-papal writings.[175] The needs of polemic, it would seem, prompt a flexible hermeneutic; in this case the narrative sequence of the sacred text does not seem to be inviolable.

Adam and Eve, then, shared lordship. But that does not mean that they owned property, either individually or jointly. Ockham accused John XXII of using the term *dominium* in an inappropriate sense, to mean individual ownership, whereas (Ockham believed) "the lordship of all temporal things given to our first parents" should be understood as "a power of reasonably ruling and directing temporal things (*potestas rationaliter regendi et gubernandi temporalia*)."[176] Contrary to the pope's interpretation, *this* is what is meant by the assertion in Ecclesiasticus 17:1–4 that God gave man "power over things upon the earth," and by the statement in Genesis 2:15 that God put man "in a paradise of pleasure, to work and take care of it." Rightly understood, according to Ockham, such lordship involved the governance of Eden without any reference to property rights; the term *dominium*, he explains at great length, is far from being coterminous with *proprietas* (ownership, property).[177]

Our first parents were given a power of ruling over all living creatures, not a power of owning.[178] Both of them used the goods of Eden; had they stood firm and not fallen, their children would have done likewise. Indeed, immediately after the Fall, this state of affairs persisted. John XXII had claimed that God made an exclusive grant to Adam when he said, "in the sweat of your brow you shall eat your bread" (Genesis 3:19).[179] But, Ockham says, it is highly unlikely that Adam would have wanted to own his bread separately from Eve, given the bond of marriage and the love between them. Here, then, is a striking affirmation of that Edenic married love which had variously been praised as *honestus amor* (Augustine), *consortium dilectionis* (Peter Lombard), *socialis conjunctio* (Aquinas), and *amisté de mariage* (Oresme):[180] a quite powerful statement in itself and appealing to modern sensibilities, though it is very much a by-product of Ockham's ruthlessly partial defense of his order's claim to be living a holy life untrammeled by ownership.

Although there was between our first parents a division of things in respect of use, nevertheless all things were common in respect of lordship of some kind. This seems probable enough because of the bond of marriage and the concord and love (*vinculum matrimonii ac concordiam et amorem*) between them. For while love and concord existed between them, it does not seem that they

should have been moved by any reason to divide temporal things between them in respect of lordship or ownership.[181]

When, then, did private property enter the lives of Adam and Eve? At Genesis 3:21 we read that "the Lord God made for Adam and his wife garments of skins, and clothed them." Given that each human wore his or her personal garment, does this episode mean that private possession was instituted by God? No, says Ockham.[182] The situation may be clarified with reference to the earlier statement that Adam and Eve "sewed together fig leaves, and made themselves aprons," when they recognized they were naked (Genesis 3:7). Here is evidence that the first division of property in respect of lordship was the result of human agency rather than divine command,[183] and this principle may be understood as applying in both cases, to the garments of skins as much as to the aprons of fig leaves.[184]

Subsequently, of course, private property did become a norm. It and the legal apparatus that accompanies it were instituted and elaborated through human laws.[185] This was effected "by God's will" inasmuch as "all things are done by God's will either commanding or permitting"[186]—which is quite different from a divine edict of the kind envisaged by John XXII, who believed that individual ownership (and indeed *dominium* in a wider sense) was introduced "by divine law, and not human."[187] All of this is crucial for Ockham's defense of Franciscan poverty against the pope: a right of merely human origin can be renounced by other humans—namely, the Franciscans.

But Ockham did not think that such an act of renunciation took the Franciscans back to a state of innocence. God's original blessing gave Adam and Eve lordship over the beasts and birds of the air (though not the power to own property, as already noted). But this was a one-off blessing, never to be repeated.[188] The absolute power of command over all living creatures which Adam and Eve enjoyed was not given to "the Apostles, their disciples and their Jewish converts":[189] if they had cattle or other animals, those creatures did not obey them in the way they would had they "remained in the state of innocence; and thus their lordship was not of the same sort as that of our first parents."[190] Neither was their human nature restored to its original condition, "repaired . . . in respect of natural shortcomings."[191] Here Ockham diverges sharply from his fellow dissident Bonagratia of Bergamo. The fact that the Franciscans had given up something that did not exist in Eden, however important it was in itself, does not mean a return to an Edenic state. That does not undervalue the Franciscans' extraordinary act of renunciation,

their voluntary choice of poverty. But it puts it on a different basis, locates it within a discourse of "the natural right of using the things necessary to sustain life," a right which does not include a claim to legal ownership of those things.[192] Thus Ockham sought to defend the Friars Minor against an attack which, he believed, "destroys and confounds the Order of blessed Francis," and implies that "blessed Francis" himself "was a pretender and a fraud"— "which it is wicked to think."[193]

Little good it did him. Ockham died in Munich, excommunicate, perhaps in 1347, the year in which his protector, Ludwig of Bavaria, went to meet the King of Kings. Michael of Cesena and Bonagratia of Bergamo had passed away a few years earlier, also unreconciled with the church. In the early 1350s a new chapter in the saga opened when Pope Clement VI appointed three doctors to investigate various issues relating to apostolic poverty and mendicancy (the friars' right to beg, to live on donations). One of them was the Irishman Richard FitzRalph (d. 1360), an Oxford-trained theologian who had been elected Archbishop of Armagh in 1346. In this case the pope probably got more than he bargained for, given the intensity with which FitzRalph pursued his mission and the amount of acrimony he stirred up in the process.

FitzRalph became quite famous, or rather infamous, for his views on the more practical consequences of the friars' privileges, which, he believed, threatened the rituals, authority—and income sources—of the parish clergy. This aspect of the archbishop's interest is well represented by a sermon he preached at the papal court in 1357. Generally known as the *Defensio curatorum*, it came to be "the most influential piece of anti-mendicant polemic published during the later Middle Ages."[194] Here FitzRalph's polemical zeal prompts him to locate the origins of work—which the friars are shirking—in Eden itself. In his Middle English translation of circa 1380, John Trevisa renders the crucial passage as follows:

> . . . in the first ordynaunce of man God ordeyned hym so that anoon as man was made, God put hym in Paradys for he schuld worche & kepe Paradys; so hit is written in the bygynnyng of Hooly Writ. Hit semeth me that there God taught that bodilich werk, possessioun and plente of riches & vnmebles [treasures], & warde [stewardship] and keping therof for mannes vse, schuld be sett to-fore beggerie [begging; i.e., mendicancy]; for god sett man in Paradys for he schuld worche [work].[195]

However, during the long period in which he composed his treatise *De pauperie Salvatoris* (finally completed in 1356), FitzRalph had come to believe

that "the nature of property, and the question of whether its use could be divorced from lordship, were central to the controversy over Franciscan poverty." His novel contribution to the debate was "a theory of dominion and grace, whereby lordship, ownership, and jurisdiction, and the valid exercise of authority were all founded on God's grace to the individual soul."[196] The *dominium* enjoyed by humankind before the Fall is different from that which appertained afterward, since "it cannot be refused when granted, nor abdicated except through sin."[197] Thanks to divine grace, FitzRalph argues, in Eden our first parents and their progeny enjoyed, or were to enjoy, a common dominion whereby they shared all things. By sinning Adam lost his original lordship, "but when he repented and received grace he received it also again, though without the full power of exercising it."[198] Since that time divine grace has bestowed a similar dominion on the righteous.[199]

"Lordship is founded in grace, and without grace there is no lordship."[200] This, the most distinctive—and potentially dangerous—aspect of FitzRalph's doctrine of dominion, was picked up and developed by John Wyclif.[201] Which brings us back to Wyclif's *De statu innocencie*, a treatise which in the present book has been used to illustrate late medieval doctrines of paradise which, while relatively commonplace, are described therein with considerable precision and verve. It is now time to confront some of the ways in which Wyclif moved away from such consensus, toward views which were judged heretical.

FitzRalph had defined original or natural lordship as the rational creature's original authoritative right "of naturally possessing the things made subject to him by nature in accordance with reason."[202] Likewise, Wyclif identifies the type of *dominium* which existed among men before the Fall as "natural dominion."[203] In the state of innocence the superior creatures exercised lordship over their natural inferiors—which means that men had dominion over the beasts. However, among themselves men held in common everything which they had at their disposal. At that time there was no private property or individual ownership; all of that originated after the Fall, in order to constrain vicious people who otherwise would have misappropriated those once-common goods. Here Wyclif is alluding to the institutions of civil dominion; indeed, he seems to have written *De statu innocencie* as he was working on his magnum opus on that subject, the *De civili dominio*.[204] In that longer treatise it is explained that civil dominion involves private and exclusive ownership, with all the social organization necessary to maintain and defend it. This was a necessary evil, in Wyclif's view, required by grim

postlapsarian conditions. There was nothing new, of course, in the distinction between "a specific era—before the sin of Adam—when all things were common" and "a subsequent age when private property was instituted."[205] It was well supported by canon law, and FitzRalph had reiterated it.[206] But Wyclif puts his own, strongly moralistic, spin on the matter.[207] As Stephen Lahey nicely puts it, for him "Natural *dominium* is inclusive, holistic, and characterized by an outwardly directed caring for others, while civil *dominium* is exclusive, individualistic, and marked by selfishness and cupidity."[208]

After the Fall many things were necessary which did not exist in the state of innocence, Wyclif emphasizes. For example, Hebrew no longer serves as a universal language, and now the mechanical arts and logical methods of reasoning are needed. All par for the course. But then Wyclif makes the striking claim that every part of the world is for the innocent to use, and, properly speaking, all things belong to the just and only to them.[209] He tries to explain that as follows. The limbs and "accidents" of every human being are individual in terms of possession (we each have our own) but common in the uses to which they are put.[210] It is not the case that the head or another member of some person belongs to me, is my member, but rather that it is mine in respect of use. The father of my dog is mine and yet is not my father, Wyclif remarks. Hardly an effective clarification. The idea seems to be that, if I own the father of my dog then I can be said to possess a father, or (to follow Wyclif's terms more precisely) gain the use of fatherliness in this indirect way. But, of course, that creature is not my biological father.

To put it in simpler language: as human beings all of us have legs in common, but each person has his or her own legs. And, if someone runs an errand for me, I benefit from that use of legs. How does this relate to the just man? Assuming that I am just, the good "accidents" and members of any of my contemporaries are mine, inasmuch as I derive use from them, profit by them. Similarly, the goods of my brother in Christ are mine—not for any use whatever, but at least inasmuch as I take pleasure in them and enjoy the profit my brother derives from them.

Wyclif daringly (perhaps even impishly?) drives this point home by remarking that, on this argument, it may be said that even my brother's wife is mine, inasmuch as I may enjoy her as she helps me, as a member of the church, to build up the church. But this, Wyclif adds hastily, has nothing to do with sex; she certainly is not my own wife. He is not thinking like Deacon Nicolaus and his followers! The Nicolaites were described as a hateful sect in Apocalypse 2:6, accused of holding the belief that one has to indulge fully in

sensuality in order to become its perfect master. Hence Irenaeus condemned them for leading "unbridled lives," committing adultery and eating things sacrificed to idols.[211] Quite a frisson.

Here, then, is the kind of life that men would have led in Eden—using goods held in common, and each other, in a wholly decorous and mutually supportive way, and taking pleasure in the profit which others derived from those goods and from oneself. One of the most compelling aspects of this doctrine—assumed here but spelled out at considerable length in *De civili dominio*—is the assumption that the state of innocence was not exclusive to Eden. At the very beginning of *De statu innocencie* Wyclif had claimed that the definition of innocence should be understood to include the life Christ led and indeed the times at which His saints (which we may generalize to mean, the predestined elect) lived free from sin. In other words, divine *dominium* can provide certain select, righteous humans living after the Fall with an approximation of the natural dominion which Wyclif found intimated in Genesis. Those happy few have replaced the Franciscans whom Bonagratia of Bergamo and other apologists for the Order of Friars Minor (Ockham excluded) had imagined as the rightful heirs of paradisal, and subsequently apostolic, innocence.

One must speak of an "approximation" of natural dominion in this case because, of course, saints did not—or do not—have to go around naked, practicing vegetarianism, expecting to live forever, etc. (Here one may recall how Ockham sought to temper his fellow friars' fantasies of recovered innocence by reminding them that, in the present world, men lack the power of command over animals which Adam enjoyed, and neither can human nature be restored to its original pristine condition.) Such views cannot be attributed to Wyclif; a *reductio ad absurdum* of that kind would be tendentious and trivializing. However, it seems quite obvious that Wyclif *did* hold the belief that, thanks to Christ's sacrifice, the righteous are restored to a state of innocence, having been freed from "the constraints of private ownership, owning nothing and sharing everything in apostolic community."[212] On the other hand, he was aware—to some extent anyway, but maybe not enough—of how difficult it was to achieve this state in present-day existence. In the postlapsarian world, we have to contend with civil dominion; make the best of a bad job, so to speak.

Wyclif was attracted to the aristocratic model of governance (as opposed to the monarchical, though he saw certain advantages in single-minded but enlightened kingship), as he makes clear in *De civili dominio*.[213] Here he

presents his idealized aristocrats as if they were Old Testament judges. This polity, he affirms, is the one that approximates most closely to lordship in Eden. In seeking to comprehend Wyclif's view of prelapsarian society, Stephen Lahey has commented: "From the outside looking in the society connected with Natural *dominium* seems like an aristocracy, but because secular lordships entail coerced commoners, Natural *dominium* cannot really be an aristocracy, because there are no commoners, no coercion, and most importantly, no sin. If everyone is an aristocrat, it is hard to label the society an aristocracy."[214] Indeed, but such is Wyclif's preferred option for paradise. It is tempting to recall the text on which John Ball preached before two thousand Kentish rebels in 1381, to the consternation of the chronicler Thomas Walsingham:

Whan Adam dalf and Eve span,
Wo was thanne a gentilman?[215]

Wyclif's answer seems to be: before the Fall *everyone* was a "gentilman." In contrast, in the fallen world, the world permeated with civil dominion, natural *dominium* is restored only to "those foreknown to be worthy to enjoy it."[216]

This account of power in paradise is, I believe, significantly different in tone and tenor from the ones I have summarized previously, and affords a particularly interesting contrast to Aquinas's treatment of inequality and disparity in Eden. In *De statu innocencie* there is no suggestion that everyone in Eden would have been equal in intelligence and ability. Wyclif simply does not investigate that issue. His interest is rather in the idea that the first humans were equal in their right to use commonly held possessions and (generally speaking) in respect of lordship—they were all aristocrats, to revert to the terms of the discussion above. I find no hint in *De statu innocencie* (or elsewhere in Wyclif's corpus) that in the state of innocence some "lords" would have been more equal than others, that some form of polity would have existed, if only to ensure that a specially gifted person or persons promoted the common good and deployed his/their superior gifts for the benefit of others. What is quite clear is that, according to Wyclif, in the state of innocence there was no physical strife, no legal system, and no disputes; all that came with the Fall. Furthermore, the moral virtues as described by Aristotle had no place in Eden either, since at that time man did not have the propensity for evildoing which came later.[217] There was no need of a ruling

or managerial class to keep the rest of the population in check, because the entire population lived in harmony and at peace together. Everyone was aware of the common good, and all served it, without needing direction from anyone else, taking pleasure in each other's use of common goods, sharing them easily in the knowledge that no one had more right to them than anyone else.

In *De statu innocencie* at least, Wyclif wanted to keep Aristotelian ethical and political theory out of Eden—in contrast with Aquinas, as quoted above, who regarded it as a viable method of analysis. Aquinas's approach is of a piece with the way in which he used Aristotle to defend and justify private property[218]—in the postlapsarian world, to be sure, but the contrast with Wyclif's views remains significant. For Wyclif private ownership was a great danger and (in absolute terms) a mere illusion, a consequence of the Fall which had no justificatory precedent in the state of innocence. All members of the "true church" (*vera ecclesia*) hold their lordship from Christ, just as before the Fall humankind originally held *dominium* 'by the title of Grace."[219] Here, then, is what Wyclif made of FitzRalph's argument that "Lordship is founded in grace, and without grace there is no lordship." He was more concerned to affirm the similarities between the various recipients of grace rather than describe the differences between them. Clearly, this was driven by his desire to affirm the possibility of states of lordship and innocence beyond the historical and geographical confines of Eden.

In bringing *De statu innocencie* to a close, Wyclif does address a specific hierarchical relationship: the dominion which angels have over men (just as, in their turn, men have dominion over the beasts).[220] *Angeli confirmati* (presumably Wyclif is using the term to distinguish them from the fallen angels)[221] rule over all of corporeal creation, this privilege being due to the excellence of their nature. In this case Wyclif is talking about angels in general, he explains, not thinking solely of the superior ones who dominate over others. In contrast, the devil—himself a fallen angel, though Wyclif does not spell this out—is no ruler, but rather a slave (*servus*) to sin. Grace or charity is needed for lordship; where they are lacking, there is no true dominion. The good angels serve the Lord of Lords, God Himself. This service is continuously free from sin and through it they work incessantly to fulfill the will of God. Wyclif contrasts this service with the dominion which characterizes the present world, warning that, in particular, clerics should detest civil dominion (that being a major theme of *De civili dominio*). Nothing is more likely to accentuate devilish pride in us, and therefore Christ preserved the innocent from such dominion, and forbade his clerics to exercise it.

At Genesis 2:15 we read of how humankind was charged with the perpetual service of God, even as the blessed angels were: "the Lord God took man, and put him into the paradise of pleasure, to dress it, and to keep it." Quite what this service entailed is difficult to envisage academically, Wyclif admits, since in the state of innocence the earth was not cultivated and the mechanical arts were not practiced. However, some suppose that it entailed traveling through paradise, contemplating sensible creatures and controlling the beasts and birds by reason of God-given lordship, so that they should not act in a disorderly way against the plant life. Such work was neither tiring nor tedious but rather a major source of comfort and solace. The text (presumably Wyclif still has Genesis 2:15 in mind) teaches us that in every state of innocence (whether angelic or human) God despises idleness, as when clerics neglect their appropriate spiritual work. FitzRalph would have warmly endorsed at least that sentiment. All things in the state of innocence were rightly ordained, Wyclif continues, with the beasts serving man and man serving God; as soon as man failed in this service, he lost his dominion over the beasts and birds. However, the laws which Truth Himself established for the state of innocence remain important for us lapsed creatures. Wyclif exhorts us to study further divine dominion first of all, then dominion both before and after the Fall, remembering in particular that all dominion concerning creatures has its pattern in divine dominion. Here he is, no doubt, referring to the books which will follow in his scheme for a full-scale *Summa theologiae*—recommending them as a good read for those who wish to learn more about his (quite eccentric) doctrine of natural, civil, and divine dominion. A doctrine which went far beyond the bounds of Catholic orthodoxy. Wyclif's teachings on the relationship between dominion and grace were singled out for criticism from the late 1370s onward; they feature prominently in the Wycliffite and Hussite propositions condemned at the Council of Constance in 1415.[222] Furthermore, and to speak with the knowledge of hindsight, in some ways they adumbrated certain Protestant imaginaries of paradisal conditions before and after the Fall.

In the opinion of some modern historians, Wyclif's belief that the right to hold power and possessions is dependent on grace was "theological dynamite, capable of blowing up the whole fabric of society, lay and ecclesiastical," a subversive doctrine capable of unmaking emperors and popes.[223] On the other hand, Michael Wilks has found here one of those many occasions on which Wyclif "took particular pleasure in indulging in lengthy speculation about divine possibilities (thereby creating great alarm and confusion) but

knowing full well that this speculation was to have no immediate results for human life."[224] A man's status in terms of salvation remains a mystery until the Day of Judgment, and since one cannot tell who is predestined to eternal glory or "foreseen" (Wyclif's term) to eternal damnation, one should not seek to challenge the status quo. Even if a prelate or a king shows clear signs of inveterate wickedness, no attempt should be made to depose him, since "the divine power still flows through his office."[225] Hardly a mandate for social change, much less revolution.

Some later dissenters took a more robust view of the relationship between theory and practice, as in the case of the seventeenth-century Levellers, Diggers, and Ranters, who, as Philip C. Almond puts it, "sought treasures on earth in the here and now by the restoration of the Adamic world."[226] The Digger Gerrard Winstanley (d. 1676) is a particularly fascinating case in point. For him the earth is a treasury common to all men; inequality and the dominion of some people over others were the result of the sins of the flesh—a result which is reversible. If men would only act together in one spirit to spread the divine power, and act in accordance with a single law of reason and equity, that social equality which characterized Eden would be restored; the rich would be brought down, and their wealth redistributed fairly.[227] As Christopher Hill has said, "for Winstanley the establishment of private property *was* the Fall; its abolition was therefore necessary if pre-lapsarian freedom was to be restored."[228] As a gesture toward that abolition—as well as a practical measure to help feed the local poor—in 1649 Winstanley led the first group of "Diggers" to grow vegetables on the common land on St. George's Hill in Surrey, thereby realizing the potential of that ground as part of the abundant "Store-House" which God had bestowed upon man at the creation.

> In the beginning of Time, the great Creator Reason, made the Earth to be a Common Treasury, to preserve Beasts, Birds, Fishes, and Man. . . . But . . . selfish imagination taking possession of the Five Sences, and ruling as King in the room of Reason . . . did set up one man to teach and rule over another; and . . . man was brought into bondage, and became a greater Slave to such of his own kind, then [= as] the Beasts of the field were to him. . . . And that Earth that is within this Creation, made a Common Store-House for all, is [now] bought and sold, and kept in the hands of a few, whereby the great Creator is mightily dishonoured . . .[229]

Aquinas's Aristotelian notion that the managerial class originated in Eden is tacitly rejected. Wyclif would have approved of that move by Winstanley, as

no doubt he would have endorsed the Digger's view of paradisal community of property, and the belief that private ownership and the legal system were consequences of sin. One can only wonder (a whimsical thought, admittedly) if Wyclif found some solace in gardening during his residence in the modest parish of Lutterworth in Leicestershire, where he spent his last years, a disappointed man, writing obsessively in defense of views which his former Oxford supporters were publicly disowning.

The belief that gardening has religious significance, that orderly horticultural activity in some way implements the legacy of the first gardener, Adam, has a long history, going back to the early Church Fathers. In Athanasius's *vita* of St. Anthony the Great (d. 356) a glowing account is given of a beautiful garden, well watered by a spring, which the saint had created. When desert animals damage some of his plant beds, Anthony has a word with one of them, and it never happens again.[230] Behold a reclamation of the dominion which Adam and Eve had over the lower creatures in Eden. Underlying this account is a belief that "something of the original paradisal state . . . survived and could be recaptured" through ardent prayer and rigorous observance of monastic rule.[231] Indeed, a monk could participate in God's plan for the ultimate redemption of humankind and the emergence of the "new heaven and new earth" (Apocalypse 21:1) which will not only restore but surpass the garden which was God's original gift to our first parents. In later monasticism, monks who were content to leave the manual labor, including the gardening, to the lesser brethren, nevertheless thought of their monasteries as present-day Edens. As Giles Constable has noted, in the eleventh and twelfth centuries there was a tendency to focus paradisiacal "imagery on the cloister rather than on the Church as a whole," and "to see the monastery as the *hortus conclusus* of Scripture."[232] To take but a few examples of Benedictine testimony, Odo of Anchin (or of Cambrai, d. 1113) attributed to his recruits the conviction that "their city" was "a prison" and "the monastery a paradise," while Peter Damian (d. 1072) called his hermitage "a paradise of pleasures," a garden in which "the colors and smells of each flower corresponded to a particular virtue."[233] By fleeing from both city and selfhood, and participating in communal worship and scriptural meditation within the depersonalizing structures of the Rule of St. Benedict, the individual monk sought to abnegate—or, better, transcend—his personal devices and desires in hierarchical subjection to his superiors and ultimately to the Almighty. Such was the paradise constituted by the cloister.

In marked contrast—and somewhat paradoxically—the nascent socialism or indeed communism within Gerrard Winstanley's Edenic fantasies derived

from a belief in personal and direct experience of God, untrammeled by the structures of any institutional church, whether Catholic or Calvinist. Winstanley's editor George H. Sabine writes of how he "was subject to flashes of insight which he attributed to an inner Light or a divine voice and his communistic experiment was directly induced by such an experience"; thus he "asserted repeatedly that he derived his beliefs from no man and from no book."[234] Not even from the Bible. To cite some of Winstanley's own words, "The experience and writings of prophets, apostles, and saints are dry shells to me and cannot comfort, unless God . . . give to me likewise some experiences of his love, as he gave to them, and then I shall have joy; yes, and my joy then will be fulfilled, and not until then."[235] With extraordinary consistency, Winstanley applied this principle to his own writings. "I do not write anything as to be a teacher of you, for I know you have a teacher within yourselves (which is the Spirit). . . . He will teach you all things and bring all things to your remembrance, so that you shall not need to run after men for instruction."[236]

The Insubordinate Fall

Such extreme Protestant individualism is (theoretically) very far from that "aspiring selfishness" which Winstanley regarded as the result of the Fall, "the desire for equality with God leading to pride, envy, discontent, and disobedience."[237] Here—perhaps surprisingly, given his many idiosyncrasies—Winstanley is well within mainstream Christian thought on the subject. The Fall has been many things to many men, but a constant emphasis has been placed on its breach of normative power relations: between man and God, between man and woman, between man and the rest of creation. Here, then, was an act of insubordination, a refusal on the part of Adam and Eve to accept their roles and responsibilities within the hierarchy of being. Hence pride has been afforded the status of the first and foremost sin, from which all others have flowed. Augustine defined pride as "the love of one's own superiority,"[238] "an appetite for a perverse kind of elevation,"[239] affirming the statement of Ecclesiasticus 10:13 that "The beginning of all sin is pride." He reconciles this with St. Paul's apparent assertion of the precedence of avarice ("The root of all evils is avarice [*avaritia*]"; I Timothy 6:10) by interpreting the term *avaritia* "in a general sense as what goads people to go for anything more greedily than is right" because of their belief in their

own superiority and the kind of love they have for what is proper to them (*quemdam propriae rei amorem*).[240] The devil fell from heaven through *avaritia* in this general sense;[241] twisted self-love deprived that prideful spirit, swollen and puffed-up, of holy companions, and reduced him to an ever-hungry wretchedness. In contrast with this disease, "charity does not seek her own," that is, does not rejoice in private preeminence and superiority, and rightly therefore is also "not puffed up" (cf. I Corinthians 13:4–5). Augustine sharply contrasts these two loves, "of which one is holy, the other unclean, one social, the other private, one taking thought for the common good . . . , the other putting even what is common at its own personal disposal because of its lordly arrogance; one of them God's subject, the other his rival." Here is the key, in his view, to the dynamic of the human Fall as well, the process whereby Adam and Eve put selfish pride before the common good of humankind.

Aquinas, who generally goes along with the Augustinian account I have just summarized, likewise says that man's first sin consisted in his craving for some spiritual good "above his measure, which is a function of pride."[242] Having heard the persuasive words of the devil in the serpent's guise, "Your eyes shall be opened and you shall be as Gods" (Genesis 3:5), Eve coveted this high status and fell into pride. While both our first parents were guilty of pride, Eve was "more puffed up than the man," committed the sin of pride more grievously than Adam, because "her pride rose to the height of desiring to obtain something against God's will."[243] Bonaventure concurs; the devil promised Eve "an excellence of dignity" quite above her true station, and "she first, in desiring to be as God, was proud." These schoolmen are following cues from Peter Lombard, who had highlighted the problem of primordial pride by devoting a substantial section of his *Sentences* to the question of who was the worse sinner, Adam or Eve.[244]

On the one hand, Adam's sin was the graver, inasmuch as he was more perfect (*perfectior*) than the woman (Aquinas)[245] and because he displayed worse ingratitude in apparently forgetting the more abundant gifts which God had bestowed upon him (Bonaventure).[246] But, in many other respects, Eve's sin was evidently the worse. She desired more ardently "to be assimilated to God," having heard the devil's words, and in addition her sin corrupted not just herself, but others—that is, her descendants, and even her husband. "Wherefore not only did she sin against herself, but also against her neighbor."[247] Thus Bonaventure. Aquinas reiterated the point about Eve having sinned against her neighbor, and added a partial excuse for Adam

(which he had found in Augustine's *De Genesi ad litteram*): the man's sin was diminished by the fact that "he consented to the sin out of a certain friendly good-will (*amicabili benevolentia*), on account of which a man sometimes will offend God rather than make an enemy of his friend."[248] The *Speculum humanae salvationis* sums up the argument well; Adam "ete for horge [huge] luf, that he shuld noght hire greue" (348).[249] Here, one might say, is the downside of that "faithful fellowship of honest love (*coniugum fida ex honesto amore societas*)" which Augustine, followed by many of the schoolmen, had commended.[250] Yet again we see the complex, indeed contested, consequences of medieval attempts to locate quintessentially human, and therefore ideologically definitive and socially requisite, behavior in Eden. The very basis of marriage must be found and securely established in Eden; the sacramental union of man and woman—read literally as a validation of "the goods of marriage" (including married love) and spiritually as an allegory of that love which Christ has for His church—must be honored by paradisal origination. But the human emotions thereby implicated can work for good or ill, pertaining either to commendable *amisté de mariage* (with its considerable "economic" value) or to a reprehensible uxoriousness which prompted Adam to fall along with Eve. Thus Duns Scotus claims that the sin of Adam was not an immoderate love of self (as was the case with the fallen angels) but an immoderate love of friendship for his wife, which Scotus distinguishes firmly from that love which involves concupiscence or lust.[251]

Adam's Fall, following Eve's, was not inevitable. He could have refused to join her in sin, and she alone would have been banished from paradise. (Cf. Plate 16, a detail from *The Vanderbilt Hours*, which illustrates the conventional way of depicting the expulsion of our first parents. Plate 17, a magnificent image from *The Rohan Hours* [c. 1418?], manages to include all the stages of the creation of the world and the divine command to leave Eden within a single frame.) In which case God would probably have created a second Eve. Bonaventure makes the point succinctly: "the man would not have commingled with the woman any more (*amplius*), but God would have formed another new one for him"; consequently, "the sentence of damnation and the corruption of death would have remained in her," rather than having been passed on to anyone else. With this new wife, Adam and his progeny would have enjoyed "original justice," rather than suffering Original Sin.[252] This is possible because, to quote Aquinas's discussion, "the active causality in generation is from the father, the mother merely providing material. Therefore original sin is not contracted from the mother but from the

father."[253] Accordingly, had Eve alone sinned, their children would not have contracted Original Sin. But when Adam sinned, in effect he sentenced successive generations of fallen humanity to that affliction. Indeed, this would have happened if Adam alone had sinned, and Eve had stood fast.

Such reasoning was not lost on the creators of the subsequent *commendatio mulierum* genre, including Agrippa: "All of us have sinned in Adam, not in Eve, and we are infected with original sin not from our mother, who is a woman, but from our father, a man."[254] Which quite ignores the point that Adam's role in human history is therefore much more significant; man's transmission of Original Sin is at once a consequence and illustration of his superiority within the gender hierarchy. Eve was deemed dispensable in a way Adam was not; to the best of my knowledge, no schoolman envisaged the scenario of a steadfast Eve having had a new husband created for her, to replace the lapsed Adam.

Eve, then, was at once dispensable and the worse sinner. Woman's role in man's destruction was further emphasized in visual representations of the serpent which depicted a female face at the head of a snake's body, as in Plate 18, another illumination from *The Vanderbilt Hours* (fol. 5v). That Book of Hours was executed in the last quarter of the fifteenth century, but maiden-headed Eden serpents began to appear in manuscript illumination in the early thirteenth century. The *Speculum humanae salvationis* refers to a serpent which "bare a womans face" (320), and its iconographic program usually includes one or two corresponding images.[255] A rationalization of this bizarre construct is offered in Bonaventure's discussion of the question of whether the temptation through the serpent was fitting.[256] Had the tempter taken on a human form "he would have been more affable (*affabilior*)" and therefore more effective at his task, since "the act of speaking" properly appertains "to a human likeness";[257] Eve would have felt quite comfortable if faced with one. But God could not allow this. In order to warn Eve she was dealing with something extraordinary, He insisted that the devil should use the body of a serpent—"which, however, had the face of a virgin, just as Bede says."[258] Rather a confused divine strategy, it would seem.

The authority for Bonaventure's statement is also problematic. Such an idea cannot be found in any work of Bede that has come down to us; the prime source seems to be Peter Comestor's *Historia scholastica*, where Bede is cited as follows: "He [Lucifer] also chose a certain kind of serpent, as Bede says, which has the countenance of a virgin (*virgineum vultum*), because like favors like."[259] Bonaventure may be misreading this passage; J. K. Bonnell

has made the plausible suggestion that Comestor is attributing to Bede only the statement that that Lucifer "chose a certain kind of serpent," and not what follows, the reference to the *virgineum vultum*.[260] In any case, the origins of this half-woman, half-snake creature are obscure. Scholars have suggested the iconographic influence of sirens or sphinxes, the belief (as found in medieval natural science) that a certain type of serpent actually had a virgin's face, or even detected here the specter of Lilith, Adam's first wife according to a Jewish tradition (which may ultimately be Persian).[261]

But there is no doubt of the misogynistic import of the depiction,[262] as indicated by Comestor's remark that "like favors like," the meaning of which is brought out clearly in the Middle English translation: the serpent "went vnto the woman, vndrestondynge that she wolde rather inclyne to his entente thanne Adam bycause they were both lyke in shap of face."[263] So, then, the adoption of a woman's face by Lucifer was a deliberate strategy, a way of making himself more convincing and appealing (or "affable," to use Bonaventure's term) to Eve. She foolishly trusts what is most like herself. But the likeness goes beyond mere appearance. The face the devil adopts is that of the creature who will be condemned as most like him. To recall an excursus of Albert the Great's, "a woman is nothing but a devil fashioned into a human appearance," for "women are more mendacious and fragile, more diffident, more shameless, more deceptively eloquent." How appropriate, then, that at the Fall the face of the devil and the face of Eve should look so alike. Eve is distanced, yet again, from the *imago Dei*.

But if the first Eve bore a heavy responsibility for the Fall of humankind, the second Eve—the Virgin Mary—played a correspondingly major role in its redemption.[264] Thus Christine de Pizan commented,

> . . . if anyone would say that man was banished because of Lady Eve, I can
> tell you that he gained more through Mary than he lost through Eve when
> humanity was conjoined to the Godhead, which would never have taken place
> if Eve's misdeed had not occurred. Thus man and woman should be glad for
> this sin, through which such an honor has come about. For as low as human
> nature fell through this creature woman, was human nature lifted higher by
> this same creature.[265]

One can easily imagine the late medieval schoolmen balking at the amount of agency and credit Eve is given here. But they would not have denied the fundamental doctrine on which Christine has built this part of her city of

ladies. The later *commendationes mulierum* did not have to labor that particular point through quotation out of context or some other form of deft manipulation, for it was available, clearly and unequivocally, for their direct use.[266] Special pleading aside, woman's reinstatement as and in Mary could be regarded as an aspect of the *felix culpa*, a Fall which was fortunate inasmuch as it enabled God's love to be manifest in ways not otherwise possible or necessary, through Christ's death and resurrection, which opened the gates of heaven for all righteous souls, rendered possible access to a paradise even better than the *paradisus voluptatis* described so evocatively in Genesis.

The schoolmen came up with an abundance of reasons why the *patria*, the homeland of the blessed, took priority over Eden. Bonaventure made much of the argument that Adam saw God less clearly and perfectly there than He will be seen in the state of glory.[267] In the initial state of innocence God was seen *per speculum*, through a mirror—albeit a clean one, in contrast with the one we presently have, the glass through which we see darkly because it was obscured by the sin of the first man (cf. I Corinthians 13:12). In the state of glory, however, God will be seen face to face; neither veil nor obscurity will hinder our cognition. Just as the terrestrial paradise was precisely that, an earthly garden of delights which had more to do with earth than with heaven, so the knowledge possible in Eden was more akin to what we possess than to the far superior knowledge yet to come. Indeed, the immortality of glory is far superior to the immortality of innocence (as experienced by Adam), asserts Richard of Middleton.[268] Immortality in Eden was contingent on the natural virtue of Adam, and involved the possibility of dying as well as the possibility of not dying, just as it involved the possibility of sinning as well as the possibility of not sinning. In sharp contrast, in glory man can neither sin nor die.

To this all-surpassing paradise, the land beyond death and without death, we may now turn. Higher argument remains.

CHAPTER 3

Death and the Paradise Beyond

> Mortals are they who can
> experience death as death.
> Animals cannot do so.
> But animals cannot speak either.
> —Martin Heidegger[1]

What is death? In the happiness of Eden, Milton's Adam admits his ignorance. The Creator God who placed them in this "Heav'n on Earth"[2] requires from Eve and himself

> . . . no other service than to keep
> This one, this easie charge, of all the Trees
> In Paradise that beare delicious fruit
> So various, not to taste that onely Tree
> Of Knowledge, planted by the Tree of Life,
> So neer grows Death to Life; what ere Death is,
> Som dreadful thing no doubt; for well thou knowst
> God hath pronounc't it death to taste that Tree,
> The onely sign of our obedience left
> Among so many signes of power and rule
> Conferrd upon us, and Dominion giv'n
> Over all other Creatures that possesse
> Earth, Aire, and Sea. (*Paradise Lost*, IV, 420–32)[3]

Had the great schoolmen of the later Middle Ages been able to read that, they probably would have asked: how could Adam refer to death so vaguely

as "Som dreadful thing," why did he not know what it was? While it is quite true that human death was not possible until after the Fall, God had decided that animals—all the other creatures that possess earth, air, and sea—would die beforehand. So, Adam and Eve had ample opportunity to observe death, and realize just how severe a prohibition had been laid upon them. But maybe they had lived in paradise for too short a time to have witnessed such a sight? Whereupon the schoolmen might have moved into a learned discussion of the duration of our first parents' residence in Eden. How long was it before Adam and Eve fell? Immediately following the creation of Eve? Later? After seven hours?[4]

The admission of animal death into Eden raised another issue, of even graver import. It was a theological truism that death was the punishment for disobedience, and that without sin death would not have entered the world. But does this not imply that animals must have been immortal?[5] For the animals of Eden did not, could not, sin. So how could they possibly die? Here I have been following John Wyclif's formulation of the problem; now we may hear his answer.

The Death of the Animal

Beasts *would* have died in the state of innocence, Wyclif says. On the positive side, their lives in Eden would have been better than they are now, because they would have lived longer and, in the normal course of events, died without suffering. But their deaths would *not* have been as a result of punishment. For beasts lack what Wyclif calls the *potentia volitiva*, the capacity for voluntary action, which is the very basis of morality and hence of punishment. Not all *dolor* (this term covers both physical and mental pain, sorrow, or distress) is *pena* (a punishment), but only that which involves creatures who enjoy the freedom of the will—that is, only rational creatures; irrational animals lack that potency. *Pena* is appropriate to man alone—though the category must be extended to include all rational creatures and angels. Presumably here Wyclif is thinking of the way in which God punished the angels who rebelled against him, by casting out Lucifer and his fellow rebels. The difference between man and beast lies in man having an immortal spirit which constitutes his whole "personhood" (*personalitas* or "personhood"; only imperfectly rendered in English as "personality"). This is not so with a beast, the soul of which attaches to matter.[6] In accordance with this animating principle a beast has an appetite to live forever in its body; humans have

a comparable desire, but it goes far beyond the one found in beasts. What we might call an animal instinct toward self-preservation[7] is rather different from the human wish to live forever. And this desire makes death a veritable punishment for humankind.

The idea that death should not always be seen as a punishment had frequently been deployed by Wyclif's predecessors, as may be illustrated from a passage in Aquinas's *Summa theologiae*, where the question under debate is whether death is a penalty for our first parents' sin.[8] At Ecclesiastes 3:19 we read that "The death of man and of beasts is one: and the condition of them both is equal."[9] But in dumb animals, death is not a punishment of sin. Therefore, why should it be so in men? To which Aquinas responds by making a distinction between matter and form.[10] Man and the animals are alike with regard to "the common condition of their material"; they share "a body composed of contrary elements." But they are unalike with regard to form, for man's soul is immortal, whereas the souls of dumb animals are mortal. In short: in the case of beasts, death is not a punishment of sin, but in the case of men, it most certainly was and is. Just as "the rebellion of the flesh against the spirit is punishment for the sin of our first parents, so too are death and all bodily ills."[11] Thus a firm wedge is driven between the death of animals and the death of humans.

Others drove in that wedge with a difference. Bonaventure's affirmation of his conclusion that "irrational souls are from their first condition mortal," and therefore would have died even in paradise, leads him into rather esoteric territory.[12] For he launches an attack on the doctrine of metempsychosis, the belief that after death the souls currently residing in beasts can pass into the bodies of newly born humans, and likewise the souls of deceased humans can pass into the bodies of newly born beasts; thus souls "move around from body to body in accordance with what their sins deserve." "This was the position of certain philosophers and heretics," Bonaventure declares. No doubt he was thinking of Pythagoras, who was credited with ideas concerning the immortality, preexistence, and transmigration of souls, all of which were censured by Augustine.[13] More recent heretics, the Cathars (Christians with dualistic beliefs who were the victims of severe repression in Bonaventure's day), were also supposed to believe in the transmigration of souls,[14] and he may well have had them in mind. (It was common practice in *Sentences* commentaries and *summae* to cite and reprove ancient versions of heresies that were troubling the church in present-day manifestations, this being an aspect of the lofty distance from transient contemporary affairs that the

schoolmen sought to maintain. Besides, they preferred to seek out what they regarded as the roots of dangerous ideas, the better to eradicate them.) At any rate, the specific point that Bonaventure wants to make here is that such doctrine is "vile" and subversive of the dignity of man, since it puts humans and beasts on an equal footing. "Its inventors and defenders" must themselves be "bestial men," he adds (seizing the opportunity for a bit of trenchant moralizing), since they believe their own souls either were the souls of beasts or will be those of beasts in the future.

That vast issue having been dealt with, Bonaventure focuses on the relationship between humans and animals in Eden.[15] Granted that the souls of beasts are not immortal like those of men, can it nevertheless be said that they had the ability to live forever, and would have done so if the sin of Adam and Eve had not introduced death into the world—for animals as much as for humankind? This, he declares, is repugnant to reason. How could one possibly argue that, because a man sins, a sheep should be killed? In no way can a sheep share the culpability for the man's sin; neither can the man transfuse his sin into the sheep! The concomitant (which Bonaventure does not spell out) is that man's prelapsarian innocence was no guarantee of the immortality of Eden's sheep.

But how exactly were beasts supposed to die in paradise—from natural causes, or because they became the prey of others? Here the foundational text is the latter part of the first book of Genesis, where God (it has widely been supposed) declares that all animal and plant life was given for man's use. "Behold I have given you every herb bearing seed upon the earth, and all trees that have in themselves seed of their own kind, to be your meat: And to all beasts of the earth, and to every fowl of the air, and to all that move upon the earth, and wherein there is life, that they may have to feed upon. And it was so done" (Genesis 1:29–30). Here, arguably, God imposes vegetarianism on all His creatures—beasts, birds, and men. And that was how the passage was often read by medieval theologians. The discussion by Robert Grosseteste may be taken as representative. In his *Hexaëmeron* he writes that "the human being and all the animals of the earth would have lived only on seed-bearing plants and on fruits of the trees, all in common and all in harmony, if the human being had not sinned. No animal would have been an enemy of others, nor would have eaten the flesh of others; nor would the human being who was put over them."[16] Grosseteste explains the change between then and now on the grounds that "eating meat was not granted to nature in a state of health by the law of nature, but in virtue of weakness, as

a medicinal remedy," rendered necessary by the deterioration of bodies after the Fall.[17]

There seems to have been a general consensus that prelapsarian humans had (or would have) abstained from meat. But a large body of opinion held, against Grosseteste, that at least some of Eden's animals were the prey of others. In his *De Genesi ad litteram* Augustine said that that if humankind had not sinned, nevertheless some animals would have lived "from plunder" (i.e., by hunting), killing other animals to conserve their own lives.[18] St. Thomas Aquinas agreed. "Some say that animals which are now savage and kill other animals would have been tame in that state, and not only towards man but towards other animals too."[19] But this view, he believes, "is altogether unreasonable. For man's sin did not so change the nature of animals, that those whose nature it is now to eat the other animals, like lions and hawks, would then have lived on a vegetable diet."[20] Aquinas is convinced that then, as now, "clashes and antipathy would have been natural between certain animals." However, all animals alike would have been subjected to the dominion of man—working, of course, under the mastership of God, the *dominium Dei*. In the prelapsarian world, man would have been the executor of God's providential plan for animals—"as is even now the case clearly enough with domestic animals," for men give their trained falcons the flesh of chickens to eat.

Here, then, we see yet more consequences of the belief that man was, in Milton's phrase, "Dominion giv'n / Over all other Creatures that possesse / Earth, Aire, and Sea" (as quoted at the beginning of this chapter). Our second chapter has already explored some of the ways in which medieval schoolmen sought justification for man's claim of dominion over nature in Genesis 1:26, where God says, "Let us make man to our image and likeness; and let him have dominion over the fishes of the sea, and the fowls of the air, and the beasts, and the whole earth, and every creeping creature that moveth upon the earth." Quite typically, Wyclif cites this passage prominently in *De statu innocencie*, along with the divine injunction to "subdue" the earth and "rule over the fishes of the sea, and the fowls of the air, and all living creatures that move upon the earth" (v. 28), and the subsequent statement that man has been given every "herb bearing seed upon the earth, and all trees that have in themselves seed of their own kind" (v. 29). These passages were reiterated by generation after generation of commentators on Peter Lombard's *Sentences*. Within their worldview, this divine gift of dominion meant that man had the right, indeed had been mandated by the highest authority,

to use and order the lower types of creation as he pleased. And that included eating them. As Bonaventure put it rather bluntly, all brute animals were made for man's use, "but man's use is in feeding on them, and he feeds on them, when he kills them."[21] Thus they serve man not only through their lives, but also through their deaths. Here Bonaventure finds a proof for the proposition that "irrational souls are from their first condition mortal." If animals were immortal, if they possessed rational souls which rendered them immortal, we wouldn't be eating them.[22] But does humankind not owe animals something, for all the services rendered to them from the Fall through the Resurrection? No, says Aquinas: "Neither animals nor plants nor any other bodies merited anything by their services to man, since they lack free-will."[23]

These beliefs are underpinned by scholastic treatments of what would have happened to animal (and plant) life had Adam and Eve not fallen, and God's original plan for mankind been fulfilled. Which is explained by Wyclif as follows.[24] Had sin not come into the world, human bodies would have developed to become as the bodies of the blessed. When they had attained their full status, attained the number set by God, those superhumans would have been relocated to the Heavenly Jerusalem. This would have involved a process whereby the elements in human bodies became mixed in a stable, equal fashion (and, to adapt a phrase of John Donne's, whatever is mixed equally cannot die).[25] However, beasts could not be transferred to heaven to share beatitude with men and angels; they are incapable of this because they lack rational souls. Neither could beasts remain perpetually in the corruptible sphere. They had been created to serve humankind and, following the translation of all the (then-incorruptible) human bodies to heaven there would be no reason for the continued existence of animals on earth. It was not just a matter of their having been rendered redundant, following the departure of their masters. For the universe itself would then cease to support the beasts; the heavens would not rotate proportionally to enable their generation and production.

Here we must think in terms of the Aristotelian/Ptolemaic theory of the universe, which held that inside the lunar orbit lay the region of generation and corruption, where the four elements and the mixed bodies generated by their various combinations were subject to perpetual change. Wyclif's basic point is that the unequally mixed bodies of beasts and birds can live only within that region, incapable of being translated to the heavens, the region of perfection where no change is possible. More specifically, Wyclif is channeling doctrine which he and his fellow schoolmen had derived largely from

Aristotle, concerning the crucial relationship between the motions of the heavens and life on earth. Citing *De generatione*, Aquinas explains that "the movement of the heavens is for the sake of continual generation in this lower world." "The heavenly bodies serve man by their movement," he elaborates, inasmuch "as by the heavenly movement the human race is multiplied, and plants and animals which are needful for man's use are generated."[26] From this Aquinas and his fellow theologians drew the conclusion that, when heavenly movement ceases, generation in this lower world will cease also. Pace Aristotle, who believed in the eternity of the world and hence the continual generation of lower life forms, the world will end, the heavens will stand still, and all plant and animal life will die.[27]

That most popular of all Middle English poems, *The Prick of Conscience* (c. 1350), explains the matter with admirable clarity and economy.[28] Its anonymous author credits "clerkes" with the belief that, if the heavens

. . . moved noght, alle suld peryssch,	*perish*
Both man and beste, foghel and fyssch	*bird and fish*
And alle that under tham may be	
That lyfes and growes, both gresse and tre.	
All suld be smored withouten dout,	*destroyed (lit. "smothered")*
Warne tha hevens ay moved obout . . .	*unless*
Of thair moveyng than have yhe no wonder,	*don't be surprised*
For it noryssch alle that es thareunder . . .	*nourishes*
Thir hevens obout gase alle erthly thynges	*revolves around*
And tham norysches and forth brynges . . .	
(7594–599, 7606–17, 7610–11)[29]	

Such is the situation which Wyclif is envisaging in the passage from *De statu innocencie* under discussion. Had heavenly motion ceased when (in accord with God's first option for humankind) the perfected human bodies of our first parents and their progeny had left for a better place, "foghel and fyssch" and "gresse and tre" would "peryssch." And this is precisely what is scheduled to happen after the General Resurrection. At that time—or, rather, at the end of time—the sun, moon, stars, planets, and spheres will indeed stop moving ("Thy sun shall go down no more, and thy moon shall not decrease"; Isaiah 60:20).[30] With the same cataclysmic result.

It might even be said that human sin, far from being the cause of animal death (which was a feature of Eden anyway), actually granted the lower creatures a whole new lease of life, enabling them to flourish far longer than originally intended by God. But this is merely a reprieve. For there is no place set aside for animal (or plant) life in the paradise which is expected to follow the Last Judgment. As Thomas Aquinas says, the world will then be renewed, passing "from the state of corruption to incorruptibility and to a state of everlasting rest." Nothing which is corruptible can be part of that world; therefore "dumb animals, plants, and minerals, and all mixed bodies" must be excluded. Hence they will not remain following the renewal (*innovatio*) of the universe.[31] Scholastic statements such as this should not be taken as implying some causal connection between human afterlife and the extinction of animal life; the former does not necessitate the latter. Rather the death of the animal is (even more chillingly) a by-product, collateral damage one might say, of the ultimate happiness of some humans and the ultimate misery of others (those condemned to hell), a fact of existence which no amount of regret or compassion can mitigate.

"I saw a new heaven and a new earth. For the first heaven and the first earth was gone" (Apocalypse 21:1). Which means that plants and animals were gone. Indeed, there is no room for them, to judge by some of Bonaventure's comments. If all the animals that have ever lived and died were to be resurrected, he asked, where could they possibly go, how could they all possibly fit into the available space? The argument proceeds as follows. If the souls of animals were immortal, therefore their bodies would have to return following the Resurrection, as is the case with human beings. But, given that "an innumerable multitude of beasts and animals continuously succeed one another," this would be impossible, and quite repugnant to imagination (*imaginatio*). Bonaventure would have found this assertion by John Wesley at once incredible and shocking.

> The whole brute creation will, then, undoubtedly be restored, not only to the vigour, strength, and swiftness which they had at their creation, but to a far higher degree of each than they ever enjoyed. They will be restored, not only to that measure of understanding which they had in paradise, but to a degree of it as much higher than that, as the understanding of an elephant is beyond that of a worm. And whatever affections they had in the garden of God, will be restored with vast increase; being exalted and refined in a manner which we

ourselves are not now able to comprehend. The liberty they then had will be
completely restored, and they will be free in all their motions.[32]

Where could all those animals possibly go? Bonaventure would have asked.
How could they possibly find sufficient space in the post-resurrection para-
dise? He seems perturbed by the prospect of an overcrowded world beyond
death, with the glorified bodies of humans jostling for position with those of
that multitude of animals—congestion which would remain static forever
because it could never get better or worse.[33] An assertion of the mortality of
animals provides a quick solution.

Wesley's words also raise the problem of how the bodies of beasts would
have been reconstituted at the Resurrection, given that they had been assimi-
lated into the bodies of the humans who ate them. Late medieval theologians
(in contrast with many of their twelfth-century predecessors) believed that
the human body incorporated food, that food became flesh.[34] So, then, would
animals have risen as the creatures they once had been (in whatever "higher"
form may be envisaged), or within the bodies of the humans who had dined
on them? To the best of my knowledge no medieval theologian actually
addressed that specific issue, but there is a considerable body of writing by
way of response to an (arguably related) question which is raised in Peter
Lombard's *Sentences*: at the General Resurrection, what happens to human
bodies that have been eaten by animals, or indeed by other humans (i.e., by
cannibals)?[35] Following Augustine, the Lombard responds that "earthly mat-
ter" will always return to be united with the soul "which first animated it,"
no matter what "substance of other bodies" it may have changed into, no
matter what "food and flesh of beasts or even of men" it may have become,
in the interim.[36] His commentators elaborated upon those ideas with relish.
In one of his later works, the *Summa contra gentiles* (c. 1259–64), Thomas
Aquinas plays some particularly interesting variations on the common
theme.[37] Imagine two cannibals, one who has eaten human flesh and other
foods, and another who has eaten only human flesh. What happens then? In
the first case, only what came to the cannibal materially from the other food-
stuffs will rise in him, as having nourished his body and become his own
flesh and blood. The human flesh he ate will return to its original owner. (As
Augustine said, "it must be regarded as borrowed . . . by the person who ate
him, and, like a loan of money, it must be repaid.")[38] In the case of the
second cannibal, whatever he drew from his parents (through their seed)
will arise in him, and anything lacking "will be supplied by the Creator's

omnipotence."[39] As with Peter Lombard's (Augustinian) solution, the key point is that "the flesh consumed will rise in him in whom it was first perfected by the rational soul." Which is bad news for any defense of animal resurrection. Animals have only "animal" souls (i.e., motive sources which keep them "animated," living, and moving), but lack rational souls. And rational souls are essential for resurrection.

In any case, there is no role for animals and plants to play in the paradise beyond death. Their *utilitas* will have expired, the fundamental services they once performed for man will no longer be needed. Currently man sees the invisible things of God by the things that are made, as Romans 1:20 attests: "the invisible things of him from the creation of the world are clearly seen, being understood by the things that are made."[40] Here was a very good reason for the numbers and variety of animals in Eden. But glorified man will receive such knowledge from God through his soul. Neither will he need to eat animals or plants. In Eden, humankind had bodies which required nurture (and, following the Fall, humankind's diet broadened to include meat), but, as Aquinas puts it, "after the Resurrection, . . . [humankind] will have a spiritual life that requires no food."[41] Here I quote from his *Summa theologiae*; in his earlier *Sentences* commentary Aquinas had raised the objection that, following his resurrection,[42] Christ is said to have eaten with his disciples (cf. Luke 24:30, 35, 41–43 and John 21:13). Since the behavior of Christ's resurrected body was taken as offering firm evidence about what the renewed bodies we shall receive at the Last Judgment will be like, this question had wide consequence.[43] Aquinas explains that Christ ate not out of necessity (His body no longer needed food) but to affirm that He retained the true human nature which He had in the days when He ate and drank with His disciples as a matter of course.[44] This action was a sort of special dispensation (as lawyers use that term, Aquinas explains), an exception to the general rule that the resurrected body does not partake of food.

In addressing the same issue, Albert the Great develops a distinction (which he had found in Augustine) between power (*potestas*) and need or craving (*indigentia*).[45] When water is absorbed by the thirsting earth, this is a matter of necessity (since the earth needs that moisture to thrive), but when it is absorbed by the sun's glowing beams, this is a matter of power. Christ did not need to restore any bodily lack, such a need not being part of true human nature. Rather he showed that he had the power of eating. Instead of being converted into nutriment the food became subtle airy material: clearly Albert has in mind that beautiful Augustinian metaphor

of the sun's absorption of moisture. Aquinas supposed that Christ's food "was not changed into flesh but returned to the prior material state," but does not go into the issue of what that reconstitution might have looked like.[46] The comparison with those occasions on which angels visited the earth and ate with men[47] was sometimes made.[48] Angels had no need of the foodstuffs described in the relevant Scriptural passages, for they did not have to eat to sustain their lives. They ate in order to be sociable, sharing the food that was essential for human life but not for theirs. In the *patria*, however, even though the human body will retain its ability to eat (this being a matter of power, as described above), it will not need to do so.[49] And in that place there will be no one who needs food to live, no lesser being to be sociable with.

As food sources, animals and plants are therefore dispensable. But what about the social comfort and pleasure they provide? Would human beings not miss their presence, in that renewed world where perfect happiness is supposed to abound? Aquinas poses that very issue in the following terms. Obviously with the account of creation at Genesis 1:11–25 in mind, he asks, are not those life forms *ad ornatum elementarum*, do they not "adorn the elements"—that is, show off to best advantage the beauty of the four foundational components of all created things, namely earth, air, fire, and water? And would it not be a great loss if they ceased to do so? The answer to the first of these questions is (obviously) in the affirmative. But not to the second, because the present-day adornment provided by plants and animals applies only to the conditions appertaining currently in the elements. Given that those conditions will not prevail following the renewal of the world, "there is no need for animals or plants to remain."[50] The blessed will have other sources of comfort and pleasure.

The myriad and wonderful beauties of nature could, of course, be celebrated in the warmest of terms by theologians, an excellent example being this passage from Augustine's *De civitate Dei*:

What discourse can adequately describe the beauty (*pulchritudo*) and utility (*utilitas*) of the rest of creation, which the divine bounty has bestowed upon man to behold and consume (*spectanda atque sumenda*), even though he has been condemned and cast forth into the labours and miseries of our present condition? Consider the manifold and varied beauty of sky and earth and sea; the plenteousness of light and its wondrous quality, in the sun, moon and stars and in the shadows of the forests; the colour and fragrance of flowers; the

diversity and multitude of the birds, with their songs and bright colours; the multiform species of living creatures of all kinds, even the smallest of which we behold with the greatest wonder—for we are more astonished at the feats of tiny ants and bees than we are at the immense bodies of the whales.[51]

However, the juxtaposition of *utilitas* with *pulchritudo*, of *sumenda* with *spectanda*, signals the wider context and ultimate significance of these remarks, which Augustine proceeds to make abundantly clear. If all "these things are only the solace of the wretched and condemned" and "not the rewards of the blessed," how much greater will those future rewards be? The mind boggles. Augustine wants it to. "What will God give to those whom He has predestined to life, if He has given all these things even to those predestined to death? What good things will He bestow in that future life of happiness upon those for whom in this life of misery He willed that His only begotten son should undergo such great evils, even unto death?"[52] His fundamental concern is not with the paradisal aspects of the present earth but with the final homeland and all the "good things" which God has in store there for His chosen ones. Augustine has positioned the paradisal aspects of the present earth as the lesser element in a comparison which aggrandizes a world which is better and beyond. Here, then, lies the true *utilitas* of creation. It is man's to learn from, to consume, and to transcend—which ultimately involves leaving it far behind. And Augustine's late medieval successors would have said, following the standard anthropocentric line: it is not that we are denigrating or despising the plants and animals which serve us nowadays in so many ways, including providing us with a measure of pleasure. The point is rather that, in the future paradise, the sources of pleasure will be greater, our senses will be heightened so as to experience them better; everything will be brighter and immeasurably more beautiful.

In sum, we are losing nothing, but gaining much. I will now substantiate that argument as best I can, acutely aware of its burdensome and irresolvable difficulties. The paradise beyond death can all too easily seem a "sterile" place, devoid of natural beauty and animal color, wherein "an autonomous and lonely humanity" spends its exclusive eternity, experiencing an afterlife which can hardly be counted as life.[53] Yet for many centuries it has constituted a prime object of spiritual desire and aspiration, channeled the most intense of loves and the deepest of fears, motivated human endeavor of the greatest magnitude (with very mixed results), justified man's inhumanity to man (and to animal) together with his transcendence of the merely human.

The following pages will seek to convey something of the complexity, sublimity—and irreducible materiality—of the final homeland.

The Body Returns

"The Resurrection will take place 'in the twinkling of an eye,' and . . . the dust of bodies long dead will return, with an ease and swiftness that we cannot understand, to members which are thereafter to live a life without end."[54] Thus Augustine, drawing on I Corinthians 15:52.[55] The doctrine of the Resurrection of the Body has been maintained by the Christian Church for centuries, in opposition to those who, like the Neoplatonic philosopher Porphyry of Tyre (d. c. 305), held that "The soul, if it is to be blessed, must avoid contact with every kind of body."[56] It is also resolutely anti-Manichaean, rejecting the opinion of "those heretics" who "asserted that all bodily things are from the evil principle, but that spiritual things are from the good principle: and from this it follows that the soul cannot reach the height of its perfection unless it be separated from the body" (to quote St. Thomas on the subject).[57] The orthodox opinion was that the soul could achieve the complete happiness associated with the final paradise only if it were reunited with its own body, that specific materiality with which it had lived and worked during its time on the old earth. No other body will do—Bonaventure compares the situation wherein a man desires his beloved woman and no other.[58] But that body would be renewed, perfected—a much improved version. Hence it would rise "of a youthful age," just as Christ rose again of youthful age, which—according to Augustine—begins around the age of thirty years.[59] Having quoted this statement by Augustine, Peter Lombard adds, "the age of Christ at his death and resurrection was thirty-two years and three months."[60] No matter if an individual had died as a baby or in extreme old age, his or her body would resurrect as it would have looked, or as it once had looked, at that "perfect age," the point at which (to follow Aquinas again) "the movement of growth terminates, and from which the movement of decrease [through debilitating aging] begins."[61]

All resurrected bodies (of both the blessed and the damned) will regain their *integritas*—rematerialize completely,[62] no part being left behind—while retaining their "numerical oneness"[63] or *integritas*. This involves the preservation of their distinguishing characteristics. They will not rise looking exactly alike, identical in "stature" or "quantity." Thus, to offer a few instances by

way of explanation, if someone was short in his old life, he will not be taller in the new; if someone had particular facial features, he will retain them. (To be more exact, he or she will have the same distinct appearance that he had, or would have had, at the "perfect age" of man's life). The blessed will recognize each other as distinct, and certainly not all look the same. John Wyclif's personification Phronesis—who in the *Trialogus* (1382) represents wisdom in the sense of "subtle and mature theology"—had "no doubt that many fat and large people carry large amounts of matter in this life, [which] they will have after resurrection in paradise."[64] Here he was contradicting Otto, Bishop of Freising (d. 1158), who believed that neither the fat will retain their "superabundance" of flesh nor the thin will retain their "lack" of flesh.[65] Augustine had allowed the possibility that the resurrected male body could be bearded, in this case citing manly beauty rather than utility—a justification which was harder, if not impossible, to apply in the case of obesity.[66]

There was widespread agreement, however, that any physical defects such as marks or malformations caused by disease will be eliminated.[67] St. Thomas sums up the point nicely:

> At the Resurrection human nature will be restored not only in the self-same species but also in the selfsame individual (*ad idem numero*), and consequently we must observe in the Resurrection what is requisite not only to the nature of the species but also to the nature of the individual.[68] . . . Therefore all will not rise again of the same quantity, but each one will rise again of that quantity which would have been his at the end of his growth if nature had not erred or failed: and the Divine power will subtract or supply what was excessive or lacking in man.[69]

As does the author of the Middle English *Prick of Conscience*, in demotic yet doctrinally precise language. All men shall then rise up "In the same stature and the same bodyse" as they had here in the days of their life (4979–82), and

. . . if any lyms be here unsemly	*unattractive/ugly*
Thurgh outragiouste of kynd namely,	*natural aberration*
God sal abate that outrage thurgh myght	*through his power*
And make tha lyms semely to sight.	*limbs beautiful to look upon*
And if any lym wanted, that shuld falle	*was lacking, belong*
Til the body, or any war over-smalle,	*be too small*

Thurgh the defaut here of kynd God than wille	*due to a natural fault*
All the defautes of the lyms fulfille,	*faults, limbs, rectify*
And thus sal he do namly to alle tha	*specifically to all those*
That [sal] be save and til blis ga.	*saved and go into bliss/paradise*
(5009–18)	

"Defautes of lyms" covered a wide range of human lacks and fragmenta-
tions, extending to abortions and monstrous births. Dead babies who have
been "cut out limb by limb" lest "their mothers should die too" cannot be
"denied a part in the Resurrection." Here I am quoting from Peter Lombard,
who was quoting from Augustine.[70] But the schoolmen went even further, in
affirming that where there was life there was death and hence resurrection.
As far as monsters are concerned, no matter how brief their lives may have
been, they too will have their share in the Resurrection, duly restored to "the
normal human form."[71] A "defaut" of a quite different kind is identified by
Otto of Freising.[72] Resurrected Ethiopians cannot be brought back "in an
affliction of color so disagreeable," he opines, adding black skin color to the
list of "blemishes and spots" from which humankind will be freed in the
state of glory. Otto enlists a passage from *De civitate Dei* in support of his
view. "All bodily beauty consists in the suitable arrangement of the parts,
together with a certain pleasantness of colour (*coloris suavitas*)," Augustine
had said, going on to enthuse about how great that pleasantness will be where
"the just shall shine forth as the sun in the kingdom of their father" (Mat-
thew 13:43).[73] There is nothing about Ethiopians here; Otto has decided that
whiteness of skin is necessary for the resurrected body's beautiful brightness.

In accordance with the principle that the "selfsame individual" shall be
"renewed" as the best possible version of that self, it was believed that men
will resurrect as men and women as women.

Alle men sal ryse than that ever had life,	*arise that were ever alive*
Man and woman, mayden and wyfe,	
Gude and ille, with fleshe and felle,	*skin*
In body and saul, als clerkes can telle . . .	
(*The Prick of Conscience*, 4965–68)	

This was not regarded as self-evident, given that men's bodies were generally
regarded as superior to women's; hence the question had been raised if all
the progeny of Adam and Eve would/should have been male (cf. pp. 47–48

above). But Augustine was adamant that "both sexes are to rise," with woman taking on "a new beauty," which "will move us to praise the wisdom and clemency of God."[74] And the schoolmen concurred. "Considering the nature of the individual, a different sex is due to different humans," explained Aquinas, "even as different statures are due." Here is another example of that rich diversity (*diversitas*) which "is becoming to the perfection of the species."[75]

Fortunately, gender *diversitas* will pose no problems in paradise because desire has gone forever, human reproduction has ceased (the number of the blessed being fixed forever), and sexual intercourse is as redundant as eating. Blessed bodies in their naked splendor will feel no "shame (*confusio*) in seeing one another, since there will no lust to invite them to shameful deeds which are the cause of shame."[76] Shame did not exist in the first paradise either, even though at that time intercourse was a divine commandment ("Be fruitful and multiply"), and—at least according to some theologians—some degree of desire (the intensity being a matter of debate) accompanied the act of intercourse.[77] But those conditions are hypothetical ones; they *would* have prevailed, had Adam and Eve not sinned so quickly. The conditions envisaged for the renewed world were hypothetical also, though for quite different reasons—not because they could have prevailed but did not, but rather because they have not prevailed yet but will. (Here the difference between "would/could" and "will" is utterly crucial.) The blessed will not engage in eating and sexual activity. Does this mean that they will be deprived of "the pleasure which there is in these acts," in a place where no pleasure is supposed to be lacking?[78] Such "bodily pleasures" will not be missed, opines Aquinas, since "the beatitude and felicity of man do not consist" in them. More lofty delights will be available there—"the pleasures in the vision of God," which we shall share with the angels.[79] By this argument, Aquinas adds, "one avoids the error of the Jews and of the Saracens, who hold that in the Resurrection men will have use for food and sexual pleasure as they do now."[80] Thus he seeks to distance his intellectual tradition from the one adumbrated by late medieval fantasies of a Muslim heaven which offered every form of "sensual gratification . . . in the society of beautiful nymphs," four score of whom would be available—their virginity perpetually renewed—to pleasure every man (according to Marco Polo and "Sir John Mandeville," respectively).[81]

Given that no corporeal multiplication will be required of the blessed, do they really need their genitalia? What is the point of them being part of the resurrected body; couldn't they just be left as dust and ashes? Aquinas poses the problem thus.[82] If the end be done away with, what is the point of

repairing the means? If a certain member is unable to act, and thereby cannot achieve its end, what is the use in keeping it, given that "nothing useless is done in the Divine works"? We read at Matthew 22:30 that, following the Resurrection, humans "shall neither marry, nor be married." The "use of certain members is not fitting to man after the Resurrection," especially those ones, so why preserve them? To which Aquinas offers the somewhat opaque reply:

> . . . it does not follow that when the operation fails the instrument is useless, because an instrument serves not only to accomplish the operation of the agent, but also to show its virtue [*virtus* in the sense of "potency," "force"]. Hence it will be appropriate for the virtue of the soul's powers to be shown in their bodily instruments, even though they never proceed to action, so that the wisdom of God be thereby commended.[83]

In other words, the human genitalia manifest the wisdom of the divine plan in the creation of mankind, and all that his body and soul required, whether or not they become surplus to requirements in God's final version of the paradise fit for select humans. Besides, it may be added that other parts of our present-day bodies will be retained in our risen bodies, such as the digestive system, even though it will have nothing to digest. No doubt the same justification applies. Defecation and urination will not be necessary any more, even though those actions were performed (albeit decorously) in Eden.[84] It seems that the entrails "will rise again in the body even as the other members," but they will be filled not with vile superfluities but with noble types of moisture.[85]

Which brings us (once again) to sperm. That will not be retained in the resurrected body, Aquinas *cum suis* insist,[86] because it is required "only for the perfection of the species" rather than for "the perfection of the individual"; that is, it is necessary for the propagation of the species, and when human reproduction becomes redundant, so too does this means of effecting it. In contrast, human hair and nails *are* required for "the perfection of the individual"—but only, Aquinas goes on to argue, in respect of the body's "secondary perfection" (*de secunda perfectione corporis humani*). His reasoning here brings forth an engaging metaphor. Art (in the sense of a craft, skill, or discipline) employs "certain instruments for the accomplishment of what is intended, and these instruments belong to the primary intention of art (*de prima intentione artis*). It also uses other instruments for the conservation of

the principal instruments, and these belong to the secondary intention of art." For example, in the art of warfare a sword is employed for fighting, and a sheath for the safekeeping of the sword; the former relates to that art's primary intention, the latter to its secondary. Likewise with the parts of the human body. Some are directed to accomplishing the operations of the soul (here likened to art), such as the heart, liver, hand, and foot. Others "are directed to the safe-keeping of the other parts"—just as leaves cover fruit protectively. "Hair and nails are in man for the protection of other parts." Therefore, "although they do not belong to the primary perfection of the human body, they belong to the secondary perfection: and since man will rise again in all the perfection of his nature, it follows that hair and nails will rise again in him."

But what about all those hair and nail clippings that a person dispenses with during his or her lifetime; will they rush en masse to become part of the resurrecting body? What a grotesque figure would result! To combat any such suggestion Augustine came up with the analogy of an artist restoring a statue, making use of its original material.[87] Matter which once occupied one location may well end up in another; "a change in the position of the parts of matter does not cause a change of identity (*in numero*)," to quote Aquinas's gloss on Peter Lombard's citation of the relevant passage.[88] So, then, it is unimportant whether hairs return to hairs or nails to nails. The point is that the original matter has been used, with a surfeit in one area compensating for a lack in another. God the "true Creator" (as Augustine called Him)[89] will ensure that nothing unseemly results. Aquinas seems a little uncomfortable with this creative carte blanche, for he introduces an earnest distinction between "essential" body parts and "accidental" ones.[90] It seems likely that the essential, major body parts will resume their previous locations, whereas the matter which once constituted the accidental ones (hair and nails) may perhaps have that flexibility of use which Augustine suggested. Aquinas seems to believe that, in terms of "congruity," this is a more probable way to discuss the resurrected body.

And what a body it will be! A creation possessing in abundance four wonderful *dotes* ("gifts"; rendered as "dowers" and "blisses" in Middle English): *impassibilitas*, *subtilitas*, *agilitas*, and *claritas*.[91] By "impassibility" is meant invulnerability—exemption from pain, suffering, sickness, decay, and death. A fifteenth-century translation of Guillaume de Deguileville's *Pèlerinage de l'âme* goes so far as to claim that, thanks to this "dower," bodies are rendered "so myghti that alle the peynes and tormentes that may be devised . . . in

erthe or in helle ne may no thing anoye them."[92] (Not that there will be any actual torments in the final paradise, of course. However, the denizens of hell will retain the capacity to suffer.) *Subtilitas* denotes extreme rarefaction, a gift enjoyed by the glorified body to the extent that it can occupy the same space as that occupied by a nonglorified body.[93] Or, as *The Myrour of Lewed Men* (c. 1350–1400) prefers to emphasize,

> . . . hit sal be so clensid of all rudnes *grossness*
> That non erthly body may lette hit to passe, *hinder its movement*
> More then the sunne-beme is lettid be the glas. (1136–38)[94]

Agilitas refers to the astonishing speed with which the blessed body can move; to draw on the language of a Wycliffite sermon, "agilite" is "swiftnesse" of the body and the power "to moven hou a man wole"—that is, to move as fast as a man desires.[95] Thus the German beguine Mechthild of Magdeburg (d. c. 1282/94) can speak of resurrected bodies, "agile, strong, and filled with love," traveling "about wherever they want as swiftly over a thousand leagues as here [in this present world] one forms a thought. Just think what such movement is like!"[96] Regarding how all of this may be rationalized, "opinion is much divided," as Aquinas put it.[97] Such agility could be instantaneous, at the speed of light, according to the *Summa theologica* associated with Alexander of Hales[98] (where the speed with which Christ could cross a body of water, or ascend to heaven, is solemnly investigated).[99] But Aquinas, aware of important passages in Aristotle's *Physics*, regarded that as impossible, while affirming that the glorified body "is prompt and apt to obey" the soul in any sudden movement which it may require.[100] Thus the bodies of the blessed "shall run to and fro like sparks among the reeds" (Wisdom 3:7).[101]

　　Claritas "establishes all the other properties of glorified bodies," the *Summa Alexandri* explains; it is the leading gift, with the other three as its corollaries.[102] Therefore "clarity" tends to receive more discussion than any of the others. "The just shall shine as the sun in the kingdom of their Father" (Matthew 13:43). This passage, together with Wisdom 3:7, was typically interpreted as describing the clarity of the glorified body, as, for example, by Aquinas, who further likens the glory of the rising bodies to the *claritas* of the stars (invoking I Corinthians 15:41).[103] The saints' bodies will be glorified by the addition of a radiant brightness, so that they become "lightsome" (*lucida*).[104] This is achieved "from the overflow (*redundantia*) of the soul's glory into the body."[105]

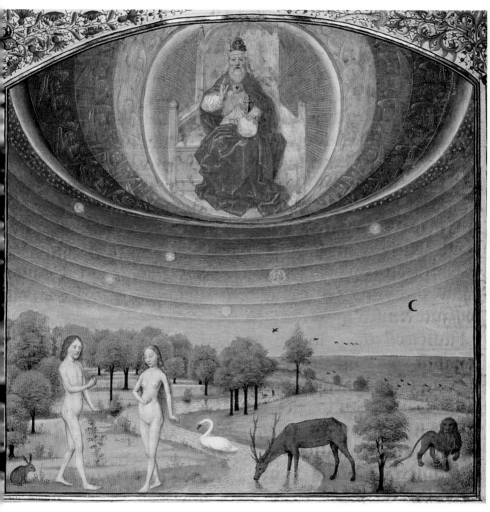

Plate 1. *Le Livre des
sept ages du monde.*
Eden. Brussels,
Bibliothèque royale de
Belgique, MS 9047,
fol. 1v. By Simon
Marmion.

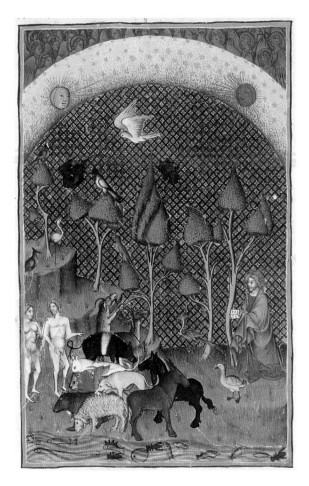

Plate 2. Nicholas of Lyre, *Postils on Genesis*. Eden's animals. Paris, Bibliothèque nationale de France, MS Lat. 364, fol. 4r.

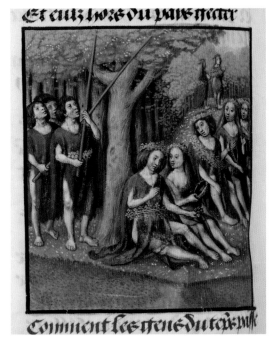

Plate 3. *Le Roman de la Rose*. The Golden Age. London, British Library, MS Harley 4425, fol. 75v. © The British Library Board.

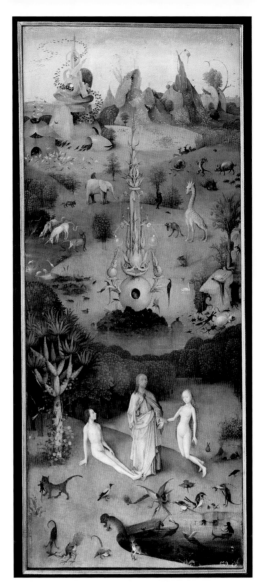

Plate 4a. Hieronymus Bosch, *Garden of Earthly Delights*. The left (Eden) panel. © Madrid, Museo Nacional del Prado.

Plate 4b. Detail from the Eden panel. Death in paradise.

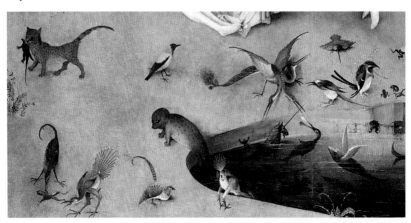

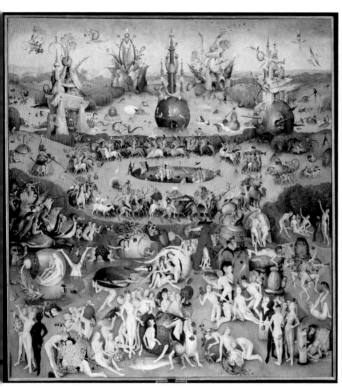

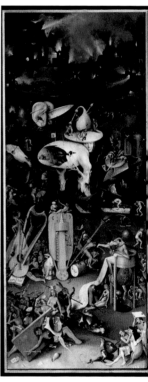

Plate 4c–d. Bosch,
*Garden of Earthly
Delights.*
The central panel.
Paradise prolonged,
or the decadent world
before the flood?
The right panel.
Lechery and its
punishment in the
afterlife.

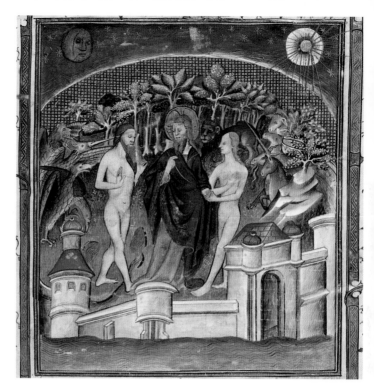

Plate 5. Paulus Orosius, *Histoire ancienne*. The marriage of Adam and Eve. London, British Library, MS Egerton 912, fol. 10r. © The British Library Board.

Plate 6. *Bestiary (The Ashmole Bestiary).* The creation of Eve. The Bodleian Libraries, The University of Oxford, MS Ashmole 1511, fol. 7r.

Plate 7. *Speculum humanae salvationis*. God re-works Adam's rib. Yale University, Beinecke Rare Book and Manuscript Library, MS 27, fol. 7v.

Et a costa uni dor
mientis plicata.
Deus quodammodo ipsam
lipsa lumen louauit.
Quia eam in loco no
luptatis plasmauit.
Non fecit eam sicut in
uiru de limo terre.
Set de osse nobilis
uiri + de eius carne.
Non est facta de pe-
de a uiro despiceretur.
Nec de capite ne su
pra uiru dominaretur.
facta est autem de la
tere maritali.
Et data est uiro pro consorte + soma collaterali.

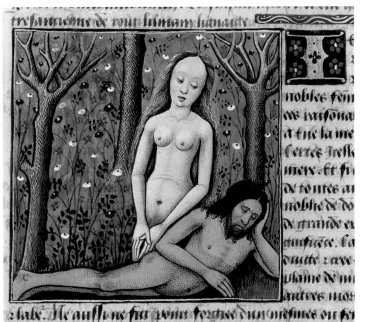

Plate 8. *Des Dames de renom* (a French translation of Boccaccio, *De mulieribus claris*). The creation of Eve, with God out of the picture. Paris, Bibliothèque nationale de France, MS fr. 599, fol. 4v. By Robinet Testard.

Plate 9. *Mandeville's Travels*. The innocent pleasures of Eden. Bibliothèque nationale de France, MS fr. 2810, fol. 221r.

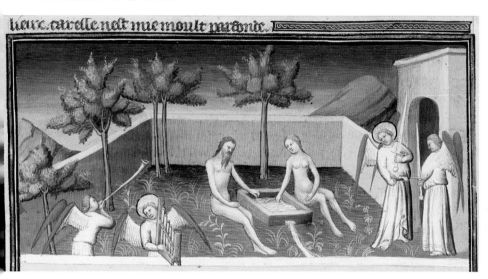

Plate 10. Marco Polo, *Le divisament dou monde.* A paradise of fleshly delights. BnF fr. 2810, fol. 16v.

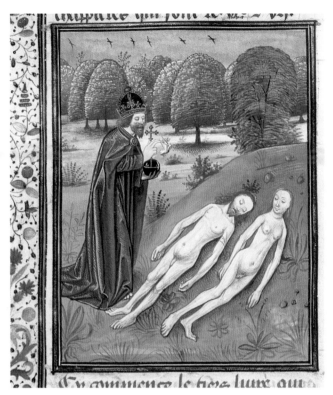

Plate 11. Jean Corbichon, translation of Bartholomew the Englishman, *De proprietatibus rerum*. The animation of Adam and Eve. Paris, Bibliothèque nationale de France, MS fr. 134, fol. 22v.

Plate 12. *Mandeville's Travels*. The rivers of Eden. Bibliothèque nationale de France, MS fr. 2810, fol. 222r.

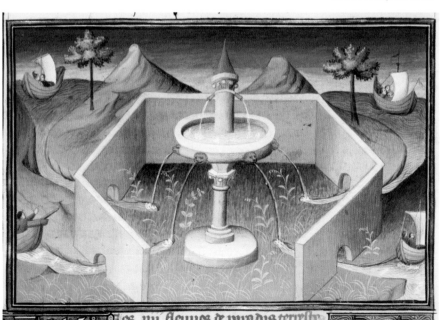

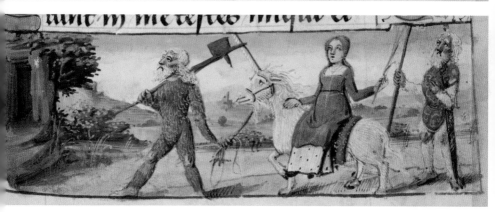

Plates 13a–c. *The Vanderbilt Hours.* Exotic encounters with wild things. Yale University, Beinecke Rare Book and Manuscript Library, MS 436, fols. 16v–17r, 74v–75, and 86r.

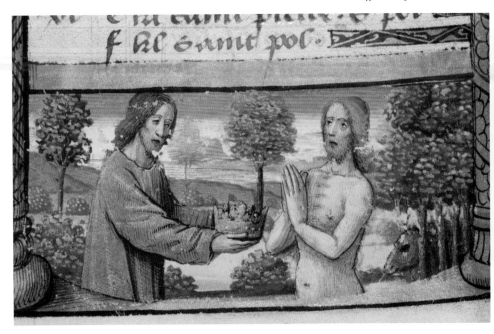

Plate 14. Adam as king of the world. Beinecke MS 436, fol. 3v.

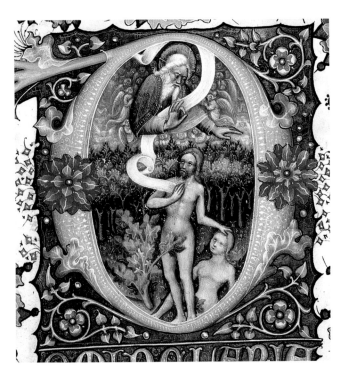

Plate 15. *The Visconti Hours.* Man's dominion over woman. Florence, Biblioteca nazionale centrale, MS Landau Finaly 22, fol. 57v.

Plate 16. The expulsion from Eden. Beinecke MS 436, fol. 6v.

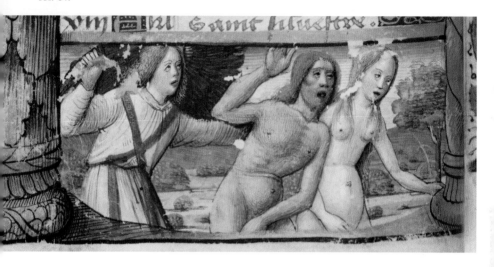

Plate 17. *Heures à l'usage de Paris (The Rohan Hours).* The creation of the world, and the command to leave Eden. Paris, Bibliothèque nationale de France, MS Lat. 9471, fol. 7v.

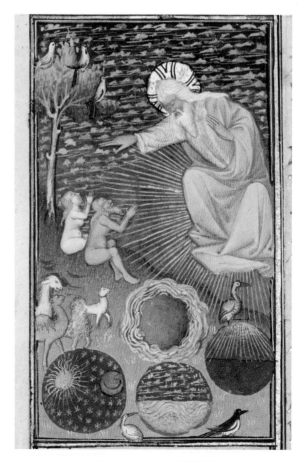

Plate 18. The serpent-woman. Beinecke MS 436, fol. 5v.

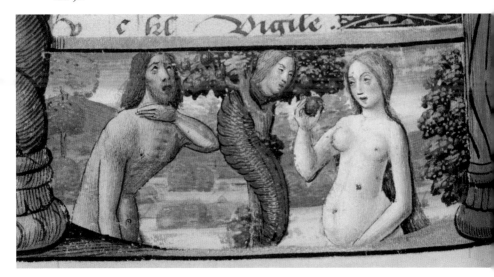

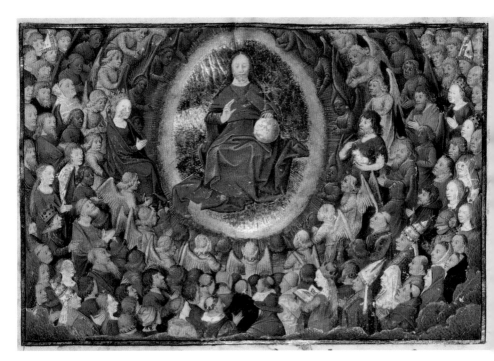

Plate 19. Dante, *The Comedy*. The heavenly host, with the humans displaying distinguishing characteristics. Paris, Bibliothèque nationale de France, MS Italien 72, fol. 60r. By the Coëtivy Master.

Plate 20. *Pearl.* The narrator encounters his dead daughter, now fully mature. London, British Library, MS Cotton Nero A 10, fol. 42r. © The British Library Board.

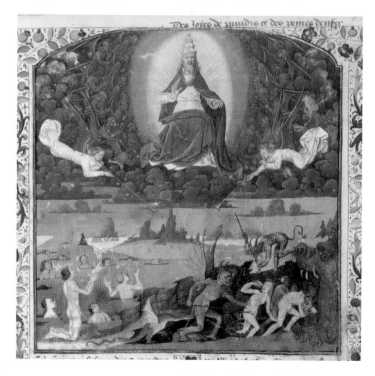

Plate 21. *Theological Treatises. The Last Judgment.* Bibliothèque nationale de France, MS fr. 9608, fol. 88r. By the Master of the *Très Petites Heures d'Anne de Bretagne.*

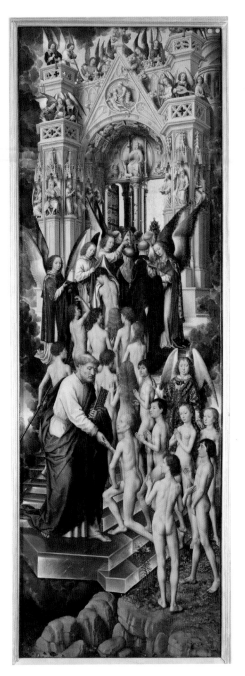

Plate 22a. Hans Memling, *The Last Judgment Triptych*. The left panel. Blessed souls enter heaven, and are clothed in garments of grace. © Muzeum Narodowe, Gdansk, Poland.

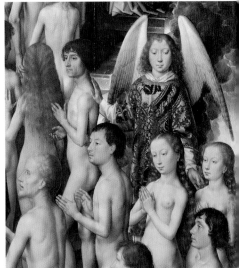

Plate 22b. Detail from *The Last Judgment Triptych*, left panel.

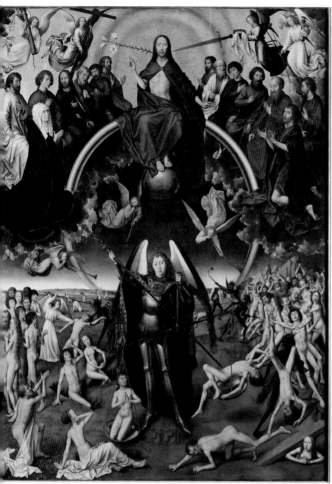
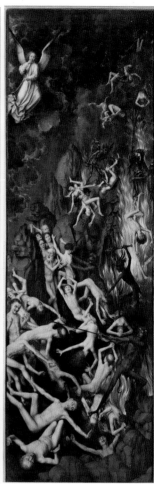

Plate 22c–d.
Memling, *The Last
Judgment Triptych.*
Central panel.
Doomsday: the
Archangel Michael
weighs the resurrected
humans.
Right panel. The
naked damned are
dispatched to suffer
in Hell.

Plate 23. *Le livre des merveilles du monde.* Enoch and Elijah live in an angel-filled Eden. Paris, Bibliothèque nationale de France, MS fr. 1378, fol. 32r.

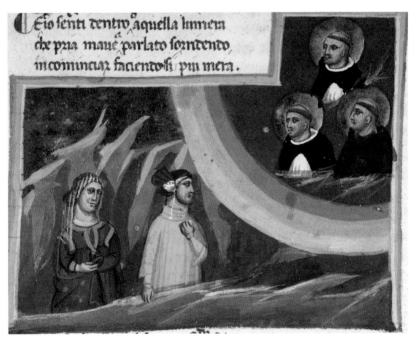

Plate 24. Dante, *The Comedy.* Dante and Beatrice with saints Dominic, Thomas Aquinas, and Francis. London, British Library, MS Egerton 943, fol. 146r. © The British Library Board.

But the glorified body, in all its wondrous *claritas*, will not obscure the glory of the soul in any way. In driving home this point, Aquinas employs a metaphor which does not quite work—or, at least, requires some exegesis. The glorified soul, he says, will be known through the glorified body, just as "through a crystal is known the color of a body contained in a crystal vessel (*in vase vitreo*)."[106] Here Aquinas is adapting a gloss from Gregory the Great's *Moralia in Job* on Job 28:17, "Gold or crystal cannot equal it" (the "it" being wisdom; cf. Job 28:12 and 20).[107] The point that an attractive exterior should not hinder one's awareness of the far more important interior is clear enough. And there is no real possibility of this occurring here, because just as "that which is enclosed in crystal is visible, so the glory of the soul enclosed in the glorified body will not be hidden." However, when Aquinas implicates a "body contained in a crystal vessel," presumably he has in mind the body, or the body part, of some saint as enshrined in a precious reliquary. It may seem somewhat strange to have the immaterial human soul likened to a corruptible (and probably corrupting) piece of matter; however holy such a relic may be, it would not normally be thought of as a major light source in competition with its light-refracting surroundings.[108] At least, not in its present earthly form. But, of course, the beautiful reliquary anticipates the future beauty of its contents when those same contents join with other limbs to constitute a brilliantly shining resurrection body. Besides, Aquinas's metaphor does make more sense if it is recalled that (in the words of Michael Camille) "new ways of displaying relics in transparent crystal or glass reliquaries" became standard in the thirteenth century. "The most sacred objects in the culture—the base matter of bones and blood"—were elevated "not by encrusting them with gold and hiding them within opaque layers, as had been the case previously, but by making them visible through the refractive layers of crystal or glass."[109] "The most sacred objects in the culture" may indeed be a fit comparator for the human soul.[110]

At any rate, Aquinas is more obviously successful in making the point (in this same *quaestio*) that "the glory of the body will not destroy nature but will perfect it" (*corporis gloria naturam non tollit, sed perficit*).[111] The problem (to continue the abovementioned metaphor for a little longer) is not so much that of some precious container threatening to obscure the value of its infinitely more precious contents, as of the precious contents threatening to radically revalue their precious container, to the extent that its original nature is eradicated. Aquinas is keen to dismiss any such implication. Whatever colors a human body may possess in nature (at around thirty-two years of

age, we may recall) will be retained, but it will experience a "superaddition" of *claritas* from the soul's glory—an act of enrichment rather than of destruction. Aquinas compares this with the way in which a present-day body, with its own natural colors, can be set "aglow" by the rays of the sun shining on it, or by some other source of additional light. Altogether a clearer metaphor. As is one offered by Mechthild of Magdeburg, whose visions of heaven often anticipate the time when saintly souls will be reunited with their glorified bodies, when she spoke of how the "godly flame of the soul" will shine through the resurrected body "as radiant gold shines through pure crystal."[112]

Those glorious souls in glorious bodies will, quite appropriately, exist in a glorious environment. As a rather feisty debating point has it, "the world was made to be man's dwelling," and when "man will be renewed therefore the world will be likewise."[113] Not only the elements (of earth, water, air, and fire) which compose men's bodies,[114] but also those which combine in other created things, will become much brighter than they are now. "The bodies of the blessed" will be "seven times" brighter than the sun, affirms St. Thomas; in its turn "the light of the sun shall be sevenfold," while "the light of the moon shall be as the light of the sun" (cf. Isaiah 30:26).[115] Here is a veritable hierarchy of brightness, with an attempt being made to convey the intensity of the higher brilliance by reference to a lesser brilliance which in its turn is becoming even more brilliant . . . a spiritual escalation of ever-brightening light.

Degrees of radiance are, it appears, to be admitted. And this radiance will also vary in relation to the specific element itself. To quote Aquinas, "it is said that the earth on its outward surface will be as transparent as glass, water as crystal, the air as heaven, fire as the lights of heaven."[116] Nowhere in Scripture is all of that said verbatim. Rather Aquinas and his contemporaries derived such imagery (either directly or through intermediaries) from St. John's Apocalypse (the Book of Revelation), commonly attributed throughout the Middle Ages to the author of the fourth gospel. This was the single most authoritative source which Christian theologians had at their disposal, as they sought to convey some impression of what life after death might be like. Here the enraptured visionary is granted a glimpse of the end of the world, the Last Judgment, and a phantasmagoric landscape which is dominated by the heavenly city of Jerusalem the Golden.[117] Thus St. John beholds "as it were a sea of glass mingled with fire (*et vidi tamquam mare vitreum mixtum igne*)"; "the city itself [was] pure gold like to clear glass (*simile vitro mundo*)," and its streets were "pure gold, as it were, transparent glass

(*tamquam vitrum perlucidum*)" (Apocalypse 15:2; 21:18; 21:21). "Water as crystal" features when the angel shows John "a river of water of life, clear as crystal (*fluvium aquae vitae splendidum tamquam cristallum*), proceeding from the throne of God and of the Lamb" (Apocalypse 22:1).[118] Aquinas attempts to improve on this by proposing that the brightness of the air will not consist in a casting forth of rays, but rather "as an enlightened transparency," whereas "the earth, although it is opaque through lack of light, yet by the divine power its surface will be clothed with the glory of brightness." Here language strains to affirm distinctions which seem curiously at odds with a spiritual landscape in which, one might well feel, all the versions of radiance emanating from God's several creations would tend to blur together in an eternal whiteout. The schoolmen, however, insist on variety and variegation, within an all-encompassing splendor.

The heavenly bodies (stars, planets, spheres) will stand still, cease to move, yet continue to exist—in marked contrast with those plants and animals which have been rendered extinct by the cessation of that movement (as noted above). Indeed, they will receive a special intensification of their brightness.[119] Aquinas explains this with reference to Wisdom 13:5, "By the greatness of the beauty and of the creature, the Creator of them may be seen, so as to be known thereby." Among all natural things, the heavenly bodies manifest their Creator the most effectively. And their beauty consists chiefly in light.[120] Therefore they will be bettered especially in that regard. Aquinas refuses to speculate concerning the extent of this bettered brightness: "But to what degree and in what way this improvement will take place is known to Him alone who will bring it about," the supreme author of betterment (*meliorationis auctor*). However, Aquinas seems quite confident that it will happen. And that this will be done as a manifestation of God's wish to make Himself more visible to man than He is nowadays, "by signs so manifest as to be perceived virtually" by the senses (*quasi sensibiliter*; that *quasi* probably reflects Aquinas's awareness of the extent to which the senses themselves will appropriately be heightened, in order to make such a degree of perception possible).[121] So, then, the sun, moon, stars, and planets get to be brighter, easier to perceive, even as the human senses become better equipped to appreciate their significance, to know the creator through these His most luminous of creations. Plants and animals, it would seem, simply cannot compete. Everything they can do by way of serving man has been superseded by more brilliant creations, which themselves have become even more brilliant in the renewed world.

Once again, the *Prick of Conscience* author deserves credit for conveying abstruse doctrine in a succinct and memorable way. Having explained that the bodies of the blessed "sal be semely and bright" (5019), he proceeds to affirm the crystalline clarity and brightness of the new earth. The succession of day and night shall cease, and the elements shall be purified of all the "corruptions" that we see here, in the present-day world:

The erthe sal be than even and hale	*level and whole/sound*
And smethe and clere als cristale.	*smooth*
The ayre obout sal shyne ful bright;	*the surrounding air*
Than sal ay be day and never nyght,[122]	*shall always*
For the elementes alle sal than clene be	*be cleansed*
Of alle + corrupciouns that we here se.	*corruptions that we see here*
(6345–50)	

Thus the entire world, in all its parts, will "seme als it war a paradys" (6351–52): that being an instance of poetic understatement, for the entire world will not only look like, seem ("seme") to be, a paradise: it will actually *be* a paradise.

The planets and the stars shall shine brighter than they ever shone since the Fall:

The planetes and the sternes ilkane	*each one*
Shal shyne brighter than ever thai shane;	
The son sal be, als som clerkes demes,	
Seven sythe brighter than it now semes;	
For it sal be als bright als it first was,	
Byfor ar Adam dud trespas.	
The mone sal be als bright and clere	
Als the son es now that shynes here.	
(6353–60)	

The reference in line 6355 to "some clerics deeming" that the sun shall be seven times brighter than it is at present is by way of a filler phrase, a redundant expression necessary to help the rhyme along. There was no real doubt on this matter (or the matter of the moon becoming as bright as the sun is nowadays), inasmuch as clerics—such as Aquinas, as quoted above—inferred

its truth from Isaiah 30:26, "the light of the moon shall be as the light of the sun, and the light of the sun shall be sevenfold."

But what of the poet's claim that the sevenfold intensification of the brightness of the sun brings us back to the way it shone in the first Paradise, the paradise before death? This may be found in Peter Lombard's *Sentences*, in his distinction "on the quality of the heavenly lights and of time after the judgment," and immediately after his quotation of Isaiah 30:26: "As much as the sun shone in the first creation of seven days, before the sin of the first man, so much shall it shine after the judgment. For the light of the sun, moon, and other heavenly bodies was lessened by the sin of the first man; but at that time the sun will receive the reward of its labour, because it will shine sevenfold."[123] Here the Lombard is building on the *Glossa ordinaria* on this same passage of Isaiah, which claims that "all things made for man's sake deteriorated at his fall, and the sun and moon diminished in light."[124]

It was one thing to say, as do Peter Lombard and the *Prick of Conscience* poet, that in Eden the sun and moon were much brighter than they are now:

Thai war than, als men may trow, *believe*
Mykel brighter than thai er now.
(6367–68)

But it was quite another to claim that the light of these heavenly bodies had been diminished by Adam's sin. How was that scientifically possible, since these bodies are unalterable in terms of their substance? Aquinas reviews two opinions.[125] First, that an actual lessening of light did occur, brought about by divine power. Second, and this Aquinas believes is the more probable explanation, maybe there was not an actual lessening of light at all, but rather a decrease in the benefits which fallen mankind received from it, due to the punishment of his sin. Further, the fact that the light of the heavenly bodies did not really decrease after sin does not mean that they could not brighten at the time of man's glorification, given the major changes to the state of the universe which will occur then.

The *Prick* tackles the issue of the post-resurrection stasis of the "moving heavens" as follows:

The movand heve[n]s, withouten dout,
Sal than ceese o turnyng obout *cease*
And na mare obout in course wende, *proceed in their courses*

For of alle thyng than sal be made ende.
The movand hevens now obout gas, *about goes*
And the son and the mone thair course mas, *move in their courses*
And the othir planetes ilkane *each one*
Moves als that thair course haf tane, *move as they have taken their course*
And alle the elementes kyndely duse *naturally do*
That that es nedeful til man[s] use. *is needful to man's use*
Thus ordaynd God tham to serve man,
Bot of alle swylk servise thai sal ceese than. *of all such service, cease*
(6369–80)

After "domesday" men shall live forever, the good in bliss and the evil in pain. And so, "What nede war that tha creatures than / Shewed swilk servyse mare for man," what need would there be then for those creatures to perform such service any longer for mankind (6385–86)? Here a rather verbose and repetitive statement about how the heavenly bodies currently follow their ordained courses gives way to the precise assertion that, following the General Resurrection, there will no longer be any need for them to perform any more service of that kind "for man." The Middle English text then leaps into a statement concerning the future absence of animals, plants, and indeed the earth's present-day natural topographical features (comprising crags, rocks, dales, hills, and mountains).

Na qwik creature sal than be lyfand *living, left alive*
Thurghout the werld in na land,
Ne nathyng sal growe than, gresse ne tre,
Ne cragges ne roches sal nan than be,
Ne dale ne hille ne mountayne.
(6387–91)

Presumably the poet meant us to carry over the explanation about the cessation of service for humanity, which he had developed in relation to the heavenly bodies, to apply to these features of creation also, features which will have nothing left to render unto mankind.

At any rate, the "new earth" will be, in contrast with the one we are living in now, flat, plain, and featureless; as if sensing the negative resonance of such terms the *Prick of Conscience* author immediately resorts to the appealingly synesthetic discourse of crystal, clarity, and cleansing.

For alle erthe sal be than even and playne
And be made als clere and fayre and clene
Als any cristal that here es sene.
For it sal be purged and fyned
 withoute, *refined on the outside (i.e., in appearance)*
Als alle other elementes sal be
 oboute, *all other elements round there/in that place*
And na mare be travayled o[n] na side *no more be employed anywhere*
Ne with na charge mare occupide. *nor occupied any more with any duty*
(6392–98)

Thus the poet seeks to evoke our final paradise by recording what is *not* there rather than what *is* there. It is defined largely by absence, exclusion, lack: the absence of almost all of the natural beauty and geographical diversity which adorns so profusely even the fallen world, and which adorned in an even more excellent degree our first paradise, the luxuriant Garden of Eden. In terms of environment, then, all the two paradises seem to have in common are intensely bright and beautiful heavenly bodies. With the glorious appearance of the *patria* being far superior, of course.

Representing Paradise: From Eden to the *Patria*

Late medieval writers and artists were faced with a major representational dilemma by this expulsion of plants, animals, and the earth's naturally diverse landscape from the second Eden. When the beauties of the natural world were declared off-limits, a crucial source of their imagery—a source of immeasurable extent and vast proportions—became problematic. The Genesis account of the Garden of Eden is hardly a long narrative, but nevertheless gave the creative imagination much to engage with and embroider. But as far as the paradise beyond death was concerned, there was little to go on. Hell was much easier to depict, with hordes of monstrous devils subjecting their victims to horrendous physical abuse. Much the same iconography worked for that temporary hell, purgatory, in which the souls of the redeemable were subjected to various periods of purification (the length depending on the extent of their sin and the efficacy of the prayers and suffrages which the living offered on their behalf), to emerge cleansed and fit for heaven. Of course, the scene of the General Resurrection itself afforded opportunities for

the portrayal of naked bodies, now wondrously whole, arising from the ground, with attitudes of wonder and reverence, their tombs split asunder and their open graves deserted.

Representation of the new heaven and new earth was much harder, in the final analysis impossible. Artists tended to opt for a safe though theologically reductive image of blessed souls and angels, arranged in concentric circles according to their different spiritual rankings, looking directly upon an anthropomorphic deity who sits at the center of their adulation. This is the model followed in the depiction of paradise included in a manuscript of Dante's *Divine Comedy* produced at Paris in the 1460s and magnificently illuminated by the Coëtivy Master (Bibliothèque nationale de France, MS Italien 72, fol. 60r; Plate 19). The blessed souls have been given distinctive characteristics, so that the identity of the two humans nearest to God—the Virgin Mary and John the Baptist—is obvious.

The representational dilemmas underlying this illumination reflect Dante's own, because his *paradiso* is not the post-resurrection paradise. All the souls which the Dante-persona meets on his epic journey through Hell, Purgatory, and Paradise are disembodied, not yet joined with their resurrected flesh. Which is hardly surprising because, to state the utterly obvious, that historical event to end all historical events has not yet occurred. However, Dante (and his illuminators after him) have created characters with distinctive physical characteristics which call to mind several crucial tenets of resurrection theology, particularly the belief that the blessed will resurrect in the very bodies their souls occupied while on earth, thereby retaining their *integritas*. Charles S. Singleton has written cogently about this phenomenon, calling the General Resurrection "that total event which so sanctified the human body that a philosophical poet could find our body in the eternal world beyond, and find it there in all reality—find it there before it could really be there, for the day of our Resurrection is not yet come when Dante visits the three realms beyond."[126] The matter is complicated, however, by Dante's use (particularly in the *Inferno*) of the idea that the bodies being encountered are temporary, aerial bodies, rather than the "real" bodies which will be experienced following the General Resurrection.[127] Yet it is resurrection theology which affords the ultimate justification for that creative maneuver, with its guarantee of the reality to come.

At one wonderful moment in the *Paradiso* the narrator half-recognizes a materialized soul in terms which evoke that combination of familiarity and otherness which one might deem an appropriate response to a resurrected

individual. In Canto III, within the sphere of the moon, he meets Piccarda Donati, and has to be reminded of "her name and her lot" (40–41). "You will recognize that I am Piccarda" (49), she says. And indeed he does, while remarking that in her "wondrous aspects a something divine shines forth that transmutes you from recollection of former times"—

"Ne' mirabilis aspetti
vostri risplende non so che divino
che vi trasmuta da' primi concetti . . ." (III, 58–60)[128]

—and hence he was not quick in calling her to mind ("non fui a rimembrar festino," 61).

Recollection is instantaneous in the anonymous Middle English *Pearl*, crafted in the late fourteenth century in Northwest Midlands dialect.[129] Most present-day readers (myself included) work on the assumption that it was written by "a secular priest or friar working in an aristocratic household, now as secretary, now as confessor"[130] to a nobleman whose daughter, probably called Marguerite/Margaret (the French for "pearl"), died before she reached her second birthday. This dream-vision poem has her appear before its first-person narrator as a fully grown woman bedecked in precious pearls, whereupon he joyfully exclaims, "I knew hyr wel" (164), "Ho was me nerre then aunte or nece" (she was more closely related to me than aunt or niece, 233 and cf. Plate 20, the illumination of this encounter from the unique manuscript, British Library, MS Cotton Nero A 10).[131] Similarly, in the Latin eclogue *Olympia* which Giovanni Boccaccio wrote circa 1367/70 in commemoration of his daughter Violante, who died when she was five and a half years old, the bereaved father figure has no difficulty in recognizing the child, even though she is now transfigured as the mature "Olympia": "My child's voice I hear, and her sweet image (*ymago*) stands before me" (43–44).[132] Here, then, are other souls who have been materialized as a matter of artistic necessity, and once again the nature of that materialization recalls aspects of resurrection theology.[133]

In the BnF Italien 72 illumination, as already noted, at least some members of the heavenly host are easily recognizable (cf. Plate 19), their identities being established by traditional iconographical features, such as the crown which the Virgin Mary wears and the lamb which John the Baptist cradles. One aspect of resurrection theology which—quite unsurprisingly—has not proven influential here (or in any comparable painting known to me) is the

belief that the renewed body will have no need of clothes. It was one thing
to present Adam and Eve as naked in Eden,[134] but quite another to present
the complete bodies of the Blessed Virgin and of Christ's immediate prophet
and precursor in this way.[135] A similar decorum seems to underlie Dante's
presentation of saintly souls in white robes, *bianche stole* (*Paradiso*, XXX,
129).[136] Such imaging finds its justification in the Apocalypse: "White robes
(*stolae albae*) were given to every one of them" (6:11)—that is, to all the
blessed. Later (at 7:14) these wearers of robes are identified as "they who are
come out of great tribulation and have washed their robes and have made
them white in the blood of the Lamb," and (at 19:8) clothes of "fine linen,
glittering and white" are explained as "the justifications of saints." Hence the
Pearl poet appropriately dresses the Pearl-maiden—a Holy Innocent and a
Bride of the Lamb—in a fine linen garment ("beau bys"), gleaming white
and beautifully trimmed with precious pearls, which she wears with a crown
similarly adorned with pearls (197–208). Another Holy Innocent, Boccaccio's
Olympia, is similarly clad in a wondrously white robe, "entwined with yellow
gold" (58–60). To enlist language from *Pearl*, in both poems such "araye
ryalle" (191) is to be understood not literally but allegorically, as garments
of grace ("innoghe of grace has innocent," 625),[137] which reflect traditions
concerning the spotless purity of virginity.

Nudity does feature prominently in a standard way of representing the
Last Judgment which attained high standards of artistic sophistication in
the fifteenth century; generic naked bodies arising out of the earth were
unproblematic. A particularly fine example is afforded by an illumination in
the Bibliothèque nationale de France, MS fr. 9608, fol. 88r (Plate 21), attrib-
uted to the Master of the *Très Petites Heures of Anne de Bretagne* and dated
around 1490. Here a representation of heaven dominates the upper part
of an illumination which also features the General Resurrection and the
condemnation of the damned to hell. The heavenly hosts are lacking in
distinguishing characteristics, appearing rather like dense versions of blue
clouds which cluster around the imperious crowned figure of God. This
seems to be a depiction of disembodied souls (insofar as any artist can suggest
disembodiment) rather than the glorified bodies that we might expect in
view of the structure of the picture. In its lower part, naked men and women,
their bodies renewed, arise from the earth, some being immediately herded
into a monstrous hell-mouth. More attention is paid to blessed bodies in the
left panel of Hans Memling's *Last Judgment Triptych*, painted circa 1467–71
and now in the Muzeum Narodowe, Gdansk (Plate 22a).[138] In the detail

reproduced as Plate 22b, beautifully proportioned bodies, serene in their naked majesty, are ushered toward St. Peter by an exquisitely dressed angel. St. Peter himself, together with the heavenly host depicted in the central panel (Plate 22c), is demurely clothed, as indeed are the angels who appear throughout the three panels, with the exception of the armor-clad Archangel Michael. Those blessed bodies will not stay naked for long. As they ascend toward the massive gateway which will admit them into the Heavenly Jerusalem, angels dress them in garments which, presumably, are meant to image their respective eternal rewards. In contrast, the damned in hell are left to suffer in their exposed, vulnerable nakedness (Plate 22d). In the upper part of the central panel Christ sits, the wounded flesh of His resurrection body affirming the humanity He shares with the multitude arising from the earth below. His divine power has been delegated to Archangel Michael, who weighs the newly resurrected humans with a passive countenance that bespeaks the objectivity of the judgments he is handing down.

Neither of these depictions of the Last Judgment offers much by way of topographical detail. However, to judge from the BnF fr. 9608 illumination, it would seem that the new earth has not yet come into being, since the old one is still being represented, with an expanse of grassland, hills and craggy mountains, a sea, and a sky. Natural landscape has remained useful to this talented illuminator. That is even more true of the van Eyck brothers, Hubert and Jan, in the case of their masterwork the Ghent Altarpiece, completed in 1432 and still on display in Ghent's Saint Bavo Cathedral. At the visual center of the entire structure is an altar on which stands the Lamb of God, blood pouring from a gash on his breast into a golden chalice, symbolizing the Eucharistic rite.[139] In front of this spectacle is a Fountain of Life (iconographically recalling the fountain from which the four great rivers flowed out of Eden), connected to a little stream, its bed covered with precious stones. Around both altar and fountain is a verdant meadow framed with luxuriant trees and bushes; a myriad of flowers enriches the scene. The four corners of this landscape are filled with different groups of human worshippers, differentiated by their spiritual status; angels encircle the altar itself. In the far background the imposing spires of the Heavenly Jerusalem are clearly visible. One of the most striking things about this extraordinary scene is the attention to detail and botanical accuracy with which the plants have been painted, so much so that their species may be identified.[140] In late medieval plastic art, there is no more elaborate, or more successful, example of the use of an earthly paradise to represent the heavenly.

If a comparably compelling instance of spiritual landscape being represented through the physical is sought in medieval vernacular literature, it would be hard to find a better nominee than *Pearl*, well described by Ian Bishop as "the most highly wrought and intricately constructed poem in Middle English."[141] Having fallen asleep on the grave of his baby daughter (itself a locus of great natural beauty), the poem's narrator dreams his way into an otherworldly garden which has strong affinities with the Garden of Eden. From this vantage point he looks across a river to an even more surreal landscape, where he sees and talks with the soul of his dead child, materialized in a mature form which anticipates her resurrected body.[142] The influence of resurrection theology on *Pearl* will be discussed below, but in the first instance we may place the poet's creations of paradise in the context of popular visionary literature, as disseminated in both Latin and vernacular and reaching an audience far in excess of that constituted by the professional theologians who studied and taught in the schools.

Popular visionary literature did not get more popular than the *Visio Tnugdali*. Dated 1149 by the author of the Latin original, this text enjoyed a quite astonishing dissemination, both in its original form (together with several Latin adaptations) and in its many translations—at least forty-three in fifteen languages, including French, Dutch, German, Icelandic, and English.[143] (In sad contrast, *Pearl* is extant in a unique manuscript, and had no discernible influence on later medieval English literature.) The *Visio* recounts how a powerful but cruel Irish nobleman—variously named "Tnugdalus," "Tunaldus," or (as in the Middle English translation I will follow here) "Tundale"— is shown the error of his ways.[144] Having being led through the pains of hell and the pleasures of heaven by an angel, finally Tundale experiences a brief glimpse of the Holy Trinity and witnesses angels basking in the radiance of the face of God,[145] before being ejected because he—far from being a holy virgin—is unworthy to dwell there. At one point Tundale is taken to a wonderful meadow, covered with multicolored and fragrant flowers. The sun shines brightly upon it; birds sing sweetly from the branches of many fruit trees.

> A feld was ther of feyr flowrys
> And hewyd aftur all kyn colowrys. *hued with*
> Of how com a swete smylle,
> Swettur than any tong may telle. *tongue*
> That plase was soo clere and soo bryght

Tundale was joyfull of that syght;
Full clerly ther schon the sonne
That well was hym that ther myght wonne. *happy was he, dwell*
Mony feyr treus in that place stood
With all kynnus fruyt that was gud. *kinds*
That Tundale hard ther ay amonge *always throughout*
Full swet noyse of fowlys song. *birds'*
(1535–46)[146]

At the center of the "feld" is a beautiful spring, from which flow many little streams of crystal-clear water. It is the Well of Life. Whoever drinks shall feel no hunger and suffer no thirst; anyone who is old will become young again. The comparisons with the Garden of Eden are obvious, though there the fruit of a tree, rather than the water of a well, served to preserve the life of the human body. Here, then, is the very threshold of heaven, filled with souls wholly cleansed of their sins.[147]

Thawye they ben clansyn of all ylle, *though*
Here mot thei abydon Goddus wylle. *endure/await*
(1567–68)

Perhaps this beautiful garden functions as an antechamber or staging area for those who will pass to an even better place.[148]

The idea of the earthly paradise as a place of waiting was reinforced by the notion that the prophets Enoch and Elijah are currently living in Eden—the only humans to be so honored—until the end of days and the emergence of the homeland. According to the apocryphal *Gospel of Nicodemus*—a primary source for that highly popular outpouring of vernacular theology, the Harrowing of Hell—when Christ frees Adam and his kin from hell-mouth, delivering them up to the archangel Michael, who will lead them into the glory of the new paradise, they meet with two men, "ancients of days," who appear to have enjoyed a privileged existence in the old one. Surprised, the newly freed souls ask of them,

Who are ye that have not yet been dead in hell with us and are set in paradise in the body? then one of them answering, said: I am Enoch which was translated hither by the word of the Lord,[149] and this that is with me is Elias the Thesbite which was taken up in a chariot of fire:[150] and up to this day we have

not tasted death, but we are received unto the coming of Antichrist to fight
against him with signs and wonders of God, and to be slain of him in Jeru-
salem, and after three days and a half to be taken up again alive on the
clouds.[151]

The spiritual pleasures with which Enoch and Elijah wiled away their time
before engaging in this war to end all wars are well illustrated in Plate 23,
from Paris, Bibliothèque nationale de France, fr. 1378, fol. 32r, a copy of *Le
Livre des merveilles du monde* or (more appropriately) *Le Livre des secrets de
l'histoire naturelle*. This treatise, which is not to be confused with either
Marco Polo's *Divisament* or Mandeville's *Travels*, was produced (by an anon-
ymous author) at the turn of the fifteenth century, probably between 1371
and 1428.[152] In the illumination we see a beautiful garden brimming with
trees filled with ripe fruits, which is ringed with fire, to keep out unwanted
and unworthy visitors. Inside, two bearded men—presumably Enoch and
Elijah—look aloft (an attitude shared by the seraphim to their right), their
hands clasped in prayerful attention. On the left-hand side of the picture two
lesser angels converse animatedly, so rapt that they are oblivious of their
neighbors. The two groups are separated by the four rivers of paradise, which
divide the entire garden into four sections.

This illumination certainly does not convey any impression that water is
creating unsurpassable barriers between men and angels, or between the sev-
eral parts of the landscape. In the *Visio Tnugdali* and its vernacular render-
ings, the terrified sinner and his guiding angel travel with effortless ease along
the tunnels, pits, and bridges of hell and, as they proceed toward heaven,
they actually pass though tall walls of silver, gold, and precious metals inter-
mixed with jewels. (No doubt a schoolman would draw a comparison with
the *subtilitas* and *agilitas* of the resurrected body.)

However, the situation of *Pearl*'s narrator is quite different. In contrast
with Enoch and Elijah, and indeed with all the purified and expectant souls
in the paradisal garden of the Middle English *Vision of Tundale*, he has a long
way to go before (hopefully) becoming one of the righteous who eagerly
await such an elevation. The Dreamer has a lot more of his life yet to live,
many tests still to face. His heavenly guide, the Pearl-maiden, remains exclu-
sively situated on the other side of the paradisal river, warning him to stay
on his side. The uncrossable stream might be intended to recall one of the
rivers of Eden (as discussed above), or—as is much more likely, I believe—the
"river of water of life, clear as crystal," which Apocalypse 22:1 describes as

"proceeding from the throne of God and of the Lamb" (and is specifically mentioned at *Pearl*, 1055–60;[153] it may also lie behind the Well of Life in the *Visio Tnugdali*). Whatever its source, it is quite clear that before the Dreamer can traverse that very real barrier he must, unlike Enoch and Elijah, taste death. As the Pearl-maiden says, his "corse in clot mot calder keve" (his body must go down, colder than it is now, into clay),

"For hit was forgarte at Paradys greve;
Oure yorefader hit con mysseyeme.
Thurgh drwry deth bos uch man dreve,
Er over thys dam hym Dryghtyn deme." (321–24)

["Because it (his body) was ruined in the Garden of Paradise (Eden); our forefather (Adam) abused it. Every man must make his way through dire death before the lord will allow him over this water."]

Having found himself in a simulacrum of that lost paradise, the Dreamer looks across its banks to what he actually calls a "Paradyse." The water seems to be a "devyse" (division) made "bytwene myrthes" (between joys), separating one place of pleasure from the other (137–40). Here one may find an excellent metaphor for the iconographic patterning of *Pearl* as a whole, since its symbolic landscape vacillates between two paradises—Eden and the land of the blessed. But in the poem the "devyse" separating these sources of imagery is actually permeable, as I now hope to show.

The Edenic habitation through which the Dreamer wanders, his spirit temporarily relieved of all earthly grief (85–86) in this recollection of a land which existed before the start of human suffering, is inexpressibly rich in adornment—a concept reiterated throughout the second section of the poem, wherein *adubbement* (adornment) is the refrain word prominent in the first and last lines of every verse. This is reminiscent of one of the theologians' rationales for the abundance of plant and animal life in Eden: *propter habitationem hominis decorandam*.[154] The *Pearl* poet's *decoratio* features "holtewodes bryght" (bright woods) with indigo tree trunks (67–76), and "frech flavores of frytes" so sweet that they refreshed him as though they were food (87–88): a wording which takes on added significance if it is recalled that in the garden of Eden the Tree of Life bore fruits which nurtured the human body to such an extent that it could neither die nor deteriorate in any significant way. Birds with bright plumage, both large and small, fly together in the woods,

singing "wyth a swete asent"—that is, in lovely harmony, producing music which in beauty exceeds anything that any stringed instrument played by human hand can achieve (89–94).

Even the gravel underfoot consists of "precious perles of oryente" (82)—an epithet justified by the belief that Eden was located in the East. And the larger rock formations are correspondingly beautiful: the dreamer sees "rych rokkes" of an unbelievable brightness, shining with "glemande glory" (gleaming glory), and hillsides adorned with "crystal klyffes" (66–74). The terrain does not hinder the Dream's progress (102). Perhaps the poet was influenced by the notion that, when Adam was put "into the paradise of pleasure, to dress it, and to keep it" (Genesis 2:15), this was not meant to involve any onerous work (that being necessary only after the Fall), but rather his habitation was naturally suited to bring him pleasure and ease. Indeed, the farther the Dreamer walks through this wondrous "feier" (meadow), the more beautiful it seems to become,

> The playn, the plonttes, the spyse, the peres,
> And rawes and randes and rych reveres—
> As fyldor fyn her bonkes brent. (104–6)

[The plants, the spices, the pear trees, and hedgerows and river lands and rich river meadows—their steep slopes like pure gold thread.]

Then he arrives at that crucial river which separates the living from the dead. Far from being a Slough of Despond of the kind encountered by John Bunyan's progressing pilgrim, its waters swirl sweetly, flowing in a straight and orderly fashion with a pleasant murmuring sound. Bright stones are visible on the river bottom, every one of them an emerald, sapphire, or some other noble gem; they glow and gleam "as glente thurgh glas" (like a beam shining through glass), or as the "stremande sternes" (stars emitting streams of light) shine brightly in winter, when men of this world are asleep (114–16). This exquisite evocation of light builds on the Dreamer's earlier statement that the very sunbeams themselves were but "blo and blynde" (dark and dim) in comparison with the *adubbement* of this amazing place (83–84). Which means that *Pearl*'s paradisal landscape must have been bright indeed, since—as we may recall from the relevant scholastic discussion and the summary account in *The Prick of Conscience*—in Eden the sun, moon, and stars shone far more brightly than they do nowadays, a brightness which will be

restored to them (though in even greater abundance) in the "new heaven and new earth" which, following the General Resurrection, will be the *habitatio* of the blessed.

In many respects, then, the landscape from which the Dreamer views his dead daughter echoes the description of the Garden of Eden which the schoolmen inherited from John of Damascus: a paradise "planted . . . by the hands of God, a storehouse of joy and universal exultation"; "evergreen plants are its pride, sweet fragrances abound, it is flooded with light, and in utter beauty and sensory freshness it transcends understanding."[155] However, some features of the imagery of the paradise after death seem to have percolated through, to color the imagery deployed in the second section of the poem. While Eden is certainly a place "flooded with light," the sheer brilliance of those "rych rokkes"—lightsome to an extent that no ordinary man would believe[156]—rather recalls the intensity of brilliance that the schoolmen associated with the paradise beyond death. More generally, the strong emphasis on precious stones and glittering jewels, the way the landscape is described as crystalline, glassy, and golden, point beyond the natural beauties of Eden to the supernatural beauties of the other world. Here is a place where even the tree leaves have a metallic cast to them, for they slide over each other "as bornyst sylver" (like burnished silver),

> . . . That thike con trylle on uch a tynde.
> Quen glem of glodes agayns hem glydes,
> With schymeryng schene ful schrylle thay schynde. (77–80)

[. . . which quivered close together on every branch. When the light fell on them from clear patches of sky, they shone most dazzlingly with shimmering brightness.]

Evidently the poet is anticipating his account of the bejeweled, gold-adorned Jerusalem (which ostentatiously follows St. John's Apocalypse), the Pearl-maiden's proper habitat. As a blessed soul in a renewed body, she belongs in the "treasure-chest of the heavenly paradise" (to borrow another phrase from Ian Bishop).[157]

Conversely, some of the imagery associated with the Garden of Eden has found its way into the poet's initial account of the land of the blessed. Looking across "that myry mere" (beautiful water), the Dreamer sees

A crystal clyffe ful relusaunt;
Mony ryal ray con fro hit rere.
At the fote therof ther sete a faunt,
A mayden of menske, ful debonere . . . (159–62)

[A greater marvel overtook my reason. I saw beyond that pleasant / "merry"
water a crystal cliff all gleaming; many a royal ray (of light) shone from it. At
the foot thereof there sat a young person, a maiden of great worth, full
gracious . . .]

You are living "a lyf of lykying lyghte [easy pleasure], / In Paradys erde [land],
of stryf unstrayned [untouched]," he tells his daughter admiringly (247–48);
sentiments which she echoes when celebrating her new existence in a "gardyn
gracios gaye, / Hereinne to lenge [dwell] for ever and play [rejoice]" (260–
61). So, clearly the poet imagines the Pearl-maiden as living in some version
of a heavenly paradise. Of course, strictly speaking the term "gardyn" can
appropriately be applied only to Eden. There will be no plant or animal life
in the land of the blessed. Neither will it be decorated with any "crystal
clyffe." To repeat a quotation from *The Prick of Conscience*,

Na qwik creature sal than be lyfand *living, left alive*
Thurghout the werld in na land,
Ne nathyng sal growe than, gresse ne tre,
Ne cragges ne roches sal nan than be,
Ne dale ne hille ne mountayne.
(6388–91)

But how can one imagine a world which, even more appropriately than Eden,
can be said to "transcend understanding"? When John of Damascus spoke
in those terms,[158] he was deploying an inexpressibility *topos*, using hyperbole
to emphasize the wonders of the *paradisus voluptatis*. No doubt any late
medieval schoolman would have said that the heightened, rationally con-
trolled imagination could, for the most part, have coped well enough with
Eden's "sensuous freshness and beauty." But the *patria* is a very different
proposition, since it lacks any such sensuous stimulus to the imagination,
offering neither earthly creature, crag, nor tree. Little wonder, then, that the
Pearl poet should reiterate an image which he had already used in his descrip-
tion of the Dreamer's Edenic environment, wherein the hillsides are adorned

with "crystal klyffes" (66–74). Imagery authorized (by Genesis and its commentary tradition) in relation to the paradise before death have proved useful in conveying some notion of the paradise after death. Besides, that "crystal clyffe" fits right in with the vision of the Heavenly Jerusalem which is deployed later in the poem, where—on the authority of St. John—we are enabled to think of a city with "stretes of golde as glasse al bare [clear]," and gleaming walls "of jasper" (1023–26).

In *Olympia*, Boccaccio eschews any attempt at materializing a heavenly cityscape, choosing rather to develop the idea of a rural idyll, with heaven depicted as nothing other than an elaborate pleasure garden. This is possible thanks to the conventions of Latin pastoral writing[159]—though he pushes them to breaking point. Olympia and her paradisal companions appear to Silvius, the lamenting parent, in a blaze of light which sets the earthly woodland aglow, in a way which illuminates rather than consumes (27–30; maybe Boccaccio was influenced by Exodus 3:2–3, where Moses encounters a bush which seems to be aflame but not to burn, "rubus arderet et non conbureretur"). Rare scents, the smell of beautiful flowers, fill the night air; the daughter that Silvius had bewailed "on mountain heights, in woods and faraway glades" (55–57) now stands before him. Resisting her doting father's impulse to lay on celebratory games with festive banqueting in the best Roman style (79–85), Olympia speaks of how Codrus (Christ) came to wash away, with his bright blood, old stains from blemished sheep (97–98). Having slain death he broke apart Pluto's fences, to free his flock (99–100). At the Last Judgment, she adds, He will come again, to separate the sheep from the goats, assigning the former to perpetual thrones and the latter to the degradations of wild beasts (108–10). Olympia's stirring words seem to be supported by a musical accompaniment, which Silvius praises as surpassing anything which Calliope or Apollo could possibly produce (38, 86–88, 117–27). Boccaccio does not wear his neoclassicism lightly.

Such overwrought pastoral discourse extends to the imaging of heaven, presented as a wooded mountaintop, "lumine perpetuo claris" ("bright with perpetual light"), and adorned with heavily scented flowers and silvery streams (171, 176–80). Here gold is the most prominent color, common to fruit, birds, lambs' fleeces, and even goats' horns. Furthermore, deer, oxen, bulls, and fat cows are all resplendent with gold, as are the manes of tame griffins and lions (181–89). Boccaccio seems to enjoy the depiction of exotic or exoticized animals, although actual animals cannot possibly exist in the heaven of disembodied souls and will not exist in the homeland. "High, on

a grassy mound, in glory sits Arcesilas"—that is, the ultimate "chieftain," almighty God, "shepherding flocks and worlds (*servatque greges et temperat orbes*)," with a "milk-white Lamb" resting on his lap (200–201, 205). "An aged band of Satyrs," their "hoary locks with rosy chaplets crowned," cele- brates this spectacle, praising the Lamb "with lute and song" (213–15). Olym- pia and her companions crown their unshorn locks with floral wreaths, dance around woods and streams, and loudly praise the Virgin and her Son. "Who can recount the wood's delights?" (268–69). Boccaccio strains to do so, iden- tifying that sacred wood as the maiden's true home.

Indeed, it seems that Olympia has simply left one grove for another. There is no impassible stream here; no "devyse bytwene myrthes" (139–40) insti- tuted by the poem's imagery. But the messages of both *Pearl* and *Olympia* are fundamentally the same: acceptance of the divine will. Olympia has come, with the full compliance of the pastoral pantheon, to "dry the tears" of her father (48) and take a proper leave of him. Boccaccio engages in self- counseling; the *Pearl* poet counsels his noble patron to believe that heaven is where the little jewel, that once was his, really belongs.

Perfecting Children's Bodies

The use in these texts of an adult female authority figure who instructs the man who fathered her in the state of misery owes a considerable debt to theological teaching concerning the beautiful body which each blessed soul will receive in the state of glory. Here may be found a justification for the writers' presentations of children who died young as bright and beautiful women, mature in body and in mind.[160] Thanks to that doctrine, in conjunc- tion with the influence exercised by iconography concerning the Garden of Eden (and its elaborations in popular visionary literature) the spiritual may, in some measure, be made material; the imagination of fallen mankind given something with which it can cope. But there is a crucial distinction to be drawn, inasmuch as at the General Resurrection human souls will actually rejoin their bodies (aspects of materiality thereby being affirmed), whereas the imagery of both Edenic landscape and Apocalyptic cityscape is, in the final analysis, just that—imagery, elaborate materializations of truths con- cerning the end of time and history which have no place in heaven. That distinction—which takes us to the very heart of the theological and represen- tational cruxes of this book—will be confronted later in the present chapter.

"Quo formed the thy fayre figure?" asks the Dreamer of his daughter, exclaiming that this could not possibly have come from nature (747–78). His hyperbolic peroration continues with the claims that the beauty of her face is far beyond the creative powers of the artist Pygmalion (who created a superlatively beautiful statue which the gods brought to life), and that her wondrous qualities defeated even the wise Aristotle, who did not describe them anywhere in his voluminous writings.

> "Thy beauté com never of nature;
> Pymalyon paynted never thy vys, *face*
> Ne Arystotel nawther by hys letture *nor did Aristotle in his writings*
> Of carped the kynde these propertés." *speak of the nature of these qualities*
> (749–52)

Thus the Dreamer reacts to his foresight of what the Pearl-maiden's blessed body will look like in the *patria*, a sight which he will enjoy in its full perfection following the Last Judgment, should he too be one of the elect. Here the poet has been influenced by standard doctrine to the effect that "A child who dies soon after birth will rise again in that stature which it would have had if it had lived until the age of thirty and had not suffered any defect of body," to quote Peter Lombard's formulation.[161] We need not wonder, the Lombard continues, how something "which was so small at birth . . . will be so great at the Resurrection," because God will multiply that substance from itself (and not from anything else), like the five loaves with which Christ fed five thousand people (Mark 6:35–44; John 6:5–13) and the rib from which Eve was made (Genesis 2: 21–22).[162] We have already seen how Aquinas and Bonaventure responded to those comparable cases, in the course of explaining how Eve's body—the body of a fully grown woman—could possibly have been made from a single male rib. The process involved was not against nature but rather a cooperation (however extraordinary in itself) with nature, they argued.[163] A similar point could easily be made about the multiplication of substance involved in perfecting children's bodies.

According to this theory, then, the answer to the Dreamer's question is that, while the Pearl-maiden's body did not grow from infancy to maturity as per the usual process of nature, its production was not in any way contrary to or subversive of nature. Turning to the poet's derogatory remarks on the limitations of pagan art and philosophy, one might imagine a schoolman

supporting them wholeheartedly. Being ignorant of the Christian dogma concerning the General Resurrection—which his philosophy would deny in any case—Aristotle was incapable of commenting on, let alone solving, the knotty problem of the constitution of the resurrected body. And no artist, pagan or otherwise, can possibly compete with God the supreme artificer (*artifex*), regarded by Augustine as the master craftsman of that body: "with wondrous speed [He] shall wondrously and ineffably restore to our flesh all of which it originally consisted. . . . And assuredly nothing unseemly shall be there; but whatever shall be there, will be seemly; for anything that is not seemly, will not be."[164]

Further, resurrected bodies will maintain (any deformities apart) the distinguishing features which they had while alive, thereby preserving their *integritas*. Which must mean that the body of a child in its "multiplied" form will resemble its appearance at the time of its death. Therefore in *Pearl* it is quite appropriate that the bereaved father should see in his interlocutor the little girl he lost. Indeed, as he continues to gaze he knows her "more and more" (164–68), even as the wonderful *claritas* of her resurrected body—here imagined, but to become material in the future—gladdens his spirit.

> The more I frayste hyr fayre face,
> Her fygure fyn quen I had fonte,
> Suche gladande glory con to me glace
> As lyttel byfore therto was wonte. (169–72)

> [The more I examined her fair face, after I had (first) noted her exquisite form, such gladdening splendor stole over me—as little it had been wont to do before][165]

That last line is a rhetorical understatement meant to make the point that the Dreamer has never experienced anything like this before. His daughter stands before him in her glorified figure: almost a heart-stopping moment ("Such a burre [blow] myght make myn herte blunt [dazed]," 176). The poet's epithets for the maiden's bright body go beyond the ones traditionally applied to beautiful aristocratic women, all of whom have complexions as white as ivory or "whalles bone" (212, cf. 178). She is a "perle wythouten spotte" (24, cf. 48), "maskelles" [spotless] (780–81), "unblemyst . . . wythouten blot" (782), and "gloryous, wythouten galle [flaw]" (915; cf. "wythouten galle," 189).

In *Olympia*, Silvius is similarly awestruck by Olympia's radiance:

"Que tibi lux oculis olim non visa refulget?" (61)

["What light shines in your eyes, which I never saw before?"]

Her mature appearance is also a source of amazement.

". . . Mirum quam grandis facta diebus
in paucis: matura viro michi, nata, videris!" (62–63)

[". . . How wondrous that you have so aged in so short a time: you were only
a little girl, but now you seem to be ready for marriage."]

She certainly is ready for marriage—indeed is actually married, one of the
virgin Brides of the Lamb, as is the Pearl-maiden: her "makeles Lambe" took
her for his bride, washed her clothes in His blood on the dais of His heavenly
throne, and crowned her "clene in vergynté" (761–68). Likewise, Olympia
recounts how she was welcomed into heaven to enjoy "eternal spousal" (*eter-
nis thalamis*, 241). Her *claritas* is specifically identified as a gift from Par-
thenos, the virgin goddess (64–67)—that is, the Virgin Mary, who is granted
a similar status in the heaven of *Pearl*, where she holds "the empyre over uus
ful hyghe" (454), has all the virgin maidens in her care. "These robes, this
form, this shimmering beauty" (66, cf. 243) which Silvius now beholds are
far superior garments to the covering of flesh which he gave his daughter,
the corporeal body which she received due to the normal process of human
generation. Those garments have been retained in earth's great lap or womb,
duly watched over by "our Berecynthian mother," the earth goddess Cybele
(64–65),[166] as is the body of the Pearl-maiden, lost to her father in the grave-
garden where he fell asleep—until, of course, the General Resurrection, when
flesh will arise again, to be reunited with spirit.

Claritas is not only a *dos* bestowed upon the blessed bodies of the Pearl-
maiden and Olympia but also a feature of their paradisal habitat. A radiant
brightness which exceeds gold or crystal in its glory, and is quite lacking in
blemish, is much in evidence in section XVIII of *Pearl*, where we told that
the denizens of the Heavenly Jerusalem have no need of light from the sun
and moon because they are amply illuminated by the divine radiance:

Of sunne ne mone had thay no need;
The self God was her lambe-lyght, *God Himself, lamplight*
The Lombe her lantyrne, wythouten drede; *lantern, without doubt*
Thurgh hym blysned the borgh al bryght. *shone, city*
(1045–48)

This closely follows Apocalypse 21:23, "And the city hath no need of the sun, nor of the moon, to shine in it. For the glory of God (*claritas Dei*) hath enlightened it: and the Lamb is the lamp thereof." Christ's *claritas* exceeds that of the sun, affirms the *Summa Alexandri*,[167] developing what the *Glossa ordinaria* had to say on Matthew 17.1–2,[168] where Christ, having brought Peter and James "up into a high mountain," is "transfigured before them. And his face did shine as the sun: and his garments became white as snow." We have already noted Aquinas's claim that the bodies of the blessed will be seven times brighter than the sun. At the same point, elaborating on Isaiah 30:26, he states that the light of the sun shall be sevenfold, while the light of the moon shall be as the light of the sun: how much more brilliant, therefore, must the brightness of blessed bodies be by comparison.[169] With the blessed body of Christ being the brightest of all.

The *Pearl* poet's account of the redundancy of the sun and moon as light sources in the "new heaven and new earth" has obviously been influenced by such doctrine, as has the following passage, which also reflects the belief that all the heavenly bodies will then cease to move and stand still. Given that there is "never nyght" (1071) in the Heavenly Jerusalem, the poet asks,

What schulde the mone ther compass clym,
And to even wyth that worthy lyght
That schynes upon the brokes brym?
The planetes arn in to pover a plyght,
And the self sunne ful fer to dym. (1072–76)

[Why should the moon rise in her circuit there, and compete with that noble light that shines upon the river's surface? The planets are in too poor a plight, and the sun itself far too dim.]

Here a theological commonplace has been turned into a powerful *interrogatio* (or *erotesis*), a question asked for rhetorical effect and not for information (because the answer is already known).[170] "Not all interrogation is grand or

sustained (or elegant)," the *Rhetorica ad Herennium* had warned.[171] But this one certainly is, and serves to enliven the discourse.

And yet: according to resurrection theology some blemishes in resurrected bodies are actually desirable, to be preserved rather than erased in the glorification process, treated as signs of honor rather than as defects. Hence the *Pearl* poet notes that the resurrected body of Christ "the Lombe" retains the large scar it sustained at the crucifixion:

. . . a wounde ful wyde and weete con wyse	*wide and wet, showed*
Anende hys hert, thurgh hyde torente;	*close to his heart, through the torn skin*
Of his quyte syde his blod outsprent . . .	*white side, gushed out*
(1135–37)	

Thomas Aquinas eloquently argues that in the glorified bodies of Christ and in His saints, the "scars of wounds" will not be retained "in so far as they imply a defect, but as signs of the most steadfast virtue" whereby they suffered "for the sake of justice and faith." In the land of the blessed this will actually "increase their own and others' joy."[172] Augustine is quoted as saying that we shall actually desire to see such scars, which, far from making the glorified bodies of the saints seem deformed, will be "a badge of honour, and the beauty of their virtue—a beauty which is in the body, but not of the body—will shine forth in it."[173] (Mechthild of Magdeburg made this point even more vividly: following Judgment Day, "the sweet wounds" of Christ "shall heal, as though a rose petal had been placed on the spot of the wound. One will then see the scars turned bright red—love's color; and they will never fade.")[174] Aquinas emphasizes that such marks of virtue should not be taken as evidence of "passibility," a capacity for suffering on the part of the blessed bodies of the saints, for in the homeland they are unable to feel pain as they did while alive. In similar vein, the *Pearl* poet emphasizes the *impassibilitas* of the Lamb's renewed body:

The Lombe delyt non lyste to wene;	
Thagh he were hurt and wounde hade,	
In his sembelaunt was never sene,	*demeanor, visible*
So wern his glentes gloryous glade.	*so gloriously joyful were his looks*
(1141–44)	

There is no doubting Christ's unalloyed pleasure, as He presides over His retinue with a joyful appearance which is glorious in its beauty.

The glory of the Pearl-maiden's blessed body is, of course, without either spot or wound. Without wound, because since she died as a baby she had no opportunity for virtuous behavior (far less martyrdom), as her father somewhat ungraciously points out. To be made a queen of heaven, he exclaims, is "to dere a date," too exalted a point to have reached, too great a reward to have been given (*Pearl* 469–92). Whereupon the Pearl-maiden proceeds to set the Dreamer straight, in no uncertain terms (uncertainty being antithetical to her current status). The authority figures who control the agenda in *Pearl* and *Olympia* emphasize that they are no longer the children their fathers once knew and loved. They have changed utterly. She "who Violante was" has become "Olympia" in heaven. As she insists to Silvius,

"Non sum que fueram, dum tecum parvula vixi,
 nam numero sum iuncta deum." (141–42)

["I am not what I was, the child you knew,
 now I am numbered among those joined to God."]

If you leave me thus wretched, he cries, I will weep myself to death (145). To which Olympia responds, "Away with grief!" and bracingly reminds her father that "we all are born for death. I have but done what you shall do" (146–49). In *Pearl* also, the child is father of the man. Now in possession of intelligence and spiritual knowledge far in excess of her earthly years, she attempts to tell her grieving parent about the comforting consequences of Christ's love for the innocent, the abundance and inclusiveness of divine grace, and the noncompetitive operation of the celestial hierarchy.

Despite the vigor of those apologetics, some of *Pearl*'s recent readers have wondered if the father had a point after all. Indeed, it has been suggested that the poet engaged in "deliberate distortion" of an "ancient . . . body of thinking about virginity."[175] To my mind, the notion of "distortion" is inappropriate here, given, on the one hand, the range of opinion possible within orthodox theological thought about the appropriate heavenly reward for virgins, and, on the other, the range of application and emphasis possible within orthodox preaching and exhortation to particular audiences with particular needs (such as a bereaved family, for example).

The Pearl-maiden claims that she was "coronde clene in vergynté" (767)—that is, the specific gift with which Christ honored her is the *aureola* or golden crown of virginity, that being one of the three rewards bestowed

upon certain blessed souls in recognition of their special merit.[176] (The other two *aureolae* are bestowed upon martyrs and teachers [*doctores*], respectively.) In considering the question of whether she really deserved that coronation, we are faced, in the first instance, with some slipperiness of definition. St. Thomas Aquinas admitted that, if we understand the aureole "in its broad (*large*) sense for any joy added to the essential joy of heaven," then the aureole of virginity is applicable "even to those who are incorrupt in flesh," although they had not actually observed perpetual virginity. "Without doubt" such people "will rejoice in the incorruption of their body, even as the innocent will rejoice in having been free from sin, although they had no opportunity of sinning, as in the case of baptized children." However, Aquinas proceeds to say that this "is not the proper meaning (*propria acceptio*) of an aureole, although it is very commonly (*communis*) taken in this sense."[177]

Could it be, then, that the *Pearl* poet has understood the term in this broad, less rigorous, sense? Perhaps. However, schoolmen do not come more rigorous than William of Ockham, and yet he felt able to at least consider a position on the crown of virginity which is more inclusive and accommodating than St. Thomas's. One does not deserve such a reward by moral virtue per se; rather, "a crown is deserved by someone who has a particular sort of integrity (*integritas*)."[178] This, Ockham continues, "is evident in the case of a virgin who dies before attaining the use of reason, since she deserves a crown."[179] That case matches the Pearl-maiden's state quite accurately, as a child who died long before she attained the use of reason but who had the requisite *integritas*.

In any case, there was a certain fluidity in the exegetical and liturgical tradition. Take the following gloss, as cited by Aquinas, on Exodus 25:25, "Thou shalt also make a little golden crown (*coronam aureolam*)." The crown is read as denoting "the new hymn which the virgins sing in the presence of the Lamb, those, to wit, who follow the Lamb whithersoever He goeth."[180] Here is a clear echo of Apocalypse 14:3–4, where 144,000 virgins are said to "follow the Lamb whithersoever he goeth," this being part of the lesson for the Mass of the Holy Innocents.[181] The differences between virgins who won a "signal victory over the flesh"[182] and innocents who rejoiced in their virginity although they had lacked the opportunity to sin could easily be eroded,[183] particularly in a poem which has as its key rhetorical objective the consolation of an I-persona who has lost a young daughter—a point which applies to Boccaccio's *Olympia* as much as to *Pearl*.[184] It is hardly surprising that in both texts we should encounter a creative iteration of the belief that the

kingdom of heaven is prepared to enable children to come unto Jesus (718–19; cf. Matthew 19:14, Mark 10:14).

Rewarding Inequality

The issue of the nature of the Pearl-maiden's reward brings us to that part of the poem which has caused its modern readers the most difficulty, the use it makes of the parable of the vineyard (Matthew 20:1–16). Here Christ likens the kingdom of heaven to the situation in which a householder gives all his laborers the same reward of one penny, even though some have "borne the burden of the day and the heats" while others have entered the vineyard only "about the eleventh hour" (20:12, 9). The Pearl-maiden, who obviously belongs within the group of latecomers, ardently justifies her penny on the grounds that there is no question of "more and lasse" in God's kingdom (601–2). God is no niggard; so abundant is his grace that infants who die shortly after their baptism are welcomed into the vineyard and will receive their reward in full.

Is the doctrine of the equality of heavenly reward being advocated here? Carleton Brown suspected as much. In his view, the *Pearl* poet, following an "evangelical" interpretation of the biblical text, ventured "to reject the casuistries of scholastic theology" and, at least in this respect, offered "a most interesting and remarkable anticipation of sixteenth-century Protestantism."[185] Presumably Brown was thinking of the theocentric heaven envisaged by Protestant reformers, in accordance with which "eternal life" is seen "primarily as the individual's unsurpassed communion with God."[186] Thus John Calvin read the parable of the vineyard in predestinarian terms, as an illustration of the way in which God awards equal reward for unequal labor, and as a refutation of any notion of the righteousness of works.[187] Calvin remarks that each person will receive a special reward,[188] but that does not mean that a hierarchical structure of reward (as per the Roman Catholic model) is in place. Furthermore, because heavenly reward is dependent on a direct relationship between God and each and every man, the relationship which those men have with each other, whether on earth or in heaven, is of little importance.

There is nothing like that in *Pearl.* According to a mainstream doctrine of late medieval scholasticism, all those who enter the kingdom of heaven share an "essential" or "common" reward, which is beatitude itself, to use St.

Thomas's words again.[189] But this is quite compatible with differences in the rewards which add to the glory of beatitude, such as the aureole of virginity— the very crown bestowed upon the Pearl-maiden. Here is a clear indication that the poet is acutely aware of the hierarchical organization of heaven. The blessed may be equal inasmuch as all of them are beatified, but some are more equal than others in respect of higher reward and the extent to which they participate in beatitude.

A cogent formulation of this doctrine is at the very heart of Peter Lombard's treatment of resurrection theology, establishing the topic's terms of reference for generations to come. Here the parable of the vineyard is deftly contextualized, and reconciled with John 14:2 ("In my Father's house there are many mansions"). Those "many mansions" refer to differences of reward in heaven, the Lombard explains. Yet, on the other hand,

> . . . all the elect shall have the same coin which the Head of the household gave to all who worked in the vineyard. By this term "coin" is understood something which is common to all the elect, namely eternal life—God Himself, whom all will enjoy, but unequally. Indeed, just as there will be different degrees of brightness in each body, so also of glory in each soul. "For star shall differ from star," that is, elect from elect, "in brightness (*in claritate*)" of mind and body (cf. I Cor. 15:41). Indeed, some shall contemplate God's beauty more closely and with greater clarity, and this very difference in contemplation is called a diversity of mansions. And so the house is one, that is, the coin is one, but there is a diversity of mansions in it, that is, a difference of glory (*claritas*). The highest good, blessedness, and life of all, is one and the same—namely God Himself. All the elect shall enjoy this good, but some more fully than others.[190]

In sum, "the good shall be glorified differently."[191] Blessed souls shall be unequal in the extent of their knowledge, while their bodies shall be unequal in *claritas, subtilitas, agilitas,* and *impassibilitas,* in accordance with their different merits. Discussing *impassibilitas,* Thomas Aquinas explains that, if it is considered in itself, of course all the blessed have this characteristic. How could one possibly say that certain resurrected individuals have a greater or lesser lack of ability to experience pain or suffering than some others?[192] Such a lack (*negatio*) cannot be calibrated; it cannot be spoken of in terms of more or less (*non recipient magis et minus*). However, if we consider *impassibilitas* in relation to its cause, "then it will be greater in one person than in another."

That cause is the "dominion of the soul over the body," the result of "the soul's unchangeable enjoyment of God." Consequently the person who enjoys God more perfectly has a greater cause of impassibility. So then: there is, and there is not, a question of *magis et minus*, "more and lasse," in God's kingdom. Some enjoy God more perfectly than the Pearl-maiden possibly can.

The poet puts comparable sentiments into her mouth. Being awarded the aureole of virginity, crowned a queen in heaven, does not mean that she has usurped the position rightly occupied by the Virgin Mary, who is *the* queen of "cortaysye" (the term denoting both aristocratic courtesy and divine grace), with all earth and heaven in her dominion (433–42). As in Plate 19, which shows her nearer to God than even the encircling seraphim, who occupy the top position within the angelic hierarchy, her position as "emperise" is unchallenged. No doubt, or envy, is possible on the part of any other blessed soul; each and every one is totally satisfied with his or her lot.[193] Conversely, the Virgin Mary does not begrudge the reward which the Pearl-maiden is enjoying. The court of the kingdom of heaven has a special property, the elevated daughter tells her literalistic and earthbound father: it is a totally noncompetitive place. So much so that each blessed soul wishes the other an even greater reward.[194]

> ". . . never other yet schal depryve,
> But uchon fayn of others hafyng,
> And wolde her corounes wern worthe tho fyve,
> If possyble were her mendyng." (449–52)

> [". . . never shall one deprive another, but each is glad of what the others have, and would that their crowns were five times as precious, if their improvement were possible."][195]

We are all members of the mystical body of Jesus Christ, the maiden continues (457–68). Just as there is no "hate" or "gawle" (hatred or bitterness) between the members of one's own body, so that the head does not resent the arm or finger being adorned with a ring, in the same way we all behave "wyth luf and lyste" (with love and joy) to our fellow queens and kings of heaven.

Augustine had used a similar body metaphor to explain how the blessed are incapable of feeling jealous of each other: "No one will wish to have what

he has not received, and he will be bound in a bond of uttermost peace to one who has received it; just as, in the body, the finger does not wish to be the eye, since both members are contained within the ordered composition of the whole body."[196] This raises the issue of whether friendship is an aspect of the resurrection community of blessed souls. In the relevant *quaestio* in his *Summa theologiae* Aquinas was somewhat circumspect, emphasizing that in our future fatherland the fellowship of others (*societas amicorum*) will not be strictly necessary for happiness.[197] Man needs God alone; a human being "is wholly and completely fulfilled" in Him. On the other hand, heavenly fellowship is certainly conducive to "the well-being of happiness (*ad bene esse beatitudinis*)."[198] As Augustine says, the blessed will "see one another and rejoice in God, at their fellowship."[199] Peter Lombard had gone further (and much closer to the priorities of *Pearl*) in remarking that, "through the charity which shall be perfect in each of them, each will rejoice in another's good as much as he would rejoice if he had it in himself."[200]

That is a clear echo of one of the most enthusiastic (and influential) accounts of friendship beyond the grave to have been produced during the entire Middle Ages, the work of Anselm of Canterbury (c. 1033–1109) and his circle. It found favor with thinkers as different as Albert the Great,[201] Bonaventure,[202] and John Wyclif (to name just a few), a fascinating instance of how aspects of monastic theology could be retained and redeployed within scholasticism.[203] However, Anselm's doctrine posed many challenges to his successors, not least his belief in mutually supportive rejoicing among the heavenly host:

> . . . surely if someone else whom you loved in every respect as yourself possessed that same blessedness, your joy would be doubled for you would rejoice as much for him as for yourself. If, then, two or three many more possessed it you would rejoice just as much for each one as for yourself, if you loved each one as yourself. Therefore in that perfect and pure love of the countless holy angels and holy men where no one will love another less than himself, each will rejoice for every other as for himself.[204]

But this seems to imply that "the joy of all shall be equal"—that would mean that "the blessedness of all is equal," which certainly is not the case. Peter Lombard, who posed the problem in this way, resolves it with the argument that the joy of the blessed does not imply an equality of knowledge, and therefore "parity of joy will not bring about parity of blessedness."[205] The

Lombard offers another possible resolution, in the notion that "equality of joy" does not involve parity in terms of "the intensity of feeling of those who rejoice" but rather applies to "the communality of things in which joy will be found." All the blessed will rejoice in the things which bring them joy, but that is not to say that each and every one of them will experience the same intensity of joy.[206]

Wyclif's Phronesis tackles the problem with a distinction between objective and subjective rejoicing.[207] Any one of the blessed can rejoice in objective terms (which involves enjoyment of the joy of another), "but he does not have a subjective joy from the same joy, because then without a doubt anyone who is joyful would have as much joy as any other." And as a consequence "there would not be many mansions in the house of God"—an allusion to John 14:2 ("In my Father's house there are many mansions"), that crucial proof-text for a hierarchy in heaven and the paradise beyond, the existence of many degrees of blessedness, of *dotes* shared but not in equal measure. So, then, all the blessed are blessed, and rejoice "in the good of others," but this does not mean that they are "equally blessed formally" and experience the same joy "subjectively." "We do not defend or hold to the teaching of Anselm nor or of other doctors beyond scriptural authority save insofar as it is in agreement with reason," declares Phronesis.[208] Evidently Anselm's doctrine on glorified *amicitia* was widely held to be in agreement with reason—though some fine-tuning was necessary.[209]

So, once again, we find the *Pearl* poet in conformity with standard doctrine concerning the General Resurrection and the afterlife of the blessed. It is this which, above all else, sets *Pearl* apart from, for instance, the *Visio Tnugdali*, which is characterized by vernacular theology of a kind so bizarre and often at variance with the official discourses concerning hell, purgatory, and paradise that its normalization to conformity is no easy task.[210]

But there is nothing slavish about the *Pearl* poet's use of that doctrine. Particularly interesting is the way in which he transfers attributes relating to the glorified body to natural features or inanimate objects, as when he speaks of bright crystal cliffs (74, 159) rather than the crystalline (or rather, supracrystalline) qualities of the blessed, which manifest their *claritas*. A similar transference has occurred in respect of the attribute of *subtilitas*. In the *Summa Alexandri* the operation of "subtlety" ("which light has by its very nature") is compared to the way in which light penetrates bodies, "especially transparent bodies, as is evident in the case of the crystalline stone, which is penetrated by light."[211] In *Pearl*, however, it is the Heavenly Jerusalem which

possesses *subtilitas*—so "sotyle cler" are its buildings that even the Dreamer's unresurrected gaze can penetrate them.

> Thurgh wowe and won my lokyng yede;
> For sotyle cler noght lette no lyght. (1049–50)

[My gaze went through wall and dwelling; because of the transparent clarity, nothing obstructed the light.]

All such modulations find their rationale and ultimate resolution in the magnificent representation of the sublime cityscape as a vast treasure chest, the final and only true repository of all things precious, which the poet takes from the Apocalypse—reminding us over and over again that this is how "the apostel Jhon" (984) devised it, John's name being the link word repeated throughout section XVII.

I syye that cyty of gret renoun,	
Jerusalem so nwe and ryally dyght,	*new, royally adorned*
As hit was lyght fro the heven adoun.	*descended*
The borgh was al of brende golde bryght,	*city, pure*
As glemande glas burnist broun,	*gleaming, burnished bright*
Wyth gentyl gemmes anunder pyght . . .	*noble, set underneath*
(986–91)	

This, as the Pearl-maiden teaches her father (in an impromptu exegetics lecture), is the New Jerusalem, not to be confused with the city in Judea where the noble David was placed on his throne, and where Christ chose to suffer for humankind's sake (919–22, 939–42). But in medieval religious thought generally, the interpretive problem extended beyond that, to encompass the imperative of not being deceived into thinking that all those beautiful things described by St. John actually have a material existence in heaven. The spiritual sense of Scripture is one thing, the spiritual nature of heaven quite another. In the *patria* the "sotyle cler" bodies of men will live forever. But, of course, there will be no subtle buildings there, and St. John (as per the standard medieval argument) never meant to suggest otherwise. The paradise beyond death cannot accommodate either "wowe" (wall) or "won" (dwelling), just as it has no place for animals and plants. Hence Mechthild of

Magdeburg could relish the thought of the agile bodies of the blessed travel-
ing at high speed wherever they like in heaven, without ever coming to the
end of its streets of gold—while entering the crucial caveat that heaven does
not have streets paved with gold.

> . . . yet never can they [the blessed] touch or grasp an end of this kingdom.
> The expanse of space and streets of gold are overly large,
> And yet are the right size and not really golden.
> They are infinitely better than gold and precious stones.
> These things are completely of the earth and shall be annihilated.[212]

The representational needs of poets and painters—indeed, of all human
beings—should not obscure the theological realities. But what *were* the theo-
logical realities, what "infinitely better" things can appropriately be expected
of the homeland? In the remainder of this chapter I shall seek out some of
them.

Negotiating the Material

The authorized imagery of St. John's Apocalypse features prominently in a
crucial passage in the *Benjamin minor* of Richard of St. Victor (d. 1173), "who
in contemplation was more than man."[213]

> They [the Holy Scriptures] describe unseen things by the forms of visible
> things and impress them upon our memories by the beauty of desirable forms.
> Thus they promise a land flowing with milk and honey; sometimes they name
> flowers or odours and describe the harmony of celestial joys either by human
> song or by the harmony of bird-song. Read John's Apocalypse and you will
> find that the Heavenly Jerusalem is often described as being adorned with gold
> and silver, pearls, and other precious gems. Yet we know that none of these
> things are present in that place from which no good thing is absent.[214]

This praise of the Bible's imaginative style is heavily influenced by the "nega-
tive theology" of Pseudo-Dionysius the Areopagite, believed to be the philos-
opher converted by St. Paul in Acts 17:34, but probably a Syrian Neoplatonic
theologian who flourished around 500. According to his *Celestial Hierarchy*,
the Bible offers us figures, formations, forms, images, signs, symbols, and

veils (to use some of the terms employed by its medieval readers), whereby
the heavenly orders are manifested. This is a mark of God's infinite conde-
scension and goodness to His creatures. For our benefit visible beauties are
made to reflect the invisible beauties of heaven, sweet sensory odors are used
as emblems of the intelligible teaching, and material lights serve as a likeness
of the gift of immaterial enlightenment. According to the *Extractio* on *The
Celestial Hierarchy* by that later "Victorine" scholar Thomas Gallus (who
carried out his major work on Pseudo-Dionysius between 1232 and 1244),
"various material figures and figurative compositions" are used in the Scrip-
tures, "so that we, as far as each is able," through these "sensible forms" may
be "led back to the contemplation of the supernal virtues" which "cannot be
given any shape, and always remain the same."

> For it is not possible for our mind to be uplifted to that immaterial imitation
> and contemplation of the heavenly hierarchies, unless that same mind, in line
> with its present blindness, employs the guidance of material figures. It then
> realizes . . . that beauties which are accessible through the senses are images of
> invisible beauty, and that fragrances that please the senses are expressions of
> the distribution of fragrance which cannot be sensed, and that material lights
> are images of a light visible [only] to the intellect . . .[215]

So, then, things which are beyond human sense are "imparted to us in the
Scriptures under the guise of forms accessible to the senses."[216]

Such "material figures" work in an "anagogic" and "reductive" way (i.e.,
an elevating and transcending manner) to raise up the mind toward things
which are simple (because uncompounded) and pure. And they are necessary
for us human beings. Ultimately we may "contemplate the divine and intel-
lectual beings," explains Robert Grosseteste in his erudite text and gloss of
The Celestial Hierarchy, "yet we shall not be able to attain to this contempla-
tion unless we first use both the uplifting forms and material figures."[217] But
contemplation of "the divine and intellectual beings" is the ultimate point of
the exercise, and all earth-bound images must, at a crucial stage in the proc-
ess, be left behind in the soul's journey to God, since heaven and heavenly
intelligences have, in reality, nothing in common with them.[218] To fail to
make this transition is to run the risk of thinking that "the heavenly regions
are filled with large numbers of lions, horses, and similar animals, and that
God's praises are sung there in the form of lowing, after the manner of oxen,
and that angels fly like birds."[219]

In order to avoid such materializing mistakes, it is more appropriate to describe God in terms which do not signify what He is but rather what He is not, as when He is called *in*visible, *in*definable, and *in*comprehensible. Such is the methodology of the "negative way" of apophatic theology. It underlies the Pseudo-Dionysian preference for "dissimilar" over "similar" similes. An example of a "similar" simile is "God is light" (I John 1:5).[220] But "no light can worthily represent" God's all-surpassing divinity, as Gallus puts it.[221] "Dissimilar" similes feature when God is referred to as an ointment, a cornerstone, a wild beast, or indeed a worm.[222] These may seem quite shocking, but there is good reason for their use. Such similes do not allow the mind to rest and remain with them: rather it is incited to disentangle all material qualities from its thinking about God, since the corporeal analogies used in those symbols are so obviously remote from Him. "Our mind" is not allowed "to rest and be content with imagery which is so patently incompatible with the heavenly substances."[223] Even those who can easily believe that "the heavenly beings have the glitter of gold, or shine with the splendour of the fire and sun," will balk at the notion that "other celestial beings are like horses or cattle or lions or some other such creatures," explains Grosseteste.[224] "By the evidence of their materiality and corruptibility [they] most manifestly cry out that they are not the divine beings, but very far removed from them and very unlike them."[225] Imagery of this kind may surprise by its blatant unsuitability, even its ugliness, but it will not deceive.

Many of Pseudo-Dionysius's readers struggled with his preference for dissimilar similes. And little wonder, for it is a major reflex of the Neoplatonism which permeates so much of his writing, the influence of Plotinus and Proclus being marked. Furthermore, they display an inclination toward Monophysitism, the belief that the incarnate Christ had only one nature (predominantly divine) rather than two (the divine and the human). The extent to which Pseudo-Dionysius's thought falls within its parameters has been disputed; some believe that he was seeking to reconcile Monophysitism with the orthodox position on the nature of Christ as defined at the Council of Chalcedon in 451. Whatever the truth of that matter might be, his distrust of the body and things corporeal is obvious. And this, inevitably, posed problems for those who sought to relate Pseudo-Dionysian theology to mainstream belief concerning the resurrection of the body and its life in the paradise beyond. One of the ways in which Richard of St. Victor qualifies his author's views, in the passage from the *Benjamin minor* quoted above, is highly significant. We know, says Richard, that the "gold and silver, pearls,

and other precious gems" which adorn the Heavenly Jerusalem in St. John's account are not "present in that place *from which no good thing is absent.*" With which may be compared Mechthild of Magdeburg's confident assertion that, while "gold and precious stones" are "completely of the earth and shall be annihilated," something "infinitely better" does exist there.

Similar moves are made, again and again, in late medieval texts which seek to place Pseudo-Dionysian thought within a broader theological context that moderates its excesses. A good example is offered by the prologue to Bartholomew the Englishman's comprehensive celebration of the properties of natural things. This begins with the claim that it is not possible for the human wit to ascend to the "contemplacioun vnmaterial" of the heavenly hierarchies except through "material ledinge [leading, guidance]."[226] For which the authority of *The Celestial Hierarchy* is invoked. But Bartholomew goes on to remark that we cannot ascend to the contemplation of unseen things unless we are led by contemplation of things that are seen—and at this point, he alludes to what "the apostle seith" at Romans 1:20, "For the invisible things of Him, from the creation of the world, are clearly seen, being understood by the things that are made." We have encountered this text when discussing the way in which Adam, in his paradisal state, learned about the universe and its maker. It is, indeed, a key proof text of the *via positiva*, which takes its point of departure from the belief that knowledge of the divine is gained through a rational progression from creature to Creator, rather than through severance of the creature from the Creator, that being a risk endemic to Pseudo-Dionysian thought.

That risk may be quantified as follows. In *De theologia mystica* Pseudo-Dionysius speaks of the way in which "man is united to God as to something altogether unknown." But how does that square with the belief that, in the Beatific Vision which is "the final destiny of the redeemed,"[227] God will be seen in His essence? That being a nonnegotiable belief, following the 1241 Parisian condemnation of the proposition that "the divine essence itself will not be seen by either a man or an angel."[228] Thomas Aquinas tries to rescue his author with the argument that, in the passage in question, Pseudo-Dionysius was talking about "the knowledge we have as wayfarers (*in via*) journeying towards happiness."[229] *Homo viator*, man traveling to his ultimate destiny, indeed can (with an exceptional gift of divine grace) achieve union of that kind, but in the Beatific Vision God must, in some measure, be known. Otherwise human happiness will be compromised, for "there can be no complete and final happiness for us save in the vision of the Divine Essence."[230]

But the problem cannot be solved that easily. For here major cruxes of the first importance for Christian belief intermesh with representational problems of the kind raised by, for instance, St. John's depiction of the Heavenly Jerusalem. Likening God to light may well be misleading, as Pseudo-Dionysius claimed, but prophecies aplenty do forecast that heaven will be a lightsome place, with the divine radiance illuminating the habitation of the blessed, and the moon shining as bright as the sun and the sun shining with seven times its present brightness. At least some of this may be mere imagery of the kind which God, in his infinite condescension and goodness to his creatures, has provided for man's use. But there is *something* behind it. *Something* of the kind, however imperfectly we are able to grasp it, will really be present in the "new heaven and new earth." Angels may not "fly like birds" in heaven, or sound trumpets, but they will have a presence there, however hard it may be for humans to envisage. And, of course, the post-resurrection paradise is the ultimate home for certain blessed humans, whose glorified souls will harmoniously be united to glorified bodies. Actual bodies they will be, too, not spirits. That view was not a mere guess, for the schoolmen had to hand an authentic record of how a glorified body functioned—a gospel account of the most perfect body of them all, that of Jesus Christ Himself.[231] When the risen Christ appears to His disciples, they wonder if they are seeing a spirit. Whereupon He shows them his hands and feet, saying, "Handle, and see: for a spirit hath not flesh and bones, as you see me to have" (Luke 24:37–39). From this Aquinas deduces that all glorified bodies are palpable, capable of being touched.[232] The contrary view, that "at the Resurrection the body will be transformed into a spirit," had been denounced by Gregory the Great.[233] So then, the palpability of the bodies of the blessed must be recognized and respected, together with the senses and modes of thinking which are characteristic of any human body, however glorified. In the next paragraphs we shall consider how resurrection theology sought to do just that.

In the life after death, "the intellect (*intellectus*) will see God clearly"; by this means man will achieve the Beatific Vision. So claims Thomas Aquinas.[234] His teacher Albert the Great had similarly elevated the *intellectus*, claiming that this was the means whereby the soul is united with God. Albert says that in a commentary on Pseudo-Dionysius's *De mystica theologia* (1255);[235] other readers of the same author held strikingly different positions, as when Thomas Gallus and Robert Grosseteste downgraded the powers of the human reason and elevated the *principalis affectus* (Gallus's term) or *amor* (Grosseteste's term) as the supra-intellectual means by which the soul

achieves union with God.[236] But I will stay with Thomas Aquinas for the moment, given the sophistication of his negotiation of the material in the context of a (highly influential) account of how the senses will function in the resurrected body. In the following section I shall work with four of the *quaestiones* in the saint's *Sentences* commentary, following the fascinating convolutions of his Aristotelian interpretive model and occasionally interweaving the statements of other thinkers by way of clarification and elaboration.

Resurrecting the Senses

Granted that the divine essence can be seen with the eyes of the mind, can it be seen with the eyes of the body?[237] No, answers Aquinas. But corporeal sight will see it "as an object of indirect vision," since the divine glory will be perceived through glorified bodies, particularly the body of Christ. Augustine is quoted as saying that in "the bodily forms of the new heaven and the new earth" we will "perceive God with total clarity and distinctness, everywhere present and governing all things, both material and spiritual."[238] While on the old earth we "see the invisible things of God as understood by the things that are made" (Romans 1:20 again), there it will be like seeing men and not having to *believe* that they live but *seeing* that they live.[239] Here is quite a dramatic foreshortening of the process of the *via positiva*. Whereas in the fallen world man needs creatures, and nature in general, to enable him to proceed from "the things that are made" to "the invisible things of God," in heaven man will not need animal and plant life to perform that service[240]—and here is a major reason for their exclusion from the paradise of the blessed, as already explained. Through the intellect God will be seen immediately in His essence. And "the carnal eye . . . will be unable to attain to this vision." But corporeal sight will receive an appropriate solace (*solatium congruens*), because in the *patria* it will perceive God in the "bodily effects" of divinity (*in suis effectibus corporalibus*)—that is, "especially in Christ's flesh, and secondarily in the bodies of the blessed, and afterwards in all other bodies."[241] Aquinas probably has in mind the chapter in Augustine's *De civitate Dei* that he had explicitly drawn on in the *quaestio* with which I began this paragraph.[242] Offering alternative ways of understanding the role that bodily perception may play in the future paradise, there the saint speculated that perhaps "we shall see Him in every body to which the keen vision of the eye of the spiritual body shall extend."[243] But Aquinas's firm specification of the

glorified bodies of Christ and the saints, together with any other corporeal form (presumably the heavenly bodies) which will exist in the homeland, as "bodily effects" by which the divine may be perceived, is an important affirmation of the presence, and the value, of the material.

Glorification will not damage or render inoperable the "carnal eye," render it incapable of sensation, Aquinas insists. *Gloria non tollit naturam*: glory does not destroy nature.[244] Hence the human eye will retain its diaphanous character (*diaphaneitas*), with the intensification of clarity in its pupil rendering its sight keen rather than defective. Here sight, the noblest, strongest, and most subtle of the senses, is enthusiastically celebrated; its preeminence in the sensory experiences to be enjoyed by the glorified body affirmed. To go into more detail than Aquinas does at this point, it was believed that the human eyeball consisted of seven enveloping membranes or tunicles, which enclosed and separated several humors or viscous liquids, these being described respectively as "crystalline, glassy and white." The crystalline was located in the "middle or the "black" of the eye, and here sight originated, "for it fongith [receives] diuers formes and schappis of coloures as cristal doth," to cite Bartholomew the Englishman.[245] So, then, this crystalline quality of sight is utterly appropriate to the crystalline and lightsome resurrected body; here was its most perfect sense, the sense capable of greatest perfection because it was so alike unto itself. And the glorified body's intensified sight will perceive the wondrous light emitting from the resurrected bodies of Christ and His saints, along with all those static but shining heavenly bodies. According to late medieval theories concerning the functioning of sight, objects of perception were themselves light sources (rather than the passive recipients of sunlight or some other form of illumination, as we believe nowadays);[246] therefore, in the *patria* each and every "bodily effect" of divinity will send out rays, in accordance with the varying degrees of *claritas* which they enjoy. Far from obstructing this process of heightened sensory experience, the medium of the sense of sight—identified as the air in Aristotle's *De anima*[247]—will be utterly accommodating. However much this medium is filled with light, it will continue to function; indeed it will function better: "the more it is illumined, the more clearly are objects seen through it."[248]

Dante conveys such doctrine with impressive dexterity in Canto XIV (the "resurrection canto") of the *Paradiso*, where the two wreaths of illustrious souls encircling Dante and Beatrice—for whom hitherto St. Thomas Aquinas has been the spokesman—intuit this question: after the General Resurrection, if "the light wherewith your substance blooms will remain with you

eternally even as it is now," will it not hurt your sight? (Cf. Plate 24, a depiction of the encounter of Dante and Beatrice with Saints Dominic, Thomas Aquinas, and Francis.) In his response, the sage Solomon[249] explains that he and the other blessed souls will retain their *claritas* (to apply the technical Latin term) "as long as the feast of Paradise (*la festa di paradiso*) shall be"—that is, forever (37–39). And there is no risk whatever of their sight being damaged:

> ". . . per che s'accrescerà ciò che ne dona
> di gratüito lume il sommo bene,
> lume ch'a lui veder ne condiziona;
> onde la vision crescer convene,
> crescer l'ardor che di quella s'accende,
> crescer lo raggio che da esso vene." (*Paradiso*, XIV, 49–51)

> [". . . wherefore whatever of gratuitous light the Supreme Good gives us will
> be increased, light which fits us to see Him; so that our vision must increase,
> our ardor increase which by that is kindled, our radiance increase which comes
> from this."][250]

God will increase the light in the medium of the air, thereby enabling the renewed corporal eye to see with greater clarity other glorified bodies, and something of God Himself—perhaps through those abovementioned "bodily effects." This enhancement of vision produces an increase in ardor which causes the glorified body to shine even more brightly—seven times brighter than the sun, according to the real St. Thomas Aquinas. So, blessed souls will not merely retain "the light wherewith" their "substance blooms" (XIV, 13–14), but gain even more glory. And their bodily organs of sense will be strengthened accordingly.

> ". . . né potrà tanta luce affaticarne:
> ché li organi del corpo saran forti
> a tutto ciò che potrà dilettarne." (XIV, 58–60)

> [". . . nor will such light have power to fatigue us, for the organs of the body
> will be strong for everything that can delight us."]

Aquinas makes a similar case for the sense of touch. Nowadays it is activated when a man's animal body comes into contact with some external

object, thereby producing that considerable amount of natural alteration or immutation (*immutatio*) which—once again, according to Aristotle's *De anima*—is the cause of touch.[251] In the homeland, "impassible" bodies (i.e., bodies incapable of change) will, of course, be immune from such natural immutation; they cannot be changed in the way in which the hand becomes hot when it touches a hot object, or becomes fragrant through contact with a fragrant object.[252] But this does not mean that the sense of touch will cease to function. To help explain this, Aquinas turns to the body of Adam as it functioned in the first paradise, echoing part of the statement by Pseudo-Isidore of Seville with which our first chapter began.[253] The Edenic body "could neither be burned by fire, nor pierced by sword." But Adam did have "the sense of such things." The fact that he could not be burned or pierced to death did not mean he was unable to sense heat or the pain that a sword stroke would cause (not that he would have had any idea what a sword was, of course). On the contrary, the Edenic body was blessed with acute senses, though certain acute sensory experiences which (unfortunately) are possible in the fallen world were not available to Adam. By the same token, in the resurrected body, the sense of touch will not cease to function because most, if not all, of those specific tactile experiences possible in the state of misery are no longer available to it. The crucial point is that, in place of that natural *immutatio* which activates the sense of touch in the unglorified body, in the glorified body there will be a "spiritual" *immutatio*, a kind of reception which causes actual sensation "without changing the nature of the recipient."[254] Hence the organ of touch will experience sensation—true sensation—without being altered materially, just as the pupil of one's eye "receives the species of whiteness and yet does not itself become white."[255] Presumably Aquinas envisages such experiences occurring in encounters between glorified bodies and/or angels and Christ's resurrected body—these being "bodily effects" through which the divine may be perceived in that future existence.

A crucial clarification: the term *spiritualis* is being used here in a specific technical sense, a sense which is "not in accordance with its proper and primary signification, from 'spirit,' as we say that God and angel and soul are spiritual things" (to borrow an explanation from Roger Bacon, O.F.M. [d. c. 1292]).[256] Rather it describes an alteration or transference involving one of the sense organs that does not include anything material; that is, the form being transferred does not effect a physical change in the organ which receives it.[257] To adopt a helpful analogy provided by Eleonore Stump: on a city map the street pattern is transferred onto a sheet of paper without any features of

the actual streets being brought with it; the paper retains its original nature, not being altered materially by asphalt or concrete. So it may be said that "the configurational state" of those streets "is received 'spiritually' in the paper."[258] In like manner, the glorified body can experience an *immutatio spiritualis* in terms of sight or touch, without receiving "corporeally and materially the similitude of the thing which is sensed."[259] That body will remain just as it was, is, and always will be, even as it enjoys extraordinary sensory perceptions, far beyond anything that any earthly body can experience.[260]

So, then, it seems that, following the renewal of the human body at the General Resurrection, sight and touch will be in full operation. This is eminently plausible because, as Aquinas remarks in his *De anima* commentary, they are the highest of the senses, and "the only ones under our control."[261] But what about the senses of taste, hearing, and smell? Bonaventure thought that, in the homeland, tasting and smelling will not actually occur, and was dubious about hearing.[262] In similar vein, John Wyclif has the chief interlocutor of his *Trialogus*, Phronesis (= subtle and mature theology), consider the possibility that "only vision and touch will be excited there"; "the three mediate senses need not be present."[263] However, soon we see Phronesis backing away from such a definite pronouncement (this whole section of Wyclif's treatise is marked by a frank admission of the impossibility of achieving certainty in many matters concerning the Last Things). Phronesis does not want to claim that any "absolute power is lost" in the blessed soul. So, while on the one hand "she" would not wish to argue against the notion that certain powers will be "rendered dormant"—that is, will not actually function—on the other "she" is convinced of two fundamental principles: "nothing there would be superfluous," and "every perception of the soul and of its power" finds "its purpose in its function." Taken together, the implication is that all the senses must function in the *patria*. Sight, as ever, is easy to justify. "The vision of the blessed would see Christ, just as the intellect finds its consummate rest in its Deity." In other words, Christ's resurrected body may be perceived by the corporeal sight of the blessed. As a concomitant of this, Phronesis thinks that "every perception of the blessed finds its rest in this mediating Person according to the purity of its final act, one in this way, and another in another, just as it deserves." Which I take to mean that, thanks to the resurrected body of Christ, all the glorified bodies of the blessed will have something with which to exercise their senses in general, each according to its individual capacity.

Aquinas is far more positive than that. First, he notes the opinion of "some" (presumably he has Bonaventure in mind) that, even though the glorified body will have all the sensitive powers, only two of them, sight and touch, will be "in act," actually function, in the paradise beyond death.[264] But does that mean the other senses will be useless, lacking in *utilitas* (that crucial criterion again)? No, says Aquinas; by their presence in the resurrected body its *integritas* is maintained, and "the wisdom of their Creator" shown forth, which I presume means that God's ingenuity in creating such a complicated mechanism as man will be manifest. (We have encountered this argument before, for instance when the retention of the genitalia in the resurrected body was justified, in face of the objection that those organs are not needed for either procreation or urination.) But Aquinas regards that argument as insufficient; clearly he wants to believe that *all* the senses function fully in the glorified body. "All the senses in the blessed will be rewarded";[265] it would be a poor sort of reward if some of them ceased to function, were left with nothing to do. So Aquinas draws on the second book of Aristotle's *De anima*, reading it in a way supportive of the proposition that the other senses share media, spheres of operation, with sight and touch. In the case of sight the medium is the air; this is also the medium for hearing and smelling.[266] Furthermore, touch shares with taste the medium of contact, since, as Aristotle says, "taste is a kind of touch."[267]

St. Thomas has little to add here by way of defense of taste.[268] The German polymath Hildegard of Bingen (d. 1179) had termed it "the prince of all the senses," and a strong medical tradition pronounced it the most reliable sense inasmuch as it accurately judged the nature of anything it perceived.[269] Furthermore, taste is mentioned in some accounts of the other world intended primarily for the instruction of layfolk; hence the *Speculum humanae salvationis* includes it in a list of the sensory pleasures we may anticipate in the world beyond death.

There is alle manere beutee lustfulle to beholdyng,	*pleasant*
Alle armonye melodyouse that pertenes til hering.	*appertains*
There is alle delicacye vnto smelle suppetyng.	*pleasure, satisfying*
There is alle suavitee delitable to touching;	*pleasurableness*
There is alle manere swetnesse vnto tast influyng.	*exerting influence*
(4413–17)[270]	

But for the professional theologians, taste was the hardest sensation to maintain in the afterlife of the Blessed, because of its association with eating and drinking[271]—activities which have no place in the future paradise.[272]

They had much more to go on when it came to the "armonye melodyouse that pertenes til hering." For his advocacy of this sense Aquinas found useful material in the *Glossa ordinaria*.[273] In heaven there will be vocal praise (though "some think otherwise," he admits). Hence a gloss on Psalm 149:6, "The high praises of God shall be in their mouth," says that "hearts and tongues shall not cease to praise God," which means that they will continue to praise God in the afterlife.[274] And a gloss on Nehemiah 12:27, where the prophet describes a celebration in the earthly city of Jerusalem which involves singing and the clashing of cymbals, explains that similar festivities will occur also in the Heavenly Jerusalem. Aquinas, then, is insisting on the literal and material import of these scriptural passages.[275] They are to be read as prophecies which provide firm evidence of what will come to pass in the future, rather than prompts for allegorical interpretation of a kind which offers exhortation rather than actuality, seeks to move rather than prove.[276]

In the generation following Aquinas's death, the secular master Henry of Ghent (d. 1293) struggled with the problem of finding a naturalistic explanation for how vocal praise will be produced in the *patria*.[277] Henry thought it reasonable to assume that resurrected bodies will indeed engage in this activity, not least because it cannot be categorized with activities like nutrition, generation, digestion, and growth, all of which are associated with imperfection. Further, the body parts which make sounds and modulate speech, the lips and teeth, will not be hindered by any imperfection in that place, and therefore will be able to vocalize praise to a superlative degree. Henry remarks that we may think of the empyrean heaven (assumed to be the residence of the blessed) in terms of a large concave structure with an inner surface which encompasses those bodies—hence (one may infer) the acoustics of heaven will be excellent.[278]

However, Henry did not share Aquinas's confidence that air will be present there, air being the medium in which sound is generated and through which it travels to the ears of its recipients.[279] He raises the possibility that the empyrean may be "in flux," fluid rather than solid and continuous. If so, such a medium, rather than air, could enable *laus vocalis*. (Here we may recall Aristotle's belief that sound travels exceptionally well through water—as is demonstrated by the acute hearing of fish.)[280] But if the empyrean is solid and continuous, then a major problem arises, since it seems highly likely that

the glorious bodies themselves will be of the same substance as the empyrean. That would be akin to our present-day bodies being in the air without causing any division of the air into parts—meaning that sounds could not be produced, because (as Aristotle says) sound is not generated in air except by the rupture and compression of the air through the tongue, lips, and teeth.[281] Henry offers a possible explanation. In voicing sounds, we intercept the parts of the air by dividing them, through the harmonious interaction of the tongue, lips, and teeth. So, if the empyrean is indeed airless, could not sound be generated by similar interception of the parts of that heavenly region, through those same bodily instruments? (Henry is continuing to argue on the assumption that the glorified body is of the same substance as the environment in which it functions.)[282] Sound thus formed would be amplified all around; the glorified body would resound throughout the entire empyrean with the greatest melody—like the way in which, according to certain philosophers, the sun, moon, and stars make distinctive noises as they proceed in their set courses, producing a harmony of the spheres.[283]

At which point Henry gives up on the naturalistic explanations, and moves to invoke the miraculous (*recurramus ad miraculum*). In the empyrean the movements of tongue, lips, and teeth will form sounds, and, having been generated miraculously, they will be multiplied miraculously to reach the ears of all the individual saints. All the options, it seems, have now been exhausted. Henry signs off with the (rather abrasive) closing remark that whoever is unsatisfied with his treatment should work out for himself whatever will please him.

So, then, "armonye melodyouse" among the blessed appears to be a given, however tortuous the explanation may be, and whether the appeal is to the natural or the supernatural, to faith or reason. Considerable support for this belief (though, unsurprisingly, the schoolmen do not go there) is to be found in demotic visions of the other world like the *Visio Tnugdali*, wherein, we are assured, the glorious souls of the virtuously married are "always experiencing joy and exulting and persevering in praise of the holy and eternal Trinity," their voices diversely resounding like the way in which musical song is produced.[284] Proceeding deeper into heaven, Tundale enjoys hearing the martyrs and virgins singing "'Alleluia' to the Lord with a new song [cf. Psalm 95:1] and with a sweet melody,"[285] and, in the most striking of all this vision's auditory manifestations, the souls of "Monks and the Virtuous" are said to have voices which exceed "all other sweetness," yet do not "spend any labor in spreading them" as they sing to instruments which produce sounds without anyone seeming to play them. "For their lips did not seem to move

nor their hands bother to rise to the musical instrument, and yet each resounded a tune at will."[286]

However, all of this—the abovementioned scriptural passages along with Tundale's testimony—may easily be reduced to *visio imaginaria*, categorized as occasions on which God showed an inspired individual certain images which betokened other things (as when Pharaoh dreamed of the ears of corn; Genesis 41:5) rather than granting him that mental understanding and insight associated with the far superior *visio intellectualis* (as when St. Paul was rapt up to the third heaven; II Corinthians 12:2–3).[287] Perhaps those images of song and instrumental music are to be reduced to their allegorical significance through Pseudo-Dionysian analysis. But Aquinas will have none of this. He insists on the plausibility of the theory that hearing will be a fully functioning sense in the homeland. To argue otherwise would be to suggest that, in that place of perfection, the human body had not attained full perfection. Glorified bodies must be able to hear such praise, he declares, "for the perfection of the sense and for the sake of [spiritual] pleasure."[288] And, yet again, he seeks a rationalization in his version of Aristotelian perception theory. In the glorified body, hearing will be brought into act "by a purely spiritual immutation," which dispenses with the natural immutation that marks it nowadays. The parallel with the operation of touch is obvious.

The sense of smell required a more elaborate treatment, a more extensive appliance of science. It must be present in the future life, Aquinas suggests, because "the Church sings" of the "most sweet odor" of the "bodies of the saints." Perhaps he had in mind this antiphon for the Feast of All Saints: "In the city of the Lord, there resound constantly the instruments of the saints, there is the most sweet odor of cinnamon and balsam, there the angels sing their songs, and the archangels their hymn, before the throne of God, alleluia."[289] However, Aquinas may have been referring not just to a single text but to a wider, central tradition, that goes back to the fourth century at least. What emerged then, as Susan Ashbrook Harvey has described so well, was "the explicit association of sweet fragrance with the deaths, bodies, and relics of the saints and martyrs."[290] That association continued to exercise considerable power in St. Thomas's time, incense-like smells frequently being said to accompany the discovery of a saint's body, the opening of his tomb, or some miracle performed either during his life or, postmortem, by his relics.[291] Indeed, when St. Thomas's own tomb was opened by the monks of Fossanova, so that his body could be moved (or rather returned) to a position of honor before the high altar, "a delicious fragrance came out, filling all the

chapel and cloister." This testimony by Nicholas, Abbot of Fossanova, was cited as a proof of Aquinas's sanctity during the first canonization enquiry into his case, as conducted during September 1319.[292] Furthermore, visions of various forms of earthly paradise also featured "sweet smells and a multitude of flowers,"[293] as did descriptions of Eden itself (as noted in Chapter 1 above). Tundale and the Monk of Eynsham (whose vision is dated 1196) experienced many wondrous aromas during their otherworldly expeditions,[294] and we have already noted that, according to the *Speculum humanae salvationis*, "There is alle delicacye vnto smelle suppetyng [satisfying]" in the *patria*. Claims of this kind obviously encouraged the belief that smell will play some role in the future paradise. "Relics were literally pieces—promises—of the redeemed body in its glorified state."[295] So, if relics exuded the odor of holiness, how much more so should the bodies of which they were part, when rendered whole and renewed at the General Resurrection? The olfactory imagination has a basis in those present and future realities.

But, Aquinas asks, how can human smell possibly function in the land of the blessed, if one believes that it "is not perceived without a volatile evaporation consisting in a certain dissolution"? If this sense cannot be activated "without some corruption having taken place," then must it not be excluded from the future paradise, where there cannot be any corruption? Here Aquinas seems to have in mind the theory (which goes back to Plato) that smell involves "a smoke or vapour," thus possessing "a physical quality."[296] To cite the *Timaeus*, "smells always proceed from bodies that are damp, or putrefying, or liquefying, or evaporating, and are perceptible only in the intermediate state, when water is changing into air and air into water; and all of them are either vapour or mist."[297]

Aquinas's answer is that we should question that theory; if the science cannot explain what we know will happen in the homeland, then the science must be wrong. Drawing on Aristotle, he asks us to consider the way in which "vultures hasten to a corpse on perceiving the odor from a very great distance."[298] Clearly their sense of smell is not triggered by an evaporation of fumes (*fumalis evaporatio*), because even if the entire corpse were to dissolve into vapor those vultures would be too far away to perceive it.[299] The implication is that the same is true of glorified bodies: if we wish to believe (as Aquinas clearly does) that they have a functioning sense of smell, then they definitely do not need corruption to trigger it. (I wonder if this is the only instance, throughout the history of theology, of glorified bodies being compared to vultures in respect of some possibly shared aptitude.) Aquinas seeks

a way forward in the (supposed) fact that nowadays *some* degree of evapora-tion is indeed involved when we smell, because in our bodies "smell is mixed with humidity" (our brain being very humid). Therefore, in order for us to smell, some dissolution must occur. But, far from seeing humidity as neces-sary for the functioning of this sense, Aquinas pronounces it a hindrance. Our renewed bodies will be unhampered by humidity; in them "odor will be in its ultimate perfection." Consequently we will enjoy an acute sense of smell, being enabled to perceive the most minute of differences between odors. Which—to extrapolate from Aquinas's words—must mean that, in the *patria*, there will indeed be many differences between odors to savor. There, it would seem, the scent of salvation will percolate in its most wonder-ful form—thus maintaining an unbroken continuity with the exquisite aromas of Eden, the olfactory convictions of liturgical celebration, and the superlative fragrance associated with saints' relics and miracles, while their bodies still remained on earth, eager for their final glorification.

This completes my review of Aquinas's justifications of the belief that, in the glorified body, the senses will be not only present but fully functional—and indeed enhanced. My focus on Aquinas is justified by the inclusiveness of his thought on this matter, the fact that he is willing to countenance all five of the senses as being *in actibus* in the ultimate paradise. Thereby he tacitly makes the case that, for all the wonderful sensations which Adam enjoyed, for all the elaborate natural alterations or immutations (*immutati-ones*) which his encounters with Eden's abundant animal and plant life acti-vated, the sensory experience to be enjoyed by the blessed will be far superior. On the one hand, Aquinas insists that the glorified body will experience true sensation. Anything less, and "the bodily life of the saints after the Resurrec-tion" would be like sleep, a mere "half-life."[300] On the other, he offers us a glorified body in which the human senses will be perfected, comforted, rewarded. Perhaps one might even say "redeemed." Redeemed from the gross, sinful, and carnal activities in which they were involved, through human misuse and abuse, during the period between paradises. And such a "redemption" is quite ill at ease with the Neoplatonic distrust of the human body which often figures in Pseudo-Dionysian thought.

Somewhere over the Rainbow

When theologians spoke of "seeing" God with the intellect, it was generally assumed that a metaphor was being used to describe a cognitive process

which did not involve the human eye. Here Pseudo-Dionysian discourse was at its most effective. Biblical imagery which draws on earthly, material beauty must be interpreted allegorically as a metaphorical materialization of invisible beauty; "fragrances that please the senses are expressions of the distribution of fragrance which cannot be censed," and material lights represent a light visible only to the intellect (here I return to some of Richard of St. Victor's phrases). It worked well in respect of disembodied souls, located in heaven awaiting the General Resurrection; when those souls were reunited with their bodies, then the schoolmen were obliged to deal with the complex consequences of the fact that "glory does not destroy nature";[301] "in the Resurrection the specific nature will remain the same in man and in all his parts."[302] Here Pseudo-Dionysian discourse is at its least effective. With the renewal of the body, and the creation of a habitation suitable for it, at least some of those "similar similes" so distrusted by Pseudo-Dionysius will come to exist in reality. The elect will contemplate God with "the eye of the mind," Richard of Middleton remarks, even as "the corporeal eye" delights in His corporal effects—thereby moving from a metaphorical expression to a factual statement about the resurrected body.[303] Richard is talking about how, in the homeland, blessed bodies will enjoy the effusion of light. Light which will be perceptible by truly corporeal sensation, which will come from the divine radiance, from the blessed bodies themselves, and from those super-brilliant heavenly bodies which are, in a manner of speaking, enjoying *their* final reward. Materialization will no longer be a major exegetical hazard to be carefully guarded against, because the "new heaven and new earth" will, in some measure, accommodate the material (albeit in forms exotic and mysterious to the unglorified senses). The *via positiva* will be given a new lease of life, ultimately vindicated.

Nowhere are such ideas expressed more eloquently than in Augustine's powerful transition from Romans 1:20, which encapsulates the *per visibilia ad invisibilia* principle, to I Corinthians 13:12, with its promise of face-to-face knowledge beyond the "dark manner" of present understanding.

> In this life, we understand the invisible things of God by the things which are made [cf. Romans 1:20], and we see Him darkly and in part, as in a glass [cf. I Corinthians 13:12], and by faith rather than perceiving corporeal appearances with our bodily eyes. In the life to come, however, it may be that we shall see Him by means of the bodies which we shall then wear, and wherever we shall turn our eyes. . . . Whenever we shall look with the spiritual eyes of our bodies,

we shall then, by means of our bodies, behold the incorporeal God ruling all things.[304]

However the great schoolmen chose to engage with or elaborate upon this conviction, there is no doubt of the strength with which they endorsed it.

Its acid test came when they confronted the role played by the body in human happiness—that ultimate happiness beyond the grave. The schoolmen who endorsed Peter Lombard's assertion that the saints "shall have greater joy after the judgment than before"[305] offered systematic defenses of the body's role in enhancing both the joy and the knowledge of the resurrected saints. Their joy will be greater in extent, argued Aquinas, because then "their happiness will be not only in the soul but also in the body"; indeed, the soul will rejoice in the body's good as well as in its own.[306] An (Aristotelian) argument based on the relationship between operation and perfection is then offered. The more perfect a thing is in its being, the more perfectly is it able to operate. Since, as a general principle, the soul operates more perfectly when it is united to a body than when it is disembodied, it would seem that when the body in question is a glorified body, fully under the direction of the spirit, that perfection will be so much the greater.[307] Until this unification takes place the soul is, in fact, operating imperfectly, and hence its progress toward God is less intense.

That conclusion is qualified in Aquinas's *Summa theologiae*, where he asserts that, following the General Resurrection, happiness will increase not in intensity but in extent (*non intensive, sed extensive*).[308] The problem with claiming that the saints were more happy after the Last Judgment was its possible implication that they were less happy during their temporary residence in heaven, awaiting the Last Judgment and reunification with their bodies. "Extent" was a different (and relatively safe) matter, since it was easy to argue that human happiness increased in its extent when the happiness specific to the body was added to that of the soul. The positions which formed the dialectical extremes may be summarized as follows. One was that the souls of saints, when separated from their bodies, cannot attain happiness until Judgment Day, "when they will receive back their bodies."[309] But no medieval theologian could easily suggest that heaven was a place of anything less than perfect happiness. The other position was that the soul cannot be happy unless it is entirely separated from the body.[310] But that looks like a challenge to an Article of Faith.

Aquinas found a solution in a distinction between what is essential for man's perfection and what is "required for its full development."[311] For the former the soul alone is sufficient, whereas the latter involves the body working with the soul. However, the situation is more complicated than that. It could be the case (following a suggestion by Augustine) that what hinders disembodied spirits from "seeing the eternal substance as the holy angels do" may be the soul's natural yearning (*appetitus*) "to work with the body."[312] At the General Resurrection that hindrance is removed, when such desire "comes to rest" and the soul can indeed work with its renewed body. There is, in sum, nothing oppositional or disjunctive between the happiness of the body and the happiness of the soul. "Since it is natural for the soul to be united to the body," it is not "credible that the perfection of the one should exclude the perfection of the other."[313] The soul enjoys (in proportion to its individual merit) the Beatific Vision in which final and perfect happiness (*ultima et perfecta beatitudo*) consists.[314] However, thanks to its glorification, the renewed body attains that well-being (*perfecta dispositio corporis*) which is required for complete and entire joy (*beatitudinem omnibus modis perfectam*).[315] The soul and the body have beatitudes proper to them, and together they constitute total happiness.

Thus the invidious proposition that, in order to attain happiness, the soul "should be detached from the body," is routed.[316] Such dismissive thinking relates to the corruptible body, which weighs upon and burdens the soul, asserts Aquinas, but not to the glorified body, "which will be completely responsive to spirit." He explains (with some assistance from Augustine)[317] that the operations of the senses also belong to happiness, because at the Resurrection "happiness of soul" will overflow into the body (*fiet redundantia ad corpus*), "which drinks of the fullness of soul." In his *Sentences* commentary, Bonaventure similarly argues that happiness exists in the soul inherently and substantially, and in the body (when joined to the soul) through a certain *redundantia* (overflow) and *comparticipatio* (co-participation).[318] The same point is made more eloquently in his *Breviloquium*, where the four *dotes* which God bestows on the human body are said to perfect it in itself and also bring it into conformity with "the heavenly dwelling and the Holy Spirit." Through God, the pleasures and rapture of beatitude "flow from God the Head down upon the skirt of the garment, the body of man," in a supreme moment of unification of divine and human, spirit and flesh.[319]

A vivid vernacular account of that wondrously unifying "overflow" appears in the "resurrection canto" (as I have been calling it) of Dante's

Paradiso. Speaking for all the virtuous souls in the sphere of the sun, Solomon joyously looks forward to the paradise beyond death,

"Come la carne glorïosa e santa
fia rivestita, la nostra persona
più grata fia per esser tutta quanta . . ." (*Paradiso,* XIV, 43–45)

["When our flesh, sanctified and glorious, shall clothe our souls once more,
our person then will be more pleasing since it is complete . . ."][320]

Then the "effulgence (*folgór*) which already surrounds us [in heaven shall] be surpassed in brightness by the flesh which the earth still covers" (55–57)—that is, by their renewed and bettered bodies.[321] Solomon's words prompt an enthusiastically unanimous "Amen!" from the choruses of souls here present. It is clear that these saints and scholars long to have their bodies back. Nowhere has the soul's natural yearning to work with the body (as Augustine put it) been presented more powerfully. Dante's exultation is generally consonant with statements such as the following: "man cannot achieve his ultimate happiness (*ultimam felicitatem*) unless the soul be once again united to the body" (Aquinas);[322] "in order for the soul's happiness to be complete (*perfecte*), its body must return to it" (Bonaventure);[323] "there is not perfect blessedness (*perfecte beata*) before the Resurrection of the Body" (Giles of Rome).[324] But he is particularly eager to give "the flesh which the earth still covers" its due. Its return is necessary for full personhood, and that joyous completion is manifest by the dramatic increase in *claritas* here evoked. Dante skirts around the difficult issue of whether the soul's happiness increases when it rejoins its body (with the troubling implication that it may have been less happy while disembodied). He does not stray into territory which, in any case, became highly dangerous only after his death in 1321, when Pope John XXII—no friend to the poet during his lifetime—was attacked for his belief that perfect joy, full *visio Dei,* was not possible until the General Resurrection.[325] What Dante does seem to be saying is that, when the blessed soul and the blessed body come together, this complete *persona* glows more brightly than the soul alone can do in heaven.[326] A bold move in itself, but one less likely to provoke disquiet.

The structural principle on which the whole edifice of the *Comedy* rests is, of course, the status quo of hell, purgatory, and paradise, rather than that future *innovatio* which will bring forth a "new heaven and new earth." Canto

XXXIII of the *Paradiso* sees the climax of Dante's fictional reenactment of the ecstasy (*raptus*) which St. Paul experienced when was "caught up to the third heaven," taken "up into paradise" where he "heard secret words which it is not granted to man to utter" (II Corinthians 12:2–4). The Dante-persona's imagination, working at its fullest stretch, expires ("A l'alta fantasia qui mancò possa"), but, thanks to a "flash" (*fulgore*) of divine grace, his desire and will become one with "the Love which moves the sun and the other stars" (142–45)—arguably the most ambitious *coup de theatre* in the whole of medieval vernacular literature. But this moment is as brief as it is intense. Like St. Paul's rapture, as described by Aquinas, here is a transitory rather than an abiding form of vision.[327] The Apostle was not in a settled state (*habitualiter*) of blessedness, not blessed in the strict sense of the term (*simpliciter beatus*). Rather he had "a momentary actualization of that blessedness (*actum beatorum*)," this being analogous to the Dantean *fulgore*. In other words, Paul—and, one may infer, the fictional Dante-persona—was beatified in a restricted and limited sense rather than wholly and completely, a phenomenon quite different from that comprehensive overflow (*redundantia*) of blessedness over flesh which the glorified post-resurrection body will experience, with permanent effect.

The expiration of the *vis imaginativa*, the image-making power of the soul which transforms sense data into phantasms for the use of the intellect, is to be expected. It simply cannot function during human contact with the highest heaven, a realm which genuinely "transcends understanding," to apply that phrase which John of Damascus had related, far less appropriately, to Eden. Imagination plays a significant role in earthly happiness, since in this present life happiness consists in the proper function of the intellect, and the intellect is incapable of functioning without a phantasm (as Aristotle said). Thus reasons Thomas Aquinas.[328] But, he continues, earthly happiness is imperfect happiness. Perfect happiness consists in the vision of God, and disembodied souls, temporarily located in heaven, hell, or purgatory, cannot see the Divine Essence "by sense or imagination but only by the mind (*solo intellectu*)." Therefore the imagination cannot be involved in such vision.[329] Rather, the cognitive activity of the disembodied soul may be enabled by direct divine agency, as it receives "an influx of intellectual knowledge in the way in which angels receive it," without any bodily involvement, and without having to turn to phantasms as produced by the imagination.[330] This seems similar to the way in which the newly created Adam had a considerable body of knowledge bestowed upon him through divine "infusion" (*infusio*),

though the first human came equipped with all the external and internal senses necessary to gain understanding through his experience of Eden (senses which no doubt he put to good use, as long as he lived there).[331]

Furthermore, the disembodied soul can "understand through species which it received" (through the normal process of perception) "from things while it was in the body."[332] Because the intellect will survive death, those species will also survive, and continue to play a role in the soul's cognitive processes. One implication is that images and memories of our past life will not be destroyed. Rather they will be preserved in the intellect, "the abode of species" (as Aristotle called it),[333] where knowledge resides,[334] even though in a heaven of disembodied souls neither the imagination nor the memory can function (for they need a body to function). Denys Turner makes the point more vividly: "For Thomas, the human soul separated from the body is a functioning store of memories that it can continue to tell but can no longer edit, add to, or revise; it is a life frozen into the shape it possessed at the moment of death."[335] To return to Thomas's technical language: separated souls have knowledge of singulars "by being made somehow determinate with respect to them, whether by a vestige of previous knowledge (*cognitio*) or affection (*affectio*), or by divine dispensation." Therefore Aquinas finds it highly unlikely that in the afterlife souls are "ignorant of things that happen among the living on earth."[336] He and his contemporaries were fond of quoting Abraham's words to Dives in Hell, "Son, remember that thou didst receive good things in thy lifetime" (Luke 16:25), which they took as evidence that souls were indeed aware of good (and bad) experiences from their past lives.[337]

All of these mental processes will, no doubt, continue in the *patria*, though there the body will rejoin its soul and the corporeal processes of gaining knowledge will, one may assume, be reactivated, contributing to the understanding of the now-complete person as best they can. Fresh acts of external sense and internal sense will then be possible; in Bonaventure's words, "the glorified senses will know through the reception of species derived from sensible things."[338] Two ways of acquiring knowledge in the ultimate paradise, are, it would seem, being envisaged: directly, by means of the intellect (functioning in contact with the Beatific Vision), or through a much-enhanced version of the cognitive process with which we are familiar here on earth (as explored in the previous section of this chapter).[339] It is hard not to think of a two-track system, one fast and the other slow—and why would anyone want to bother with the slow, given all the instantaneous knowledge on offer?

But the schoolmen are eager to present a one-track, fully integrated, system, the unity of which expresses and implements the unity of body and soul.

Such are the complex consequences of the soul being "clothed again" in its "skin," and in its "flesh" seeing God (cf. Job 19:25–26). As far as the functioning of the reactivated body and its senses is concerned, the imaginative power will inevitably be well behaved (as Bonaventure thought it would have been in Eden, though Aquinas partially demurred).[340] Besides, it will have little if any chance of going astray, given that the objects of its perception will be the blessed bodies of Christ, the Virgin Mary, and the saints, together with the immobile sun, moon, stars, and spheres. There will be no quotidian world (the world we know) to work on, no way of acquiring the specific sense data which once was the beginning of human cognitive activity. All animal and plant life will have perished; no crag or rock, no dale, hill, or mountain will be present (to recall the rhetoric of *The Prick of Conscience*). Artistic activity of any kind, whether writing, painting, or sculpture, is impossible in this environment. None of the raw materials will exist anymore— there will be no marble to carve, no plants from which to make inks and paints, no sheep to provide parchment for the production of books. Even if such products could be obtained, the blessed would have no use for them. What need of mimesis of any kind or of any thing, when ultimate reality may be seen directly, thanks to the Beatific Vision?

The greater the knowledge, the more assured the cognitive process, the less room there is for the associative imagination, that power which can construct the image of a golden mountain and which enabled St. John and his successors to think of Jerusalem the Golden. However, in the here and now, we can find great comfort and consolation in such imagery, as the *Prick of Conscience* says.

Bot alle-if I kan noght descryve that stede,	*place*
Yhit will I ymagyn on myne awen hede,	
For to gyf it a descripcion,	
For I have thareto full gret affeccyon,	
And gret comforth and solace it es to me	
To thynk and spek of that fayr cete.	
That travaile may greve me nathyng,	*not displease me in any way*
For thare-in have I gret lykyng.	*pleasure*
(8870–77)	

Thus the poet's imagination of heaven as "a cete that war wroght / Of gold, and of precyouse stanes sere [many, various]" (8894–95), which follows the precedent of the Apocalypse but which he personalizes as his own mental work, is warmly justified.[341]

"I have recently thought of an interpretation (*consideracion*) that I should like to express here," says Nicole Oresme with equal enthusiasm, when, at the end of his "commentated translation" of *De caelo et mundo*, he breaks away from Aristotelian philosophy to offer a personal vision of the *patria*.[342] Given that so many blessed bodies will be present there, how can all of them simultaneously see Christ face to face? Proceeding *selon ymaginacion*, Oresme draws an analogy with "the common phenomenon which we call the rainbow." Two or more men who are differently aligned in relation to a rainbow cannot see its "arc in the same identical place, nor can they see it as a perfect arc" (i.e., no individual can see all of the arc), but "nevertheless, one man like the other sees it straight before his face." So then, why could not Omnipotent God "do something similar above the heavens—that is, in the supercelestial heaven, where the saved bodies would be situated"?[343] Surely God could "have the entire body of Christ and each of His members present throughout every part of this heaven in the same way that the colors of the rainbow are situated in every part of a cloud, except that Christ's body would be everywhere the same, even according to number. And thus will He show Himself, and each holy body, wherever it may be, will see Him face to face in his own shape."

Oresme alludes here to the anagogical (*anagogique*) imagery of the Bible (described as such "by the doctors of the Church"), but intimates that his image of the rainbow may well be more than a metaphor. "The Sage" (= Solomon) is quoted as saying, "Look upon the rainbow, and bless him that made it: it is very beautiful in its brightness. It encompasseth the heaven about with the circle of its glory, the hands of the most High have displayed it" (Ecclesiasticus 43:12–13). It seems from this that Solomon literally means (*a la letter entende*) the supercelestial rainbow, as opposed to "the one that we see here below in the dark and cloudy air," which "is not so glorious." Here, Oresme adds, we may find a means of understanding Apocalypse 10:1, where St. John speaks of a "mighty angel" coming "down from heaven, clothed with a cloud" and with "a rainbow . . . on his head."[344] Perhaps true prophecy is involved here.

Not content with one rainbow, Oresme risks a second. On earth we sometimes see "a second arc containing the first or principal rainbow," "all the

colors of this second arc" being "present throughout the entire cloud in which the two rainbows appear; and by nature more of them cannot appear. Therefore, we could possibly say (*par aventure*) that the body of the glorious Virgin Mary, which contained the body of Christ, is, as it were, the second rainbow and that these two glorious bodies so close to each other in nature are or will be throughout the entire heaven where the blessed bodies are."[345] Even more effusive praise of the "Virgin mother, daughter of thy Son" (*Paradiso*, XXXIII, 1) introduces Dante's use of the same image, in this case to render the triune Godhead visible to the (temporarily) strengthened sight of his persona, whose body is not yet (cannot yet be) blessed:

> Ne la profunda e chiara sussistenza
> de l'alto lume parvermi tre giri
> di tre colori e d'una contenenza;
> e l'un da l'altro come iri da iri
> parea reflesso . . . (*Paradiso*, XXXIII, 115–19)

> [Within the profound and shining subsistence of the Lofty Light appeared to me three circles of three colors and one magnitude; and one seemed reflected by the other, as rainbow by rainbow . . .][346]

Alta fantasia, however elevated, can soar no higher than this, and indeed Dante is dramatizing the imagination in an action which is at once a triumph and a failure (139–42). He is not, of course, affirming this rainbow encounter as a factual account of heavenly conditions, any more than was Oresme, who—caught between competing means of justification, the appeal to prophetic truth and the appeal to imaginative *consideracion*—plays safe by explicitly denying any such intention, professing his own humility and respect for "the majesty of the Catholic faith."[347] A little earlier Oresme had acknowledged that "no mortal man can know" the truth of such matters "without a revelation from God; even the greatest philosophers who ever lived were ignorant of many things and were mistaken and erred many times."[348]

Somewhere over the rainbow, way up high, there's a land that I've heard of Even (especially?) the greatest thinkers "who ever lived" were uncertain about what that land will be like, and obliged to speak *par aventure*. St. Augustine allowed himself to speculate about how different things may be—"In the world to come, then, the power of our eyes will greatly surpass what it is now. It will not do so merely in respect of the keenness of sight which serpents or

eagles are said to have; for those creatures, no matter how keenly they see, can discern nothing but corporeal substances. Rather, our eyes will then have the power of seeing incorporeal things"[349]—while admitting freely that he cannot possibly know "how the saints are to be occupied when they are clothed in immortal and spiritual bodies." "I have never seen it with my bodily sight"! And how could our present-day intellect possibly "comprehend so excellent a condition"?[350] "What shall we be? What shall we be like?" He cannot tell.[351]

Elsewhere Augustine confesses that he is "not able to answer satisfactorily all the questions that are ordinarily raised" about the General Resurrection, while stating that "a Christian must not doubt in any way that the flesh of all those who have been born and those who shall be born, of those who have died and those who shall die, shall be raised again."[352] This is a non-negotiable Article of Faith; the final lines of the Apostles' Creed affirm belief in the "vp-risyng als-so of my flesse, and lyf with-outen ende" (to quote a Middle English version).[353] Yet it is surrounded with uncertainty.

Some of St. Augustine's expressions of such uncertainty are quoted in Peter Lombard's *Sentences*,[354] where they are treated as *dubitationes* in the technical scholastic sense of the term—that is, issues presented for debate. For instance: at the Resurrection, shall the wicked rise again with the deformities which they had here on earth (this being a "usual" question to ask, according to Peter)?[355] Augustine leaves this matter "in doubt," he notes, citing the *Enchiridion*: "the uncertainty of the appearance or beauty of those whose damnation is certain and eternal ought not to weary us."[356] Such speculation is tiresome. And the Lombard adds many *dubitationes* of his own. For example: it seems clear that the sins of the damned shall be known to all, but what about the sins committed by the elect, those blessed souls who will spend eternity in the *patria*? Will they too become known, or erased from the record? "I have not seen this expressly stated (*expressum*) in Scripture," Peter says. So all he can do is offer a suggestion; one which, he hopes, is not unreasonable. "Those sins which have been revealed and blotted out here through penance, will not be revealed there to others; but other evils will be made public to all."[357] Full disclosure of unpurged sins seems the best bet.

There were uncertainties aplenty about the material conditions which will prevail in man's final habitation. Having said that the heavenly bodies will be bettered especially as regards their brightness, Thomas Aquinas (echoing a comment by his master Albert the Great)[358] remarks that God alone knows to what extent, and how, this will happen. Responding to that oft-cited prophesy that the moon will be as bright as the sun is now, while "the light

of the sun shall be sevenfold" (Isaiah 30:26 yet again), he affirms that the
bodies of the blessed will shine "seven times more than the sun"—while
admitting that "there is no authority or reason to prove this."[359] And what is
the *point* of adornments like the sun and moon in the land of the blessed? To
say that the heavenly bodies will then stand still, in their ultra-bright perfec-
tion (whereas in the Garden of Eden they actually moved, keeping plant and
animal life in existence), obscures rather than answers the question, why
exactly are they there at all?

That is not the question of some contemporary cynic. It was posed by
Peter Lombard, over nine centuries ago. "If it should be asked what the use
of the light of the sun and the moon is at that time, I acknowledge that I do
not know, because I do not recall that I ever read it in the Scriptures."[360]
Richard of Middleton did come up with an answer—it's all about pleasure.[361]
When heavenly bodies are gifted with an intensification of their brightness,
this is not on account of some deficiency in the resurrected body which
thereby must be met (in the way in which sunlight helps us to live our lives
here on the old earth). Rather this is a matter of the spiritual benefit which
accrues from the resurrected body's pleasure as God's creature. The corporeal
eye delights in the corporal effects of the divine, and therefore it is quite
appropriate to suppose that, together with the *innovatio* of the human body,
the light in heavenly bodies will be augmented, so the upgraded body will
receive with greater amplitude the flow of celestial light.

Throughout this discussion Richard appeals to what is *conveniens*—
appropriate, becoming, decorous—in what basically is guesswork. He does
not know for sure, cannot know for sure. The most secure thing that can be
said is: all shall be revealed. It is pointless to argue "like stammering dead
men" about the richness of the life of the blessed soul, every power of which
will work "most perfectly without any need for rest, purified in its most
perfect operating."[362] Here I am quoting Wyclif's personification of subtle
and mature theology, who confidently adds that "There, without doubt or
error we will understand according to the natural order."[363] Or, as Dante
puts it with far greater elegance,

> Lì si vedrà ciò che tenem per fede,
> non dimostrato, ma fia per sé noto
> a guisa del ver primo che l'uom crede. (*Paradiso*, II, 43–45)[364]

[Once there we shall behold what we hold true through faith, not proven but
self-evident, a primal truth, incontrovertible.][365]

Between Paradises

One foot in Eden still, I stand
And look across the other land.
The world's great day is growing late,
Yet strange these fields that we have planted
So long with crops of love and hate.
　　　　　　　　　　　—Edwin Muir[1]

At Genesis 2:9, it is said that "the Lord God brought forth of the ground all manner of trees, fair to behold, and pleasant to eat of." But, in the same verse, only two trees are named: "the tree of life also in the midst of paradise: and the tree of knowledge of good and evil." Does this mean that only two trees actually grew in the primal garden of delights? If so, it wasn't much of a garden—hardly an earthly paradise.

Bonaventure, who poses this question, proceeds to defend the honor of Eden's natural environment.[2] There was an abundance of trees there and no fewer than three types, as categorized in relation to their usefulness (*utilitas*) to humankind—whether to the body, the soul, or both together. The fruit-bearing trees of Eden appertained to the sustenance of man's body. The Tree of the Knowledge of Good and Evil appertained to his soul, having been placed in paradise to test man's obedience. The Tree of Life, which worked for "the perpetuation of human life," appertained to the conjunction of body and soul, because its function was to keep Adam alive, to hold his body and soul together. Only two trees in particular were named because of the extraordinary things they did, and this is also why the Lord placed them together in the very middle of paradise, the one beside the other. From the

one man learned about love; from the other, about fear. Those trees which merely sustained the human body were relatively unimportant and therefore did not merit a mention.

Here, then, is yet another example of how scholastic realizations of Eden vacillate between somewhat whimsical speculation about matters which seem to be (at least prima facie) of marginal importance, and uncompromisingly serious engagement with matters believed to constitute the very ground and foundation of human existence in this life and in the next. The bottom line within such inquiry itself, and when it came to deciding on which specific lines of inquiry should be followed, was the criterion of usefulness (*utilitas*), often used in contrast with curiosity (*curiositas*). In this context "curiosity" may be defined as the excessive desire for unsuitable, inappropriate, or forbidden knowledge, as prompted by intellectual pride. Thus Augustine condemned a "vain inquisitiveness" which is falsely "dignified with the title of knowledge and science," as pursued by those who "study the operations of nature which lie beyond our grasp, when there is no advantage in knowing, and the investigators simply desire knowledge for its own sake."[3] *Curiositas* originated in the Garden of Eden, Augustine claimed, when Adam and Eve plucked and ate the forbidden fruit, as driven by pride (the primal sin which precipitated humankind from paradise into misery).[4]

Peter Lombard detected this sin behind some questions frequently asked about paradise itself. "It is usual to ask many things regarding the first state of man before sin, namely what man was like before he sinned, both in respect to the body and the soul, and whether mortal or immortal, and whether capable or incapable if suffering; regarding the end of the lower life and the transition to the higher one; regarding the manner of propagating children, and many other things which it is not useless (*non inutiliter*) to know, although they are sometimes asked out of curiosity (*curiositate*)."[5] Some of his commentators were particularly perturbed by questions "regarding the manner of propagating children." In the state of innocence would there "have been in carnal union a corruption of integrity," asks Bonaventure; could Eve's womb indeed have been opened "without punishment and filthiness," as Augustine suggested?[6] This matter "has more of curiosity than of utility," he declares; *plus habet curiositatis quam utilitatis*. But since it arises from a statement by Augustine it has to be investigated, and Bonaventure proceeds to do just that, making a clear distinction between the perfections of Eve and the superior perfections of the Virgin Mary.[7]

Conflicts between *utilitas* and *curiositas* also arose when questions were asked about the end of days and General Resurrection. As far as the time of

the Last Judgment is concerned, "astronomers and other prognosticators ought to be held in check," warns John Wyclif, for they have no way of knowing the truth of this matter, which is, quite appropriately, hidden from us.[8] "Nobody save the fool concerns himself with when the proper time will be and when it will happen; the blessed Evangelist says that 'it is at the latest hour' [I John 2:18] but, as said, we remain thoroughly ignorant about the length of this hour, or whose hour it is. What, then, ought to occupy curiosity (*curiositas*) about that which God wills that we remain so ignorant? It is enough that we believe from the faith that this day will come, and that we pray from the merits of our lives that we will be saved on that day." These words are put into the mouth of Phronesis (i.e., "subtle and mature theology"). In the next chapter of the *Trialogus* Wyclif puts into the mouth of Pseustis (personifying "fallacious unbelief")[9] an expression of amazement that the doctors of theology should be opposed to one another on the number and nature of the *dotes* bestowed upon blessed bodies, matters which bear on that major (and indisputable) component of the Christian Creed, belief in the corporeal resurrection.[10] "Fallacious unbelief"—Wyclif's intellectual *agent provocateur*—is speaking here, and therefore to be heard with caution. But his frustration was widely shared.

Also widely shared was a *modus procedendi* for the proper conduct of such investigation, here expressed cogently by Aquinas. "Whatever goes beyond nature we grasp by faith alone; and all that we believe [by faith alone], we owe to authority. So in making any assertion we ought to follow the nature of things, except in those matters which are handed down to us by divine authority, for these go beyond nature."[11] Aquinas is discussing the physical strength which children begotten in the first paradise would have enjoyed, but his remark applies equally well to the methodology of speculation concerning the ultimate paradise. The geography of the *patria* devised by Aquinas *cum suis* accommodated what had to be believed by faith (such as the puzzling presence of those immobile heavenly bodies),[12] followed nature as far as possible, and asserted the otherness of the supernatural when that ceased to be possible. And the relationship between nature and glory was understood in terms of progression rather than destruction. Describing the "impassability" of blessed bodies, Aquinas assures his audience that this imperviousness to suffering will not interfere with that modification (*immundatio*) essential to sense knowledge, for they will use their senses for pleasure to the extent that this is compatible with their state of incorruption.[13] In his *Sentences* commentary Aquinas went beyond this in affirming that all five exterior senses will be "in act" in the homeland (as noted in our previous

chapter). The *Prick of Conscience* poet seems equally confident that, following "the glorifying of man" when "the body and saule" will come "togyder" (8640–41), the blessed will experience joy in all their senses:

> Thai sall have ioy in alle thair wittes
> In heven with God thare he syttes.
> First thai sall se with thair eghen bryght
> Many a fayre blysfull syght . . . (8644–47)[14]

Not just the eyes but the entire body will be "bryght," of course, thanks to the glorification process which, while not destroying nature, does render it rich and strange—as is made particularly clear by Albert the Great's *quaestio* on whether the interior members of the body, such as the heart, and the liver, will shine forth (*lucebunt*) or not.[15] There will indeed be differences in light within the interior body, Albert explains. *Claritas*, it would seem, is far from monochrome. Blood will shine as polished red gold, the animal spirits as clear light, the nerves as polished silver. The permeable exterior body will be porous rather than diaphanous, by which is meant a lack of total transparency. However, this porosity will not in any way obstruct or diminish the light sources within. Brilliant shades of gold and silver, beautiful lights of varying brightness, will all glow together through a delicate but indestructible membrane of what once was lackluster human skin. Here, then, is what happens when a natural body arises as a spiritual body; when the corruptible puts on incorruption, the mortal assumes immortality (cf. I Corinthians 15:44, 53). Yet it remains a human body still, recognizably the same body which walked the earth, no matter how transformative the effects of its renewal.

This body and its constituent parts are irrefutably physical, not mere figures of some higher and immaterial truth. The contrast with what Pseudo-Dionysius said about the body parts of angels, thus named in Scripture for their anagogic import, is striking—and theologically crucial. "It is possible to create images appropriate to designate the heavenly powers seen in terms of the individual parts of the body," Thomas Gallus writes in his *extractio* of *The Celestial Hierarchy*.[16] For example, "the human eyes are said to designate in celestial minds the very clear gaze of those minds as they look upon the divine light," whereas the "back signifies the joining up of all those powers which produce good works and all movements towards good, just as all the

ribs spring and flow from the spine."[17] The senses should be allegorized in a similar way:

> . . . the sense of smell signalizes in celestial minds the ability to receive the divine sweetness which pours its fragrance over the mind. . . . The sense of hearing signifies the power which the angels have of sharing in and receiving in a cognitive way the divine inspiration. The sense of taste signifies the ability to receive to satiety the forms of nourishment which can be taken in by the mind. . . . The sense of touch designates the knowledge which discerns those things which help nature from those things which harm it.[18]

However, this hermeneutic simply cannot work in respect of the resurrected bodies of humans, which signify and designate nothing other than themselves. Dante praised Pseudo-Dionysius as "that candle which . . . saw deepest into the angelic nature and its ministry."[19] But his monophysite theology saw insufficiently deep into the nature of those other denizens of the *patria*, souls no longer disembodied but clothed in flesh once more. "I shall be clothed again with my skin, and in my flesh I shall see my God" (Job 19:25–26).

In particular, Pseudo-Dionysius had a major problem with the notion of God being seen in the flesh, given his conviction that the divine "is beyond every act of mind and every way of knowing."[20] And this problem became even more acute in the disquisitions of his thirteenth-century scholastic readers. "Dionysius says in his *Epistle to Dorotheus*: 'The divine darkness is that unapproachable light in which God is said to live and it is invisible because of a superabundant clarity, and that light cannot be approached because of the outpouring of supersubstantial light.'"[21] Here I am quoting a quotation of the *Epistle to Dorotheus* by Albert the Great, which forms one of the "contrary" opinions in his *quaestio de visione Dei in patria* (written c. 1245–46). Of course, Albert proceeds to reject any suggestion that the beatific vision cannot be approached and attained by human understanding. He had no choice in the matter, since the notion that "the divine essence itself will not be seen by either a man or an angel" was the first of a series of ten propositions condemned at Paris a few years previously, in 1241. "This error we condemn," declared William of Auvergne, Bishop of Paris, "and we excommunicate those asserting and defending it. . . . We firmly believe and assert that God in His essence or substance will be seen by angels and all the saints, and it is seen now by all glorified souls."[22] This is, in itself, an "astonishing statement" (as Jeffrey P. Hergan robustly remarks), "because it affirms that a

finite created intellect can know the infinite essence of God."[23] And it calls in question an array of theological statements which appear to posit the opposite view—not only the words of Pseudo-Dionysius as quoted above but also passages in treatises by Saints Augustine and Chrysostom,[24] not to mention John 1:18, "No man hath seen God at any time." Further, some quite distinguished Parisian theologians apparently had held, or at least taken very seriously, such opinions before 1241. The Dominican masters Hugh of St. Cher and Guerric of St.-Quentin may have been among their number—and perhaps even Alexander of Hales, who, St. Bonaventure assures us, was fully behind the 1241 condemnations.[25]

The febrile intellectual context of William of Auvergne's "astonishing statement" may be better understood if it be recalled that this was a time of considerable anxiety concerning the impact on Christian orthodoxy of Aristotle and the Arabic scholars who traveled in his wake. Aristotle believed that the world was eternal, and the heavens will perpetually move to sustain the existence of human, animal, and plant life on earth. Consequently there was neither Eden nor *patria*, no first man or last man either; and certainly no General Resurrection following a cataclysmic end of the world. All of those shocking denials were condemned by a later Bishop of Paris, Stephen Tempier, in 1270 and 1277. They are usefully enumerated in the *Errores philosophorum* which Giles of Rome composed around 1270. Among the *errores Aristotelis* we find: "That the sun will always cause generation and corruption in the sublunary world" (no. 7), and "That the resurrection of the dead is impossible" (no. 9).[26]

Aristotle was, to be sure, no supporter of negative theology, but some of his Muslim fellow travelers were, and Giles duly takes Avicenna to task for erring on "the subject of the divine attributes": he held "knowledge and other perfections in God do not denote anything positive (*aliquid positive*) in Him, but are applied to Him only by remotion" (*per remotionem*, i.e., in terms constitutive of the *via negativa*).[27] Similarly, Alkindi is criticized because he believed that "it was unfitting to speak of God as the creator, the first principle and the Lord of Lords. For he held that the perfections which are attributed to God do not affirm anything positive concerning God (*nihil positive de Deo dicunt*)."[28] Giles believed that the *via positiva* is a secure way to God, since knowledge and other perfections *do* denote positive things in Him. And in Him there is much for the human intellect—suitably elevated, of course—to perceive. As William of Auvergne's definition of orthodoxy has it, the divine "essence or substance" will be seen not just by angels but by

"all glorified souls" as well. To which it may be added that, when those souls are reunited with their bodies, the senses will enjoy *their* reward.

But does this mean—to return to an issue raised in Chapter 3—that the soul cannot enjoy complete happiness until it is reunited with its body? Pope John XXII (who became pope in the year of Giles's death, and presided over Aquinas's canonization in 1323) seems to have thought so. The last phase of John's pontificate was marred by, inter alia, a controversy sparked by his assertion that full *visio Dei,* and therefore complete happiness, was possible only after the General Resurrection, the soul's bliss therefore being imperfect until then. (Concomitant with this was the idea that the final damnation of the wicked is deferred until the Last Judgment.) Why all the furore? After all, Peter Lombard had declared, "without hesitation it is to be believed" that the blessed "shall have greater glory after the judgment than before because their joy shall also be greater,"[29] and his commentators managed to come to terms with that proposition in one way or another (as indeed did Dante, in *Paradiso,* canto XIV).[30] Therefore it is hard to resist the suspicion that some of the objections to John's position were more political than theological: a beleaguered pope's many enemies seized upon an issue which ordinarily could have been contained and resolved within the schools, as a convenient means of discrediting him.

But John survived this assault, even as he weathered the controversy over Franciscan poverty, maintaining most of his power and living to a ripe old age. On his deathbed he at least partly recanted, maintaining the crucial qualification that souls in heaven see God face to face inasmuch as this is permitted by their condition as separated souls. John's successor, Benedict XII (who had participated in the controversy, taking a position counter to John's), attempted to draw a line under the debate by promulgating the bull *Benedictus Deus* (in 1336):

> . . . already before they take up their bodies again and before the general judgment, [blessed souls] have been, are and will be with Christ in heaven, in the heavenly kingdom and paradise, joined to the company of the holy angels. Since the passion and death of the Lord Jesus Christ, these souls have seen and see the divine essence with an intuitive vision and even face to face, without the mediation of any creature by way of object of vision; rather the divine essence immediately manifests itself to them, plainly, clearly and openly, and in this vision they enjoy the divine essence. . . . And after such intuitive and face-to-face vision and enjoyment has or will have begun for these souls, the

same vision and enjoyment has continued and will continue without any inter-
ruption and without end until the Last Judgment and from then on forever.[31]

So then, the Beatific Vision starts in heaven and continues unchanged *in
patria*. The concomitant (which the bull also asserts) is that "the souls of
those who die in actual mortal sin go down into Hell immediately (*mox*)
after death and there suffer the pain of Hell." However, on the Day of Judg-
ment they, and all other souls, "will appear with their bodies 'before the
judgment seat of Christ' to give an account of their personal deeds, 'so that
each one may receive good or evil, according to what he has done in the
body' [II Corinthians 5:10]."[32] That last clause is probably an attempt to
dispel the obvious objection that the damned have been judged and punished
already, so what more degradation could they possibly suffer following the
Last Judgment? The point Benedict evidently wants to emphasize is that the
bodies of the damned must accept their share of divine punishment. But
what, then, of the bodies of the blessed? Do they receive some proportionate
reward? Though he did not say so in his bull, Benedict believed—and here
he departed from the later Aquinas—that the Beatific Vision was more
"intense" (*intensus*) after the General Resurrection.

For the most part, *Benedictus Deus* settled the matter, though a few ripples
remained, as when, on November 9, 1368, the archbishop of Canterbury,
Simon Langham, censured the view of the Benedictine monk Uthred of Bol-
don (c. 1320–1397) that every human being enjoyed at death a "clear vision"
of God, as the result of which he or she was sent to heaven or hell.[33] The
problem with this was that it seemed to put the cart before the horse, the
vision before the judgment—and, why should the damned enjoy direct vision
of God? So, then, the issue of what happened to the soul from the time it
left the body to the time it was reunited with the body remained a troubling
one. During the English Reformation some theologians tried to solve it with
the doctrine of mortalism, according to which the souls of the faithful do not
proceed immediately to the beatific vision, but "sleep" until the General
Resurrection, when they will awake to rejoin their bodies.[34] Such ideas were
particularly associated with Martin Luther, and several early English reform-
ers, including William Tyndale and John Firth, found them attractive. How-
ever, John Calvin was vehemently opposed, and following the advocacy of
"soul sleep" by the Anabaptists, the Protestant establishment backed away
from it. Medieval precedents have occasionally been suggested, usually
unconvincingly, though a strange statement in Mechthild of Magdeburg's

Flowing Light of the Godhead gives one cause for pause. Here Mechthild is recording her vision of St. John, whose body (according to James of Voragine's *Legenda aurea*) had been assumed into heaven, like those of Christ and the Virgin Mary.[35]

> I actually saw the body of St. John the Evangelist with the eyes of my unworthy soul. He lies unburied[36] in great bliss above all corruptible things beneath the creation of the eternal kingdom.[37] His body has now taken on so much of divine eternity that it glows like a fiery crystal. He lies there so lovely in his human form, as though his spirit had fallen asleep in the midst of a heavenly rapture. His eyebrows are still brown; his eyes are closed and he is lying on his back. Beneath, above, and all around him everything is bright, and every seven hours the holy angels come to his body with a song of praise. . . . Between his body and the creation of the kingdom of heaven exists only a thin wall, like the membrane of an egg, and yet it is forever tough, so that no body is able to pass through it until the last day.

It seems that the saint's body is lying in state, honored by the heavenly host and sleeping until "the last day," when the boundary between the present heaven and earth will be broken and the "new heaven and new earth" created. Already it has taken on something of that crystalline glow which is one of God's gifts to the glorified body, but those brown eyebrows indicate that the process is far from complete—indeed, it cannot be completed until the General Resurrection.

However this extraordinary passage should be interpreted, Mechthild certainly believed that the General Resurrection brought greater benefits to the soul than it could possibly enjoy in heaven, no matter what wondrous pleasures were available there. Hence she speaks of how disembodied souls, albeit "all suffused with light and all permeated with love," do not have "the dignity" which they will enjoy "after the last day," when they shall be seated beside their Bridegroom. At which point "love shall come to love, body to soul, and they shall possess full power in eternal glory."[38] In yet another vision she sees the Virgin Mary in heaven,[39] not asleep in this case and certainly a "glorious vessel," but as yet "lacking the great adornment that the heavenly Father shall give to the bodies of the blessed on the last day. Our Lady shall be without it as long as the earth floats on the sea."[40] Here we may recall Dante's vivid anticipation of the time when the glory with which heavenly souls are already surrounded shall "be surpassed in brightness by

the flesh which the earth still covers," and "our person then will be more pleasing since it is complete" (*Paradiso*, XIV, 56–57, 43–45).[41] Indeed, there was a widespread assumption that the return of the body added something to the sum of human happiness, even though it was difficult to describe what that might be, and some schoolmen, visionaries, and poets were prepared to value its role and importance more highly than others.

Therefore, Caroline Walker Bynum has considerable justification for her claim that

> . . . the materialism of [such] eschatology expressed not body-soul dualism but rather a sense of the self as psychosomatic unity. The idea of person, bequeathed by the Middle Ages to the modern world, was not a concept of soul escaping body or soul using body; it was a concept of self in which physicality was integrally bound to sensation, emotion, reasoning, identity—and therefore finally to whatever one means by salvation. Despite its suspicion of flesh and lust, Western Christianity did not hate or discount the body. Indeed, person was not person without body, and body was the carrier or the expression . . . of what we today call individuality.[42]

But the situation was a lot more fraught than these attractive generalizations would suggest, the consensus (if indeed that term applies) more tentative and timorous.[43] "It makes no sense to see a deep concern with disciplining and experiencing the body and a tendency to express religious response in it as hostility toward or discounting of the somatic."[44] Indeed. However, it is difficult to affirm that position unequivocally, in face of the sheer volume of medieval writing which is deeply (and sometimes, it could be said, pathologically) concerned with disciplining the body. In my view, the notion that "self is by definition embodied" falls somewhat short of what Bynum calls a "conviction,"[45] given the vast number of scholastic affirmations of the full spiritual functioning, total intellectual satisfaction, and utter spiritual happiness of the disembodied soul in the heaven which currently is in existence, pending the creation of the *patria*. These discussions are a common feature of late medieval commentaries on book four of the *Sentences* and of quodlibet literature, in vogue long before the specific controversies which produced *Benedictus Deus*. In reading them, it is easy to wonder if there is any real need for the body to return.

For a grand narrative which postulates the ultimate victory of the body as a crucial constituent of selfhood, I would substitute one of incessant battle

for the soul of Christianity—or, more accurately, for the dignity of the soul incarnate within the Christian ideology of salvation. That battle comprises many encounters of the first historical importance: Irenaeus of Lyons (c. 140–200) arguing for a "compensatory" afterlife of corporeal fulfillment and material blessings against Gnostic Christians "who felt that the present world was intrinsically bad and probably the work of an evil god."[46] St. Augustine struggling to reconcile the orthodox imperative of belief in the General Resurrection with the attractions of a Manichaeistic dualism which emphasized the sinfulness of the flesh (as encapsulated in the sexual act) and prompted a vision of an afterlife wherein ascetic *contemptus mundi* was rewarded with purely spiritual joys, as humans came close to enjoying an angelic existence. (The later Augustine modified such views considerably, as his *Retractions* attest.)[47] And, within late medieval scholasticism, the standoff between (Neo-)Plato and Aristotle, between *via negativa* and *via positiva*, between a legacy of monasticism which saw heaven as a continuation of the communal life of the monastery and the new philosophical and medical doctrines (predominantly of Arab transmission) which necessitated a radical reappraisal of the relationship between body and soul, and hence of the ultimate happiness of the reunited body and soul.

Again and again we encounter medieval writers expressing a distrust of physicality so profound that the higher valuations of "sensation, emotion, reasoning, [and] identity" which were sometimes possible while speaking of paradise were set at naught, occluded in ways which can have the appearance (if not the reality) of willfulness. This point may be developed through a contrast between discordant views expressed by Mechthild of Magdeburg and Bridget of Sweden, which show them assuming different attitudes—at least in the texts I have chosen—to the common default position of bruising body "to pleasure soul."[48]

En route to Vadstena with members of her household, Bridget experiences a vision in which a religious, "a man of great erudition in the science of theology but full of guile and diabolic malice," poses a series of aggressive questions to Christ Himself, as Judge. "You have given me eyes," this contrarian says. "May I not see with them those things that delight me?" To which Christ answers, "I gave you eyes that you might see evils to be fled and healthful things to be kept."[49] "You have given me ears. Why am I not to hear with them those things that please me?" Christ answers, "I gave you ears that you might hear those things that belong to truth and honesty."[50] "Why have you given me limbs for my body if I am not to move them and

exercise them as I will?" Christ answers, "The body's limbs are given to man so that they may represent for the soul a similitude of the virtues and be for the soul, as it were, its instruments for duty and virtue."[51] And so on. The fearsome Judge insists that man was given corporeal senses and intelligence "so that he might consider and imitate the ways of life, and flee the ways of death."[52] Foods and other delights were given "for the body's moderate sustenance and so that it might more vigorously execute the virtues of the soul and not be weakened by excessive consumption."[53] Men and women were given "sexual organs and the seed for intercourse" not so that it may be "spilt according to the appetites of the flesh," but rather that "it might germinate in the proper way and in the proper place and that it might bear fruit for a just and rational cause."[54] The complainant's allusion to his own handsomeness (*pulchritudo*) and noble descent is met with the crushing retort that what he received from his "father was worthless, putrid, and dirty"; "in your mother's womb you were as if dead and totally unclean."[55] For those reasons, and a lot more (I have been paraphrasing Bridget drastically), "it is necessary to be devoutly cautious, to weep, and to pray," so as "not to deviate from the way of heaven."[56]

"But why," asks Bridget's remarkably persistent religious, "must I hate the world's beauty?" To which Christ replies,

> "Friend, the ugliness (*vilitas*) and the beauty (*pulchritudo*) of this world are like bitterness and sweetness. The ugliness of the world—which is its contempt and its adversity—is a profitable sort of bitterness that heals the just. The world's beauty is its prosperity; and this is a flattering sort of sweetness, but false and seductive. Therefore he who flees the beauty of the world and spits out its sweetness will not come to the ugliness of hell or taste its bitterness but will ascend to my joy. Therefore, in order to escape the ugliness of hell and to acquire the sweetness of heaven, it is necessary to follow after the world's ugliness rather than its beauty. For even though all things were well created by me and are all very good, nevertheless one must beware especially of those things which can furnish an occasion for the loss of the souls of those who use my gifts irrationally."[57]

Nothing in nature lacks "a cause or a use," the Judge affirms, and "I, the wonderful and incomprehensible God, may be known and honored by mankind out of admiration for my wisdom in the creation of my so many creatures."[58] Evidently Bridget has Romans 1:20 in mind. But the positive

message of the *via positiva* is somewhat diminished here, with the emphasis falling rather on the notion that "man . . . is like a boy nurtured in a prison, in darkness. If one were to tell him that light and stars exist, he would not believe because he has never seen."[59] Similarly, "ever since man deserted the true light,"—that is, since the Fall—"he delights only in darkness."[60] Indeed, man has reason to be thankful for the actual darkness of night and of the winter months, for it gives him some little respite from the great burdens he must bear. Even further, the light and darkness which he experiences in this fallen world function to remind him of what he has lost (Eden) and what he may gain (the *patria*):

> ". . . light has been made so that man, who has a common bond with higher and lower beings, may be able to subsist by laboring in the day and remembering the sweetness of the everlasting light that he lost. Night has been made that he may rest his body with the will of coming to that place where there is neither night nor labor, but rather everlasting day and eternal glory."[61]

But the prospect of any mere mortal of "coming to that place" seems rather bleak. The Christ of book five of Bridget's *Revelationes* talks like a withholding and jealous God, who ensures that His saints "are not heard or seen, as they now exist, in order that all honor may be shown to me and that man may know that no one is to be loved above me."[62] Here is a creator who seems scarcely accessible by His benighted creatures, as they live trapped in their perishable bodies and hindered by the "frailty of flesh." The specter of Gnosticism, or some similar iteration of radical body-soul dualism, seems to haunt Bridget's disquisition.

However, its specific purpose must be recognized and appreciated. Bridget is trying to put a smart but diabolic straw man in his place, and here (as ever) she fights to win, eschewing half-measures and concessions. Nevertheless, there is a striking difference between the attitudes to nature and the human body she conveys in book five of the *Revelationes* and the discourse of the *via positiva* which permeates so much of Mechthild of Magdeburg's *Das fließende Licht der Gottheit*. An excellent example is afforded by the chapter in which "a Bride" (one of Mechthild's self-projections) "who is united with God" enters into dialogue with His other creatures—indeed, with creation at large. When the creatures ask, "can't this beautiful world and all the good it contains console you?" the Bride answers "no," because she "sees the snake of deceit and how treacherous cunning slithers into all the pleasures of this

world."[63] But here is no totalizing iteration of *contemptus mundi*; we are dealing with a passionate desire to have "this world" exceeded, not rejected. Its "taste" is valued highly; to give it up in favor of the all-surpassing "sweet pleasure of the Holy Spirit" is no small thing, but a move of major significance.

The Bride wishes to be taken to the source of all that is good, "the sparkling sun of the living Godhead" which "shines through the bright water of cheerful humanity." Far from any sharp dissonance between the corporeal and the spiritual being in play here, the prevailing mood is of consonance, as the Bride asks all creatures to praise God with her and for her, thereby recalling their origin in Eden.

> I send all creatures to court
> And bid them that they praise God for me
> With all their wisdom,
> With all their love,
> With all their beauty,
> And with all their longing,
> Just as they were created by God in innocence.[64]

Thus a choir of creation praises God—and consequently the Bride "feels no pain." Mechthild is "no advocate of pain," as Bynum has insightfully noted.[65] "Lady Pain" was "born from Lucifer's heart," Mechthild has Christ unequivocally assert later in this same chapter. Christ may have "loved" Pain during his time on earth, inasmuch as He suffered for humankind, and this "Lady" may have led many holy people to heaven,[66] but "she" herself is barred from entry into its kingdom. Here is an impressive climax to a chapter which displays an acute sensitivity to the spiritual relativities of existence as it was, as it is now, and as it will become.

Mechthild's *Flowing Light of the Godhead* shows no interest in following "after the world's ugliness rather than its beauty." The extreme opposite is true of *De miseria condicionis humane* of Pope Innocent III (d. 1216), otherwise known as "the wretched engendering of mankind"—from the title of the English translation which we know that Geoffrey Chaucer made but which has been lost. Taking as his point of departure Genesis 2:7, "The Lord God formed man of the slime of the earth,"[67] Innocent avers that slime is inferior to the other elements, and indicates man's worthlessness. It is hard not to find here a large measure of "hostility toward . . . the somatic."

[God] made the planets and stars from fire, made the breezes and the winds from air, made the fish and the birds from water, made men and beasts from earth. If man therefore considers the creatures of the water, he will discover that he is vile; if he considers the things of the air, he will know that he is more vile; if he considers the things of fire, he will consider that he is most vile. He will neither be able to make himself equal to the stars nor dare to prefer himself to earthly things, because he will discover that he is equal to the beasts, will know that he is similar. "Therefore the death of men and of beasts is one, and the condition of them both is equal, and man hath nothing more than beast. Of earth they were made, and into earth they return together" (Eccles. 3:19–20). The words are not those of just any man, but of wisest Solomon.

As argumentation, this is totally specious—a tissue of selective and/or partial quotations, with concepts being wrenched from the contexts which determine their meaning. And easily refuted with standard scholastic doctrine, as I will now illustrate, drawing on material from Aquinas and Bonaventure. Everything said in the next paragraph is either direct translation or paraphrase of their words.[68]

God bestowed perfection on all his creatures "according to their capacity." Man may be inferior to the angels, but he is superior to the animals. The human body is fittingly made of all four of the elements, so that man might have something in common with both the superior bodies and the inferior bodies, being positioned between spiritual and corporeal substances. In a manner of speaking, "all parts of the created world are to be found in him one way or another," whence he is called a "little world or microcosm."[69] There is nothing derogatory about "slime," for it is simply a mixture of earth and water, two of man's component elements, all four of which are mingled in an even balance which is appropriate to his status in the order of being. Fire and air are there also—albeit in smaller quantities, to ensure that they do not dominate in that mingling, unbalance it. Those elements are not mentioned in connection with the composition of man for the simple reason that they are not mentioned *anywhere* in the entire biblical account of creation. Scripture was originally written for the uncultured, and since fire and air were not "very evident to primitive people (*a rudibus*)," not perceptible by their senses, it did not include mention of them.[70] It is quite true that, considered in themselves, heavenly bodies like the stars and planets are nobler than earthly bodies. But the human body has the greatest nobility because it is perfected by the noblest form, which is the rational soul. And thanks to

the rational soul man is immortal, whereas beasts are corruptible, and hence absent from the homeland.

But what, then, of the comparison between men and beasts made by "wisest Solomon," as Innocent called him? At that point in Ecclesiastes Solomon is speaking in the person of a foolish man, says Aquinas.[71] It is false to say simply that "man hath nothing more than beast," for "death comes to both alike as to the body, but not as to the soul."[72] Bonaventure responds similarly to the same passage of Scripture (i.e., Ecclesiastes 3:19–20); this is spoken by a man who "works according to a carnal understanding," thinks only of exterior things.[73] The wise man, Ecclesiastes the preacher, who speaks at the end of this book, knows full well that this is an error, and "for every error God shall lead thee unto judgment" (Ecclesiastes 12:14).

I am not suggesting that Pope Innocent should be led into judgment for his misrepresentation of Solomon, or (even more fundamentally) for his denigration of the human body, which deserves respect at least inasmuch as it was made de novo for Eden and renewed for the *patria*. Innocent was a trained scholastic debater (as well as a highly effective and often ruthless politician), and he could easily have offered a refutation of the kind sketched out above. Indeed, it's easy to imagine him thinking of "contrary opinions" even as he penned the harangue I've quoted. But the fact of the matter is, he *did* write that harangue, without qualification or explanation of the bigger picture. He was not alone. An abundance of similar anti-corporeal assertion exists, a corpus of material which discloses an editing-out of the positive valuations of the human body which were possible when, within due academic process, it was placed in paradise. What we are witnessing in *De miseria condicionis humane* and its cognates is an egregious totalizing of conditions which appertained between paradises to fill the entire conceptual space. True, a lot of time has passed—indeed, is continuing to pass—between paradises. But eternity surpasses time; there is and there will be (if the quantifying metaphor may be permitted) a lot more of it. Had Adam and Eve stood fast the first paradise would have been a prelude to eternity; the last paradise will exist within it. So, then, *sub specie aeternitatis* the economy of salvation which came into existence after the Fall is, in Boethian phrase, a mere speck, fleeting and fugitive in its temporariness.

John Wyclif once remarked that the moral virtues as delineated by Aristotle had no place in the state of innocence, because the behaviors which they define and seek to regulate had not yet begun.[74] Further, the high esteem in which virginity is held in our present dystopia was widely regarded as having

been placed in its historical context—a context which denies it universal value—by the initial instruction to be fruitful and multiply. In Eden this commandment applied to everyone, Bonaventure says; anyone abstaining from the work of procreation would have been in breach of the divine command (which is not to say, as he is careful to make clear, that such work was to be done every minute of the day).[75] At that time men were not inclined to impurity, he explains. "To control oneself was no better than to marry"; indeed, marriage and the generation of offspring were obligatory. Nowadays, however, not everyone has to follow the order to be fruitful and multiply; a sufficient number of people do produce offspring, while others preserve their virginity.[76] Given present-day conditions, including the great difficulty of self-control, virginity now "belongs to great virtue and dignity."[77] The same is true of continence. Aquinas says that "in the state of innocence no particular esteem would have attached to continence, which is esteemed in this present time not for its lack of fruitfulness but for its freedom from disordered lust. But in that time there would have been fruitfulness without lust."[78]

What, then, of other kinds of behavior which nowadays "belong to great virtue and dignity," such as fasting and mortification of the flesh? Bonaventure says that Adam was commanded to eat from the trees of Paradise and of course he would have obeyed (at least, it may be added, right up to the time when he ate the forbidden fruit). Besides, his robust and finely balanced constitution would have regulated itself, in terms of how much food it needed, and when. A "well-instituted nature would have dictated" the appropriate behavior in terms of physical well-being, for nature "dictates that no one ought to lay hands upon oneself," engage in self-harm.[79] In sum, whatever food prohibitions and inhibitions may have arisen after the Fall, they did not exist in Eden. Fasting was simply not an option, and holy anorexia would have been unthinkable—a perversion of nature, an act of disobedience to God, an affront to the divine plan. Such relativism is quite absent from Innocent's treatise. There the world is predominantly a thoroughfare of woe, rather than an interregnum between realms of perfection which tacitly set limits on, maybe even subvert, many of the values and actions which, under current but temporary conditions, are associated with spiritual success.

De miseria condicionis humane ends with chapters on hellfire, the unspeakable anguish of the damned, the unfailing supply of torments which they must endure, and the total absence of anything which might help them. Innocent is nothing if not consistent. That later theoretician of human misery

John Calvin does include in his *Institutes* a chapter on the General Resurrection and "eternal felicity." But it is remarkably short, and its author is anxious "to cultivate sobriety in this matter, lest unmindful of our feeble capacity we presume to take too lofty a flight, and be overwhelmed by the brightness of the celestial glory. We feel how much we are stimulated by an excessive desire of knowing more than is given us to know, and hence frivolous and noxious questions are ever and anon springing forth."[80] Calvin believed that St. Paul styled the Resurrection a mystery to exhort "us to soberness, in order that he may curb a licentious indulgence in free and subtle speculation." Unfortunately, "men puffed up with vain science . . . leave not a corner of heaven untouched by their speculations."[81]

> Alluring speculations instantly captivate the unwary, who are afterwards led farther into the labyrinth, until at length, every one becoming pleased with his own views there is no limit to disputation, the best and shortest course for us will be to rest contented with seeing through a glass darkly until we shall see face to face. Few out of the vast multitude of mankind feel concerned how they are to get to heaven; all would fain know before the time what is done in heaven. Almost all, while slow and sluggish in entering upon the contest, are already depicting to themselves imaginary triumphs.[82]

Here we may recall the schoolmen's anxiety about matters which have "more of curiosity than of utility," particularly Wyclif's impatience with those who indulge their curiosity "about that which God wills that we remain so ignorant."

But, generally speaking, the Catholic theological systems of the late medieval and early modern periods were more tolerant of speculations which sought to touch every corner of heaven than were their Protestant counterparts. The *Tractatus de glorificatione sensuum in paradiso* of Bartholomaeus Rimbertinus, which was published in 1498, is an excellent case in point. Following a preface in which St. Thomas's affirmation of the total functionality of the senses *in patria* is endorsed warmly, Bartholomaeus proceeds to a sense-by-sense account of the wondrous pleasures which the glorified body will enjoy. Take sight, for instance. This will be so acute that even the slightest variations in color and shape will be discernible; it will not be impeded "by distance or by the interposition of solid bodies"—for it can see right through them. Following his ascension into heaven, had Christ wished to look upon his mother "still on earth and at prayer in her chamber," neither

extreme distance nor solid wall would have blocked His vision. And no part of her body would have been hidden to Him. For the blessed can see all sides, the front and rear, of an object simultaneously—"the face through the back of the head."[83] A few years later, Celso Maffei (1425–1508), abbot general of the Canon Regulars of the Lateran, published a similar treatise, entitled *Delitiosa explicatio de sensibilibus deliciis paradisi.*[84] The problem of posthumous taste which had so troubled Aquinas and his contemporaries is here addressed with the confident assertion that "The body of the lowest saint will taste fifty times better than honey, sugar, or some natural or artificial drink of this world; another saint will taste a hundred times sweeter, and a third one more than a thousand times better—and so on."[85] On this reasoning, degrees of heavenly reward have direct saporific consequences; the better the saint, the better he or she will taste. And touch—the sense so compromised by its contact with the carnal—will also be accentuated to a level unthinkable on the old earth. Blessed bodies can embrace each other, and Christ can embrace them. Furthermore, kissing will be a common occurrence—and (as in the case of vision) distance will be no object, because the blessed will be able to exchange kisses even though their bodies are thousands of miles apart in paradise.

Even more extreme is the *De voluptate* of Lorenzo Valla (1407–57), priest, rhetorician, and humanist, who brought the teachings of Epicurus to bear on the topic of heavenly bliss. To be more precise, this treatise has a tripartite structure, with spokesmen for Stoicism and Epicureanism holding forth in books one and two, respectively, and the Franciscan friar Antonio Raudense (Antonio da Rio) being given the floor in book three.[86] Scholarly opinion is divided on the relationship between these parts, but it seems reasonable to work on the assumption that "the optimistic, constructive vision of the world" that Valla expresses earlier in the treatise becomes "a kind of prefiguration" of life in the *patria*[87]—where, according to Antonio, the senses will have much to enjoy.

> "As for the bodily senses, either we shall continue to enjoy the use of the same ones, or if some of those are no longer present, we shall be given much better ones in their place. What would be the meaning of the restoration of our bodies if we should then have nothing more than we had without them? The soul will be sufficient unto itself for its own actions and its own adornment. But aside from this, will the eyes of the body not be able to see bodily things? Or will the other senses cease to function? Who in his right mind will believe

such a thing? When we have recovered our bodies, those interrupted joys will be returned to us in a more sanctified form and with much interest, . . . but not immediately after death. First come the joys of the soul [i.e., in heaven]; the body's joys are reserved for the last period."[88]

"The eyes of each of us will be fed by beholding the majesty of his own body and others," and their fragrance "will delight themselves and each other." As they enjoy the heavenly banquet of the body and blood of Christ, their "sense of taste will conquer the other senses." Yet our glorified bodies will "never be satiated with this nourishment; it will not permit hunger and thirst to return, but will leave a continuous sweetness in all our parts"—a "suavity" which "will be so intimately diffused through all the body, even to the marrow of our bones."[89] Indeed, it exceeds earthly orgasm: "no venery can be compared to it." But, Antonio adds hastily, "perhaps I am using here language that is too obscene for the dignity of the subject."[90]

Perhaps he is. At the very least, this is a far cry from Aquinas's evocation of the intensity of sexual pleasure in Eden. And light-years away from John Calvin's attempt to "curb a licentious indulgence in free and subtle speculation" concerning the "imaginary triumphs" of heaven, as quoted above. Those words well exemplify the common Protestant worry that speculation about the end times distracts from the urgent matter of leading a good Christian life on this imperfect earth. Getting to heaven is a more pressing problem than what will be done when—and *if*—we get there. Theologies which are marked by predestinarian pessimism seem impatient with "alluring speculations" and imaginations concerning future joys which only a select few will have any chance of enjoying. Even though it lacked the assistance of Epicurus, and the resources of a latter-day Neoplatonism which valorized erotic pagan mysteries as a means of comprehending the divine, late medieval scholasticism rarely, if ever, plumbed such depths of despair.

Neither did late medieval religious poetry. *Pearl* affords the prospect of joy after grief, blessedness beyond death, the ultimate and unbreakable reunion of father and child. The *moul* (earth) does not really mar the narrator's *myry juele:* immortal diamond is immortal diamond. To rejoin her is "ful ethe" (1202), quite easy, for a good Christian man like the narrator.[91] Similar discourse figures in *Olympia*, when Silvius, deeply impressed by his daughter's alluring account of a pastoral heaven, asks her to show him the easy way (*viam facilem*) to get there (272–74). Olympia explains what needs to be done: "Feed your brother's hunger, to the weary offer cups of milk,

visit the prisoner, clothe the naked; when you can, raise up the fallen" (275–77). This is not an "easy" route in the sense of something to be traversed without great effort or difficulty: the point, in both poems, is rather that the way to salvation is well charted, with specific charitable activities and expenditure of meritorious effort being required of the hopeful sinner. Whose rewards are at once obvious and immeasurable. "I'm parted for you for a little while," Olympia reassures her father; "but truly you will see me after this and gladly live with me through endless years" (153–54).[92] And not just with her. A remarkable number of Boccaccio's family members seem to be in heaven already: his natural father, Boccaccino di Chellino, and several other (illegitimate) children who apparently had died before Violante.[93]

Dante treats the matter with even greater *gravitas*. In Canto XIV of the *Paradiso*, Solomon—a very different figure from the misanthrope constructed by Innocent III—looks forward to the time when he, and the other souls in the sphere of the sun, will joyously be reunited with their own bodies, and also, perhaps, witness the happiness of others.

> Che ben mostrar disio d'i corpi morti:
> forse non pur per lor, ma per le mamme,
> per li padre e per li altri che fuor cari
> anzi che fosser sempiterne fiamme. (*Paradiso*, XIV, 63–66)

> [Truly they showed desire for their dead bodies—perhaps not only for themselves, but also for their mothers, for their fathers, and for the others who were dear before they (i.e., the saints) became eternal flames.][94]

That is to say, these saints and scholars may be envisaging the joy that their loved ones will experience when they receive their blessed bodies. The emphasis is on the shared nature of this future glorification, as parents and children are reunited, friends with friends—and they will know each other, since (in accord with standard resurrection theology) their bodies will be recognizable, their identities distinct. That all-important *forse* ("perhaps," "maybe") keeps this thought, precisely speaking, within the realm of the tentative, but its power is undiminished. The inconvenient truth that not all those "others who were dear" may merit beatitude is quietly ignored—even as Boccaccio would occlude the fact that his children, now lovingly awaiting him in the afterlife, were the products of extramarital sex, as he himself had been. Both poets reconfigure that future *societas amicorum* (which Anselm of

Canterbury had evoked so well) as a potential family reunion.[95] Hardly an end to the battle within Christianity over the status of the incarnated soul. But at least a truce, however uneasy.

> An aged man is but a paltry thing,
> A tattered coat upon a stick, unless
> Soul clap its hands and sing, and louder sing
> For every tatter in its mortal dress . . .
> (W. B. Yeats, "Sailing to Byzantium")[96]

What is in store for the "aged man" after death; is this a land peopled (if that word even applies) with inhuman "monuments of unageing intellect," a place wherein "whatever is begotten, born, and dies" is left far behind, as is the "sensual music" in which those creatures once delighted?

> Once out of nature I shall never take
> My bodily form from any natural thing,
> But such a form as Grecian goldsmiths make
> Of hammered gold and gold enamelling.

Late medieval culture offered a vision of "the artifice of eternity" wherein glorified bodies, in their bright and beautiful materiality far exceeding the merely metaphorical splendor of the "hammered gold and gold enamelling" of the Heavenly Jerusalem, enjoyed sensory delights of a kind not experienced on earth since the time of Eden. And, indeed, those delights exceeded even those of that initial *paradisus voluptatis* which was, according to the scheme of salvation history, an anticipation and foretaste of greater delights, both spiritual and material, to come. In humanity's true homeland "every tatter" of one's "mortal dress" will rise again, made not just as good as new but far better than the original article could ever be in the present world. The bodily forms that will live throughout eternity in the "new earth, new heaven" are at once "out of nature" (if by that is understood fallen nature) and the very perfection of nature. *Corporis gloria naturam non tollit, sed perficit.*[97]

Of course, in making such a statement we should not derogate the contrasting, contextualizing indignities to which the "miserable body"—our present-day body—is subjected, as wayfaring and wayward humankind travels through this vale of tears, moving between paradises. Neither should we

forget that, following the General Resurrection, the wondrous enhancement of sensory capacities which is very good news for the blessed is, simultaneously, very bad news for the damned. The schoolmen spent much time and effort in proving that the wicked will feel the torments of hell to the full, experience unimaginable depths of pain, even as the righteous experience unimaginable heights of pleasure.[98] It is hard to find support for a positive valuation of body in an economy of punishment which needs to keep the body's pain receptors functioning so that due penalties are imposed on the damned. Here the body has been turned against itself, made its own worst enemy, the agent of its perpetual degradation.[99] For some, the bond of "sensation, emotion, reasoning, [and] identity" with "physicality" is a curse.[100] For others, it is—quite literally—a blessing, a divine gift which transcends human understanding even as it perfects the human. Those happy few are the only true beneficiaries of the scholastic apotheosis of the material (a rigorously selective move which rationalizes the destruction of the materiality of animals, plants, and the natural landscape). Their case (their case alone?) presents irrefutable evidence for the proposition that "Western Christianity did not hate or discount the body."[101]

That said, it would, I believe, be ridiculous to see affirmations of the pleasures of paradise as a mere by-product, reached as an inescapable consequence (and to be admitted only grudgingly) of what the theologians really wanted to write about, the body in pain. Their analyses of human happiness are too frequent, extensive, and thoroughgoing to suggest otherwise, and affirmations of such efforts may be found in the work of some of the most remarkable poets and artists of the time. In some measure (the extent being open for debate) late medieval culture achieved an ideological accommodation of the body in pleasure—or, more accurately, of the full person as experiencing pleasure in which the somatic is honored.

Here, then, is a precarious equipoise of spirit and flesh—a fragile vision which was buffeted within the debates of its own time, and subjected to harsh diminution during the Reformation. *Mutatis mutandis*, it has been sidelined in recent scholarship which has concentrated on more visceral manifestations of medieval religion, involving sensory deprivation and abnegation, corporeal pain and punishment. But we should not be strangers to medieval paradises. Or undervalue what was at stake in their creation.

Albert the Great,
De animalibus

Albert the Great, *De animalibus libri XXVI,*
nach der Cölner Urschrift, ed. Hermann
Stadler (Münster: Aschendorff, 1916–21). Tr.
Kenneth F. Kitchell, Jr. and Irven Michael
Resnick, *On Animals: A Medieval Summa*
Zoologica (Baltimore: Johns Hopkins
University Press, 1999)

Albert the Great,
Quaestiones de animalibus

Albert the Great, *Quaestiones super de*
animalibus, ed. Ephrem Filthaut in *Opera*
omnia (Cologne ed.), xii. 77–309. Tr. Irven
M. Resnick and Kenneth F. Kitchell,
Questions concerning Aristotle's On Animals
(Washington, D.C.: Catholic University of
America Press, 2008)

Alberti opera

Albert the Great, *Opera omnia,* ed. A. Borgnet
(Paris: Vivès, 1890–99)

Alberti opera
(Cologne ed.)

Albert the Great, *Opera omnia edenda curavit*
Institutum Alberti Magni Coloniense
(Monasterii Westfalorum: Aschendorff,
1951–)

Aquinas,
Summa theologiae

Thomas Aquinas, *Summa theologiae*, Blackfriars
ed. (London: Eyre and Spottiswoode,
1964–81)

Aquinatis opera

Thomas Aquinas, *Opera omnia* (Parma: Ex
Typis Petri Fiaccadori, 1852–72)

Augustine, *De civitate Dei*

Augustine, *De civitate Dei* (CSEL, 40.1–2). Tr.
R. W. Dyson (Cambridge: Cambridge
University Press, 1998)

Augustine, *De Genesi ad litteram*	Augustine, *De Genesi ad litteram* (CSEL, 28.1). Tr. Edmund Hill, *The Works of Saint Augustine: A Translation for the 21st Century*, 1.13: *On Genesis* (New York: New City Press, 2002)
Biblia glossata	*Biblia sacra cum Glossa ordinaria et Postilla Nicolai Lyrani*, 6 vols. (Venice: Franciscus Fevardentium, 1603)
Bonaventurae opera	Bonaventure, *Opera omnia* (Quaracchi: Editiones Collegii S. Bonaventurae ad Claras Aquas, 1882–1902)
CCCM	Corpus Christianorum, continuatio medievalis
CCSL	Corpus Christianorum, series Latina
CSEL	Corpus Scriptorum ecclesiasticorum Latinorum
EETS OS	Early English Text Society, Original Series
EETS ES	Early English Text Society, Extra Series
Giles of Rome, *In II Sent.*	Giles of Rome, *In secundum librum sententiarum quaestiones* (Venice: F. Zilettum, 1581; rpt. Frankfurt a/M.: Minerva, 1968)
Grosseteste, *Hexaëmeron*	Robert Grosseteste, *Hexaëmeron*, ed. Richard C. Dales and Servus Gieben (Oxford: published for the British Academy by Oxford University Press, 1982). Tr. C. F. J. Martin (Oxford: published for the British Academy by Oxford University Press, 1996)
Lombard, *Lib. sent.*	Peter Lombard, *Sententiae in IV libris distinctae*, Spicilegium Bonaventurianum, 4–5 (Grottaferrata: Editiones Collegii S. Bonaventurae ad Claras Aquas, 1971–81). Tr. Giulio Silano, 4 vols. (Toronto: Pontifical Institute of Mediaeval Studies, 2007–10)
MED	*Middle English Dictionary*, ed. Hans Kurath, Sherman M. Kuhn et al., in the *Middle English Compendium* (Ann Arbor, Mich.), online edition, http://ets.umdl.umich.edu/m/med/

ODCC	*The Oxford Dictionary of the Christian Church*, ed. F. L. Cross and E. A. Livingstone, 3rd ed. (Oxford: Oxford University Press, 1997)
Peter of Tarantasia, *In lib. sent.*	Peter of Tarantasia / Pope Innocent V, *Innocenti quinti in IV libros sententiarum*, 4 vols. (Toulouse, 1649–52; rpt. Ridgewood, N.J.: Gregg, 1964)
PG	*Patrologia Graeca*
PL	*Patrologia Latina*
PMLA	*Publications of the Modern Language Association of America*
Richard of Middleton, *In lib. sent.*	Richard of Middleton, *Super quatuor libros sententiarum* (Brescia, 1591; rpt. Frankfurt a/ M.: Minerva, 1963)
RTAM	*Recherches de théologie ancienne et médiévale*
Scoti opera	John Duns Scotus, *Opera omnia* (Paris: Vivès, 1891–95; rpt. Farnborough: Gregg, 1969)
Summa Alexandri	Alexander of Hales, *Summa theologica* (Quaracchi: Editiones Collegii S. Bonaventurae ad Claras Aquas, 1924–48)
Wyclif, *De statu innocencie*	John Wyclif, *De statu innocencie*, in *Tractatus de mandatis divinis, accedit Tractatus de statu innocencie*, ed. Johann Loserth and Frederic D. Matthew (London: Wyclif Society, 1922), pp. 475–524

My translations of biblical quotations by medieval authors generally follow Challoner's revision of the Douay Bible, as being close to the Latin Vulgate. When quoting modern English translations of medieval Latin texts I have made occasional alterations, and when quoting Middle English texts I have modernized lightly the spelling.

NOTES

INTRODUCTION

1. Walter de la Mare (1873–1956); from "All that's past," in his *Collected Poems* (New York: Henry Holt, 1941), p. 65.

2. My use of the term "eternity" follows the basic definition provided in the *ODCC*, s.v. "eternal life," which is adequate for the purposes of this book: "not only a life of endless duration but the fullness of life of which the believer becomes possessed here and now through participation in God's eternal being" (p. 564). In fact, thirteenth-century schoolmen could use the term *aeternitas* in at least ten different ways, as is explained by Rory Fox, *Time and Eternity in Mid-Thirteenth-Century Thought* (Oxford: Oxford University Press, 2006), pp. 282–308.

3. For discussion, see Philip C. Almond, *Adam and Eve in Seventeenth-Century Thought* (Cambridge: Cambridge University Press, 1999), pp. 166–68. The extraordinary range of opinion may be illustrated by the sharply contrasting views of John Scotus Erigena (d. c. 877) and Peter Abelard (d. 1142). Erigena believed that if our progenitors had been in paradise for a long time they would have devised a way to reproduce which better matched their dignity—i.e., without sexual intercourse; indeed, the division of humankind into sexes was not part of God's original plan, but rather a perversion of it. Abelard believed that, since language was well developed in Eden (Genesis 2:19–20, 2:23, 3:1–5, 3:9, etc.) and language takes time to develop, it follows that Adam and Eve lived there for some time before the Fall. Furthermore, he interpreted the reference in Malachi 3:4 to the "days of old" and "the ancient years" as designating a long duration of life in paradise. On Erigena, see Marta Cristiani, "Paradise and Nature in Johannes Scotus Erigena," in F. Regina Psaki and Charles Hindley (eds.), *The Earthly Paradise: The Garden of Eden from Antiquity to Modernity* (Binghamton, N.Y.: Global Publications, 2002), pp. 91–100, and Edouard Jeauneau, "La division des sexes chez Grégoire de Nysse et chez Jean Scot Érigène," in Jeauneau, *Études Érigéniennes* (Paris: Études augustiniennes, 1987), pp. 343–364 (esp. p. 359). For Abelard, see his *In Hexaëmeron, PL* 178, 781B–D.

4. *De Genesi ad litteram*, ix.4,8 (CSEL 28.1, 272; tr. Hill, p. 380). Reiterated by Peter Lombard, *II Sent.*, dist. xx, 2 (117) (*Lib. sent.*, i.2, 438; tr. Silano, ii.87), and many others, including Saint Thomas Aquinas, *Summa theologiae*, 1a, qu. 98, art. 2, ad 2um (xiii.156).

5. Lombard, *II Sent.*, dist. xxix, 6 (190) (*Lib. sent.*, i.ii, 495; tr. Silano, ii.145). On Peter's teachings on the creation of humankind and the Fall, see Marcia L. Colish, *Peter Lombard* (Leiden: E. J. Brill, 1994), i.366–72, 377–81; on their relationship to the thought of other "agenda-setting theologians" of the time, see i.329–66, 372–77.

6. Augustine, *De civitate Dei*, xxii.21 (CSEL 40.2, 635; tr. Dyson, p. 1153).

7. Augustine, *De civitate Dei*, xiv.22 (CSEL 40.2, 45; tr. Dyson, p. 621).

8. Chaucer, *The Riverside Chaucer*, general ed. Larry D. Benson, 3rd ed. (Oxford: Oxford University Press, 2008), p. 321.

9. "The Wife of Bath's Prologue"; *Canterbury Tales*, III(D), 614; *Riverside Chaucer*, ed. Benson, p. 113.

10. On the extraordinarily long influence of Augustine's thought on Christian marital behavior and sexual ethics, as responses to postlapsarian conditions, see especially Michael Müller, *Die Lehre des hl. Augustinus von der Paradiesesehe und ihre Auswirkung in der Sexualethik des 12. und 13. Jahrhunderts bis Thomas von Aquin; eine moralgeschichtliche Untersuchung* (Regensburg: F. Pustet, 1954). A useful summary of the issues is provided on pp. 19–41. See further Leopold Brandl's pioneering study, *Die Sexualethik des heiligen Albertus Magnus: eine moralgeschichtliche Untersuchung* (Regensburg: F. Pustet, 1955), especially pp. 18–25 (another overview of the scope of Augustine's influence).

11. *De civitate Dei*, xix.23 (CSEL 40.2, 47–48; tr. Dyson, p. 623).

12. Albert the Great, *Quaestiones de animalibus*, v, qu. 5, 2 (p. 156); tr. Resnick and Kitchell, p. 192. This is a series of disputed questions on Aristotle's *De animalibus*, conducted in Cologne in 1258 and preserved in Conrad of Austria's *reportatio* of perhaps c. 1260—not to be confused with the more substantial and far more influential commentary which Albert completed by 1263. One of the great polymaths of the thirteenth century, Albert was as accomplished in philosophy, medicine, and natural science as he was in theology.

13. To quote the standard etymological explanation, encapsulated by Isidore of Seville: "Paradise is located in the east. This name, translated from Greek into Latin, means 'garden.' In Hebrew in turn it is called Eden, which in our language means 'delights.' The combination of both names gives us the expression 'garden of delights,' for every kind of fruit-tree and non-fruit bearing tree is found in this place, including the tree of life." *Etymologiae*, XIV.iii, 2–5, in *Etymologiarum sive originum libri XX*, ed. W. M. Lindsay (Oxford: Clarendon Press, 1911; repr. 1987), unpag.

14. Among many good reasons for choosing the Lombard's *Sentences* as a major point of departure is the fact that until his time, "man's physical nature and life in Eden"—major concerns of the present book—attracted "the least speculative attention from the masters," as Marcia Colish says (*Lombard*, i.354).

15. This awkward convolution is necessary because the *Summa Alexandri* was compiled and completed by Alexander's pupils and fellow Franciscans after his death.

16. *Summa Alexandri*, 1a 2ae, inq. IV, tr. II, sect. ii, qu. 2, cap. 3, solutio (ii.620–21).

17. Ibid., p. 621.

18. *Summa Alexandri*, 1a 2ae, inq. IV, tr. II, sect. ii, qu. 2, cap. 4: *de corporis Evae integritate* (ii.626).

19. Cf. Romans 8:13 and Colossians 3:5.

20. *De civitate Dei*, xiv.26 (CSEL 40.2, 54; tr. Dyson, p. 629).

21. Bonaventure, *In II Sent.*, dist. xx, art. un., qu. 4, resp. (*Bonaventurae opera*, ii.482–83). Some of my citations of this commentary draw on the (ongoing and at present partial) English translation which Br. Alexis Bugnolo, editor of the Franciscan Archive, is coordinating, and which he kindly sent me on CD. For discussion of the issue of sexual pleasure in Eden, see pp. 42–47 below.

22. On the gendered pain inflicted on women due to Eve's part in the fall, see Donald Mowbray, *Pain and Suffering in Medieval Theology: Academic Debates at the University of Paris in the Thirteenth Century* (Woodbridge: Boydell, 2009), pp. 54–60.

23. A similar solution is offered by Albert the Great. Had Eve conceived in Eden, she would have remained incorrupt inasmuch as no lust would have accompanied the sexual act, but, technically speaking, she would have been rendered "impure" (*impuritas*) by the mixing of Adam's seed with hers. Only the Virgin Mary conceived without such impurity, no male seed having entered her body. *Summa theologiae*, pars II, tract. xiv, qu. 84, conclusio (*Alberti opera*, xxxiii.132). Aquinas poses the problem as follows. In the state of innocence there was no place for anything being spoiled (*corruptio*). But copulation spoils virginal integrity; therefore "there would have been no copulation in the state of innocence." His answer is that copulation would indeed have occurred in Eden, as a natural process, but without being deformed by immoderate desire. Somewhat inconsistently, the words of Augustine at *De civitate Dei*, xiv.26, are quoted without the passage's insistence on physical integrity being addressed. *Summa theologiae*, 1a, qu. 98, art. 2, 4, responsio, and ad 4um (xiii.154–55, 158–59).

24. The verb used is *commisceo*, "to mix or mingle together."

25. For the secular master William of Auxerre (d. 1231), a pivotal figure in early Parisian scholasticism, the crucial question is, would Eve have given birth with or without *fractio* (fracture, violation)? If without *fractio*, then she would have had children while remaining a virgin, and therefore the manner in which the Virgin Mary gave birth to Christ would not have been a miracle. (Presumably William's point is that Mary's parturition would then have lost its exceptional status.) If with *fractio*, Eve's generative members would have functioned without any sin being involved, as is the case with the movement of other members of the body (such as the hands and feet, one may add, echoing Augustine's words). William finds a solution in the different meanings of the verb *frēgi* (or *fragendi*, as he has it). If fracture implies *violentia* (violence or fierceness), then it may be said that Adam would have "known" Eve sexually without fracture—i.e., without violence. If, however, the word merely means *separatio* (the state of being separated or parted), Eve's generative organs may be understood to have been "fractured" in a good sense, just as they were designed to do, as nature intended. So then, if Adam and Eve had engaged in sexual relations, Eve would have ceased to be a virgin in physical terms—quite unlike Mary, who was not "known" sexually and kept her virginity. She remains uniquely blessed among women. *Summa aurea*, Book II, tr. ix. cap. ii, qu. 4, in *Summa aurea, Liber secundus*, ed. Jean Ribaillier (Paris: Éditions du Centre national de la recherche scientifique; Rome: Editiones Collegii S. Bonaventurae ad Claras Aquas, 1982), pp. 251–52.

26. My use of the term "vernacular" encompasses discussion, which could be conducted either in one of the emerging European vernaculars or indeed in Latin, of a kind which reached far beyond the theology of the schools and even, on occasion, shows a marked degree of independence from such doctrine. Thus I seek to regain the original meanings of the Latin verb *vulgo*, "to make available to the mass of the population, make common to all"; "to make widely known, spread a report of, make public, broadcast"; "to make general, common, or universal." Cf. my discussion in *Translations of Authority in the Later Middle Ages: Valuing the Vernacular* (Cambridge: Cambridge University Press, 2009), pp. 1–4.

27. *The Mirour of Mans Saluacioun: A Middle English Translation of Speculum humanae salvationis*, ed. Avril Henry (Philadelphia: University of Pennsylvania Press, 1987), pp. 43, 45.

28. Heinrich Cornelius Agrippa von Nettesheim, *Declamatio de nobilitate et praecellentia foeminei sexus*, ed. R. Antonioli et al. (Geneva: Droz, 1990), p. 66; tr. Albert Rabil, *Declamation on the Nobility and Preeminence of the Female Sex* (Chicago: University of Chicago Press, 1996), p. 63. The idea of Eve's ignorance was extensively discussed by the schoolmen, given its potential as a viable excuse for her behavior. Peter Lombard resolved the problem with a distinction which generally was maintained in the commentary tradition on his *Sentences*: Eve was ignorant

inasmuch as she believed what the devil suggested was true, "but she did not fail to know that it was God's mandate and it was a sin to act against it. And so she could not be excused from sin through ignorance." *II Sent.*, dist. xxii, 4 (133), 12 (*Lib. sent.*, i.2, 445; tr. Silano, ii.102).

29. *Hexaëmeron*, xi.5.5 (ed. Dales and Gieben, pp. 311–12; tr. Martin, p. 319).

30. Augustine, *De Genesi ad litteram*, viii.1,1 (CSEL 28.1, 229; tr. Hill, p. 346). Frequently quoted by the schoolmen; see, for example, the affirmation and amplification of Augustine's view in the *Summa Alexandri*; 1a 2ae, inq. III, tr. III. qu. 2, art. 1 (ii.374).

31. Cf. Genesis 2:7, "And the Lord God formed man of the slime of the earth."

32. Augustine, *De Genesi ad litteram*, viii.1,2 (CSEL 28.1, 229–30; tr. Hill, pp. 346–47).

33. Augustine, *De Genesi ad litteram*, viii.1,4 (CSEL 28.1, 231; tr. Hill, p. 347). By "proper" here is meant speech which is direct, explicit, literal, in contrast with figurative or allegorical discourse with its many obliquities and obscurities.

34. Augustine, *De Genesi ad litteram*, viii.1,4 (CSEL 28.1, 231; tr. Hill, pp. 347–48).

35. Augustine, *De Genesi ad litteram*, viii.1,2 (CSEL 28.1, 230; tr. Hill, pp. 346–47).

36. *Hexaëmeron*, xi.5.3 (ed. Dales and Gieben, p. 311; tr. Martin, p. 318).

37. Augustine, *De Genesi ad litteram*, viii.2,5 (CSEL 281, 232; tr. Hill, p. 348).

38. *De Genesi contra Manichaeos*, ii.2,3 (*PL* 34, 197).

39. *De Genesi ad litteram*, viii.2,5 (CSEL 28.1, 233; tr. Hill, p. 349). This approach separates Augustine's Genesis commentary from the treatise *De paradiso* written by a preacher who had played a major role in his conversion, Ambrose of Milan (d. 397). While not denying the historical materiality of a place called paradise (and attentive to the practical moral issues raised by the text), Ambrose's exposition consistently seeks to transcend it, as when paradise is described as "a land of fertility—that is to say, a soul which is fertile—planted in Eden, that is, in a certain delightful or well-tilled land in which the soul finds pleasure." *De paradiso*, iii.12 (*PL* 14, 279C–D); tr. John J. Savage, *Saint Ambrose: Hexameron, Paradise, and Cain and Abel* (New York: Fathers of the Church, 1961), p. 294.

40. *Hexaëmeron*, viii.30,1 (ed. Dales and Gieben, p. 253; tr. Martin, p. 258).

41. Cf. Augustine, *De Genesi contra Manichaeos*, ii.9,12 (*PL* 34, 202).

42. Again from Augustine, this time *De Genesi ad litteram*, xii.28,56 (*CSEL* 28.1, 422; tr. Hill, pp. 496–97).

43. *Hexaëmeron*, xi.6,1–5 (ed. Dales and Gieben, p. 312; tr. Martin, pp. 319–20).

44. Aquinas, *In II Sent.*, dist. xvii, qu. 2, art. 2, solutio (*Aquinatis opera*, vi.538–39). For the Origenist belief that "the origin and final destiny of the rational creature was bodiless," and its implications for allegorical accounts of Genesis and the resurrected human, see Elizabeth A. Clark, *The Origenist Controversy: The Cultural Construction of an Early Christian Debate* (Princeton, N.J.: Princeton University Press, 1992), pp. 4, 6, 87–89, 95–97, 115–16, 133–34, 143–45, 148, 153–55, 162. Clark argues that this approach "'spiritualized' and dehistoricized . . . Scripture as a whole" (p. 60).

45. Martin Luther, *Table Talk*, ed. and tr. T. G. Tappert, *Luther's Works*, 54 (Philadelphia: Fortress, 1967), p. 406 (no. 5285). In contrast, he found "life, comfort, power, instruction and skill" in the literal sense. William Tyndale (d. 1536) complained about "false glosses" which the pope and his clergy "have patched to the scripture in plain places, to destroy the literal sense, for to set up a false feigned sense of allegories, when there is none such." William Tyndale, *An Answer to Sir Thomas More's "Dialogue,"* ed. Henry Walter, the Parker Society (Cambridge: Cambridge University Press, 1850), p. 44. Later in the same treatise he asserts that "Allegories, which every man may feign at his pleasure, can prove nothing" (p. 93).

46. In particular, figural reading—the interpretation of Old Testament events as foretell-ings of their New Testament fulfillments—sat well with literal exposition, as when John Calvin interpreted Adam's weakness following Eve's creation from his rib as "a true resemblance of our union with the Son of God; for He became weak that he might have members of His body [i.e., his followers] endued with strength." Commentary on Genesis 2:21, in John Calvin, *A Commentary on Genesis*, tr. and ed. John King (London: Banner of Truth Trust, 1965), p. 133. Sometimes Tyndale read certain Old Testament passages as figural allegories of the present-day errors of the Roman Church. See James Simpson, "Tyndale as Promoter of Figural Allegory and Figurative Language: *A Brief Declaration of the Sacraments*," *Archiv*, 245 (2008), 37–55, and *Burning to Read: English Fundamentalism and Its Reformation Opponents* (Cambridge, Mass.: Belknap Press, 2007), pp. 168–69, 194–201, 209, 211–21.

47. Bunyan, *Exposition on the First Ten Chapters of Genesis and Part of the Eleventh*, in *The Works of John Bunyan*, ed. George Offor (Glasgow: Blackie, 1862), ii.2, 425.

48. *De statu innocencie*, iii, ed. Loserth and Matthew, pp. 489–90.

49. *De statu innocencie*, iii, ed. Loserth and Matthew, p. 492. Cf. Augustine, *De Genesi ad litteram*, iii.18,28 (CSEL 28.1, 83–84; tr. Hill, pp. 232–33).

50. Tr. V. E. Watts (Harmondsworth: Penguin Books, 1969), p. 69.

51. *Le Roman de la Rose*, ed. Félix Lecoy, 3 vols. (Paris: Champion, 1973–85), ii.4–7; tr. Frances Horgan (Oxford: Oxford University Press, 1994), pp. 128–30.

52. On which, see Ernest Langlois, "Le jeu du Roi qui ne ment et le jeu du Roi et de la Reine," *Romanische Forschungen*, 23 (1907), 163–73; and Richard Firth Green, "*Le Roi que ne ment* and Aristocratic Courtship," in Keith Busby and Erik Kooper (eds.), *Courtly Literature: Culture and Context* (Amsterdam: Benjamins, 1990), pp. 211–25. Green notes that the game included "among its players pairs of lovers or would-be lovers"; indeed, in at least one surviving testimony, "assigning partners" appears to have been "a preliminary to playing the game itself" (p. 212). This fits well the Harley 4425 illumination. I am grateful to Ardis Butterfield for suggesting this convincing explanation.

53. The headgear worn by the loving couples was probably suggested by Jean de Meun's reference to how Zephyrus (the god of the west wind) and his wife Flora produce the flowers used "to honour maidens and favoured young men with lovely, gay chaplets (*biaus chapelez ranvaisiez*). They do this for the sake of true lovers (*fins amoreus*), who are very dear to them" (*Rose*, 8381–92).

54. Joan Ferrante has described Matelda as "a restored Eve, now the only inhabitant of the Earthly Paradise"; *Woman as Image in Medieval Literature, from the Twelfth Century to Dante* (New York: Columbia University Press, 1975), p. 149. See further John Flood, *Representations of Eve in Antiquity and the English Middle Ages* (New York: Routledge, 2011), pp. 78–79, and (for the various interpretations), Caron Cioffi, "Matelda," in Richard Lansing (ed.), *The Dante Encyclopedia*, 2nd ed. (London: Routledge, 2010), pp. 599–602.

55. *The Divine Comedy: Purgatorio*, ed. and tr. Charles S. Singleton (Princeton, N.J.: Princeton University Press, 1973), pp. 312–13.

56. *De statu innocencie*, iii, ed. Loserth and Matthew, p. 495.

57. *De statu innocencie*, iv, ed. Loserth and Matthew, pp. 495–97.

58. *De statu innocencie*, iv, ed. Loserth and Matthew, p. 498.

59. In a much-quoted passage in *De civitate Dei*, Augustine had explained that nakedness was not shameful before the Fall, since Adam and Eve, having no experience of their genitalia warring against their will, were protected by a "garment of grace" (*indumento gratiae*). But when they were stripped of this, "there began in the movement of their bodily members a

shameless novelty which made nakedness indecent" (xiv.17; CSEL 40.2, 39; tr. Dyson, p. 615). In Eden, matters relating to sex and generation could have been talked about openly, "unhampered by any fear of obscenity." At that time discussion could easily and freely have included reference to bodily organs; "whatever was said on this subject would be as honourable as what we say when speaking of the other parts of the body" (xiv.23; CSEL 40.2, 49; tr. Dyson, p. 625). On the relationship between nakedness (particularly female nakedness), sin, and guilt, see Margaret Ruth Miles, *Carnal Knowing: Female Nakedness and Religious Meaning in the Christian West* (Boston: Beacon Press, 1989), esp. pp. 90–116. The Augustinian notion of the garment of grace, as part of a weighty theological legacy which marks nudity in our culture, is considered by Giorgio Agamben, *Nudities*, tr. David Kishik and Stefan Pedatell (Stanford, Calif.: Stanford University Press, 2011), pp. 55–90. See further the collection of essays edited by Sherry C. M. Lindquist, *The Meanings of Nudity in Medieval Art* (Farnham, Surrey, England: Ashgate, 2012), particularly Lindquist's introductory essay on pp. 1–46.

60. *De statu innocencie*, v, ed. Loserth and Matthew, pp. 500–505.

61. *De statu innocencie*, ii, ed. Loserth and Matthew, p. 484.

62. *II Sent.*, dist. xx, 6 (121), 1 (*Lib. sent.*, i.2, 432–33; tr. Silano, ii.91).

63. This is one of the translations of the Anglo-Norman *Château d'amour* attributed to Robert Grosseteste and dated between 1230 and 1253. *The Middle English Translations of Robert Grosseteste's Château d'Amour*, ed. Kari Sajavaara, Mémoires de la Société Néophilologique, 32 (Helsinki: Société Néophilologique, 1967), p. 265. The passage here quoted slightly amplifies the original Anglo-Norman, as edited by J. Murray, *Le Château d'amour de Robert Grosseteste, e'vêque de Lincoln* (Paris: Champion, 1918), p. 92.

64. *De fide orthodoxa*, ii.11 (*PG* 94, 912), which corresponds to cap. 25 in the Latin translation by Burgundio of Pisa (1150); ed. E. M. Buytaert, Franciscan Institute Publications, Text Series 8 (St. Bonaventure, N.Y.: Franciscan Institute, 1955), pp. 106–7.

65. Here I follow Aquinas's highly selective quotation from *De civitate Dei*, xiv.10 (CSEL 40.2, 25; tr. Dyson, p. 602); *Summa theologiae*, 1a, qu. 94, art. 1, 1 (xiii.87).

66. *Summa theologiae*, 1a, qu. 94, art. 1 (xiii.86–91).

67. From *The Monarche*, in Lindsay, *Sir David Lyndesay's Works*, parts 1 and 2, ed. Fitzedward Hall, EETS OS 11 and 19 (London: Trübner, 1865–66), pp. 1–206 (ongoing pagination). Lindsay is a fascinatingly liminal figure, whose writings increasingly display the influence of Protestantism.

68. Lindsay calls this a *doute* ("doubt"), thus translating the technical Latin term *dubitacio*, which denoted a proposition raised in the course of an academic disputation, to be dealt with in the final resolution.

69. However, Abelard was skeptical; *In Hexaëmeron, PL* 178, 781C.

70. Augustine, *De Genesi ad litteram*, ix.4,8 (*CSEL* 28.1, 272–73; tr. Hill, p. 380).

71. To cite one of Albert the Great's many endorsements of Aristotle. *De animalibus*, xxi, tract. 1, i(7), ed. Stadler, ii.1325; tr. Kitchell and Resnick, ii.1413.

72. *In II Sent.*, dist. xv, art. 2, qu. 1 (*Bonaventurae opera*, ii.382–84).

73. *Summa theologiae*, 1a, qu. 96, art. 1, ad 3 (xiii.126–27). Aquinas adds: "This is suggested by God leading the animals to Adam for him to give them their names, which designate their natures" (p. 127).

74. However, any move to enlist St. Francis as the patron saint of ecology must negotiate the discourses of poverty and humility which drive such stories in the *vitae*. In particular, they function to turn the world upside down by elevating the lowly over the mighty, the weak over the strong, the poor over the rich. Here, it could be argued, is yet another example of how

medieval writers saw animals as "serving" humankind. Cf. the caveats entered by Lisa Kiser, "The Garden of St. Francis: Plants, Landscape, and Economy in Thirteenth-Century Italy," *Environmental History* 8.2 (2003), 229–45.

75. *Hexaëmeron*, viii.11.7 (ed. Dales and Gieben, p. 250; tr. Martin, p. 255). Cf. Saint Basil's discussion in his own *Hexaëmeron*, xi.7, in *Sur l'origine de l'homme. Homelie X et XI de l'Hexaéméron par Basile de Césarée*, ed. Alexis Smets and Michel Van Esbroeck (Paris: Éditions du Cerf, 1970), pp. 244–46.

76. See pp. 144–45.

77. To use a commonplace phrase which has its origins in Isaiah 11:6.

78. This Bosch triptych is notoriously difficult to interpret, but—given the acceptance of animal death in Eden by so many medieval theologians—there is no reason whatever to see in the left panel an expression of the Manichaean idea that both evil and good existed in the world from its inception, as has been proposed by Lynda Harris, *The Secret Heresy of Hieronymus Bosch* (Edinburgh: Floris Books, 1995). (It is quite possible to suppose that, however normal those animal encounters would have been in Eden, their rather menacing depiction points ahead to conditions in the postlapsarian world. Bosch's triptychs are marked by a desire to stage transitions from one state to another.) A similar point may be made with reference to Wilhelm Fränger's theory that the Heresy of the Free Spirit underpins Bosch's depiction, a position from which Fränger argues that "Bosch is . . . presenting death as a principle of the existential world inherent in it since its beginning, not inherited as a result of man's sinfulness. He completely dissociates death from the Fall by giving it a place in Paradise, where man still lives in a state of primal innocence. Dogmatically speaking, this is heresy; philosophically, it shows that the Free Spirit view of nature and the world was a boldly syncretistic one, which sought to fuse Christianity's doctrine of salvation with the esoteric knowledge of the ancient world." *Hieronymus Bosch*, tr. Helen Sebba (Amsterdam: G + B Arts International, 1999), pp. 37–38. "Heresy" need not be detected here. It may be added that, following the research of Robert E. Lerner, the so-called Heresy of the Free Spirit has generally been regarded as an "artificial" heresy, its alleged sect dismissed as the mere invention of suspicious clerics. See Lerner, *The Heresy of the Free Spirit in the Later Middle Ages* (Berkeley: University of California Press, 1972), esp. pp. 5–6, and Malcolm Lambert, *Medieval Heresy: Popular Movements from the Gregorian Reform to the Reformation*, 3rd ed. (Oxford: Blackwell, 2002), pp. 205–6, 418.

79. See the discussion in Chapter 3.

80. Cf. Isaiah 65:17: "Behold I create new heavens and a new earth, and the former things shall not be in remembrance."

81. The denial of rationality to animals has, as Richard Sorabji remarks, made "the difference between them and us a chasm," and constituted "a crisis both for the philosophy of mind and for theories of morality." *Animal Minds and Human Morals: The Origins of the Western Debate* (Ithaca, N.Y.: Cornell University Press, 1993), pp. 7–8, 154–57, 201–4. For centuries this has been the single most important factor in denying animals a place in the afterlife. The ethical implications are enormous also, given the common inference that, because animals are not part of our human community, we do not owe them justice, which appertains only to rational beings.

82. *In IV Sent.*, dist. xlviii, qu. 2, art. 5 (*Utrum plantae et animalia remaneant in illa innovatione*), solutio (*Aquinatis opera*, vi.1178).

83. Colleen McDannell and Bernhard Lang, *Heaven: A History*, 2nd ed. (New Haven, Conn.: Yale University Press, 2001), pp. 152–54.

84. From "The General Deliverance," sermon 60 in *The Works of John Wesley*, ed. Thomas Jackson (1831, rpt. London: Wesleyan Conference Office, 1872), vi.241–52.

85. John Donne, Holy Sonnet VII, in *The Poems of John Donne*, ed. Herbert Grierson (London: Oxford University Press, 1964), p. 296.

86. Around which the planets, stars, and spheres revolved. As a man of a later time, Donne had come to believe that the earth revolved around the sun.

87. Margaret Ruth Miles has written eloquently of how Augustine never "ceased to respect" the Neoplatonic formulation of how the "escape from the fetters of the body as from a prison" could be effected. *Augustine on the Body* (Missoula, Mont.: Scholars Press, 1979), p. 5.

88. Here I borrow idioms from W. B. Yeats's "Sailing to Byzantium," which struggles brilliantly (though—inevitably—unsuccessfully) with the reconciliation of soul and sense. We shall return to this poem in the Coda.

89. *Historye of the Patriarks*, ed. Mayumi Taguchi (Heidelberg: Winter Universitätsverlag, 2010), pp. 3, 5. Cf. the Latin original in *PL* 198, 1053. The Middle English translation is preserved uniquely in a fifteenth-century manuscript, Cambridge, St. John's College, MS 198. (Taguchi also prints the parallel passages from the Latin text and the French *Bible historiale*.) In addition, I consulted the earlier edition of the English text by Saralyn Ruth Daly (Ph.D. dissertation, Ohio State University, 1950).

90. *Hexaëmeron*, i.4.1 (ed. Dales and Gieben, p. 54; tr. Martin, p. 52).

91. *De civitate Dei*, xix.23 (CSEL 40.2, 47; tr. Dyson, p. 623).

92. *IV Sent.*, dist. xliii, 6 (249), 5 (*Lib. sent.*, i.2, 515; tr. Silano, ii.237–38).

93. "There is no man with a heart (= no living man) who can think (conceive), no cleric who can write with ink, of the great joy which is given to those who perform here my commandment." *The Southern Version of "Cursor Mundi*, "vol. 1, ed. Sarah M. Horrall (Ottawa: University of Ottawa Press, 1978), pp. 53–54.

94. Cf. the Latin term *ingenium*, meaning "skill" or "ingenuity," rather than "genius" in the modern sense of the term.

95. *The Divine Comedy: Paradiso*, ed. and tr. Charles S. Singleton (Princeton, N.J.: Princeton University Press, 1982), pp. 108–9. On Dante's attitudes to the "complex, forever ambivalent, and protean faculty" of imagination/fantasy, see especially Giuseppe Mazzotta's discussion in *Dante's Vision and the Circle of Knowledge* (Princeton, N.J.: Princeton University Press, 1993), pp. 116–34, which elucidates its "doubleness" as "both the portal to a knowledge of reality and as exceeding the domain of material reality" (p. 132).

96. Thus St. Ambrose, wondering why the Tree of the Knowledge of Good and Evil was placed in Eden, declared, "We should not form a hasty judgment in respect to this product of creation, if it presents to our intellect what seems to us—like the creation of serpents and certain poisonous creatures—difficult and incomprehensible. In fact, we are unable, owing to human weakness, yet to know and understand the reason for the creation of each and every object. Let us, therefore, not criticise in holy Scripture something which we cannot comprehend. There are very many things which must not be subjected to the judgment of our intellect." *De paradiso*, ii.7 (*PL* 14, 277B–C; tr. Savage, p. 290).

97. *De statu innocencie*, iii, ed. Loserth and Matthew, p. 493.

98. The criterion of *utilitas* (as the direct opposite of *curiositas*) will be discussed in the Coda.

99. Augustine, *De Genesi ad litteram*, v.8, 23 (CSEL 28.1, 152; tr. Hill, p. 287).

100. Hans Belting, *Hieronymus Bosch, Garden of Earthly Delights* (Munich: Prestel, 2002), p. 87. The major interpretative crux of this triptych is whether its central panel depicts a continuation of Eden's innocent pleasures or a false paradise of vice, soon to be purged by Noah's Flood. This will be discussed at the end of Chapter 1.

101. Jeffrey Hamburger has gone beyond the argument that art historians should "draw on theology and exegesis as a set of interpretive practices that can inform, without being allowed to control, modern readings of medieval images," to make the compelling case that theology itself should be viewed as "an historical artifact in its own right, less a body of doctrine than itself a variety of methods." Thus we may speak of "modes of theological discourse, whether in texts or images, as ways of seeing and shaping the world, and as ways of framing and forming religious experience." Jeffrey Hamburger and Anne-Marie Bouché (eds.), *The Mind's Eye: Art and Theological Argument in the Middle Ages* (Princeton, N.J.: Princeton University Press, 2006), pp. 5–6, 25. I heartily endorse this view, particularly if "texts" may be understood as inclusive of writings whether theological, philosophical, or poetical.

CHAPTER 1. THE BODY IN EDEN

1. Mark Twain, *The Diaries of Adam and Eve* (New York: Prometheus Books, 2000), p. 179.

2. *Liber de ordine creaturarum*, x: *de paradiso*, 8, ed. Manuel C. Díaz y Díaz, *Un anónimo irlandés del siglo VII*, Monografías de la Universidad de Santiago de Compostela, 10 (Santiago de Compostela, 1972), p. 160. This book circulated under the name of Isidore of Seville. Augustine was equally enthusiastic. Man "lived without any want, and he had it in his power to live for ever. Food was present, lest he hunger; drink, lest he thirst; and the tree of life, lest age decay him. There was no corruption in the body, or arising from the body, to bring any distress to any of his senses. There was no fear of disease from within or injury from without. He enjoyed supreme health of body, and entire tranquility of soul. Just as there was no extreme of heat or cold in Paradise, so there arose in him who dwelt there no desire or fear to hinder his good will. There was nothing of sadness; neither was there any empty pleasure. Rather, true joy poured continually from God . . . ; there was a concord and alertness of mind and body, and God's commandment was kept without labour. In his leisure, man did not know the weariness of fatigue, and sleep never pressed upon him against his will." *De civitate Dei*, xiv.26 (CSEL 40.2, 53–54; tr. Dyson, pp. 628–29).

3. *The Play of Adam (Ordo representacionis Ade)*, ed. Carol J. Odenkirchen (Brookline, Mass.: Classical Folia Editions, 1976), pp. 46–49.

4. *Paradiso*, ed. and tr. Singleton, pp. 296–97.

5. Augustine, *De Genesi ad litteram*, ix.3,6; ix.6,10 (CSEL 28.1, 271–72; tr. Hill, pp. 378–79). Quoted by Peter Lombard, *II Sent.*, dist. xx, 3 (118), 2 (*Lib. sent.*, i.2, 429; tr. Silano, ii.88).

6. Bonaventure, *In II Sent.*, dist. xix, art. 2, qu. 1 (*Bonaventurae opera*, ii.465).

7. *In II Sent.*, dist. xix, qu. unica: *utrum in statu innocentiae habuissemus corpora immortalia* (*Scoti opera*, 6.ii, 810–13). On the medicalization of scholastic debate on this subject which, it is argued, took place during the second third of the thirteenth century, see especially Joseph Ziegler, "Medicine and Immortality in Terrestrial Paradise," in Peter Biller and Joseph Ziegler (eds.), *Religion and Medicine in the Middle Ages* (York: York Medieval Press in association with Boydell and Brewer, 2001), pp. 201–42.

8. On Giles of Rome's views on these same issues, see Kieran Nolan, *The Immortality of the Soul and the Resurrection of the Body According to Giles of Rome* (Rome: Studium theologicum Augustinianum, 1967). pp. 40–46. Even if Adam had remained in Eden, immortal, he would still have fallen under the definition of mortality inasmuch as he had the capacity for death, the possibility of dying. Giles of Rome, *In II Sent.*, dist. xix, qu. 2, art. 1, ad 5 (ii.132C).Thanks to divine grace, nothing would have happened to his body which would have caused the separation of the soul from it; *In II Sent.*, dist. xix, qu. 2, art. 1, ad 4 (ii.132A–B). But when "Adam rebelled against God, . . . as a result Adam's body rebelled against Adam himself." The ongoing restoration of Adam's body through food (which originally was converted into pure nourishment) ceased to be as pure as before, which "meant that the body became more impure and indisposed until finally the soul could no longer remain in it but was forced to leave, and thereby man died" (Nolan, p. 43; Giles of Rome, *In II Sent.*, dist. xix, qu. 2, art. 1, ad 1 (ii.132A–B).

9. The *Summa Alexandri* offers particularly full accounts. See 1a 2ae, inq. IV, tract. II, sect. 2, qu. 2, tit. 1, mem. 3: *de dignitate et nobilitate corporis Adae* (ii.577–88); and 1a 2ae, inq. IV, tr. II, sect. 2, qu. 2, cap. 4: *de corporis Evae integritate*, cap. 5: *de fortitudine corporis Evae*, and cap. 6: *de dignitate corporis Evae* (ii.623–30).

10. Peter Lombard, *II Sent.*, dist. xvii, 3 (98), 1 (*Lib. sent.*, i.2, 412; tr. Silano, ii.73).

11. *Apologiae duae*, ed. R. B. C. Huygens, with an introduction on beards in the Middle Ages by Giles Constable, CCCM 62 (Turnholt: Brepols, 1985), p. 66. Mechthild of Magdeburg (d. c. 1282/94) uses hair to symbolize good works, as once performed in this life by a group of now-blessed souls. She records a vision of people in heaven dressed in white but "who did not have any hair. Instead, they wore simple crowns on their heads. These were those people who had not lived according to the law. They lack the ornament of hair, which is good works. How, then, did they get into heaven? By sorrow and good will at the hour of death." *Das fließende Licht der Gottheit*, ii.4, ed. Hans Neumann, Münchener Texte und Untersuchungen zur deutschen Literatur des Mittelalters, 100–101 (Munich: Artemis, 1990–93), i.43; tr. Frank Tobin, *The Flowing Light of the Godhead* (New York: Paulist Press, 1998), p. 73.

12. Constable, introduction on beards in *Apologiae duae*, ed. Huygens, p. 56.

13. *Enarrationes in psalmos*, 132, 7 (CCSL 40, 1931).

14. *Le Livre des Eschez amoureux moralisés*, ed. Françoise Guichard-Tesson and Bruno Roy, Bibliothèque du moyen français, 2 (Montreal: CERES, 1993), p. 343.

15. Ibid. On the similarities between hair and feathers, see Pseudo-Aristotle, *Problemata*, iv.31, ed. W. S. Hett (Cambridge, Mass.: Harvard University Press, 1936–65), i.133.

16. *Problemata*, iv.4; ed. Hett, i.111–12.

17. Cf. Augustine, who claimed that "certain things are associated with the body in such a way as to have beauty but no use. Cases in point are the nipples on a man's chest and the beard on his face. The fact that the beard exists as a manly adornment and not for purposes of protection is shown by the beardless faces of women, who are the weaker sex and for whom a beard would therefore be more suitable if it were a protective device." In Eden, "when the body was created, dignity took precedence over necessity. After all, necessity is a transitory thing; whereas the time is coming [i.e., in the *patria*] when we shall enjoy each other's beauty without any lust" (*De civitate Dei*, xxii.24 [CSEL 40.2, 648; tr. Dyson, p. 1164]).

18. *Le Livre des Eschez amoureux moralisés*, ed. Guichard-Tesson and Roy, p. 343.

19. Cf. the controversy concerning the beardlessness of Chaucer's Pardoner, discussed in Alastair Minnis, *Fallible Authors: Chaucer's Pardoner and Wife of Bath* (Philadelphia: University of Pennsylvania Press, 2007), pp. 147–69.

20. This is the gesture known as *conturbatio*, "disquiet" not in the sense of being upset or incredulous, but rather astonishment and awe in face of the great and marvelous events which are unfolding. See Michael Baxandall, *Painting and Experience in Fifteenth-Century Italy* (Oxford: Clarendon Press, 1972), p. 51. The standard work on the subject of hand gestures remains J.-C. Schmitt, *La raison des gestes dans l'occident médiéval* (Paris: Gallimard, 1990).

21. See Constable, introduction on beards in *Apologiae duae*, ed. Huygens, p. 61, and, for more on this exegete, Beryl Smalley, "Ralph of Flaix on Leviticus," *RTAM* 35 (1968), 35–82.

22. See especially Peter Lombard, *IV Sent.*, dist. xliv, 1 (251), 3 (*Lib. sent.*, ii.517; tr. Silano, iv.239). Cf. Lombard, *II Sent.*, dist. xvii, 3 (98) (*Lib. sent.*, ii.412–13; tr. Silano, ii.73–74). Others argued that Christ died in his thirty-fourth year; see J. A. Burrow, *The Ages of Man: A Study in Medieval Writing and Thought* (Oxford: Clarendon Press, 1986), pp. 142–43.

23. It should be noted, however, that this gesture anticipates the moment at which God will join her hand to Adam's, as they plight their troth to each other in marriage, as regularly represented in late medieval depictions of Eden. For excellent examples, see Paris, Bibliothèque nationale de France, fr. 11 (1483?), fol. 3v; BnF fr. 21 (1414?), fol. 40v; BnF fr. 174 (c. 1403–5?), fol. 57v; and BnF, fr. 247 (mid-fifteenth century?), fol. 3r. These may conveniently be accessed in the library's *banque d'images,* http://images.bnf.fr/jsp/index.jsp, under the following references: RC-A-87415, RC-A-91428, RC-A-46129, and RC-C-02621. On the joining of hands as necessary for (and representative of) a formal agreement, see J. A. Burrow, *Gestures and Looks in Medieval Narrative* (Cambridge: Cambridge University Press, 2002), pp. 14–16.

24. Here I follow Aquinas, *Summa theologiae*, 1a, qu. 91, art. 1 (xiii.16–21), which discusses whether the body of the first man "was made out of the slime of the earth (*de limo terræ*)." Cf. pp. 232–33 in the Coda.

25. Cf. Aristotle, *Politics*, i, 1253a31.

26. Aquinas, *Summa theologiae*, 1a, qu. 91, art. 3: *utrum corpus hominis habuerit convenientem dispositionem* (xiii.24–31).

27. *Summa theologiae*, 1a, qu. 91, art. 3, ad 3um (xiii.28–29). For Aquinas's views on sensory pleasures, see especially Mary Carruthers, *The Experience of Beauty in the Middle Ages* (Oxford: Clarendon Press, 2013), pp. 71–76.

28. As is made clear by, for example, *Summa theologiae*, 1a 2ae, qu. 27, art. 1 ad 3 (xix.76–77), where Aquinas states that beauty is especially associated with those senses which—when they are ministering to reason—contribute most to our knowledge. The senses in question are sight and hearing: for "we speak of beautiful sights and beautiful sounds, but not of beautiful tastes and smells; we do not speak of beauty in reference to the other three senses." Cf. *Summa theologiae*, 1a, qu. 5, art. 4, ad 1um (ii.72–73).

29. Other expressions of such ideas are discussed in Karl Steel's thought-provoking monograph, *How to Make a Human: Animals and Violence in the Middle Ages* (Columbus: Ohio State University Press, 2011), pp. 44–57.

30. *Summa theologiae*, 1a, qu. 91, art. 3, ad 3 (xiii.28–29). Cf. Augustine, *De civitate Dei*, xxii.24 (CSEL 40.2, 646; tr. Dyson, p. 1163). See further Ambrose's commendation of the beautiful and rational construction of the human body, which specially emphasizes the excellent location of the head and its constituent features; Ambrose, *Hexaëmeron*, Liber VI: de opera sexti diei, ix.55–74 (*PL* 14, 265A–272B). Later in the same treatise, Ambrose likens God to an artificer (*artifex*) and painter (*pictor*) in his depiction of man—the picture thus created should not be obliterated or adulterated, which is what happens when women apply cosmetics to their faces (viii.47; *PL* 14, 260C–261A).

31. The notion that speech is an exclusive marker of humanity has a long history, going back at least to Plato's *Protagoras*; cf. Giulio Lepschy (ed.), *History of Linguistics*, vol. 2: *Classical and Medieval Linguistics* (London: Longman, 1994), p. 22.

32. Recent elaborations of "monster theory" have addressed the important cultural work performed by monsters in general, and giants in particular, in establishing the boundary which demarcates the limits of the human, beyond which lies the irrational, the disorderly, and the uncivilized. See especially Marie-Hélène Huet, *Monstrous Imagination* (Cambridge, Mass.: Harvard University Press, 1993); Jeffrey Jerome Cohen, *Of Giants: Sex, Monsters, and the Middle Ages* (Minneapolis: University of Minnesota Press, 1999), esp. pp. xi–xiii; and Jeffrey Jerome Cohen (ed.), *Monster Theory: Reading Culture* (Minneapolis: University of Minnesota Press, 1996). See further Jeffrey Jerome Cohen and Gail Weiss (eds.), *Thinking the Limits of the Body* (Albany: State University of New York Press, 2003), pp. 1–10 ("Introduction"); Dorothy Yamamoto, *The Boundaries of the Human in Medieval English Literature* (Oxford: Oxford University Press, 2000); and Steel, *How to Make a Human*, pp. 136–78.

33. Grosseteste, *Hexaëmeron*, viii.20.1 (ed. Dales and Gieben, p. 245; tr. Martin, p. 250).

34. *II Sent.*, dist. xviii, 4 (106), 1 (*Lib. sent.*, i.2, 417–18; tr. Silano, ii.78).

35. *Summa theologiae*, 1a, qu. 92, art. 3: *utrum mulier debuerit formari de costa viri* (xiii.41–45).

36. Here Aquinas is following the scientific principles described by Aristotle at *Physica*, iv.9 (217a25). The gold ingot metaphor is my own.

37. *In Johannis Evangelium tractatus CXXIV*, xxiv, 1 (on John 6:2); *PL* 35, 1593.

38. The comparison with the five loaves of bread had already been made in the Lombard's *Sentences*, where the idea is affirmed that they "were multiplied from themselves." "The body of the woman [was] made by divine power from the substance of that rib alone, without any extrinsic addition, by that very same miracle (*miraculo*) by which Jesus would later multiply the five loaves of bread with a heavenly blessing, and five thousand men were filled" (*II Sent.*, dist. xviii, 4 [106], 1 [*Lib. sent.*, i.2, 417–18; tr. Silano, ii.78]). See further Colish, *Lombard*, i.332, 367–69.

39. Thomas Aquinas offers a cogent discussion of the various ways in which the term *miraculum* may be used, in his *Summa contra gentiles*, iii.101 (*Aquinatis opera*, v.243).

40. See *In II Sent.*, dist. xviii, art. 1, qu. 2, ad 5 and 6 (*Bonaventurae opera*, ii.437–38); see further the relevant *dubia*, *In II Sent.*, dist. xviii, *dubia* (*Bonaventurae opera*, ii.454–55). In the latter discussion Bonaventure reacts against what he took to be Hugh of St. Victor's view—i.e., that the creation of Eve was miraculous (having proceeded by multiplication in the way Christ had multiplied the loaves), a position he wished to qualify. Cf. Hugh of St. Victor, *De sacramentis*, I.vi.36 (*PL* 176, 284D).

41. *In II Sent.*, dist. xviii, art. 1, qu. 1, ad 7–9 (*Bonaventurae opera*, ii.434).

42. Here I adopt some phrases from Bonaventure, *In II Sent.*, dist. xviii: *de formatione mulieris de viro*, art. 1, qu. 1, conclusio (*Bonaventurae opera*, ii.432).

43. Indeed, some schoolmen entertained the possibility that Adam had not (or rather, would not have) slept during his time in paradise. The *Summa Alexandri* seems to incline to this position, citing Pseudo-Isidore and St. Gregory in support. *Summa Alexandri*, 1a 2ae, inq. IV, tr. III, qu. 1, tit. 1, cap. 3, 2 (ii.638–39); cf. Pseudo-Isidore, *Liber de ordine creaturarum*, xii.3, ed. Díaz y Díaz, p. 174, and St. Gregory, *Moralium libri*, viii.32 (*PL* 75, 834).

44. The following summary of the issue is influenced by Bonaventure's formulation, at *In II Sent.*, dist. xviii, art. 1, qu. 1, contrary opinions 4, 5, and 6, and the responses to them (*Bonaventurae opera*, ii.432, 433–34).

45. See n. 20 above.

46. *In II Sent.*, dist. xviii, art. 1, qu. 1, conclusio (*Bonaventurae opera*, ii.432).

47. Ibid.

48. *In II Sent.*, dist. xviii, qu. 1, art. 1 (ii.151). Peter was appointed pope (as Innocent V) in January 1276, but died in June of the same year.

49. *In II Sent.*, dist. xviii, art. 1, qu. 1, responses to 4–6 (*Bonaventurae opera*, ii.433).

50. Perhaps Bonaventure had in mind what one "saint" in particular had said—St. Augustine, who in his *De Genesi ad Litteram*, ix.19,36, claimed that God sent an "ecstasy" (*ecstasis*) upon Adam to put him into a deep sleep, so that in "his mind" he might become "a member of the angelic court, and so 'enter into the sanctuary of God and understand the last things' [Ps. 73:17]" (CSEL 28.1, 294; tr. Hill, pp. 396–97).

51. Ephesians 5:31–32: "For this cause shall a man leave his father and mother, and shall cleave to his wife, and they shall be two in one flesh. This is a great sacrament."

52. *II Sent.*, dist. xviii, 3 (105), 2 (*Lib. sent.*, i.2, 417; tr. Silano, ii.77). See further Colish, *Lombard*, i.331–32, 367.

53. *In II Sent.*, dist. xviii, art. 1, qu. 1, conclusio (*Bonaventurae opera*, ii.433).

54. Specifically, it ends with an account of the seven sorrows and the seven joys of Mary.

55. Cf. *The Mirour of Mans Saluacioun*, ed. Henry, pp. 10–11.

56. Augustine, *De civitate Dei*, xiii.20 (CSEL 40.1, 644; tr. Dyson, pp. 566–67).

57. *II Sent.*, dist. xvii, 6 (101), 2 (*Lib. sent.*, i.2, 414–15; tr. Silano, ii.75). The Lombard is drawing on Bede, *Hexaëmeron, sive libri quatuor in principium Genesis*, ii.9 (*PL* 91, 44B), and the *Glossa ordinaria* on Genesis 2:9 (*Biblia glossata*, i.67–68).

58. *De Genesi ad litteram*, viii.5,11 (CSEL 28.1, 238–39; tr. Hill, pp. 353–54).

59. *De malo*, qu. 5, art. 5, 9, and ad 9um; in *The De Malo of Thomas Aquinas*, ed. and tr. Brian Davies and Richard Regan (Oxford: Oxford University Press, 2001), pp. 433, 441.

60. Augustine, *De civitate Dei*, xiii.20 (CSEL 40.1, 644; tr. Dyson, pp. 566–67).

61. Aquinas, *Summa theologiae*, 1a, qu. 97, art. 3, resp. and ad 1 (xiii.142–45). Cf. Aristotle, *De anima*, ii.4 (415a23) and iii.9 (432b8). On scholastic discussions of the need of Adam's body for food, and the role played by the Tree of Life in sustaining his immortality, see especially Ziegler, "Medicine and Immortality in Terrestrial Paradise."

62. This refers to the role of the digestion of food in the production of sperm, discussed below.

63. To be more exact, the body's "radical moisture," which is consumed through the body's natural heat, needs to be replenished by moisture from food. Cf. Philip Lyndon Reynolds's important study *Food and the Body: Some Peculiar Questions in High Medieval Theology* (Leiden: Brill, 1999), esp. p. 116.

64. Aquinas, *Summa theologiae*, 1a, qu. 97, art. 3, ad 4 (xiii.144–45).

65. *In II Sent.*, dist. xx, art. unicus, qu. 2, conclusio (*Bonaventurae opera*, ii.480).

66. To be more precise, "seed is a superfluity of the third digestion," whereas feces and urine were superfluities of "the second digestion." Following Bonaventure, *In II Sent.*, dist. xx, art. unicus, qu. 2, sed contra 2 (*Bonaventurae opera*, ii.479). In his *De generatione animalium*, Aristotle had given a full account of how semen came from nutriment that had been all but digested. In other words, it is a residue from blood—"not blood as such but rather blood that has undergone some further decoction and refinement." Hence a man who has had too much sex is physically weakened by this activity, for when he has emitted all "the fully refined material" he begins "to use blood in a cruder form, blood that should have served as nutriment." Reynolds, *Food and the Body*, p. 9; cf. Aristotle, *De generatione animalium*, i.19 (726b6–11), and

also i.19 (725a11–12, 725a24–25, 726a26–28) along with i.19 (9726b1–5). See further Agamben, *Nudities*, pp. 92–93.

67. *In II Sent.*, dist. xx, art. unicus, qu. 2, contrary opinions 1–3, and Bonaventure's resolutions of them (*Bonaventurae opera*, ii.479–80).

68. Aquinas, *Summa theologiae*, 1a, qu. 91, art. 3, 1 (xiii.24–25).

69. *In II Sent.*, dist. xix, qu. 2, art. 1 (ii.130D). Indeed, the notion that animals may be deemed superior to humans in certain respects and circumstances is a commonplace of Genesis commentary; see, for example, Ambrose, *Hexaëmeron*, Liber VI: de opera sexti diei, viii.44 (*PL* 14, 259A).

70. Aquinas, *Summa theologiae*, 1a, qu. 91, art. 3, 1 (xiii.24–25).

71. *Summa theologiae*, 1a, qu. 91, art. 3, resp. (xiii.26–27).

72. *Summa theologiae*, 1a, qu. 91, art. 3, resp. (xiii.28–29).

73. Cf. Aristotle, *De Anima*, iii.8 (432a1). In his *De anima* commentary, when discussing this passage Aquinas says "the hand is the most perfect of organs, for it takes the place in man of all the other organs given to other animals for purposes of defence or attack or covering. Man can provide all these needs for himself with his hands." *In Aristotelis librum de Anima commentarium*, iii.8, 790 [lect. 13], ed. Angelo M. Pirotta, 2nd ed. (Turin: Marietti, 1936), p. 257; tr. Kenelm Foster and Silvester Humphries, *Aristotle's* De Anima *in the Version of William of Moerbeke and the Commentary of St. Thomas Aquinas* (New Haven, Conn.: Yale University Press, 1951), p. 456. I have also consulted the more recent translation by Robert Pasnau, *Thomas Aquinas: A Commentary on Aristotle's* De anima (New Haven, Conn.: Yale University Press, 1999).

74. *Summa theologiae*, 1a, qu. 101, art. 1, resp. (xiii.176–77).

75. Bonaventure, *In II Sent.*, dist. xx, art. unicus, qu. 3, 4 (*Bonaventurae opera*, ii.480).

76. Therefore, Bonaventure continues, when Adam had sex with Eve, and when he ate, he would have had greater pleasure than we do nowadays. But he proceeds to question the logic of that inference. See pp. 44–45 below.

77. Cf. C. M. Woolgar, *The Senses in Late Medieval England* (New Haven, Conn.: Yale University Press, 2006), p. 23. This was in large measure due to the influence of Aristotle's *De anima* and *De sensu et sensato*.

78. *Summa theologiae*, 1a 2ae, qu. 27, art. 1, ad 3um (xix, 76–77).

79. Cf. Bartholomew the Englishman, O.F.M. (d. 1272), who, as Woolgar notes, regards touch as "the least subtle of the wits" (whereas sight is the most subtle), "by which he meant it was the most earthy and beast-like sense"; *Senses in Late Medieval England*, p. 29. Cf. *On the Properties of Things. John Trevisa's translation of Bartholomaeus Anglicus De proprietatibus rerum*, general ed. M. C. Seymour (Oxford: Clarendon Press, 1975), i.108: "the laste and the most boistous of alle his the gropinge, for the kinde therof is erthy and is nedeful to fele harde things as bones and senewis [sinews], rowe [rough] and smethe [smooth], colde and hote." (Here I quote from the Middle English version of Bartholomew's compilation which John Trevisa completed in 1398.) Alan of Lille's allegory of the five horses (i.e., senses) which draw Reason's chariot ranks Touch as the fifth, last, and least (whereas Sight is the first and best); "beauty smiles somewhat more grudgingly" on this horse, "and he droops his head more to earth as he goes," his eyes looking "down to the ground." *Anticlaudianus*, iv.95–212, ed. Massimo Sannelli (Trento: La Finestra, 2004), pp. 76–79; tr. J. J. Sheridan (Toronto: Pontifical Institute, 1973), pp. 121–25. Cf. Elizabeth Sears, "Sense Perception and Its Metaphors in the Time of Richard of Fournival," in W. F. Bynum and R. Porter (eds.), *Medicine and the Five Senses* (Cambridge:

Cambridge University Press, 1993), pp. 17–39 (pp. 29–33). On touch and smell as the most "bestial" of our sensations see Carruthers, *Experience of Beauty*, p. 75.

80. *Summa theologiae*, 1a, qu. 91, art. 3, ad 1um (xiii.26–27). Cf. Aristotle's *De anima*, ii.9 (according to the Moerbeke translation), where it is affirmed that, "whereas in the other senses" man "is inferior to many animals, by touch he can discriminate with exactness far beyond the rest of the animal world. Hence man is the most sagacious of animals." *In Aristotelis librum de Anima commentarium*, ii.9, Moerbeke 421a–b (ed. Pirotta, p. 165; tr. Foster and Humphries, p. 300). There is no inconsistency between this claim and what Aquinas says in this same *quaestio* and elsewhere about the preeminence of sight. Here Aquinas, in the context of a comparison of man to other animals, is affirming the superiority of the human sense of touch. But whereas the senses are bestowed on the other animals solely "for obtaining the necessities of life" (i.e., food and sex), in man they also serve to gain knowledge—and thus the superiority of the sense of sight may be maintained, since it "is finer than the others and shows him more distinctions between things" (hence man's face should be elevated above the earth, to give his eyes an excellent vantage point). *Summa theologiae*, 1a, qu. 91, art. 3, ad 3um (xiii.28–29). When speaking of the relative value of the senses, Aquinas uses different systems of classification, a point well made by Neil Campbell, "Aquinas' Reasons for the Aesthetic Irrelevance of Tastes and Smells," *British Journal of Aesthetics*, 36.2 (1996), 166–76. See further Charles Burnett's discussion of an anonymous *Summa de saporibus* which claims that taste is the most discerning and trustworthy of all the senses, because it is the least likely to be deceived in identifying the things with which it comes into contact. "The Superiority of Taste," *Journal of the Warburg and Courtauld Institutes*, 54 (1991), 230–38.

81. Bonaventure, *In II Sent.*, dist. XX, articulus unicus, qu. 3, ad 4um (*Bonaventurae opera*, ii.482).

82. Bonaventure, *In IV Sent.*, dist. xlix, p. 11, sect. 1, art. 3, qu. 1 (*Bonaventurae opera*, iv.1018–19).

83. *In IV Sent.*, dist. xliv, qu. 2, art. 1, questiuncula 4, solutio 4, ad 1um (*Aquinatis opera*, vii.2, 1087).

84. *De anima*, ii.5 (416b33–34). In his *De anima* commentary Aquinas explains as follows: "I mean by 'material change' (*immutatio naturalis*) what happens when a quality is received by a subject according to the *material* mode of the subject's own experience, as e.g. when something is cooled, or heated, or moved about in space. . . . Now in the case of touching and tasting . . . it is clear that a material change occurs: the organ itself grows hot or cold by contact with a hot or cold object." *In Aristotelis librum de Anima commentarium*, ii.7, 418 [lect. 14], ed. Pirotta, p. 144; tr. Foster and Humphries, pp. 267–68.

85. *In IV Sent.*, dist. xliv, qu. 82, art. 1, questiuncula 3, solutio 3 (*Aquinatis opera*, vii.2, 1086).

86. *In IV Sent.*, dist. xliv, qu. 2, art. 1, questiuncula 4, solutio 4, ad 1 (*Aquinatis opera*, vii.2, 1087).

87. This phenomenon is described as "spiritual immutation," the term *spiritualis* being used in a technical sense which hitherto we have not encountered in this book. It will be discussed in Chapter 3.

88. To use yet another of Aquinas's examples, from *In IV Sent.*, dist. xliv, qu. 82, art. 1, questiuncula 3, solutio 3 (*Aquinatis opera*, vii.2, 1086).

89. *Ordo representacionis Ade*, ed. Odenkirchen, pp. 52–55.

90. The origins of this treatise are something of a mystery, and the original has been lost. The earliest surviving text is in Franco-Italian (or, Franco-Veneto). A revised version of Luigi

Bernadetto's 1928 edition of this work is included in the composite edition by Gabriella Ronchi, *Milione / Le Divisament dou monde. Il Milione nelle redazioni toscana e franco-italiana* (Milan: Mondadori, 1982). The text represented in BnF fr. 2810 is an Old French version, recently edited in six volumes under the direction of Philippe Ménard; *Marco Polo: Le devisement du monde* (Geneva: Droz, 2001–9). Cf. Suzanne Conklin Akbari, "Introduction," in Suzanne Conklin Akbari and Amilcare Iannucci (eds.), *Marco Polo and the Encounter of East and West* (Toronto: University of Toronto Press, 2008), pp. 3–20 (pp. 8–9, 19n).

91. Iain Macleod Higgins dates the original to c. 1356/7; *Writing East: The "Travels" of Sir John Mandeville* (Philadelphia: University of Pennsylvania Press, 1997), p. 6.

92. Mandeville, *Travels*, ch. 33, ed. M. C. Seymour (Oxford: Clarendon Press, 1967), p. 219. This edition is based on the unique text (made c. 1400) of a Middle English version in London, British Library, MS Cotton Titus C.XVI.

93. In the Franco-Italian text; "Aloadain" in the Old French version. *Divisament*, xli, ed. Rochi, p. 353; *Devisement du monde*, ed. Ménard et al., i.166.

94. *Travels of Marco Polo*, i.21, tr. W. Marsden, with revisions by T. Wright and Peter Harris (New York: Knopf, 2008), pp. 54–55. This translation is based on Bernadetto's 1928 edition of the Franco-Italian text.

95. By this means Alaodin motivates a team of assassins, rendering them eager to do their master's will at any cost. Whereupon his tyranny is feared in all the surrounding countries; none of his enemies, however powerful, can escape assassination. Eventually Ulaù (Hülagü), the brother of the grand khan Möngke (Khubilai Khan's predecessor), sends one of his armies to besiege Alaodin's castle. Having been forced to surrender for want of provisions, Alaodin is made prisoner and put to death; his castle and paradisal garden are destroyed. *Travels of Marco Polo*, i.21, tr. Marsden et al., pp. 56–57. On Mandeville's manipulation of this story, see Higgins, *Writing East*, pp. 193–94.

96. Mandeville, *Travels*, ch. 15, ed. Seymour, p. 96.

97. Cf. Martine Clouzot, *Images de musiciens (1350–1500): Typologie, figurations et pratiques sociales*, Centre d'Études supérieures de la Renaissance (Turnhout: Brepols, 2007), pp. 263–75, 276–80, 301–3.

98. A third illumination, on BnF fr. 2810, fol. 214r, also has some relevance here. This illustrates Mandeville's story of the deceitful Gatholonabes, which has obvious similarities with Marco Polo's tale of Alaodin. Gatholonabes's mountain stronghold included "the fairest gardyn that ony man myghte beholde," filled with beautiful flowers and herbs, exotic beasts and birds, and fair wells, halls, and chambers, together with "the faireste damyseles that myght be founde" under the age of fifteen years. He called this place paradise. When good knights came to visit Gatholonabes, he would show them this land of milk, honey, and "delicious" bird song, promising that if they would fight and die for him they would be rewarded with his paradise. Here they would "ben of the age of tho damyselles and thei shoulde pleyer with hem and yit be maydenes." Indeed, Gatholonabes promises them entry into an even better paradise than the one shown them, where (strange combination!) in addition to being sexually pleasured by perpetual young virgins they will also "see God of Nature visibely in His magestee and in His blisse." At last "the worthi men of the contree" become aware of Gatholonabes' "sotylle falshod." They attack his castle, kill him, and destroy "alle the faire places and alle the nobletees of that paradys." Mandeville, *Travels*, ch. 30, ed. Seymour, pp. 200–202.

99. Mandeville, *Travels*, ch. 33, ed. Seymour, pp. 220–21. "Men . . . seyn that alle the swete watres of the world abouen and benethen taken hire begynnynge of that welle of Paradys, and

out of that welle all watres comen and gon" (p. 221). Cf. Higgins, *Writing East*, pp. 4, 128–29, 130.

100. *II Sent.*, dist. xx, 1 (116), 1–3 (*Lib. sent.*, i.2, 427–28; tr. Silano, ii.86).

101. Cf. pp. 2, 247 n. 3 above.

102. Here the Lombard follows Augustine, *De Genesi ad litteram*, ix.8,13–9,14 (CSEL 28.1, 276–7; tr. Hill, p. 383).

103. *Summa theologiae*, 1a, qu. 98, art. 2, resp. (xiii.154–55). Cf. Gregory of Nyssa, *De hominis opificio*, 17; *PG* 44, 189. See further John Chrysostom, *In Genesim*, Hom. 16 and Hom. 18 (*PG* 53, 126, 153); and John of Damascus, *De fide orthodoxa*, ii.11 (*PG* 94, 916).

104. *Summa theologiae*, 1a, qu. 98, art. 2, resp. (xiii.156–57).

105. *II Sent.*, dist. xx, 2 (117) (*Lib. sent.*, i.2, 428; tr. Silano, ii.87). Cf. Augustine, *De Genesi ad litteram*, ix.4,8 (CSEL 28.1, 272–73; tr. Hill, p. 380).

106. Aquinas sums up Augustine's two reasons as follows: either "once the woman was fashioned they were in next to no time thrown out of Paradise for sin; or else they were waiting for the definite time of waiting to be laid down by the same divine authority which had given them the general commandment to be fruitful." *Summa theologiae*, 1a, qu. 98, art. 2, ad 2 (xiii.157).

107. *II Sent.*, dist. xx, 1 (116), 3 (*Lib. sent.*, i.ii, 427–28; tr. Silano, ii.86–87). Cf. Augustine, *De Genesi ad litteram*, ix.8,13–10,16 (CSEL 28.1, 276–78; tr. Hill, pp. 383–84).

108. Cf. Hebrews 13:4; "honorabile conubium in omnibus et torus inmaculatus" ("marriage honourable in all, and the bed undefiled").

109. Cf. Augustine, *De Genesi ad litteram*, ix.10,17–18 (CSEL 28.1, 279–80; tr. Hill, p. 385), and also *De Genesi ad litteram*, ix.3,5–6 (CSEL 28.1, 271–72; tr. Hill, pp. 378–79). See further Augustine, *De civitate Dei*, xiv.24 (CSEL 40.2, 50; tr. Dyson, pp. 625–26).

110. Given this frequently cited disagreement, it is necessary to qualify the views of Thomas Laqueur, who has argued that the "two seed model" of human reproduction (accompanied by an insistence that female orgasm was essential for generation) was dominant throughout Western Europe until the late eighteenth century, when we begin to see the emergence of an obsession with the passionless bourgeois wife and mother, which is judged to be particularly characteristic of the Victorian era. *The Making of the Modern Body: Sexuality and Society in the Nineteenth Century* (Berkeley: University of California Press, 1987), esp. pp. 5–7. Crucial corrections and cautions are provided throughout Joan Cadden's study *The Meanings of Sex Difference in the Middle Ages: Medicine, Science, and Culture* (Cambridge: Cambridge University Press, 1993); see especially p. 4. Other critiques of aspects of the Laqueur thesis include Monica Green, "Bodily Essences: Bodies as Categories of Difference," in Linda Kalof (ed.), *A Cultural History of the Human Body*, vol. 2: *The Middle Ages* (Oxford: Berg, 2010), pp. 149–71 (esp. pp. 154–61), and Jürgen Voss, *Making Sex Revisited: Dekonstruktion des Geschlechts aus biologisch-medizinischer Perspektive* (Bielefeld: Transcript, 2010).

111. Albert the Great, *De animalibus*, ix, tract. 2, 3(107), ed. Stadler, i.717; tr. Kitchell and Resnick, i.815.

112. Albert the Great, *De animalibus*, ix, tract. 2, 3(99–100), ed. Stadler, i, 714–15; tr. Kitchell and Resnick, i.812.

113. Albert the Great, *Quaestiones de animalibus*, xv, qu. 12 (p. 456) and xv, qu. 19, 3 (p. 272); tr. Resnick and Kitchell, i.456, 469.

114. Albert the Great, *Quaestiones de animalibus*, ix, qu. 19–23 (p. 212); tr. Resnick and Kitchell, p. 323. Albert notes in particular the pleasure, and hence the enhanced conceptive potential, caused by touching the female breasts: "when the breasts are touched, the sperm is

driven out of them and they pour it out into the womb. This effusion into the womb arouses a soporific warmth in her, just like water cascading over limestone. For this reason, women particularly desire intercourse then." Albert explains that he learned this from hearing the confessions of "crafty suitors" in Cologne, "men who tempt women with this kind of trick and touch"—i.e., who sexually arouse women by fondling their breasts. *Quaestiones de animalibus*, xiii, qu. 17–18 (p. 248); tr. Resnick and Kitchell, p. 411.

115. Albert the Great, *De animalibus*, xv, tract. 2, 6 (109), ed. Stadler, ii.1038–39; tr. Kitchell and Resnick, ii.1134. Albert discusses this phenomenon with reference to the so-called wind egg which a certain type of female bird "first conceives and which is then completed by the sperm that comes over it through intercourse with the cock"; i.e., the male's subsequent action is necessary to ensure that a chick will hatch, but the hen has taken no pleasure from any physical contact with it. Here Albert contradicts the notion that on such an occasion the egg is impregnated by the wind. *De animalibus*, xv, tract. 2, 11(144), ed. Stadler, ii.1056; tr. Kitchell and Resnick, ii.1151. See further the extensive discussion by Conway Zirkle, "Animals Impregnated by the Wind," *Isis*, 25 (1936), 95–130.

116. Giles of Rome, *Tractatus aurea de formatione corpus humanum in utero* (Paris, 1515), fols. 13v–16r; cf. Faith Wallis (ed.), *Medieval Medicine: A Reader* (Toronto: University of Toronto Press, 2010), pp. 222–27 (esp. p. 226). On the pleasure principle, see further Danielle Jacquart and Claude Thomasset, *Sexuality and Medicine in the Middle Ages*, tr. Matthew Adamson (Princeton, N.J.: Princeton University Press, 1988), pp. 31, 37, 41–42, 47, 55, 61–70, 79–86, 90, 94–96, 124–25, 128, 130–34, 144, etc., and Laqueur, *Making Sex*, pp. 8, 44–52, 66–67, 99–103.

117. *Summa Alexandri*, 1a 2ae, inq. IV, tract. III, qu. 2, cap. 2 (ii.701–3).

118. *In II Sent.*, dist. xx, art. unicus, qu. 3: *utrum in emissione seminis in statu innocentiae fuisset delectationis intensio*, conclusio (*Bonaventurae opera*, ii.481–82).

119. *Summa theologiae*, 1a, qu. 98, art. 2, ad 3um (xiii.157).

120. Albert the Great seems to have been influential here, particularly his argument that it is foolish to say that, in paradise, the activity of the sexual members was directed by reason rather than due to sexual passion or heat, so that *ratio* and *calor* were in opposition. In fact, passion was a necessary instrument in the process, necessary to ensure the movement of the members. Sexual ardor should not be thought of as something which reason stifled. Albert readily concedes that then there was greater (*major*) and more honest or genuine (*sincerior*) pleasure in this work—and yet this was under reason's rule, so nothing violent (*vehemens*) would have occurred. *In IV Sent.*, dist. xxvi, B, art. 7: *an in paradiso fuisset conceptus sine ardore libidinis* (*Alberti opera*, xxx.105–6). Discussed by Brandl, *Die Sexualethik des heiligen Albertus Magnus*, pp. 73–78.

121. In my view, Müller's discussion of Aquinas's treatment undervalues the extent to which Aquinas has altered the Augustinian account; *Die Lehre des hl. Augustinus von der Paradiesesehe*, pp. 254–72.

122. *Summa theologiae*, 1a, qu. 98, art. 2, resp. (xiii.157). Cf. *De civitate Dei*, xiv.26 (CSEL 40.2, 53–54; tr. Dyson, p. 629), and p. 42 above.

123. *In II Sent.*, dist. xx, art. 1, qu. 2 (ii.252). Richard's predecessor in the Franciscan school at Paris, William de la Mare (fl. 1272–79), also includes in his *Sentences* commentary a discussion of sexual pleasure in paradise. For William the "more probable" opinion is that it was as great or greater than it is now, though he proceeds to suggest that it was definitely greater. The spirit (*anima*) which is strong thanks to the power of its imagination and memory does not

impede sensory activity (according to Avicenna). In Eden there was nothing to impede imagination, memory, and cognition, and consequently there was no hindrance of sensory activity, particularly not in respect of the sense of touch around the genitals. So, William is in agreement with St. Thomas, but offers fresh material. In the attenuated form in which it has survived, the "less probable" opinion is not elaborated beyond the notion that in Eden reason was strong (and hence, by implication, restrained desire). *In II Sent.*, dist. xx, qu. 2, in *Guillelmus de la Mare, Scriptum in secundum librum sententiarum*, ed. Hans Kraml (Munich: Bayerischen Akademie, 1995), pp. 255–56.

124. Another *quaestio* from Richard. When the will greatly applies itself to taking pleasure, then (all things being equal) the pleasure is more intense. But, since in Eden the will did not apply itself in this way, surely sexual pleasure then was less intense than it is now? This principle is quite true, Richard concludes, but in this case all things are *not* equal. Conditions in Eden were quite different from the way they are now, and therefore the resolution of the problem he offered previously—i.e., the Thomistic position—also applies here. *In II Sent.*, dist. xx, qu. 2 (p. 252).

125. *Summa theologiae*, 1a, qu. 98, art. 2, ad 3um (xiii.156–57).

126. Cf. Aquinas's statement that "in the state of innocence procreation was directed to the multiplication of men"; *Summa theologiae*, 1a, qu. 99, art. 2, 3um (xiii.164–65). Cf. William de la Mare, *In II Sent.*, dist. xx, qu. 3, ed. Kraml, p. 257.

127. *In II Sent.*, dist. xx, art. unicus, qu. 5, sed contra 2 (*Bonaventurae opera*, ii.483).

128. *In II Sent.*, dist. xx, art. unicus, qu. 5, sed contra 3 (*Bonaventurae opera*, ii.483).

129. *In II Sent.*, dist. xx, art. unicus, qu. 5, conclusio (*Bonaventurae opera*, ii.484).

130. *In II Sent.*, dist. xx, art. unicus, qu. 5, ad 2um (*Bonaventurae opera*, ii.484).

131. *In II Sent.*, dist. xx, art. unicus, qu. 5, ad 3um (*Bonaventurae opera*, ii.484).

132. *De generatione animalium*, ii.3 (737a25); cf. iv. 6 (775a14–15).

133. *In II Sent.*, dist. xx, art. unicus, qu. 6, sed contra 2 (*Bonaventurae opera*, ii.485). Cf. Aristotle, *De generatione et corruptione*, ii.10 (336b).

134. *In II Sent.*, dist. xx, art. unicus, qu. 6, sed contra 3 (*Bonaventurae opera*, ii.485).

135. *In II Sent.*, dist. xx, art. unicus, qu. 6, conclusio (*Bonaventurae opera*, ii.485–86). Here is an excellent example of the demographic thought which Peter Biller has discovered in late medieval scholasticism. On treatments of Eden's potential sex ratio by Bonaventure, Aquinas, Richard of Middleton, Duns Scotus, and Giles of Rome, see his *The Measure of Multitude: Population in Medieval Thought* (Oxford: Oxford University Press, 2000), pp. 91–96. The relevant views of William of Auxerre and William of Auvergne (inter alia) are discussed on pp. 97–102. Biller comments, "The theme of prelapsarian perfection and 'what would have happened if' gave commentators extraordinary freedom to think and speculate about *this*-worldly things: generation, birth, ageing, and inhabitation in their own real world" (p. 91).

136. *In II Sent.*, dist. xx, art. unicus, qu. 6, conclusio (*Bonaventurae opera*, ii.485–86). As Albert the Great remarked in a discussion of such issues, "the cause of masculinity and femininity is almost always varied and it rarely has a simple cause." *De animalibus*, ix, tract. 2, 3(102), ed. Stadler, i.715; tr. Kitchell and Resnick, i.813.

137. The principle being that "heat is dominant in the form of the male, whereas cold is dominant in the female." Albert the Great, *De animalibus*, xviii, tract. I, iii(24), ed. Stadler, ii.1201; tr. Kitchell and Resnick, ii.1292. It is true that a male "is often produced on the left of the womb and a female often on the right, but such a male has certain feminine characteristics and such a female has certain male characteristics" (ed. Stadler, i.715; tr. Kitchell and Resnick, ii.813).

138. Here Bonaventure is speaking of the "female seed" in a sense which Albert the Great would regard as equivocal; cf. p. 43 above.

139. Similarly, Albert the Great declares that "the whole and true cause" of the generation of a male child "is the heat of the sperm, while the other causes which lie in the material of the woman or in the location of the womb are the causes that arrange, unify, and prepare." *De animalibus*, ix, tract. 2, 3(102), i.715; tr. Kitchell and Resnick, i.813.

140. Albert the Great, *Quaestiones de animalibus*, vi, qu. 19–20 (p. 167); tr. Resnick and Kitchell, p. 219. Cf. Aristotle, *Historia animalium*, vi.19 (574a1–5). The cleansing north wind, which "purifies the air and vapors and sharpens the natural powers," causes a constriction of "the external parts." "It puts the heat and spirit to flight inwards and consolidates them there, and the unified power is stronger than when it is dispersed, whereas the opposite occurs from the south wind," which "is humid and rain-filled." "And this is why the north wind is better suited for generation, as the Philosopher intimates." A concomitant is that the constricting north wind "is conducive to constipation," whereas the softening south wind, "as a result of its heat and moisture, causes diarrhea." Here I have amalgamated materials from Conrad of Austria's *reportatio* of two of Albert's Cologne disputed questions; *Quaestiones de animalibus*, vi, qu. 19–22 (p. 168) and 18, qu. 1 (pp. 296–97), tr. Resnick and Kitchell, pp. 220–21 and 531–32. Cf. the similar statement in Albert's later *De animalibus* commentary: "if the north wind should blow, then males are most often conceived. For this wind closes the pores with its coldness so that the natural heat, turned inward in this way, digests the sperm better. When, however, the southern winds blow, then females are most often conceived. For their bodies grow moist and the heat which is in them is turned loose in the warm, southerly wind which, with its own heat, opens the pores and loosens the bodies." *De animalibus*, xviii, tract. 1, 3(27), ed. Stadler, ii.1203–4; tr. Kitchell and Resnick, i.1293.

141. Cf. Augustine, *De Genesi ad litteram*, ix.10,18 (CSEL 28.1, 279; tr. Hill, p. 385).

142. *In II Sent.*, dist. xx, art. unicus, qu. 6, conclusio (*Bonaventurae opera*, ii.486).

143. For a summary account of medieval theories of imagination, see Alastair Minnis, "Medieval Imagination and Memory," in Alastair Minnis and Ian Johnson (eds.), *The Cambridge History of Literary Criticism*, vol. 2: *The Middle Ages* (Cambridge: Cambridge University Press, 2005), pp. 239–74; also Simon Kemp, *Medieval Psychology*, Contributions in Psychology, 14 (New York: Greenwood Press, 1992), pp. 53–76.

144. A more routine source, for Albert and his contemporaries, would have been the treatise on animals which forms the twelfth book of Isidore of Seville's *Etymologiae*. But here the emphasis is different, at least initially. The story from Genesis 30 is cited to illustrate how human intervention has forced animals of different species to breed. In this case "colors contrary to nature" were obtained, for Jacob's "sheep conceived offspring similar to the image of the ram mounting them . . . that they saw as a reflection in the water." However, Isidore goes on to describe how, if the best possible form of a given species is presented to females of that species as they conceive, they will produce offspring of similar appearance. This is exemplified with reference to the breeding of horses and doves. "Whence also people advise pregnant women not to gaze at repulsive animals faces, such as *cynocephali* or apes, lest they should bear offspring resembling what they have seen." Indeed, the nature of women is such that, whatever sort of thing they gaze upon or conceive mentally "in the extreme heat of desire, when they are conceiving, is the sort of progeny they will bear." Isidore of Seville, *Étymologies, Livre XII*, ed. Jacques André (Paris: Les Belles Lettres, 1986), pp. 80–87; cf. *The Etymologies of Isidore of Seville*, tr. Stephen A. Barney et al. (Cambridge: Cambridge University Press, 2006), pp. 250–51.

145. Albert the Great, *Quaestiones de animalibus*, vii, qu. 3 (p. 172), xviii, qu. 3 (p. 298); tr. Resnick and Kitchell, pp. 230, 534.

146. Albert the Great, *Quaestiones de animalibus*, xviii, qu. 3 (p. 298); tr. Resnick and Kitchell, p. 536.

147. Henry Bracken, *The Midwife's Companion; or, a Treatise of Midwifery* (London: Clarke and Shuckburgh, 1713), p. 40; cited by Jenny Davidson, *Breeding: A Partial History of the Eighteenth Century* (New York: Columbia University Press, 2009), p. 22. Davidson also notes that the sheep story appears in the treatise on monsters which the French surgeon Ambroise Paré first published in 1573 (p. 22).

148. Jacques Gélis, *History of Childbirth: Fertility, Pregnancy, and Birth in Early Modern Europe*, tr. Rosemary Morris (Cambridge: Polity Press, 1991), p. 55. Marie-Hélène Huet notes that, in the early modern period, "women's imaginations were thought to be strongly affected by images"; Empedocles was credited with the "suggestion that the shape of progeny could be modified by the statues and paintings that the mother gazed on during her pregnancy." And a woman's *vis imaginativa* was believed to be particularly prone to such influences "at the moment of conception." Huet, *Monstrous Imagination*, p. 19. "There are no desires, shameful or innocent, that one's progeny does not publicly disclose" (p. 17).

149. This yarn is the inverse of one alluded to by Albert the Great, about how a royal white woman, having imagined an Ethiopian, produced a child of like appearance. Albert the Great, *Quaestiones de animalibus*, xviii, qu. 3 (p. 298); tr. Resnick and Kitchell, p. 536. On such stories of black-white reversal, see Huet, *Monstrous Imagination*, pp. 22–23.

150. Valeria Finucci, "Maternal Imagination and Monstrous Birth: Tasso's *Gerusalemme liberata*," in Valeria Finucci and Kevin Brownlee (eds.), *Generation and Degeneration: Tropes of Reproduction in Literature and History from Antiquity Through Early Modern Europe* (Durham, N.C.: Duke University Press, 2001), pp. 41–77 (esp. pp. 43–48).

151. Finucci, "Maternal Imagination," following Tasso's "Il messaggiero"; p. 48.

152. The point being that, "although the man's sperm is related to the female's semen as an agent relates to matter, nevertheless sometimes the female's semen [or whatever the female's contribution should be called] is disobedient and resists the agent too much, and then the male's power cannot entirely prevail, and this is why it cannot perfectly assimilate the fetus to itself." Albert the Great, *Quaestiones de animalibus*, xviii, qu. 1 (p. 257); tr. Resnick and Kitchell, p. 532. Here Albert is talking about the ways in which a mother may resist the natural and primary tendency to conceive a male in his father's likeness. "The complete victory of the male semen or sperm over the female's matter is the cause why the fetus resembles the father" (*Quaestiones de animalibus*, xviii, qu. 3 (p. 298); tr. Resnick and Kitchell. p. 535).

153. Albert the Great, *Quaestiones de animalibus*, vii, qu. 3 (p. 172); tr. Resnick and Kitchell, p. 230. This capacity for wonder has considerable cultural ramifications. Karl Steel, who (with good reason) describes medieval texts as "relentlessly pessimistic and anxious in their interaction with what they denigrate as animal," nevertheless finds a few exceptional encounters where animals are offered "to humans not for domination, not even quite for understanding, but for interest and wonder in a world no longer anthropocentric." *How to Make a Human*, pp. 57, 58. A similar statement could be made, with even more vigor, for Albert the Great's animal scholarship, not least because here the boundary between the animal and the human is (occasionally) breached, as the workings of the animal bodies of humans are subjected to rigorous inquiry. Here (as in Nicole Oresme's *De causis mirabilium*) a capacity for wonder at the marvels of nature can override the commonplace, and heavily Aristotelian, attitude to animals as mere instruments which exist for the sake of mankind. No doubt the experience of animal nature

retains its ultimate justification as a means of learning more about God's grand design (cf. Aquinas's statement to that effect, quoted on p. 16 in the Introduction).Yet this may allow, indeed encourage, an interest in the complexity of subordinated life-forms, which makes their reductive treatment as simple instruments rather more difficult. Anthropocentrism may prevail, but it has been rendered more responsive to the rich (and valorizing) details of the lives of Others.

154. *De causis mirabilium*, ed. Bert Hansen, in *Nicole Oresme and the Marvels of Nature: A Study of his* De causis mirabilium *with Critical Edition, Translation, and Commentary* (Toronto, Ont., Canada: Pontifical Institute of Mediaeval Studies, 1985), p. 346.

155. *De causis mirabilium*, ed. Hansen, p. 346.

156. As Oresme's editor Bert Hansen notes; p. 414, n. 71.

157. The camel also shows up in Giles of Rome's *Errores philosophorum* (c. 1270?), where Algazel is criticized for the erroneous belief that the imagination can act on other bodies, "and that the influence of the soul passes over to other bodies in such a way that by its thinking it destroys a spirit or kills a man"—which is said to be *fascinatio* (enchantment). In this sense, "the eye" can cast "a man into the ditch" and cast "a camel into a hot pool." *Errores philosophorum*, ed. Joseph Koch and English tr. by John O. Riedl (Milwaukee, Wisc.: Marquette University Press, 1944), pp. 44–45. The notion that an *incantator* could by sight alone make a camel fall into a pit was one of the articles (no. 112) condemned at Paris in 1277. *Chartularium Universitatis Parisiensis*, ed. Henricus Denifle and Aemilio Chatelain (Paris: ex typis fratrum Delalain, 1889–1897), i.549.

158. Albert the Great, *Quaestiones de animalibus*, xviii, qu. 3 (p. 298); tr. Resnick and Kitchell, p. 536.

159. *In II Sent.*, dist. xx, art. unicus, qu. 6, conclusio (*Bonaventurae opera*, ii.486).

160. In this discussion Bonaventure fails to address the question of whether the father of humankind experienced nocturnal omissions, but given the context it may promptly be inferred that he did not, since such production of sperm would have been at once useless, gratuitous, and indecorous. So, then, it would seem that sexual dreams about Eve were not an option for Adam.

161. *In II Sent.*, dist. xx, art. unicus, qu. 6, conclusio (*Bonaventurae opera*, ii.486).

162. *Summa theologiae*, 1a, qu. 99, art. 2 (xiii.164–67).

163. *Summa theologiae*, 1a, qu. 92, art. 1, ad 1um (xiii.36–37).

164. I.e., in *Summa theologiae*, 1a, qu. 99, art. 2 (xiii.164–67).

165. *Historia animalium*, vi.19 (574a1–5). In the related discussion in *Summa theologiae*, 1a, qu. 92, art. 1 resp. (xiii.36–37), Aquinas cites *De generatione animalium* (iv.2, 766b33) as saying that the south wind is damp. The point being that this will encourage the generation of women, since the female temperament is generally wet and cold (in contrast with the male temperament, which is hot and dry).

166. *Summa theologiae*, 1a, qu. 99, art. 2, ad 2um (xiii.164–65).

167. On Peter Lombard's defense of this position—argued on what Marcia Colish terms "the basis of naturalism and common sense"—see Colish, *Lombard*, i.368–69.

168. *Summa theologiae*, 1a, qu. 99, art. 1 (xiii.160–63).

169. *Summa theologiae*, 1a, qu. 99, art. 1, resp. (xiii.162–63). Cf. Pseudo-Aristotle, *Problemata*, i.16 (861a), i.19 (861b), and iii.7 (872a). See further Aquinas, *Quaestiones disputatae de veritate*, qu. 18, art. 7 and art. 8, in *Quaestiones disputatae*, 9th rev. ed., by Raymundus Spiazzi (Turin: Marietti, 1953), i.352–56; tr. V. McGlynn, *The Disputed Questions on Truth* (Chicago: Henry Regnery, 1953), ii.374–82.

170. *In II Sent.*, dist. xx, art. 2, qu. 2, ad 3um (ii.256).

171. *Summa theologiae*, 1a, qu. 101, art. 2 (xiii.178–79).

172. *Summa theologiae*, 1a, qu. 101, art. 2, resp. (xiii.180–81).

173. *Summa theologiae*, 1a, qu. 101, art. 1, resp. (xiii.176–77).

174. *Summa theologiae*, 1a, qu. 84, art. 7, resp. (xii.40–41). Furthermore, acts of the imagination and the other faculties (*virtutes*) are necessary not only for the intellect's acquisition of fresh knowledge but also for its use of knowledge already acquired.

175. *Summa theologiae*, 1a, qu. 101, art. 1, resp. (xiii.176–79).

176. *Summa theologiae*, 1a, qu. 94, art. 3, ad 1um (xiii.98–99).

177. *Quaestiones disputatae de veritate*, qu. 18, art. 2, resp.; ed. Spiazzi, i.341; tr. McGlynn, ii.348. A particularly interesting issue concerns prelapsarian knowledge of medicine, which, according to James of Viterbo (c. 1255–1308), Adam would have possessed although he would not have needed it for the care and cure of his body. Cf. Ziegler, "Medicine and Immorality in Terrestrial Paradise," pp. 201–3.

178. *Summa theologiae*, 1a, qu. 94, art. 3, resp. (xiii.96–99).

179. *Summa theologiae*, 1a, qu. 94, art. 3, resp. (xiii.98–99).

180. *Summa theologiae*, 1a, qu. 94, art. 3, ad 1 (xiii.98–99).

181. For discussion, see E. Ruth Harvey, *The Inner Wits: Psychological Theory in the Middle Ages and the Renaissance*, Warburg Institute Surveys, 6 (London: Warburg Institute, 1975); Mary Carruthers, *The Book of Memory: A Study of Memory in Medieval Culture* (Cambridge: Cambridge University Press, 1990), pp. 51–60, 197.

182. *De anima*, iii.7 (431a16).

183. *In Aristotelis librum de Anima commentarium*, iii.8, 791 [lect. 13], ed. Pirotta, pp. 257–58; tr. Foster and Humphries, p. 456.

184. *Summa theologiae*, 1a, qu. 84, art. 7, resp. (xii.40–41). Bonaventure remarks that the soul "combines and sorts through imagination (*phantasia*), which is the foremost collating aptitude"; *Breviloquium*, ii.9,5, in *Tria opuscula S. Bonaventurae* (Quaracchi: Ex Typographia Collegi S. Bonaventurae, 1938), p. 84.

185. *De proprietatibus rerum*, iii.11; tr. Trevisa, ed. Seymour, i.99.

186. Cf. Aquinas, *Summa theologiae*, 1a, qu. 78, art. 4, resp. (xi.140–41). In his commentary on *De anima*, iii.3 (427b16–21), Aquinas notes how "images can arise in us at will, for it is in our power to make things appear, as it were, before our eyes—golden mountains, for instance, or anything else we please, as people do when they recall past experiences and form them at will into imaginary pictures." *In Aristotelis librum de Anima commentarium*, iii.3, 633 [lect. 4], ed. Pirotta, p. 214; tr. Foster and Humphries, p. 383. See further Minnis, "Medieval Imagination and Memory," pp. 241–43.

187. Cf. Aristotle, *De somniis*, 3 (460b–1a).

188. Assuming that Adam slept in Eden; see p. 258 n. 43.

189. *The Poetical Works of John Milton*, ed. Henry Darbishire (London: Oxford University Press, 1958, rpt. 1963), p. 93.

190. *In II Sent.*, dist. xxiii, art. 2, qu. 2, 4 and ad 4 (*Bonaventurae opera*, ii.540–41).

191. *De statu innocencie*, iii, ed. Loserth and Matthew, pp. 494–95.

192. *Quaestiones disputatae de veritate*, qu. 18, art, 6, responses to issues 14 and 15; ed. Spiazzi, i.352, tr. McGlynn, ii.373–74.

193. *Summa theologiae*, 1a, qu. 94, art. 4, ad 4um (xiii.102–3).

194. *Summa theologiae*, 1a, qu. 94, art. 4, ad 5um (xiii.102–3).

195. *De memoria et reminiscentia*, ii (452b9–22).

196. *Summa theologiae*, 1a, qu. 94, art. 4, 3 (xiii.102–3).

197. *Summa theologiae*, 1a, qu. 94, art. 4, ad 3um (xiii.102–3). Cf. Bonaventure's assertion that Adam would have known full well that a thing at a more remote distance appears to be smaller. Not relying on "the appearance of the eye only" he would have made a right judgment, and not been deceived. *In II Sent.*, dist. xxiii, art. 2, qu. 2 (*Bonaventurae opera*, ii.541).

198. *Summa theologiae*, 1a, qu. 94, art. 4, ad 1um and ad 5um (xiii.102–3). Augustine had specified Eve's sin as a "love of her own independent authority (*propriae potestatis*) and a certain proud over-confidence in herself (*superbia praesumtio*)"; *De Genesi ad litteram*, xi.30,38 (CSEL 28.1, 363; tr. Hill, p. 451).

199. *Summa theologiae*, 1a, qu. 94, art. 4, responsio (xiii.102–3).

200. *Summa aurea*, Lib. II, tr. ix. cap. iii, qu. 11, in *Summa aurea, Liber secundus*, ed. Ribaillier, pp. 272–74. Cf. Augustine, *De civitate Dei*, xxi.26 (CSEL 40.2, 568–70, 572–73; tr. Dyson, pp. 1094–95, 1098), and *De bono coniugali*, xi, 12 (*PL* 40, 382).

201. *Summa theologiae*, 1a, qu. 94, art. 1 (xiii.86–91).

202. *IV Sent.*, dist. i, cap. 5 (3); *Lib. sent.*, ii.235; tr. Silano, i.5 (with some changes made).

203. *Summa theologiae*, 1a, qu. 94, art. 1, 1 (xiii.86–87).

204. *De Genesi ad litteram*, xi.18,24 (CSEL 28.1, 350; tr. Hill, p. 442); cited by Aquinas, *Summa theologiae*, 1a, qu. 94, art. 1, ad 1 (xiii.90–91).

205. *De statu innocencie*, iii, ed. Loserth and Matthew, p. 495.

206. *De Genesi ad litteram*, xi.33,43 (CSEL 28.1, 367; tr. Hill, p. 454). Cf. Aquinas, *Summa theologiae*, 1a, qu. 94, art. 1, resp. (xiii.90–91).

207. *Summa theologiae*, 1a, qu. 94, art. 2 (xiii.90–95).

208. Cf. Gregory the Great, *Dialogi*, iv.1 (*PL* 77, 317).

209. Cf. Bonaventure, who explains that all his authorities "posit the cognition which Adam had of God as an intermediary one (*medium inter cognitionem*) between the cognition which is in the state of misery and the cognition which will be in the state of glory," while noting that they differ greatly in the way they posit this. *In II Sent.*, dist. xxiii, art. 2, qu. 3, resp. (*Bonaventurae opera*, ii.543).

210. *In II Sent.*, dist. xxiii, art. 2, qu. 3, resp. (*Bonaventurae opera*, ii.545).

211. *In II Sent.*, dist. xvii, art. 1, qu. 3 (*Bonaventurae opera*, ii.416–18).

212. *II Sent.*, dist. xvii, 2 (97), 1 (*Lib. sent.*, i.2, 411; tr. Silano, ii.72).

213. Cf. Augustine, *De Genesi ad litteram*, vii.23,34–25,35 (CSEL 28.1, 221–23; tr. Hill, pp. 340–41).

214. *II Sent.*, dist. xvii, 2 (97), 4 (*Lib. sent.*, 1.2, 412; tr. Silano, ii.73).

215. *In II Sent.*, dist. xviii, art. 2, qu. 2 (*Bonaventurae opera*, ii.450).

216. *In II Sent.*, dist. xvii, art. 1, qu. 3, resp. (*Bonaventurae opera*, ii.417).

217. *De Genesi ad litteram*, vii.24,35 (CSEL 28.1, 233; tr. Hill, p. 341). The argument here is that the soul was indeed created before the body, and "stored away among the works of God until in due time he chose" to breathe it "into the body formed of mud."

218. This should not be read as some sort of desire to withhold information on Peter Lombard's part. In the interests of his dialectical method, he wants to pit clearly defined positions against each other.

219. On the interpretive importance of the distinction between asserting and reporting, see Alastair Minnis, *Medieval Theory of Authorship: Scholastic Literary Attitudes in the Later Middle Ages*, 2nd ed. with a new preface (Philadelphia: University of Pennsylvania Press, 2009), pp. 100–102.

220. *Summa theologiae*, 1a, qu. 90, art. 4: *utrum anima hominis fuerit product ante corpus* (xiii.10–15). Aquinas continues: "Soul, as a part of human nature, has no natural perfection on its own, except insofar as it is united to a body. So it would have been most unsuitable for soul to be created without body" (xiii.14–15).

221. Cf. Aquinas's formulation of what sort of argument is needed to uphold Augustine's view: "you could say that the human soul, thanks to a certain general likeness it has with the angels as a substance of intelligent nature, did come first in the works of creation," though "in itself it was actually created at the same time as the body." But he immediately adds: "According to the other Saints, however, both the body and soul of the first man were produced in the work of the six days" (specifically, on the Sixth Day). *Summa theologiae*, 1a, qu. 90, art. 4, resp. (xiii.14–15).

222. Bonaventure's argument here was actually prompted by Augustine; cf. Augustine, *De Genesi ad litteram*, vi.1,1–2,3 (CSEL 28.1, 170–72; tr. Hill, pp. 301–3).

223. Hence his condemnation by the Second Ecumenical Council of Constantinople (553) and three subsequent ecumenical councils. Aquinas took Origen to task for believing that "not only the first man's soul, but all men's souls were created at the same time as the angels, before bodies"; *Summa theologiae*, 1a, qu. 90, art. 4, resp. (xiii.12–13); cf. Origen, *Peri Archon*, i.6 and 8, and ii.9 (*PG* 11, 166, 178, 229). Faced with the problem of why certain people are beset by many ills, whereas others seem to be very lucky (to use the modern colloquialism) and enjoy all kinds of good fortune, Origen suggested that they were being punished or rewarded for actions performed in a previous life. That doctrine was roundly rejected by Aquinas (among many others): "we should not say that souls earned merits or demerits before their union with the body." This is quite contrary to the authority of Scripture, and also to reason, for "the soul, inasmuch as it is by nature part of human nature, is incomplete when it is without the body, as is any part separated from the whole. And it would have been inappropriate for God to begin his work of creation with incomplete things. And so it is just as unreasonable to suppose that God created souls before he created bodies as it is to suppose that he formed hands apart from human beings." *De Malo*, qu. 5, art. 4, resp.; ed. and tr. Davies and Regan, p. 429.

224. Cited from the modern scholion to Bonaventure, *In II Sent.*, dist. xvii, art. 1, qu. 3 (*Bonaventurae opera*, ii.418).

225. *In II Sent.*, dist. xviii, art. 2, qu. 2: *utrum animae omnium fuerint simul productae* (*Bonaventurae opera*, ii.448–51).

226. Cf. Plato, *Timaeus*, 41e, 42b–d, 90e–92c, and also *Phaedo*, 80b–84b.

227. Macrobius, *In Somnium Scipionis*, i.21 [33]; cf. i.14 [1–11], ed. Luigi Scarpa (Padova: Liviana, 1981), pp. 238–39, 170–75; tr. W. H. Stahl, *Macrobius: Commentary on the Dream of Scipio* (New York: Columbia University Press: 1990), pp. 181, 143–44.

228. Alastair Minnis and Lodi Nauta, *"More Platonico loquitur*: What Nicholas Trevet Really Did to William of Conches," in Alastair Minnis (ed.), *Chaucer's "Boece" and the Medieval Tradition of Boethius* (Cambridge: D. S. Brewer, 1993), pp. 1–33 (pp. 24–25). Here Nicholas is substantially revising the interpretation he found in the Boethius commentary of William of Conches (d. after 1154). William had argued that the chariots refer to the reason and intellect, called chariots of the soul because they transport the soul to knowledge of heavenly and earthly things. Alternatively, they may be read as stars which bring the soul to the body in the sense that by stellar influence the soul is able to exist and function in the human body. Souls are connected to stars because as long as the constellations will endure in their present condition

the soul will live in the body—until, one may presume, the end of time and the creation of the new paradise.

229. *Paradiso*, ed. and tr. Singleton, p. 411.

230. Cf. Aristotle, *De anima*, ii.1 (412a20) and ii.2 (414a14–19).

231. *In II Sent.*, dist. xviii, art. 2, qu. 2, resp. (*Bonaventurae opera*, ii.449). Cf. Augustine, *De trinitate*, xiii.7,10 and xiv.14,20 (*PL* 42, 1020–22, 1051), and *De civitate Dei*, x.30, xii.20, and xxii.27 (CSEL 40.1, 500–502, 600–601, and 40.2, 653–54; tr. Dyson, pp. 438–41, 527–28, 1169–70).

232. *In II Sent.*, dist. xviii, art. 2, qu. 2, resp. (*Bonaventurae opera*, ii.449).

233. As Margaret Miles has emphasized, Augustine spent "nearly a decade of his formative youth" within "the Gnostic-Manichaean tradition." Although the saint's earlier "tendency to view the body as the ground of existential alienation" developed into an "affirmation of the whole person," comprising both body and soul, Miles holds that Augustine had a "psychological predilection for dualism" and "never ceased to experience the world dualistically, that is, as a struggle against the tremendous capacity of sensory objects for distortion." *Augustine on the Body*, pp. 4, 7–8, 52.

234. *In II Sent.*, dist. xviii, art. 2, qu. 2, resp. (*Bonaventurae opera*, ii.449).

235. *In II Sent.*, dist. xviii, art. 2, qu. 2, resp. (*Bonaventurae opera*, ii.449–50). Here Bonaventure appeals to the ubiquitous scholastic principle of "reverent interpretation," which M.-D. Chenu has robustly described as "an effective re-touching of a text, or a noticeable redressing of it, or again a discreet deflecting of its meaning." Chenu, *Toward Understanding Saint Thomas* (Chicago: Regnery, 1964), p. 145. Aquinas justifies the practice as follows: "If, in the sayings of the ancient doctors, we find certain statements that are not worded with as much caution as is practiced by the moderns [i.e., contemporary theologians], these statements are not to be taken with contempt or cast aside; nor, however, are they to be extended in their use. They must, on the contrary, be interpreted reverentially (*exponere reverenter*)," *Contra errores Graecorum*, prooem., in *Opuscula theologica* (Rome: Marietti, 1954), i.315; cf. Chenu, *Toward Understanding Saint Thomas*, pp. 148–49. Similarly, Roger Bacon remarked that, at the present time, Catholic doctors have "changed . . . in public utterances many statements made by the saints, expounding the sacred authors reverently (*pie exponentes*) with the purpose of saving as much as possible of their truth." Even sacred authors were subject to human infirmity inasmuch as they could, and did, fall into error, as was admitted by such major figures as Augustine and Jerome, who did not hesitate to retract some of the opinions they had expressed. *Opus maius*, 1a pars, cap. 6, ed. J. H. Bridges (London: Williams and Norgate, 1900), i.15.

236. Bonaventure also advises similar treatment of St. Gregory of Nazianus (d. 389 or 390) and St. John of Damascus (d. 749).

237. Here I pass over Bonaventure's treatment of whether a rational soul produced by transduction (through propagation); *In II Sent.*, dist. xviii, art. 2, qu. 3 (*Bonaventurae opera*, ii.451–54).

238. *In II Sent.*, dist. xviii, art. 2, qu. 1, conclusio (*Bonaventurae opera*, ii.446–47).

239. "in corporibus per coitum seminatis atque formatis infundi et infundendo creari"; *II Sent.*, dist. xviii, 7 (109), 2 (*Lib. sent.*, 1.2, 421; tr. Silano, ii.81).

240. Cf. Isidore of Seville, *Etymologiae*, XIV.iii, 2–5, in *Etymologiarum libri*, ed. Lindsay, unpag.

241. The point here is that no lesser a creature than man made its dwelling here; St. John was certainly not questioning the existence of other creatures as well.

242. *De fide orthodoxa*, ii.11 (*PG* 94, 912; cf. the Latin translation by Burgundio of Pisa, ed. Buytaert, pp. 106–7).

243. Mandeville, *Travels*, ch. 33, ed. Seymour, p. 220.

244. Mandeville, *Travels*, ch. 33, ed. Seymour, p. 221.

245. Mandeville, *Travels*, ch. 33, ed. Seymour, p. 220. Cf. Higgins, *Writing East*, p. 204.

246. *II Sent.*, dist. xvii, 5 (100), 4 (*Lib. sent.*, 1.2, 414; tr. Silano, ii.75 (with some alteration). Most but not all of this derives from Bede, and reappears (attributed to him), in altered form, in the *Glossa ordinaria*. Bede, *Hexaëmeron, sive libri quatuor in principium Genesis*, i (*PL* 91, 43D); cf. *Biblia glossata*, i.67–68. Peter of Tarantasia wonders how the mountain of paradise could possibly have escaped Noah's Flood, since Genesis 7:19 states that "all the high mountains under the whole heaven were covered." This would seem to include Eden. His response is that the Genesis passage refers not to every mountain in the world, but only to those on which humans lived. (Following the Fall, of course, humans were prohibited from living in Eden.) But a further question arises: the first sin of man was a crime committed in paradise; therefore paradise should be cleansed by water, just like the other parts of the world. Peter's answer is that sin in heaven (as committed by the evil angels) and in Eden was expiated by the immediate expulsion of the sinners in question, and therefore no other expiation was necessary. *In II Sent.*, dist. xvii, qu. 3, art. 2 (ii.146–47).

247. *Summa theologiae*, 1a, qu. 102, art. 1: *utrum Paradisus sit locus corporeus* (xiii.182–87).

248. Bonaventure, *In II Sent.*, dist. xvii, dub. 3 (*Bonaventurae opera*, ii.427–28).

249. In his unfinished work, *De Genesi ad litteram inperfectus liber*, xiv (CSEL 28.1, 490); cf. Augustine, *De Genesi ad litteram*, iii.6,8 (CSEL 28.1, 68), tr. Hill, pp. 220–21.

250. *In II Sent.*, dist. xvii, qu. 3, art. 2 (ii.146–47).

251. *Summa theologiae*, 1a, qu. 102, art. 1, 2 (xiii.182–83).

252. *Summa theologiae*, 1a, qu. 102, art. 1, 3 (xiii.182–83).

253. See the discussion in the Introduction.

254. *II Sent.*, dist. xvii, 5 (100), 2 (*Lib. sent.*, i.2, 413–14; tr. Silano, ii.74).

255. In the sense of being an anticipation or forerunner of a future institution, situation, or action, which forms part of the divine master plan.

256. *II Sent.*, dist. xvii, cap. 5 (100), 4 (*Lib. sent.*, i.2, 414; tr. Silano, ii.74).

257. *De Genesi ad litteram*, viii.1.1 (CSEL 28.1, 229; tr. Hill, p. 346).

258. *Summa theologiae*, 1a, qu. 102, art. 1, resp. (xiii.184–85); cf. Isidore of Seville, *Etymologiae*, xiv, 3.

259. Aristotle, *De caelo*, ii.2 (285b16–19).

260. Richard of Middleton wonders if the air was of such purity (and not mixed with vapors as it is in the fallen world) that it would not be possible for men to live in such an atmosphere, but then reassures himself that in the state of innocence men could indeed live in purer air, since then their nature was purer. *In II Sent.*, dist. xvii, dubium and ad dub. (ii.230).

261. Though it is not to be found in the editions of Bede's *Hexaëmeron* and the *Glossa ordinaria* cited in n. 246 above.

262. *Summa theologiae*, 1a, qu. 102, art. 1, ad 1 (xiii.184–85); cf. once again Isidore of Seville, *Etymologiae*, xiv, 3. "Bede's remark is not true if it is taken in the obvious (*manifestum*) sense," Aquinas emphasizes.

263. The schoolmen also address the specific notion that paradise was on the equator. Aquinas's discussion is particularly cogent. If that is indeed the location of this supposedly temperate land, he says, then it actually would suffer conditions of extreme heat, since twice a year "the sun crosses directly over the heads" of the inhabitants of equatorial lands. But those

who hold this view, he proceeds to explain, are thinking positively about the climatic situation there, for they believe such a location is "the most temperate," for the sun is never too far off, "so that they are not subjected to excessive cold." Neither is there a problem of "excessive heat, because even if the sun passes directly overhead, it does not stay long in that position." On the other hand, Aristotle (*Meteorologica*, ii.5 [362b25–27]) distinctly says that such a "region is uninhabitable because of the heat," and for Aquinas this is the more likely position. "Countries where the sun never passes directly overhead have excessive hot climates from the mere proximity of the sun," and therefore a place where the sun *does* pass directly overhead must be even hotter, and difficult if not impossible to live in. Whatever the truth of this may be, it is perfectly clear "that Paradise was situated in the most temperate locality, whether this is on the equator or elsewhere." *Summa theologiae*, 1a, qu. 102, art. 2, 4 and ad 4 (xiii.188–89 and 190–91).

264. *Summa theologiae*, 1a, qu. 102, art. 1, ad 2 (xiii.184–85), citing Augustine, *De Genesi ad litteram*, viii.7,14 (CSEL 28.1, 241–42; tr. Hill, p. 356).

265. *Summa theologiae*, 1a, qu. 102, art. 1, ad 3 (xiii.186–87). In fact, many topographers did speculate about the location of Eden, and sought to include it on their maps as a definite place. See Alessandro Scafi, *Mapping Paradise: A History of Heaven on Earth* (London: British Library, 2006).

266. *In II Sent.*, dist. xvii, qu. 3, art. 2, resp. (ii.146).

267. *In II Sent.*, dist. xvii, dubia 2, responsio (*Bonaventurae opera*, ii.427).

268. See pp. 171–72.

269. *Summa theologiae*, 1a, qu. 102, art. 2, 3 (xiii.188–89).

270. *Summa theologiae*, 1a, qu. 102, art. 2, ad 3 (xiii.188–89).

271. *In II Sent.*, dist. xvii, dubium 2 (*Bonaventurae opera*, ii.426–27).

272. Bonaventure, *In II Sent.*, dist. xvii, dubium 2 (*Bonaventurae opera*, ii.427).

273. However, with growing awareness of animals from remote parts of the world, the variety of wildlife became even richer, more international; cf. n. 286 below.

274. On this series, see especially Timothy Husband, *The Wild Man: Medieval Myth and Symbolism, Catalogue of an Exhibition Held at the Cloisters, Metropolitan Museum of Art* (New York: Metropolitan Museum of Art, 1980), pp. 144–47, with plate xl (a–d) and figs. 89, 94, and 95.

275. This interpretation also applies if the unicorn is read, alternatively, as a symbol of sexual desire. See, for example, Michael Camille's discussion of how this image functions in "The Lady with the Unicorn" tapestries (c. 1500, and now in the Cluny Museum, Paris); *The Medieval Art of Love: Objects and Subjects of Desire* (New York: Abrams, 1998), p. 49. In any case, the *Vanderbilt Hours* artist may be playing variations on the theme of the passionate wild man and the civilized knight who fight over possession of the lady, well described in Richard Bernheimer's chapter on "The Erotic Connotations" in his *Wild Men in the Middle Ages: A Study in Art, Sentiment, and Demonology* (New York: Octagon Books, 1979), pp. 121–75.

276. However, his illustrator prefers to depict them in rough woolen garments, as already noted.

277. To use the Middle English term for wild men; cf. *MED*, s.v. "wode-wose," defined as "A wild creature of woods and wasteland, human or semi-human in form and savage in appearance." On wild men and women and medieval English literature, see Yamamoto, *The Boundaries of the Human*, pp. 144–224.

278. Since we have a record of this work being seen in the hôtel of Henry III, count of Nassau-Dillenburg-Dietz, the year after Bosch's death, it has often been assumed that Henry commissioned it. However, given that the date of the triptych is not established definitely, we

cannot be sure of this; the patron might have been Henry's predecessor, Engelbert II. See E. H. Gombrich, "The Earliest Description of Bosch's *Garden of Delight*," *Journal of the Warburg and Courtauld Institutes*, 30 (1967), 403–6, and Larry Silver, *Hieronymus Bosch* (New York: Abbeville Press, 2006), p. 21. At any rate, a courtly audience for *The Garden of Earthly Delights* seems appropriate; it is hard to imagine it as an altarpiece, the result of a church commission.

279. Writing in Jos Koldeweij, Paul Vandenbroeck, and Bernard Vermet, *Hieronymus Bosch: The Complete Paintings and Drawings* (Amsterdam: Ludion and NAi, 2001), pp. 100–193 (pp. 105–6).

280. Vandenbroeck, in Koldeweij, Vandenbroeck, and Vermet, *Bosch: Complete Paintings*, p. 106.

281. Laurinda S. Dixon, *Bosch* (London: Phaidon, 2003), p. 135. Dixon goes on to seek answers to the interpretive puzzle in alchemical doctrine and symbolism.

282. Fränger, *Hieronymus Bosch*, p. 14.

283. Fränger's approach was developed further by Clément A. Wertheim-Aymès, *Hieronymus Bosch: Eine Einführung in seine geheime Symbolik, dargestellt am "Garten der himmlischen Freuden," am Heuwagen-Triptychon, am Lissaboner Altar und an Motiven aus anderer Werke* (Berlin: K. H. Henssel, 1957).

284. Another of Vandenbroeck's terms; Koldeweij, Vandenbroeck, and Vermet, *Bosch: Complete Paintings*, p. 107.

285. Albert the Great claims that because "black women (*nigrae*) are hotter and particularly dark (*fuscae*), they are the sweetest for sex, as lechers"; another factor is that "they have a tempered opening of the vulva so that it embraces the penis very pleasantly." Albert the Great, *Quaestiones de animalibus,* tr. Resnick and Kitchell, p. 468. For positive readings of blackness, see Carruthers, *Experience of Beauty*, pp. 67–68.

286. Yet another contrast may be drawn with the bizarre (perhaps even sinister?) beasts found on the left-hand panel of *The Garden of Earthly Delights*. A three-headed lizard crawls out of the river which is its central feature, while, at the bottom, a three-headed bird pecks at smaller creatures in a swamp-like pond. Strangest of all, a duck/fish hybrid floats in that same pond, reading an open book. Perhaps Bosch wanted to emphasize the scarcely expressible potential that nature has for the production of a rich abundance of species, including many that humankind does not yet know—though an array of strange animals could be found in the pages of, for example, medieval bestiaries, Mandeville's *Travels*, and Albert the Great's lectures on Aristotle's *De animalibus*. Furthermore, Bosch's era was one of exploration, and more and more animal species were being added to the painter's repertoire—thus a giraffe and an ele-phant (both accurately represented) are included in his Eden. Nicole Oresme wrote a treatise which emphasized that the marvels of nature should not be confused with the miraculous. Neither, one might add, should they be confused with the monstrous. It may be remembered that the first man was made from slime—a combination of water and mud not unlike the environment in which Bosch places his strangest creatures. Also of relevance here is Augustine's insistence that the monstrous races (who lived in strange parts of the world) had descended from Adam (*De civitate Dei*, xvi.8); cf. Valerie J. Flint, "Monsters and the Antipodes in the Early Middle Ages and Enlightenment," *Viator* 15 (1984), 65–80.

287. As has been done by, for example, Silver, *Hieronymus Bosch*, pp. 21–79, and Keith Moxley, "Hieronymus Bosch and the 'World Upside Down': The Case of *The Garden of Earthly Delights*," in Norman Bryson, Michael Ann Holly, and Keith Moxey (eds.), *Visual Culture: Images and Interpretations* (Hanover, N.H.: University Press of New England, 1994), pp. 104–40 (p. 127). The argument that some of the central panel's images are reminiscent of

those used to illustrate the sin of *luxuria* as it functions in the fallen world loses its force if it is assumed that Bosch had moved back in time to figure activities as yet unsullied by sin.

288. See pp. 168, 251–52 n. The postlapsarian connection between looking and lusting is discussed by Suzannah Biernoff, *Sight and Embodiment in the Middle Ages* (Houndmills, Basingstoke: Palgrave Macmillan, 2002), pp. 42–57.

289. Silver suggests that many of the "dangerous or threatening elements" of the Hell panel "allude specifically to property and power," and hence would have been particularly unsettling for an aristocratic audience—a community "steeped in the issues of courtly love and its possible temptations." *Hieronymus Bosch*, pp. 70–78. It is quite possible to endorse this reading while balking at Silver's reading of the central panel as displaying people "obviously indulging in *luxuria*" (p. 32).

290. But why is Christ, rather than the more usual God the Father, uniting this couple? Perhaps because of the tradition that marriage signifies the union of Christ and the Church, or the union of Christ with the soul of the righteous person.

291. However, these passages in the *Rose* are themselves open to a wide range of interpretation, and so cannot be taken as a secure, uncontentious vantage point from which to view Bosch's art. For differing approaches, see John V. Fleming, *The* Roman de la Rose: *A Study in Allegory and Iconography* (Princeton, N.J.: Princeton University Press, 1969), pp. 53–103 (on the *Hortus deliciarum*), 211–49; and Alastair Minnis, *Magister amoris: The* Roman de la Rose *and Vernacular Hermeneutics* (Oxford: Clarendon Press, 2001), pp. 165–208.

292. See Peter Lombard, *IV Sent.*, IV, dist. xxxi, 1 (*Lib. sent.*, i.2, 442), which draws on Augustine, *De Genesi ad litteram*, ix.7,12 (CSEL 28.1, 275–76), tr. Hill, p. 382. Elsewhere Augustine says that marriage protects from the sins of adultery and fornication a couple who "have sexual intercourse even without the purpose of procreation." On account of the marriage this is "pardoned"—i.e., this is a reasonable concession to human frailty, what St. Paul termed an *indulgentia* (cf. I Corinthians 7:6). See Augustine, *De bono coniugali*, vi; *PL* 40, 377.

293. Defenders of this position often quoted St. Paul's words, "It is better to marry than to burn" (I Corinthians 7:8), and, "if thou take a wife, thou hast not sinned" (I Corinthians 7:28, cf. 36). Wyclif's formidable opponent Thomas Netter (d. 1430) accused him of holding the view that, because Adam and Eve, and consequently other couples, can generate children "without crime," therefore procreation is the very essence (*quidditas*) of marriage and, in order to be married legally, couples must have children or at least be able to have them. Which would mean that childless couples could divorce and remarry— a recipe for social disorder, in Netter's view. Furthermore, the sexless but quite valid marriage of Mary and Joseph (and subsequent "spiritual marriages," wherein couples agreed to abstain from sex) would be rendered problematic. See Minnis, *Fallible Authors*, pp. 279–80. Therefore, the "procreation justification" of marital sex had carefully policed boundaries.

294. Yet another controversy concerns the view offered by the closed outer panels of the work. This large grisaille shows a picture of the earth, with God the Father in the left-hand corner, which often has been understood as a depiction of the creation (specifically, the third day of creation). However, E. H. Gombrich sees here an image of the world just before the Flood, which he links to a reading of the central panel as representing the iniquities that God punished by unleashing the waters. See his article "Bosch's *Garden of Earthly Delights*: A Progress Report," *Journal of the Warburg and Courtauld Institutes*, 32 (1969), 162–70. However the grisaille may be interpreted (and Gombrich's interpretation has by no means met with general approval), the central panel remains, I believe, open to interpretation of the kind I have advanced.

295. In the words of St. John of Damascus; see p. 74 above.

296. See p. 22 above.

CHAPTER 2. POWER IN PARADISE

1. *Discourse on the Origin and Foundations of Inequality among Men*, second discourse, 2nd part, in *The Collected Writings of Rousseau*, vol. 3, ed. Roger D. Masters and Christopher Kelly (Hanover, N.H.: University Press of New England, 1992), p. 43.

2. Psalm 2:10–12, and Psalm 94:3 ("For the Lord is a great God, and a great King above all gods").

3. *The Joys of the Blessed, being a Practical Discourse concerning the Eternal Happiness of the Saints in Heaven, translated from the original Latin of Cardinal Bellarmin by Thomas Foxton, with an Essay on the same Subject written by Mr. Addison* (London: Curll, 1822), pp. 14, 16. (I have lightly modernized the spelling and conventions of capitalization.) Foxton assures his Protestant readers that "in the following tract, you will not find him striving to make a pompous display of the excellencies of the Roman Catholick Religion, but most piously setting before us a judicious description of the glory of the New Jerusalem, to wean us from the deceitful vanities of a wretched world, and inspire us with a true Christian courage, to enable us patiently to sustain the greatest afflictions and calamities" (Preface).

4. *Joys of the Blessed*, tr. Foxton, pp. 18 (emphasis mine), 19, 77.

5. *Paradise Lost*, V, 792–93, in Milton, *Poetical Works*, ed. Darbishire, p. 120.

6. *Cursor Mundi*, the Southern Version, vol. 1, ed. Horrall, pp. 54–55.

7. *Play of Adam (Ordo representacionis Ade)*, ed. Odenkirchen, pp. 48–49.

8. *Historye of the Patriarks*, ed. Taguchi, p. 29. On the representation of the naming of animals in manuscript illumination, with special reference to bestiaries of the twelfth and thirteenth centuries, see Xénia Muratova, "'Adam donne leurs noms aux animaux': L'iconographie de la scène dans l'art du Moyen Âge," *Studi medievali*, 3rd ser., 18 (1977), 367–394 + plates.

9. *Historye of the Patriarks*, ed. Taguchi, p. 8.

10. *De Genesei ad litteram*, iii.15, 24 (CSEL 28.1, 80–81; tr. Hill, p. 230).

11. *II Sent.*, dist. xv, 3 (84) (*Lib. sent.*, i.2, 401; tr. Silano, ii.64).

12. *De Genesi ad litteram*, iii.15,24 and 16,25 (CSEL 28.1, 80–82; tr. Hill, pp. 230–31).

13. Daniel 6:22; Acts 28:3–8.

14. *In II Sent.*, dist. xv, art. 2, qu. 1, ad 3um (*Bonaventurae opera*, ii.383). Bonaventure follows Augustine in citing the example of Daniel in the lions' den.

15. *Historye of the Patriarks*, ed. Taguchi, p. 21.

16. Comestor adds that God had intended plants, like animals, to flourish and multiply, "thof we fynd hit not in Screpture"—i.e., this is not made explicit in the Bible (*Historye of the Patriarks*, ed. Taguchi, p. 21).

17. *De Genesi ad litteram*, iii.14,22 (CSEL 28.1, 79–80; tr. Hill, p. 229).

18. *De Genesi ad litteram*, iii.14,23 (CSEL 28.1, 80; tr. Hill, p. 229).

19. *De Genesi ad litteram*, iii.14,23 (CSEL 28.1, 80; tr. Hill, p. 229).

20. *II Sent.*, dist. xv, 4 (85) (*Lib. sent.*, i.2, 401; tr. Silano, ii.64).

21. *Hexaëmeron*, vii.5.1 (ed. Dales and Gieben, pp. 202–3; tr. Martin, p. 206).

22. *Historye of the Patriarks*, ed. Taguchi, p. 19.

23. *Historye of the Patriarks*, ed. Taguchi, p. 19.

24. *Historye of the Patriarks*, ed. Taguchi, p. 23. Over two hundred years later, Bridget of Sweden (d. 1373) offered her version of the same argument. God is quoted as saying that He created worms in order to show "the manifold power" of His wisdom and goodness. "For even though they can harm, nevertheless they do not harm except by my permission and because sin requires it in order that man, who scorns submission to his own superior, may groan over his ability to be troubled by this lowest of things." Thus man knows "that he is nothing" without God, "whom even irrational things serve and at whose beckoning all things stand." *Sancta Birgitta Revelaciones Book V*, ed. Birger Bergh (Uppsala: Almqvist & Wiksells Boktryckeri, 1971), int. 5, p. 105; tr. Albert R. Kezel, in *Birgitta of Sweden: Life and Selected Revelations*, ed. Marguerite T. Harris and Albert R. Kezel (New York: Paulist Press, 1990), p. 106.

25. *Exameron Anglice*, or *The Old English Hexameron*, ed. S. J. Crawford (Hamburg: Henri Grand, 1921), p. 68.

26. *The Problem of Pain* (New York: Macmillan, 1973), pp. 127–28. "It seems to me possible that certain animals may have an immortality, not in themselves, but in the immortality of their masters." In one of Lewis's thinly fictionalized exercises in Christian apologetics, *The Great Divorce*, the narrator encounters, during his visit to heaven, the sanctified "Sarah Smith," who is surrounded by animals—dozens of cats and many dogs, birds, and horses. All "are her beasts." "Every beast and bird that came near her had its place in her love. In her they became themselves. And now the abundance of life she has in Christ from the Father flows over into them." *The Great Divorce* (New York: Macmillan, 1946), pp. 110–11.

27. *Problem of Pain*, pp. 120, 125. Were a newt to be resurrected, "it would not recognize itself as the same newt; the pleasant sensations of any other newt that lived after its death would be just as much, or just as little, a recompense for its earthly sufferings (if any) as those of its resurrected—I was going to say 'self,' but the whole point is that the newt probably has no self. . . . There is, therefore, I take it, no question of immortality for creatures that are merely sentient" (pp. 125–26).

28. McDannell and Lang, *Heaven: A History*, p. 153.

29. Antonio da Rio's role in *De voluptate*, and the respectful treatment Valla affords him, is discussed by Lodi Nauta, *In Defense of Common Sense: Lorenzo Valla's Humanist Critique of Scholastic Philosophy* (Cambridge, Mass.: Harvard University Press, 2009), pp. 176–78, 185–89.

30. Lorenzo Valla, *On Pleasure/De voluptate*, ed. and tr. A. Kent Hieatt and Maristella Lorch (New York: Abaris Books, 1977), pp. 302–3.

31. *Summa theologiae*, 1a, qu. 96, art 1, resp. (xiii.123, 125).

32. *Politics*, i.8 (1256b24–25).

33. Here I have substituted "acumen" for "shrewdness" as a translation of *prudentia*, as indicating better, I believe, the qualities of awareness, foresightedness, and self-preservatory intelligence which Aquinas regards as characteristic of animal behavior.

34. But not everyone believed that, had the Fall not occurred, all the animals would have lived at peace with each other, as the next chapter will explain.

35. *Hexaëmeron*, viii.13.6 (CSEL 28.1, 238–39; tr. Martin, p. 243).

36. The triumphal assertion that even the powerful lion can be subjugated by man is regularly made in Genesis commentary; see, for example, Basil, *Hexaëmeron*, i.10, in *Homelie X et XI de l'Hexaéméron*, ed. Smets and Van Esbroeck, pp. 190–93, and Ambrose, *Hexaëmeron*, Liber VI: de opera sexti diei, vi, 36 (*PL* 14, 255B); *De Cain et Abel libri duo*, Liber II, i, 3 (*PL* 14, 340C–D). Ambrose is heavily indebted to Basil in this, and many other, respects.

37. J. R. Hyland, "Church Violence—Doctrinally Sanctioned: Aquinas, Animal Rights, and Christianity," at http://www.all-creatures.org/sof/aquinas.html. Accessed December 11, 2013.

38. *On Aquinas*, ed. Brian Davies with a foreword by Anthony Kenny (London: Continuum, 2008), pp. 147, 154–55. McCabe probably had in mind the views of Tom Regan and Peter Singer. In his *The Case for Animal Rights* (Berkeley: University of California Press, 1983), Regan argues that animals have certain value-giving attributes, including beliefs and desires, memory, a sense of the future, and an emotional life. One major limitation of his approach derives from his conviction that rights belong to individuals, not species. Therefore, action to rescue an endangered species from extinction is no more pressing than ensuring the well-being of a particular dog, though its kind flourishes in vast numbers. For Singer, the "argument is really about equality rather than about rights." From the utilitarian philosopher Jeremy Bentham he derives a moral principle of equality between humans—which, he believes, can be extended to form a "sound moral basis" for relations with those outside our own species, because animals share with us the capacity to suffer. "If a being suffers there can be no moral justification for refusing to take that suffering into consideration. No matter what the nature of the being, the principle of equality requires that its suffering be counted equally with the like suffering . . . of any other being." Singer is sweepingly dismissive of the attitudes to animals which he deems characteristic of medieval Christianity, judging them to lack sympathy and compassion. Thomas Aquinas is criticized for his "speciesism" (a term coined by Richard Ryder), meaning "a prejudice or attitude of bias in favor of the interests of members of one's own species and against those of members of another species." "If possessing a higher degree of intelligence does not entitle one human to use another for his or her own ends, how can it entitle humans to exploit nonhumans for the same purpose?" *Animal Liberation*, 2nd ed. (London: Jonathan Cape, 1990), pp. 2, 5–8, 192–98; cf. Singer's *Practical Ethics*, 3rd ed. (Cambridge: Cambridge University Press, 2011), pp. 48–70, and Richard Ryder, *Animal Revolution* (Oxford: Blackwell, 1989), p. 328. Singer suspects "that Aquinas simply doesn't believe that animals other than human beings are capable of suffering at all" (*Animal Liberation*, p. 195), a view which, in my own opinion, arrantly simplifies Aquinas's thought. In his turn, Singer has been criticized by those who are troubled by the thought that his utilitarian egalitarianism renders equally significant the pleasures and pains of all living things. For the ongoing debate, see Sorabji, *Animal Minds and Human Morals*, pp. 211–19; Dale Jamieson (ed.), *Singer and His Critics* (Oxford: Blackwell, 1999), esp. pp. 150–61 and 209–68; the essays by David DeGrazia and Cora Diamond in Carl Elliott (ed.), *Slow Cures and Bad Philosophers: Essays on Wittgenstein, Medicine, and Bioethics* (Durham, N.C.: Duke University Press, 2001), pp. 103–17, 118–48; and Stanley Cavell, Cora Diamond, et al., *Philosophy and Animal Life* (New York: Columbia University Press, 2008).

39. *On Aquinas*, p. 155. Here McCabe attempts to negotiate with, or around, the Aristotelian and Stoic belief (as inherited by medieval Christianity, and very much in evidence in Augustine's thought) that justice can naturally reach only as far as beings who are rational like us. The issues are well addressed in Sorabji, *Animal Minds and Human Morals*, esp. pp. 201–4. Matthew Scully appeals to mercy rather than justice or temperateness in his *Dominion: The Power of Man, the Suffering of Animals, and the Call to Mercy* (New York: St. Martin's Press, 2002).

40. For this interpretive principle as exemplified by Bonaventure, see p. 72; cf. p. 272 n. 235.

41. *In II Sent.*, dist. xix, art. 1, qu. 2, ad 3um (*Bonaventurae opera*, ii.463).

42. *Problem of Pain*, pp. 120, 125–26.

43. *De Genesi ad litteram*, iii.16,25 (CSEL 28.1, 82; tr. Hill, p. 231).

44. On this notion, see especially Richard Holton and Rae Langton, "Empathy and Animal Ethics," in Jamieson (ed.), *Singer and His Critics*, pp. 209–32, and Singer's response on pp. 318–22.

45. *Revelaciones*, V, int. 14, ed. Bergh, pp. 151–52; tr. Kezel, pp. 139–40.

46. Bridget notes that sometimes animals may die simply because of a change of season—though the carelessness of humans who are trying to get work out of them is definitely another factor. *Revelaciones*, V, int. 14, ed. Bergh, p. 152; tr. Kezel, p. 140.

47. *Revelaciones*, V, int. 14, ed. Bergh, p. 152; tr. Kezel, p. 140.

48. *Hexaëmeron*, viii.13.4 (ed. Dales and Gieben, p. 238; tr. Martin, p. 242).

49. *Hexaëmeron*, viii.13.5 (ed. Dales and Gieben, p. 238; tr. Martin, pp. 242–43).

50. Cf. Aristotle, *Politics*, iii.4 (1277a5–30) and iii.6 (1278b30–1279a3).

51. *Le Livre de Yconomique d'Aristote*, ed. Albert Douglas Menut, *Transactions of the American Philosophical Society*, n.s. 47, pt. 5 (Philadelphia: American Philosophical Society, 1957), p. 807.

52. *Le Livre de Yconomique*, ed. Menut, p. 811. This concern should be primary, Oresme/Aristotle explains, "because of six conditions which exist in the relationship of husband to wife more than in any other domestic relationship; (1) because it is natural, (2) rational, (3) amiable, (4) profitable, (5) divine, and (6) in keeping with social conventions."

53. *De anima*, ii.4 (415a28–29). To quote from Moerbeke's version of this passage: "The most natural of the operations of such living beings as are mature . . . is to produce others like themselves: an animal an animal, and a plant a plant. To this extent do they participate as far as they are able, in the imperishable and the divine." Aquinas, *In librum de Anima commentarium*, ii.4, 311–17 (lect. 7), ed. Pirotta, pp. 111–12; tr. Foster and Humphries, p. 210.

54. *Summa theologiae*, 1a, qu. 92, resp. (xiii.34–37).

55. See, for example, Gregory of Nyssa, *De hominis opificio*, 17 (*PG* 44, 189), cited by Aquinas, *Summa theologiae*, 1a, qu. 98, art. 2, resp. (xiii.154–55). Cf. Chrysostom, *In Genesim*, hom. 16 (*PG* 53, 126) and hom. 18 (ibid., 153); John of Damascus, *De fide orthodoxa*, ii.30 (*PG* 94, 976) and iv.24 (*PG* 94, 1208). Augustine refers to such beliefs at *De civitate Dei*, xiv.21, in order to dismiss them in the following chapter (CSEL 40.2, 46–47; tr. Dyson, p. 621).

56. *Ethics*, viii.12 (1162a19).

57. *Summa theologiae*, 1a, qu. 92, art. 2, resp., 3 (xiii. 40–41).

58. Oresme, *Le Livre de Yconomique*, ed. Menut, p. 812.

59. *Politics*, vii.16 (1335b38–41).

60. Oresme, *Le Livre de Yconomique*, ed. Menut, p. 813.

61. *Politics*, ii.4 (1262b12).

62. Hugh of St. Victor, *De sacramentis*, I, vi.35 (*PL* 176, 284C). On the history of this reasoning, see Colish, *Lombard*, i.365 and Alcuin Blamires, "Paradox in the Medieval Gender Doctrine of Head and Body," in Peter Biller and Alastair Minnis (eds.), *Medieval Theology and the Natural Body* (York: York Medieval Press with Boydell and Brewer, 1997), pp. 13–29.

63. *II Sent.*, dist. xviii, 2 (104) (*Lib. sent.*, i.2, 416–17; tr. Silano, ii.77).

64. Chaucer, *Riverside Chaucer*, p. 321. This treatise (it can hardly be called a tale) falls squarely within the tradition of the penitential manual, given its use of materials also found in two major thirteenth-century examples of that genre, the *Summa de poenitentia* of Raymond of Peñafort and the *Summa vitiorum* of William Peraldus.

65. *Summa theologiae*, 1a, qu. 92, art. 3, resp. (xiii.42–43).

66. *Summa theologiae*, 1a, qu. 92, art. 1, resp., 2 (xiii.36–39).

67. Giles of Rome, *In II Sent.*, dist. xviii, qu. 2, dubitatio VI litteralis (ii.99).

68. Aristotle, *Politics*, i.3 (1253b1–14), i.5 (1254b12–21), and i.12 (1259a37–b4).

69. Giles develops the contrast between a wife and a servant, and the correct form of husbandly governance, in his *De regimine principum*, ii, pars 2, xiv–xv. Cf. the Middle English

translation by John Trevisa, *The Governance of Kings and Princes: John Trevisa's Middle English Translation of the* De regimine principum *of Aegidius Romanus*, ed. David C. Fowler, Charles F. Briggs, and Paul G. Remley (New York: Garland, 1997), pp. 190–94.

70. *Summa theologiae*, Ia, qu. 92, art. I, I (xiii.34–35).

71. *Summa theologiae*, Ia, qu. 92, art. I, ad 2um (xiii.36–39).

72. *De civitate Dei*, xxii.17 (CSEL 40.2, 625–26; tr. Dyson, pp. 1144–45).

73. *Hexaëmeron*, vii.14.7 (ed. Dales and Gieben, p. 214; tr. Martin, p. 218).

74. *Historia animalium*, ix.I (608a–b).

75. Albert the Great, *Quaestiones de animalibus*, xv, qu. II (p. 265–66); tr. Resnick and Kitchell, p. 454.

76. Aristotle, *De generatione animalium*, ii.3 (737a27) and iv.I (766a17–20). See further the important discussion by Cadden, *Meanings of Sex Difference*, pp. 133–34, 195.

77. Albert the Great, *Quaestiones de animalibus*, xv, qu. II (p. 265); tr. Resnick and Kitchell, p. 454.

78. Elsewhere in this same text Albert cites information he has gleaned from the confessions of "crafty suitors" (*subtiles proci*) who know how to arouse women sexually; *Quaestiones de animalibus*, xiii, qu. 18 (p. 248); tr. Resnick and Kitchell, p. 411.

79. *Summa theologiae*, pars II, tract. XIII, qu. 80, solutio (*Alberti opera*, xxxiii.114–16).

80. It is in this sense that Albert here rejects the argument that a divinity who engaged in work of the most perfect kind would not have deigned to make a flawed male.

81. *Quaestiones de animalibus*, xv, qu. 2 (pp. 260–61); tr. Resnick and Kitchell, p. 441.

82. Cf. Albert's later statement, "this production is natural because it proceeds from a natural cause." *Quaestiones de animalibus*, xviii, qu. 2 (p. 297); tr. Resnick and Kitchell, p. 533.

83. *Quaestiones de animalibus*, xv, qu. 2 (pp. 260–61); tr. Resnick and Kitchell, pp. 441–42.

84. Grosseteste, *Hexaëmeron*, viii.18.4 (ed. Dales and Gieben, p. 244; tr. Martin, p. 249).

85. Cf. Basil, *Hexaëmeron*, x.18, in *Homelie X et XI de l'Hexaéméron*, ed. Smets and Van Esbroeck, pp. 212–14; also Basil, *St. Basil the Great: On the Human Condition*, tr. Nonna V. Harrison (Crestwood, N.Y.: St. Vladimir's Seminary Press, 2005), pp. 45–47. "There is no excuse for one who wishes to allege that the [woman's] body is weak," Basil continues, going on to praise "the vigor of women in fastings, the love of toil in prayers, the abundance in tears, the readiness for good works." "Do not cling to the outer human being. . . . The soul is placed within, under the coverings and the delicate body. Soul indeed is equal in honor to soul; in the coverings is the difference" (p. 46).

86. *II P. Sum. theol.*, tract. xiii, qu. 82, mem. I, sol. (*Alberti opera*, xxxiii.124).

87. *II P. Sum. theol.*, tract. xiii, qu. 82, mem. 2, especially I and ad I (*Alberti opera*, xxxiii.125–26).

88. *Politics*, i.5 (1254b12–15), cf. i.12 (1259b2–10).

89. *II P. Sum. theol.*, tract. xiii, qu. 82, mem. 2, ad 4 (*Alberti opera*, xxxiii.126).

90. *II P. Sum. theol.*, tract. xiii, qu. 82, mem. I, sol. (*Alberti opera*, xxxiii.124).

91. *Summa theologiae*, Ia, qu. 93, art. 6, ad 2 (*Alberti opera*, xiii.71).

92. In fact, at this point Aquinas conflates two phrases from St. Paul; "according to the image of him that created him" (Colossians 3:10) there is neither male nor female (Galatians 3:28), as Aquinas's editor Thomas Gilby notes (p. 70, n. 13).

93. *In II Sent.*, dist. xvi, art. 2, qu. 2, conclusio (*Bonaventurae opera*, ii.403).

94. A point emphasized by Christine de Pizan, who affirms that Eve "was created in the image of God," and attacks those "men who are foolish enough to think, when they hear that God made man in His image, that this refers to the material body. . . . The soul is meant, the

intellectual spirit which lasts eternally just like the Deity. God created the soul and placed wholly similar souls, equally good and noble in the feminine and in the masculine bodies." *Le livre de la cité des dames*, 1.9.2; tr. Earl Jeffrey Richards, *Christine de Pizan: The Book of the City of Ladies* (New York: Persea Books, 1998), p. 23.

95. *Summa theologiae*, 1a, qu. 93, art 4, ad 1 (xiii.61).

96. In a subsequent discussion of Bonaventure's, of whether God should have assumed the female rather than the male sex, this distinction becomes threefold: dignity of origination, virtue in action, and authority in presiding. First, the human race originated in one man, who expressly represents the point of departure of all things from a principle which is the first and highest. Second, man's role is to act, while woman's is to submit (man being stronger than woman). Third, man is the head of woman, as St. Paul says (I Corinthians 11:3 and Ephesians 5:23). Therefore it was more appropriate for the increate Word to assume the male sex. *In III Sent.*, dist. xii, art. 3, qu. 1 (*Bonaventurae opera*, iii.270–71).

97. Cf. the discussion in Peter of Tarantasia's *Sentences* commentary, where it is claimed that, in treating the *imago Dei*, two things must be considered—its essential parts, which are in the soul absolutely (and here there is no distinction between male and female), and its accidental and consequent parts (where there are indeed distinctions, relating to degrees of dignity and comeliness, in respect of the body or of the soul in relation to its conjunction with the body or with other corporeal things). The principles of "presiding" and "origination" are present to a greater extent in man, whence man is the head of woman. So, then, if those accidental qualities which concern comeliness are considered, the *imago Dei* is greater in man than in woman, but if those qualities which are integral to the essence of the image are considered, there is equality. *In II Sent.*, dist. xvi, quaestio unica, art. 5: *an vir et mulier sint imago Dei æqualiter* (ii.136). But cannot all God's creatures, including animals as much as humans, be considered as part of His image? Once again, the truth is sought through a crucial distinction. An image is a direct likeness (*similitudo expressa*), and the more direct, the better—by which is meant, the more noble. In terms of nobility, man excels, due to his unique rationality. When we seek a likeness, we look at the face rather than the foot. Each and every creature indeed has a certain likeness to God, but man's may be compared to a facial resemblance, whereas the other creatures are vestiges which represent Him in the inferior part of creation, occupying a position comparable to the foot's. *In II Sent.*, quaestio unica, art. 2: *an omnis creatura sit imago Dei, vel rationalis tantum* (ii.134).

98. *Imago* derives from the act of imitation (*ab actu imitandi*), explains Peter of Tarantasia, and this can be either natural or artificial. Man truly imitates God in a natural form, in contrast with a picture of God on a wall, which is the product of an artificial imitation. *In II Sent.*, dist. xvi, quaestio unica, art. 7 (ii.136).

99. *In II Sent.*, dist. xvi, art. 2, qu. 2, 1 (*Bonaventurae opera*, ii.403). For the tradition that Eve was created in the likeness (*similitudo*) but not the image (*imago*) of God, see especially Marie-Thérèse d'Alverny, "Comment les théologiens et les philosophes voient la femme," *Cahiers de civilisation médiévale*, 20 (1977), 105–29. See further Judith Chelius Stark, "Augustine on Women: In God's Image, but Less so," in Judith Chelius Stark (ed.), *Feminist Interpretations of Augustine* (University Park: Pennsylvania State University Press, 2007), 215–42.

100. *Decretum Gratiani*, causa 33, qu. 5, cap. 13; *Corpus Iuris Canonici*, ed. A. Friedberg (Leipzig, 1879–81; repr. Graz: Akademische Druck- u. Verlagsanstalt, 1959), i.1254.

101. *Decretum Gratiani*, causa 33, qu. 5, cap. 19; i.1255–56.

102. *De Genesi ad litteram*, xi.42,58 (CSEL 28.1, 376–77; tr. Hill, p. 462). Augustine's attitudes concerning Eve and the *imago Dei* are, however, a lot more complicated than that. In a

particularly difficult passage in *De trinitate*, xii.7,10 (*PL* 42, 1004–5), he states that "the woman together with the man is the image of God, so that the whole substance is one image." But Eve on her own does not fully and completely bear the *imago Dei*, whereas Adam does. On account of such sentiments, Elaine Pagels, in her book *Adam, Eve, and the Serpent* (New York: Random House, 1988), blames Augustine for a thousand years of sexism in the Catholic Church. For an excellent discussion of recent interpretations of, and responses to, the relevant doctrine, see E. Ann Matter, "Christ, God and Women," in Robert Dodaro and George Lawless (eds.), *Augustine and His Critics* (London: Routledge, 2000), pp. 164–75. Matter explains the *De trinitate* passage as follows: "At the level of embodiment, the category woman (*femina, mulier*) does not participate in the *imago Dei*; but woman as part of the category *homo*, human being, does. . . . Women participate in the *imago Dei* only in their status as human beings, not as women. Women are spiritually equal to men . . . but only without regard to the particular characteristics that make them women, for these things are, by the order of creation, inferior and subordinate to the characteristics of humanity attributed to men" (p. 170).

103. Hostiensis, *Commentaria in quinque libros decretalium* (Venice, 1581; rpt. Turin: Bottega d'Erasmo, 1965), i.173r–v. Cf. Ida Raming, *The Exclusion of Women from the Priesthood*, tr. Norman R. Adams (Metuchen, N.J.: Scarecrow Press, 1976), pp. 134, 153 n. 96.

104. Aquinas, *In IV Sent.*, dist. xxv, qu. 2, art. 1, quaestiuncula 1, 3 (*Aquinatis opera*, vii.2, 907).

105. *In IV Sent.*, dist. xxv, art. 2, qu. 1 (*Bonaventurae opera*, iv.649–51).

106. *In IV Sent.*, dist. xxv, art. 2, qu. 1, conclusio (*Bonaventurae opera*, iv.650).

107. Aquinas, *In IV Sent.*, dist. xxv, qu. 2, art. 1, quaestiuncula 1, 3 (*Aquinatis opera*, vii.2, 907).

108. Duns Scotus, Reportata Parisiensia, *In IV Sent.*, dist. xxv, qu. 2 (*Scoti opera*, xxiv.370).

109. Paul then adds, "And Adam was not seduced; but the woman, being seduced, was in the transgression" (2:14).

110. *In IV Sent.*, dist. xxv, art. 2, qu. 1, 1 contra, and ad 1 (*Bonaventurae opera*, iv.649–50).

111. *In IV Sent.*, dist. xxv, qu. 2, art. 1, solutio 1, ad 2 (*Aquinatis opera*, vii.2, 908).

112. See Alastair Minnis, "Religious Roles: Public and Private," in Alastair Minnis and Rosalynn Voaden (eds.), *Medieval Holy Women in the Christian Tradition, c. 1100–c. 1500* (Turnhout: Brepols, 2010), pp. 47–81.

113. *Le livre de la cité des dames*, 1.9.2; tr. Richards, pp. 22–23.

114. *Le livre de la cité des dames*, 1.9.3; tr. Richards, p. 24.

115. *Summa Alexandri*, 1a 2ae, inq. IV, tract. II. sect. 2, qu. 1, tit. 2, mem. 2, cap. 1: *utrum corpus Adae fuerit conditum in paradiso*, esp. 2 and ad 2um (ii.602–3). Elaborated at 1a 2ae, inq. IV, tract. II, sect. 2, qu. 2, cap. 6: *de dignitate corporis Evae* (ii.629–30).

116. *II Sent.*, dist. xvii, 4 (99) (*Lib. sent.*, i.2, 413; tr. Silano, ii.74).

117. *In II Sent.*, dist. xviii, qu. 1, art. 1, dubitatio VI lateralis (ii.64).

118. Giles of Rome asks, is it not better for something to remain in the place of its origin, as being most conducive to its conservation? (Here he is building on Aristotle's *Physics*, iv.4.) Not necessarily, he replies. That is true only if it moves to a worse place, and certainly not true if it moves to a better place. If a beast born in a sterile place proceeds to a more fertile land, it will certainly have a happier existence. But what if all the earth were fruitful, as it was in the beginning? Giles assures us that, no matter how fruitful the other parts of the world may have been, Eden was better in this regard—and, furthermore, it had a more amenable atmosphere, a better location in terms of altitude, and more abundant water. There is no doubt, then, that

Adam moved to a better place, where he could live a better life. *In II Sent.*, dist. xviii, qu. 1, art. 1, dubitatio VI lateralis (ii.63–64).

119. *In II Sent.*, dist. xviii, qu. 1, art. 1, 3 and ad 3um (pp. 149–50). Cf. *De consolatione philosophiae*, III, prosa 10.

120. On which, see especially the chapter "Eve and the Privileges of Women" in Alcuin Blamires, *The Case for Women in Medieval Culture* (Oxford: Oxford University Press, 1997), pp. 96–125.

121. "Three Early Renaissance Treatises on Women," *Italian Studies*, 11 (1956), 47–55. For further discussion and bibliography, see Francine Daenens, "Superiore perchè inferiore: il paradoso della superiorità della donna in alcuni trattati italiani del Cinquecento," in Vanna Gentili (ed.), *Trasgressione tragica e norma domestica. Esemplari di tipologie femminili dalla letteratura Europea* (Rome: Edizioni di Storia e Letteratura, 1983), pp. 11–49, and Marina Zancan, *Nel cerchio della luna: figure di donna in alcuni testi del XVI secolo* (Venice: Marsilio, 1983).

122. *Declamatio de nobilitate*, ed. Antonioli, p. 53; tr. Rabil, pp. 47, 48. Rabil brings out well the parallels between Agrippa's treatise and an earlier work which seems to have been one of its sources, Jean Rodríguez del Padrón's *Triunfo de las donas* (c. 1440), pp. 19–21; on Rodríguez, see further Flood, *Eve*, pp. 82–91.

123. Rosalie Colie, *Paradoxia epidemica: The Renaissance Tradition of Paradox* (Princeton, N.J.: Princeton University Press, 1966), p. 10, cf. p. 7.

124. This argument is canvassed but regarded as too simplistic in Linda Woodbridge's comprehensive discussion of the *commendatio mulierum* genre, *Women and the English Renaissance: Literature and the Nature of Womankind, 1540–1620* (Urbana: University of Illinois Press, 1984), p. 42. A useful summary of modern responses to Agrippa's treatise is provided by Rabil in the introduction to his translation of the *Declamatio*, pp. 29–33. See further Pamela Benson, *The Invention of the Renaissance Woman* (University Park: Pennsylvania State University Press, 1992).

125. Agrippa's flattery succeeded, since Margaret appointed him as imperial archivist and historian at her court. The practice continued. In 1670 Henry Care addressed his new translation of the *Declamatio de nobilitate* to Catherine, queen of England, the wife of Charles II.

126. Fahy, "Three Early Renaissance Treatises," pp. 32–33, 36.

127. As suggested in Alastair Minnis with V. J. Scattergood and J. J. Smith, *Chaucer's Shorter Poems* (Oxford: Clarendon Press, 1995), p. 446.

128. John Flood sees the issue in terms of an entrapping rhetorical *topos*: "Defenders of Eve found themselves trapped in a *topos* the inherently rhetorical nature of which was such that it was impossible to escape it." Associated with this, he believes, was the "relegation of the question of women's worth to that of a mere game." Flood, *Eve*, p. 91. The element of "game" is certainly there, but I myself do not believe that the matter can be seen as a *mere* game, in the sense of something trivial and ephemeral. Dialectical paradox and rhetorical "games," insofar as they participate in the formation and communication of alternative viewpoints, may play a role in processes of ideological change. An alternative viewpoint which today has currency within a high-status group (and functions within its exclusive power plays) may tomorrow be the intellectual property of larger and more diverse communities, who see it as of relevance to their sociopolitical ambitions.

129. Tr. Anne Dunhill, *The Nobility and Excellence of Women, and the Defects and Vices of Men* (Chicago: University of Chicago Press, 1999), p. 54. Cf. Agrippa: "Woman is superior to man by reason of the material of her creation, because she was made not from something

inanimate, not from vile clay as man was, but from a purified material, endowed with life and soul" (*Declamatio de nobilitate*, ed. Antonioli, p. 51; tr. Rabil, p. 50).

130. Cf. Agrippa: "Woman in fact was fashioned with the angels in Paradise, a place absolutely full of nobility and delight, while man was made outside of Paradise in the countryside among brute beasts and then transported to Paradise for the creation of woman" (*Declamatio de nobilitate*, ed. Antonioli, p. 54; tr. Rabil, p. 48).

131. *The Worth of Women: Wherein Is Clearly Revealed Their Nobility and Their Superiority to Men*, tr. Virginia Cox (Chicago: University of Chicago Press, 1997), p. 60. See further Paola Malpezzi Price and Christine Ristaino, *Lucrezia Marinella and the Querelle des Femmes in Seventeenth-Century Italy* (Madison, N.J.: Fairleigh Dickinson University Press, 2008), and Stephen Kolsky, "Moderata Fonte, Lucrezia Marinella, Giuseppe Passi: An Early Seventeenth-Century Feminist Controversy," *Modern Language Review*, 96.4 (2001), 973–89.

132. Barbara K. Lewalski, "Speght, Rachel," *Oxford Dictionary of National Biography*, Oxford University Press, 2004; online ed., October 2008 (http://www.oxforddnb.com/view/article/45825, accessed December 29, 2011). See further Elaine V. Beilin, *Redeeming Eve: Women Writers of the English Renaissance* (Princeton, N.J.: Princeton University Press, 1987), pp. 110–17; the chapter "Piety and Spirituality" in Patricia Crawford's *Women and Religion in England, 1500–1720* (London: Routledge, 1993), pp. 73–97, and especially Barbara K. Lewalski, *Writing Women in Jacobean England* (Cambridge, Mass.: Harvard University Press, 1993), pp. 153–75.

133. Two further responses to Swetnam were produced, by the pseudonymous Ester Sowernam ("Esther hath hanged Haman") and Constantia Munda ("The Worming of a Mad Dog"), the former complaining about the "slenderness" of Speght's "answer." See Katherine U. Henderson and Barbara F. McManus, *Half Humankind: Contexts and Texts of the Controversy About Women in England, 1540–1640* (Urbana: University of Illinois Press, 1985), pp. 218–62; cf. pp. 16–18, 24–26, 37–38.

134. The evaluative model of Aristotle's four causes had been rediscovered, and was endlessly analyzed and developed, in the later Middle Ages. See Minnis, *Medieval Theory of Authorship*, pp. 28–29, and chapters 3 and 4 passim.

135. Rachel Speght, *The Polemics and Poems*, ed. Barbara K. Lewalski (New York: Oxford University Press, 1996), p. 18.

136. Speght, *Polemics and Poems*, ed. Lewalski, p. 19.

137. *In II Sent.*, dist. xvi, art. 2, qu. 2, 1 (*Bonaventurae opera*, ii.403), already quoted above.

138. *In II Sent.*, dist. xvi, art. 1, qu. 6 (ii.210–11).

139. See further Richard's treatment of the ordination question, *In IV Sent.*, dist. xxv, art. 4, qu. 1: *utrum sexus muliebris impedit ordinis susceptionem* (iv.388–89), discussion of which is included in Alastair Minnis, "*De impedimento sexus*: Women's Bodies and Medieval Impediments to Female Ordination," in Biller and Minnis (eds.), *Medieval Theology and the Natural Body*, pp. 109–39.

140. "Quae autem sunt a Deo ordinatae sunt."

141. *Summa theologiae*, 1a, qu. 96, art. 3: *utrum homines in statu innocentiae fuissent æquales* (xiii.128–33).

142. *De civitate Dei*, xix.13 (CSEL 40.2, 395; tr. Dyson, p. 938).

143. *Summa theologiae*, 1a, qu. 96, art. 4: *utrum homo in statu innocentiae homini dominabatur* (xiii.132–35).

144. Cf. Grosseteste: "It was not God's will that one human being should by coercive power have dominion over another who, being rational, voluntarily obeys the laws of reason." *Hexaëmeron*, viii.35.6 (ed. Dales and Gieben, p. 261; tr. Martin, p. 266). Grosseteste proceeds

to cite Augustine, *De civitate Dei*, xix.15: God "did not intend that His rational creature, made in his own image, should have lordship over any but irrational creatures: not man over man, but man over the beasts. Hence, the first just men were established as shepherds of flocks, rather than kings of men. . . . For we believe that it is with justice that a condition of servitude is imposed on the sinner. That is why we do not read the word 'slave' anywhere in the Scriptures until Noah, the just man, punished his son's sin with this name" (CSEL 40.2, 400; tr. Dyson, pp. 942–43). Cf. *De Genesi ad litteram*, xi.37,50 (CSEL 28.1, 372; tr. Hill, 458–59). William de la Mare relies on this Augustinian doctrine in his discussion of whether there was rank in the state of innocence, the placing of one person before another (*praelatio*). Servitude or subservience may be understood in two senses, he concludes, one being in accord with the natural order (which did exist in Eden) and the other resulting from disturbance of the natural order and involving domination (which was introduced by sin). A further distinction may be made, between service against one's will and service freely rendered. The former relates to the relationship between humankind and the beasts—and, when imposed by some men upon others, is called penal servitude. Augustine speaks of the latter in his *Enchiridion*: "He serves freely who freely does the will of his master." William de la Mare, *In II Sent.*, dist. xliv, qu. 4; in *Scriptum in secundum librum sententiarum*, ed. Kraml, p. 555; cf. Augustine, *Enchiridion*, ix.30, ed. Otto Scheel (Tübingen: Mohr, 1930), p. 20.

145. Aristotle, *Politics*, i.2 (1253a3–9).

146. Aristotle, *Politics*, i.2 (1254a28).

147. *De civitate Dei*, xix.14 (CSEL 40.2, 399; tr. Dyson, p. 942).

148. *Summa theologiae*, 1a, qu. 98, art. 1, ad 3 (xiii.153). Cf. *Politics*, ii.5 (1263a21–29).

149. *Summa theologiae*, 2a, 2ae, qu. 66, art. 2: *utrum liceat alicui rem aliquam quasi propriam possidere* (xxxviii.67).

150. *Politics*, ii.5 (1262b38–64b25).

151. Here I return to *Summa theologiae*, 1a, qu. 98, art. 1, ad 3 (xiii.152–53).

152. *Opus nonaginta dierum*, 2, in William of Ockham, *Opera politica*, ed. G. Sikes, B. L. Manning, R. F. Bennett, H. S. Offler, and R. H. Snape (Manchester: Manchester University Press, 1940–63), i.307. The title derives from Ockham's claim to have written it within ninety days; *Opus nonaginta dierum*, 124, ed. Sikes et al., ii.857; tr. Kilcullen and Scott, ii.848.

153. *Opus nonaginta dierum*, 26, ed. Sikes et al., p. 485; tr. Kilcullen and Scott, i.309.

154. *Apologia pauperum contra calumniatorem* (*Bonaventurae opera*, viii.233–330). For a succinct summary of this agenda-setting treatise, see Malcolm D. Lambert, *Franciscan Poverty: The Doctrine of the Absolute Poverty of Christ and the Apostles in the Franciscan Order, 1210–1323* (London: SPCK, 1961), pp. 126–40. *Dominium* and *usus* are discussed at pp. 127–28, 133–34. An excellent commentary has been provided by Virpi Mäkinen, *Property Rights in the Late Medieval Discussion on Franciscan Poverty* (Leuven: Peeters, 2001), pp. 57–94, 197–200. See further John Moorman, *A History of the Franciscan Order from Its Origins to the Year 1517* (Oxford: Clarendon Press, 1968), pp. 179–81, 315–17.

155. Lambert, *Franciscan Poverty*, pp. 141–48; Mäkinen, *Property Rights*, pp. 71–73, 77–81.

156. Around this time other polemical documents were published, by participants in the order's general chapter at Perugia on June 4, 1322, under the leadership of Michael of Cesena. The most significant of these, the *Declaratio magistrorum et baccalariorum de paupertate Christi et Apostolorum*, is discussed by Mäkinen, *Property Rights*, pp. 154–61, 202–3.

157. Brian Tierney, *The Idea of Natural Rights: Studies on Natural Rights, Natural Law, and Church Law, 1150–1625* (Grand Rapids, Mich.: Eerdmans, 2001), p. 150.

158. See John Oakley, "John XXII and Franciscan Innocence," *Franciscan Studies*, n.s. 46 (1986), 217–26 (esp. pp. 221–24). Bonagratia developed a distinction which Bonaventure had made between "interior" and "exterior" acts. In terms of interior act, Christ and the Apostles did not own anything, though in terms of exterior act, Judas carried a common purse on behalf of the group, as a concession to human weakness; money was dispensed from it to meet their physical needs and to support the poor. Therefore Christ and his first followers could be said to have lived in a state of innocence akin to the one before the Fall, here seen in terms of an absence of all property rights. Ockham proceeded to emphasize Christ's perfection of poverty in both interior and exterior acts. See Lambert, *Franciscan Poverty*, pp. 129, 133, 135–38; Mäkinen, *Property Rights*, pp. 91–92, 174–90; Takashi Shogimen, *Ockham and Political Discourse in the Late Middle Ages* (Cambridge: Cambridge University Press, 2007), pp. 45–46, 56; and J. W. Dawson, "Richard FitzRalph and the Fourteenth-Century Poverty Controversy," *Journal of Ecclesiastical History*, 34 (1983), 315–44 (pp. 325–26).

159. Tierney, *The Idea of Natural Rights*, p. 152.

160. Tierney, *The Idea of Natural Rights*, p. 153.

161. Elsewhere Aquinas addresses the issue of whether the natural law can be changed—of particular relevance here because of Isidore of Seville's statement (*Etymologiae*, v.4, in *Etymologiarum libri*, ed. Lindsay, unpag.) that "the possession of all things in common (*communis omnium possessio*), and universal freedom (*una libertas*), are matters of natural law." Aquinas's answer is that the idea of such change can be understood in two ways—in terms of either addition or subtraction. Addition is quite unproblematic, since many things which are beneficial for our existence have been added by laws both divine and human. That is the case with distinctions relating to possessions and servitude—introduced not by nature but by human reason for the benefit (*utilitas*) of human life. *Summa theologiae*, 1a 2ae, qu. 94, art. 5, 3, resp., and ad 3 (xxii.95). Here, at least, Aquinas sounds rather sanguine; other treatments emphasize how positive law now acts as a defense against human greed and iniquity—as when Henry of Ghent, one of Aquinas's successors in the Parisian faculty of theology, contrasts contemporary conditions with the state of innocence, when "all temporal goods would have been shared as one common hereditary property," a situation which cannot be replicated today. All we can hope for is the charitable sharing of goods which are understood to be privately owned. In religious communities, certain individuals who are more perfect than the usual run of humankind can "observe a *measure* of common possession" of a kind which is unattainable in secular, political communities. But this is merely a moderation of imperfection rather than the attainment of perfection itself (which, given man's expulsion from Eden, can now be attained only in heaven). See Janet Coleman, "Are There Any Individual Rights or Only Duties? On the Limits of Obedience in the Avoidance of Sin According to Late Medieval and Early Modern Scholars," in Virpi Mäkinen and Petter Korkman (eds.), *Transformations in Medieval and Early-Modern Rights Discourse* (Dordrecht: Springer, 2006), pp. 3–36 (pp. 17–19).

162. Tierney, *The Idea of Natural Rights*, p. 150. Tierney finds "embedded in the texts of *Decretum* . . . an historical account of how human government emerged after an original age of prelapsarian innocence. After the Fall of Adam, men lived for a time as scattered individuals guided only by natural law. According to Gratian this lasted until people began 'to gather as one and live together' in the time of Cain who first built a city (Genesis 4:17). Then there came an age of customary law until, finally, actual legislation began in the time of Moses" (p. 145).

163. Tierney, *The Idea of Natural Rights*, p. 153.

164. Lambert, *Franciscan Poverty*, pp. 226–30, 239, 242. For John XXII's earlier attempts at relevant legislation, the bulls *Quia nonnunquam* (1322), *Ad conditorem canonum* (1322, revised

in 1323), and *Cum inter nonnullos* (1323), see Mäkinen, *Property Rights*, pp. 146–52, 162–73, and Patrick Nold, *Pope John XXII and His Franciscan Cardinal: Bertrand de la Tour and the Apostolic Poverty Controversy* (Oxford: Clarendon Press, 2003), pp. 144–77. Nold regards John's "limitations as a politician" as a crucial factor in the eruption of Franciscan poverty as a major controversy (p. 176).

165. Here John also sought to affirm the papacy's spiritual authority over learning—this being, in part, an attempt to stem the outpouring of Franciscan erudition concerning dominion.

166. *Opus nonaginta dierum*, 27, ed. Sikes et al., p. 486; tr. Kilcullen and Scott, i.310–11.

167. Cf. Tierney, *The Idea of Natural Rights*, pp. 155–56, 163–66.

168. *Opus nonaginta dierum*, 27, ed. Sikes et al., p. 487; tr. Kilcullen and Scott, i.312.

169. Ibid.

170. For the argument that Ockham's understanding of the crucial concept "factual use" (*usus facti*) parted company from what had gone before, see Annabel S. Brett, *Liberty, Right, and Nature: Individual Rights in Later Scholastic Thought* (Cambridge: Cambridge University Press, 1997), pp. 58–59, 63–64.

171. *Opus nonaginta dierum*, 27, ed. Sikes et al., p. 488; tr. Kilcullen and Scott, i.313.

172. "Ordo scripturae non semper ordinem rei gestae." *Opus nonaginta dierum*, 27, ed. Sykes et al., p. 491; cf. p. 489, "ordo litterae non semper sequitur ordinem rei gestae."

173. *Opus nonaginta dierum*, 27, ed. Sykes et al., p. 490; tr. Kilcullen and Scott, i.317.

174. *Opus nonaginta dierum*, 27, ed. Sykes et al., p. 491; tr. Kilcullen and Scott, i.318.

175. For example, in his *Breviloquium de principatu tyrannico super divina et humana*, which focuses on the "two swords" mentioned at Luke 22:38 (generally read as signifying the competing powers of church and state), Ockham attacks his opponents' case on the grounds that they are citing an allegorical sense which is unsupported elsewhere in Scripture by a literal sense. See Alastair Minnis, "Material Swords and Literal Lights: The Status of Allegory in William of Ockham's *Breviloquium* on Papal Power," in Jane Dammen McAuliffe, Barry D. Walfish, and Joseph W. Goering (eds.), *With Reverence for the Word: Medieval Scriptural Exegesis in Judaism, Christianity, and Islam* (New York: Oxford University Press, 2003), pp. 292–308.

176. *Opus nonaginta dierum*, 14, ed. Sykes et al., p. 432; tr. Kilcullen and Scott, i.234. See further Shogimen, *Ockham and Political Discourse*, pp. 61–62.

177. See especially *Opus nonaginta dierum*, 26, ed. Sikes et al., p. 485; tr. Kilcullen and Scott, i.309.

178. Cf. Tierney, *The Idea of Natural Rights*, p. 160.

179. *Opus nonaginta dierum*, 88, ed. Sikes et al., p. 654; tr. Kilcullen and Scott, ii.551.

180. *De civitate Dei*, xix.26 (CSEL 40.2, 53; tr. Dyson, p. 629). For the other citations, see above, pp. 96–98, cf. p. 136.

181. *Opus nonaginta dierum*, 88, ed. Sikes et al., pp. 656–57; tr. Kilcullen and Scott, ii.555. Indeed, reading those words one might detect an underlying belief that love obviates private possessions. When people come together in love and concord, the division of goods between them—a practice established after the Fall in order to maintain social order—is rendered unnecessary. There is no evidence that Ockham was much interested in such a train of thought, but it definitely features in Bonaventure's *Apologia pauperum*, due to the relationship there postulated between *dominium* over temporal goods and *affectus* (the term being understood as "an inclination of the soul to something based on love"). "Through the Fall the originally good affection (*affectio ordinata*) became disordered (*affectio inordinata*)," connected with cupidity and greed; thus material goods became objects of sinful desire, the occasion of a

dangerous possessiveness which civil law had to control, through the maintenance and defense of property rights. However, Bonaventure is quite clear on the point that property itself is not inherently sinful; each and every individual possession is not to be regarded as a failure of love. Indeed, Bonaventure "never denied the right of the Church to acquire and own temporal goods." Mäkinen, *Property Rights*, pp. 77, 84–87, 93–94.

182. Ockham argues that the first actual "division of lordships" (*divisio dominiorum*) that we read of in Scripture was between Cain the farmer and Abel the shepherd (Genesis 4:2–5). *Opus nonaginta dierum*, 88, ed. Sikes et al., p. 656; tr. Kilcullen and Scott, ii.554.

183. *Opus nonaginta dierum*, 88, ed. Sikes et al., p. 657; tr. Kilcullen and Scott, ii.555.

184. On the cultural significance of those garments and the representational problem of how they should be depicted, see the first part of Peter Stallybrass's article "Visible and Invisible Letters: Text Versus Image in Renaissance England and Europe," in Marija Dalbello and Mary Shaw (eds.), *Visible Writings: Cultures, Forms, Readings* (New Brunswick, N.J.: Rutgers University Press, 2011), pp. 77–98.

185. Tierney sums up Ockham's thought on this matter succinctly: he "distinguished three epochs of human history. There was a time before sin when our first parents had no property but a power of using things; then there was a middle time after sin but before the division of things when they had a power of appropriation; and finally a time after division was made when individual possessions came to exist" (*The Idea of Natural Rights*, p. 166).

186. *Opus nonaginta dierum*, 89, ed. Skyes et al., p. 664; tr. Kilcullen and Scott, ii.567.

187. *Opus nonaginta dierum*, 88, ed. Sykes et al., p. 654; tr. Kilcullen and Scott, ii.550.

188. Cf. Tierney, *The Idea of Natural Rights*, p. 163.

189. *Opus nonaginta dierum*, 14, ed. Sykes et al., p. 434; tr. Kilcullen and Scott, i.233–34.

190. *Opus nonaginta dierum*, 14, ed. Sykes et al., p. 433; tr. Kilcullen and Scott, i.236.

191. *Opus nonaginta dierum*, 14, ed. Sykes et al., p. 434; tr. Kilcullen and Scott, i.237.

192. Cf. Tierney, *The Idea of Natural Rights*, p. 169. See further Arthur Stephen McGrade, "Right(s) in Ockham: A Reasonable Vision of Politics," in Mäkinen and Korkman (eds.), *Transformations in Medieval and Early-Modern Rights Discourse*, pp. 63–94, for a masterly contextualization of Ockham's discourse of natural rights in relation to major trends in his philosophy and theology.

193. *Opus nonaginta dierum*, 8, ed. Sykes et al., p. 378; tr. Kilcullen and Scott, i.157; *Opus nonaginta dierum*, 77, ed. Sykes et al., p. 630; tr. Kilcullen and Scott, ii.517.

194. Katherine Walsh, *Richard FitzRalph in Oxford, Avignon, and Armagh: A Fourteenth-Century Scholar and Primate* (Oxford: Clarendon Press, 1981), p. 413.

195. *Dialogus inter militem et clericum, Richard FitzRalph's Sermon "Defensio curatorum" and Methodius, "Þe bygynnyng of þe world and þe ende of worldes," by John Trevisa*, ed. Aaron J. Perry, EETS 167 (London: Oxford University Press, 1925), p. 71.

196. Katherine Walsh, "FitzRalph, Richard," *Oxford Dictionary of National Biography*, Oxford University Press, 2004; online ed., May 2010 (http://www.oxforddnb.com/view/article/9627, accessed January 21, 2012).

197. *De pauperie salvatoris*, books 1–4, published as an appendix to John Wyclif, *De dominio divino libri tres*, ed. Reginald Lane Poole (London: Trübner, 1890), p. xl (from Poole's summary of FitzRalph's text); cf. book ii.20–21 (pp. 362–64).

198. *De pauperie salvatoris*, ed. Poole, p. xl; book ii.15–18 (pp. 356–61).

199. Walsh, *Richard FitzRalph in Oxford, Avignon, and Armagh*, p. 395.

200. *De pauperie salvatoris*, ed. Poole, pp. xxxix–xl; see especially book ii.6 (pp. 3444–46). Dawson robustly claims that "with respect to the distribution of lordships on the earth," this

doctrine appears to mean "nothing at all." The law may intend to "distribute property accord-
ing to merit, since lawgivers may prescribe nothing against the laws of God or nature," but in
practice it "knows nothing of the state of grace of individuals." Therefore "civil law recognises
the title of one who inherits by primogeniture and does not inquire whether he is in mortal sin
or not," even though, in theory, "no one in mortal sin has a just title to any property" ("Fitz-
Ralph," pp. 336–37).

201. Walsh seeks to exonerate FitzRalph from blame for what Wyclif and the hereticated
Czech priest Jan Hus were to make of *De pauperie Salvatoris*: "To interpret him in terms of
what Wyclif, the Lollards, or the Reformers in Prague subsequently made of his thesis, is to
ignore the manner in which an orthodox, ambitious, and essentially conservative and
hierarchically-minded prelate made his own a doctrine which had been hierocratic in its con-
ception." *Richard FitzRalph in Oxford, Avignon, and Armagh*, p. 385.

202. *De pauperie salvatoris*, ii.2, ed. Poole, p. 335; cf. Dawson, "FitzRalph," pp. 334–35, and
Brett, *Liberty, Right, and Nature*, p. 70.

203. *De statu innocencie*, vi, ed. Loserth and Matthew, pp. 505–6.

204. Cf. Stephen Lahey, *Philosophy and Politics in the Thought of John Wyclif* (Cambridge:
Cambridge University Press, 2003), p. 162.

205. Tierney, *The Idea of Natural Rights*, p. 141.

206. *De pauperie Salvatoris*, ii.25, ed. Poole, pp. 368–69.

207. See especially *De civili dominio*, i.18 and iii.11, ed. R. L. Poole and J. Loserth, 4 vols.
(London: Trübner & Co., 1885–1904), i.126, iii.183–85.

208. Lahey, *Philosophy and Politics*, p. 118; cf. Brett, *Liberty, Right, and Nature*, pp. 73–74.

209. *De statu innocencie*, vi, ed. Loserth and Matthew, p. 507.

210. *De statu innocencie*, vi, ed. Loserth and Matthew, p. 508.

211. Irenaeus, *Adversus haereses*, i.26,3; *St. Irenaeus of Lyons: Against the Heresies, Book I*, tr.
Dominic J. Unger (New York: Paulist Press, 1992), pp. 90–91.

212. Here I borrow a phrase from Lahey, *Philosophy and Politics*, p. 118.

213. *De civili dominio*, i.27, ed. Poole and Loserth, i.192.

214. *Philosophy and Politics*, p. 163.

215. Thomas Walsingham, *Historia anglicana*, ed. H. T. Riley, Rolls Series (London: Long-
man, 1863–64), ii.32–33. As Anne Hudson notes, the couplet certainly pre-dated Ball, and was
probably a traditional verse. See Hudson, "Poor Preachers, Poor Men: Views of Poverty in
Wyclif and His Followers," in František Šmahel and Mitarbeit von Elisabeth Müller-Luckner
(eds.), *Häresie und vorzeitige Reformation im Spätmittelalter*, Schriften des Historischen Kollegs,
39 (Munich: Oldenbourg, 1998), pp. 41–53 (p. 41).

216. Lahey, *Philosophy and Politics*, p. 163.

217. *De statu innocencie*, viii, ed. Loserth and Matthew, pp. 512–14. It is harder to decide,
Wyclif opines, whether the theological virtues of Faith, Hope, and Charity would have been
in play then. Charity certainly—but, we ourselves have a greater knowledge of that, since we
know (thanks to Christ's sacrifice) of that great love whereby one lays down one's life for one's
friend (John 15:13). Faith and Hope? Maybe, but in Eden man would have enjoyed clear vision
of God and the articles of faith, so faith and hope would not have been as needed as they are
now. But, we need not concern ourselves unduly about the exact nature of the innocent's
knowledge—that is as inane a question as asking the name of Tobit's dog (cf. Tobias 6:1, 11:9).
On scholastic use of this whimsical detail, see Alastair Minnis, "Tobit's Dog and the Dangers
of Literalism: William Woodford OFM as Critic of Wycliffite Exegesis," in Michael Cusato

and G. Geltner (eds.), *Defenders and Critics of Franciscan Life: Essays in Honor of John Fleming* (Leiden: Brill, 2009), pp. 41–52.

218. As quoted above, pp. 116–117.

219. Cf. *De civili dominio*, iii.13, ed. Poole and Loserth, iii.230.

220. *De statu innocencie*, x, ed. Loserth and Matthew, pp. 522–23.

221. As suggested by Loserth, p. xxvii. Later (p. 523, line 18). Wyclif calls them *beati angeli*.

222. See Michael Wilks, "Predestination, Property, and Power: Wyclif's Theory of Dominion and Grace," rpt. in Wilks, *Wyclif: Political Ideas and Practice: Papers by Michael Wilks*, ed. Anne Hudson (Oxford: Oxbow Books, 2000), pp. 16–32.

223. M. Hurley, "*Scriptura Sola*: Wyclif and His Critics," *Traditio*, 16 (1960), 275–352 (pp. 286–87). Cf. R. R. Betts, "Richard FitzRalph, Archbishop of Armagh, and the Doctrine of Dominion," in H. A. Cronne, T. W. Moody, and D. W. Quinn (eds.), *Essays in British and Irish History in Memory of J. E. Todd* (London: Muller, 1949), pp. 46–60 (pp. 46–48).

224. Wilks, "Predestination, Property, and Power," p. 24. With this may be compared Dawson's view of FitzRalph's claim that dominion is dependent on grace: "Since it is impossible to determine who is in a state of grace, this doctrine was entirely without practical effect" ("FitzRalph," p. 337; also Dawson's remarks as quoted above in n. 200).

225. Wilks, "Predestination, Property, and Power," p. 22.

226. *Adam and Eve in Seventeenth-Century Thought*, p. 108.

227. J. C. Davis and J. D. Alsop, "Winstanley, Gerrard," *Oxford Dictionary of National Biography*, Oxford University Press, 2004; online ed., October 2009 (http://www.oxforddnb .com/view/article/29755, accessed January 15, 2012).

228. Christopher Hill, "The Religion of Gerrard Winstanley," *Past and Present*, supplement 5 (1978), p. 33. See further Christopher Hill, *The World Turned Upside Down: Radical Ideas During the English Revolution* (Harmondsworth: Penguin, 1975), pp. 163–64.

229. *The Works of Gerrard Winstanley, with an appendix of documents relating to the Digger Movement*, ed. George H. Sabine (Ithaca, N.Y.: Cornell University Press, 1941), pp. 251–52; cf. Almond, *Adam and Eve in Seventeenth-Century Thought*, p. 109.

230. St. Athanasius, *The Life of Saint Anthony*, tr. Robert T. Myers (Westminster, Md.: Newman Press, 1950), p. 63.

231. Boniface Ramsey, *Beginning to Read the Fathers* (London: S.C.M. Press, 1993), p. 152.

232. Giles Constable, "Renewal and Reform in Religious Life," in *Renaissance and Renewal in the Twelfth Century*, ed. Robert L. Benson and Giles Constable (Toronto: University of Toronto Press, 1991), pp. 37–109 (p. 48). See further George H. Williams, *Wilderness and Paradise in Christian Thought: The Biblical Experience of the Desert in the History of Christianity and the Paradise Theme in the Theological Idea of the University* (New York: Harper, 1962), pp. 38–48.

233. Cited by Constable, "Renewal and Reform," pp. 48–49.

234. Introduction to Winstanley, *Works*, ed. Sabine, p. 21.

235. *The Breaking of the Day of God* (1648), cit. Sabine, p. 43. "You are not to be saved by believing that a man lived and died long ago in Jerusalem, but by the power of the spirit within you treading down all unrighteousness of the flesh." *The Saints Paradice*, abstract by Sabine, in Winstanley, *Works*, p. 96.

236. *The Saints Paradice*, cited by Sabine in Winstanley, *Works*, p. 9. The comparison with John Milton's views is obvious. "Under the gospel we possess, as it were, a twofold Scripture; one external, which is the written word, and the other internal, which is the Holy Spirit, written in the hearts of believers, according to the promise of God, and with the intent that it

should by no means be neglected. . . . That which is internal, and the peculiar possession of each believer, is far superior to all, namely, the Spirit itself. . . . Even on the authority of Scripture itself, everything is to be finally referred to the Spirit and the unwritten word." A little earlier, Milton claims that "every believer has a right to interpret the Scriptures for himself, inasmuch as he has the Spirit for his guide, and the mind of Christ is in him; nay, the expositions of the public interpreter can be of no use to him, except so far as they are confirmed by his own conscience." *On Christian Doctrine*, i.30, ed. K. M. Burton, in Milton, *Prose Writings* (London: Dent, 1961), pp. 126, 128–29.

237. Davis and Alsop, "Winstanley, Gerrard," *Oxford Dictionary of National Biography*. Winstanley was confident that the Spirit would teach all men consistently, and that all men would be able to understand that teaching consistently.

238. *De Genesi ad litteram*, xi.14,18 (CSEL 28.1, 346; tr. Hill, p. 438).

239. *De civitate Dei*, xiv.13; tr. Dyson, p. 609.

240. Gluttony also had a claim to be termed the top sin, given that "the woman saw that the tree was good to eat, and fair to the eyes, and delightful to behold" (Genesis 3:6). Peter Lombard notes that "humankind was tempted in three ways, namely by gluttony, vain glory (*vana gloria*), and avarice," erroneously citing Augustine at this point, whereas the actual source is Gregory's *In Evangelia*, hom. 16, n. 2; Lombard, *II Sent.*, dist. xxi, 5 (126), 6 (*Lib. sent.*, i.2, 436), tr. Silano, ii.95. "The sin of the woman was undertaken in pride, had its progress in avarice, and had its consummation in gluttony," says Bonaventure; "lastly" the devil "held out before her an experience of sweetness, when he showed her that the tree was beautiful to look at and sweet to eat." *In II Sent.*, dist. xxii, art. 1, qu. 1, conclusio (*Bonaventurae opera*, ii.517).

241. The devil certainly did not desire money—i.e., *avaritia* understood in a particular sense. Here St. Paul signifies the general by the particular, Augustine explains; when he used the term at I Timothy 6:10 "he wished universal avarice to be understood." *De Genesi ad litteram*, xi.15,19 (CSEL 28.1, 437; tr. Hill, p. 439). For discussion, see Richard Newhauser, *The Early History of Greed: The Sin of Avarice in Early Medieval Thought and Literature* (Cambridge: Cambridge University Press, 2000), pp. 13, 91–95, 100, 103, 113–16.

242. *Summa theologiae*, 2a 2ae, qu. 163, art. 1, resp. (xliv.151).

243. Adam's pride was constituted differently; it was an excess of confidence in his own powers, Aquinas argues. Peter Lombard believes Adam had some pride first in his mind, then was encouraged to try the fruit when he saw the woman had not died from eating it. *II Sent.*, dist. xxii, 3 (132), 4 (*Lib. sent.*, i.2, 442; tr. Silano, ii.100). "Perhaps some stirring of ambition moved the man," even though he did not believe it true or possible that he could be like God—whereas Eve did believe that. *II Sent.*, dist. xxii, 4 (133), 9 (*Lib. sent.*, i.2, 444–45; tr. Silano, ii.102).

244. Lombard, *II Sent.*, dist. xxii, 4 (133) (*Lib. sent.*, ii.100–102),tr. Silano, ii.100–101.

245. Aquinas, *Summa theologiae*, 2a 2ae, qu. 163, art. 4 (xliv.160–61).

246. *In II Sent.*, dist. xxii, art. 1, qu. 3, 1 (*Bonaventurae opera*, ii.520).

247. *In II Sent.*, dist. xxii, art. 1, qu. 3, conclusio (*Bonaventurae opera*, ii.520).

248. Aquinas, *Summa theologiae*, 2a 2ae, qu. 163, art. 4 (xliv.160–63). Augustine had compared Adam's case with that of Solomon, who was unable to resist the love of those women ("his death-dealing darlings," *mortiferas delicias*) who dragged him into the evil of idol worship. In the same way Adam was unable to cross Eve; "he believed she might easily pine away without him to comfort her, if she found herself estranged from his way of thinking, and might quite simply perish from that conflict." Augustine emphasizes that no "lust of the flesh" was

involved here—for that came only after the Fall—but rather a kind of loving concern for their mutual friendship. *De Genesi ad litteram*, xi.42,59 (CSEL 28.1, 378; tr. Hill, pp. 462–63).

249. *Mirour of Mans Saluacioun*, ed. Henry, p. 43. The text continues: "And thus Adam for luf ete with dame Eue his wyve / Bot he ne hoped neuere the more to be like God olyve. / *The woman therefore sinned more than the man / Because she thought herself capable of being made like God*" (351–54). The lines in italics represent Henry's translation of a passage in the original Latin which the Middle English version omits.

250. *De civitate Dei*, xiv.26 (CSEL 40.2, 53; tr. Dyson, p. 629).

251. Here Scotus is building on Augustine (particularly *De Genesi ad litteram*, xi.42,59, as quoted in n. 249 above). He proceeds by arguing that, in formal terms (*formaliter*), Adam's sin was less grave than Eve's—her sin involved seeking equality with God, a sin into which neither the fallen angels nor Adam fell. However, if Adam's sin is considered in terms of its circumstances (*ex circumstantiis accidentalibus*)—i.e., Adam's greater dignity of person and the fact that he was stronger and better able to resist—then his sin may be judged the more grave. *In II Sent.*, dist. xxi, qu. 2 (*Scoti opera*, xiii.139–44), and Reportata Parisiensia, *In II Sent.*, dist. xxii, quaestio unica (*Scoti opera*, xxiii.104–5).

252. *In II Sent.*, dist. xxii, dub. 1 (*Bonaventurae opera*, ii.527–28).

253. *Summa theologiae*, 1a 2ae, qu. 81, art. 5, resp. (xxvi.24–25). Elsewhere Aquinas explains this patrilineal process as follows. "Every father in begetting offspring transmits original sin because he begets as Adam, not because he begets as Peter or Martin, that is, he transmits original sin because he begets by what he has from Adam, not by what is particular to himself." That sin is the privation (*defectus*) of that original justice which was gifted by God "to the first human being at his creation" and extends "to all his descendants," in respect of both body and soul. "As the souls infused by God belong to the human nature originating from Adam because of the flesh to which the souls are united, so also the aforementioned privation of original justice belongs to the souls because of the flesh that Adam propagated." *De malo*, qu. 4, art. 1, resp. and ad 8, ed. and tr. Davies and Regan, pp. 335, 337.

254. *Declamatio de nobilitate*, ed. Antonioli et al., p. 66; tr. Rabil, pp. 62–63.

255. *Mirour of Mans Saluacioun*, ed. Henry, p. 43; cf. the images on pp. 42 and 44.

256. *In II Sent.*, dist. xxi, art. 1, qu. 2 (*Bonaventurae opera*, ii.494–95).

257. *In II Sent.*, dist. xxi, art. 1, qu. 2, 2 and ad 2um (*Bonaventurae opera*, ii.494–95).

258. This interpretation, not specifically attributed to Bede, is dismissed as having "no scriptural authority" by Nicholas of Lyre in his comment on Genesis 3:1. However, Lyre insists that God willed the temptation to take place in a form in which the deception of the demon could have been perceived more readily. *Biblia glossata*, i.88; cf. H. A. Kelly, "The Metamorphoses of the Eden Serpent During the Middle Ages and Renaissance," *Viator*, 2 (1971), 301–27 (p. 326).

259. *Historia scholastica*, Historia libri Genesis, xxi; *PL* 198, 1072B.

260. J. K. Bonnell, "The Serpent with a Human Head in Art and in Mystery Play," *American Journal of Archaeology* 2.21 (1917), 255–91 (p. 290 n. 2); supported by Kelly, "Metamorphoses of the Eden Serpent," p. 309. See further Robert A. Koch, "The Salamander in Van der Goes' *Garden of Eden*," *Journal of the Warburg and Courtauld Institutes*, 28 (1965), 323–26.

261. Kelly, "Metamorphoses of the Eden Serpent," pp. 302, 309–16, 320, 322–24. For the (unsubstantiated and unconvincing) suggestion concerning Lilith, see Jeffrey M. Hoffeld, "Adam's Two Wives," *Metropolitan Museum of Art Bulletin*, 26 (June 1968), 430–40.

262. This is well brought out by Nona C. Flores, "'Effigies Amicitiae . . . Veritas Inimicit-iae': Antifeminism in the Iconography of the Woman-Headed Serpent in Medieval and Renais-sance Art and Literature," in Nona C. Flores (ed.), *Animals in the Middle Ages: A Book of Essays* (New York: Garland, 1996), pp. 167–95.

263. *Historye of the Patriarks*, ed. Taguchi, p. 31. Lucifer "chaungid hymself into the shape of a serpent, havynge the face of a virgyne and goynge upryght lyke a man." The Latin text's mention of Bede is omitted in the Middle English translation.

264. Genesis 3:15, where God predicts that woman shall crush the head of the serpent, was frequently interpreted as being "fulfilled in the annunciation to the glorious Blessed Virgin Mary," as the *Biblia pauperum* puts it; *Biblia pauperum: A Facsimile and Edition*, ed. Avril Henry (Ithaca, N.Y.: Cornell University Press, 1987), p. 50. Cf. Nicholas of Lyre on Genesis 3:15, and the *Glossa ordinaria* on Genesis 3:16 ("Mariae typus Eua fuit"); *Biblia glossata*, i.102–3. On the punning connection made between *Eva* (Eve) and *Ave* (as in *Ave Maria*, Gabriel's salutation to the Blessed Virgin), see John Fyler, *Language and the Declining World in Chaucer, Dante and Jean de Meun* (Cambridge: Cambridge University Press, 2007), pp. 16–17. Fyler cites the *Aurora*, Peter Riga's versified Bible, as saying that "the 'ave' of Gabriel dissolves the whole woe of Eva." Cf. *Aurora*, Liber Genesis, 321–28, in Riga, *Aurora: Petri Rigae Biblia versificata*, ed. Paul E. Beichner (Notre Dame: University of Notre Dame, 1965), p. 39. See further Blamires, *Case for Women*, pp. 13, 60, 112, 123, 202. Medieval understandings of the relationship between Eve and Mary are cogently discussed by Flood, *Eve*, pp. 14–16, 55–57, 78, 80, 86–87, 90–91, and 119.

265. *Book of the City of Ladies*, I.9.3, tr. Richards, p. 24. For parallel statements, see Alcuin Blamires with Karen Pratt and C. W. Marx (eds.), *Woman Defamed and Woman Defended: An Anthology of Medieval Texts* (Oxford: Clarendon Press, 1992), pp. 236 (Peter Abelard's seventh letter, on the Origin of Nuns) and 266 (the Middle English treatise *Dives et Pauper*).

266. See, for example, how it was used by Agrippa, *Declamatio de nobilitate*, ed. Antonioli, pp. 66–67; tr. Rabil, pp. 63–64.

267. *In II Sent.*, dist. xxiii, art. 3, qu. 3: *utrum Adam in statu innocentiae ita cognoverit Deum, sicut Deus in statu gloriae cognoscitur* (*Bonaventurae opera*, ii.542–48).

268. *In II Sent.*, dist. xix, art. 3, qu. 2 (ii.248).

CHAPTER 3. DEATH AND THE PARADISE BEYOND

1. *On the Way to Language*, tr. Peter D. Hertz (New York: Harper & Row, 1971), pp. 107–8. Heidegger's treatment of animal life has been charged with being naïvely anthropocentric. For a succinct review of the issues, see Matthew Calarco, "Heidegger's Zoontology," in Matthew Calarco and Peter Atterton (eds.), *Animal Philosophy: Ethics and Identity* (London: Continuum, 2004), pp. 18–30.

2. Milton, *Paradise Lost*, IV, 208; in *Poetical Works*, ed. Darbishire, p. 78.

3. *Poetical Works*, ed. Darbishire, p. 84.

4. This is the period assigned in Peter Comestor's *Historia scholastica*, Historia libri Gene-sis, xxiv, additio 1 (*PL* 198, 1075); and in the *Elucidarium* (c. 1100) attributed to Honorius "of Autun" (Honorius Augustodunensis), i.15 (*PL* 172, 1119).

5. Wyclif, *De statu innocencie*, ii, ed. Loserth and Matthew, p. 483.

6. "Cuius anima educitur de potencia materie" (p. 510).

7. Aquinas remarks that animals have a "certain share of shrewdness and reason in proportion to their connatural power of assessing things"; *Summa theologiae*, 1a, qu. 96, art. 2, ad 4um (xiii.127). I prefer "acumen" to "shrewdness" as a translation of *prudentia* as deployed here; cf. p. 00 above.

8. *Summa theologiae*, 2a 2ae, qu. 164, art. 1: *de poenis peccata primi hominis* (xliv.164–73).

9. Cf. Bonaventure, *In II Sent.*, dist. xix, art. 1, qu. 2, 1 (*Bonaventurae opera*, ii.461).

10. *Summa theologiae*, 2a 2ae, qu. 164, art. 1, ad 2um (xliv.168–69).

11. *Summa theologiae*, 2a 2ae, qu. 164, art. 1, resp. (xliv.166–67).

12. *In II Sent.*, dist. xix, art.1, qu. 2, conclusio (*Bonaventurae opera*, ii.462).

13. See, for example, Augustine's *De trinitate*, xii.15,24 (*PL* 42, 1011–12) and *Contra academicos*, iii.17,37 (*PL* 32, 954); cf. Isidore of Seville, *Etymologiae*, viii.5 (in *Etymologiarum libri*, ed. Lindsay, unpag.): *de haeresibus Christianorum*, 69. Tertullian was particularly vocal on the subject of metempsychosis; see his *Apologeticus adversus gentes pro christianis*, 48 (*PL* 1, 521A–27B), *Ad nationes*, 1.19 (*PL* 1, 585B), and *De anima*, 28 (*PL* 2, 697A–98C). See further Catherine Osborne, *Dumb Beasts and Dead Philosophers: Humanity and the Humane in Ancient Philosophy and Literature* (Oxford: Oxford University Press, 2007), pp. 41–61 (which covers the reincarnation theories of Pythagoras, Empedocles, and Plato).

14. Cf. the statement in Alan of Lille's *De fide catholica*, 1.xi: "asseruit animam hominis merito peccati post mortem intrare in corpus alterius hominis vel bruti animalis" (*PL* 210, 317B–C); also Bernard Gui, *Manuel de l'Inquisiteur*, ed. G. Mollat (New York: AMS Press, 1980), p. 18, and Moneta of Cremona, *Adversus Catharos et Valdenses libri quinque*, I.iv.5; ed. T. Ricchini (Rome, 1743; rpt. Ridgewood, N.J.: Gregg Press, 1964), pp. 61–62. A general discussion has been provided by Roland Poupin, *Les Cathares, l'âme et la reincarnation* (Portet-sur-Garonne: Loubatières, 2000).

15. *In II Sent.*, dist. xix, art. 1, qu. 2, conclusio (*Bonaventurae opera*, ii.462).

16. Grosseteste, *Hexaëmeron*, viii.24.4 (ed. Dales and Gieben, p. 248; tr. Martin, p. 253). Cf. *Hexaëmeron*, viii.13.6 (ed. Dales and Gieben, pp. 238–39; tr. Martin, p. 243).

17. *Hexaëmeron*, viii.25.1 (ed. Dales and Gieben, p. 249; tr. Martin, p. 254).

18. *De Genesi ad litteram*, iii.16,25 (CSEL 28.1, 81–82; tr. Hill, pp. 230–31).

19. *Summa theologiae*, 1a, qu. 96, art. 1, ad 2um (xiii.125).

20. Aquinas notes that the *Glossa ordinaria*, quoting Bede on Genesis, does not say that trees and grass were given as food to all animals, but only to some of them (*Summa theologiae*, 1a, qu. 96, art. 1, ad 2um; xiii.125, 127).

21. *In II Sent.*, dist. xix. art. 1, qu. 2, sed contra 2 (*Bonaventurae opera*, ii.462).

22. One motivation driving medieval Christian defenses of meat-eating was the desire to counter Manichean prohibitions of this form of food (which reappear in Catharism). For Augustine's relevant opinions, see Sorabji, *Animal Minds and Human Morals*, pp. 195–98.

23. *In IV Sent.*, dist. 48, qu. 2, art. 5: *utrum plantae et animalia remaneant in illa innovatione* (*Aquinatis opera*, vii.2, 1178–79).

24. *De statu innocencie*, ii, ed. Loserth and Matthew, p. 484.

25. *The Good Morrow*, l. 19: "What ever dyes, was not mixt equally." *Poems of Donne*, ed. Grierson, p. 8.

26. *In IV Sent.*, dist. xlviii, qu. 2, art. 2, solutio (*Aquinatis opera*, vii.2, 1174).

27. Aristotle's belief in the eternity of the world was supposed to be linked to a belief in the ongoing, perpetual generation of animals. According to Giles of Rome, "Since generation in the sublunary world is brought about through the sun, he [Aristotle] was forced to posit that the sun 'will never cease to generate plants and animals.'" For Giles this is linked to a denial

of "the resurrection of the dead." *Errores philosophorum,* ed. Koch and tr. Riedl, pp. 6–9. Aristotle's explanation of how animals and plants are generated therefore came with unwanted baggage.

28. Steel's denigration of this text as "stultifyingly orthodox" (*How to Make a Human,* p. 99) strikes me as otiose.

29. References are to *Richard Morris's Prick of Conscience,* prepared by Ralph Hanna and Sarah Wood, EETS OS 342 (Oxford: Oxford University Press, 2013).

30. Cf. Aquinas, *In IV Sent.,* dist. xlviii, qu. 2, art. 2, sed contra, 2 (*Aquinatis opera,* vii.2, 1174).

31. *In IV Sent.,* dist. 48, qu. 2, art. 5 (*utrum plantae et animalia remaneant in illa innovatione*); *Aquinatis opera,* vii.2, 1178–79. On scholastic elaborations of this ubiquitous idea, with special reference to William of Auvergne and Thomas Aquinas, see Francesco Santi, "*Utrum plantae et bruta animalia et corpora mineralia remaneant post finem mundi.* L'animale eterno," in *Micrologus. Natura, scienze e società medievali (Nature, Sciences and Medieval Societies),* Rivista della Società Internazionale per lo Studio del Medio Evo Latino, 4 (Turnhout: Brepols, 1996), 231–64.

32. "The General Deliverance," in *Works of John Wesley,* ed. Jackson, vi.249.

33. A similar concern, albeit concerning Eden rather than the *patria,* appears in the *Sentences* commentary of the Oxford Dominican Richard Fishacre (d. 1248). How could such a little place as the earthly paradise have accommodated the great multitude of the saved, pending their transference to an even higher state (as per God's original plan)? See Biller, *The Measure of Multitude,* pp. 244–46.

34. Such changing attitudes are comprehensively tracked by Reynolds, *Food and the Body.* Cf. especially p. 19: "The body is the agent of digestion, for it converts food into itself. The body turns food, which is potential flesh, into actual flesh." A question arose, however, concerning the *type* of flesh into which food was converted. Peter Lombard formulates it thus: "we do not deny that foods and liquids pass into the flesh and blood, but not into that truth of human nature (*in veritatem humanae naturae*) which descends from the first parents; this alone will exist at the Resurrection. But the rest of the flesh, into which foods pass, will be laid aside at the Resurrection as superfluous; nevertheless, it grows with the nourishment of foods and other things." *II Sent.,* dist. xxx, 15 (205), 2 (*Lib. sent.,* i.2, 505; tr. Silano, ii.153). In other words, food is not translated into "the substance of human nature" but rather into a sort of "'second-rate' flesh," as Nolan puts it; *Immortality,* p. 117. This does help address the problem of how the resurrected body can be formed or reconstituted: for it may be argued that only the *veritas humanae naturae,* the flesh we inherit from our forefathers and which goes right back to Adam, will resurrect, whereas the flesh that is made from our assimilation of food will not. Cf. Reynolds, *Food and the Body,* pp. ix, 1–2, 4, etc. This view of two kinds of flesh in man was rejected—or, at least, heavily qualified—by many later theologians. For example, Aquinas and Giles of Rome hold that food is (as Reynolds puts it) "truly converted into an individual, concrete truth of human nature." Reynolds, *Food and the Body,* pp. 370–71; cf. Nolan, *Immortality,* pp. 115–22. See further Steel's lively discussion, *How to Make a Human,* pp. 110–18.

35. *IV Sent.,* dist. xliv, 2 (252), 1 (*Lib. sent.,* ii.517; tr. Silano, iv.239). Cf. Caroline Walker Bynum, *The Resurrection of the Body in Western Christianity, 200–1336* (New York: Columbia University Press, 1995), pp. 124–26.

36. Quoting Augustine, *Enchiridion,* xxii, 88 (ed. Scheel, 55); cf. *De civitate Dei,* xxii.20 (CSEL 40.2, 631–32; tr. Dyson, pp. 1150–51).

37. *Summa contra gentiles,* iv.81[13] (*Aquinatis opera,* v.372).

38. *De civitate Dei*, xxii.20 (CSEL 40.2, 632; tr. Dyson, p. 1151).

39. But what if both his parents had lived on human flesh? And therefore their seed—from which he was formed—was "generated from the flesh of others"? This principle always applies: "the seed . . . will rise in him who was generated from the seed." So, the parental seed will arise in the child, with God supplying anything lacking. This principle can be applied as far back up the family tree as is necessary.

40. Cf. Thomas Aquinas's use of this passage; *In IV Sent.*, dist. xlviii, qu. 2, art. 1, solutio (*Aquinatis opera*, vii.2, 1175).

41. *Summa theologiae*, 1a, qu. 97, art. 3, resp. (xiii.143).

42. *In IV Sent.*, dist. xliv, qu. 1, art. 3, quaestiuncula 1 and the relevant response at solutio 1 (*Aquinatis opera*, vii.2, 1081, 1083).

43. Thus, Albert the Great affirms that whatever can be proved concerning the resurrection of Christ (who is the head) may be concluded concerning the resurrection of others. *De resurrectione*, tract. ii, art. 5, in *Alberti opera* (Cologne ed.), xxvi.278.

44. With this discussion in Aquinas's *Sentences* commentary, cf. *Summa contra gentiles*, iv.83[19]: Christ "ate after the Resurrection not out of necessity, but to establish the truth of the Resurrection" (*Aquinatis opera*, v.375). Tr. Charles J. O'Neil, *On the Truth of the Catholic Faith. Summa contra gentiles, Book 4: Salvation* (Garden City, N.Y.: Hanover House, 1955–57), iv.318.

45. Albert, *De resurrectione*, tract. ii, art. 5 (xxvi.278). Cf. Augustine, *Epistula* 102, 6 (*PL* 33, 372), and the revised version of this passage in the *Glossa ordinaria* on Luke 24:41 (*Biblia glossata*, v.1005).

46. Hence the "impassibility" of Christ's resurrected body was not compromised. The concept of *impassibilitas* will be discussed later in this chapter. See further Alain Boureau's chapter on "Le corps mort de Christ" in his *Théologie, science et censure au XIIIe siècle: Le cas de Jean Peckham* (Paris: Belles Lettres, 1999), pp. 87–136.

47. For instance, Abraham entertains three messengers from God (Genesis 18:2–9), and Lot prepares a feast for the two angels who protect him in Sodom (Genesis 19:1–3).

48. As by Augustine, *Epistula* 102, 6 (*PL* 33, 372).

49. "There will be no such reason for eating in the General Resurrection." Aquinas, *Summa contra gentiles*, iv.83 [19] (*Aquinatis opera*, v.375; tr. O'Neil, iv.318).

50. *In IV Sent.*, dist. xlviii, qu. 2, art. 5, ad 1 (*Aquinatis opera*, vii.2, 1178).

51. Augustine, *De civitate Dei*, xxii.24 (CSEL 40.2, 648; tr. Dyson, p. 1164). On *diversitas* as an aesthetic principle, see especially Carruthers, *Experience of Beauty*, pp. 155–64.

52. Augustine, *De civitate Dei*, xxii.24 (CSEL 40.2, 649; tr. Dyson, p. 1165).

53. Here I have adapted a few phrases from Steel, *How to Make a Human*, pp. 96 (including n. 17) and 106.

54. Augustine, *De civitate Dei*, xx.20 (CSEL 40.2, 477; tr. Dyson, p. 1013). The Augustine passage was afforded even greater prominence thanks to its citation by Peter Lombard, *IV Sent.*, dist. xliii, 6 (249), 2 (*Lib. sent.*, ii.514, tr. Silano, iv.237).

55. "In a moment, in the twinkling of an eye, at the last trumpet: for the trumpet shall sound and the dead shall rise again incorruptible. And we shall be changed."

56. Quoted by Augustine, *De civitate Dei*, xxii.26 (CSEL 40.2, 651–52; tr. Dyson, pp. 1167–68).

57. *In IV Sent.*, dist. xliii, qu. 1, art. 1, quaestiuncula 1 and solutio 1 (*Aquinatis opera*, vii.2, 1057, 1058).

58. *In IV Sent.*, dist. xliii, art. 1, qu. 5, conclusio (*Bonaventurae opera*, iv.893–94). On this comparison, see Bynum, *Resurrection*, pp. 237, 242–44. Richard of Middleton also deploys it: see Antonia Fitzpatrick, "Richard de Mediavilla on the Resurrection of the Body," *Studi Francescani*, 107 (2010), 89–124 (pp. 106–8).

59. *De civitate Dei*, xxii.15 (CSEL 40.2, 623–24; tr. Dyson, p. 1143). Cf. Aquinas, *In IV Sent.*, dist. xliv, qu. 1, art. 3, quaestiuncula 1, sed contra (*Aquinatis opera*, vii.2, 1081).

60. *IV Sent.*, dist. xliv, 1 (251), 3 (*Lib. sent.*, ii.517; tr. Silano, iv.239).

61. *In IV Sent.*, dist. xliv, art. 3, quaestiuncula 1 and solutio 1 (*Aquinatis opera*, vii.2, 1081, 1082).

62. If "rematerialize" may be permitted as a placeholder term. Is this process best described in terms of reassemblage, reconstitution, reconstitution, growth, renovation, or of abundant overflow from soul to body? During the Middle Ages, shifts in such metaphorical discourse were crucially related to major developments in intellectual culture (particularly, of course, the impact of the rediscovered Aristotle), as Bynum brings out brilliantly throughout her major study, *The Resurrection of the Body*. See especially *Resurrection*, chapters 3 and 6 (pp. 117–55, 229–78).

63. The issue of how each human being could possibly rise again "numerically" the same, in his or her own flesh, was a matter of considerable controversy during the thirteenth century, and colored by the debate on the "plurality of forms." According to Aquinas, the soul is the only determining form, which substantially makes a person all that he or she is (this being the "unicist" explanation), whereas for others (various Franciscan "pluralists," including Duns Scotus), in addition man is corporeal in virtue of a corporeal form, animal in virtue of an animal form, and so forth, all of these forms constituting his identity. These different theories necessitated different estimates of what the body contributed to the reunification of body and soul at the General Resurrection. For discussion, see Bynum, *Resurrection*, pp. 8–11, 126–37, 259–61, 269–70; Roberto Zavalloni, *Richard de Mediavilla et la controverse sur la pluralité des formes* (Louvain: Éditions de l'Institut supérieur de philosophie, 1951); Hermann J. Weber, *Die Lehre von der Auferstehung der Toten in den Haupttraktaten der scholastischen Theologie; von Alexander von Hales zu Duns Skotus* (Freiburg: Herder, 1973), esp. pp. 217–63; Jorge J. E. Gracia (ed.), *Individuation in Scholasticism: The Later Middle Ages and the Counter-Reformation, 1150–1650* (Albany: State University of New York Press, 1994); Boureau, *Théologie, science et censure au XIIIe siècle*, esp. pp. 245–331; and Antonia Fitzpatrick, "Bodily Identity in Scholastic Theology," Ph.D. thesis, University of London, 2013, along with her article "Richard de Mediavilla on the Resurrection of the Body."

64. *Trialogus*, iv.40, in Wyclif, *Trialogus cum supplementi Trialogi*, ed. G. Lechler (Oxford: Clarendon Press, 1869), p. 393; tr. Stephen Lahey, *Wyclif: Trialogus* (Cambridge: Cambridge University Press, 2013), p. 310. However, Phronesis adds, "But I know, that in all of these things God has ordered things according to a rule." So, maybe Wyclif had a little "doubt" on this issue after all. Or, at least, was anxious to avoid sounding ridiculous. (I am grateful to Stephen Lahey for allowing me to consult his translation of the *Trialogus* before it was published.)

65. *The Two Cities: A Chronicle of Universal History to the Year 1146 A.D.*, tr. Charles Christopher Mierow, ed. Austin P. Evans and Charles Knapp (New York: Columbia University Press, 1928), p. 470. Augustine had raised the issue of fatness and thinness at *De civitate Dei,* xxii.12 (CSEL 40.2, 620; tr. Dyson p. 1140), concluding (rather convolutedly) that, at the Resurrection, "neither far persons nor thin ones" should "fear that their appearance . . . will be other than they would have wished it to be here [i.e., in their earthly life] if they could" (*De*

civitate Dei, xxii.19; CSEL 40.2, 631; tr. Dyson, p.1149). What they might have wished for is not explored.

66. See Augustine, *Sermo* 243, 7 (*PL* 38, 1146); cf. Bynum, *Resurrection*, pp. 99–100.

67. For an extensive discussion, see Irina Metzler, *Disability in Medieval Europe: Thinking About Physical Impairment During the High Middle Ages, c. 1100–1400* (London: Routledge, 2006), pp. 54–64.

68. On Aquinas's thought on this issue, see especially Fitzpatrick's revisionary discussion, "Bodily Identity in Scholastic Theology," pp. 176–94, which diverges from Bynum's account in several crucial respects. Further, Fitzpatrick's article on Richard of Middleton brings out the limitations of the hypothesis (as advanced by Bynum) that "the pluralist account of human nature and of matter" could "make it easier to conceive the material continuity of individual human bodies between death and resurrection." "Richard de Mediavilla on the Resurrection of the Body," pp. 122–23.

69. *In IV Sent.*, dist. xliv, qu. 1, art. 3, quaestiuncula 2 and solutio 2 (*Aquinatis opera*, vii.2, 1081, 1082).

70. *IV Sent.*, dist. xliv, 8 (258), 2 (*Lib. sent.*, ii.522; tr. Silano, iv.243); following Augustine's *Enchiridion*, xxii, 85–86 (ed. Scheel, 54–55), but see also *De civitate Dei*, xxii.13 (CSEL 40.2, 621–22; tr. Dyson, pp. 1141–42).

71. *IV Sent.*, dist. xliv, 8 (258), 3 (*Lib. sent.*, ii.522; tr. Silano, iv.244); following Augustine, *Enchiridion*, xxiii, 87 (ed. Scheel, 54–55).

72. *The Two Cities*, tr. Mierow, p. 470.

73. Augustine, *De civitate Dei*, xxii.19 (CSEL 40.2, 630; tr. Dyson, p. 1149).

74. *De civitate Dei*, xxii.17 (CSEL 40.2, 625; tr. Dyson, pp. 1144–45).

75. *In IV Sent.*, dist. xliv, qu. 1, art. 3, quaestiuncula 3 and solutio 3 (*Aquinatis opera*, vii.2, 1081, 1082).

76. *In IV Sent.*, dist. xliv, qu. 1, art. 3, solutio 3 (*Aquinatis opera*, vii.2, 1082). Cf. Augustine *De civitate Dei*, xxii.17 (CSEL 40.2, 625–26; tr. Dyson, pp. 1144–46). A rare moment of holy nudity features in Mechthild of Magdeburg's description of Our Lady "at the throne to the left hand of the heavenly Father," with "her lovely uncovered breasts . . . so full of sweet milk that drops flow forth in honor of the heavenly Father and as a favor to humankind, so that man may be perfect above all creatures." *Das fließende Licht der Gottheit*, ii.3, ed. Neumann, i.40; tr. Tobin, p. 71.

77. Cf. pp. 44–46 above.

78. *Summa contra gentiles*, iv.83 [9] (*Aquinatis opera*, v. 374; tr. O'Neil, iv.314).

79. *Summa contra gentiles*, iv.83 [13] (*Aquinatis opera*, v. 375; tr. O'Neil, iv.316).

80. *Summa contra gentiles*, iv. 83 [14] (*Aquinatis opera*, v. 375; tr. O'Neil, iv. 316).

81. See the discussion in Chapter 1.

82. *In IV Sent.*, dist. xliv, qu. 1, art. 2, quaestiuncula 1, 1 (*Aquinatis opera*, vii.2, 1075).

83. *In IV Sent.*, dist. xliv, qu. 1, art. 2, solutio 1, ad 1um (*Aquinatis opera*, vii.2, 1077).

84. Cf. pp. 34–35 above.

85. *In IV Sent.*, dist. xliv, qu. 1, art. 2, solutio 1, ad 2 (*Aquinatis opera*, vii.2, 1077). As Agamben explains quite succinctly, some moistures (or humors or humidities), "including urine, mucus, and sweat, are in fact extraneous to the perfection of the individual, insofar as they are residues that nature expels *in via corruptionis*: they will not, therefore, be resurrected." As neither will be "those involved with procreation (sperm) and nutrition (milk)." However, "the other humors familiar to medieval medicine—above all the four that define the body's

temperaments: blood, black bile or melancholy, yellow bile, and phlegm . . . —will be resurrected in the glorious body, since they are directed to its natural perfection and are inseparable from it." *Nudities*, p. 97.

86. *In IV Sent.*, dist. xliv, qu. 1, art. 2, quaestiuncula 2, 2 and solutio 2 (*Aquinatis opera*, vii.2, 1075, 1077).

87. Augustine, *Enchiridion*, xxiii, 89–90 (ed. Scheel, 55–57); cited by Peter Lombard, *IV Sent.*, dist. xliv, 2 (252) 3 (*Lib. sent.*, ii.518; tr. Silano, iv.240). Cf. Augustine, *De civitate Dei*, xxii.19 (CSEL 40.2, 629; tr. Dyson, p. 1148). The statue analogy caused the late medieval schoolmen much grief; many of them concluded that it had to be revised radically or discarded altogether. See Bynum, *Resurrection*, pp. 232–47, cf. pp. 123, 128. The metaphor of a fructifying seed ("It is sown a natural body: it shall rise a spiritual body"; I Corinthians 15:44, cf. 42–43) was similarly controversial, as Bynum brings out well in the same discussion.

88. *In IV Sent.*, dist. xliv, qu. 1, art. 1, solutio 3, ad 2 (*Aquinatis opera*, vii.2, 1075).

89. "Creatori utique": *De civitate Dei*, xxii.14 (CSEL 40.2, 623; tr. Dyson, p. 1143).

90. *In IV Sent.*, dist. xliv, qu. 1, art. 1, solutio 3 (*Aquinatis opera*, vii.2, 1075).

91. A more elaborate list, of seven gifts, was associated with Anselm of Canterbury (c. 1033–1109), as provided in the *Proslogion* and described further in the *Dicta Anselmi* compiled by Anselm's secretary Alexander. Upon the beatified body is bestowed the gifts of *pulchritudo* (beauty), *velocitas* (swiftness), *fortitudo* (strength), *libertas* (freedom of movement), *sanitas* (well-being), *voluptas* (spiritual desire), and *diuturnitas* (long duration), while the beatified soul enjoys seven further gifts, of *sapientia* (wisdom), *amicitia* (friendship), *concordia* (concord), *honor* (dignity), *potestas* (power), *securitas* (security), and *gaudium* (joy). *Proslogion*, ch. 25, in Anselm of Canterbury, *Opera omnia*, ed. F. S. Schmitt (Edinburgh: Thomas Nelson & Sons, 1940–61), i.118–20; *Dicta Anselmi*, ch. 5, ed. R. W. Southern and F. S. Schmitt, in *Memorials of St. Anselm*, Auctores Britannici Medii Ævi, 1 (London: Oxford University Press, 1969), pp. 127–41. Anglo-Norman and Middle English translations of the fifth chapter of the *Dicta Anselmi* have been edited by Avril Henry and D. A. Trotter; *De quatuordecim partibus beatitudinis*, Medium Ævum Monographs, n.s. xvii (Oxford: Society for the Study of Mediæval Languages and Literature, 1994). The schoolmen sought to assimilate Anselm's seven bodily gifts to the four preeminent ones listed here; see, for example, Albert the Great's *Quaestio de dotibus sanctorum in patria*, art. 6, in *Alberti opera* (Cologne ed.), 25.2, 109–11; Wyclif, *Trialogus*, iv.41–42, ed. Lechler, pp. 393–400; tr. Levy, pp. 311–16. Such maneuvers are clear evidence of the enduring appeal of Anselm's doctrine, which also was endorsed by the *Prick of Conscience* poet, who draws extensively on "Saint Anselme" (albeit at secondhand, via an intermediary Anglo-Norman work, *Les Peines de purgatorie*) in his account of the two sets of "seven maners of blysses" and their hellish contraries; *Prick of Conscience*, ll. 7873–8643.

92. *MED*, s.v. "impassibilite" (n.).

93. Theoretically, two glorified bodies could occupy the same space, but that would be unbecoming and disorderly, so it does not happen, Aquinas thinks. *In IV Sent.*, dist. xliv, qu. 2, art. 2, quaestincula 4 and solutio 4 (*Aquinatis opera*, vii.2, 1089, 1092).

94. *Middle English translations of Grosseteste's* Château d'Amour, ed. Sajavaara, p. 350. The *Myrour*'s account of the body's "dowers" is a considerable amplification of the original Anglo-Norman; cf. *Le Château d'amour*, ed. Murray, p. 315.

95. John Wyclif, *Select English Works*, ed. Thomas Arnold, 2 vols. (Oxford: Clarendon Press, 1869–71), i.142. Cf. *The Myrour of Lewed Men*, 1140–42:

... hit sal be clensid so wel of alkyn heuynes *all kinds of*
That sudanly whedir as the saul has yernyng *desire*
Thedir sal the body glide withouten more letting. *hindrance*

Middle English Translations of Grosseteste's Château d'Amour, ed. Sajavaara, p. 350.

96. *Das fließende Licht der Gottheit*, vii.1, ed. Neumann, i.256–57; tr. Tobin, pp. 274–75. Elsewhere Mechthild describes the blessed gliding "effortlessly, as birds in the air do when not moving their wings, and they fly wherever they want, body and soul." *Das fließende Licht*, ii.3, ed. Neumann, i.39–40; tr. Tobin, p. 71.

97. *In IV Sent.*, dist. xliv, qu. 1, art. 3, solutio 3 (*Aquinatis opera*, vii.2, 1096).

98. *Summa Alexandri*, 3a, inq. un., tract. VI, qu. 2, tit. 1, cap. 7 (iv.260–61), and tract. VII, qu. 1, capi. 1–2 (iv.1, 278–82).

99. Cf. the same Wycliffite sermon we quoted above: "this dower usid Crist whan he wente upon the water, and specialy at that tyme that he stied in to heven." *Select English Works*, ed. Arnold, i.142.

100. *In IV Sent.*, dist. xliv, qu. 2, art. 3, solutio 1 (*Aquinatis opera*, vii.2, 1095).

101. *In IV Sent.*, dist. xliv, qu. 2, art. 3, quaestiuncula 2, sed contra (*Aquinatis opera*, vii.2, 1094).

102. "Claritas point omnes alias proprietates, quae sunt corporum glorifatorum"; "Claritas est principalis ad quam consequuntur ceterae." *Summa Alexandri*, 3a, inq. un., tract. VI, qu. 2, tit. 2, cap. 7, solutio 1 (iv.1, 260).

103. *In IV Sent.*, dist. xliv, dist. xliv, qu. 2, art. 4, quaestiuncula 1, sed contra, 2 (*Aquinatis opera*, vii.2, 1098).

104. *In IV Sent.*, dist. xliv, qu. 2, art. 4, quaestiuncula 1 and solutio 1 (*Aquinatis opera*, vii.2, 1098–99). By using the term "lightsome" to convey something of the significance of *claritas*, I follow the practice of the Fathers of the English Dominican Province in their translation of the *Summa theologiae*, originally published in New York by Benziger Brothers, 1912–25, and now available on the Internet, http://www.newadvent.org/summa.

105. *In IV Sent.*, dist. xliv, qu. 2, art. 4, solutio 1 (*Aquinatis opera*, vii.2, 1098–99).

106. *In IV Sent.*, dist. xliv, qu. 2, art. 4, solutio 1 (*Aquinatis opera*, vii.2, 1099).

107. *Moralium libri*, xviii.48, 77–78 (*PL* 76, 83C–84B).

108. On the relationship between relics and the resurrected body, see particularly Bynum, *Resurrection*, pp. 201–14.

109. Michael Camille, "Before the Gaze: The Internal Senses and Late Medieval Practices of Seeing," in Robert S. Nelson (ed.), *Visuality Before and Beyond the Renaissance* (Cambridge: Cambridge University Press, 2000), pp. 197–223 (p. 204). "The luminous had been a major aesthetic impulse since early Christian times," Camille notes, "but with the aid of Euclidian geometry, Arab optical theory, and Aristotelian materialism, attitudes to light now emphasized not the instantaneous Augustinian 'illumination' of the highest mode of vision but light's refraction and radiation in more mundane, mathematical terms. The sacred itself was affected by this more earthly luminosity."

110. A parallel may be drawn with theologians' assertions that the scars and wounds endured by the saints for the love of God will remain prominently visible on their bright resurrected bodies, as an enhancement to their glory rather than a diminution of it; cf. p. 183.

111. *In IV Sent.*, dist. xliv, qu. 2, art. 4, solutio 1, ad 3 (*Aquinatis opera*, vii.2, 1099).

112. Bynum, *Resurrection*, p. 338; Mechthild, *Das fließende Licht der Gottheit*, vii.1, ed. Neumann, i.257; tr. Tobin, p. 274. In particular, the "human body" of the Virgin Mary is visualized as being "bathed and formed in the noble light of the soul." *Das fließende Licht*, ii.3, ed. Neumann, i.40; tr. Tobin, p. 71.

113. *In IV Sent.*, dist. xlviii, qu. 2, art. 1, sed contra (*Aquinatis opera*, vii.2, 1173).

114. The belief that the "four elements" of earth, water, air, and fire are the building blocks of everything in the universe, including humankind, has its roots in Greek mythology, and was a cornerstone of thought in the spheres of philosophy, theology, cosmology, and medicine for over two thousand years.

115. *In IV Sent.*, dist. xlviii, qu. 2, art. 3, sed contra, ad 3um and ad 4um (*Aquinatis opera*, vii.2, 1176–77).

116. *In IV Sent.*, dist. xlviii, qu. 2, art. 4, solutio (*Aquinatis opera*, vii.2, 1177).

117. The scholarship on late medieval apocalyptic discourse and imagery is vast. I have particularly benefited from the work of Richard K. Emmerson and Bernard McGinn. For Emmerson, see especially *Antichrist in the Middle Ages: A Study of Medieval Apocalypticism, Art, and Literature* (Seattle: University of Washington Press, 1981). For McGinn, see *Visions of the End: Apocalyptic Traditions in the Middle Ages* (New York: Columbia University Press, 1998), *Apocalypticism in the Western Tradition* (Aldershot, Hampshire: Variorum, 1994), and *Antichrist: Two Thousand Years of the Human Fascination with Evil* (San Francisco: HarperSanFrancisco, 1994). See further Emmerson and McGinn (eds.), *The Apocalypse in the Middle Ages* (Ithaca, N.Y.: Cornell University Press, 1992).

118. See also Apocalypse 4:6, "And in the sight of the throne was, as it were, a sea of glass like to crystal (*tamquam mare vitreum simile cristallo*)."

119. *In IV Sent.*, dist. xlviii, qu. 2, art. 3, solutio (*Aquinatis opera*, vii.2, 1176).

120. In support Aquinas cites Ecclesiasticus 43:10, "The glory of the stars is the beauty of heaven, the Lord enlighteneth the world on high."

121. *In IV Sent.*, dist. xlviii, qu. 2, art. 3, solutio (*Aquinatis opera*, vii.2, 1176). That heightening of the senses will be discussed below.

122. Cf. Zachariah 14:7, "And there shall be one day, which is known to the Lord, not day nor night: and in the time of the evening there shall be light." Peter Lombard explains that "then there shall not be the change of day and night which occurs now, but a continuous day and night." *IV Sent.*, dist. xlviii, 5 (279), 4 (*Lib. sent.*, ii.546–47; tr. Silano, iv.265). Nicholas of Lyre reads "not day nor night" as referring to conditions following the resurrection of the dead, when generation and corruption in the elements will cease, together with the movement of the heavens, which is the cause of generation and corruption; then there will be neither day nor night, due to cessation of the motion of the sun. The "light" in question will be the light of the blessed in celestial glory, whereas the reprobate will not have any light, but rather "cold and frost" (v. 6). The "Jerusalem" of v. 8 is identified as the Heavenly Jerusalem. *Biblia glossata*, iv.2163–64.

123. *IV Sent.*, dist. xlviii, 5 (279), 3 (*Lib. sent.*, ii.546; tr. Silano, iv.265).

124. *Glossa ordinaria interlinearis*; *Biblia glossata*, iv.283–84.

125. *In IV Sent.*, dist. xlviii, qu. 2, art. 3 (*Aquinatis opera*, vii.2, 1176–77).

126. Charles S. Singleton, *Dante's* Commedia: *Elements of Structure*, Dante Studies, 1 (Cambridge, Mass.: Harvard University Press, 1954), p. 75; cf. Kevin Marti's pioneering article "Traditional Characteristics of the Resurrected Body in *Pearl*," *Viator*, 24 (1993), 311–35 (esp. pp. 313–14, 316–18), and Bynum, *Resurrection*, pp. 298, 302–3.

127. On the "somatomorphic" body in the *Comedy*, see Bynum, *Resurrection*, pp. 299–302, and Manuele Gragnolati, *Experiencing the Afterlife: Soul and Body in Dante and Medieval Culture* (Notre Dame, Ind.: University of Notre Dame Press, 2005), pp. 53–87 (esp. pp. 74–77). On the ways in which the dead made themselves visible to the living, see Peter Dinzelbacher, "Il corpo nelle visioni dell' aldilà," in *Micrologus. Natura, scienze e società medievali (Nature, Sciences and Medieval Societies)*, Rivista della Società Internazionale per lo Studio del Medio Evo Latino, 1 (Turnhout: Brepols, 1993), pp. 301–26.

128. *Paradiso*, ed. and tr. Singleton, pp. 30–31.

129. Its mysterious author is generally held to be the same person who wrote the Arthurian romance *Sir Gawain and the Green Knight* and two ambitious religious poems, *Patience* and *Cleanness*.

130. Here I borrow some phrases from Nicholas Watson's elegant account, "The *Gawain*-Poet as a Vernacular Theologian," in Derek Brewer and Jonathan Gibson (eds.), *A Companion to the Gawain-Poet* (Cambridge: D. S. Brewer, 1997), pp. 293–313 (p. 299).

131. I have used the edition included in *The Poems of the Pearl Manuscript*, ed. Malcolm Andrew and Ronald Waldron, 5th ed. (Exeter: University of Exeter Press, 2011), pp. 53–110, but quoted from the lightly modernized text in *Sir Gawain and the Green Knight, Pearl, Cleanness, Patience*, ed. J. J. Anderson (London: Dent, 1996), pp. 1–46.

132. All *Olympia* references are to the edition of Boccaccio's *Buccolicum Carmen* by Giorgio Bernardi Perini (which includes an Italian translation), in *Tutte le opere di Giovanni Boccaccio*, ed. Vittore Branca, vol. 5, pt. 2 (Milan: Mondadori, 1994), pp. 689–1085. I also consulted the editions (which include modern English translations) in *Pearl: An English Poem of the XIVth Century, with Boccaccio's Olympia*, ed. Israel Gollancz (London: Chatto and Windus, 1921; rpt. New York: Cooper Square, 1966), and Boccaccio, *Eclogues*, ed. Janet Levarie Smarr (New York: Garland, 1987), pp. 154–73, along with the (sometimes rather supercilious) English translation by David R. Slavitt, *Boccaccio: The Latin Eclogues* (Baltimore: Johns Hopkins University Press, 2010), pp. 116–27. Critical discussion of *Olympia* is sparse, but see especially Giuseppe Chiecchi, "Per l'interpretazione dell'*Egloga Olimpia* di Giovanni Boccaccio," *Studi sul Boccaccio*, 23 (1995), 219–44, and David Lummus, "The Changing Landscape of the Self (*Buccolicum Carmen*)," in Victoria Kirkham, Michael Sherberg, and Janet Smarr (eds.), *Boccaccio: A Critical Guide to the Complete Works* (Chicago: University of Chicago Press, 2013), pp. 155–69 and 406–13. Chiecchi (pp. 219–20) argues that *Olympia* gestures toward a rejection of earthly life for the eternal, whereas Lummus holds that the poem's vision of paradise rather reinforces Boccaccio's engagement in contemporary affairs; "Silvius should continue to take care of his world and its inhabitants" (pp. 166–67).

133. The similarities between the two poems may be accounted for by the fact that both are drawing on, and developing, standard resurrection theology together with doctrine relating to holy innocence; there is no need to find here "one of the strange coincidences of literary history," as proclaimed by Norman Davis in his revised edition of *Sir Gawain and the Green Knight*, ed. J. R. R. Tolkien and E. V. Gordon (Oxford: Clarendon Press, 1967), p. 18. The case for direct influence was made by William H. Schofield, who believed that the similarities are "so close as to preclude the possibility of accidental coincidence"; "The Nature and Fabric of the *Pearl*," *PMLA*, 19 (1904), 154–215 (p. 204). However, *Pearl*'s editors and critics have generally rejected this claim, taking their lead from the rebuttal by Gollancz (as cited in the previous note). I myself would add that the "coincidence" in question is hardly "accidental," but rather due to the influence of a shared body of theological and devotional teaching. A valuable discussion has recently been contributed by David Carlson, who concludes that the

very limited fourteenth-century dissemination of *Olympia* militates against the notion that the *Pearl* poet used it. "A handful of manuscript copies" seem to have been "made and all kept in Italy at least well into the fifteenth century." "The *Pearl*-Poet's *Olympia*," *Manuscripta*, 31 (1987), 181–89 (p. 186).

134. Though, inevitably, the stage directions to the *Ordo representacionis Ade* balk at that, insisting that "Adam is to wear a red tunic, Eve a white woman's garment, a white silk robe" (or perhaps "with a white silk collar"). *The Play of Adam (Ordo representacionis Ade)*, ed. Oden-kirchen, pp. 42–43. For the argument that, in late medieval representation of Adam and Eve, nudity can function as a natural and noble garment which implies positive claims concerning the value of physical labor, and the interdependent relationship of mankind and nature in general, see Linda Seidel, "Nudity as Natural Garment: Seeing Through Adam and Eve's Skin," in Lindquist (ed.), *The Meanings of Nudity*, pp. 207–30.

135. However, in late medieval images of the Virgin and Child, one of Mary's breasts is sometimes exposed. This was justified by her nurturing role as the mother of the infant Christ, but the possibility of sexual arousal was a potential problem, as in the case of the exposed body of the crucified Christ. For scholarly debate on these pressing interpretive issues, see Margaret R. Miles, "The Virgin's One Bare Breast," in Norma Broude and Mary D. Garrard (eds.), *The Expanding Discourse: Feminism and Art History* (New York: Icon Editions, 1992), pp. 26–37; Caroline Walker Bynum, *Fragmentation and Redemption: Essays on Gender and the Human Body in Medieval Religion* (New York: Zone Books, 1991), pp. 79–117; Richard C. Trexler, "Gender-ing Jesus Crucified," in Brendan Cassiday (ed.), *Iconography at the Crossroads* (Princeton, N.J.: Index of Christian Art, 1993), pp. 107–20; Leo Steinberg, *The Sexuality of Christ in Renaissance Art and in Modern Oblivion*, 2nd ed. (Chicago: University of Chicago Press, 1996), especially the response to Bynum on pp. 364–89; Sherry Lindquist's introductory essay to her edited volume, *The Meanings of Nudity*, pp. 1–46 (pp. 10–19); and Corine Schleif's essay in that same collection, "Christ Bared: Problems of Viewing and Powers of Exposing," pp. 251–78.

136. For discussion, see Anna Maria Chiavacci Leonardi, "'Le bianche stole': Il tema della resurrezione nel *Paradiso*," in Giovanni Barblan (ed.), *Dante e la Bibbia: Atti del convegno internazionale promosso da "Biblia," Firenze, 26–27–28 settembre 1986* (Florence: Olschki, 1988), pp. 249–71. In one particularly richly illuminated manuscript of the *Comedy*, London, British Library, MS Yates Thompson 36, Adam and his kin are depicted as naked, as are sinners in Hell. But when we get to paradise, the bodies are becomingly clothed (http://www.worldof dante.org/gallery_yates_thompson.html).

137. See further the Introduction, n. 59.

138. This Memling work is in important ways dependent on *The Last Judgment* (the Beaune Altarpiece) of Rogier van der Weyden (d. 1464), on which see Shirley Neilsen Blum, *Early Netherlandish Triptychs: A Study in Patronage* (Berkeley: University of California Press, 1969), pp. 37–48, and Maurice B. McNamee, *Vested Angels: Eucharistic Allusions in Early Netherlandish Paintings* (Leuven: Peeters, 1998), pp. 181–200.

139. See especially McNamee's discussion of this altarpiece as "a visual Eucharistic *summa*"; *Vested Angels*, pp. 87–117.

140. The two outer panels depict Adam and Eve, in Edenic nakedness. Georges Duby has described them as the earliest example of the human nude painted in the style of early Nether-landish naturalism. *A History of Private Life*, vol. 2: *Revelations of the Medieval World*, tr. Arthur Goldhammer (Cambridge, Mass.: Belknap Press, Harvard University, 1988), p. 582.

141. Ian Bishop, *Pearl in Its Setting* (Oxford: Blackwell, 1968), p. 27.

142. There is an obvious parallel between this encounter and one described in the *Purgatorio*, canto XXVIII, where the Dante-persona, walking through a beautiful landscape which is identified as the Garden of Eden, meets and is instructed by a mysterious Matelda (whose identity remains a matter of scholarly debate) wandering on the other side of a stream. But there is no evidence of direct influence.

143. The tale is set in Cork, and dated 1149, by the author of the Latin original, one Marcus, an Irish Benedictine monk from Cashel, who had moved to the Cistercian house of St. James in Regensburg. Nigel Palmer, whose study concentrates on the Dutch and German translations, lists 154 surviving Latin manuscripts, in addition to many adaptations and extracts. Of particular importance is the abridgment by the Cistercian monk Helinand of Froidmont (c. 1160–after 1229), which was known to Vincent of Beauvais and adapted in his *Speculum historiale*. See Palmer, *"Visio Tnugdali": The German and Dutch Translations and Circulation in the Later Middle Ages*, Münchener Texte und Untersuchungen zur deutschen Literatur des Mittelalters, 76 (Munich: Artemis, 1982), pp. 19–20. On the magnificent illuminated version of a French translation which was made c. 1470 for Margaret of York, Duchess of Burgundy (now Los Angeles, J. Paul Getty Museum, MS 30), see Thomas Kren and Roger S. Wieck, *The Visions of Tondal from the Library of Margaret of York* (Malibu, Calif.: Getty Museum, 1990), and Thomas Kren (ed.), *Margaret of York, Simon Marmion, and the Visions of Tondal: Papers Delivered at a Symposium Organized by the Department of Manuscripts of the J. Paul Getty Museum in Collaboration with the Huntington Library and Art Collections, June 21–24, 1990* (Malibu, Calif.: Getty Museum, 1992).

144. Cf. the partial summary of the Latin text by Robert Easting, *Visions of the Other World in Middle English* (Cambridge: D. S. Brewer, 1997), pp. 70–71; the Middle English version is summarized on pp. 74–75.

145. *The Vision of Tundale*, ll. 2135–48, quoted from the edition in *Three Purgatory Poems*, ed. Edward E. Foster (Kalamazoo, Mich.: Medieval Institute Publications, 2004). This account goes beyond the original Latin; *Visio Tnugdali: Lateinisch und Altdeutsch*, ed. Albrecht Wagner (Erlangen: Deichert, 1882), pp. 52–53. Earlier in the Latin text, it was made clear that Tundale may not be among those souls who enjoy the presence of the Holy Trinity; cf. *Visio Tnugdali*, ed. Wagner, p. 49. The Middle English poet does translate that passage (ll. 1945–54) but subsequently seems to ignore its significance.

146. In both the Latin original and the Middle English version of this confusingly structured text, another beautiful tree appears later in the narrative, full of flowers, fruits, and birds, and surrounded by lilies, roses, herbs, and spices. Here we are in the region reserved for defenders and builders of churches, and the tree is interpreted as a figure of Holy Church itself. *Visio Tnugdali*, ed. Wagner, p. 50; *Vision of Tundale*, ll. 2026–84.

147. Here the Middle English poet may be offering a somewhat optimistic presentation of the "good but not very good" (*non valde bonorum*) as described in the Latin original, souls who are free from the sufferings of hell yet do not merit the fellowship of the union of saints. Cf. *Visio Tnugdali*, ed. Wagner, p. 41. No doubt the doctrine of purgatory and its cleansing fires, which was substantially developed between the twelfth century, when the original text was written, and the fifteenth century, when the Middle English poem was composed, encouraged the thought that the not-very-good would eventually be rendered good enough to enter heaven. For souls to be completely purged of their sins and yet barred from their eternal reward would have been unthinkable, in light of that doctrine.

148. In the second chapter of his *History of Paradise*, Jean Delumeau discusses paradise as "a place of waiting," with initial reference to early Jewish and Christian apocalyptic texts,

which (by late medieval standards) blur together the material and the spiritual, the earthly and the heavenly, though at least some of the ideas found therein did continue to exercise some influence in the High Middle Ages and beyond, on account of the continuous dissemination of certain apocryphal texts, together with citations by such Church Fathers as Ambrose and Clement of Alexandria. *History of Paradise: The Garden of Eden in Myth and Tradition*, tr. Matthew O'Connell (New York: Continuum, 1995), pp. 23–38. To focus on one specific treatise, in the fourth-century Apocalypse of Paul, "the identification of the earthly paradise as a staging point before the definitive heaven is especially clear" (*History of Paradise*, p. 26). On the medieval reception of this work, see especially Lenka Jiroušková, *Die Visio Pauli: Wege und Wandlungen einer orientalischen Apokryphe im lateinischen Mittelalter unter Einschluß der alttsechischen und deutschsprachigen Textzeugen*, Mittellateinische Studien und Texte, 34 (Leiden: Brill, 2006). Delumeau (p. 37) also mentions the late medieval controversy surrounding the notion that, pending the General Resurrection, heaven is a place of waiting and therefore of incomplete happiness, which was brought to a head by the incautious sermons of Pope John XXII, on whom see our subsequent discussion.

149. Genesis 5:24: "And he [Enoch] walked with God, and was seen no more: because God took him."

150. IV Kings 2:11: "And as they went on, walking and talking together, behold, a fiery chariot and fiery horses parted them both asunder: and Elias went up by a whirlwind into heaven." Like Enoch, Elijah does not experience a normal death, and thus their presence in the earthly paradise could be explained.

151. *Gospel of Nicodemus*, IX (xxv). Enoch and Elijah were commonly taken to be the "two witnesses" or prophets who, according to Apocalypse 11:3, were mandated to usher in the final times. Cf. Malachi 4:5, "Behold, I will send you Elias the prophet, before the coming of the great and dreadful day of the Lord," and the episode in Matthew 17 where Peter, James, and John see the transfigured Jesus talk with Elijah and Moses. Christ subsequently tells his followers that Elijah "indeed shall come, and restore all things" (17:11).

152. The even richer illuminations in another copy of the same text, Paris, Bibliothèque nationale de France, fr. 22971 (produced in 1480), have been attributed to Robinet Testard; a facsimile has been published by Anne-Caroline Beaugendre, *Les merveilles du monde ou Les secrets de l'histoire naturelle* (Paris: Bibliothèque nationale de France, 1996). Yet another copy is New York, Pierpont Morgan Library, M. 461. The work itself consists of two major parts, a description of fifty-six countries or regions and an account of the natural world together with the composition of humankind.

153. Another possible influence might be the river Acheron of pagan mythology, across which Charon transported the shades of the dead into the underworld, which medieval Christians knew about from book VI of Virgil's *Aeneid*. It appears in Dante's *Inferno*, Canto III, as the river across which "wicked souls" are ferried to Hell, "into eternal darkness, into fire and cold" (III, 84, 86–87), this being in marked contrast with the *Pearl* poet's river, which forms the border with some kind of Heavenly Paradise.

154. *In II Sent.*, dist. xv, art. 2, qu. 1 (*Bonaventurae opera*, ii.382–83).

155. Cf. pp. 73–74.

156. "The lyght of hem might no mon leven" (69).

157. Bishop, Pearl *in Its Setting*, p. 1.

158. Cf. p. 74.

159. Boccaccio's debt to those conventions are well discussed by Chiecchi, "Per l'interpretazione dell'*Egloga Olimpia*," who also points out the commanding presence of Dante in this poem.

160. Presumably both the Pearl-maiden and Olympia have attained their "perfect age." For a man, this frequently was understood to mean around thirty-two—the age at which Christ had died, according to Peter Lombard (cf. pp. 27, 257 n.). For a woman, the ideal age was less clear. See Mary Dove, *The Perfect Age of Man's Life* (Cambridge: Cambridge University Press, 1986), especially pp. 20–25.

161. *II Sent.*, dist. xxx, 15 (205), 1 (*Lib. sent.*, i.2, 504–5; tr. Silano, ii.153). Cf. Augustine, *De civitate Dei*, xxii.14–15 and 19 (CSEL 40.2, 622–24, 628–31; tr. Dyson, pp. 1142–43, 1147–50). See further Lombard, *IV Sent.*, dist. xliv, 1 (251)–3 (253) (*Lib. sent.*, i.2, 516–19; tr. Silano, iv.238–39).

162. Cf. pp. 29–30.

163. Cf. p. 30 above.

164. *Enchiridion*, xxiii, 89 (ed. Scheel, 55–56), quoted by Peter Lombard, *IV Sent.*, dist. xliv, 2 (252), 3 (*Lib. sent.*, ii.518; tr. Silano, iv.240).

165. This experience may be seen as comparable to that *redundantia* which will occur when, following the General Resurrection, the soul's joys spill over to complete the body's happiness (a phenomenon discussed below). In this present life, a similar overflow—from the Beatific Vision—can help the bodies of the saints endure torture; cf. Bynum, *Resurrection*, p. 310.

166. As Smarr notes, "Cybele was worshipped on Mount Berecinthius," hence she can be called "our Berecynthian mother." Boccaccio, *Eclogues*, ed. Smarr, pp. 239, 253.

167. *Summa Alexandri*, 3a, inq. un., tract. VI, qu. 2, tit. 1, cap. 9: *utrum visio apostolorum potuerit fieri oculis corporalibus*, 1 and ad 1 (iv.1, 263).

168. *Biblia glossata*, v. 288–89 (both the interlinear and marginal glosses). Cf. Bede's gloss on Matthew 17:2 in *Homilia* xviii (*PL* 94, 98A–C).

169. *In IV Sent.*, dist. xlviii, qu. 2, art. 3, sed contra, ad 3 and ad 4 (*Aquinatis opera*, vii.2, 1176–77).

170. Cf. Geoffrey of Vinsauf, *Poetria nova*, l. 1109, in *Les arts poétiques du XIIe et du XIIIe siècle*, ed. Edmond Faral (Paris: Champion, 1924), p. 231.

171. *Rhetorica ad Herennium*, iv.22; quoted in the gloss on *Poetria nova*, l. 1109, in *An Early Commentary on the "Poetria Nova" of Geoffrey of Vinsauf*, ed. Marjorie Curry Woods (New York: Garland, 1985), pp. 98–99.

172. *In IV Sent.*, dist. xliv, qu. 2, art. 1, qu. 1, 5, and solutio 1, ad 5 (*Aquinatis opera*, vii.2, 1083, 1085–86). Aquinas also follows Augustine's distinction between such special scars and those incurred by "martyrs who have had limbs hacked off and taken away." The saints will have those body parts restored (in line with the principle of the *integritas* of the renewed body) at the General Resurrection, for to them it is said, "A hair of your head shall not perish" (Luke 21:18). See further Aquinas, *Summa theologiae*, 3a, qu. 54, art. 4 (lv.30–35), where he argues that, far from implying impairment, defect, or temporariness, Christ's wounds are "a perpetual sign of his glorious triumph." "Although the openings made by the wounds involved a certain rupturing, this was more than compensated for by the greater glory of their appearance (*decorum gloriae*)."

173. *De civitate Dei*, xxii.19 (CSEL 40.2, 631; tr. Dyson, 1149–50). Such doctrine helps explain why Christ's stigmata are so prominently on display in the central panel of Hans Memling's *Last Judgment Triptych* (Plate 22c).

174. *Das fließende Licht der Gottheit*, ii.3, ed. Neumann, i.40; tr. Tobin, p. 72. Thus she supposes that Christ's wounds will remain, but in a perfected, beautified form.

175. Watson, "The *Gawain*-Poet as Vernacular Theologian," p. 302.

176. *In IV Sent.*, dist. xlix, qu. 5, art. 1, solutio (*Aquinatis opera*, vii.2, 1233).

177. *In IV Sent.*, dist. xlix, qu. 5, art. 3, quaestiuncula 1 and solutio 1 (*Aquinatis opera,* vii.2, 1237, 1238–39). Similar attitudes underpin Albert the Great's *quaestio de aureola.* Is a child martyr owed a reward? It seems not, because where there is no battle there is no victor's crown. On the other hand, the Holy Innocents are said to be martyrs by the Church, which cannot err. The martyr's crown may be understood in three ways, Albert claims; it relates to those who combined the desire (*voluntas*) for martyrdom with the act (*actus*), those who had the desire alone, and those who had the act alone—or, in other words, the matter without the form. (The first situation is attested by St. Stephen, the second by St. John, and the third by the Holy Innocents.) *Quaestio de aureola,* art. 5, 6, in *Alberti opera* (Cologne ed.), 25.2, 137. This distinction between *materia* and *forma* is clarified in a previous discussion within the same *quaestio,* where Albert asks, are those who do not solemnly vow themselves to virginity owed the aureole? This would seem to be appropriate, since the aureole of virginity is the reward for the preservation of virginity, which is the case here. Furthermore, the perfect victor is the one who does not succumb, which also is the case here. However, Albert continues, a formal as well as a material aspect is involved—a specific undertaking to bring oneself into conformity with Christ. The virginity of those who have not made such a vow has the *materia* but lacks the *forma.* Therefore Albert concludes that, if the term *aureola* is taken in its proper sense, it does not relate to virgins who did not make that formal commitment. *Quaestio de aureola,* art. 5, 3, in *Alberti opera* (Cologne ed.), 25.2, 134–35.

178. *Quodlibet I,* qu. 20, art. 2, prob. 5; William of Ockham, *Quodlibeta septem,* in *Guillelmi de Ockham opera philosophica et theologica,* 9 (St. Bonaventure: Franciscan Institute, 1980), p. 104; tr. Alfred J. Freddoso and Francis E. Kelley, *William of Ockham: Quodlibetal Questions* (New Haven, Conn.: Yale University Press, 1991), i.89.

179. In contrast, Albert the Great emphasized that Christ does not delight solely in the *integritas* of the person in whom virginity is preserved, but also in the vigor (*strenuitas*) with which that virginity is preserved. *Quaestio de aureola,* art. 5, 3, solutio (3), in *Alberti opera* (Cologne ed.), 25.2, 135.

180. Aquinas, *In IV Sent.,* dist. xlix, qu. 5, art. 3, quaestiuncula 1, sed contra (*Aquinatis opera,* vii.2, 1237).

181. A point well taken by Nicholas Watson, who says, "The poet's version of the mystical marriage of virgins to Christ can be defended in various ways, most convincingly as a consequence of his reading of Revelation 14 in its liturgical context as the epistle for the feast of the Innocents" ("The *Gawain*-Poet as Vernacular Theologian," p. 302).

182. Following Aquinas's phrasing here; *In IV Sent.,* dist. xlix, qu. 5, art. 3, solutio 1 (*Aquinatis opera,* vii.2, 1238).

183. Cf. Santha Bhattacharji's important study, which points out that "the Common of Virgins, together with the Consecration of Virgins, assigns the high estate of bride of the Lamb to certain persons purely on the grounds of their spotless *state,* a state not so much earned as preserved." "*Pearl* and the Liturgical 'Common of Virgins,'" *Medium Ævum,* 64 (1995), 37–50 (p. 47). Particularly important is her point that the parable of the "pearl of great price" (Matthew 13:45–46) regularly formed the Gospel reading for the mass of a virgin martyr.

184. On *Olympia* as a poem of consolation, see Chiecchi, "Per l'interpretazione dell'*Egloga Olimpia,*" pp. 239–44.

185. Carleton F. Brown, "The Author of *The Pearl,* Considered in the Light of His Theological Opinions," *PMLA,* 19.1 (1904), 115–45 (pp. 140, 145).

186. McDannell and Lang, *Heaven,* p. 148.

187. Calvin, *Institutes*, iii.18, 3. Interestingly, here Calvin places considerable weight on Prosper of Aquitaine's *De vocatione omnium gentium*, i.17, applying it for his own purpose.

188. Calvin, *Institutes*, iii.25, 10.

189. *In IV Sent.*, dist. xlix, qu. 5, art. 1, solutio (*Aquinatis opera*, vii.2, 1233).

190. *IV Sent.*, dist. xlix, cap. 1 (280), 2 (*Lib. sent.*, ii.548–9, tr. Silano, iv.266). This hierarchical system for the conferral and radiation of *claritas* also extended to angels. For discussion, see Susanna Barsella, *In the Light of the Angels: Angelology and Cosmology in Dante's* Divina Commedia (Florence: Olschki, 2010), esp. pp. 44–56, 126–33.

191. *IV Sent.*, dist. xlix, cap. 1 (280), 2 (*Lib. sent.*, ii.548–49, tr. Silano, iv.266).

192. *In IV Sent.*, dist. xliv, qu. 2, art. 1, quaestiuncula 2 and solutio 2 (*Aquinatis opera*, vii.2, 1083–84, 1086–87).

193. Sir David Lindsay explains the situation with a homely analogy, a "rude exempyll." Take a small bottle (*crowat*), a pint pail and a quart one, a gallon pitcher, a large cask (*puntioun*), and a barrel (*tun*), of wine or ointment. Fill them up until they overflow. Though the quantities involved are different, each container is totally full, utterly replenished. So it will be with the blessed: "Thocht [though] euerilk one be nocht alike in glore, / Ar satyfeit so that thay desyre no more" (*The Monarche*, ll. 6176–96).

194. Cf. the statement by Dante's Piccarda Donati that, though she is in the lowest group of souls, she is perfectly happy with her lot: "the power of love quiets our will and makes us wish only for that which we have and gives us no other thirst. Did we desire to be more aloft, our longings would be discordant with His will who assigns us here." Such discord is in fact impossible in those circles, where existence in charity is statutory, a matter of necessity (*Paradiso*, III, 70–77; ed. and tr. Singleton, pp. 30–31). For discussion, see Vittorio Montemaggi, "In Unknowability as Love: The Theology of Dante's *Commedia*," in Vittorio Montemaggi and Matthew Treherne (eds.), *Dante's Commedia: Theology as Poetry* (Notre Dame, Ind.: University of Notre Dame Press, 2010), pp. 60–94 (esp. pp. 65–67).

195. Purely hypothetical, of course. No such improvement is possible, since the hierarchical disposition of the earthly paradise is fixed forever.

196. Augustine, *De civitate Dei*, xxii.30 (CSEL 40.2, 666; tr. Dyson, p. 1179). Cf. the discussion by Marti, "Resurrected Body in *Pearl*," pp. 318–19.

197. *Summa theologiae*, 1a 2ae, qu. 4, art. 8, resp. (xvi.112–15).

198. *Summa theologiae*, 1a 2ae, qu. 4, art. 8, resp. (xvi.114–15).

199. *De Genesi ad litteram*, viii.25,47 (CSEL 28.1, 264; tr. Hill, p. 373).

200. Lombard, *IV Sent.*, dist. xlix, 3 (282), 2 (*Lib. sent.*, ii.552; tr. Silano, iv.269).

201. *Quaestio de dotibus sanctorum in patria*, esp. art. 1 and art. 6, in *Alberti opera* (Cologne ed.), 25.2, 103–4, 109–11.

202. Bonaventure expresses his approval through extensive quotation from Anselm's *Proslogion* in his *Breviloquium*, vii.7, 6–8, in *Tria opuscula*, pp. 281–84; also *In IV Sent.*, dist. xlix, P.2, sect. 1, art. 2, qu. 1: *de numero et sufficientia dotorum* (*Bonaventurae opera*, iv.1015); *In IV Sent.*, dist. xlix, P.2, sect. 2, art. 1, qu. 2 (iv.1023–24).

203. See Nikolaus Wicki, *Die Lehre von der himmlischen Seligkeit in der mittelalterlichen Scholastik von Petrus Lombardus bis Thomas von Aquin* (Freiburg, Schweiz: Universitätsverlag, 1954), pp. 202–12.

204. *Proslogion*, ch. 25, ed. Schmitt, i.120; tr. M. J. Charlesworth in Anselm of Canterbury, *The Major Works*, ed. Brian Davies and Gillian Evans (Oxford: Oxford University Press, 1998, rpt. 2008), p. 102.

205. *IV Sent.*, dist. xlix, 3 (282), 3 (*Lib. sent.*, ii.552; tr. Silano, iv.270).

206. Ibid.

207. *Trialogus*, iv.42, ed. Lechler, pp. 397–400; tr. Levy, p. 316.

208. *Trialogus*, iv.41, ed. Lechler, p. 395; tr. Levy, pp. 312–13. In *Trialogus,* iv.42, Anselm's list of the seven gifts of the blessed body is cited, and several gifts of the soul which he had identified, particularly wisdom, friendship, security, and joy, are discussed. Phronesis believes that "friendship (*amicitia*) is as much a gift of the soul as it is a gift of the body, since friendship ought chiefly be given to the whole composite, but foremost by reason of the soul, since created spirits should be [friends by reason of their] souls, but not [by reason of their] bodies, unless first they are friends by reason of their souls." The gift of security (*securitas*) is termed "the greater part of blessedness"; Phronesis is certain that the blessed have no fear that their happy situation will ever diminish, and "ridicule" those "babbling sophists" who are skeptical about its fixity. *Trialogus,* ed. Lechler, pp. 399–400; tr. Levy, pp. 315–16. Cf. Anselm, *Proslogion,* ch. 25, ed. Schmitt, i.118–20; and *Dicta Anselmi,* ch. 4, ed. Southern and Schmitt, pp. 124–27.

209. The vernacular iterations usually avoid engagement with such subtlety, preferring to emphasize the joy each soul takes in another's joy. Good examples may be found in the Middle English translations of the *Château d'amour* attributed to Grosseteste. In *The Castle of Love* blessed souls greet each other enthusiastically, one saying, "So myche blys I see on the / That all my blisse neweth me [is renewed in me]," with another responding in identical terms, thereby emphasizing the point (1793–94; cf. 1799–1800). *The Myrour of Lewed Men* asserts, "Ilkon [each one] of other ioye sal haue a liking, / And that sal be thaim of ioye a doubling" (1203–4). *Middle English translations of Grosseteste's* Château d'Amour, ed. Sajavaara, pp. 317–18, 351. The first of these translations is particularly close to the original Anglo-Norman, ed. Murray, pp. 135–36.

210. But some did believe it was possible. According to Henry of Hereford's chronicle entry for the year 1331, Pope John XXII—he of the Beatific Vision scandal—had the tale of Tundale read to him, whereupon he experienced the vision afresh in a dream, and declared that it was in accord with his own beliefs. Palmer, *Visio Tnugdali*, p. 22.

211. *Summa Alexandri,* 3a, inq. un., tract. VII, qu. 2, tit. 1, cap. 7, solutio 1 (iv.1, 260).

212. *Das fließende Licht der Gottheit*, vii.1, ed. Neumann, i.257; tr. Tobin, p. 275.

213. According to Dante, *Paradiso,* Canto X, 132 ("che a considerar fu più che viro"); ed. and tr. Singleton, pp. 114–15.

214. *Benjamin minor,* cap. xv (*PL* 196, 10D–11B); tr. Clare Kirchberger, in *Richard of St. Victor, Selected Writings on Contemplation* (London: Faber and Faber, 1957), pp. 92–93.

215. Tr. in Alastair Minnis and A. B. Scott with David Wallace (eds.), *Medieval Literary Theory and Criticism c. 1100–c. 1375: The Commentary Tradition,* rev. ed. (Oxford: Clarendon Press, 1991), pp. 174–75.

216. Tr. in Minnis and Scott (eds.), *Medieval Literary Theory,* p. 175.

217. Robert Grosseteste, *The Celestial Hierarchy of Pseudo-Dionysius the Areopagite,* ed. and tr. J. S. McQuade (Ph.D. thesis, Queen's University of Belfast, 1961), p. 20. For discussion, see James McEvoy, *The Philosophy of Robert Grosseteste* (Oxford: Clarendon Press, 1982), pp. 354–68.

218. However: behind the dissimilar simile of light, beyond the divine darkness which uplifted souls enter into, could there actually be—Light? Understood as substance, offered as exegesis of Genesis 1:3, "And God said: Be light made (*fiat lux*). And light was made." James McEvoy has well argued that Pseudo-Dionysius was "a light-symbolist, not a light-metaphysician"—i.e., he "only developed the Platonic analogy of the sun and the good in a

Christian sense." However, Augustine had advanced (though not developed fully) the proposition that light "is not a mere metaphor for the unsayable, but a concept which names intelligible reality properly and fittingly, factually." See McEvoy, "The Metaphysics of Light in the Middle Ages," *Philosophical Studies*, 26 (1979), 126–45 (pp. 139–41). The Aristotelian thought systems devised by thirteenth-century schoolmen were a major hindrance to its subsequent development, but Grosseteste certainly made some significant moves in that direction. In his *Hexaëmeron*, he tantalizingly remarks, "God is light: not bodily light but non-bodily light. Or rather, perhaps, neither bodily nor bodily, but beyond either." *Hexaëmeron*, viii.3,1 (ed. Dales and Gieben, p. 220; tr. Martin, p. 224). In his treatise *De luce* the bodily implications are emphasized further. "The first corporeal form, which some call corporeity, is . . . light." By its very nature light has "the function of multiplying itself and diffusing itself instantaneously in all directions," thereby enforming matter. This diffused, dispersed light is called *lumen*, while its originary form, which emanates from the first sphere, is called *lux*. Indeed, light is the principle of both unity and diversity in the universe: unity, because it is common to all things from the lowest to the highest (even the firmament), and diversity, because "the things which are many are many through the multiplication of light itself in different degrees." *De luce, Die Philosophischen Werke Des Robert Grosseteste, Bischofs Von Lincoln*, ed. Ludwig Baur (Münster: Aschendorff, 1912), VII, pp. 51–69; tr. Clare C. Riedl, *Robert Grosseteste on Light (De luce)* (Milwaukee, Wisc.: Marquette University Press, 1942), pp. 10, 16. See further McEvoy, *Philosophy of Robert Grosseteste*, esp. pp. 151–205, 173–77, 335–37; Servus Gieben, "Robert Grosseteste and Adam Marsh on Light in a Summary Attributed to St. Bonaventure," in Gunar Freibergs (ed.), *Aspectus and Affectus: Essays and Editions in Grosseteste and Medieval Intellectual Life in Honor of Richard C. Dales* (New York: AMS Press, 1993), 17–36; *Robert Grosseteste at Munich: The Abbreviatio by Frater Andreas, O.F.M., of the commentaries by Robert Grosseteste on the Pseudo-Dionysius*, edition, translation, and introduction by James McEvoy; prepared for publication by Philipp W. Rosemann (Paris: Peeters, 2012), pp. 45–46, 56–59, 80–81.

219. Tr. in Minnis and Scott (eds.), *Medieval Literary Theory*, p. 177. This is not to dismiss such imagery. On the contrary, "when Holy Scripture designates things heavenly and divine by more lowly forms, it honours rather than dishonours them [i.e., things heavenly and divine], and shows thereby that they surpass all material things in a way that is on a higher plane than this world" (Gallus, tr. on p. 178). So, correct interpretation is vital. As is recognition of the necessity of leaving behind such imagery when the soul raises itself above and beyond all material things and the similes based upon them.

220. Minnis and Scott (eds.), *Medieval Literary Theory*, p. 177.

221. Tr. in Minnis and Scott (eds.), *Medieval Literary Theory*, p. 178.

222. For discussion of these examples, see Minnis and Scott (eds.), *Medieval Literary Theory*, p. 181. The worm reference derives from Psalm 21:7.

223. Tr. in Minnis and Scott (eds.), *Medieval Literary Theory*, p. 182.

224. Grosseteste, *The Celestial Hierarchy*, ed. and tr. McQuade, pp. 70–71.

225. Grosseteste, *The Celestial Hierarchy*, ed. and tr. McQuade, p. 65.

226. *On the Properties of Things*, Middle English translation by John Trevisa, ed. Seymour, i.41.

227. Here I adopt a working definition from the *ODCC*, pp. 173–74, s.v. "Beatific Vision."

228. Denifle and Chatelain (eds.), *Chartularium universitatis Parisiensis*, i, 170–71; cf. Jeffrey P. Hergan, *St. Albert the Great's Theory of the Beatific Vision* (New York: Peter Lang, 2002), pp. 1–2.

229. *Summa theologiae*, 1a 2ae, qu. 3, art. 8, ad 1um (xvi.86–87).

230. *Summa theologiae*, 1a 2ae, qu. 3, art. 8, resp. (xvi.84–85).

231. On the notion that Christ went before, to show the way and the nature of the resurrection to all the other blessed bodies and souls that would follow after Him, see Oliver Davies, "Dante's *Commedia* and the Body of Christ," in Montemaggi and Treherne (eds.), *Dante's Commedia: Theology as Poetry*, pp. 161–79.

232. *In IV Sent.*, dist. xliv, qu. 2, art. 2, quaestiuncula 1, 1, and solutio 1 (*Aquinatis opera*, vii.2, 1088, 1090); also quaestiuncula 6 with solutio 6 (1089–90, 1093–94).

233. Gregory, *Moralium libri*, xiv, 56 (*PL* 75, 1077C–80A).

234. *In IV Sent.*, dist. xlix, qu. 2, art. 2, solutio (*Aquinatis opera*, vii.2, 1202).

235. *Alberti opera*, xiv, 824, 829; cf. Walther Völker, *Kontemplation und Ekstase bei Pseudo-Dionysius Areopagita* (Wiesbaden: Steiner, 1958), pp. 241–45.

236. This development has been described by Dennis D. Martin as "the affective taming of Pseudo-Denis," a process which he sees as being continued by Hugh of Balma. Cf. the introduction to his translations, *Carthusian Spirituality: The Writings of Hugh of Balma and Guigo de Ponte* (New York: Paulist Press, 1997), pp. 38–47. An excellent means of comparing the relevant scholarship of Gallus and Grosseteste has been provided by the editions and translations of James McEvoy (ed. and trans.), *Mystical Theology: The Glosses by Thomas Gallus and the Commentary of Robert Grosseteste on* De Mystica Theologia, Dallas Medieval Texts and Translations, 3 (Paris: Peeters, 2003). Gallus is named as a source at the beginning of the *Cloud* author's translation of Pseudo-Dionysius's *Mystical Theology*. See Minnis and Scott (eds.), *Medieval Literary Theory*, p. 167; for further discussion, see Alastair Minnis, "Affection and Imagination in *The Cloud of Unknowing* and Hilton's *Scale of Perfection*," *Traditio*, 39 (1983), 323–66.

237. *In IV Sent.*, dist. xlix, qu. 2, art. 2, solutio (*Aquinatis opera*, vii.2, 1202).

238. *De civitate Dei*, xxii.29 (CSEL 40.2, 663; tr. Dyson, p. 1177).

239. Once again following Augustine; *De civitate Dei*, xxii.29 (CSEL 40.2, 663; tr. Dyson, p. 1177).

240. *In IV Sent.*, dist. xlviii, qu. 2, art. 1, solutio (*Aquinatis opera*, vii.2, 1173).

241. Ibid.

242. I.e., *In IV Sent.*, dist. xlix, qu. 2, art. 2, solutio (*Aquinatis opera*, vii.2, 1202).

243. *De civitate Dei*, xxii.29 (CSEL 40.2, 663–64; tr. Dyson, pp. 1177–78).

244. *In IV Sent.*, dist. xliv, qu. 2, art. 1, quaestiuncula 4 and solutio 4, ad 5um (*Aquinatis opera*, vii.2, 1084, 1087).

245. *De proprietatibus rerum*, tr. Trevisa, ed. Seymour, i.108. Cf. Woolgar, *Senses in Late Medieval England*, p. 147. "The crystalline humour—the 'middle eye' or 'black of the eye'—was clear and bright so that it might change to different colours and take their likeness without interference."

246. Cf. Woolgar, *Senses in Late Medieval England*, pp. 148–50. Aquinas and his followers generally follow the "intromission" explanation of the operation of sight, which holds that sight results from light arising from the object of perception, with no ray emanating from the eye itself. This contrasts with the "extramission" theory (which originated in Neoplatonism and was influential on St. Augustine's thought), according to which the eye sends out rays of its own, which return to it following contact with the object of perception. Cf. Woolgar, *Senses in Late Medieval England*, pp. 21–22; see further David Lindberg, *Theories of Vision from al-Kindi to Kepler* (Chicago: University of Chicago Press, 1976), pp. 51–52, 136–49, together with his "The Science of Optics," in *Science in the Middle Ages*, ed. David C. Lindberg (Chicago:

University of Chicago Press, 1978), pp. 338–68; also Kemp, *Medieval Psychology*, pp. 36–40, 47–49. Kemp discusses Roger Bacon's doctrine of vision and light on pp. 40–45.

247. *De anima*, ii.7 (418b4–9 and 419a12–21); also iii.1 (424b30–425a9).

248. *In IV Sent.*, dist. xliv, qu. 2, art. 1, solutio 4, ad 5um (*Aquinatis opera*, vii.2, 1087).

249. Presumably Solomon was chosen here, at least in part, because of his alleged authorship of the Song of Songs, read allegorically as a celebration of the loving union between Christ and His Church and/or the soul of the righteous man. See Jean Leclercq, *Monks and Love in Twelfth-Century France* (Oxford: Oxford University Press, 1979), pp. 27–61 ("A Biblical Master of Love: Solomon"), 76, 81, 138; E. Ann Matter, *The Voice of My Beloved: The Song of Songs in Western Mediaeval Christianity* (Philadelphia: University of Pennsylvania Press, 1990); A. W. Astell, *The Song of Songs in the Middle Ages* (Ithaca, N.Y.: Cornell University Press, 1991); and Denys Turner, *Eros and Allegory: Medieval Exegesis of the Song of Songs* (Kalamazoo, Mich.: Cistercian Publications, 1995).

250. *Paradiso*, ed. and tr. Singleton, pp. 154–55.

251. Cf. our previous discussion of the dynamics of this sense in Chapter 1.

252. *In IV Sent.*, dist. xliv, qu. 2, art. 1, quaestiuncula 3 and solutio 3 (*Aquinatis opera*, vii.2, 1084, 1086). See further *Summa contra gentiles*, iv.84[14]: "The body of man when he rises must have the capacity to touch, for without touch there is no animal" (*Aquinatis opera*, v.377; tr. O'Neil iv.322–23). The *capacity* to touch was one thing, the actuality of touching another—and in this *Sentences* question Aquinas is defending the resurrected body's ability to experience touch.

253. *In IV Sent.*, dist. xliv, qu. 2, art. 1, solutio 4, ad 1 (*Aquinatis opera*, vii.2, 1087); cf. *Liber de ordine creaturarum*, x.8, ed. Díaz y Díaz, p. 160.

254. *In IV Sent.*, dist. xliv, qu. 2, art. 1, solutio 3 (*Aquinatis opera*, vii.2, 1086).

255. Ibid.

256. *Opus majus*, pars V, perspectivae pars prima, dist. vi, cap. 4; ed. Bridges, i.43. Bacon blames the confusion on Aristotle and Averroës, for when they say "that the species (*species*) has a spiritual existence in the medium and in the sense, it is evident that 'spiritual' is not taken from 'spirit' nor is the word used in its proper sense. Therefore it is used equivocally and improperly (*aequivoce et improprie*). . . . For it is taken in the sense of 'insensible' (*insensibile*); for since everything really spiritual, as, for example, God, angel, and soul, is insensible and does not fall under the sense, we therefore convert the terms and call that which is insensible spiritual.' But this is equivocal, and outside the true and proper meaning of a spiritual thing" (ed. Bridges, i.44).

257. In his *De anima* commentary Aquinas explains that by "spiritual change" is meant "what happens when the likeness of an object is received in the sense-organ, or in the medium between object and organ, *as a form causing knowledge*, and not merely as a form in matter." *In librum de Anima commentarium*, ii.7, 418 [lect. 14], ed. Pirotta, p. 144; tr. Foster and Humphries, pp. 267–68.

258. Eleonore Stump, *Aquinas* (London: Routledge, 2003), p. 252.

259. Stump, *Aquinas*, p. 39.

260. Aquinas postulates two types of *immutatio*, as normally occurring in sensory perception. "In some senses, namely sight, there is supraphysical change (*immutatio spiritualis*) only. In others, along with this, there is physical change (*immutatio naturalis*) as well, either on the object's part only, or on the part of the organ also" (*Summa theologiae*, 1a, qu. 78, art. 3 [xi.130–31]). Sight involves no natural alteration or "immutation" since "the eye itself is not coloured when it perceives a coloured object" (as Neil Campbell puts it in his useful account,

"Aquinas' Reasons for the Aesthetic Irrelevance of Tastes and Smells," p. 170). For example, if the eye perceives whiteness, it itself does not turn white, no material change occurring. Writing on *De anima*, ii.vi, Aquinas explains that seeing involves "only a spiritual change," while "in the case of touching and tasting (which is a kind of touching) it is clear that a material change occurs: the organ itself grows hot or cold by contact with a hot or cold object; there is not merely a spiritual change." *In librum de Anima commentarium*, ii.vii, 418 [lect. 14], ed. Pirotta, p. 144; tr. Foster and Humphries, p. 268. For Aquinas the theologian the challenge is to find a way of allowing senses other than sight to function in the glorified body, without any "material change" occurring. Thus in his *quaestiones* on sensation in the glorified body (*In IV Sent.*, dist. xliv, qu. 2, art. 1, quaestiunculae 3 and 4 and solutiones 3 and 4; *Aquinatis opera*, vii.2, 1084, 1086–87), he is seeking substitutes for, or ways to circumvent, any natural immutation which, while normal for our current bodies, is impossible for our renewed ones—with the objective of proving that all the human senses will indeed operate in the homeland.

261. Aquinas, *In librum de Anima commentarium*, ii.7, 416–18 [lect. 14], ed. Pirotta p. 144; tr. Foster and Humphries, p. 268. "From the very nature of the object it would appear that sight is the highest of the senses; with hearing nearest to it, and the others still more remote from its dignity" (417, ed. Pirotta, p. 144; tr. Foster and Humphries, p. 267). Seeing and sound share the medium of air (Moerbeke, 419a–b; ed. Pirotta, p. 146; tr. Foster and Humphries, p. 272).

262. Bonaventure, *In IV Sent.*, dist. xlix, p. 11, sect. 1, art. 3, qu. 1 (*Bonaventurae opera*, iv.1018–19). In respect of hearing, and the issue of vocal praise in the *patria*, Bonaventure believes that disagreement is quite permissible ("hic opinari est licitum").

263. *Trialogus*, iv.44: *de beatorum sensibus tam internis quam externis*, ed. Lechler, pp. 402–4; tr. Levy, p. 318.

264. *In IV Sent.*, dist. xliv, qu. 2, art. 1, solutio 4 (*Aquinatis opera*, vii.2, 1087–88).

265. The argument is that the body will be rewarded or punished on account of the merits or demerits of the soul. Therefore it may be said that the senses in the blessed will be rewarded (with pleasure) and those in the wicked punished (with pain or sorrow).

266. To be more precise, air is the medium for these senses in the case of land-based animals; for water-based animals, the medium is water. See especially *De anima*, ii.7 (419a29–b1) and Aquinas's lectures thereon, along with *De anima*, iii.11, 423a22–424a15; *In librum de Anima commentarium*, ed. Pirotta, pp. 139–49, 182–83; tr. Foster and Humphries, pp. 260–76, 327–29.

267. Cf. *De Anima*, ii.9 (423a22–424a15). "It seems that while smell has an analogy with taste, . . . yet we have a sharper perception of taste, because this is a sort of touch"—touch being "the sense which man possesses to the highest degree of perfection." *In librum de Anima commentarium*, ii.9, 481–86 [lect. 19], ed. Pirotta, pp. 167–68; tr. Foster and Humphries, pp. 300, 303–4. Cf. *In librum de Anima commentarium*, ii.7, 418 [lect. 14], ed. Pirotta, p. 144; tr. Foster and Humphries, p. 267, where tasting is called "a kind of touching." This relationship between taste and touch was disputed by the English schoolman John Blund (d. 1248), in his *Tractatus de anima* (written c. 1200); cf. Woolgar, *Senses in Late Medieval England*, pp. 19–20.

268. In the *quaestio* which we have been following here, on whether, in the blessed, all the senses will be in act; *In IV Sent.*, dist. xliv, qu. 2, art. 1, quaestiuncula 4 and solutio 4 (*Aquinatis opera*, vii.2, 1084, 1087–88).

269. Hildegard of Bingen, *Expositio Evangeliorum*, as discussed by Peter Dronke, "Platonic-Christian Allegories in the Homilies of Hildegard of Bingen," in Haijo J. Westra (ed.), *From

Athens to Chartres: Neoplatonism and Medieval Thought: Studies in Honour of Edouard Jeauneau (Leiden: Brill, 1992), pp. 381–96. For more arguments in support of taste, see Burnett, "The Superiority of Taste," and Carruthers, *Experience of Beauty*, pp. 129–33.

270. *The Mirour of Mans Saluacioun*, ed. Henry, p. 207.

271. Aristotle describes taste as "a sense of the tangible and the nutritive." *De anima*, iii.7.861; Moerbeke's version and Aquinas's commentary, tr. Foster and Humphries, p. 484.

272. While it is true that the resurrected Christ returned to earth to eat with men, his glorified body had no *need* of such sustenance (cf. *In IV Sent.*, dist. xliv, qu. 1, art. 3, quaestiuncula 4 and solutio 4; *Aquinatis opera*, vii.2, 1081–82, 1083). Cf. p. 149 above. In seeking some possible type of activation, Aquinas quotes the opinion of "some" who say that "there will be taste in act through the tongue being affected by some neighboring humor (*humiditas*)"; *In IV Sent.*, dist. xliv, qu. 2, art. 1, solutio 4 (*Aquinatis opera*, vii.2, 1087–88).

273. *In IV Sent.*, dist. xliv, qu. 2, art. 1, solutio 4 (*Aquinatis opera*, vii.2, 1087–88).

274. *Glossa ordinaria marginalis*, in *Biblia glossata*, iv.1585.

275. *Glossa ordinaria interlinearis et marginalis*, in *Biblia glossata*, ii.1400–1401.

276. On scholastic views of allegorical interpretation as subjective and incapable of offering firm proof (as in logical argument) though invaluable in terms of "edification" (building up the faith) and "exhortation" (pious encouragement, as in sermons), see Beryl Smalley, "Use of the 'Spiritual' Sense of Scripture in Persuasion and Argument by Scholars in the Middle Ages," *RTAM*, 52 (1985), 44–63, and Minnis, "Material Swords and Literal Lights".

277. Quodlibet vii, qu. 7, in Henry of Ghent, *Quodlibet VII*, ed. G. A. Wilson (Leuven: Leuven University Press, 1991), pp. 44–47.

278. The acoustic effects enabled by concave surfaces are well explained by Aquinas in his *De anima* commentary. "When sounding bodies strike together the air is moved in a circular motion and the sounds diffused in all directions." The circles thus formed extend larger and larger as they move farther away from the point of impact, the sound thereby diminishing and becoming fainter. However, if before the circles vanish entirely (and particularly when they are quite small) they come up against a resistant surface, "the undulations return on their tracks and a new sound comes in the reverse direction. And this is called 'echo.' " "When the obstacle in question is concave" this effect is "realized most perfectly," because "it acts like a vessel" that prevents the dispersal of the moving air, which, "held together and unable to move further because of the obstacle, is thrown back on the air behind and a reverse movement begins—just as when a ball thrown against an obstacle rebounds." *In librum de Anima commentarium*, ii.8, 448–49 [lect. 19], ed. Pirotta, p. 168; tr. Foster and Humphries, p. 283. The ball metaphor is Aristotle's; cf. *De anima*, ii.8 (419b25–28). If such theory may be related to a concave empyrean heaven, one may think of a massive echo chamber in which heavenly praise resonates magnificently.

279. Cf. Ronald Polansky, *Aristotle's* De anima: *A Critical Commentary* (Cambridge: Cambridge University Press, 2007), p. 291, discussing *De anima*, ii.8 (420a3–19). Sound, explains Aquinas, "is caused by impact and movement in the air (*ex percussione et aëris commotione*)"; *Summa theologiae*, 1a, qu. 78, art. 3, conclusio (xi.130–31).

280. Aristotle, *Historia animalium*, iv.8 (533b4–534a11); cf. Thomas K. Johansen, *The Power of Aristotle's Soul* (Oxford: Oxford University Press, 2012), pp. 175–76.

281. *De anima*, ii.8 (419b9–22, 420a14–21).

282. To risk here an (admittedly partial) modern analogy—one might think of a music box, in which the mobile figurines which chime as they encounter other parts of the structure are made of the same material as the box itself.

283. Aristotle is cited as the authority for this statement, though in fact he had made it only to refute it. *De caelo et mundo*, ii.9 (290b12–291a25).

284. *Visio Tnugdali*, ed. Wagner, p. 45.

285. *Visio Tnugdali*, ed. Wagner, p. 48.

286. *Visio Tnugdali*, ed. Wagner, p. 50.

287. Minnis, "Medieval Imagination and Memory," pp. 245–46. For St. Augustine's highly influential categorization of vision into three types (*corporalis, imaginaria seu spiritualis*, and *intellectualis*), see Augustine, *De Genesi ad litteram*, xii.6,16–7,18 (CSEL 28.1, 386–89; tr. Hill, pp. 470–72).

288. *In IV Sent.*, dist. xliv, qu. 2, art. 1, solutio 4, ad 4um (*Aquinatis opera*, vii.2, 1087).

289. "In civitate domini ibi sonant jugiter organa sanctorum, ibi cinnamomum et balsamum odor suavissimus carmina eorum; ibi angeli et archangeli hymnum Deo decantant ante thronum dei, alleluia." *Corpus antiphonalium officii*, ed. Renate-Joanne Hesbert (Rome: Herder, 1963–79), iii, 270 (Cantus ID: 3210). I am grateful to Margot Fassler for identifying this antiphon as one which Aquinas might, quite plausibly, have had in mind.

290. Susan Ashbrook Harvey, *Scenting Salvation: Ancient Christianity and the Olfactory Imagination* (Berkeley: University of California Press, 2006), p. 227.

291. Cf. Woolgar, *Senses in Medieval England*, pp. 118–19.

292. *The Life of Saint Thomas Aquinas: Biographical Documents*, tr. and ed. with an introduction by Kenelm Foster (London: Longmans, 1959), pp. 85–86. Cf. Ann W. Astell's discussion of Bonaventure's affirmation of the fragrant body of St. Francis, even though he had questioned the presence of smell in the *patria*. "A Discerning Smell: Olfaction Among the Senses in St. Bonaventure's *Long Life of St. Francis*," *Franciscan Studies*, 67 (2009), 125–30 (pp. 126–30). This article brings out well the difficulty of knowing when to read sensory descriptions allegorically/exegetically and when to read them as reliable intimations of conditions in the afterlife.

293. Woolgar, *Senses in Medieval England*, p. 119.

294. For the latter, see Robert Easting's edition of the Middle English translation, *The Revelation of the Monk of Eynsham*, EETS OS 318 (Oxford: Oxford University Press, 2002).

295. Harvey, *Scenting Salvation*, p. 227.

296. Woolgar, *Senses in Medieval England*, p. 15; reiterated by, for example, Constantine the African (d. before 1099), and Bartholomew the Englishman in his *De proprietatibus rerum*. See also R. Palmer, "In Bad Odour: Smell and Its Significance in Medicine from Antiquity to the Seventeenth Century," in Bynum and Porter (eds.), *Medicine and the Five Senses*, pp. 61–68, 285–87 (esp. p. 63, on the theory that smell is material).

297. Plato, *Timaeus*, 66C, tr. Benjamin Jowett, *The Dialogues of Plato*, 3rd ed. (Oxford: Oxford University Press, 1892), iii.488. Cf. Simon Kemp, "A Medieval Controversy About Odor," *Journal of the History of the Behavioral Sciences*, 33 (1997), 211–19 (p. 212), and Palmer, "In Bad Odour," p. 65.

298. *In IV Sent.*, dist. xliv, qu. 2, art. 1, solutio 4, ad 3 (*Aquinatis opera*, vii.2, 1087). In the medieval bestiary tradition, vultures are regularly credited with an exceptional power of smell. For example, according to the treatise in Oxford, Bodleian Library, MS Bodley 764, "vultures . . . can scent corpses from above the sea." *Bestiary, or Book of Beasts: MS Bodley 764*, ed. and tr. Richard Barber (Woodbridge: Boydell Press, 1999), p. 126. In his *De animalibus*, Albert the Great places the emphasis rather on the bird's keen vision; the vulture inhabits "high mountain cliffs," from which locations "it sees its food at a distance . . . because it has keen vision, which sees well from a distance." *De animalibus*, viii, tract. 2, 6 (103), ed. Stadler, i.614; tr. Kitchell

and Resnick, i.713. High-flying vultures' powers of observation are also emphasized in the bestiaries: "They fly very high and can see much that is concealed in the darkness of the mountains." *Bestiary: MS Bodley 764*, ed. Barber, p. 126.

299. Cf. Aquinas's remarks in his *De anima* commentary: "When vultures smell carrion at a distance of fifty miles of more, this cannot be due to any bodily evaporation from the carrion being diffused over to great a space. . . . There would not be enough of the object to occupy so much space, even if the whole corpse were to evaporate." *In librum de Anima commentarium*, ii.9, 494, ed. Pirotta, p. 170; tr. Foster and Humphries, p. 309. Aristotle believed that smell was transmitted through a medium (which has no name, but which must exist in both air and water, since different creatures evidently possess this sense). In his commentary on *De anima*, Avicenna disagreed, and offered two possibilities for the behavior of certain birds. First, the vapors released by corpses could be carried long distances by winds, enabling birds to perceive them. Second, the birds in question may have sharp eyesight, "and because vultures fly so high, over the highest mountains, we know from geometry that this would enable them to see further." So, they may see the corpses from afar rather than smell them. Albert the Great quotes those two theories, while seeking to defend Aristotle's medium theory. Kemp, "Medieval Controversy About Odor," pp. 212–13, 214–15.

300. *In IV Sent.*, dist. xliv, qu. 2, art. 1, solutio 3 (*Aquinatis opera*, vii.2, 1086). Cf. Aristotle, *Ethics*, i.13 (1102b4–9), the original Greek being garbled.

301. See p. 159 above.

302. *In IV Sent.*, dist. xliv, qu. 2, art. 1, solutio 3 (*Aquinatis opera*, vii.2, 1086).

303. *In IV Sent.*, dist. xlviii, art. 2, qu. 5 (iv.642).

304. *De civitate Dei*, xxii. 29 (CSEL 40.2, 663; tr. Dyson, p. 1177).

305. *IV Sent.*, dist. xlix, 4 (283), 1–3 (*Lib. sent.*, ii.552–53; tr. Silano, iv.270). Cf. *IV Sent.*, dist. xlv, 1 (259), 1–2 (*Lib. sent.*, ii.523; tr. Silano, iv.244).

306. *In IV Sent.*, dist. xlix, qu. 1, art. 4, solutio 1 (*Aquinatis opera*, vii.2, 1194–95).

307. Cf. *Summa contra gentiles*, iv.79 [11]: "Every imperfect thing naturally desires to achieve its perfection. But the soul separated from the body is in a way imperfect, as is every part existing outside of its whole, for the soul is naturally a part of human nature, Therefore, man cannot achieve his ultimate happiness unless the soul be once again united to the body" (*Aquinatis opera*, v.370; tr. O'Neil, iv.299).

308. *Summa theologiae*, 1a 2ae, qu. 4, art. 5, ad 5um (xvi.106–7). A succinct discussion is provided in Albert the Great's *Sentences* commentary. Happiness will then be more "extensive," but it would not be more "intensive" except insofar as the *quietatio* of natural desire means that more intense contemplation of God is possible. *In IV Sent.*, dist. xlix, E, art. 11 (*Alberti opera*, xxx.684).

309. *Summa theologiae*, 1a 2ae, qu. 4, art. 5, resp. (xvi.102–3).

310. *Summa theologiae*, 1a 2ae, qu. 4, art. 6, resp. (xvi.108–9). As already noted, this view was attributed to Porphyry by Augustine, *De civitate Dei*, xxii.26 (CSEL 40.2, 651–53; tr. Dyson, pp. 1167–69).

311. *Summa theologiae*, 1a 2ae, qu. 4, art. 5, resp. (xvi.102–3).

312. *Summa theologiae*, 1a 2ae, qu. 4, art. 6, resp. (xvi.108–9). Cf. Augustine, *De Genesi ad litteram*, xii.35,68 (CSEL 28.1, 432; tr. Hill, pp. 504–5).

313. *Summa theologiae*, 1a 2ae, qu. 4, art. 6, resp. (xvi.108–9).

314. *Summa theologiae*, 1a 2ae, 3, art. 8, resp. (xvi.84–85).

315. *Summa theologiae*, xvi.108.

316. *Summa theologiae*, 1a 2ae, qu. 4, art. 6, obj. 3 and ad 3um (xvi.106–9).

317. *Summa theologiae*, 1a 2ae, qu. 4, art. 6, resp. (xvi.108–9); cf. Augustine, *Epist.* cxviii, 3, *ad Dioscurum*; *PL* 44, 439.

318. *In IV Sent.*, dist. xlix, P.1, art. unicus, qu. 2 (*Bonaventurae opera*, iv.1004–6). Cf. Bynum, *Resurrection*, pp. 252–53.

319. *Breviloquium*, vii.7.4, in *Tria opuscula*, pp. 279–80. Here Bonaventure is recalling Psalm 132, which affirms "how pleasant it is for brethren to dwell together in unity"; "Like the precious ointment on the head, that ran down upon the beard, the beard of Aaron, Which ran down to the skirt of his garment" (1–2).

320. *Paradiso*, ed. and tr. Singleton, p. 154; here I follow the translation by Mark Musa, *The Divine Comedy*, vol. 3: *Paradise* (Harmondsworth: Penguin Books, 1986), p. 169.

321. *Paradiso*, ed. and tr. Singleton, p. 157.

322. *Summa contra gentiles*, iv.79 [11] (*Aquinatis opera*, v.370). Cf. Aquinas, *In IV Sent.*, dist. xliii, qu. 1, art. 1, sol. 2 (*Aquinatis opera*, vii.2, 1059).

323. *In IV Sent.*, dist. xliii, art. 1, qu. 1, 4 (*Bonaventurae opera*, iv.883).

324. *Quaestiones Aegidii de resurrectione mortuorum et de poena damnatorum*, ed. Nolan, pp. 69–75 (p. 71).

325. See Bynum, *Resurrection*, pp. 283–88.

326. For discussion of this passage, see Gragnolati, *Experiencing the Afterlife*, pp. 155–61; Leonardi, "Le bianche stole"; and Paola Nasti, "*Caritas* and Ecclesiology in Dante's Heaven of the Sun," in Montemaggi and Treherne (eds.), *Dante's* Commedia: *Theology as Poetry*, pp. 210–44. Gragnolati's comment may be taken as representative: "Dante, like Aquinas, removes any impediment from the separated souls' enjoyment of beatific vision and stresses its perfection and fullness even before the Resurrection; however, he also indicates poignantly that the separated souls still desire their body, and that bodily return entails an increase of happiness both in intensity and extension" (p. 161). Which prompts the question: how can the soul be completely happy in heaven yet somehow happier after the Resurrection? Thus these contemporary scholars are, in effect, emulating the late medieval theologians in their struggle to reconcile belief in the total happiness of the blessed disembodied soul with the impulse to reserve something even better for the *patria*, when that soul will be re-embodied (the very issue which Benedict XII's *Benedictus Deus* sought to settle). Gragnolati enters a particularly difficult area with the remark, "no matter how bright and luminous the blessed soul may be, only at the end of time will it stop being an incomplete fragment, because only then will it finally be reunited with its real body in the fleshly, tangible, embraceable perfection of the whole person" (p. 161). The schoolmen I have studied would, I suspect, have found the notion of the soul as an "incomplete fragment" quite troubling. In like wise, Leonardi suggests that the resurrected body itself will glow brightly in a way which surpasses the glory which radiates from the disembodied soul (pp. 260–64, 270), and Nasti claims that it "will actually add light to light and love to love" (p. 233). In my view, this manner of speaking allows too much agency to the body by overrating what it can do as an autonomous unit, and moves too far away from the schoolmen's ideas of *redundantia* (overflow from soul to body) and *comparticipatio* (co-participation of soul and body). Much hangs on the interpretation of *Paradiso*, XIV, 55–57. Either: the future *folgór* of the resurrection body will surpass the glory presently emanating from the separated soul in heaven, these sources of glory being taken as distinctive, and even in competition with each other—a suggestion which would have shocked Aquinas and Bonaventure. Or: the post-resurrection composite of body and soul will shine more brightly than the heaven-based separated soul can possibly do. In other words, when soul and body reunite and the Supreme Good increases His gracious gift of light (cf. ll. 46–48), the body will glow

more brightly, inasmuch as it manifests this increase in intensity—an increase which is enjoyed by the composite of body and soul and is only possible after their post-resurrection reunification. (Here I am in agreement with Gragnolati's relevant remarks in *Experiencing the Afterlife*, p. 156, but not with those on p. 158, which take a different turn.) That is to say, this body is expressing enhanced *claritas* on behalf of the full and integrated person; *that* is the object perceived by the (greatly strengthened) eyesight of the blessed. This latter reading—which, I believe, is more consonant with the thought of Dante's favored theologians—is the one I offer here.

327. Here I draw on the discourse of Thomas's *quaestio*, "Whether Paul when 'rapt to heaven' [*in raptu*] saw God's essence?"; *Summa theologiae*, 2a 2ae, qu. 175, art. 3 (xlv.102–7). Richard of Middleton argues that it is impossible by any human power whatsoever for a soul to remain in the state of full beatitude, without death intervening. However, by God's "absolute power" a soul may indeed be transferred from this mortal life to enjoy clear vision of God—but this would not a "congruent," suitable, thing to do, since it was not done in the case of the Virgin Mary. *In IV Sent.*, dist. xlix, art. 2, qu. 6, 6 (iv.661).

328. *Summa theologiae*, 1a 2ae, qu. 4, art. 5, "does our body come into (*requiratur*) our happiness?" (xvi.100–7, esp. pp. 100–103).

329. *Summa theologiae*, 1a, qu. 12, art. 3, resp. (iii.10–11).

330. Aquinas, *Quaestiones disputatae de veritate*, qu. 19, art. 1, responsio; ed. Spiazzi, i.359, tr. McGlynn, ii.390. Cf. *Summa theologiae*, 1a, qu. 12, art. 3, resp. (iii.10–11): "It is impossible to see God by any power of sight or by any other sense or sensitive power."

331. *Summa theologiae*, 1a, qu. 94, art. 3 (xiii.98–99); cf. pp. 57–58.

332. Aquinas, *Quaestiones disputatae de veritate*, qu. 19, art. 1; ed. Spiazzi, i.359, tr. McGlynn, ii.391.

333. *De Anima*, iii.4 (429a27).

334. *Summa theologiae*, 1a, qu. 89. art. 5, resp. (xii.152–53).

335. Turner, *Thomas Aquinas: A Portrait* (New Haven, Conn.: Yale University Press, 2013), pp. 79–80.

336. *Summa theologiae*, 1a, qu. 89, art. 8, resp. (xii.160–63). See further John Wippel, "Thomas Aquinas on the Separated Soul's Natural Knowledge," in James McEvoy and Michael Dunne (eds.), *Aquinas: Approaches to Truth* (Dublin: Four Courts Press, 2002), pp. 114–40.

337. Aquinas's own discussion is at *Summa theologiae*, 1a, qu. 89, art. 6 (xii.154–59). One complication: as a divine kindness a saint's memory of his sins may be obliterated, or at least removed of the power to hurt—this issue was raised by Peter Lombard, and the subject of some debate. See *IV Sent.*, dist. xliii, 5 (248), 1–4 (*Lib. sent.*, ii.513–14; tr. Silano, iv.236–37). Similar doctrine may be found in the *Prick*, ll. 8294–373.

338. Bonaventure, *In IV Sent.*, dist. xlix, P. 2, sect. 1, art. 3, qu. 2 (*Bonaventurae opera*, iv.1020–21).

339. This discussion was related to another, about whether, in addition to his divine knowledge, Christ possessed human knowledge. Which was generally answered in the affirmative, as when Aquinas, having remarked that Christ's human intellect would be frustrated if it were not allowed its proper operation, goes on to conclude that some human knowledge was demanded not only by the perfection of Christ's human nature but also by the integrity thereof. See William J. Forster, *The Beatific Knowledge of Christ in the Theology of the Twelfth and Thirteenth Centuries* (Rome: Officium Libri Catholici, 1958), pp. 96–97.

340. Cf. pp. 59–63.

341. For a fascinating attempt to depict the Beatific Vision, see Lucy Freeman Sandler, "Face to Face with God: A Pictorial Image of the Beatific Vision," in W. Mark Ormrod (ed.), *England in the Fourteenth Century: Proceedings of the 1985 Harlaxton Symposium* (Woodbridge: Boydell Press, 1986), pp. 224–35.

342. Oresme, *Le livre du ciel et du monde*, ed. Albert D. Menut and Alexander J. Denomy (Madison: University of Wisconsin Press, 1968), pp. 726–27.

343. Oresme, *Livre du ciel et du monde*, ed. Menut and Denomy, pp. 728–29.

344. Oresme, *Livre du ciel et du monde*, ed. Menut and Denomy, pp. 728–31.

345. Oresme, *Livre du ciel et du monde*, ed. Menut and Denomy, pp. 730–31.

346. *Paradiso*, ed. and tr. Singleton, pp. 370–71, 378–79. On Dante's use of the rainbow image, see Patrick Boyde, *Dante, Philomythes and Philosopher: Man in the Cosmos* (Cambridge: Cambridge University Press, 1981), pp. 76, 318–19.

347. But it is obvious that Oresme sees his rainbow speculation as a fitting end to a work (his own treatise!) of which he holds a very high opinion: "I venture to say and feel quite certain that no mortal man has ever seen a finer or better book of natural philosophy in Hebrew, in Greek or Arabic, in Latin or French than this one." Oresme, *Livre du ciel et du monde*, ed. Menut and Denomy, p. 731.

348. Oresme, *Livre du ciel et du monde*, ed. Menut and Denomy, pp. 724–25.

349. Augustine, *De civitate Dei*, xxii.29 (CSEL 40.2, 660; tr. Dyson, pp. 1174–75). Augustine goes on to offer a more secure argument, that, whatever the truth of this may be, God will be seen with the "eyes of the heart" (p. 1175).

350. Augustine, *De civitate Dei*, xxii.29 (CSEL 40.2, 656; tr. Dyson, p. 1171). Aquinas says that here Augustine "is merely making a suggestion and not committing himself to a definite position." *Summa theologiae*, 1a, qu. 12, art. 4, ad 2um (iii.12–13).

351. *De civitate Dei*, xxii.24 (CSEL 40.2, 649; tr. Dyson, p. 1165).

352. Augustine, *Enchiridion*, xxiii, 84, ed. Scheel, 53–54.

353. *The Lay Folks Mass Book*, ed. T. F. Simmons, EETS 71 (London: Trübner & Co., 1879), p. 239.

354. *IV Sent.*, dist. xliii, 1 (244), 1–2 (*Lib. sent.*, ii.510; tr. Silano, iv.233).

355. *IV Sent.*, dist. xliv, 4 (254) (*Lib. sent.*, ii.519; tr. Silano, iv.241).

356. *Enchiridion*, xxii, 92 (ed. Scheel, 57). In his *Sentences* commentary, noting Augustine's hesitation, Aquinas says that "modern masters" disagree on this subject, some holding that deformities and defects will indeed remain in the bodies of the damned (as a contributory factor in their unhappiness), while others (including himself) prefer the opinion that any deformity caused by disease or violence will be repaired, while those limitations which are now part of the body's nature, such as heaviness and passability, will remain in the bodies of the damned, while they will be removed from the bodies of the blessed. In other words, the bodies of the damned will not enjoy the gifts of *agilitas, impassibilitas,* and so forth, in the perfect way in which the bodies of the blessed will. *In IV Sent.*, dist. xliv, qu. 3, art. 1, quaestiunc. 1, solutio (*Aquinatis opera*, vii.2, 1100–1101). See further Mowbray, *Pain and Suffering*, pp. 144–49, who describes how Bonaventure (in contrast with both Albert the Great and Aquinas) believed that "the bodies of the damned will not possess beauty, and any deformities which they possessed in life will remain with them" (p. 147).

357. *IV Sent.*, dist. xliii, 5 (248), 4 (*Lib. sent.*, ii.514; tr. Silano, iv.236).

358. Albert the Great, *In IV Sent.*, dist. xliv, C, art. 29, resp. (xxx.582); also *In IV Sent.*, dist. xlviii, E, art. 7, solutio (xxx.662).

359. *In IV Sent.*, dist. xlviii, qu. 2, art. 3, ad 4um (*Aquinatis opera*, vii.2, 1177).

360. *IV Sent.*, dist. xlviii, 5 (279), 7 (*Lib. sent.*, ii.547; tr. Silano, ii.265).

361. *In IV Sent.*, dist. xlviii, art. 2, qu. 5 (iv.642). Following this major increase in *claritas*, Richard asks, will some heavenly bodies impress light upon others? This is an uncertain matter, he concludes, but if that circumstance were supposed it would by no means be an inappropriate thought (*nullum est inconveniens*)—the idiom of what is *conveniens* appearing yet again.

362. Wyclif, *Trialogus*, iv.44, ed. Lechler, pp. 403–4; tr. Levy, p. 319.

363. Phronesis continues: "Here we proceed from imperfect knowledge to the perfect, with only slight pleasure, if any, in our souls as a result, but there our knowledge will flow from the congress of our more perfect powers to each imperfect power, and will complete the imperfection of the imperfect power in an act of beatitude, and will find quietus in the superior acts, and from both there will be a consummate delight" (tr. Levy, p. 319).

364. *Paradiso*, ed. and tr. Singleton, p. 16.

365. Tr. Musa, *The Divine Comedy*, vol. 3: *Paradise*, p. 19. Cf. Augustine, *De civitate dei*, xxii.24: "How complete, how splendid, how assured will its [the blessed soul's] knowledge of all things be: a knowledge acquired without any error or toil, by drinking God's wisdom at its very source, with supreme happiness and without any hindrance!" (CSEL 40.2, 649; tr. Dyson, p. 1165).

CODA

1. From "One Foot in Eden," in Edwin Muir, *Collected Poems* (New York: Oxford University Press, 1965), p. 227. The poem takes a different turn when Muir goes on to affirm that "flowers in Eden never known," "Blossoms of grief and charity" bloom in the "darkened fields" of our present life.

2. Bonaventure, *In II Sent.*, dist. xvii, dubium 4 (*Bonaventurae opera*, ii.428).

3. *Confessions*, X.xxxv.54–55, tr. Henry Chadwick (Oxford: Oxford University Press, 1991), pp. 211–12.

4. See Peter Harrison, *The Fall of Man and the Foundations of Science* (Cambridge: Cambridge University Press, 2007), p. 36. The seductions of curious knowledge were attacked not only in texts but also in images, as is brought out well by Katherine H. Tachau, "God's Compass and *Vana Curiositas*: Scientific Study in the Old French *Bible moralisée*," *Art Bulletin*, 80 (1998), 7–33.

5. *II Sent.*, dist. xix, 1 (110), 1 (*Lib. sent.*, i.2, 421; tr. Silano, ii.81).

6. Bonaventure, *In II Sent.*, dist. xx, articulus unicus, qu. 4, conclusio (*Bonaventurae opera*, ii.482–83). Cf. *De civitate Dei*, xiv.26 (CSEL 40.2, 54; tr. Dyson, p. 629).

7. Bonaventure, *In II Sent.*, dist. xx, articulus unicus, qu. 4, sed contra (*Bonaventurae opera*, ii.482). Cf. the discussion in the Introduction.

8. *Trialogus*, iv.40, ed. Lechler, pp. 390–91; tr. Levy, p. 308. These words are spoken by Phronesis.

9. As defined in Wyclif's prologue to the *Trialogus*, ed. Lechler, p. 38; tr. Levy, p. 38.

10. *Trialogus*, iv.41, ed. Lechler, p. 395; tr. Levy, p. 312.

11. *Summa theologiae*, 1a, qu. 99, art. 1, resp. (xiii.162–63). In an adjacent *quaestio* Aquinas shows the other side of the coin: "The only reason we can have for believing anything that goes beyond nature is authority; so where authority is wanting, we should shape our opinions to the pattern of nature." *Summa theologiae*, 1a, qu. 101, art. 1, resp. (xiii.176–77).

12. Cf. p. 218.

13. *Summa contra gentiles*, iv.86[4] (*Aquinatis opera*, v.378; tr. O'Neil. iv.326).

14. Cf. Sir David Lindsay's statement that "in all thare wyttis fyne/ Thay sall haue sensuall plesouris delectabyll" (*The Monarche*, 6129–30). He goes on to specify "the sycht of Crist Iesus, our Kyng" (6132) and of "the heuinlye brycht colowris/ Schenyng amang those Creaturis Diuyne" (6159–60). A "heuinlye sound . . . In thare eris continuallye sall ryng" (6131–32); the blessed will also experience a smell which exceeds the best of flowers, and a taste in the mouth of "sweit and Supernaturall Sapowris" (6155–56).

15. *In IV Sent.*, dist. xliv, C, art. 28, quaestio ulterius (*Alberti opera*, xxx.581).

16. Thomas Gallus, *Extraction of The Celestial Hierarchy*, xv, tr. in Minnis and Scott (eds.), *Medieval Literary Theory*, p. 185.

17. Tr. in Minnis and Scott (eds.), *Medieval Literary Theory*, pp. 185, 186. Likewise, Grosseteste describes the heart as "a symbol of the godlike life" of the angels, "which generously disseminates its own vital power to things under their providence" (p. 185, n. 75).

18. Tr. in Minnis and Scott (eds.), *Medieval Literary Theory*, p. 185.

19. *Paradiso*, X, 115–17, ed. and tr. Singleton, p. 115.

20. *Letter 5: To Dorotheus, the Deacon*, in *Pseudo-Dionysius: The Complete Works*, tr. Colm Luibheid with Paul Rorem (New York: Paulist Press, 1987), p. 265.

21. Ibid. Cf. Hergan, *St. Albert the Great's Theory of the Beatific Vision*, p. 3 and n.5.

22. Denifle and Chatelain (eds.), *Chartularium universitatis Parisiensis*, i.170–72 (no. 128).

23. Hergan, *Albert the Great's Theory of the Beatific Vision*, p. 149.

24. Such passages are presented as further "contrary" opinions in Albert's *quaestio de visione Dei in patria*; cf. Hergan, *Albert the Great's Theory of the Beatific Vision*, pp. 2–3.

25. Cf. Bonaventure's statement at *In II Sent.*, dist. xxiii, art. 2, qu. 3, ad 7um (ii.546–47), where Alexander is given the accolade of "our father and master." See Hergan, *Albert the Great's Theory of the Beatific Vision*, pp. 4–6. There was no ambiguity whatever in the case of William of Auxerre, who in his *Summa aurea* (written between 1215 and 1229) attacked certain "stupid people" (*stulti*) who "believed and preached that the souls of the elect will not enter the heavenly paradise until Judgment Day." Book IV, tr. xviii, cap. iv, qu. 1, art. 4, solutio, in *Summa aurea, Liber quartus*, ed. Jean Ribaillier (Paris: Éditions du Centre national de la recherche scientifique; Rome: Editiones Collegii S. Bonaventurae ad Claras Aquas, 1985), p. 549.

26. Giles of Rome, *Errores philosophorum*, ed. and tr. Koch and Riedl, pp. 12–13, cf. 6–7, 8–9.

27. *Errores philosophorum*, ed. and tr. Koch and Riedl, pp. 32–33.

28. *Errores philosophorum*, ed. and tr. Koch and Riedl, pp. 50–51.

29. *IV Sent.*, dist. xlix, 4 (283), 1–3 (*Lib. sent.*, ii.552–53; tr. Silano, iv.270). Cf. *IV Sent.*, dist. xlv, 1 (259), 1–2 (*Lib. sent.*, ii.523; tr. Silano, iv.244). In his commentary on I Corinthians 15:17–19, Aquinas makes the powerful statement, "when the soul is part of the human body it is not the whole man, and my soul is not I (*anima mea non est ego*); consequently, were the soul to survive into another life, it would neither be I nor any other man." Here, arguably, St. Thomas opens himself up to the objection that he is denying full personhood, and hence complete joy, to the disembodied soul. *Super I Epistolam B. Pauli ad Corinthios lectura*, cap. 15, lect. 2; consulted in the edition on the *Corpus Thomisticum* website, http://www.corpusthomisticum.org/c1v.html. Admittedly, this statement is recorded only in the *reportatio* of an anonymous student, and elsewhere Aquinas affirms the soul's preeminence, as when he says that "when the soul goes, what is left is called animal or man only in a derived (*aequivoce*) sense, the way a painted or sculpted animal is" *Summa theologiae*, 1a, qu. 76, art. 8, resp. (11.84–85).

However, it may be seen as generally reflective of Aquinas's mature theology, as is argued by Turner, *Thomas Aquinas: A Portrait*, esp. pp. 56–57, 74–78. See further n. 43 below.

30. To the relevant discussions quoted in the previous chapter may be added the testimony of Godfrey of Fontaines (*magister regens* at the University of Paris in the final quarter of the thirteenth century), who argued that "the separated soul does not enjoy its full natural perfection in its state of separation"; therefore "he does not hesitate to deny to the separated soul personality in the full and proper sense." John F. Wippel, *The Metaphysical Thought of Godfrey of Fontaines* (Washington, D.C.: Catholic University of America Press, 1981), pp. 246–47.

31. Tr. in J. Neuner and J. Dupuis (eds.), *The Christian Faith in the Doctrinal Documents of the Catholic Church*, rev. 4th ed. (New York: Alba House, 1982), pp. 684–85.

32. Neuner and Dupuis (eds.), *The Christian Faith*, p. 685.

33. See M. E. Marcett, *Uthred de Boldon, Friar William Jordan and "Piers Plowman"* (New York: privately printed, 1938); M. David Knowles, "The Censured Opinions of Uthred of Boldon," *Proceedings of the British Academy*, 37 (1951), 306–42; and Kathryn Kerby-Fulton, *Books Under Suspicion: Censorship and Tolerance of Revelatory Writing in Late Medieval England* (Notre Dame, Ind.: University of Notre Dame Press, 2006), pp. 98, 358–94.

34. Peter Marshall, "The Map of God's Word: Geographies of the Afterlife in Tudor and Early Stuart England," in Bruce Gordon and Peter Marshall (eds.), *The Place of the Dead: Death and Remembrance in Late Medieval and Early Modern Europe* (Cambridge: Cambridge University Press, 2000), pp. 110–30 (p. 116). For further discussion of the doctrine, see Norman T. Burns, *Christian Mortalism from Tyndale to Milton* (Cambridge, Mass.: Harvard University Press, 1972); Nicholas Constas, "'To Sleep, Perchance to Dream': The Middle State of Souls in Patristic and Byzantine Literature," *Dumbarton Oaks Papers*, 55 (2001), 91–124; and Bryan W. Ball, *The Soul Sleepers: Christian Mortalism from Wycliffe to Priestley* (Cambridge: James Clarke & Co., 2008).

35. *Das fließende Licht der Gottheit*, iv.23, ed. Neumann, i.139–40; tr. Tobin, pp. 167–68. Cf. Jacobus de Voragine (Iacopo da Varazze), *Legenda aurea: vulgo historia lombardica dicta*, ed. T. Graesse (Dresden: Impensis Librariae Arnoldianae, 1846), pp. 56–62, and the discussion in Bynum, *Resurrection*, pp. 10, 313, 338–39.

36. Cf. Neumann's emendation, following the Latin version of this work, the *Lux divinitatis*. *Das fließende Licht der Gottheit*, ed. Neumann, ii.79, note to *Das fließende Licht*, iv.23,3.

37. Here, as Tobin notes, Mechthild seems to be using the phrase "creation (*schoepfnisse*) of the eternal kingdom" to "denote heaven as a place or space with a clear but thin border between it and what is beneath it." Tr. Tobin, pp. 274–75 and p. 355, n. 41.

38. *Das fließende Licht der Gottheit*, iii.1, ed. Neumann, i.77; tr. Tobin, p. 105.

39. *Das fließende Licht der Gottheit*, ii.3, ed. Neumann, p. 40; tr. Tobin, p. 71.

40. I.e., as long as the earth exists in its present form.

41. *Paradiso*, ed. and tr. Singleton, pp. 154–57, with the translation by Musa, *The Divine Comedy*, vol. 3: *Paradise*, p. 169.

42. *Resurrection*, p. 11.

43. Bynum is, of course, acutely aware of this problem. For example, in considering Bonaventure's "ambivalent" and "inconsistent" treatment of the desire which body and soul feel for union, she finds definite constraints and "limits of what was possible, at least to a scholastic theologian, in positive conceptions of body" (*Resurrection*, p. 248). Later she remarks that "Aquinas is ambivalent about body itself" (p. 266; cf. p. 268). See also her important comments on pp. 272–78, 279. Furthermore, we must frankly admit the extent to which modern scholars can disagree in interpreting the relevant views of even a schoolman as extensively studied as

Aquinas. Robert Pasnau and Antonia Fitzpatrick think that, according to St. Thomas, the disembodied soul alone cannot accurately be considered an individual human being; see Pasnau, *Thomas Aquinas on Human Nature* (Cambridge: Cambridge University Press, 2002), pp. 387–88, 393, and Fitzpatrick, "Bodily Identity in Scholastic Theology," pp. 282–83. In sharp contrast, the following scholars offer versions of the argument that, for Aquinas, a human being can exist composed of only his separated soul: Eleonore Stump, "Resurrection, Reassembly and Reconstitution: Aquinas on the Soul," in Bruno Niederbacher and Edmund Runggaldier (eds.), *Die menschliche Seele: Brauchen wir den Dualismus?* (Frankfurt: Ontos-Verlag, 2006), pp. 151–71 (esp. pp. 157–60, 168–69); Jason T. Eberl, "Aquinas on the Nature of Human Beings," *Review of Metaphysics*, 58 (2004), 333–65 (esp. pp. 337–38); and Christopher M. Brown, *Aquinas and the Ship of Theseus: Solving Puzzles About Material Objects* (London: Continuum, 2005), pp. 113–43 (esp. pp. 119–21).

 44. *Resurrection*, p. 11, n. 17. Bynum speaks of the emergence of "what was, from one point of view, an eclipsing of body by soul but was, from another, the emergence of an eschatology in which body and soul truly became the person" (p. 247). It is quite possible to sympathize with the latter viewpoint while admitting the frequency, and the force, with which body was eclipsed by soul in scholastic theology and penitential practice.

 45. Bynum, *Resurrection*, p. 225.

 46. McDannell and Lang, *Heaven: A History*, p. 50.

 47. *Revelaciones*, V, prologus, ed. Bergh, pp. 87–88; tr. Kezel, p. 101.

 48. Here I borrow a phrase from W. B. Yeats's poem "Among School Children"; *The Collected Poems of W. B. Yeats*, rev. 2nd ed. by Richard J. Finneran (New York: Simon & Schuster, 1996), p. 217.

 49. *Revelaciones*, V, int. 1, ed. Bergh, p. 99; tr. Kezel, p. 102.

 50. *Revelaciones*, V, int. 1, ed. Bergh, pp. 99–100; tr. Kezel, p. 102–3.

 51. *Revelaciones*, V, int. 2, ed. Bergh, pp. 100–1; tr. Kezel, p. 103.

 52. *Revelaciones*, V, int. 3, ed. Bergh, pp. 101–2; tr. Kezel, p. 104.

 53. *Revelaciones*, V, int. 3, ed. Bergh, p. 102; tr. Kezel, p. 104.

 54. *Revelaciones*, V, int. 3, ed. Bergh, pp. 101–2; tr. Kezel, p. 104.

 55. *Revelaciones*, V, int. 7, ed. Bergh, pp. 110–11; tr. Kezel, pp. 110–11.

 56. *Revelaciones*, V, int. 4, ed. Bergh, p. 104; tr. Kezel, p. 105.

 57. *Revelaciones*, V, int. 7, ed. Bergh, pp. 110–11; tr. Kezel, p. 110.

 58. *Revelaciones*, V, int. 15, ed. Bergh, p. 159; tr. Kezel, p. 145.

 59. *Revelaciones*, V, int. 15, ed. Bergh, p. 157; tr. Kezel, pp. 143–44.

 60. *Revelaciones*, V, int. 15, ed. Bergh, p. 157; tr. Kezel, p. 144.

 61. *Revelaciones*, V, int. 9, ed. Bergh, p. 121; tr. Kezel, p. 118.

 62. *Revelaciones*, V, int. 8, ed. Bergh, pp. 114–15; tr. Kezel, p. 113.

 63. *Das fließende Licht der Gottheit*, iv.12, ed. Neumann, i.123; tr. Tobin, p. 152.

 64. *Das fließende Licht der Gottheit*, iv.12, ed. Neumann, i.124; tr. Tobin, p. 153.

 65. Bynum, *Resurrection*, p. 337.

 66. Presumably Mechthild has in mind the idea of redemptive pain, which is discussed in Mowbray's chapter on "Pain as a restorative power"; *Pain and Suffering*, pp. 61–80. See further the cogent treatment of "productive pain" in Gragnolati, *Experiencing the Afterlife*, pp. 89–137. Esther Cohen has written provocatively about what she calls the "philopassianism" of the later Middle Ages, whereby pain, far from avoided, is actually sought as an avenue to knowledge ("Knowledge of the body, of the soul, of truth, of reality, and of God"). See her article

"Towards a History of European Physical Sensibility: Pain in the Later Middle Ages," *Science in Context*, 8 (1995), 47–74.

67. Here we return to issues discussed in Chapter 1.

68. I have drawn particularly on Aquinas, *Summa theologiae*, 1a, qu. 91, art. 1 (xiii. 16–21), and Bonaventure, *In II Sent.*, dist. xix, art. 1, qu. 2 (*Bonaventurae opera*, ii.461–64).

69. *Summa theologiae*, 1a, qu. 91, art. 1, resp. (xiii.18–19).

70. *Summa theologiae*, 1a, qu. 91, art. 1, ad 4 (xiii.20–21).

71. *Summa theologiae*, 1a, qu. 75, art. 6, 1, and ad 1 (xi.26–27, 30–31).

72. See further Giles of Rome's use of this same *auctoritas* in the course of what Kieran Nolan describes as a "tirade" against those philosophers who do not distinguish between the death of man and the death of animals, well summarized by Nolan, *Immortality*, pp. 34–40 (pp. 37, 39); cf. *In II Sent.*, dist. xix, qu. 2, art. 1 (ii.131A–B).

73. *In II Sent.*, dist. xix, art. 1, qu. 2, 1, and ad 1um (*Bonaventurae opera*, ii.461, 463).

74. *De statu innocencie*, viii, ed. Loserth and Matthew, p. 512.

75. *In II Sent.*, dist. xx, articulus unicus, qu. 5, ad 2um (*Bonaventurae opera*, ii.484).

76. Peter Biller has noted that, in the decade beginning in 1249, *Sentences* commentators came to treat formally the issues of whether the precept of marriage, which appertained in Eden, remained in force in the fallen world, and whether virginity is licit or preferable to marriage. *The Measure of Multitude*, pp. 119–29. A solution was found in the principle of "diversification of tasks in the multitude." Not everyone had to carry out a task which was for the common good. I find the relativism implicit in these discussions quite fascinating. "Whether marriage or virginity is higher depends on the condition of the time" (p. 120; here Biller is discussing Aquinas).

77. *In II Sent.*, dist. xx, dubium 3 (*Bonaventurae opera*, ii.488).

78. *Summa theologiae*, 1a, qu. 98, art. 3, ad 3um (xiii.159). But see also *Summa theologiae*, 1a, qu. 95, art. 3 (xiii.112–19), where Aquinas argues that, in a manner of speaking, "in one way or another man had all the virtues in the state of innocence" (p. 115).

79. *In II Sent.*, dist. xix, art. 2, qu. 1, ad 4 (*Bonaventurae opera*, i.466).

80. John Calvin, *Institutes of the Christian Religion*, iii.25.10; tr. Henry Beveridge (Edinburgh: Calvin Translation Society, 1845–46), ii.627.

81. Calvin, *Institutes*, iii.25.11; tr. Beveridge, ii.628.

82. Calvin, *Institutes*, iii.25.11; tr. Beveridge, ii.629.

83. Rimbertinus, *Tractatus de glorificatione sensuum in paradiso* (Venice, 1498), unfol. Cf. Baxandall, *Painting and Experience in Fifteenth Century Italy*, p. 104. An earlier elaboration of Aquinas's views, the treatise *De sensibilibus deliciis paradisi*, which was produced by John of Dambach, O.P. (d. 1372), in 1350 and dedicated to Pope Clement VI, is unfortunately not yet edited; cf. the comments by Santi, "*Utrum plantae et bruta animalia et corpora mineralia remaneant post finem mundi*," pp. 262–63, and Francesco Santi, "Un nome di persona al corpo e la massa dei corpi gloriosi," in *Micrologus. Natura, scienze e società medievali (Nature, Sciences and Medieval Societies)*, Rivista della Società Internazionale per lo Studio del Medio Evo Latino, 1 (Turnhout: Brepols, 1993), pp. 273–300 (pp. 291–99).

84. *Delitiosa explicatio de sensibilibus deliciis paradisi* (Verona: Lucas Antonibus Florentinus, 1504), unpag.

85. McDannell and Lang, *Heaven: A History*, pp. 134–36. Their lively discussion of "The Pleasures of Renaissance Paradise" is compromised by the occasional false distinction between late medieval and Renaissance thought, and insufficient differentiation between the practical needs of artistic representation and the rigorous abstractions of theologians. For example: "the

medieval saints" may indeed "have sat in rigid immobility" in certain paintings of the period, as McDannell and Lang claim, but schoolmen and visionaries celebrated their wonderful *agilitas* (as described in Chapter 3). There is nothing innovative about the appearance of that concept in Girolamo Savonarola's *Compendium revelationum*, where blessed souls are described as moving between the different realms of paradise with effortless ease (p. 119).

86. On the oratorical strategies deployed in this work, wherein fictionalized versions of real people express views they did not necessarily hold, see Lodi Nauta, "Lorenzo Valla and Quattrocento Scepticism," *Vivarium*, 44 (2006), 375–95 (at pp. 379–80).

87. Valla, *De voluptate*, ed. and tr. Hieatt and Lorch, p. 31.

88. Valla, *De voluptate*, iii.24.5, ed. and tr. Hieatt and Lorch, pp. 298–99. The important role which Valla tacitly affords the imagination in this part of his treatise, which features vigorous rhetorical performances intended to convince his audience of the supreme joys of the homeland, is in marked contrast to the negative attitudes to this mental faculty which he expresses in philosophical and theological discussion. There the "dangerous and darker sides" of *imaginatio* are brought out, though Valla's main quarrel is with what he regarded as the excessive abstraction and rebarbative terminology characteristic of scholasticism. See Lodi Nauta, *In Defense of Common Sense*, pp. 101–2, together with his article "Lorenzo Valla and the Limits of Imagination," in Lodi Nauta and Detlev Pätzold (eds.), *Imagination in the Later Middle Ages and Early Modern Times* (Peeters: Leuven, 2004), pp. 93–113.

89. Valla, *De voluptate*, iii.24.10–12, ed. and tr. Hieatt and Lorch, pp. 300–301. Antonio explains that, since he cannot convey a proper account of the soul's goods, he is focusing on the body's goods (and assuming they arrive immediately, after death, rather than in the future *patria*), in order to satisfy his listeners' desire to hear about the afterlife (p. 299).

90. Cf. McDannell and Lang, *Heaven: A History*, pp. 127–28. This passage may be found in the *apparatus criticus* to Hieatt and Lorch's edition of *De voluptate*, p. 411. There is no reason to doubt its authenticity; the textual tradition of Valla's treatise, which he revised several times, is complex. I am grateful to Lodi Nauta for his help here.

91. See further Alastair Minnis, "Unquiet Graves: *Pearl* and the Hope of Reunion," in Fiona Somerset and Nicholas Watson (eds.), *Truth and Tales: Cultural Mobility and Medieval Media* (Columbus: Ohio State University Press, 2015), pp. 117–34.

92. A similarly optimistic statement may be found in *The Myrour of Lewed Men*: "alle is fryndys he shall knowe ther / That he hede in this world her. / Fadur and moder, systur and brother, / Miche ioy euerichon shall make with other, / Mor then eny hert may vnderstonde" (1775–79; *Middle English Translations of Grosseteste's Château d'Amour*, ed. Sajavaara, p. 317). This anticipation of the reunion of earthly family and friends is unparalleled in the original Anglo-Norman; cf. *Le Château d'amour*, ed. Murray, p. 315.

93. The "Asylas" of *Olympia*, 225, is usually identified as Boccaccino. At ll. 72–73 Olympia refers to "Marius and Iulus and my sisters," this being the only evidence for their existence. For discussion, see Vittore Branca, *Giovanni Boccaccio: Profilo biografico*, new ed. (Florence: Sansoni, 1997), pp. 79–80, and Perini's note in his edition of the *Buccolicum Carmen*, on pp. 689–89. I am grateful to David Lummus for his help here.

94. *Paradiso*, ed. and tr. Singleton, pp. 156–57. For discussion, see Gragnolati, *Experiencing the Afterlife*, pp. 158–60, and Nasti, "*Caritas* and Ecclesiology in Dante's Heaven of the Sun." I would quibble with Gragnolati's understanding of "sociability" in heaven (p. 159). Nasti states that "the resurrected soul could not come to fruition in isolation: mothers, fathers, sons, and

daughters are necessary for that joy to be complete" (p. 234), a view which, I believe, is problematic. The fact that the blessed rejoice in the good of others does not mean, cannot mean, that the happiness of a given soul is in some way dependent on that of others; such a circumstance would be quite antithetical to the hierarchical structure of individual merit and reward which the schoolmen describe (see pp. 187–190).

95. McDannell and Lang claim that, in the early modern period, friends "became an important ingredient of paradise. In its boldest form, the new theology envisioned heaven as a place of erotic human love in the bucolic setting of a comfortable natural landscape"; "the restored paradise garden, the new Jerusalem, and heavenly love were redefined and brought into a new configuration. Without losing its divine center, heaven became more worldly, more human" (*Heaven: A History*, p. 112). This applies predominantly to Catholic Europe—and bespeaks posthumous relationships which trouble further the attempted reconciliations between inequality of reward (as related to personal merit) and the community of shared beatitude, which are characteristic of late medieval scholasticism. In contrast, as McDannell and Lang note, the Protestant reformers envisaged a theocentric heaven, with "eternal life" being seen "primarily as the individual's unsurpassed communion with God" (p. 148).

96. *Collected Poems*, ed. Finneran, p. 193.

97. Thomas Aquinas, *In IV Sent.*, dist. xliv, qu. 2, art. 4, solutio 1, ad 3um (*Aquinatis opera*, vii.2, 1099). See p. 159. Or, to cite Giorgio Agamben's elegant elaboration of a version of this thinking, "The naked, simple human body is not displaced here into a higher and nobler reality; instead, liberated from the witchcraft that once separated it from itself, it is as if this body were now able to gain access to its own truth for the first time. . . . The glorious body is not some other body, more agile and beautiful, more luminous and spiritual; it is the body itself." *Nudities*, pp. 102–3.

98. Following the Last Judgment, the bodies of the damned—dark rather than brilliantly bright, burdensome rather than agile—will remain capable of suffering, and be afflicted by corporeal fire. See the summary account in Aquinas, *Summa contra gentiles*, iv.89–80 (*Aquinatis opera*, v.379–80); cf. Peter Lombard, *IV Sent.*, dist. xliv, 5 (255), 6 (256), and 7 (257); also dist. xlix, 1 (280), 2 (*Lib. sent.*, ii.519–20, 548–49; tr. Silano, iv.241–43, 266). The issue of whether the sufferings of the separated souls of the damned are in some way corporeal was far more difficult to resolve; for discussion, see Mowbray, *Pain and Suffering*, pp. 104–58. A tendency to see that torment simply in terms of internal, mental suffering was condemned in 1270 by Bishop Tempier of Paris, who insisted that disembodied souls could indeed suffer the pain of corporeal fire. Denifle and Chatelain (eds.), *Chartularium universitatis Parisiensis*, i.543. The implications for figurative language are fascinating. At *Summa contra gentiles*, iv.90[8–9], Aquinas explains that when Scripture "threatens certain bodily punishments to sinners, these are to be understood in a bodily fashion (*corporaliter*)" and as "properly [i.e., non-figuratively] spoken." However, in certain cases some of them can be understood figuratively—at least, when referring to the hell of disembodied souls (though that situation has its own complications involving bodiliness, as already noted). Thus, the "weeping and gnashing of teeth" referred to at Matthew 8:12 "cannot be understood of spiritual substances except metaphorically (*metaphorice*)." But conditions are quite different in the *patria*: with regard to the bodies of the damned after the resurrection, there is "nothing to stop" such a statement "being read corporeally (*corporaliter*)." (Aquinas adds the scientific qualification that, since the damned body has to remain stable in order to endure perpetually its punishments, it cannot lose moisture in the form of tears; nevertheless, there will be "the sorrow of the heart and the perturbation of the

eyes and head which usually accompany weeping.") So, yet again, the principle seems apparent: when bodies rematerialize, metaphors materialize. *Aquinatis opera*, v.379–80.

99. Mowbray makes a related point, in noting that Albert the Great argued that "a perfectly formed body was required in order for it to suffer the punishments of hell," and "Aquinas was in agreement with Albert that the body required perfection in order to suffer" (*Pain and Suffering*, pp. 147, 149). No bodily deformity sustained in the present life must hinder the damned body's capacity to suffer in the next.

100. Elaine Scarry has asserted that "to acknowledge the radical subjectivity of pain is to acknowledge the simple and absolute incompatibility of pain and the world. The survival of each depends on its separation from the other": *The Body in Pain: The Making and Unmaking of the World* (New York: Oxford University Press, 1985), p. 50. Medieval theologies of pain and punishment simply do not bear this out. Acknowledgment of "the radical subjectivity of pain" was quite compatible with makings of worlds wherein the presence and infliction of pain is not just allowed but systematically justified, and assigned a secure place within larger structures, other parts of which offer the prospect of pleasure—while making it grimly clear that pleasure is not for all.

101. The debate may be framed in a different way, with arguments concerning positive or negative "conceptions of the body" (which cite paradisal pleasures and hellish pains, respectively) being separated out from those concerning the body as a constituent of selfhood. Whether the body is in pleasure or in pain does not necessarily affect the issue of whether a distinctive "self" is involved in either experience. And, of course, any such discussion has to address the fact that scholastic notions of numerical oneness ("identity" in a quite technical sense) are some distance away from most modern notions of selfhood and "individuality"; the danger of semantic slippage is obvious.

BIBLIOGRAPHY

PRIMARY SOURCES

Abelard, Peter. *In Hexaëmeron*, PL 178, 729–84.

Agrippa, Heinrich Cornelius, von Nettesheim. *Declamatio de nobilitate et praecellentia foeminei sexus*, ed. R. Antonioli et al. (Geneva: Droz, 1990). Tr. Albert Rabil, *Declamation on the Nobility and Preeminence of the Female Sex* (Chicago: University of Chicago Press, 1996).

Alan of Lille. *Anticlaudianus*, ed. Massimo Sannelli (Trento: La Finestra, 2004). Tr. J. J. Sheridan (Toronto: Pontifical Institute, 1973).

———. *De fide catholica*. PL 210, 305–430.

Ambrose. *De Cain et Abel libri duo*. PL 14, 315–60.

———. *De paradiso*. PL 14, 275–314.

———. *Hexameron, Paradise, and Cain and Abel*, tr. John J. Savage (New York: Fathers of the Church, 1961).

Anselm of Canterbury. *Dicta Anselmi*, in *Memorials of St. Anselm*, ed. R. W. Southern and F. S. Schmitt, Auctores Britannici Medii Ævi, 1 (London: Oxford University Press, 1969), pp. 105–95.

———. *The Major Works*, ed. Brian Davies and Gillian Evans (Oxford: Oxford University Press, 1998, rpt. 2008).

———. *Opera omnia*, ed. F. S. Schmitt, 6 vols. (Edinburgh: Thomas Nelson & Sons, 1940–61).

Apologiae duae, ed. R. B. C. Huygens, with an introduction on beards in the Middle Ages by Giles Constable, CCCM 62 (Turnholt: Brepols, 1985).

Aquinas, Thomas. *Super I Epistolam B. Pauli ad Corinthios lectura*, cap. 15, lect. 2; on the *Corpus Thomisticum* website, http://www.corpusthomisticum.org/c1v.html.

———. *In Aristotelis librum de Anima commentarium*, ed. Angelo M. Pirotta, 2nd ed. (Turin: Marietti, 1936). Tr. Kenelm Foster and Silvester Humphries, *Aristotle's* De Anima *in the Version of William of Moerbeke and the Commentary of St. Thomas Aquinas* (New Haven, Conn.: Yale University Press, 1951). Also tr. by Robert Pasnau, *Thomas Aquinas: A Commentary on Aristotle's* De anima (New Haven, Conn.: Yale University Press, 1999).

———. *De malo*, ed. and tr. Brian Davies and Richard Regan (Oxford: Oxford University Press, 2001).

———. *Opuscula theologica* (Rome: Marietti, 1954).

———. *Quaestiones disputatae,* ed. Raymundus Spiazzi, 9th ed., 2 vols. (Turin: Marietti, 1953). Tr. Robert W. Mulligan, James V. McGlynn, and Robert W. Schmidt, *The Disputed Questions on Truth*, 3 vols. (Chicago: Henry Regnery, 1952–54).

————. *Summa contra gentiles. On the Truth of the Catholic Faith.* Book Four: *Salvation*, tr. Charles J. O'Neil, 4 vols. in 5 parts (Garden City, N.Y., Hanover House, 1955–57).

Aristotle, Pseudo-. *Problemata*, ed. W. S. Hett, 2 vols. (Cambridge, Mass.: Harvard University Press, 1936–65).

Les arts poétiques du XIIe et du XIIIe siècle, ed. Edmond Faral (Paris: Champion, 1924).

Athanasius. *The Life of Saint Anthony*, tr. Robert T. Myers (Westminster, Md.: Newman Press, 1950).

Augustine. *De bono coniugali. PL* 40, 371–96.

————. *Confessions*, tr. Henry Chadwick (Oxford: Oxford University Press, 1991).

————. *Contra academicos. PL* 32, 903–58.

————. *Enchiridion*, ed. Otto Scheel (Tübingen: Mohr, 1930).

————. *Epistula* 102. *PL* 33, 370–86.

————. *De Genesi ad litteram inperfectus liber.* CSEL 28.1, 459–503. Tr. Edmund Hill in *The Works of Saint Augustine: A Translation for the 21st Century*, 1.13: *On Genesis* (New York: New City Press, 2002), pp. 105–51.

————. *In Johannis Evangelium tractatus CXXIV. PL* 35, 1379–976.

————. *De trinitate. PL* 42, 819–1098.

Bacon, Roger. *Opus maius*, ed. J. H. Bridges, 3 vols. (London: Williams and Norgate, 1900).

Bartholomew the Englishman. *On the Properties of Things. John Trevisa's translation of Bartholomaeus Anglicus* De proprietatibus rerum, general ed. M. C. Seymour, 3 vols. (Oxford: Clarendon Press, 1975–88).

Basil the Great. *Sur l'origine de l'homme. Homelie X et XI de l'Hexaéméron par Basile de Césarée*, ed. Alexis Smets and Michel Van Esbroeck (Paris: E'ditions du Cerf, 1970).

————. *St. Basil the Great: On the Human Condition*, tr. Nonna V. Harrison (Crestwood, N.Y.: St. Vladimir's Seminary Press, 2005).

Bede, the Venerable. *Hexaëmeron, sive libri quatuor in principium Genesis. PL* 91, 9–190.

————. *Homilia* xviii. *PL* 94, 96–101.

Bellarmine, Robert. *The Joys of the Blessed, being a Practical Discourse concerning the Eternal Happiness of the Saints in Heaven, translated from the original Latin of Cardinal Bellarmin by Thomas Foxton, with an Essay on the same Subject written by Mr. Addison* (London: Curll, 1822).

Bestiary, or Book of Beasts: MS Bodley 764, ed. and tr. Richard Barber (Woodbridge: Boydell Press, 1999).

Biblia pauperum: A Facsimile and Edition, ed. Avril Henry (Ithaca, N.Y.: Cornell University Press, 1987).

Blamires, Alcuin, with Karen Pratt and C. W. Marx (eds.). *Woman Defamed and Woman Defended: An Anthology of Medieval Texts* (Oxford: Clarendon Press, 1992).

Boccaccio, Giovanni. *Eclogues*, ed. Janet Levarie Smarr (New York: Garland, 1987).

————. *The Latin Eclogues*, tr. David R. Slavitt (Baltimore: Johns Hopkins University Press, 2010).

————. *Olympia*, ed. Giorgio Bernardi Perini in *Tutte le opere di Giovanni Boccaccio*, ed. Vittore Branca, vol. 5, pt. 2 (Milan: Mondadori, 1994), pp. 689–1085.

Boethius, Anicius Manlius Severinus. *De consolatione philosophiae.* Tr. V. E. Watts (Harmondsworth: Penguin Books, 1969).

Bonaventure. *Tria opuscula* (Quaracchi: Ex Typographia Collegi S. Bonaventurae, 1938).

Bracken, Henry. *The Midwife's Companion; or, a Treatise of Midwifery* (London: Clarke and Shuckburgh, 1713).

Bridget of Sweden. *Revelaciones Book V*, ed. Birger Bergh (Uppsala: Almqvist & Wiksells Boktryckeri, 1971). Tr. Albert R. Kezel in *Birgitta of Sweden: Life and Selected Revelations*, ed. Marguerite T. Harris and Albert R. Kezel (New York: Paulist Press, 1990).

Bunyan, John. *Works*, ed. George Offor, 3 vols. (Glasgow: Blackie, 1862).

Calvin, John. *A Commentary on Genesis*, tr. and ed. John King (London: Banner of Truth Trust, 1965).

———. *Institutes of the Christian Religion*, tr. Henry Beveridge, 3 vols. (Edinburgh: Calvin Translation Society, 1845–46).

Carthusian Spirituality: The Writings of Hugh of Balma and Guigo de Ponte, tr. Dennis D. Martin (New York: Paulist Press, 1997).

Chartularium Universitatis Parisiensis, ed. Henricus Denifle and Aemilio Chatelain, 4 vols. (Paris: ex typis fratrum Delalain, 1889–97).

Chaucer, Geoffrey. *The Riverside Chaucer*, general ed. Larry D. Benson, 3rd ed. (Oxford: Oxford University Press, 2008).

Christine de Pizan. *Le livre de la cité des dames*. Tr. Earl Jeffrey Richards, *Christine de Pizan: The Book of the City of Ladies* (New York: Persea Books, 1998).

Chrysostom, John. *In Genesim. PG* 53, 21–386.

Comestor, Peter. *Historia scholastica. PL* 198, 1049–722.

Corpus antiphonalium officii, ed. Renate-Joanne Hesbert, 6 vols. (Rome: Herder, 1963–79).

Corpus Iuris Canonici, ed. A. Friedberg, 2 vols. (Leipzig, 1879–81; repr. Graz: Akademische Druck- u. Verlagsanstalt, 1959).

Cursor Mundi, the Southern Version, vol. 1, ed. Sarah M. Horrall (Ottawa: University of Ottawa Press, 1978).

Dante Alighieri. *The Divine Comedy: Paradiso*, ed. and tr. Charles S. Singleton (Princeton, N.J.: Princeton University Press, 1982).

———. *The Divine Comedy: Purgatorio*, ed. and tr. Charles S. Singleton (Princeton, N.J.: Princeton University Press, 1973).

———. *The Divine Comedy*, vol. 3: *Paradise*, tr. Mark Musa (Harmondsworth: Penguin Books, 1986).

De Lorris, Guillaume, and Jean de Meun. *Le Roman de la Rose*, ed. Félix Lecoy, 3 vols. (Paris: Champion, 1973–85). Tr. Frances Horgan (Oxford: Oxford University Press, 1994).

Dionysius, Pseudo-. *The Complete Works,* tr. Colm Luibheid with Paul Rorem (New York: Paulist Press, 1987).

Donne, John. *The Poems*, ed. Herbert Grierson (London: Oxford University Press, 1964).

An Early Commentary on the "Poetria Nova" of Geoffrey of Vinsauf, ed. Marjorie Curry Woods (New York: Garland, 1985).

Evrart de Conty. *Le Livre des Eschez amoureux moralisés*, ed. Françoise Guichard-Tesson and Bruno Roy, Bibliothèque du moyen français, 2 (Montreal: CERES, 1993).

Exameron Anglice, or *The Old English Hexameron*, ed. S. J. Crawford (Hamburg: Henri Grand, 1921)

FitzRalph, Richard. *Defensio curatorum* (Middle English version), in *Dialogus inter militem et clericum, Richard FitzRalph's Sermon "Defensio curatorum" and Methodius, "Þe bygynnyng of þe world and þe ende of worldes," by John Trevisa*, ed. Aaron J. Perry, EETS 167 (London: Oxford University Press, 1925), pp. 39–93.

———. *De pauperie salvatoris*, books 1–4, published as an appendix to John Wyclif, *De dominio divino libri tres*, ed. Reginald Lane Poole (London: Trübner, 1890), pp. 273–476.

Fonte, Moderata. *Il merito delle donne*, tr. Virginia Cox, *The Worth of Women: Wherein Is Clearly Revealed Their Nobility and Their Superiority to Men* (Chicago: University of Chicago Press, 1997).

Giles of Rome. *Errores philosophorum*, ed. Joseph Koch and English tr. by John O. Riedl (Milwaukee, Wisc.: Marquette University Press, 1944).

———. *De regimine principum*. Tr. John Trevisa, *The Governance of Kings and Princes: John Trevisa's Middle English Translation of the* De regimine principum *of Aegidius Romanus*, ed. David C. Fowler, Charles F. Briggs, and Paul G. Remley (New York: Garland, 1997).

———. *Tractatus aurea de formatione corpus humanum in utero* (Paris, 1515).

Gregory of Nyssa. *De hominis opificio*. PG 44, 123–256.

Gregory the Great. *Moralium libri*. PL 75, 509–1161.

Grosseteste, Robert. *Abbreviatio by Frater Andreas, O.F.M., of the commentaries by Robert Grosseteste on the Pseudo-Dionysius*, ed. and tr. James McEvoy, prepared for publication by Philipp W. Rosemann (Paris: Peeters, 2012).

———. *Commentary on The Celestial Hierarchy of Pseudo-Dionysius the Areopagite*, ed. and tr. J. S. McQuade (Ph.D. thesis, Queen's University of Belfast, 1961). [See also under "*Mystical Theology*" below]

———. *Le Château d'amour de Robert Grosseteste, évêque de Lincoln*, ed. J. Murray (Paris: Champion, 1918).

———. *De luce*, in *Die Philosophischen Werke Des Robert Grosseteste, Bischofs Von Lincoln*, ed. Ludwig Baur (Münster: Aschendorff, 1912), VII, pp. 51–69. Tr. Clare C. Riedl, *Robert Grosseteste on Light (De luce)* (Milwaukee, Wisc.: Marquette University Press, 1942).

———. *The Middle English Translations of Robert Grosseteste's* Château d'Amour, ed. Kari Sajavaara, Mémoires de la Société Néophilologique, 32 (Helsinki: Société Néophilologique, 1967).

Gui, Bernard. *Manuel de l'Inquisiteur*, ed. G. Mollat (New York: AMS Press, 1980).

Henry of Ghent. *Quodlibet VII*, ed. G. A. Wilson (Leuven: Leuven University Press, 1991).

Honorius "of Autun." *Elucidarium*. PL 172, 1109–76.

Historye of the Patriarks, ed. Mayumi Taguchi (Heidelberg: Winter Universitätsverlag, 2010).

Hostiensis (Henry of Susa). *Commentaria in quinque libros decretalium* (Venice, 1581; rpt. Turin: Bottega d'Erasmo, 1965).

Hugh of Saint Victor. *De sacramentis*. PL 176, 173–618.

Irenaeus. *Adversus haereses*; *St. Irenaeus of Lyons: Against the Heresies, Book I*, tr. Dominic J. Unger (New York: Paulist Press, 1992).

Isidore of Seville. *Etymologiarum sive originum libri XX*, ed. W. M. Lindsay (Oxford: Clarendon Press, 1911; repr. 1987). Tr. Stephen A. Barney et al. (Cambridge: Cambridge University Press, 2006).

———. *Étymologies, Livre XII*, ed. Jacques André (Paris: Les Belles Lettres, 1986).

Isidore of Seville, Pseudo-. *Liber de ordine creaturarum*, ed. Manuel C. Díaz y Díaz, Monografías de la Universidad de Santiago de Compostela, 10 (Santiago de Compostela, 1972).

Jacobus de Voragine (Iacopo da Varazze). *Legenda aurea: vulgo historia lombardica dicta*, ed. T. Graesse (Dresden: Impensis Librariae Arnoldianae, 1846).

Jean de Meun. *See* De Lorris, Guillaume.

John of Damascus, *De fide orthodoxa*. PG 94, 781–1228. Latin translation by Burgundio of Pisa (1150), ed. E. M. Buytaert, Franciscan Institute Publications, Text Series 8 (St. Bonaventure, N.Y.: Franciscan Institute, 1955).

The Lay Folks Mass Book, ed. T. F. Simmons, EETS 71 (London: Trübner & Co., 1879).

The Life of Saint Thomas Aquinas: Biographical Documents, tr. and ed. with an introduction by Kenelm Foster (London: Longmans, 1959),

Luther, Martin. *Table Talk*, ed. and tr. T. G. Tappert, Luther's Works, 54 (Philadelphia: Fortress, 1967).

Macrobius. *In Somnium Scipionis*, ed. Luigi Scarpa (Padova: Liviana, 1981). Tr. W. H. Stahl, *Macrobius: Commentary on the Dream of Scipio* (New York: Columbia University Press: 1990).

Maffei, Celso. *Delitiosa explicatio de sensibilibus deliciis paradisi* (Verona: Lucas Antonibus Florentinus, 1504).

Mandeville, Sir John. *Travels*, ed. M. C. Seymour (Oxford: Clarendon Press, 1967).

Marinella, Lucrezia. *La Nobilta et l'eccellenza delle donne, co' difetti et mancamenti degli uomoni*, tr. Anne Dunhill, *The Nobility and Excellence of Women, and the Defects and Vices of Men* (Chicago: University of Chicago Press, 1999).

Mechthild of Magdeburg. *Das fließende Licht der Gottheit*, ed. Hans Neumann, 2 vols., Münchener Texte und Untersuchungen zur deutschen Literatur des Mittelalters, 100–101 (Munich: Artemis, 1990–93). Tr. Frank Tobin, *The Flowing Light of the Godhead* (New York: Paulist Press, 1998).

Les merveilles du monde ou Les secrets de l'histoire naturelle, facsimile ed. by Anne-Caroline Beaugendre (Paris: Bibliothèque nationale de France, 1996).

Lindsay, Sir David. *Sir David Lyndesay's Works*, parts 1 and 2, ed. Fitzedward Hall, 2 vols., EETS OS 11 and 19 (London: Trübner, 1865–66).

Milton, John. *Poetical Works*, ed. Henry Darbishire (London: Oxford University Press, 1958, rpt. 1963).

———. *Prose Writings*, ed. K. M. Burton (London: Dent, 1961).

Mirour of Mans Saluacioun: A Middle English Translation of Speculum humanae salvationis, ed. Avril Henry (Philadelphia: University of Pennsylvania Press, 1987).

Moneta of Cremona, *Adversus Catharos et Valdenses libri quinque*, ed. T. Ricchini (Rome, 1743; rpt. Ridgewood, N.J.: Gregg Press, 1964).

Monk of Eynsham. *The Revelation of the Monk of Eynsham*, ed. Robert Easting, EETS OS 318 (Oxford: Oxford University Press, 2002).

Mystical Theology: The Glosses by Thomas Gallus and the Commentary of Robert Grosseteste on De Mystica Theologia, ed. and tr. James McEvoy, Dallas Medieval Texts and Translations, 3 (Paris: Peeters, 2003).

Neuner, J., and J. Dupuis (eds.), *The Christian Faith in the Doctrinal Documents of the Catholic Church*, rev. 4th ed. (New York: Alba House, 1982).

Oresme, Nicole. *De causis mirabilium*, ed. Bert Hansen (Toronto: Pontifical Institute of Mediaeval Studies, 1985).

———. *Le Livre de Yconomique d'Aristote*, ed. Albert Douglas Menut, Transactions of the American Philosophical Society, n.s. 47, pt. 5 (Philadelphia: American Philosophical Society, 1957).

———. *Le Livre du ciel et du monde*, ed. Albert D. Menut and Alexander J. Denomy (Madison: University of Wisconsin Press, 1968).

Origen. *Peri Archon*, PG 11, 112–414.

Otto of Freising. *The Two Cities: A Chronicle of Universal History to the Year 1146 A.D.*, tr. Charles Christopher Mierow, ed. Austin P. Evans and Charles Knapp (New York: Columbia University Press, 1928).

Pearl (Middle English poem). *Pearl: An English Poem of the XIVth Century, with Boccaccio's Olympia*, ed. Israel Gollancz (London: Chatto and Windus, 1921; rpt. New York: Cooper Square Publishers, 1966).

———. *The Poems of the Pearl Manuscript*, ed. Malcolm Andrew and Ronald Waldron, 5th ed. (Exeter: University of Exeter Press, 2011), pp. 53–110.

———. *Sir Gawain and the Green Knight, Pearl, Cleanness, Patience*, ed. J. J. Anderson (London: Dent, 1996).

Play of Adam (*Ordo representacionis Ade*), ed. Carol J. Odenkirchen (Brookline, Mass: Classical Folia Editions, 1976).

Polo, Marco. *Le devisement du monde*, ed. Philippe Ménard et al., 6 vols. (Geneva: Droz, 2001–9).

———. *Milione / Le Divisament dou monde. Il Milione nelle redazioni toscana e franco-italiana*, ed. Gabriella Ronchi (Milan: Mondadori, 1982).

———. *Travels of Marco Polo*, tr. W. Marsden, with revisions by T. Wright and Peter Harris (New York: Knopf, 2008).

The Prick of Conscience. Richard Morris's Prick of Conscience, ed. Ralph Hanna and Sarah Wood, EETS OS 342 (Oxford: Oxford University Press, 2013).

De quatuordecim partibus beatitudinis, ed. Avril Henry and D. A Trotter, Medium Ævum Monographs, n.s. xvii (Oxford: Society for the Study of Mediæval Languages and Literature, 1994).

Richard of Saint Victor. *Benjamin minor. PL* 196, 1–64.

———. *Selected Writings on Contemplation*, tr. Clare Kirchberger (London: Faber and Faber, 1957).

Riga, Peter. *Aurora: Biblia versificata*, ed. Paul E. Beichner (Notre Dame: University of Notre Dame, 1965).

Rimbertinus, Bartholomaeus. *Tractatus de glorificatione sensuum in paradiso* (Venice, 1498).

Sir Gawain and the Green Knight, ed. J. R. R. Tolkien and E. V. Gordon, rev. ed. by Norman Davis (Oxford: Clarendon Press, 1967).

Speght, Rachel. *The Polemics and Poems*, ed. Barbara K. Lewalski (New York: Oxford University Press, 1996).

Tertullian. *Ad nationes. PL* 1, 559–608.

———. *De anima. PL* 2, 641–752.

———. *Apologeticus adversus gentes pro christianis. PL* 1, 257–536.

Tyndale, William. *An Answer to Sir Thomas More's "Dialogue,"* ed. Henry Walter, Parker Society (Cambridge: Cambridge University Press, 1850).

Valla, Lorenzo. *On Pleasure / De voluptate*, ed. and tr. A. Kent Hieatt and Maristella Lorch (New York: Abaris Books, 1977).

Visio Tnugdali: Lateinisch und Altdeutsch, ed. Albrecht Wagner (Erlangen: Deichert, 1882).

The Vision of Tundale, in *Three Purgatory Poems*, ed. Edward E. Foster (Kalamazoo, Mich.: Medieval Institute Publications, 2004), pp. 179–279.

Wesley, John. *Works*, ed. Thomas Jackson, 14 vols. (1831; rpt. London: Wesleyan Conference Office, 1872).

William de la Mare, *Scriptum in secundum librum sententiarum*, ed. Hans Kraml (Munich: Bayerischen Akademie, 1995).

William of Auxerre. *Summa aurea, Liber secundus*, ed. Jean Ribaillier (Paris: E'ditions du Centre national de la recherché scientifique; Rome: Editiones Collegii S. Bonaventurae ad Claras Aquas, 1982).

———. *Summa aurea, Liber quartus*, ed. Jean Ribaillier (Paris: E'ditions du Centre national de la recherche scientifique; Rome: Editiones Collegii S. Bonaventurae ad Claras Aquas, 1985).

William of Ockham. *Opera politica*, ed. G. Sikes, B. L. Manning, R. F. Bennett, H. S. Offler, and R. H. Snape, 3 vols. (Manchester: Manchester University Press, 1940–63).

———. *Quodlibeta septem*, in *Guillelmi de Ockham opera philosophica et theologica. Opera theologica*, 9 (St. Bonaventure: Franciscan Institute, 1980). Tr. Alfred J. Freddoso and Francis E. Kelley, *William of Ockham: Quodlibetal Questions*, 2 vols. (New Haven, Conn.: Yale University Press, 1991).

Winstanley, Gerrard. *Works, with an appendix of documents relating to the Digger Movement*, ed. George H. Sabine (Ithaca, N.Y.: Cornell University Press, 1941).

Wyclif, John. *Select English Works*, ed. Thomas Arnold, 2 vols. (Oxford: Clarendon Press, 1869–71).

———*De civili dominio*, ed. Reginald Lane Poole and Johann Loserth, 4 vols. (London: Trübner & Co., 1885–1904).

———. *Trialogus cum supplementi Trialogi*, ed. G. Lechler (Oxford: Clarendon Press, 1869). Tr. Stephen Lahey, *Wyclif: Trialogus* (Cambridge: Cambridge University Press, 2013).

Yeats, W. B. *The Collected Poems*, ed. Richard J. Finneran, rev. 2nd ed. (New York: Simon & Schuster, 1996).

Secondary Sources

Agamben, Giorgio. *Nudities*, tr. David Kishik and Stefan Pedatell (Stanford, Calif.: Stanford University Press, 2011).

Akbari, Suzanne Conklin, and Amilcare Iannucci (eds.). *Marco Polo and the Encounter of East and West* (Toronto: University of Toronto Press, 2008).

Almond, Philip C. *Adam and Eve in Seventeenth-Century Thought* (Cambridge: Cambridge University Press, 1999).

Astell, Ann W. "A Discerning Smell: Olfaction Among the Senses in St. Bonaventure's *Long Life of St. Francis*," *Franciscan Studies*, 67 (2009), 125–30.

———. *The Song of Songs in the Middle Ages* (Ithaca, N.Y.: Cornell University Press, 1991).

Ball, Bryan W. *The Soul Sleepers: Christian Mortalism from Wycliffe to Priestley* (Cambridge: James Clarke & Co., 2008).

Barsella, Susanna. *In the Light of the Angels: Angelology and Cosmology in Dante's Divina Commedia* (Florence: Olschki, 2010).

Baxandall, Michael. *Painting and Experience in Fifteenth-Century Italy* (Oxford: Clarendon Press, 1972).

Beilin, Elaine V. *Redeeming Eve: Women Writers of the English Renaissance* (Princeton, N.J.: Princeton University Press, 1987).

Belting, Hans. *Hieronymus Bosch, Garden of Earthly Delights* (Munich: Prestel, 2002).

Benson, Pamela. *The Invention of the Renaissance Woman* (University Park: Pennsylvania State University Press, 1992).

Bernheimer, Richard. *Wild Men in the Middle Ages: A Study in Art, Sentiment, and Demonology* (New York: Octagon Books, 1979).

Betts, R. R. "Richard FitzRalph, Archbishop of Armagh, and the Doctrine of Dominion," in H. A. Cronne, T. W. Moody, and D. W. Quinn (eds.), *Essays in British and Irish History in Memory of J. E. Todd* (London: Muller, 1949), pp. 46–60.

Bhattacharji, Santha. "*Pearl* and the Liturgical 'Common of Virgins,'" *Medium Ævum*, 64 (1995), 37–50.

Biernoff, Suzannah. *Sight and Embodiment in the Middle Ages* (Houndmills, Basingstoke: Palgrave Macmillan, 2002).

Biller, Peter. *The Measure of Multitude: Population in Medieval Thought* (Oxford: Oxford University Press, 2000).

Biller, Peter, and Alastair Minnis (eds.), *Medieval Theology and the Natural Body* (York: York Medieval Press with Boydell and Brewer, 1997).

Bishop, Ian. Pearl *in Its Setting* (Oxford: Blackwell, 1968).

Blamires, Alcuin. *The Case for Women in Medieval Culture* (Oxford: Oxford University Press, 1997).

———. "Paradox in the Medieval Gender Doctrine of Head and Body," in Biller and Minnis (eds.), *Medieval Theology and the Natural Body*, pp. 13–29.

Blum, Shirley Neilsen. *Early Netherlandish Triptychs: A Study in Patronage* (Berkeley: University of California Press, 1969).

Bonnell, J. K. "The Serpent with a Human Head in Art and in Mystery Play," *American Journal of Archaeology*, 2.21 (1917), 255–91.

Boureau, Alain. *Théologie, science et censure au XIIIe siècle: le cas de Jean Peckham* (Paris: Belles lettres, 1999).

Boyde, Patrick. *Dante, Philomythes and Philosopher: Man in the Cosmos* (Cambridge: Cambridge University Press, 1981).

Branca, Vittore. *Giovanni Boccaccio: Profilo biografico*, nuova ed. (Florence: Sansoni, 1997).

Brandl, Leopold. *Die Sexualethik des heiligen Albertus Magnus: eine moralgeschichtliche Untersuchung* (Regensburg: F. Pustet, 1955).

Brett, Annabel S. *Liberty, Right, and Nature: Individual Rights in Later Scholastic Thought* (Cambridge: Cambridge University Press, 1997).

Brown, Carleton F. "The Author of *The Pearl*, Considered in the Light of His Theological Opinions," *PMLA*, 19.1 (1904), 115–45.

Brown, Christopher M. *Aquinas and the Ship of Theseus: Solving Puzzles About Material Objects* (London: Continuum, 2005).

Burnett, Charles. "The Superiority of Taste," *Journal of the Warburg and Courtauld Institutes*, 54 (1991), 230–38.

Burns, Norman T. *Christian Mortalism from Tyndale to Milton* (Cambridge, Mass.: Harvard University Press, 1972).

Burrow, J. A. *The Ages of Man: A Study in Medieval Writing and Thought* (Oxford: Clarendon Press, 1986).

———. *Gestures and Looks in Medieval Narrative* (Cambridge: Cambridge University Press, 2002).

Bynum, Caroline Walker. *Christian Materiality: An Essay on Religion in Late Medieval Europe* (New York: Zone Books, 2011).

———. *Fragmentation and Redemption: Essays on Gender and the Human Body in Medieval Religion* (New York: Zone Books, 1991).

———. *The Resurrection of the Body in Western Christianity, 200–1336* (New York: Columbia University Press, 1995).

Bynum, W. F., and R. Porter (eds.). *Medicine and the Five Senses* (Cambridge: Cambridge University Press, 1993).

Cadden, Joan. *The Meanings of Sex Difference in the Middle Ages: Medicine, Science, and Culture* (Cambridge: Cambridge University Press, 1993).

Calarco, Matthew. "Heidegger's Zoontology," in Matthew Calarco and Peter Atterton (eds.), *Animal Philosophy: Ethics and Identity* (New York: Continuum, 2004), pp. 18–30.

Camille, Michael. "Before the Gaze: The Internal Senses and Late Medieval Practices of Seeing," in Robert S. Nelson (ed.), *Visuality Before and Beyond the Renaissance* (Cambridge: Cambridge University Press, 2000), pp. 197–223.

———. *The Medieval Art of Love: Objects and Subjects of Desire* (New York: Abrams, 1998).

Campbell, Neil. "Aquinas' Reasons for the Aesthetic Irrelevance of Tastes and Smells," *British Journal of Aesthetics*, 36.2 (1996), 166–76.

Carlson, David. "The *Pearl*-Poet's *Olympia*," *Manuscripta*, 31 (1987), 181–89.

Carruthers, Mary. *The Book of Memory: A Study of Memory in Medieval Culture* (Cambridge: Cambridge University Press, 1990).

———. *The Experience of Beauty in the Middle Ages* (Oxford: Clarendon Press, 2013).

Cavell, Stanley, Cora Diamond, et al., *Philosophy and Animal Life* (New York: Columbia University Press, 2008).

Chenu, M.-D. *Toward Understanding Saint Thomas* (Chicago: Regnery, 1964).

Chiecchi, Giuseppe. "Per l'interpretazione dell'*Egloga Olimpia* di Giovanni Boccaccio," *Studi sul Boccaccio*, 23 (1995), 219–44.

Cioffi, Caron. "Matelda," in Richard Lansing (ed.), *The Dante Encyclopedia*, 2nd ed. (London: Routledge, 2010), pp. 599–602.

Clouzot, Martine. *Images de musiciens (1350–1500): Typologie, figurations et pratiques sociales*, Centre d'Études supérieures de la Renaissance (Turnhout: Brepols, 2007).

Cohen, Esther. "Towards a History of European Physical Sensibility: Pain in the Later Middle Ages," *Science in Context*, 8 (1995), 47–74.

Cohen, Jeffrey Jerome. *Of Giants: Sex, Monsters, and the Middle Ages* (Minneapolis: University of Minnesota Press, 1999).

———(ed.). *Monster Theory: Reading Culture* (Minneapolis: University of Minnesota Press, 1996).

Cohen, Jeffrey Jerome, and Gail Weiss (eds.). *Thinking the Limits of the Body* (Albany: State University of New York Press, 2003).

Coleman, Janet. "Are There Any Individual Rights or Only Duties? On the Limits of Obedience in the Avoidance of Sin According to Late Medieval and Early Modern Scholars," in Virpi Mäkinen and Petter Korkman (eds.), *Transformations in Medieval and Early-Modern Rights Discourse* (Dordrecht: Springer, 2006), pp. 3–36.

Colie, Rosalie. *Paradoxia epidemica: The Renaissance Tradition of Paradox* (Princeton, N.J.: Princeton University Press, 1966).

Colish, Marcia L. *Peter Lombard*, 2 vols. (Leiden: E. J. Brill, 1994).

Constable, Giles. "Renewal and Reform in Religious Life," in Robert L. Benson and Giles Constable (eds.), *Renaissance and Renewal in the Twelfth Century* (Toronto: University of Toronto Press, 1991), pp. 37–109.

Constas, Nicholas. "'To Sleep, Perchance to Dream': The Middle State of Souls in Patristic and Byzantine Literature," *Dumbarton Oaks Papers*, 55 (2001), 91–124.

Crawford, Patricia. *Women and Religion in England, 1500–1720* (London: Routledge, 1993).

Cristiani, Marta. "Paradise and Nature in Johannes Scotus Erigena," in F. Regina Psaki and Charles Hindley (eds.), *The Earthly Paradise: The Garden of Eden from Antiquity to Modernity* (Binghamton, N.Y.: Global Publications, 2002), pp. 91–100.

Daenens, Francine. "Superiore perchè inferiore: il paradoso della superiorità della donna in alcuni trattati italiani del Cinquecento," in Vanna Gentili (ed.), *Trasgressione tragica e norma domestica. Esemplari di tipologie femminili dalla letteratura Europea* (Rome: Edizioni di Storia e Letteratura, 1983), pp. 11–49.

d'Alverny, Marie-Thérèse. "Comment les théologiens et les philosophes voient la femme," *Cahiers de civilisation médiévale*, 20 (1977), 105–29.

Davidson, Jenny. *Breeding: A Partial History of the Eighteenth Century* (New York: Columbia University Press, 2009).

Davies, Oliver. "Dante's *Commedia* and the Body of Christ," in Montemaggi and Treherne (eds.), *Dante's Commedia: Theology as Poetry*, pp. 161–79.

Davis, J. C., and J. D. Alsop, "Winstanley, Gerrard (bap. 1609, d. 1676)," *Oxford Dictionary of National Biography*, Oxford University Press, 2004; online ed., October 2009 [http://www.oxforddnb.com/view/article/29755, accessed January 15, 2012].

Dawson, J. W. "Richard FitzRalph and the Fourteenth-Century Poverty Controversy," *Journal of Ecclesiastical History*, 34 (1983), 315–44.

Delumeau, Jean. *History of Paradise: The Garden of Eden in Myth and Tradition*, tr. Matthew O'Connell (New York: Continuum, 1995).

Dinzelbacher, Peter. "Il corpo nelle visioni dell'aldilà," in *Micrologus. Natura, scienze e società medievali (Nature, Sciences and Medieval Societies)*, Rivista della Società Internazionale per lo Studio del Medio Evo Latino, 1 (Turnhout: Brepols, 1993), pp. 301–26.

Dixon, Laurinda S. *Bosch* (London: Phaidon, 2003).

Dove, Mary. *The Perfect Age of Man's Life* (Cambridge: Cambridge University Press, 1986).

Dronke, Peter. "Platonic-Christian Allegories in the Homilies of Hildegard of Bingen," in Haijo J. Westra (ed.), *From Athens to Chartres: Neoplatonism and Medieval Thought: Studies in Honour of Edouard Jeauneau* (Leiden: Brill, 1992), pp. 381–96.

Duby, Georges. *A History of Private Life*, vol. 2: *Revelations of the Medieval World*, tr. Arthur Goldhammer (Cambridge, Mass.: Belknap Press, Harvard University, 1988).

Easting, Robert. *Visions of the Other World in Middle English* (Cambridge: D. S. Brewer, 1997).

Eberl, Jason T. "Aquinas on the Nature of Human Beings," *Review of Metaphysics*, 58 (2004), 333–65.

Elliott, Carl (ed.). *Slow Cures and Bad Philosophers: Essays on Wittgenstein, Medicine, and Bioethics* (Durham, N.C.: Duke University Press, 2001).

Emmerson, Richard K. *Antichrist in the Middle Ages: A Study of Medieval Apocalypticism, Art, and Literature* (Seattle: University of Washington Press, 1981).

Emmerson, Richard K., and Bernard McGinn (eds.), *The Apocalypse in the Middle Ages* (Ithaca, N.Y.: Cornell University Press, 1992).

Fahy, Conor. "Three Early Renaissance Treatises on Women," *Italian Studies*, 11 (1956), 47–55.

Ferrante, Joan. *Woman as Image in Medieval Literature, from the Twelfth Century to Dante* (New York: Columbia University Press, 1975).

Finucci, Valeria. "Maternal Imagination and Monstrous Birth: Tasso's *Gerusalemme liberata*," in Valeria Finucci and Kevin Brownlee (eds.), *Generation and Degeneration: Tropes of Reproduction in Literature and History from Antiquity Rhrough Early Modern Europe* (Durham, N.C.: Duke University Press, 2001), pp. 41–77.

Fitzpatrick, Antonia. "Bodily Identity in Scholastic Theology," Ph.D. thesis, University of London, 2013.

———. "Richard de Mediavilla on the Resurrection of the Body," *Studi Francescani*, 107 (2010), 89–124.

Fleming, John V. *The* Roman de la Rose: *A Study in Allegory and Iconography* (Princeton, N.J.: Princeton University Press, 1969).

Flint, Valerie J. "Monsters and the Antipodes in the Early Middle Ages and Enlightenment," *Viator*, 15 (1984), 65–80.

Flood, John. *Representations of Eve in Antiquity and the English Middle Ages* (New York: Routledge, 2011).

Flores, Nona C. " 'Effigies Amicitiae . . . Veritas Inimicitiae': Antifeminism in the Iconography of the Woman-Headed Serpent in Medieval and Renaissance Art and Literature," in Nona C. Flores (ed.), *Animals in the Middle Ages: A Book of Essays* (New York: Garland, 1996), pp. 167–95.

Forster, William J. *The Beatific Knowledge of Christ in the Theology of the Twelfth and Thirteenth Centuries* (Rome: Officium Libri Catholici, 1958).

Fox, Rory. *Time and Eternity in Mid-Thirteenth-Century Thought* (Oxford: Oxford University Press, 2006).

Fränger, Wilhelm. *Hieronymus Bosch*, tr. Helen Sebba (Amsterdam: G + B Arts International, 1999).

Fyler, John. *Language and the Declining World in Chaucer, Dante and Jean de Meun* (Cambridge: Cambridge University Press, 2007).

Gélis, Jacques. *History of Childbirth: Fertility, Pregnancy, and Birth in Early Modern Europe*, tr. Rosemary Morris (Cambridge: Polity Press, 1991).

Gieben, Servus. "Robert Grosseteste and Adam Marsh on Light in a Summary Attributed to St. Bonaventure," in Gunar Freibergs (ed.), *Aspectus and Affectus. Essays and Editions in Grosseteste and Medieval Intellectual Life in Honor of Richard C. Dales* (New York: AMS Press, 1993), 17–36.

Gombrich, E. H. "Bosch's *Garden of Earthly Delights*: A Progress Report," *Journal of the Warburg and Courtauld Institutes*, 32 (1969), 162–70.

———. "The Earliest Description of Bosch's *Garden of Delight*," *Journal of the Warburg and Courtauld Institutes*, 30 (1967), 403–6.

Gracia, Jorge J. E. (ed.). *Individuation in Scholasticism: The Later Middle Ages and the Counter-Reformation, 1150–1650* (Albany: State University of New York Press, 1994).

Gragnolati, Manuele. *Experiencing the Afterlife: Soul and Body in Dante and Medieval Culture* (Notre Dame, Ind.: University of Notre Dame Press, 2005).

Green, Monica. "Bodily Essences: Bodies as Categories of Difference," in Linda Kalof (ed.), *A Cultural History of the Human Body*, vol. 2: *The Middle Ages* (Oxford: Berg, 2010), pp. 149–71.

Green, Richard Firth. "*Le Roi que ne ment* and Aristocratic Courtship," in Keith Busby and Erik Kooper (eds.), *Courtly Literature: Culture and Context* (Amsterdam: Benjamins, 1990), pp. 211–25.

Hamburger, Jeffrey, and Anne-Marie Bouché (eds.). *The Mind's Eye: Art and Theological Argument in the Middle Ages* (Princeton, N.J.: Princeton University Press, 2006).

Harris, Lynda. *The Secret Heresy of Hieronymus Bosch* (Edinburgh: Floris Books, 1995).

Harrison, Peter. *The Fall of Man and the Foundations of Science* (Cambridge: Cambridge University Press, 2007).

Harvey, E. Ruth. *The Inner Wits: Psychological Theory in the Middle Ages and the Renaissance*, Warburg Institute Surveys, 6 (London: Warburg Institute, 1975).

Harvey, Susan Ashbrook. *Scenting Salvation: Ancient Christianity and the Olfactory Imagination* (Berkeley: University of California Press, 2006).

Henderson, Katherine U., and Barbara F. McManus, *Half Humankind: Contexts and Texts of the Controversy About Women in England, 1540–1640* (Urbana: University of Illinois Press, 1985).

Hergan, Jeffrey P. *St. Albert the Great's Theory of the Beatific Vision* (New York: Peter Lang, 2002).

Higgins, Iain Macleod. *Writing East: The "Travels" of Sir John Mandeville* (Philadelphia: University of Pennsylvania Press, 1997).

Hill, Christopher. "The Religion of Gerrard Winstanley," *Past and Present*, supplement 5 (1978).

———. *The World Turned Upside Down: Radical Ideas During the English Revolution* (Harmondsworth: Penguin, 1975).

Hoffeld, Jeffrey M. "Adam's Two Wives," *Metropolitan Museum of Art Bulletin*, 26 (June 1968), 430–40.

Hudson, Anne. "Poor Preachers, Poor Men: Views of Poverty in Wyclif and His Followers," in František Šmahel and Mitarbeit von Elisabeth Müller-Luckner (eds.), *Häresie und vorzeitige Reformation im Spätmittelalter*, Schriften des Historischen Kollegs, 39 (Munich: Oldenbourg, 1998), pp. 41–53.

Huet, Marie-Hélène. *Monstrous Imagination* (Cambridge, Mass.: Harvard University Press, 1993).

Hurley, M. "*Scriptura Sola*: Wyclif and His Critics," *Traditio*, 16 (1960), 275–352.

Husband, Timothy. *The Wild Man: Medieval Myth and Symbolism, Catalogue of an Exhibition Held at the Cloisters, Metropolitan Museum of Art* (New York: Metropolitan Museum of Art, 1980).

Hyland, J. R. "Church Violence—Doctrinally Sanctioned: Aquinas, Animal Rights, and Christianity," at http://www.all-creatures.org/sof/aquinas.html. Accessed December 11, 2013.

Jacquart, Danielle, and Claude Thomasset, *Sexuality and Medicine in the Middle Ages*, tr. Matthew Adamson (Princeton, N.J.: Princeton University Press, 1988).

Jamieson, Dale (ed.). *Singer and His Critics* (Oxford: Blackwell, 1999).

Jeauneau, Edouard. "La division des sexes chez Grégoire de Nysse et chez Jean Scot Érigène," in Jeauneau, *Études Érigéniennes* (Paris: Études augustiniennes, 1987), pp. 343–364.

Jiroušková, Lenka. *Die Visio Pauli: Wege und Wandlungen einer orientalischen Apokryphe im lateinischen Mittelalter unter Einschluß der alttsechischen und deutschsprachigen Textzeugen*, Mittellateinische Studien und Texte, 34 (Leiden: Brill, 2006).

Johansen, Thomas K. *The Power of Aristotle's Soul* (Oxford: Oxford University Press, 2012).

Kelly, H. A. "The Metamorphoses of the Eden Serpent During the Middle Ages and Renaissance," *Viator*, 2 (1971), 301–27.

Kemp, Simon. "A Medieval Controversy About Odor," *Journal of the History of the Behavioral Sciences*, 33 (1997), 211–19.

———. *Medieval Psychology*, Contributions in Psychology, 14 (New York: Greenwood Press, 1992).

Kerby-Fulton, Kathryn. *Books Under Suspicion: Censorship and Tolerance of Revelatory Writing in Late Medieval England* (Notre Dame, Ind.: University of Notre Dame Press, 2006).

Kiser, Lisa. "The Garden of St. Francis: Plants, Landscape, and Economy in Thirteenth-Century Italy," *Environmental History* 8.2 (2003), 229–45.

Knowles, M. David. "The Censured Opinions of Uthred of Boldon," *Proceedings of the British Academy*, 37 (1951), 306–42.

Koch, Robert A. "The Salamander in Van der Goes' *Garden of Eden*," *Journal of the Warburg and Courtauld Institutes*, 28 (1965), 323–26.

Koldeweij, Jos, Paul Vandenbroeck, and Bernard Vermet, *Hieronymus Bosch: The Complete Paintings and Drawings* (Amsterdam: Ludion and NAi, 2001).

Kolsky, Stephen. "Moderata Fonte, Lucrezia Marinella, Giuseppe Passi: An Early Seventeenth-Century Feminist Controversy," *Modern Language Review*, 96.4 (2001), 973–89.

Kren, Thomas (ed.). *Margaret of York, Simon Marmion, and the Visions of Tondal: Papers Delivered at a Symposium Organized by the Department of Manuscripts of the J. Paul Getty Museum in Collaboration with the Huntington Library and Art Collections, June 21–24, 1990* (Malibu, Calif.: Getty Museum, 1992).

Kren, Thomas, and Roger S. Wieck. *The Visions of Tondal from the Library of Margaret of York* (Malibu, Calif.: Getty Museum, 1990).

Lahey, Stephen. *Philosophy and Politics in the Thought of John Wyclif* (Cambridge: Cambridge University Press, 2003).

Lambert, Malcolm D. *Franciscan Poverty: The Doctrine of the Absolute Poverty of Christ and the Apostles in the Franciscan Order, 1210–1323* (London: SPCK, 1961).

———. *Medieval Heresy: Popular Movements from the Gregorian Reform to the Reformation*, 3rd ed. (Oxford: Blackwell, 2002).

Langlois, Ernest. "Le jeu du Roi qui ne ment et le jeu du Roi et de la Reine," *Romanische Forschungen*, 23 (1907), 163–73.

Laqueur, Thomas. *The Making of the Modern Body: Sexuality and Society in the Nineteenth Century* (Berkeley: University of California Press, 1987).

Leclercq, Jean. *Monks and Love in Twelfth-Century France* (Oxford: Oxford University Press, 1979).

Leonardi, Anna Maria Chiavacci. "'Le bianche stole': Il tema della resurrezione nel *Paradiso*," in Giovanni Barblan (ed.), *Dante e la Bibbia: Atti del convegno internazionale promosso da "Biblia," Firenze, 26–27–28 settembre 1986* (Florence: Olschki, 1988), pp. 249–71.

Lepschy, Giulio (ed.). *History of Linguistics*, vol. 2: *Classical and Medieval Linguistics* (London: Longman, 1994).

Lerner, Robert E. *The Heresy of the Free Spirit in the Later Middle Ages* (Berkeley: University of California Press, 1972).

Lewalski, Barbara K. "Speght, Rachel," *Oxford Dictionary of National Biography*, Oxford University Press, 2004; online ed., October 2008 [http://www.oxforddnb.com/view/article/45825, accessed December 29, 2011].

———. *Writing Women in Jacobean England* (Cambridge, Mass.: Harvard University Press, 1993).

Lewis, C. S. *The Great Divorce* (New York: Macmillan, 1946).

———. *The Problem of Pain* (New York: Macmillan, 1973).

Lindberg, David. *Theories of Vision from al-Kindi to Kepler* (Chicago: University of Chicago Press, 1976).

———, (ed.). *Science in the Middle Ages* (Chicago: University of Chicago Press, 1978).

Lindquist, Sherry C. M. *The Meanings of Nudity in Medieval Art* (Farnham, Surrey, England: Ashgate, 2012).

Lummus, David. "The Changing Landscape of the Self (*Buccolicum Carmen*)," in Victoria Kirkham, Michael Sherberg, and Janet Smarr (eds.), *Boccaccio: A Critical Guide to the Complete Works* (Chicago: University of Chicago Press, 2013), pp. 155–69 and 406–13.

Mäkinen, Virpi. *Property Rights in the Late Medieval Discussion on Franciscan Poverty* (Leuven: Peeters, 2001).

Marcett, M. E. *Uthred de Boldon, Friar William Jordan and "Piers Plowman"* (New York: privately printed, 1938).

Marshall, Peter. "The Map of God's Word: Geographies of the Afterlife in Tudor and Early Stuart England," in Bruce Gordon and Peter Marshall (eds.), *The Place of the Dead: Death and Remembrance in Late Medieval and Early Modern Europe* (Cambridge: Cambridge University Press, 2000), pp. 110–30.

Marti, Kevin. "Traditional Characteristics of the Resurrected Body in *Pearl*," *Viator*, 24 (1993), 311–35.

Matter, E. Ann. "Christ, God and Women," in Robert Dodaro and George Lawless (eds.), *Augustine and His Critics* (London: Routledge, 2000), pp. 164–75.

———. *The Voice of My Beloved: The Song of Songs in Western Mediaeval Christianity* (Philadelphia: University of Pennsylvania Press, 1990).

Mazzotta, Giuseppe. *Dante's Vision and the Circle of Knowledge* (Princeton, N.J.: Princeton University Press, 1993).

McCabe, Herbert. *On Aquinas*, ed. Brian Davies with a foreword by Anthony Kenny (London: Continuum, 2008).

McDannell, Colleen, and Bernhard Lang. *Heaven: A History*, 2nd ed. (New Haven, Conn.: Yale University Press, 1998, rpt. 2001).

McEvoy, James. "The Metaphysics of Light in the Middle Ages," *Philosophical Studies*, 26 (1979), 126–45.

———. *The Philosophy of Robert Grosseteste* (Oxford: Clarendon Press, 1982).

McGinn, Bernard. *Antichrist: Two Thousand Years of the Human Fascination with Evil* (San Francisco: HarperSanFrancisco, 1994).

———. *Apocalypticism in the Western Tradition* (Aldershot, Hampshire: Variorum, 1994).

———. *The Foundations of Mysticism* (New York: Crossroad, 1991).

———. *Visions of the End: Apocalyptic Traditions in the Middle Ages* (New York: Columbia University Press, 1998).

McNamee, Maurice B. *Vested Angels: Eucharistic Allusions in Early Netherlandish Paintings* (Leuven: Peeters, 1998).

Metzler, Irina. *Disability in Medieval Europe: Thinking About Physical Impairment During the High Middle Ages, c. 1100–1400* (London: Routledge, 2006),

Miles, Margaret Ruth. *Augustine on the Body* (Missoula, Mont.: Scholars Press, 1979).

———. *Carnal Knowing: Female Nakedness and Religious Meaning in the Christian West* (Boston: Beacon Press, 1989).

———. "The Virgin's One Bare Breast," in Norma Broude and Mary D. Garrard (eds.), *The Expanding Discourse: Feminism and Art History* (New York: Icon Editions, 1992), pp. 26–37.

Minnis, Alastair. "Affection and Imagination in *The Cloud of Unknowing* and Hilton's *Scale of Perfection*," *Traditio*, 39 (1983), 323–66.

———. "*De impedimento sexus*: Women's Bodies and Medieval Impediments to Female Ordination," in Biller and Minnis (eds.), *Medieval Theology and the Natural Body*, pp. 109–39.

———. *Fallible Authors: Chaucer's Pardoner and Wife of Bath* (Philadelphia: University of Pennsylvania Press, 2007).

———. *Magister amoris: The* Roman de la Rose *and Vernacular Hermeneutics* (Oxford: Clarendon Press, 2001).

————. "Material Swords and Literal Lights: The Status of Allegory in William of Ockham's *Breviloquium* on Papal Power," in Jane Dammen McAuliffe, Barry D. Walfish and Joseph W. Goering (eds.), *With Reverence for the Word: Medieval Scriptural Exegesis in Judaism, Christianity and Islam* (New York: Oxford University Press, 2003), pp. 292–308.

————. "Medieval Imagination and Memory," in Alastair Minnis and Ian Johnson (eds.), *The Cambridge History of Literary Criticism*, vol. 2: *The Middle Ages* (Cambridge: Cambridge University Press, 2005), pp. 239–74.

————. *Medieval Theory of Authorship: Scholastic Literary Attitudes in the Later Middle Ages*, 2nd ed. with a new preface (Philadelphia: University of Pennsylvania Press, 2009).

————. "Religious Roles: Public and Private," in Alastair Minnis and Rosalynn Voaden (eds.), *Medieval Holy Women in the Christian Tradition, c. 1100–c. 1500* (Turnhout: Brepols, 2010), pp. 47–81.

————. "Tobit's Dog and the Dangers of Literalism: William Woodford OFM as Critic of Wycliffite Exegesis," in Michael Cusato and G. Geltner (eds.), *Defenders and Critics of Franciscan Life: Essays in Honor of John Fleming* (Leiden: Brill, 2009), pp. 41–52.

————. *Translations of Authority in the Later Middle Ages: Valuing the Vernacular* (Cambridge: Cambridge University Press, 2009).

————. "Unquiet Graves: *Pearl* and the Hope of Reunion," in Fiona Somerset and Nicholas Watson (eds.), *Truth and Tales: Cultural Mobiblity and Medieval Media* (Columbus: Ohio State University Press, 2015), pp. 117–34.

————, and Lodi Nauta, "*More Platonico loquitur*: What Nicholas Trevet Really Did to William of Conches," in Alastair Minnis (ed.), *Chaucer's "Boece" and the Medieval Tradition of Boethius* (Cambridge: D. S. Brewer, 1993), pp. 1–33.

Minnis, Alastair, and A. B. Scott with David Wallace (eds.), *Medieval Literary Theory and Criticism c. 1100–c. 1375: The Commentary Tradition*, rev. ed. (Oxford: Clarendon Press, 1991).

Minnis, Alastair, with V. J. Scattergood and J. J. Smith. *Chaucer's Shorter Poems* (Oxford: Clarendon Press, 1995).

Montemaggi, Vittorio. "In Unknowability as Love: The Theology of Dante's *Commedia*," in Montemaggi and Treherne (eds.), *Dante's Commedia: Theology as Poetry*, pp. 60–94.

Montemaggi, Vittorio, and Matthew Treherne (eds.), *Dante's Commedia: Theology as Poetry* (Notre Dame, Ind.: University of Notre Dame Press, 2010).

Moorman, John. *A History of the Franciscan Order from Its Origins to the Year 1517* (Oxford: Clarendon Press, 1968).

Mowbray, Donald. *Pain and Suffering in Medieval Theology: Academic Debates at the University of Paris in the Thirteenth Century* (Woodbridge: Boydell Press, 2009).

Moxley, Keith. "Hieronymus Bosch and the 'World Upside Down': The Case of *The Garden of Earthly Delights*," in Norman Bryson, Michael Ann Holly, and Keith Moxey (eds.), *Visual Culture: Images and Interpretations* (Hanover, N.H.: University Press of New England, 1994), pp. 104–40.

Müller, Michael. *Die Lehre des hl. Augustinus von der Paradiesesehe und ihre Auswirkung in der Sexualethik des 12. und 13. Jahrhunderts bis Thomas von Aquin; eine moralgeschichtliche Untersuchung* (Regensburg: F. Pustet, 1954).

Muratova, Xénia. "'Adam donne leurs noms aux animaux': L'iconographie de la scène dans l'art du Moyen Âge," *Studi medievali*, 3rd ser., 18 (1977), 367–394 + plates.

Nasti, Paola. "*Caritas* and Ecclesiology in Dante's Heaven of the Sun," in Montemaggi and Treherne (eds.), *Dante's Commedia: Theology as Poetry*, pp. 210–44.

Nauta, Lodi. *In Defense of Common Sense: Lorenzo Valla's Humanist Critique of Scholastic Philosophy* (Cambridge, Mass.: Harvard University Press, 2009).

———. "Lorenzo Valla and the Limits of Imagination," in Lodi Nauta and Detlev Pätzold (eds.), *Imagination in the Later Middle Ages and Early Modern Times* (Peeters: Leuven, 2004), pp. 93–113.

———. "Lorenzo Valla and Quattrocento Scepticism," *Vivarium*, 44 (2006), 375–95.

Newhauser, Richard. *The Early History of Greed: The Sin of Avarice in Early Medieval Thought and Literature* (Cambridge: Cambridge University Press, 2000).

Nolan, Kieran. *The Immortality of the Soul and the Resurrection of the Body according to Giles of Rome* (Rome: Studium theologicum Augustinianum, 1967).

Nold, Patrick. *Pope John XXII and His Franciscan Cardinal: Bertrand de la Tour and the Apostolic Poverty Controversy* (Oxford: Clarendon Press, 2003).

Oakley, John. "John XXII and Franciscan Innocence," *Franciscan Studies*, n.s. 46 (1986), 217–26.

Osborne, Catherine. *Dumb Beasts and Dead Philosophers: Humanity and the Humane in Ancient Philosophy and Literature* (Oxford: Oxford University Press, 2007).

Pagels, Elaine. *Adam, Eve, and the Serpent* (New York: Random House, 1988).

Palmer, Nigel. *"Visio Tnugdali": The German and Dutch Translations and Circulation in the Later Middle Ages*, Münchener Texte und Untersuchungen zur deutschen Literatur des Mittelalters, 76 (Munich: Artemis, 1982).

Palmer, R. "In Bad Odour: Smell and Its Significance in Medicine from Antiquity to the Seventeenth Century," in Bynum and Porter (eds.), *Medicine and the Five Senses*, pp. 61–68 and 285–87.

Pasnau, Robert. *Thomas Aquinas on Human Nature* (Cambridge: Cambridge University Press, 2002).

Polansky, Ronald. *Aristotle's De anima: A Critical Commentary* (Cambridge: Cambridge University Press, 2007).

Poupin, Roland. *Les Cathares, l'âme et la réincarnation* (Portet-sur-Garonne: Loubatières, 2000).

Price, Paola Malpezzi, and Christine Ristaino, *Lucrezia Marinella and the Querelle des Femmes in Seventeenth-Century Italy* (Madison, N.J.: Fairleigh Dickinson University Press, 2008).

Raming, Ida. *The Exclusion of Women from the Priesthood*, tr. Norman R. Adams (Metuchen, N.J.: Scarecrow Press, 1976).

Ramsey, Boniface. *Beginning to Read the Fathers* (London: SCM Press, 1993).

Regan, Tom. *The Case for Animal Rights* (Berkeley: University of California Press, 1983).

Reynolds, Philip Lyndon. *Food and the Body: Some Peculiar Questions in High Medieval Theology* (Leiden: Brill, 1999).

Ryder, Richard. *Animal Revolution* (Oxford: Blackwell, 1989).

Sandler, Lucy Freeman. "Face to Face with God: A Pictorial Image of the Beatific Vision," in W. Mark Ormrod (ed.), *England in the Fourteenth Century: Proceedings of the 1985 Harlaxton Symposium* (Woodbridge: Boydell Press, 1986), pp. 224–35.

Santi, Francesco. "Un nome di persona al corpo e la massa dei corpi gloriosi," in *Micrologus. Natura, scienze e società medievali (Nature, Sciences and Medieval Societies)*, Rivista della Società Internazionale per lo Studio del Medio Evo Latino, 1 (Turnhout: Brepols, 1993), pp. 273–300.

———. "*Utrum plantae et bruta animalia et corpora mineralia remaneant post finem mundi.* L'animale eterno," in *Micrologus. Natura, scienze e società medievali (Nature, Sciences and*

Medieval Societies), Rivista della Società Internazionale per lo Studio del Medio Evo Latino, 4 (Turnhout: Brepols, 1996), 231–64.

Scafi, Alessandro. *Mapping Paradise: A History of Heaven on Earth* (London: British Library, 2006).

Scarry, Elaine. *The Body in Pain: The Making and Unmaking of the World* (New York: Oxford University Press, 1985).

Schleif, Corine. "Christ Bared: Problems of Viewing and Powers of Exposing," in Lindquist (ed.), *The Meanings of Nudity*, pp. 251–78.

Schmitt, J.-C. *La raison des gestes dans l'occident médiéval* (Paris: Gallimard, 1990).

Schofield, William H. "The Nature and Fabric of the *Pearl*," *PMLA*, 19 (1904), 154–215.

Scully, Matthew. *Dominion: The Power of Man, the Suffering of Animals, and the Call to Mercy* (New York: St. Martin's Press, 2002).

Sears, Elizabeth. "Sense Perception and Its Metaphors in the Time of Richard of Fournival," in Bynum and Porter (eds.), *Medicine and the Five Senses*, pp. 17–39.

Shogimen, Takashi. *Ockham and Political Discourse in the Late Middle Ages* (Cambridge: Cambridge University Press, 2007).

Silver, Larry. *Hieronymus Bosch* (New York: Abbeville Press, 2006).

Simpson, James. *Burning to Read: English Fundamentalism and Its Reformation Opponents* (Cambridge, Mass.: Belknap Press, 2007).

———. "Tyndale as Promoter of Figural Allegory and Figurative Language: *A Brief Declaration of the Sacraments*," *Archiv*, 245 (2008), 37–55.

Singer, Peter. *Animal Liberation*, 2nd ed. (London: Jonathan Cape, 1990).

———. *Practical Ethics*, 3rd ed. (Cambridge: Cambridge University Press, 2011).

Singleton, Charles S. *Dante's* Commedia: *Elements of Structure*, Dante Studies, 1 (Cambridge, Mass.: Harvard University Press, 1954).

Smalley, Beryl. "Ralph of Flaix on Leviticus," *RTAM* 35 (1968), 35–82.

———. "Use of the 'Spiritual' Sense of Scripture in Persuasion and Argument by Scholars in the Middle Ages," *RTAM,* 52 (1985), 44–63.

Sorabji, Richard. *Animal Minds and Human Morals: The Origins of the Western Debate* (Ithaca, N.Y.: Cornell University Press, 1993).

Stallybrass, Peter. "Visible and Invisible Letters: Text Versus Image in Renaissance England and Europe," in Marija Dalbello and Mary Shaw (eds.), *Visible Writings: Cultures, Forms, Readings* (New Brunswick, N.J.: Rutgers University Press, 2011), pp. 77–98.

Stark, Judith Chelius. "Augustine on Women: In God's Image, but Less so," in Judith Chelius Stark (ed.), *Feminist Interpretations of Augustine* (University Park: Pennsylvania State University Press, 2007), 215–42.

Steel, Karl. *How to Make a Human: Animals and Violence in the Middle Ages* (Columbus: Ohio State University Press, 2011).

Steinberg, Leo. *The Sexuality of Christ in Renaissance Art and in Modern Oblivion*, 2nd ed. (Chicago: University of Chicago Press, 1996).

Stump, Eleonore. *Aquinas* (London: Routledge, 2003).

———. "Resurrection, Reassembly and Reconstitution: Aquinas on the Soul," in Bruno Niederbacher and Edmund Runggaldier (eds.), *Die menschliche Seele: Brauchen wir den Dualismus?* (Frankfurt: Ontos-Verlag, 2006), pp. 151–71.

Tachau, Katherine H. "God's Compass and *Vana Curiositas*: Scientific Study in the Old French *Bible moralisée*," *Art Bulletin*, 80 (1998), 7–33.

————. *Vision and Certitude in the Age of Ockham: Optics, Epistemology, and the Foundations of Semantics, 1250–1345* (Leiden: Brill, 1988).

Tierney, Brian. *The Idea of Natural Rights: Studies on Natural Rights, Natural Law, and Church Law, 1150–1625* (Grand Rapids, Mich.: Eerdmans, 2001).

Trexler, Richard C. "Gendering Jesus Crucified," in Brendan Cassiday (ed.), *Iconography at the Crossroads* (Princeton, N.J.: Index of Christian Art, 1993), pp. 107–20.

Turner, Denys. *Eros and Allegory: Medieval Exegesis of the Song of Songs* (Kalamazoo, Mich.: Cistercian Publications, 1995).

————. *Thomas Aquinas: A Portrait* (New Haven, Conn.: Yale University Press, 2013).

Völker, Walther, *Kontemplation und Ekstase bei Pseudo-Dionysius Areopagita* (Wiesbaden: Steiner, 1958)

Voss, Jürgen. *Making Sex Revisited: Dekonstruktion des Geschlechts aus biologisch-medizinischer Perspektive* (Bielefeld: Transcript, 2010).

Wallis, Faith (ed.). *Medieval Medicine: A Reader* (Toronto: University of Toronto Press, 2010).

Walsh, Katherine. "FitzRalph, Richard," *Oxford Dictionary of National Biography*, Oxford University Press, 2004; online ed., May 2010 [http://www.oxforddnb.com/view/article/9627, accessed January 21, 2012]

————. *Richard FitzRalph in Oxford, Avignon, and Armagh: A Fourteenth-Century Scholar and Primate* (Oxford: Clarendon Press, 1981).

Walsingham, Thomas. *Historia anglicana*, ed. H. T. Riley, 2 vols., Rolls Series (London: Longman, 1863–64).

Watson, Nicholas. "The *Gawain*-Poet as a Vernacular Theologian," in Derek Brewer and Jonathan Gibson (eds.), *A Companion to the Gawain-Poet* (Cambridge: D. S. Brewer, 1997), pp. 293–313.

Weber, Hermann J. *Die Lehre von der Auferstehung der Toten in den Haupttraktaten der scholastischen Theologie; von Alexander von Hales zu Duns Skotus* (Freiburg: Herder, 1973).

Wertheim-Aymès, Clément A. *Hieronymus Bosch: Eine Einführung in seine geheime Symbolik, dargestellt am "Garten der himmlischen Freuden," am Heuwagen-Triptychon, am Lissaboner Altar und an Motiven aus anderer Werke* (Berlin: K. H. Henssel, 1957).

Wicki, Nikolaus. *Die Lehre von der himmlischen Seligkeit in der mittelalterlichen Scholastik von Petrus Lombardus bis Thomas von Aquin* (Freiburg: Universitätsverlag, 1954).

Wilks, Michael. "Predestination, Property, and Power: Wyclif's Theory of Dominion and Grace," rpt. in Wilks, *Wyclif: Political Ideas and Practice: Papers by Michael Wilks*, ed. Anne Hudson (Oxford: Oxbow Books, 2000), pp. 16–32.

Williams, George H. *Wilderness and Paradise in Christian Thought: The Biblical Experience of the Desert in the History of Christianity and the Paradise Theme in the Theological Idea of the University* (New York: Harper, 1962).

Wippel, John F. *The Metaphysical Thought of Godfrey of Fontaines* (Washington, D.C.: Catholic University of America Press, 1981).

————. "Thomas Aquinas on the Separated Soul's Natural Knowledge," in James McEvoy and Michael Dunne (eds.), *Aquinas: Approaches to Truth* (Dublin: Four Courts Press, 2002), pp. 114–40.

Woodbridge, Linda. *Women and the English Renaissance: Literature and the Nature of Womankind, 1540–1620* (Urbana: University of Illinois Press, 1984).

Woolgar, C. M. *The Senses in Late Medieval England* (New Haven, Conn.: Yale University Press, 2006).

Yamamoto, Dorothy. *The Boundaries of the Human in Medieval English Literature* (Oxford: Oxford University Press, 2000).

Zancan, Marina. *Nel cerchio della luna: figure di donna in alcuni testi del XVI secolo* (Venice: Marsilio, 1983).

Zavalloni, Roberto. *Richard de Mediavilla et la controverse sur la pluralité des formes* (Louvain: Éditions de l'Institut supérieur de philosophie, 1951).

Ziegler, Joseph. "Medicine and Immortality in Terrestrial Paradise," in Peter Biller and Joseph Ziegler (eds.), *Religion and Medicine in the Middle Ages* (York: York Medieval Press in association with Boydell and Brewer, 2001), pp. 201–42.

Zirkle, Conway. "Animals Impregnated by the Wind," *Isis*, 25 (1936), 95–130.

GENERAL INDEX

INDEX OF BIBLICAL CITATIONS

ACKNOWLEDGMENTS

I am most grateful to David d'Avray, Susan Crane, Vincent Gillespie, Jeffrey Hamburger, Gillian Rudd, Denys Turner, and Nicholas Watson, for reading my manuscript in an earlier version, and offering me much sage advice. Jim Binns, Ardis Butterfield, Margot Fassler, Bernard McGinn, Lodi Nauta, and Eamonn O'Carragain were generous in their responses to specific queries. Stephen Lahey allowed me to consult a pre-publication text of his translation of John Wyclif's *Trialogus*, and Br. Alexis Bugnolo, editor of the Franciscan Archive, provided me with an installment of the translation of Bonaventure's *Sentences* commentary which he is coordinating. I owe a special debt to Andrew Kraebel, the best research assistant one could wish for, who obtained the high-resolution copies of the images which are published here, along with the requisite permissions. The superb library resources and research support provided by Yale University provided ideal conditions in which to pursue this project. I carried out an extensive revision in the paradisal surroundings of the Bogliasco Foundation's Study Center in Bogliasco, near Genoa; to the staff there I owe many thanks for their superlative hospitality. *From Eden to Eternity* is the third book I have published with Jerry Singerman, Senior Humanities Editor at the University of Pennsylvania Press; his diligence, care, and support are exemplary, and warmly appreciated.

Plate 1 is reproduced courtesy of the Bibliothèque royale de Belgique, Brussels. Plates 2, 8, 9, 10, 11, 12, 17, 19, 21, and 23 are reproduced courtesy of the Bibliothèque nationale de France, Paris. Plates 3, 5, 20, and 24 are reproduced courtesy of the British Library, London. © The British Library Board. Plates 4a–d are reproduced courtesy of the Museo Nacional del Prado, Madrid. Plate 6 is reproduced courtesy of the Bodleian Libraries, The University of Oxford. Plates 7, 13a–c, 14, 16, and 18 are reproduced courtesy of the Beinecke Rare Book and Manuscript Library, Yale University, New

Haven CT. Plate 15 is reproduced courtesy of the Biblioteca nazionale centrale, Florence. Plates 22a–d are reproduced courtesy of the Muzeum Narodowe, Gdansk.

I dedicate this book to my grandson Felix, who arrived in the world alarmingly early, as I was putting the finishing touches to it. A lucky boy indeed.